Notes:

Mini lop bunnys

~~Fro~~ for my birthday

THE ENCYCLOPEDIA OF
HORSES & PONIES

This edition published by Barnes & Noble Publishing, Inc.,
by arrangement with Parragon Publishing

2005 Barnes & Noble Books

M 10 9 8 7 6 5 4 3 2 1

ISBN 0-7607-7277-0

Printed and bound in China

THE ENCYCLOPEDIA OF
HORSES & PONIES

TAMSIN PICKERAL

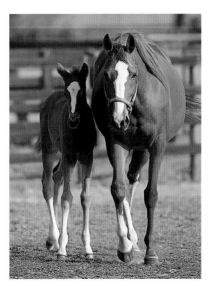

BARNES & NOBLE BOOKS

NEW YORK

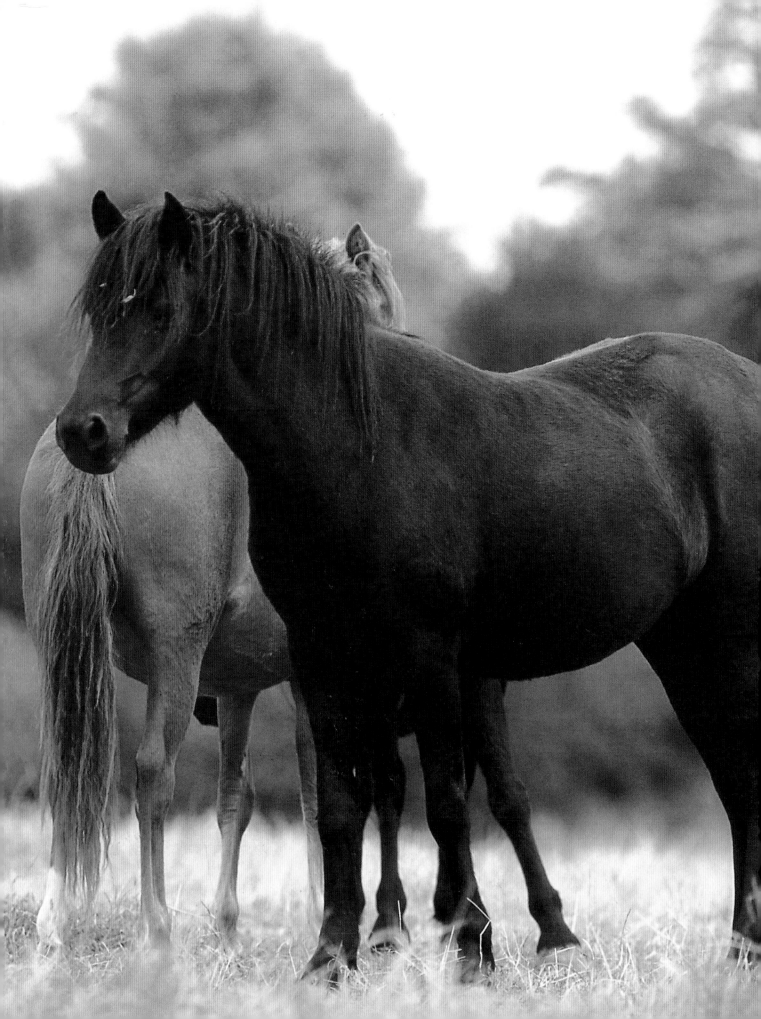

Contents

How to Use this Book

This book contains a number of important features:

- **Eight chapters of detailed information** on all aspects of owning and looking after a horse, the history of horses, and their place in the human world. Photographs, illustrations, informative captions, and 'horse-fact' boxes provide extra detail on every page.
- **Descriptions of nearly 200 horse breeds**. This chapter is divided in to three sections, listing ponies, heavy horses, and light horses in A-Z order.
- **Icons** provide additional information about the blood temperature, primary uses, and temperament of each breed of horse and pony.
- **'Breed Information' boxes** cover height, coat color, and country of origin of each breed.
- **The reference section** comprises a reading list, useful contacts such as riding associations, a glossary of vital equine terms, and an extensive index.

SYMBOLS USED IN THIS ENCYCLOPEDIA

There are certain symbols used throughout the breed sections of the encyclopedia to provide the reader with extra information at a glance. These are as follows: the three blood temperatures of horses and ponies; their primary function, for example whether they are used for dressage, draftwork, general hacking, trotting, jumping, or are feral; and an indication of their temperament, ranging from one to four according to breed sociability, with a symbol containing one horse indicating the most wilful and solitary breeds.

KEY TO SYMBOLS USED IN THIS ENCYCLOPEDIA

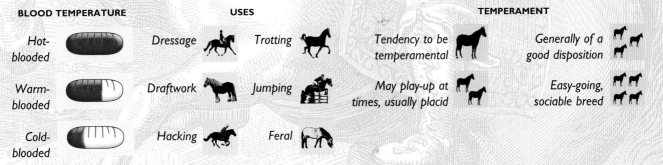

BLOOD TEMPERATURE	USES		TEMPERAMENT
Hot-blooded	Dressage	Trotting	Tendency to be temperamental / Generally of a good disposition
Warm-blooded	Draftwork	Jumping	May play-up at times, usually placid / Easy-going, sociable breed
Cold-blooded	Hacking	Feral	

Introduction

'GOD FORBID THAT I should go to any heaven in which there are no horses,' wrote Robert Bontine Cunningham-Graham in 1917, and this is, I am sure, a true sentiment that is shared by all horse lovers. Over thousands of years the horse has always had the ability to inspire great emotions in people, and these have been expressed through the centuries in myriad art, literature, myths, and legends. There is perhaps nothing as beautiful as the spectacle of man and horse performing together in unity through mutual understanding. I am wholeheartedly a horse devotee and could wax lyrical on the qualities of the horse at great length, but I have tried to remain my objectivity and have put together in this book an unsentimental overview of the horse.

ALL THE key areas of the equestrian world are covered in this book to provide a comprehensive encyclopedia of the many different breeds of horse and pony, and to give an insight in to the horse's role in society over the years. The book is divided into sections to make it easier to find the relevant information. The horse has, since the virtual beginnings of time, been of enormous importance to man, whether for food, for travel, or working on farmland. I have tried to keep the relationship of man and horse as a central theme through the relevant history sections, as well as touching on horse legends and looking at the horse in art.

Hopefully this book will also serve to provide the novice and inexperienced rider with some basic information necessary for dealing with horses. This covers elementary first aid, health, and other areas of stable management. A section on the rudiments of riding is also included, and it must be emphasized that this has been written to provide the very bare bones of the skill of riding; in no way should it be regarded as a comprehensive guide to riding. Similarly, the chapter on training young horses is designed to give merely the basic steps and general ground work. I make no pretence about this being a comprehensive training manual. Inexperienced riders should not be attempting to train young horses, but need to understand the processes involved – hopefully this comes across in this section.

To the various experts in the equine world, I apologize for anything left unsaid and for any margin of human error; this book aims to provide a broad and general insight into key topics of the equine world, and is not in any way designed as an intellectual or detailed study.

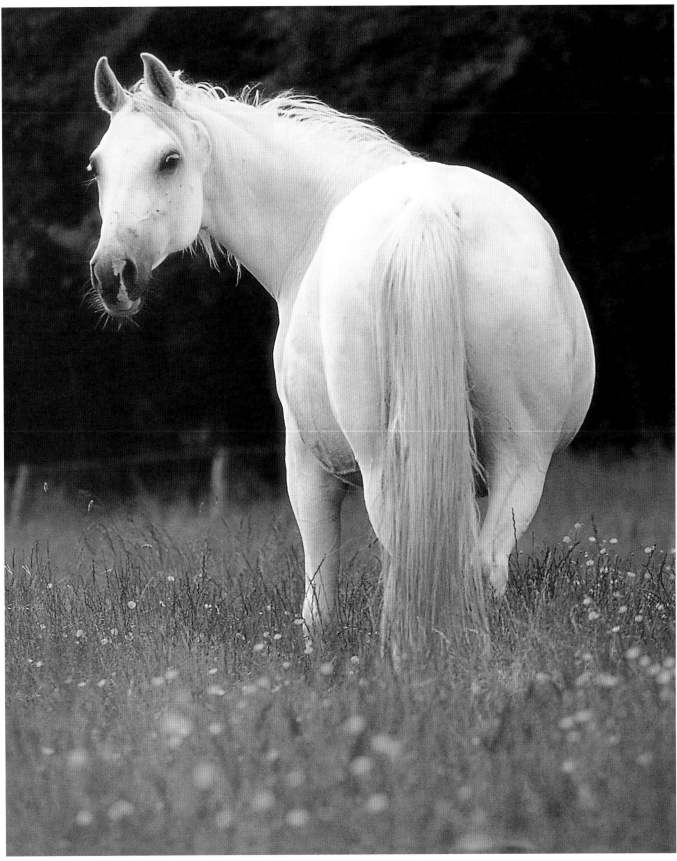

A World of Horses

HORSES MUST surely be the most versatile animals in the world today. They have existed for millions of years, and have over the centuries been used for food, for their hides, for work in agriculture and industry, as a tool of war, a means of transport, for racing, competing, and for pleasure riding. They are highly adaptable, and can live in a wide variety of different climates and terrains.

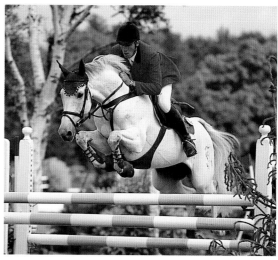

THE BHUTIA and Spiti ponies found in the Himalayas of India, for example, thrive at the high altitude and are ideally suited for this mountainous region, but find the greater humidity and high temperatures of the lowlands hard to cope with. The Akhal-Teke horse from the Karakum Desert in Turkmenistan is able to withstand the extreme heat and cold of the desert climate. There is the famous story of how some Akhal-Teke horses were ridden from Ashkhabad to Moscow in 1935. They covered a distance of two thousand five hundred miles in eighty-four days, and the trip included a two hundred and thirty-five mile journey across the desert, in three days, with no water – a sure testament to their extreme endurance and stamina.

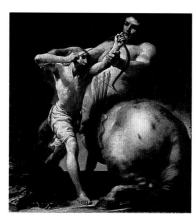

Top
Show jumping is a highly competitive sport which challenges the skill of the horse to the extreme.

Center
A mythological horse is depicted in The Centaur Chiron Teaches the Young Achilles Archery *by Lo Spagnulo.*

Bottom
An Akhal-Teke mare and foal graze in a field.

EVOLUTION OF BREEDS

OVER THE CENTURIES, as different breeds of horse have evolved, they have each become highly adapted to their particular environment, which in part explains why their evolution has been so successful. Consider what a huge impact it must have been when the first horses were domesticated and able to be ridden and driven. It has often been thought that the myth of the Centaur, a half-human and half-horse creature, was inspired by original sightings of the first man on horseback. From a distance they must have appeared to be one animal, half-man and half-horse, and the first sightings of people on horseback probably caused great fear and alarm. Suddenly, our small world became much larger, and with the taming of the horse, whole new horizons were opened up to man.

EARLY HORSEMEN

GENGHIS KHAN, (1162–1227), is perhaps one of the most famous early horsemen. He was an indomitable warrior, conquering northern China and then moving westwards, always on horseback, with his highly trained nomadic soldiers, who were also skilled horsemen. According to the writings of Marco Polo, (1254–1324), Genghis Khan's grandson, the Great Khan, established an incredible message-relaying service which included ten thou-

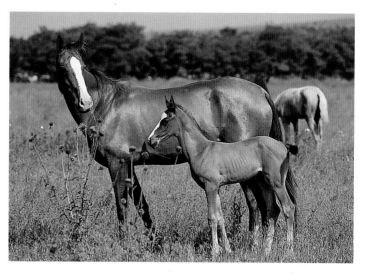

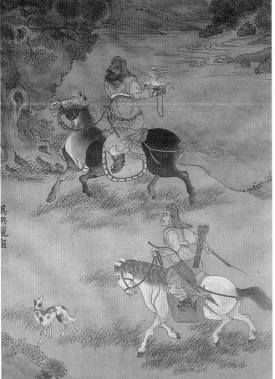

used in agriculture and for transport, and there will always be areas where the horse can work and the tractor cannot. For the main part however, and in our privileged societies, the role of the horse has changed somewhat. Technology has largely replaced the horse in industry and agriculture, and many of the impressive draft breeds are diminishing in numbers and are in danger of disappearing completely, although the breed societies are rigorous in their efforts to maintain the those at risk.

Many of the draft breeds are often crossed with lighter breeds, such as the Thoroughbred, to produce a medium-weight, quality riding horse. Several breweries around England and Europe still keep teams of draft horses, such as Shires, Clydesdales, and Jutlands, which can still be seen pulling brewery drays at larger agricultural shows and in promotional work for the breweries.

Top
Genghis Khan, the founder of the Mongolian empire, on horseback during a falcon hunt.

Center
A beautifully turned out Hanoverian horse and rider in a dressage ring.

Bottom
Shire horses are still used for pulling drays for some breweries; here they are in full show regalia.

sand posts set up thirty miles apart along all of the major highways in his empire. Each resting post boasted four hundred horses, with two hundred resting and another two hundred available, to be ridden in the relay of messages.

MAN AND HIS HORSE

MAN AND HORSE have a seemingly endless relationship, forged through history and continuing today. Indeed, in a few cultures, such as the Kazak people of Eurasia, the horse is still an intrinsic part of everyday life. In some countries, the horse is still

HORSES TODAY

TO A GREATER EXTENT nowadays, horses and ponies are used primarily in recreational pursuits. They provide pleasure to people of all riding abilities and levels, and from all walks of life, from simple pony trekking holidays to international level competitions. It is interesting to note, as just one example of how the horse's role in society has changed, how the Oldenburgh and Hanoverian breeds, which were once most sought after as carriage horses, are now highly popular as competition and riding horses. A large amount of time and money goes into breeding top-rate competition and race horses, and it is every breeder's dream to produce the ultimate equine winner.

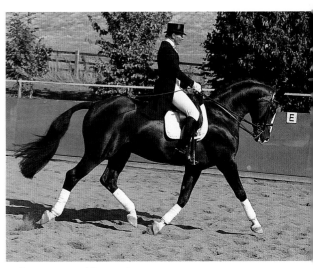

The Anatomy of the Horse

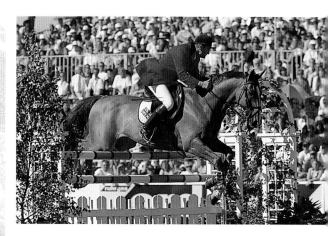

THE SKELETON of the horse is intrinsically linked to the horse's performance, well-being and appearance. It supports the body, maintains body shape, allows for movement, and provides points of attachment for the muscles and tendons – it is the framework around which a horse's body is built. Parts of the equine skeleton protect vital organs; for example, the skull protects the brain and the rib cage protects the lungs and heart.

POINTS OF THE HORSE

Below

Annotated picture of a horse, showing the terms used to describe the different points of the body.

DIFFERENT PARTS of the horse are given names that may seem strange to the new horsey convert. This diagram illustrates the main points of the horse, and it is worth being familiar with these as they occur throughout the book.

HORSE FACT

'The one great precept and practice in using a horse is this, never deal with him when you are in a fit of passion.'
Xenophon, *The Art of Horsemanship*, 400 BC.

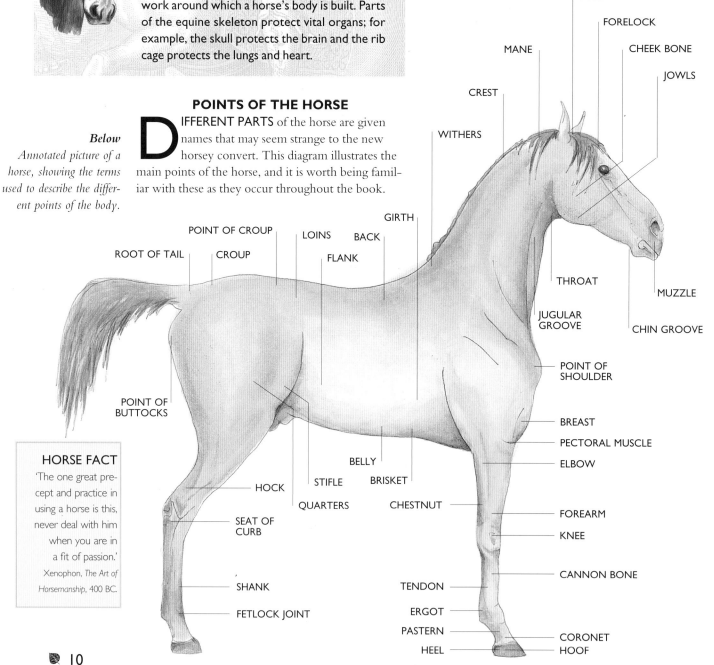

POLL
FORELOCK
CHEEK BONE
MANE
JOWLS
CREST
WITHERS
GIRTH
POINT OF CROUP
LOINS
BACK
ROOT OF TAIL
CROUP
FLANK
THROAT
JUGULAR GROOVE
MUZZLE
CHIN GROOVE
POINT OF SHOULDER
POINT OF BUTTOCKS
BREAST
PECTORAL MUSCLE
BELLY
ELBOW
HOCK
STIFLE
BRISKET
QUARTERS
CHESTNUT
FOREARM
SEAT OF CURB
KNEE
CANNON BONE
SHANK
TENDON
FETLOCK JOINT
ERGOT
PASTERN
CORONET
HEEL
HOOF

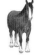

Conformation

HOW TALL?

HORSES AND PONIES are measured in units called 'hands.' One hand is the equivalent of four inches or ten centimeters. Height is referred to in hands and inches, so a pony that is 12.2 hh (hands high) is twelve hands and two inches high. Generally, equids up to 14.2 hh are considered to be ponies, and over 14.2 hh they are considered to be horses. There is now a growing trend to refer to height in centimeters. Whether being measured in hands and inches, or in centimeters, the height is always taken from the ground to the highest point of the withers, and for an accurate reading, the horse should be measured standing on a flat level surface, and without shoes.

CONFORMATION

WHEN REFERRING to the appearance of horses, the term 'conformation' is invariably used. The conformation of a horse is the way the horse has been put together, which is effectively the bone structure beneath the skin. A horse can be described as having 'good conformation', meaning that he is considered to have been put together correctly, and in proportion and balance for the job he has been bred to do. Alternatively, 'bad' or 'poor' conformation' describes a horse that has certain weaknesses in its frame, and that may lead to injury, or at the very least, an impaired ability to do his job. When looking at a horse and considering its conformation, it is important to distinguish between the actual skeletal structure of the horse, and the condition the animal is in.

CONDITION

THE 'CONDITION' of a horse is governed by several factors; what type of work he is doing, what he is fed, his state of health, and how well he is being looked after. A horse that is eventing fit, in good health, and eating the correct amount of food, will have good solid muscle development, and could be described as being in 'good, hard' condition. Similarly, a well-fed, healthy horse that is not working hard, and, therefore, does not have well-developed muscles, could be described as being in 'good, but soft' condition. To the untrained eye, it is easy to mistake a horse lacking in muscle development as having poor conformation; similarly, an overweight horse with an excess of fatty tissue around the quarters and on the crest can be mistaken for being of good conformation. It is important to remember that 'conformation' and 'condition' are two very different things.

Above

This horse has good conformation; its skeletal structure makes it an excellent riding horse.

Above

A horse that is used for racing, eventing, or show jumping should be in optimum condition.

Left

The horse's skeleton has around 250 bones; this varies from breed to breed.

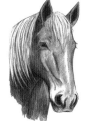

ROUGH GUIDE TO GOOD CONFORMATION

THE FIRST thing to assess when judging a horse's conformation is to establish what type or breed of horse you are looking at. Every breed has different characteristics that you should look for, and if you do not see them, there is some kind of conformational fault. For example, Arabs have a high-set and carried tail because they have one less vertebra in the back than other breeds. Therefore, if you are looking at an Arab horse, and it has a low and poorly-set tail, then it is safe to assume that this is an area of poor conformation.

There are two other points to bear in mind before starting to assess conformation. Firstly, what sex is the horse? Mares invariably have a slightly longer back than geldings, and it is a good idea to keep this in mind. Secondly, how old is the horse? A very old horse sags naturally in the back and will have lost muscle tone, so it is important to take this into account when discussing his conformation.

The head: This should appear to be in proportion to the rest of the body, and the ears should be alert and pricked. A horse should have a broad and flat forehead – a bulging forehead is thought to indicate bad temper and unpredictability – with large, 'kind' eyes set well apart to allow for good peripheral vision. The nostrils should be large enough to allow for maximum intake of air, and the mouth should be neither too long, nor too short. A horse with a very small mouth may be difficult to fit bits to, and a horse with a long mouth can often be strong and a 'puller.' The incisors of the top and the bottom jaw should meet exactly at the front of the mouth, with the top jaw somewhat wider than the bottom jaw. There should be at least a fist-sized space between

the two bones of the lower jaw, indicating unrestricted room for the start of the respiratory tract.

The head should be 'well set' to the neck, meaning that the horse should not be thick in the jowl and gullet region, which would restrict flexion. The neck should be long enough to allow for 'a good length of rein,' with a well-developed top line and a gentle curve from the withers to the poll. As a rough guide, the length of the neck should be equal to one-and-a-half times the length from the poll down the front of the face to the lower lip. The neck should be 'well set' to the shoulder, being neither too low nor too high.

The shoulder: This should be nicely sloping, which allows the horse to move freely. Ideally, the slope should be on a 45 degree angle from the wither to the point of shoulder, in relation to a horizontal ground line. The shoulder blade, or scapula, needs to be longer than the humerus bone to allow for a long, low, smooth stride.

The withers: This should be well formed, being neither too prominent, nor too flat. During a growth spurt young horses will often appear to be lower in the wither than the croup, but as they mature, they should become level. Horses with very flat but mus-

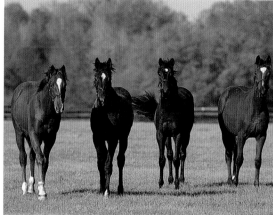

HORSE FACT:

The tallest documented mule is called Apollo. He foaled in 1977, measures 19.1 hh, and is the offspring of a Belgian mare crossed with a mammoth jack.
Guinness Book of Records

Top Right
It is important that the horse's ears are pricked and alert, and the eyes bright and healthy.

Right
When looking at the horse as a whole, the head should be in proportion to the body.

Far Right
These thoroughbred yearlings have well-shaped withers; neither too sloped or too flat.

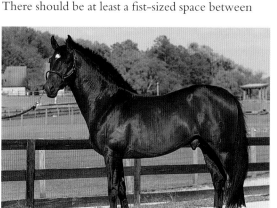

cular withers are not ideal as riding horses but do travel well in harness. They tend to have a somewhat 'rolling' action and can be difficult to fit a saddle to.

The chest: This should be broad and deep, with enough room for a baseball cap to be fitted between the two forearms. This allows ample room for the heart and lungs. The horse should appear to have a 'leg at each corner,' which prevents a close action in front. However, if the chest is too wide, it can again lead to a 'rolling' action which is undesirable. The ideal is a happy medium. The front legs should be straight and in pairs, with a long muscular forearm and short dense cannon bone. The elbow should be clear of the ribs, and you should be able to run a hand between the two. The knees should be a 'pair', facing directly forward, and broad and flat, and the pasterns should slope on a similar angle to the shoulder. If the pasterns are too long, there may be a potential weakness, but if too short, they are less able to cope with concussion. The feet should be in pairs, and well made with tough horn.

OTHER POINTS TO NOTE

THE HORSE should be 'deep through the girth,' so that when viewed from the side, it appears that there is plenty of room for the heart and lungs. As a guide, the distance from the top of the withers to a point just behind and below the elbow should be the same as that from the elbow to the ground, therefore making the horse appear to be short legged. Ideally, the first eight 'true' ribs. which attach to the vertebrae and the sternum, should be long and flattish, which allows the rider's leg to sit nicely behind the triceps

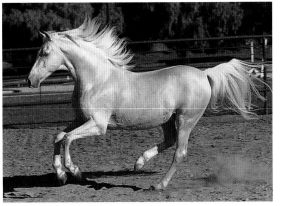

muscle. The ten 'false' ribs, which attach to the vertebrae, and to cartilage attaching them to the sternum, should be rounded and well sprung, giving the appearance of a nicely rounded barrel. There should never be more than a handspan between the last rib and the hip bone; more is a serious conformational defect termed 'being short of a rib.'

The length of the back should be proportionate to the overall size of the horse, from nose to girth should be the same length as from girth to point of buttock. The back should be strong and not too narrow or too broad. The loins and hindquarters should be muscular; from behind, the horse should have well-rounded quarters, be level through the pelvis and have a well-set tail. In the hind legs, the hocks should be 'well let down' (close to the ground), with long and muscular thighs. One should be able to draw a straight line from the point of buttock to the point of hock, to the back of the fetlock joint. Both hock and fetlock joints should be clearly defined with no swelling or lumps, and the hind pasterns and feet should slope at an angle of about fifty degrees.

Left
Horses, such as this palomino, should have broad and deep chests with sufficient room for heart and lungs.

Bottom
The profile of this horse shows that it is deep through the girth, with plenty of room for healthy lungs and heart.

HORSE FACT:
Showjumping was first televized in Great Britain in 1948 during the Olympic Games at Wembley, London.

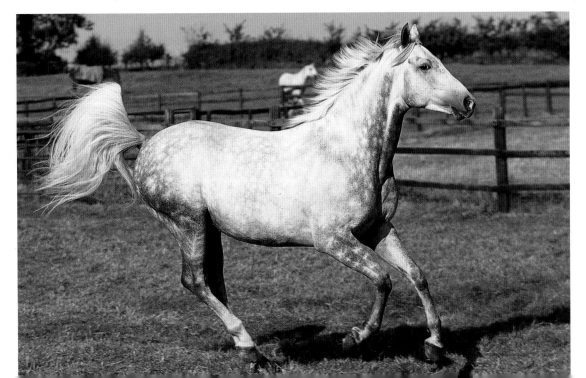

Colors

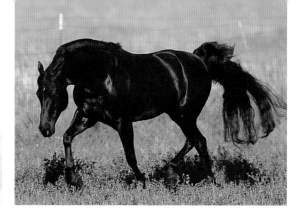

A HORSE'S COAT can come in a wide range of colors which is determined by the dominant and recessive color chromosomes of his parents. A great deal of scientific research has gone into coat coloring, and this has become important as different coat colors have become more, or less, fashionable through the years. In fact, for some breeds, although correct conformation and temperament is required, the main requirement is a set coat color, for example, with the Palomino and the Appaloosa. It is interesting to note that it is believed that the spotted and colored coats (such as the skewbald) originally descended from the Spanish Horse, although this breed today never exhibits that type of coloring.

This Page
Horses have a variety of coat colours; a set coat colour can be an important element in breeding.

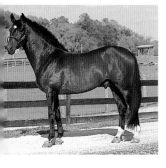

Bay: The body coloring is brown with a black mane and tail, occasional white socks or stockings, and white markings on the face. Bay horses will often have black points, which are black markings on the muzzle, tips of the ears, mane, tail, and lower part of the legs. There are different kinds of bay, described as bright bay, dark bay, light bay, and mahogany bay; these colors are determined by the amount of lighter brown or darker brown hairs in the coat.

Chestnut: The body coloring is reddish brown with no black points. The mane and tail are either a lighter (flaxen) or darker shade of the body color. There may be white markings on the legs or face. There are different kinds of chestnut, such as bright chestnut, red chestnut, and liver chestnut. The different kinds are determined by the reddish-gold shades of the hair; the liver-chestnut has a dark, liver-colored coat.

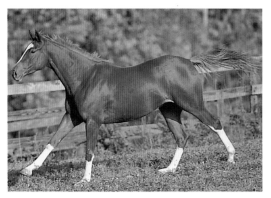

Black: The coat must be a definite black color with no trace of brown hair. The mane and tail must be black, but they may have white markings on the legs or face.

Brown: The body is a mixture of black and brown hair, with a dark brown mane and tail.

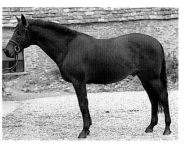

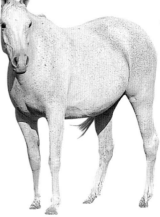

Gray: Their skin pigment is dark and the coat contains black and white hairs. Gray horses are generally born dark and lighten with age. There are different kinds of gray: light gray, which appears 'white;' flea-bitten, which is when a white coat contains dark specks like freckles; iron, which is a very dark gray coat; and dappled, which has dark rings on a gray coat.

Roan: White hairs are mixed evenly into the main coat coloring, and the mane and tail may also contain some white hairs. There are different shades of roan, such as strawberry and red roan, in which white hairs are mixed into either a chestnut or bay coat; blue roan, which is a black, or a black-and-brown body mixed with gray which gives the coat a blue tinge; gray roan; and bay roan.

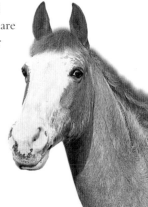

Palomino: The coat is gold, and should be the color of a new cent piece, the mane and tail are lighter, and the horses can have white markings on the legs below the knee, or hock, or on the face.

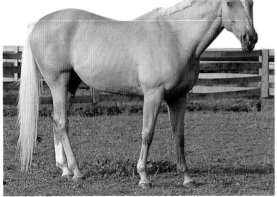

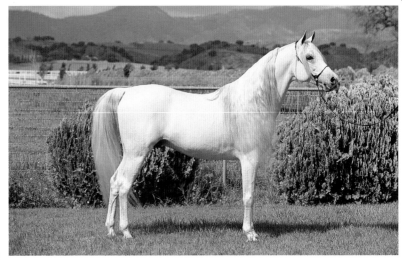

Skewbald: The coat is covered in large irregular patches of white and any other color except black. The skin pigment will be pink under the white patches, and dark under the dark patches. The mane and tail are invariably two-colored, and the mane continues the colorings displayed on the neck – if part of the neck is white and part brown, then the mane will correspond accordingly.

Piebald: Similar to skewbald, except that the coat has patches of black and white.

Dun: The skin is dark, but the coat is a beige or biscuit color, they have black points, a dark dorsal stripe, and can have dark wither stripes and zebra stripes on the legs. Duns range in shades, and a creamy-yellow coat is called a yellow dun.

Cream: The skin pigment is pale, and the coat coloring a pale-cream color, with the mane and tail a pale cream also. Sometimes it is possible to distinguish white leg and face markings.

Appaloosa: There are five recognized color patterns for the Appaloosa, but not all spotted horses are actually Appaloosas. The coat configurations are: blanket, which has white hair over the hips, which may or may not have dark spots; marble, when the coat is a red-or blue-roan, with dark coloring at the edges of the body and a white, frost pattern in the middle; leopard, a white coat coloring with dark spots; snowflake, with dominant spotting over the hips; and frost, which is white speckling on a dark coat. All Appaloosas have mottled skin on the nose and genitalia, and tend to have white sclera round the eyes. Often the hooves have vertical dark stripes on them.

Top and Top Left
A cream Arab, and a Palomino, which always has a lighter mane and tail than coat.

Center and Bottom
Piebald horses are black and white whereas the Appaloosa breed can be any one of five different colour variations.

Bottom Far Left
Dun is a primitive horse coloring which is often accompanied by a dark line of dorsal hair on the back.

HORSE FACT:
The smallest recorded horse was a stallion called Little Pumpkin; foaled on April 15, 1973; he stood 14 in (35.5 cm) high and weighed just 20 lb (9 kg) in 1975.
Guinness Book of Records

15

Markings

MANY HORSES have white markings on them; as they are useful as a means of identification, these are carefully noted by the breed societies. Many breed societies lay down strict regulations on the amount of white a horse may carry to be eligible for registration.

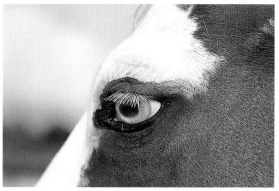

Wall eye: Usually one of the eyes has white or blue-white coloring instead of the normal eye color.

Sclera: The outer membrane of the eyeball is white and is often seen in the Appaloosa.

Top Right
'Wall' describes eyes that are white, blue, or any shade other than the normal brown coloring.

Right and Far Right
These horses have blaze markings on their faces; the pony shows black stockings on its legs.

Far Right and Bottom Right
A dorsal stripe and dapple; a common marking in gray horses.

Bottom
Mealy marking are shown around the mouth of the Exmoor pony.

FACIAL MARKINGS

Star: A small white mark on the forehead, often diamond-shaped.

Stripe: A narrow white line extending down the front of the face.

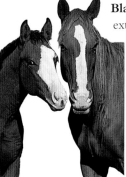

Blaze: A wide white line extending down the middle of the face, usually starting on the forehead and extending to the upper lip.

White face: Similar to a blaze but covering a wider area.

Snip: A small white marking between the nostrils.

White nostril: White markings around the nostrils, similar a to snip.

White muzzle: A completely white muzzle.

Mealy muzzle: A light brown muzzle area; often seen in the Exmoor pony.

Lip marks: White markings on or around the lips.

BODY MARKINGS

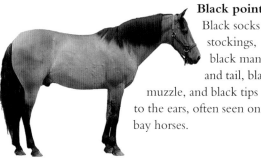

Black points: Black socks or stockings, black mane and tail, black muzzle, and black tips to the ears, often seen on bay horses.

Flaxen mane and tail: The mane and tail are a light cream color; often seen on chestnut horses.

Dorsal or eel stripe: A black or dark brown stripe that extends from the withers along the backbone and down into the tail; often seen on dun horses. Wither stripes sometimes accompany a dorsal stripe – these are lines extending across the wither on either side.

Dapples: Dark circles or rings that appear over lighter areas of the body. Most commonly seen in grays, they can occur in any coat coloring, especially bay, and are usually more visible in the spring or autumn, when the horse is changing its coat.

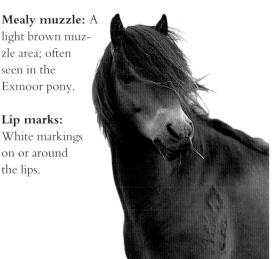

HORSE FACT:
The oldest horse recorded was Old Billy. Foaled in 1760, he died on November 27, 1822, having reached an incredible 62 years of age. *Guinness Book of Records.*

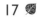

Whorls: Sometimes called 'cowlicks,' these are patterns formed by irregular hair growth, often resembling a rosette-type formation with the hair growing up and out from a central point. They may be seen along the crest or on the underside of the neck, although they can occur anywhere on the body, and are used as an identification marking. Interestingly, both Indian and Arabian cultures lay great significance on the position and type of seen on their horses, to the extent that whorls in some positions they are believed to be a warning, and the horse will not be purchased on account of them. The *Asva Sastra* is a 14th-century Hindu book that details the significance of whorls and other body markings.

LEG MARKINGS

White sock: Front or hind limbs are white from the coronet band upward to any point below the knee or hock.

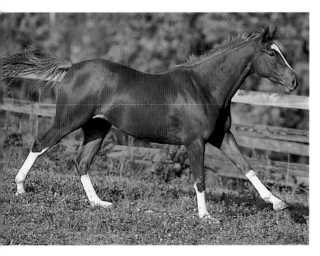

White stocking: Front or hind limbs are white from the coronet band upward to above the knee or hock.

White coronet: The area of the coronet band is white.

Ermine marks: Black or brown dots that appear on or around the coronet or pastern on a white sock.

Zebra marks: Rings of dark hair appearing round the lower leg, which are associated with primitive or feral breeds.

HOOF MARKINGS

Blue hoof: The hooves are of a slate blue-black color. Blue hooves are considered denser and stronger than white hooves, although there is no scientific proof to substantiate this.

White hoof: The hoof has white horn; this is often seen where there is a white markings, such as a sock or stockings, on the leg.

Striped hoof: The hooves have vertical black and white stripes running down them; this is often associated with Appaloosa and other spotted horses.

ARTIFICIAL MARKINGS FOR IDENTIFICATION

Freeze branding: A painless process involving the use of branding irons that have been cooled in liquid nitrogen. The cold destroys the pigment cells in the skin and the hair grows back white. The numbers and letters of the brand are then registered as a permanent record.

Hot-iron branding: This is especially common with warmblood breeds such as the Hanoverian and Oldenburgh, as well as British native pony breeds. Some brands signify a particular breed, while others are the owner's personal mark. They are generally placed on the shoulder or thigh and are permanent.

Hoof branding: The owner's postcode is hot-iron branded onto the hoof wall. This is a painless process, but needs to be redone every six months as the brand grows out with the growth of the hoof wall.

Microchip: A microchip is injected into the skin of the neck by a vet; this commonly used on dogs and cats as well as horses. The details of the horse that has been 'chipped' are registered with a computerized system, and the chip can be read using a scanner.

Top
Stripped hooves are common in Appaloosa and spotted horse breeds.

Above
Freeze marking is a permanent and painless way of branding horses.

Center Left
White socks reach up to the knee on this showy chestnut horse.

Below Left and Bottom
Hoof branding is an alternative painless method of marking horses for easy identification.

17

Teeth and Aging the Horse

I T IS VERY IMPORTANT to keep a close eye on your horse's teeth, and it is a good idea to learn how to open your horse's mouth without injuring yourself or your horse. The best way to do this is under supervision from someone experienced in this practice, who can show you exactly what to do.

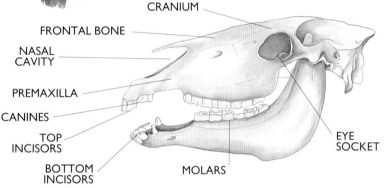

- CRANIUM
- FRONTAL BONE
- NASAL CAVITY
- PREMAXILLA
- CANINES
- TOP INCISORS
- BOTTOM INCISORS
- MOLARS
- EYE SOCKET

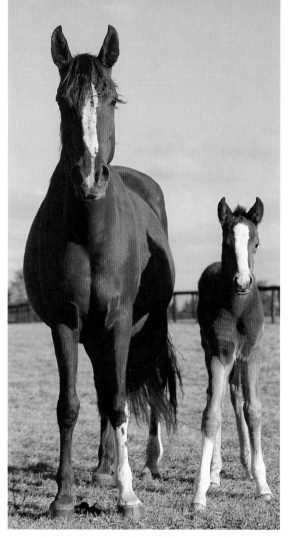

Top Right, Right, and Bottom Right
A horse's skull is elongated to provide enough room for its teeth.

Bottom
The age of a horse can be quite accurately assessed by examining its teeth.

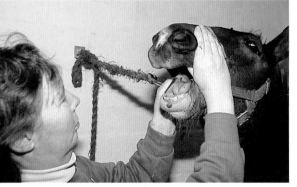

AGING YOUR HORSE

YOUR HORSE'S TEETH need care and attention, and providing a good diet for the animal will go a long way toward aiding this. The teeth are also important as they change quite dramatically as the horse ages, so it is possible to look at the shape and number of the teeth and age the horse

OPENING THE HORSE'S MOUTH

IN FACT, THE MOST accurate way to age a horse, apart from knowing his birth date, is by looking at his teeth. This is, however, quite a skilled job, not least in managing to avoid getting bitten while trying to look in the mouth. Do not attempt to do this unless you are under supervision, or have some experience with horses. If you do, do not stand in front of the horse, but position yourself to the side of his head. Place your left hand on the upper lip under the nostrils, and your right hand under the jaw. To open the horse's mouth, insert the fingers of your right hand into the gap behind the incisors. The horse should now open his mouth. Never grab the tongue as this can result in serious injury to the horse.

THE STRUCTURE OF THE MOUTH

THE ADULT male horse has a total of 40 teeth, made up of 24 molars, 12 incisors, and four tushes. They may also have up to four wolf teeth. Adult female horses do not usually grow tushes, and so have a total of 36

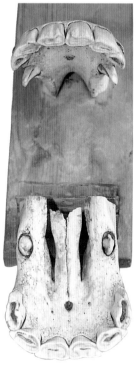

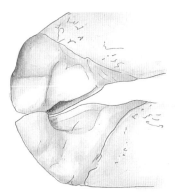

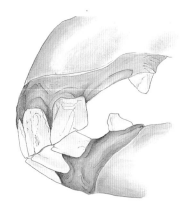

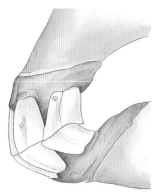

TEETH OF A FOAL　　　**TEETH OF AN EIGHT-YEAR OLD**　　　**TEETH OF A 15-YEAR-OLD**

teeth, plus possibly up to four wolf teeth. Horses are naturally grazing and chewing animals, and as they grind up their food, they are continually wearing down their teeth. By around five years old or so, a horse's permanent teeth will have grown to their full length, and from then on, the teeth are gradually pushed up through the gums to compensate for the continual wearing down of the crown. As the teeth are slowly pushed up from the gums, different sections come into view, and this is how we can tell approximately how old the horse is.

Another point to bear in mind is that the horse's top jaw is wider than the bottom jaw. This means that over time as the horse is grinding up his food, the teeth wear out unevenly. Sharp edges develop on the outside edge of the molars of the top jaw, and the inside edge of the bottom jaw, and these cut into the

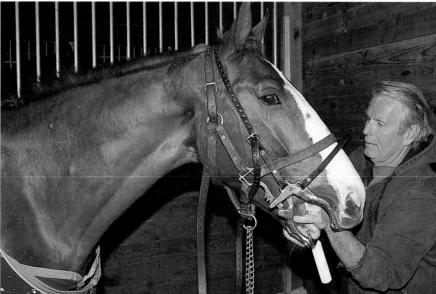

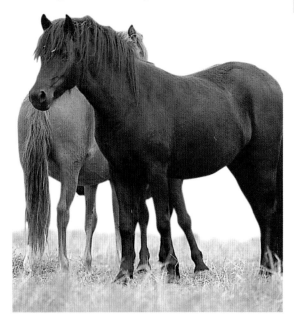

cheeks and cause pain and discomfort, which is why it is very important to have horses teeth rasped. Horses need to have their teeth 'rasped' approximately twice a year, and this involves either a veterinary surgeon or equine dentist checking the teeth and rasping off any sharp points that may have developed on them.

FOALS

LIKE HUMANS, horses grow milk teeth before growing their permanent teeth. The newborn foal probably has its temporary premolars, but generally the central incisors come through in approximately one week. Foals have a full set of milk teeth by around nine months, which consists of six incisors in the top and bottom jaw, and three premolars on each side of the top and bottom jaw. They therefore have a total of 12 incisors and 12 premolars, and they do not grow temporary tushes.

Top
The teeth of the horse as a foal, aged eight years and finally at 15 years.

Center
Tooth rasping is necessary to prevent sharp edges from cutting in to the horse's mouth.

Bottom
Horses first develop milk teeth; they have a full set of milk teeth at around nine months old.

TWO-AND-A-HALF TO THREE YEARS OLD

THE TEMPORARY central incisors are pushed out and replaced by permanent incisors at about two-and-a-half years. The permanent teeth are easy to spot because they are longer, wider, and often more yellow in color than the milk teeth. At around this time, two of the permanent molar teeth appear on each side of the top and bottom jaw.

Right
This chestnut foal was born with a set of pre-molars but will soon develop a set of milk teeth.

Bottom
By four-and-a-half years old, horses will usually have their last two permanent molars.

THREE-AND-A-HALF YEARS OLD

THE LATERAL incisors are also temporary, replaced by permanent incisors, and a further two permanent molars appear on each side of the top and bottom jaw.

FOUR TO FOUR-AND-A-HALF YEARS OLD

THE TEMPORARY corner incisors are replaced with permanent incisors, and the last two permanent molars appear on each side of the top and bottom jaw. At around this time, the male horse starts to grow tushes. By five years old, a horse should have all its permanent teeth.

SIX YEARS OLD

THE FLAT tops of the teeth are called 'tables,' and it is the wear on the tables of the incisors of the lower jaw that is usually studied to determine how old a horse is. By the time the horse is six years old, three main changes occur on the tables of the incisors. First, a dark hole called the infundibulum appears on the tables of the horse's corner incisors. Second, a dark brown line appears on the tables of the central incisors; this is called the dental star. Third, the tables of the lateral incisors show an infundibulum which decreases in size, and between this and the front of the tooth, a dental star will be found.

SEVEN YEARS OLD

THREE MAIN changes occur at around seven years old; first, the dental star becomes more obvious on the tables of both the central and lateral incisors. Second, the infundibulum disappears from

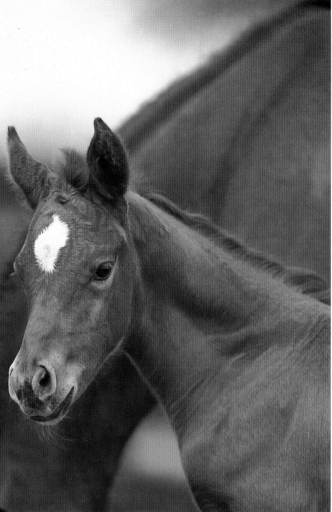

> HORSE FACT:
> 'The one great precept and practice in using a horse is this, never deal with him when you are in a fit of passion.'
> Xenophon, *The Art of Horsemanship*, 400 BC.

Left
After eight years old, it becomes more difficult to age a horse simply by looking at its teeth.

Bottom
By the time that a horse reaches its teenage years, the table of incisors begin to change shape.

the central and lateral incisors, and decreases in size on the corner laterals. Third, a hook starts to appear on the back corner of the upper, corner incisors which is due to uneven wear of the teeth; this generally disappears at around eight years old.

EIGHT YEARS OLD
THE HOOK generally has disappeared, as have the infundibulums. The tables of the teeth, usually starting with the central incisors, start to change shape from oval to triangular. From eight years old and over, it becomes increasingly difficult to age the horse accurately .

TEN YEARS OLD
SOME HORSES start to grow a Galvayne's groove at around 10 years old. This is a groove that appears at the top of the upper corner incisors and begins to grow downward.

ELEVEN TO THIRTEEN YEARS OLD
A PRONOUNCED HOOK sometimes appears on the corner incisors, which should not be mistaken for the hook that appears at seven years old. This larger hook usually remains on the teeth and does not disappear, as in the earlier case.

FIFTEEN YEARS OLD AND OVER
GALVAYNE'S GROOVE appears to have grown about half-way down the tooth by the time the horse is approximately 15 years old, and by 20, the groove will have reached the bottom. From then on, the groove starts to gradually disappear from the top of the tooth downwards, and by the time the horse is approximately thirty years old, it should have completely gone. During the teenage years, the tables of the incisors gradually change shape from triangular to rounded, the teeth appear to slant forward more and they appear longer. The dental star gradually decreases in size, and ending up as a small dot in the middle of the tables of the incisors.

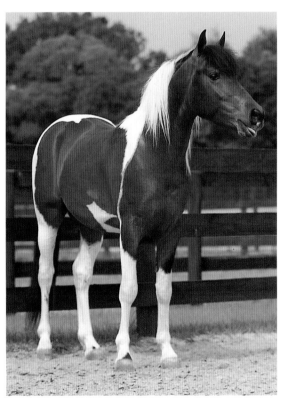

> **HORSE FACT:**
> The tallest documented horse was a Shire gelding called Sampson; foaled in 1846, he measured 21.2 hh in 1850 and weighed 3,360 lb (1524 kg).
> *Guinness Book of Records.*

Horse Behavior

THE MOST basic instinct for any animal, including the horse, is to survive and reproduce. Horses in the wild live in herds, which are led by a dominant stallion, and usually also have a dominant mare. Interestingly, they show a fundamental instinct to form long-lasting relationships and to 'bond,' making the herd, or the 'harem,' a secure environment.

THE HAREM

ONCE A DOMINANT STALLION has selected his 'harem,' he will rarely look for new mares and, in fact, recent studies on feral horses in America have shown that the average size of a harem is only five, consisting of a dominant stallion, two or three mares, and their offspring. The bonding process is not restricted to that between a stallion and mare; often two mares will pair off and become close friends, spending time grooming each other. Similarly, young stallions that have not yet established their own harems will band together, forming bachelor groups. Within the structure of the harem or herd, the weakest members of the group, who may be bullied, will often form an attachment to a dominant member by staying close to them. In doing so, they are left alone by the bullies and assured a good food supply.

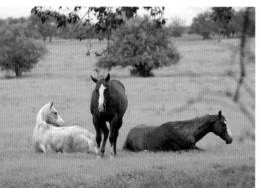

Top
Wild horses typically live in the secure environment of a harem or herd, where there is safety in numbers.

Above
A dominant stallion will normally have two or three mares to protect and breed from, and a close bond will be formed among them.

Right
Mutual grooming enables individual horses within a herd to bond together.

THE HERDING INSTINCT

THIS IS a greatly simplified account of the horse living in the wild. However, to live in a herd and to bond, is instinctive for all horses and should be considered when keeping a domestic horse. They are naturally sociable animals and, when removed from the herd, a horse will bond with a surrogate. In the domesticate horse, the surrogate often becomes the owner.

When turning a group of domestic horses out in the field, it is generally advisable to turn mares and geldings out separately, especially in the spring when the mares start to come into season, which can cause geldings to exhibit some stallion-like behaviour. It is possible to turn one gelding out with several mares, but it is inadvisable to turn several geldings out with one mare.

Horses show their attachment to, and form bonds with one another in a variety of ways, and one of these is grooming. They stand head to tail and chew up and down each other's neck and back. This is nearly always mutual, and if one horse stops, the other will too. Mutual grooming is an effective way to remove parasites as well as cementing friendships. During the summer, it is also common to see horses that have formed bonds together standing head to tail, swishing their tails to keep the flies off one another.

REACTING TO DANGER

EVEN DOMESTIC horses out in the field maintain their basic herd instincts. Horses generally stand and graze fairly close together, and if one horse is apart at a distance, it is often an indication that something is wrong and should be investigated. The structure of the herd provides the horse with his basic security – safety in numbers. The horse is a flight animal and in the face of danger, will take fright and run away. If one member of the herd senses danger and takes off, the rest will follow.

Horses are well adapted to a herd lifestyle and communicate with each other using body language, such as ear movements and vocal sounds. They sleep standing up, which allows them to retreat quickly in the face of danger. In cases where horses are seen lying down, there will often be one or two standing up on 'guard duty,' ready to alert the rest of the herd if need be.

Horses spend most of their day grazing, and are a classic example of 'little and often' feeders. Their stomachs are kept approximately half-full all the time, so that if they need to take flight, they are not running with a full belly. Another evolutionary adaptation the horse has to its 'flight not fight' lifestyle is its vision. This is very nearly 360 degrees and the distance between the eyes and the mouth allows the horse to see all around it at the same time as grazing. Although flight animals, if cornered and unable to take flight, horses will defend themselves by kicking and biting.

It is important to bear in mind the strong herd instinct that horses have when dealing with the domestic horse. A classic example is to avoid removing all the horses from a field at one time, leaving one horse left behind on its own. The horse that has been left will exhibit signs of distress including rushing up and down the fence line, whinnying, and in some cases, trying to jump out to join its companions. This is because his 'herd,' which is his safety net, has been removed, and he feels vulnerable.

Top
When a horse lays its ears back, it normally signifies that it feels threatened and may be ready to show aggressive behavior.

Bottom Far Left
This horse is looking for its companions; it is not ideal to leave a horse on its own in a field.

Bottom
These horses display aggressive behavior toward each other; this is most commonly found between stallions.

HORSE FACT:
The oldest horse to win a race was 18-year old Revenge, who won at Shrewsbury, England in 1790.
Guinness Book of Records

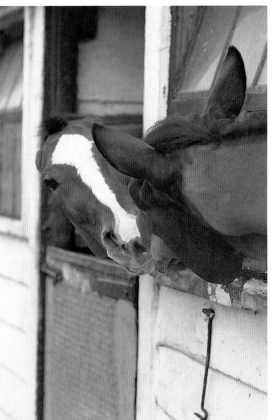

The Senses

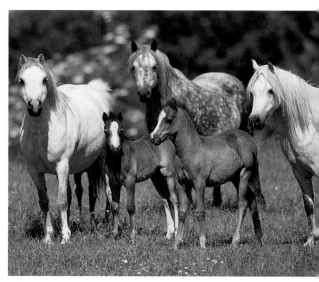

HORSES ARE SOCIABLE creatures and as such communicate with each other in various ways using their senses. They have exceptionally good hearing, and their ears are invariably mobile for much of the time, listening for possible signs of danger. The ears also provide a good indication as to what the horse is feeling or thinking – when they are laid flat back, it can be a sign of aggression, fear, or distress; ears pricked and forward shows an alert horse checking out the environment around it.

HEARING AND SENSE OF SMELL

WHEN LUNGING a domestic horse, it will often have the inside ear cocked toward you, while the outside ear is pricked, indicating that the horse is concentrating and listening. Horses in the herd will observe the ear movements of their fellows and react accordingly. Their sense of smell is also highly developed. In the wild, the sense of smell allows the stallion to identify mares in heat, as well being able to smell rival stallions through their dung, which is an important form of communication. Perhaps the most interesting of the senses is, however, the horse's keen vision.

SIGHT

THE EXTENT of a horse's sight, and how it perceives the world around it, has been the cause of much debate and an increasing amount of research. The position of the eyes on the side of the head allows the horse to have almost a 360 degree field of vision. They do, however, have two blind spots; one directly in front of their nose, and the other extending a few metres behind their rump. The distance between a horse's eyes and his muzzle allows him to be able to graze while also being able to watch for predators. The fact that a horse has such a huge field of vision means that often when he suddenly sees something that has been in his blind spot, it can make him jump. There is also a lot of research going on into the horse's ability to focus, see in color and perceive depth. Due to their eyes being so different from our own, the horse sees the world in a totally different way from us, which is a point well worth remembering.

Top and Above

Horses in a herd observe the ear movements of the others; these all have pricked ears and are looking in the same direction.

Bottom

Evolution has allowed the horse to have almost 360 degrees of vision.

intelligence in the horse. With people, intelligence is measured on the individual's natural ability to solve problems. Studies have been carried out on horses, setting them a variety of basic problem-solving tests, such as getting through a maze to find food. In these the horse 'learns' the answer – with each trial of the same test, the horse responds more quickly.

Horses learn by habit. For example, a domestic horse following a set routine daily will recognize feed time, exercise time, which stable he lives in, and so on. They learn as part of their training to respond to rider aids and, as the horse progresses, the aids and movements he learns become highly complicated. Horses have memories; they will recognize each other as well as places, and will often exhibit an uncanny homing instinct. The majority of domestic horses are relatively easy to train, as demonstrated by the 'film horse,' whose training is highly specific and developed, and invariably involves the horse carrying out unnatural actions.

Intelligence in animals can also be linked to instinct. A herd of wild horses will maintain a social structure, look after each other, reproduce, find food and water, and escape predators – all of which are primary instincts, and yet also show intelligence.

As with people, some horses are more intelligent than others – the Quarter Horse breed is often credited with being highly intelligent. However, it is more accurate to realize that they have a good capacity for learning, and a good memory rather than actual Einstein-like natural intelligence.

VOCAL COMMUNICATION

ALTHOUGH STUDIES are currently ongoing as to the importance of the voice in the horse, there is still little hard evidence as to the actual meaning of the different sounds. The vocal range in the horse is relatively restricted, due to the close proximity in which the wild horse lives with its herd, and there is little need for extensive vocal communication. There are four main types of voice in the horse: the nicker, the blow or snort, the squeal, and the whinny. All these are used to 'say' different things – a nicker can be a call for food or a mating call; similarly, a snort can be a sign of fear or excitement.

THE CLEVER HORSE

A HORSE actually has a relatively large brain in comparison to its size, but it is thought that the majority of the brain is taken up by co-ordinating movement. It is difficult to define

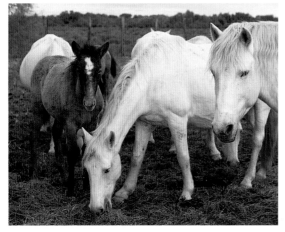

HORSE FACT:
The fastest horse recorded was Big Racket, who reached an amazing 43.26 mph in a quarter-of-a-mile race in Mexico City on 5 February 1945.
Guinness Book of Records

Left
While grazing, horses will continue to be alert for the signs of danger; these have their ears pricked and eyes open.

Above and Left
Within a herd, the natural instinct of horses is to protect each other; some remain on watch while the others are feeding.

Horse Care and Management

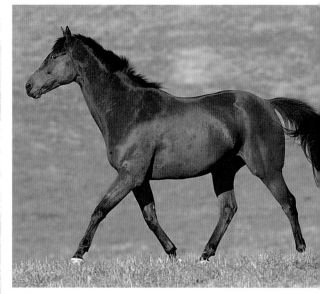

BEFORE DECIDING to buy a horse or pony, it is very important to realize that owning one involves time, work and money. The initial cost of buying a horse is invariably cheap compared to the cost of keeping one. If you are thinking about keeping a horse at home, you must ensure that you have the correct facilities. Alternatively, you can keep your horse at a livery yard, which can be expensive, but may suit some people better.

Top Right
A feisty or inexperienced horse is unsuitable for a novice rider

Above
There is a variety of facilities that a horse requires, such as a field and stable. These should be taken into account when deciding whether to buy a horse.

Right
It is important that the horse's temperament makes the rider feel safe and comfortable

CHOOSING AND BUYING A HORSE

WHEN YOU BUY a horse, it is likely that you will have it for several years, so make sure you are buying a horse that is suitable for you, your circumstances, your knowledge, and your ability. For the novice or first-time owner it is a good idea to take along an experienced friend when viewing a horse; often they will spot something you may overlook. It is also helpful to make a list of points that you want in a horse before you even start looking. You can then focus on the type of horse you need and ignore ones you don't need. Buying a horse can be a lengthy process and you may spend months looking at different kinds before finding the one that suits you best. However, it is well worth taking the time to do this

rather than rushing in to buy something for the sake of it. When looking at horses, it is often what the seller does not tell you that is important, so try to ask as many relevant questions as possible in order to find out as much about the horse and its history as you can.

POINTS TO CONSIDER BEFORE LOOKING

Temperament: This is one of the most important criteria. It is vital to look for a horse that you will feel safe riding and that will give you confidence. You need to find a horse that is calm and quiet and easy to be around.

Age: It is a good idea to buy an inexperienced horse that has seen and done all the things you are likely to want to do. This is likely to be a horse

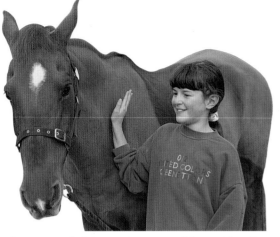

Height: You need to look for a horse that you are not going to outgrow in a few months, but also one that is not too big for you.

Ability: As mentioned, it is a good idea to buy a horse that has done more than you have and that you can learn from. However, once again, it is a matter of common sense to judge whether a horse has too much ability and scope for an inexperienced or novice rider.

Price: Always have a fixed price limit in mind. Every week there are thousands of horses advertized for sale, and invariably it will be the one just outside your price range that sounds perfect. You should not even consider going to look at a horse if it is outside your price bracket, but it is always worth asking the seller if they are open to offer.

Below
When buying a horse or pony, consider whether you want a hack or a show animal.

from around eight or nine years old, or older. By buying an experienced horse, you are likely to have more confidence when, for example, jumping cross-country for the first time.

Sex: Never consider buying a stallion. Mares can become temperamental during the spring and summer months when they will come into season at regular intervals. Some mares, however, seem totally unaffected by this and show no change in attitude. In general, a gelding is less likely to be temperamental than a mare. However, in the end, buying a horse is based on common sense. Once you find a horse that is ideal for you, it really should make no difference whether it is a mare or a gelding.

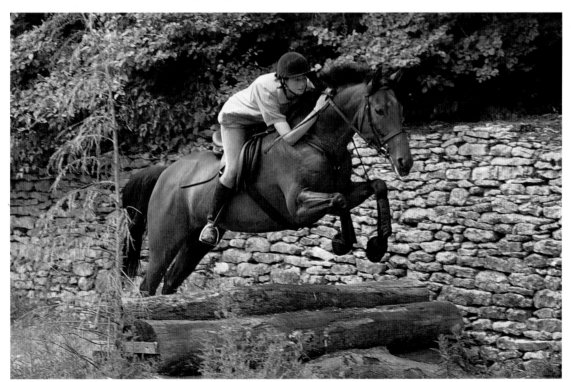

Top Left
Height is an important factor to consider when buying a horse; the rider will not want to grow out of it within a short period.

Left
An experienced horse can help teach a young rider to jump.

Where to Look

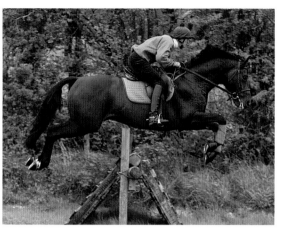

Once you have decided exactly what you are looking for in a horse, it is time to begin. The best way to buy a horse is through word of mouth or personal recommendation. It is a good idea to ring your local riding club, in case they know of anything for sale. You can also ask your riding instructor as he or she will come into contact with a huge range of horses every day and may know of one for sale. The more people you speak to the better. If you buy a horse that has been recommended by someone you know, you are less likely to make a mistake.

BUYING THROUGH AN ADVERTISEMENT

AS IN EVERY selling game, unfortunately there are unscrupulous people who sell horses that are not what they say they are. When you look at a horse, you must try and ascertain if it really matches up to its glowing advertisement. It is advisable to keep an open mind and to ask lots of questions. It is also a good idea to check up on the prizes and award that a horse is alleged to won. If a horse is said to have won in competitions, it is important to see documentary evidence of this. Find the organization with which the horse has been accredited points and check up.

Similarly, when you go to look at a horse, find out if it has been active in the riding clubs. If it has, you can ring the secretary of a particular club to find out more about the horse. There are many publications that advertise horses. Any horse magazine, for example, will have a large 'for sale' section at the back offering a wide range of horses. Often your local feed or tack stores will have a notice board with a 'for sale' section.

BUYING THROUGH A HORSE DEALER

YOU CAN ALSO buy through a horse dealer, but try to find out about the dealer's reputation first. Many dealers are excellent, but sadly there is the odd one who is not so scrupulous. One advantage of buying from a reputable dealer is that they will often allow you to have a horse on a week's trial. There are also dealers who specialize in different types of

Above
It is important to establish which bit the horse is accustomed to.

Top Right
The horse should be ridden by the potential owner before any agreement is made.

Right
This potential buyer is assessing the behavior of the horse in its field.

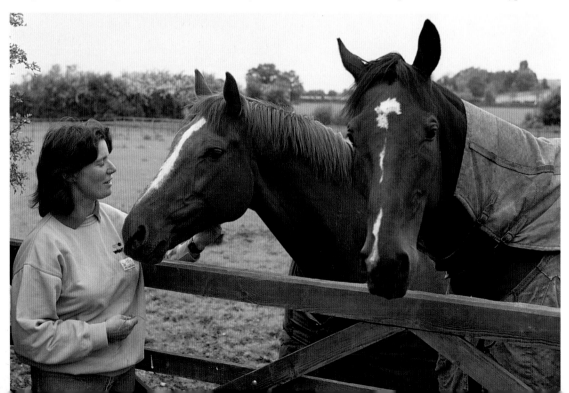

horse, such as showjumpers or young event horses. There are also innumerable horse sales and fairs held throughout the country, which range from the 'don't touch them at any cost' to the immensely respectable and reputable.

It is not advisable to buy a horse from a sale, unless you are extremely knowledgeable or have an expert with you. It is not worth being tempted by the thought of getting a real bargain; if a horse is being sold at a poor-quality sale, there is usually a very good reason. On the other hand, there are an increasing number of performance horse sales taking place. These sales are strictly regulated, usually offer a warranty, and are a good place to see a lot of quality horses going through the ring in one sitting. However, the first-time buyer should treat sales with caution, and always take someone experienced and knowledgeable with them.

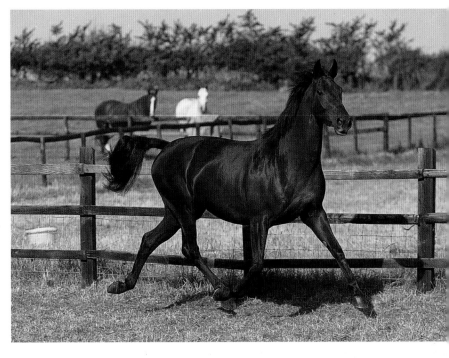

WHAT TO LOOK FOR

ONCE YOU HAVE made an appointment to view a horse, try to find someone experienced to go with you, such as your riding instructor or trainer. When you arrive, you should observe the horse in the stable, and watch while the owner catches it and puts the head collar on. This should give you some idea of the horse's temperament and attitude. You need to see the horse without any tack on, and with no bandages or boots on its legs.

Assess the conformation, looking to see if it has any major conformational defects – your knowledgeable friend could be useful here. Feel the horse's legs to see if it has any lumps, bumps, or heat that should not be there. Pick up all its feet in turn. (Always exercise caution and good sense when approaching an unknown horse.) Ask to see the horse run up, that is, walked away from you, and trotted back toward you and past you.

Assess the horse's soundness, and also look at its action, i.e., is it very close in front or behind, and does it move straight? If you still like the horse, ask to see it tacked up, and observe how the horse reacts. Does it object to the saddle being put on, etc? This can give you another clue to its temperament. It is generally normal practice for the person selling the horse to ride it first. Observe how it goes, and then if you still like it, ask to ride it yourself. You should try the horse at all paces, and also try jumping it. You should also consider riding it up the road. By now you should have a good idea as to whether or not the horse will be suitable for you.

BUYING THE HORSE

IF YOU LIKE the horse and wish to buy it, ask the seller if you may try it for a week. If the seller agrees, this gives you an opportunity to try the horse properly in your own environment, and see if it really is the one for you. You should only do this if you are serious about buying the horse as it is not fair to the seller otherwise. Before buying a horse it is a very good idea to have it vetted. This is a professional inspection by a vet who will test it for soundness of limb, wind, and heart.

Buying the right horse can be a lengthy process, and it is common to view several horses before finding one that you like. It is not something you should rush into, and it is wise to think long and hard before making a decision.

Above
It is important to find out the temperament of the horse in order to establish if it is what you require.

Below
One of the first, obvious, questions to consider is the height and age of the horse you are buying.

Questions to Ask

ONCE YOU HAVE found a horse that you would like to try out, there are some questions that you should ask before you go and look at it. Obviously there are hundreds of questions you can ask and there will be some points that are particular to your circumstances. Success in buying a horse is largely to do with using your common sense, and asking questions applicable to you and your circumstances. Bear in mind that there is no such thing as the perfect horse. Every horse will have some faults. You need to establish which set of faults you personally can live with, and which you cannot. The following are a few general questions and pointers that you should consider:

• Try to ascertain why the horse is for sale.

• The advertisement should have mentioned age, sex, and height. If not, establish these points. Also ask what breed the horse is.

• Ask about the horse's temperament. Find out if it is quiet, strong, difficult, excitable and so on. Does it kick or bite? What is it like in the stable and the field? Is it a bully, or can it be turned out with other horses?

• Does it have any vices? Vices such as weaving, cribbing, windsucking, rug tearing, and pacing the stall are really undesirable features in a horse, and should be reflected in the price being asked.

Top Right
It may be worth watching the horse in action before deciding to buy.

Bottom
Before purchasing a horse you should know whether it is used to being ridden in traffic as this may limit your riding experiences with it.

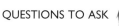

• Find out what the horse is like in traffic. If you are likely to be riding on the roads at all, it is very important to make sure that the horse will be safe, and is used to vehicles.

• Ask what the horse is like to shoe, catch, clip, and box.

• Try to establish as much of the horse's history as you can. What type of work has it been doing? Has it entered any competitions? Has it won anything? Has it been cross-country? Will it go through water and jump ditches? Has it showjumped? What is its flat work like?

• If the horse is a mare, ask what she is like when in season.

• Find out if the horse naps.

• Ask if it has been hunting? If so, how does it behave, how strong is it, and what type of bit is it ridden in? Will it go first or last, is it mannered, can you open and shut gates on it?

• Find out what type of bit the horse is usually ridden in.

• Ask if the horse has ever had any major illnesses or injuries, and whether or not it has any significant scars. If you wish to pursue a career in the showring, you do not want a horse with scarred knees, etc.

• Enquire if the horse has ever had colic. If so, has it had colic more than once? Some horses are prone to colic, and it is important to know if this is the case.

• Find out what type of environment the horse is living in, for example, is it kept in a small private yard, a large busy yard, on its own, out at grass all the time or in a stall?

• Ask what type of feed the horse is on and the amount it needs.

• Success in buying a horse is largely to do with using your common sense, and asking questions applicable to you and your circumstances. Bear in mind that there is no such thing as the perfect horse. Every horse will have some faults. You need to establish which set of faults you can live with, and which you cannot.

Bottom
This horse is being turned on a tight circle to check for lameness.

HORSE FACT:
Charles Pahud de Mortanges (Netherlands) holds the record for winning four Olympic gold medals for three-day eventing in 1924 (team), 1928 (team and individual), and 1932 (individual).
Guinness Book of Records.

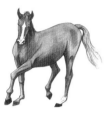

Feeding a Horse

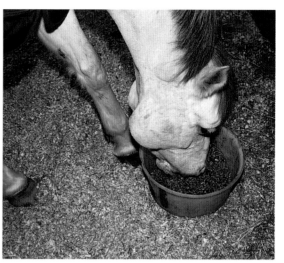

FEEDING THE HORSE is a complex and highly skilled process requiring understanding of the nutrient requirements of the individual horse, as well the nutrient value of the different feedstuffs available. There can be serious consequences to both over- and under-feeding and it is very important that horses receive a balanced diet that includes the correct amount of vitamins and minerals. For the novice owner or rider, it is best to seek advice and help when deciding what, and how much, to feed your horse, but as a rule of thumb, a horse's appetite is approximately 2.5 percent of its total body weight.

HORSE FACT:

The Thoroughbred, Janus, who was imported to the U.S.A. in 1756, is considered to be one of the foundation sires of the Quarter Horse.

WEIGHT: FOOD RATIO

THE MOST ACCURATE way to weigh a horse is on a weighbridge; but if you do not have access to one, most feed stores sell weight tapes. Having established the weight of your horse, some simple arithmetic needs to follow. Divide the weight of the horse by 100, and then multiply the result by 2.5, which gives you the weight of food that your horse should be receiving. When using formulas like this, it is a good idea to feed slightly less than your target amount and monitor how the horse goes. This total weight of food covers both the horse's concentrates and its roughage, so the next step is to work out the proportion you should feed of one to the other.

This is worked out on a percentage basis and as a rough guide, a horse that is out of work should be on 100 percent roughage (hay, grass, etc.) with no concentrate. Horses in light work should probably be on roughly 75 percent roughage and 25 percent concentrate; horses in medium work should be on roughly 60 percent roughage and 40 percent concentrate; and the horse in heavy work should be on roughly 50 percent roughage and 50 percent concentrate. This is actually not as confusing as it sounds. It is a good idea to practice working out rations for different-sized horses in this way, and very quickly it becomes very easy.

Top Right
This horse is eating hard feed from a bowl; it provides vitamins and minerals necessary for a balanced diet.

Bottom Right and Bottom Left
A swinging feed manger in a stable. This horse is being weighed on a weigh bridge.

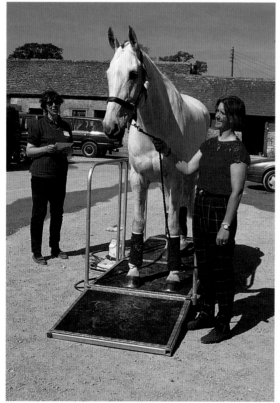

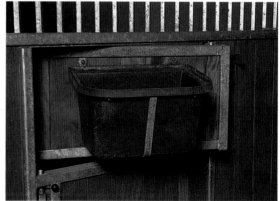

RULES OF FEEDING AND WATERING

• Feed little and often as this most closely resembles the horse's natural way of feeding, and enables them to keep their relatively small stomach constantly about half full.

• Adjust feed according to the amount of work that the horse is doing, the time of year, the age of the horse, the size and build of the horse, whether it is grass-kept or stable-kept, its temperament, and the ability of the rider. All these factors affect the type and quantity of food you should feed.

• Always feed good quality food. Poor quality food can lead to respiratory problems and can be low in nutritional value, leading to costliness.

• Make sure you feed at regular intervals during the day. The horse quickly establishes a routine and expects its food at certain times; disrupting this can lead to frustration-related vices.

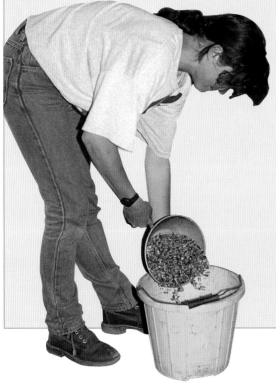

• Do not feed directly before exercise. The horse's stomach sits behind the diaphragm and if full will restrict the expansion of the lungs. You should allow a minimum of one hour after feeding before exercise, and preferably longer.

• For the same reason, do not let your horse drink large quantities of water before hard work. If it is likely to do this, then the water should be removed approximately one hour before the work begins.

• You should allow your horse access to a constant supply of clean, fresh water. If you are not able to do this, make sure you offer it water before it feeds, and not directly afterward. The latter can cause undigested food to be washed through and may cause colic and poor digestion.

• Using plenty of bulk and roughage in feed will aid the horse's digestion and keep the digestive tract in good working order.

• Feed succulent foods daily to aid digestion and to provide vitamins and minerals.

• Only use clean bowls for feeding and watering.

• Do not make any sudden changes to the horse's diet as this can upset the bacterial balance of the gut and lead to poor digestion and colic. Changes should be made gradually over several days.

• After strenuous exercise, only allow your horse a maximum of about 4–6 pints (2–3.5 liters) of luke-warm water at a time, with a 20-minute break between each drink. This will prevent large amounts of cold water shocking the system while the horse is still recovering from exertion.

• Do not feed more than 4–6 lb (1.8–2.7 kg) of concentrates at any one time – a greater quantity than this will overload the stomach and cause poor digestion and, in some cases, colic.

• Always weigh your feed out so that you know exactly how much food your horse is getting.

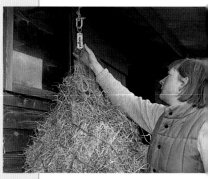

Top Left
A horse should not be fed just before exercise.

Above
This owner is weighing the hay in a hay net to prevent overfeeding.

Bottom Left
Measure out food carefully to ensure that your horse receives its correct dietary requirements.

Basic Feed Types

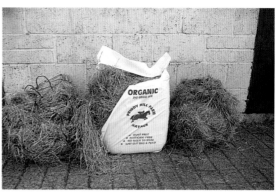

Hay (or grass): This makes up a large part of the roughage and bulk requirements of the diet. Always feed good quality hay that is free from dust and weeds. Even good hay may have some dust spores, and soaking it in water for 20 minutes before feeding will help to remove them. Meadow hay is most commonly fed, and is soft and palatable. There are hay alternatives, one of which is haylage. This is semi-wilted vacuum-packed grass that is dust free and as it is of a higher nutritional value than hay, it is fed in smaller quantities.

HORSE FACT:
Horses will generally begin to grow their winter coats from September, when the hair thickens and becomes coarser and dull. This gives rise to the saying, 'no horse looks well at blackberry time.'

Oats: These should be fed rolled, bruised, or crushed, in which case they are nutritious, energy giving, and contain fiber. When fed whole, however, they are not digested properly so the horse does not receive the proper nutrition from them. They should only be fed to horses in hard work and make some horses over excitable; for this reason they are rarely fed to ponies.

Barley: This is usually fed rolled or crushed, but can also be boiled, flaked, extruded, or micronized, depending on the manufacturer's cooking process. Barley is also energy giving, as well as being fattening. It is sometimes fed instead of oats because it does not usually make horses as excitable as oats, but some horse are allergic to it.

This Page
Three types of hay: (top right) organic; (left) seed hay; (center) haylace; and (right) meadow hay.

Bottom Right
Horses enjoy sugar beet as it is succulent and tasty.

Maize: This is fed cooked and flaked; it is high energy, fattening, and can make horses excitable.

Cubes: These come in various forms such as Horse and Pony, Competition, Stud nuts, and so on. Each type is formulated to provide a balanced diet and include essential vitamins and minerals needed in the diet. They vary from type to type in nutritional- and energy-giving value but rarely produce the same excitable effect as oats.

Coarse Mix: This comes in various forms like cubes. They all provide a balanced diet and are generally well liked by most horses.

Sugar beet: This can be bought in cubes or shreds. It must be soaked in water before being fed – this is vital, otherwise it swells in the stomach and causes severe colic. Shreds should be soaked in ample water for at least 12 hours and cubes for 24 hours. Sugar beet is very high in fiber and is succulent and tasty; most horses will eat it with relish. Once it has been soaked, it should be fed straight away, otherwise it ferments and goes bad, a process which is greatly accelerated in hot weather. The soaking water must be discarded.

Chaff: This is chopped hay, straw, or a mixture of both, and can have molasses added. It provides good bulk, encourages the horse to chew properly, and slows down a horse that bolts its food. Chaff must only be made from good quality hay and straw.

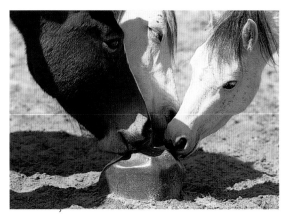

Bran: Bran is high in fiber and absorbs water well. It may be fed as a bran mash, which acts as a laxative.

Add boiling water to 1–2 lb (0.5–1 kg) of bran in a bucket to form a crumbly consistency, cover, and leave to cool and steam; you can add a spoon of salt, a few oats, or some epsom salts as well. Feed while still just warm. Bran should not be fed in large quantities as it is has a low calcium/high phosphorus ratio, which is not desirable for horses.

Linseed: This has a very high oil content and is useful for improving condition and making the coat shine. It must be cooked before being fed and is poisonous if it is not. Approximately 1 lb (0.5 kg) of linseed should be soaked in 3–4 in (7–10 cm) of water for 12 hours, it should then be brought to the boil and allowed to simmer for several hours. It turns into a form of jelly, which can then be added either to the normal feed or to a bran mash. Linseed should not be fed in large amounts, and no more than 1 lb (0.5 kg), unsoaked weight, should be fed a week.

VITAMINS AND MINERALS
HORSES SHOULD BE FED some kind of succulent daily such as green foods, carrots, apples, etc. They are a tasty addition to the diet, but more importantly provide vitamins and minerals, variety, and help to satisfy the horse's natural desire for grass, if not available.

Horses require certain vitamins and minerals to maintain a balanced diet and most of these are found in the concentrate feed, especially in the coarse mixes and cubes. However, many diets are deficient in salt and this should either be included in the diet or a salt lick should be installed where the horse can help itself. Beware of the numerous supplements on the market today and take advice from a vet or a nutritionist before feeding them – in many instances it can be harmful to overfeed supplements, or to feed more than one variety at one time.

HORSE FACT:
A 'war horse' is the term given to someone who has lived through many hardships and can always be relied upon.

Top Right
Many horses are given salt blocks to lick to help balance their diets.

Top Left
Bran is a natural laxative for horses and humans.

Bottom
This horse enjoys the taste of its salt lick.

Grass-kept Horses

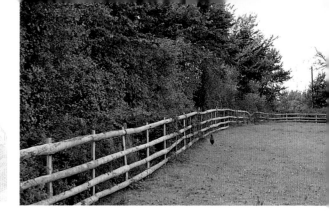

BEFORE KEEPING your horse at grass, you need to provide a safe and healthy field environment for it and there are certain things you need to consider.

AREA

YOU NEED TO ALLOW at least 1.5 acres (0.6 hectares), (preferably 2 acres/0.8 hectares), per horse. Horses are naturally sociable creatures so it is best to keep more than one but you need to multiply your area accordingly per horse. It is advisable to have a field large enough to allow you to subdivide it, and so start a system of rotation. By doing this, you allow the resting section of the field to recuperate, while your horse is grazing in the other half. Try to work your rotation so that the area of field that drains the best is used during the wetter months and the wetter part of the field is used during the summer, when it should dry out.

FENCES

THE BEST TYPE of fencing is a non-poisonous thick hedge, which provides natural protection from the elements, with a post and rail in front. However, this is invariably not possible, so three rails of post and rail, or post and taut smooth wire, is also acceptable. The wire must be regularly checked to prevent it sagging, when it becomes dangerous. Horses respect barbed wire but it can inadvertently cause horrendous injuries and damage New Zealand rugs and is, therefore, best avoided.

Sheep netting can also be dangerous, in case a horse paws at the ground and gets a foot stuck through the wire. There are many different types of fencing, but these are the most common. Wide band electric fencing can be used but is best used in conjunction with post and rails, and should not be used as a perimeter fence. Post and rail fencing is expensive so if you buy it make sure the wood has been treated with preservative to prolong its life. The gateway should always open into the field and should be wide enough to allow a vehicle through. Keep gates padlocked on both ends for security and to prevent theft, and ensure that latches are secure and safe for horses.

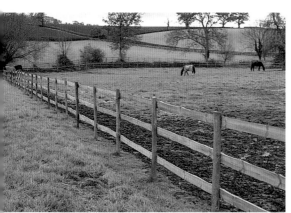

Above
Keep horses in a field which can be fenced off so the grass can regrow.

Top Right
A field enclosed by secure fencing and hedging provides natural protection.

Bottom Left
This stockproof fence has a secure rail along the top but the wire mesh could lead to horses catching their hooves in it.

Bottom Right
Avoid barbed wire fencing as it can be dangerous to both horse and rider.

SUPPLYING WATER

A FRESH CLEAN WATER supply is essential. A natural stream is perfect, providing it comes from an unpolluted source, and has a firm standing on which the horse can stand. A stagnant pond is not suitable, nor is a stream with a sandy bottom. Self-filling troughs are good, but must be regularly cleaned, and the ice broken in winter. Do not situate your troughs next to the gateway or in a corner where horses can be bullied, and avoid placing them under trees. If you have two fields sharing a fence line, it can be useful to place the trough midway along the fence so that the horses can access it from both sides. Make sure that there are no sharp edges on the trough. Buckets work well providing the horse does not continually tip them up. Make sure that there are enough large buckets to provide plenty of water for all horses in the field. Generally buckets are best used where there are just a few horses. You should inspect the buckets or trough at least twice a day in the summer. If it is very hot, buckets need to be refilled during the day.

SHELTER

THE FIELD MUST have some kind of shelter. Trees and hedges form the best kind of natural shelter. Man-made constructions need to be three-sided to allow for protection from the elements, and also to allow the horses to get in and out easily; they need to be situated on ground that drains well, and to be out of the prevailing winds. Make sure that the shelter is more than big enough. Field shelters must be inspected, and the roof needs to be looked at for soundness and waterproofing.

POISONOUS PLANTS

IT IS VITAL to search the field on a very regular basis for any poisonous plants. Do not use a field for horses if it contains a large number of poisonous trees, such as oak, because the horses will eat the acorns, which lead to severe colic. Also, if a field is surrounded by a hedge, make sure it is not a poisonous one. Watch for poisonous plants in neighboring fields because the spores will invariably seed themselves in your pasture. It is just as important to inspect fields that you may wish to take a hay crop from for poisonous plants, which are sometimes just as deadly eaten in hay as in the pasture.

GRASS

YOU WILL NEED TO MAINTAIN the quality of the grass in the field you keep your horse in by rotating and resting. You also need to follow a fieldcare system of harrowing, seeding, and fertilizing, as well as removing the animal droppings on a regular basis and looking for harmful rubbish, such as broken glass, and poisonous plants.

HORSE FACT:
'Venery,' from the Latin word *venari* meaning to hunt, was the sport that fully developed as a social pastime for the elite of society during the 14th century. Expertise in the art of venery was considered an essential part of social life and was also used for training for war and chivalry.

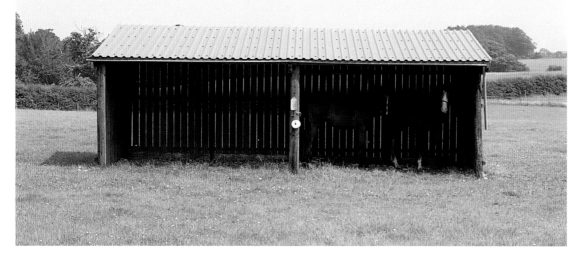

Top Right
This trough has been placed in an excellent position for the horses to access. However, it must be cleaned regularly and the water should be prevented from stagnating.

Bottom
This wooden field shelter protects the horses from the weather.

CARE OF THE FIELD

IT IS IMPORTANT to take good care of your fields so that they are safe and nutritious for your horse. If possible, droppings should be removed on a daily basis but if this is not possible then, in dry weather only, the droppings should harrowed once a week. Fencing should be checked on a daily basis where possible; you need to look for any holes, such as rabbit or badger, which may appear along hedge lines. You need to look for any debris that may have found its way into the field.

If you are taking on a new pasture, or feel your present area is in need of some help, you can talk to the U.S. Environmental Protection Agency (EPA) or to your local farming contractors, seed merchants, or fertilizer companies. They generally send someone out to assess your fields and are happy to help you decide what course of action to take.

SOIL TYPE

ONE OF THE first things to consider is your type of soil: this determines what grasses grow best, how well your drainage works, and what effect the seasons will have on your field. It is helpful to have a soil test done, which shows you what type of fertilizer to use, and how to care of the field. The best type of soil is the most nutritious soil, which holds enough water for plant life but which also drains efficiently. Grass grows best in soil with a 6.5 pH value, which is the measure of the soils acidity. This value is just on the acid side of neutral – neutral being 7.0 pH.

DRAINAGE

IT IS VERY IMPORTANT for your field to drain well. Where fields are very wet it is necessary to lay underground drains. This is an expensive and time-consuming process but is generally very effective. Underground pipes leading to ditches at the edge of the field are laid. These pipes have small holes in the top which allow water to drain into them and away to the ditches. Many fields simply have drainage ditches around the edge of the field, which often work very well.

Above
Foxgloves should be removed from the horses' field as they are very poisonous.

Top Right
The flower and fruit of deadly nightshade; this plant is extremely poisonous and should not be eaten by horses.

Bottom Right
The berries of this yew tree can also be harmful to horses.

In some cases, when there have been a lot of horses on one pasture, the soil becomes compacted to such a degree that water is unable to drain away. This problem is usually simply solved by subsoiling, which is pulling plough shares through the subsoil to allow the water to drain again, causing very little damage to the top soil. Another type of drainage that works well in clay soil only is mole drainage. In this case a mole plough is used to create channels for drainage approximately 3 ft (1 m) under the ground.

WEED CONTROL

WEED CONTROL is very important because once they take hold, they will take over your field. Large quantities of weeds can be sprayed with herbicides, but due to the dangerous nature of these chemicals, spraying should only be done by a professional. It is necessary, in most cases, to keep horses off the pasture for a specific time after they have been sprayed. Weeds growing in small amounts can be pulled up by hand and should be burnt.

Always seek professional advice before using fertilizer. There are many different types of fertilizer, some of which are more suitable for horse pastures than others. It is best to apply fertiliser, if needed, in the spring and autumn, which is also the best time to apply lime. Lime is only needed in cases where the soil is too acidic and should only need to be applied every three or four years. Horses will need to be kept off the field after it has been fertilized until it has all been washed into the soil.

During the spring and summer, it is necessary to keep your fields topped. This is basically keeping the length of the grass reasonably short, which encourages it to grow more densely. Topping can either be done by grazing or by using a tractor mower. Try to keep the grass topped regularly.

You should harrow your fields regularly throughout the year. Harrowing in dry weather spreads the droppings and also pulls up any dead herbage, allowing the young grass to grow through.

Top Left
Another poisonous bush is the laburnum.

Top Right
Horses will have to be kept off the field after herbicides are used to remove plants such as hemlock.

Bottom
If weeds such as ragwort are not checked, they soon take over the field. Ragwort is also very poisonous and cause death.

TYPE OF GRASS

THERE ARE MANY different types of grasses, some of which are better for horse pastures than others. In general, it is good to have a mix of nutritious grasses such as perennial rye grass, Timothy, meadow grass, crested dog's tail, creeping red fescue, and wild white clover. It is also a good idea to plant some herbs such as wild garlic, comfrey, sheep's parsley, chicory, and plantains, all of which most horses will eat enthusiastically and which are thought to have some medicinal qualities. Ideally, the sward, the grasses, and herbs growing should have different flowering times, to provide continual nutritious growth.

HORSE FACT:
It was not until the Middle Ages in Europe that the horse began to be used for agricultural purposes in earnest. Up until then, the horse was primarily used for transport and in warfare, while oxen were used for working the land.

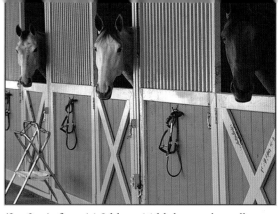

Stable-kept Horses

A STALL IS NOT the horse's natural environment, although once they have adapted to it, the majority of horses do not mind being stalled. You will need to provide a safe and healthy stall environment in order to keep your horse happy and relaxed.

SITE AND SIZE

WHETHER YOU are constructing your own stables or using an existing stable, you must consider the site. Stables preferably need to be situated in an area that drains well, is out of the prevailing winds, has electricity and water, and has vehicular access. It is an advantage to have your stables within a gated yard for security reasons. You must consider safety first and foremost when stalling horses. Stables should be away from the haybarn, which is a fire risk area. Where there are two rows of stalls facing each other, they should be at least 60 ft (18 m) apart to prevent fire jumping from one row to the other.

Stalls need to be big enough to house your horse comfortably. As a guide, a pony up to 14.2 hh requires a stall to be at least 10 x 10 ft (3 x 3 m); for a 14.2 hh to 16 hh horse, the stall must be at least 12 x 12 ft (3.6 x 3.6 m); for a horse over 16 hh, the stall should be at least 12 x 14 ft (3.6 x 4.3 m). Foaling boxes, or boxes for very large horses, need to be at least 16 x 16 ft (4.8 x 4.8 m). It is also important to consider the height and width of the door frame, and the height of the roof. Doors should not be less than 4 ft (1.2 m) wide, and should have a total doorway height of not less than 7 ft (2.1 m). The bottom half of the door will vary in height depending on the size of pony or horse that the stall has been constructed for. The walls need to be at least 8 ft (2.4 m) high to the bottom of the eaves to allow ample head room.

MATERIALS

STABLES ARE OFTEN wooden, which is adequate, but not fire resistant. Brick-built stables are excellent, but very expensive. A good combination is wood and brick – a wooden structure built onto a brick base. Breeze blocks are quite good as an alternative to brick and are, of course, like brick, being fire resistant and durable. There needs to be a drainage hole in the base of the walls, and they

Top
These horses are well housed; the stable door is roof height, they have good visibility and adequate space to move around in.

Bottom
Stables should always be constructed away from the hay barn as this can be a serious fire risk.

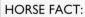

should be lined with wooden 'kicking' boards to a height of approximately 4 ft (1.2 m).

Stall floors are generally concrete with ridges on the surface to provide grip. Drainage in the stall is extremely important, and can be effectively achieved in a number of ways. Some floors are built with a slight slope either to the front, or the back, of the stall, which then leads to a drainage channel. These work well, but must be kept clear. Drainage channels such as these are easy to clean out if they are at the front of the stall, but this then means the horse is likely to be standing in the wettest part of the stall.

When the drains are at the back of the stall, they are harder to clean, but the horse will probably be in drier area. Some stall floors will slope to a central drain, which has advantages and disadvantages. Usually the floor is extended beyond the front of the stall so that there is hard standing outside the stable.

The roof needs to be high and pitched, and should overhang the front of the box to prevent rain driving in. There should be air vents in the roof, which needs to be constructed with suitable materials. Roofing tiles are excellent, but expensive; roofing felt works, but it is not fireproof and its insulation properties are poor. Corrugated plastic or iron can be used, but they have very poor insulation properties and are noisy.

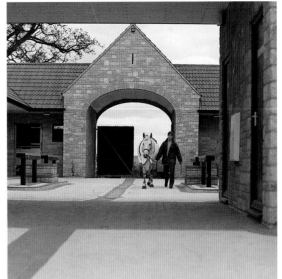

The windows should be on the same side of the stall as the door, and should hinge on the bottom and open outward to prevent drafts; they should be covered with wire mesh and be glazed with wired safety glass. Stables need a constant clean supply of water, and this can be provided by buckets or automatic waterers. All lights in the stable should be out of reach of the horses, and should be covered to prevent glass shattering into the bed. All electrical switches and leads should be well out of reach of the horse. Any fittings or fixtures, such as tie-up rings, hay racks. or feed managers should be free from sharp edges and placed so as not to cause injury.

If you intend to keep your horse at a livery stables, be sure to inspect the fields and stable complex where your horse is to be kept, and ensure that they are safe and clean.

Top Right
This purpose-built stable, is made of brick, a more expensive material than wood, but inflammable.

Top Left
This is an American barn stable at a stud farm in Kentucky.

Bottom
This stable yard has tie-up posts for horses and a concrete surface that has been grooved to prevent slipping.

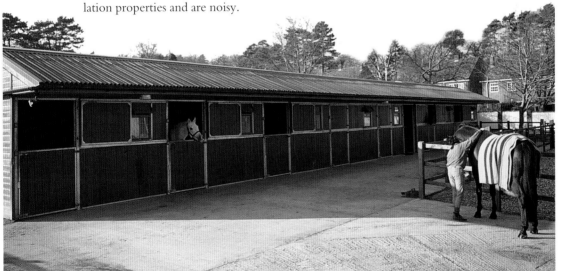

BEDDING

THERE ARE VARIOUS different types of bedding that can be used in a stall including straw, shavings, paper, rubber, and peat, and each one has its own advantages and disadvantages. Straw is one of the most widely used and one of the most inexpensive; there are three types of straw – oat, barley, and wheat. Wheat is the best kind to use for bedding as it is tough, readily available, and drains well. Horses are inclined to eat oat straw, which is highly palatable, and is also soft and porous, so becomes sodden very quickly. Barley straw can make adequate bedding, but often contains prickly awns, which will irritate the skin. Greedy horses may eat straw regardless of what type it is.

Shavings are very good, especially for horses that suffer from respiratory problems. They are expensive but are highly absorbent and very easy to work with; carefully managed, a shavings bed can make a good deep litter bed. Wood shavings have the added advantage of being wrapped in plastic and therefore stored outside if necessary. On the downside, a shavings muck heap takes a long time to rot down, although once it has, it makes very good compost.

Paper bedding comes like shavings in plastic bale-bags and is made of shredded dustfree paper. It is very good for horses with allergies and respiratory problems, and is suitable for horses which eat their bedding – they are highly unlikely to eat this. It is extremely absorbent but needs careful management to prevent it packing down and becoming too wet and heavy.

Rubber is a relatively recent type of bedding that was originally designed for trailer and horse-box floors. It is a thick rubber matting which fits the floor space of the stall. Used as a bedding on its own, it is

very easy to clean, can be hosed and washed down, is a good nonslip floor, and is supposed to have good insulation properties. It also reduces the size of the muck heap. Rubber flooring can be used quite efficiently with a thinner than normal layer of straw or shavings on top.

Peat is an old fashioned form of bedding that is not often used now. It is very absorbent, and wet patches need to be removed frequently to prevent it becoming soggy; it can be quite heavy to work with, and is slow to rot in the muck heap.

MUCKING OUT

IT IS ESSENTIAL to keep the stall clean and hygienic at all times and to do this it must be skipped out and mucked out regularly. The stall should be always thoroughly cleaned out every morning, and then throughout the day should be skipped out, which is basically just removing any droppings. In the evenings the bed again needs to be inspected, laid down properly, and skipped out.

Always do a thorough clean out without the horse in the stall. First remove all the droppings that are visible, then start working all the clean bedding into one corner, removing the soiled bedding as you go. You should end up with one corner full of clean bedding; sweep the dirt from the floor, then lay the bed back down again. Each day choose a different corner to store the clean bedding in, so that in four days all the corners have been cleaned and swept. Some people choose to lay just some of the bedding down, leaving most of it piled up around the walls – this is known as a day bed – then in the evening the rest of the bedding is replaced to make a thicker night bed.

Another system of mucking out is known as deep litter, which is especially effective when using shavings. Droppings are removed throughout the day, but the rest of the bed is left undisturbed, with

HORSE FACT:
The Great Khan, grandson of Genghis Khan, kept a herd of approximately 10,000 pure white mares, along with pure white stallions, and these horses were treated as sacred.

Top Left
This is a shavings bed which is ideal for horses with respiratory problems.

Top Right
Straw is the most inexpensive material for bedding and it is also excellent for drainage.

Bottom Left
This horse has a paper bed, which is preferable for those that have allergies or eat their bedding.

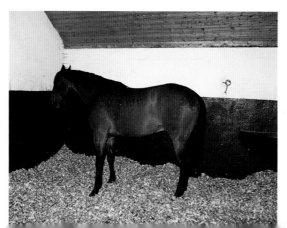

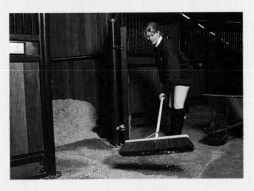

KEEPING STALLS TIDY

Always remove water buckets from the stalls before mucking out; replace them when you have finished.

Tie your horse up in the stall if you are mucking out with it in there too.

Be very aware of your fork; use it away from the horse to avoid any injury to it.

Keep your stall and the stable yard clean.

Provide a thick bed to protect your horse from the concrete stall floor.

Always maintain a tidy muck heap.

Top Left
Rubber bedding is relatively easy to clean.

Top Right
This girl sweeps the shavings into the stable; the bedding will need to be completely dug out once a month.

Bottom
This horse has a thick paper bed that protects it from the concrete floor.

fresh bedding being added on top. Using this system, the bed needs to be completely dug out at least once a month, when the bedding should be removed, the floor swept, scrubbed or disinfected, and left to dry, before putting in a new bed. It is a good idea to once a week remove the excessive wet patches leaving the rest of the bed undisturbed. If you do this then the monthly removal of the bed is slightly easier. With good management this type of mucking out can work very well, although monthly removal of bedding is heavy work.

HORSE FACT:

Koumiss is the name given to a drink made from fermented mare's milk that is a speciality among the nomadic Kazaks of Kazakstan, Eurasia. The Kazaks believe that this drink can cure many diseases.

Grooming a Horse

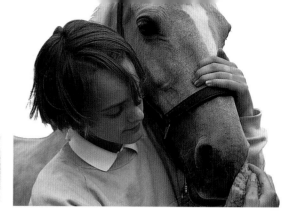

REGULAR, THOROUGH grooming is necessary to keep your horse clean and healthy; it also stimulates circulation, keeps your horse looking good, and can help to build a relationship between the two of you. Thorough grooming also gives you the chance to check your horse over for any lumps, bumps, or heat, and for this reason, you should not wear gloves when grooming so you can feel any abnormalities. You should always tie your horse up when grooming, and, if in its stall, either remove its water buckets, or clean its automatic water dispenser when you have finished, as the dust generated will contaminate the water.

Dandy brush: A hard-bristled brush that removes caked mud and sweat from the coat, and is the primary tool used for grooming the grasskept horse. The dandy brush should not be used on the mane and tail because it will break the hairs.

Water brush: It is a good idea to have two separate water brushes. One for use dampened at the end of the grooming process to take any surface dust off the coat, and also to lay the mane smooth and flat on the right side of the neck. The other one can be used just for cleaning the feet if they are very muddy.

Plastic/rubber curry comb: These are very useful for removing mud and dried sweat, for stimulating the skin and for bringing grease to the surface of the coat.

Rubber grooming mitt: This is a mitt that can be used all over the horse to remove mud and dried sweat; they tend to work in a similar way to the rubber curry comb and will bring the grease to the surface.

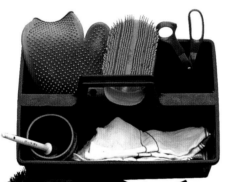

Top Right
This owner cleans her horse's muzzle out with a sponge.

Right
A grooming kit containing brushes, combs, scissors, and hoof picks.

Bottom Right
This owner uses a body brush and curry comb to clean her horse's coat.

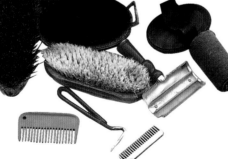

GROOMING KIT

Body brush: A soft-bristled brush that removes dust and grease from deep down in the coat, generally rarely used on the grasskept horse, and always used in conjunction with the metal curry comb.

Cactus cloth: This is a piece of hairy sackcloth, which can be used all over the body to remove dried sweat and mud. If it is slightly dampened before being used, it will remove the surface dirt and bring a shine to the coat.

Metal curry comb: Only ever used for cleaning the body brush and never used on the horse.

Hoof pick: Used for cleaning out the feet, always in a downward motion from heel to toe to prevent accidentally damaging the frog or heels.

Mane comb: A long tooth comb is used for combing out the mane and tail; it is necessary to change to a short-tooth comb to pull the mane.

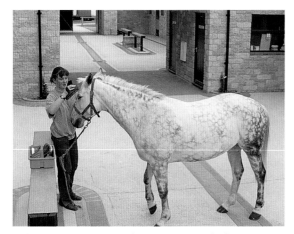

Wisp or massage pad: A wisp is made from a woven rope of hay, which is then knotted together. It should be slightly dampened before being used. The massage pad is a leather pad with a strap on the back. Both of these are used in conjunction with a stable rubber to improve muscle tone and put a shine on the coat. The horse should be able to see you raise the pad and it will tense its muscles; you bang down, followed by a stroke with the stable rubber, which makes the horse relax its muscles. Used in a steady rhythm, the constant tensing and relaxing will help to improve the muscle tone. This should only be done in muscular areas such as the quarters, thighs, and neck, and you should avoid bony areas. The pad should not be banged down violently, which will cause fear and injury, but should be used firmly.

Sponges: It is generally best to have two of a different color. One is used for cleaning the eyes, mouth, and nose; the other for cleaning the dock area.

Stable rubber: Similar in appearance to a drying-up cloth, the stable rubber is used at the end of the grooming process to add extra shine to the coat.

Sweat scraper: This is a tool with a curved rubber piece on one side and a metal piece on the other, both attached to a handle. It is very effective at removing excess water from the coat after the horse has been washed down. The rubber side should be used in the more bony areas, while the metal side can be used, with care, over the body.

Hoof oil: Used on the feet to create a shine.

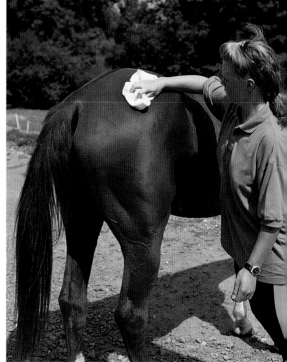

Shampoo: It is sometimes necessary to shampoo the tail, using a suitable equine shampoo.

Scissors: Rounded-ended scissors should be a part of every grooming kit. They are required for general trimming.

Grooming machine: There are several different varieties on the market and they can be a useful addition to a large yard. They basically act like a vacuum cleaner sucking the dirt out but should be introduced to the horse with care, as they may initially cause alarm.

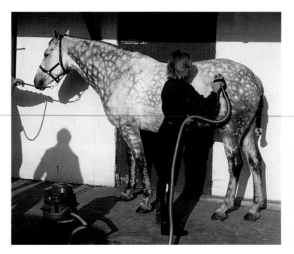

Above
The groom uses a stable rubber at the end of the grooming process to give her horse's coat a beautiful shine.

Left
The horse's forelock is groomed with a long-toothed mane comb.

Bottom
A grooming machine is used to suck out the dirt from this dappled-gray horse's coat.

HORSE FACT:
Old horses will often grow white hairs around the face and their muzzle.

Shoeing a Horse

'NO FEET, NO HORSE' – of course, a horse's feet are of utmost importance to its health and performance and as every self-respecting farrier will tell you, it does not matter how good your horse is, if its feet are poor you are in for trouble.

WHY A HORSE NEEDS SHOEING

A HORSE IS a very big and heavy animal in comparison to the size of its feet and so a large part of the internal structure of the foot deals with absorbing the concussion that arises every time the horse puts its foot to the ground. Different types of horse have different types of feet; for example, the Thoroughbred is renowned for having thin soles, which means that its feet are particularly prone to bruising, while the Jomud, of the Soviet Union, has exceptionally hard feet, as do many of the native breeds of pony. Horses' feet can tell you a great deal about the horse – if it has small feet for its size, it will be less able to cope with concussion and may be prone to lameness if ridden excessively on hard ground. Very large flat feet will also be prone to excessive concussion.

If prominent ridges or rings appear around the feet it can indicate problems within the foot, or over-feeding, and should be a matter of concern. If a horse stands pigeon-toed, with its feet turned in, it will probably not move straight; if it stands with its feet turned out, again it will not move straight, and will probably brush its legs together, possibly causing injury. Feet should always be a pair, of the same size and shape, and with the same angle to the ground, and should be cared for as a matter of priority.

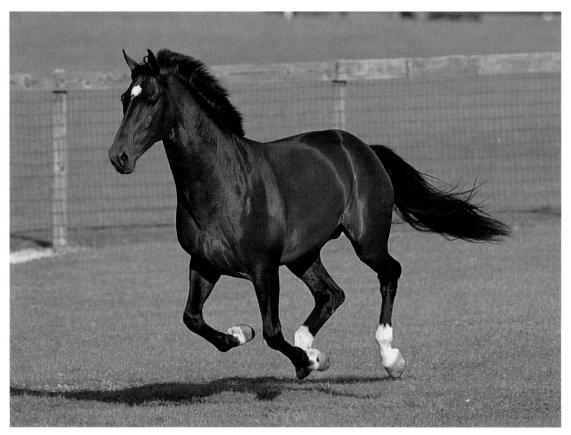

Right
An animal with poor feet would not have the healthy and spirited appearance of this horse.

HORSE FACT:
Vaqueros is the name given to Spanish cowboy; they were among the first cowboys in America.

STRUCTURE OF THE FOOT

THE FOOT CAN be divided into three areas – the toe, the quarters, and the heel, although no natural division exists. The wall is the part of the hoof that can be seen when the horse is standing, and bears most of the horse's weight. The wall is made up of insensitive horn which turns inward at the heels to form the bars; the bars can be seen on the ground surface of the foot and look like hard ridges between the frog and sole. The fact that the wall does not form a complete circle allows for expansion of the foot as it hits the ground during movement.

The outside of the wall will often appear to have small ridges running horizontal to the coronet band, which are referred to as growth rings. The horn grows downward from the coronet band, and is made up of thousands of tubules, which are cemented together by intertubular horn. The wall is covered by a thin protective membrane called the periople, the main function of which is to protect the area where the coronet band meets with the hoof wall.

The periople will naturally wear away on the lower half of the wall, and therefore only plays a minor role in reducing evaporation of moisture from this area. The ground surface of the foot is largely made up by the sole, which should be concave to the ground, the white line which runs between the edge of the sole and the wall, and the frog, which acts as a shock absorber and antislip agent. The frog is elastic, wedge-shaped horn that should be in contact with the ground. It is very important to keep the frog healthy and free from infections such as thrush.

Inside the foot, the insensitive horny laminae of the wall are attached to the sensitive laminae that in turn help to support the pedal bone. There are three bones in the foot – the pedal bone, the navicular bone, and the lower part of the short pastern bone. Above the sole is the sensitive sole, and above the frog is the plantar cushion. All these sensitive internal structures help the horse to feel the ground it is walking on. The frog, bars, plantar cushion, and the lateral cartilages are all elastic structures, and play a vital role in absorbing concussion.

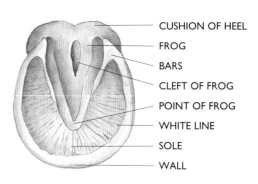

- CUSHION OF HEEL
- FROG
- BARS
- CLEFT OF FROG
- POINT OF FROG
- WHITE LINE
- SOLE
- WALL

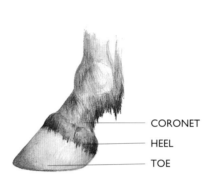

- CORONET
- HEEL
- TOE

- CORONET
- HOOF WALL
- BULB OF HEEL

- INSENSITIVE LAMINAE
- FROG
- SOLE
- WHITE LINE

- HOOF WALL
- BAR
- BULBS OF FROG/HEEL
- WHITE LINE

Top
The inferior face of a horse's foot.

Center
The profile view of a horse's foot (see center top) and a posterior view of a horse's foot (see center bottom).

Bottom
The antero-posterior and vertical section of the horse hoof (see bottom left) and the transverse section of the horse's hoof (see bottom right).

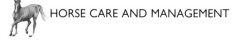

SHOEING THE HORSE

IT IS VERY IMPORTANT to ensure that your horse will be well behaved for the farrier and is used to having its feet picked up. With young horses, it is a good idea to spend some time every day picking up their feet and banging with the flat of your hand on their soles to accustom them to activity and noise in this area. Your horse will need to be reshod every four to six weeks, and your farrier will advise you of this. Before he arrives, have the horse standing on a hard, flat surface with clean, dry, and picked-out feet; you will also need a bucket of water nearby if your farrier hotshoes.

First your farrier will remove the old shoes, and he will begin doing this by knocking up the clenches. He takes his buffer and places it under each nail, and then bangs this with the hammer until the nail has been levered up. Alternatively he might take his pinchers and cut the top of the nail off. He will next carefully lever the shoe off the foot using the pinchers, starting at the heels and working toward the toe using an inward-pulling motion. Great care must be taken when removing the shoe to prevent any pieces of horn being pulled off.

Once the shoes have been removed, the feet need to be prepared for shoeing. The farrier will trim the excess hoof growth as necessary using hoofcutters and drawing or toe knife, and will clean out any ragged parts of the frog or sole. Then he will level the foot using the rasp, and cut the notch for the toe clip using either the rasp or drawing knife.

Top Left
This mobile farrier carries different sizes of shoes in his van.

Right and Above
A farrier shaping a new shoe (see top and bottom right) and removing an old shoe (see center left and above).

THE NEW SHOES

THE FARRIER WILL have placed suitably sized shoes in the forge, which heats the metal to a great temperature making it somewhat pliable. He will remove one of the hot shoes from the forge using the forge tongs, and will then transfer it onto the pritchel, which is used to carry the shoe to the horse. The hot shoe is held against the foot, which burns a mark onto the insensitive horn. This mark tells the farrier what adjustments he may need to make to the shoe. He will then carry the shoe back to the anvil where

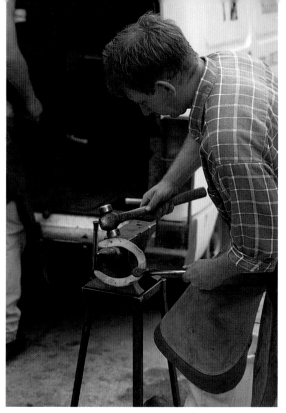

he is able to shape it, as required, to fit the foot, using his turning hammer. Once he is happy that the shoe is a perfect fit, it is plunged into cold water to cool it down, and is then nailed to the foot.

The farrier will usually start nailing from the toe, and will drive nails, using the driving hammer, alternating from side to side. Most shoes have four nails on the outside and three on the inside of the shoe. Front shoes will generally have a toe clip while back shoes have quarter clips which help to keep the shoe in place and prevent twisting and slipping. After every nail is driven, the farrier will twist the sharp point off using the claw end of his hammer.

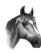

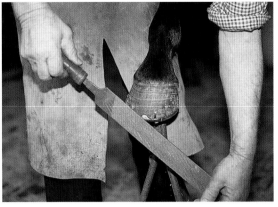

When the nails have been driven, they need to be clenched. The farrier will make a bed for the clenches using his rasp, then knock the remaining blunt ends of the nails down into the bed to form the clenches. Once the clenches have been knocked into place using the hammer, the farrier will further secure them by squeezing them tightly with the clenching tongs. The whole foot is then finished off using the rasp. The farrier will rasp any untidy edges between the shoe and the horn so that the two lie flush.

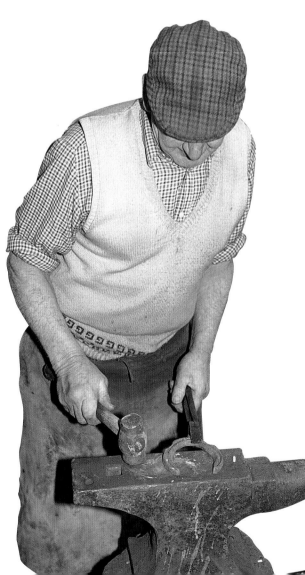

THE WELL-SHOD FOOT

THE SHOE SHOULD HAVE been made to fit the foot, and not the other way around. The feet should be balanced, and as far as the conformation dictates, should appear to be in pairs. There needs to be a straight foot to pastern angle. If this is broken then it affects the horse's natural way of moving and will put stress on the internal structures of the foot and lower limb. As a rough guide, the front feet should have an angle of 45 degrees at the toe, and the hind feet should have an angle of 50–55 degrees. The bearing surface of the foot should be level, with no gaps between that and the surface of the shoe. There should be no evidence of excessive use of the knife on the sole or the frog, which should come into contact with the ground. There should be no evidence of excessive use of the rasp, or dumping of the toe.

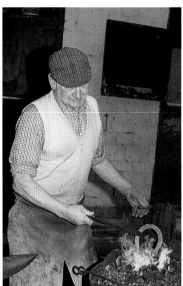

The clenches should appear level, approximately one third of the way up the foot, and should be smooth with no sharp edges. The heels of the shoe should be neither too short, which will not support the foot sufficiently and will lead to collapsed heels, nor excessively long, when the horse may overreach and pull the shoe off. It is important that the correct size of nail has been used for the shoe. If they are too small they will not fill the nail hole, and if too large they will wear away too quickly – both instances lead to loosening of the shoe. The horse should be shod with a weight and type of shoe suitable to the job it performs. The toe and quarter clips should be well drawn and fit the notch made in the hoof.

Top Left
A farrier rasps the hoof of this horse.

Above and Bottom Left
A blacksmith at work shaping a new shoe.

Below
Well-shod hooves.

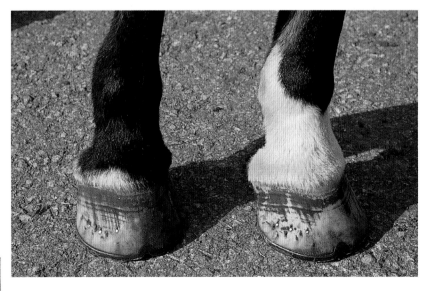

Strapping a Horse

THIS IS THE COMPLETE grooming process used on the stall-kept horse, which should be done daily and should take half to three-quarters of an hour. It is best done after the horse has returned from exercise, as when the skin is warm the scurf will loosen and the pores will be open making the grooming process more efficient.

WHILE THE HORSE IS TIED UP

FIRST TIE THE HORSE up and remove its rugs, or if it is cold, simply turn them back over its quarters leaving the front end free so that you have access to the head, neck, and front legs.

Pick the feet out into a skep, and use this opportunity to check the feet and shoes for wear and tear. The feet should be picked out both morning and night, and each time the horse is led out of the stable and also when he is brought in from the field. It is best not to wash the horse's feet every day, especially in cold weather, but if they are very muddy and need to be washed off, try to avoid getting the heels too wet, and make sure you dry them off properly.

HORSE FACT:
When a horse or pony loses a shoe, it is sometimes said to have 'thrown a shoe.'

Top Right
Grass-kept horses should not have the layer of grease removed from their coats as it protects them from the elements.

Bottom Left
This young owner gently cleans the eyes of her horse with a sponge.

Bottom Far Right
This horse is being groomed by machine.

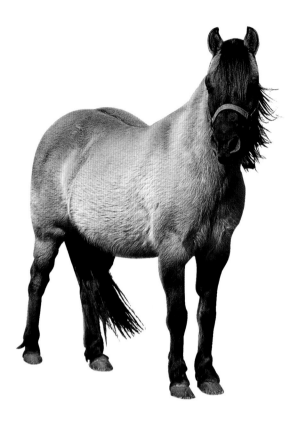

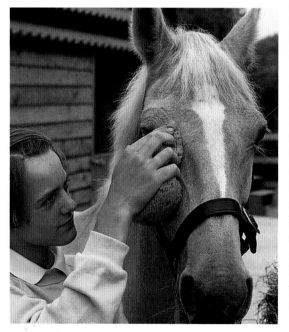

Next, start to remove all the caked sweat and dirt from the coat using the dandy brush. Start by the poll and work down and back until all the body has been covered. If your horse is particularly sensitive, or has been clipped out, it is sometimes better to use a rubber curry comb instead of the dandy brush.

Once all the worst of the dirt has been removed, take the body brush and start to untangle the mane. Sweep the mane onto the wrong side of the neck and brush the crest, then replace the mane and, starting at the poll, take a few strands at a time and brush them out. Work down the neck until the mane is completely brushed out. Next, start grooming the body using the body brush in conjunction with the metal curry comb. Start at the poll and begin to brush using short strokes. After every two or three strokes, clean the brush out on the metal curry comb. When brushing the near side of the horse, hold the body brush in your left hand, then when you start on the off side, switch the brush into your right hand.

WITH THE HORSE UNTIED

THE NEXT STEP is to untie the horse and slip the headcollar back around its neck. Taking the body brush, brush out the forelock, and then carefully brush around the head region, making sure that any dried sweat around the ears and browband patch has been removed. When you have finished, tie the horse up again.

Now take the wisp or massage pad, and begin the wisping process as described in the grooming section. When you have finished this, wash the eyes, mouth and nose with one sponge, rinsing and wringing it out between each wipe, and the dock region with the second sponge. Take the water brush, slightly dampen it and 'lay' the mane flat and smooth on the right side of the neck. For a final polish, use the stable rubber over the horse to bring a shine to the coat – if dampened, it will remove surface dust.

Next, take the body brush and start working on the tail. Stand to one side of the horse, take the whole tail in one hand, and start to brush a few strands out at a time. Once this is done, very slightly dampen the top of the tail, and then put on a tail bandage. Finally, if the hooves are dry, you can paint on hoof oil.

QUARTERING

THIS IS A QUICK clean up of the rugged stalled horse before work, involving folding back a section of the rug at a time, hence quartering, and cleaning each section in turn. Pick out the feet, and brush out each quarter, including the mane and tail. It may be necessary to use a dampened water brush to clean any stable stains. Sponge the eyes, mouth, nose, and under the dock. Do not forget to fasten the rug back up.

GROOMING THE GRASSKEPT HORSE

IT IS IMPORTANT to keep the grasskept horse clean, but you should not remove all the grease from the coat because this natural protection from rain and cold. Using common sense, you need to groom the horse mostly with the dandy brush, removing excess mud and sweat. Use the body brush on its head, but sparingly on the body. You can wisp to improve muscle tone but will probably not need to use the stable rubber, unless in preparation for a show. Obviously, you do need to keep the mane and tail combed; the eyes, mouth, nose, and dock clean; and the feet picked out.

HORSE FACT:

Mr. Ed, the talking equine star of the 1960s television series, was a golden palomino. He learnt an enormous amount of tricks for his role, including answering a telephone, opening doors, writing notes with a pencil, and unplugging a light. Apparently, Mr. Ed would occasionally have a fit of temper, as befitting his star status, and would stand stock still, wheezing and refusing to move.

Clipping, Trimming, and Braiding

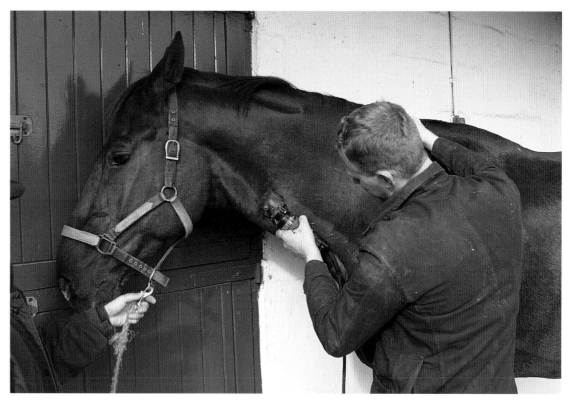

IN THE WINTER the horse's coat will become much thicker and when it is worked this can cause heavy sweating and distress, both of which will lead to a loss of condition. By removing some, or all, of the coat, the horse is able to continue in hard and fast work without profuse sweating.

WHY DO WE CLIP?

THE CLIPPED HORSE will dry off quickly if it does sweat up, which reduces the chance of it catching a chill. The clipped horse is much easier to keep clean and is therefore labor saving, and it is also easy to spot any abnormalities such as swellings, heat, or injuries. From a purely cosmetic view, many horses

Right
This horse is having its winter coat clipped.

appear much smarter when clipped, rather than when wearing their hairy winter coats. Clipping is mostly done in the winter, although occasionally a horse with a very thick natural coat may need to be clipped out during a hot summer if it is doing very fast work, such as eventing. The first clip of the year is generally done around October when the winter coat is fully established, and a horse will probably need at least two, and sometimes three, clippings during the winter. The final clip should not take place any later than the last week of January, otherwise it will affect the spring coat growing through.

CLIPPING EQUIPMENT

AS WITH ALL AREAS of horsemanship, safety is of the utmost importance, and there are some procedures you need to take when preparing to clip a horse. Remember that some horses find the noise and vibration of clippers very frightening and, if you are clipping a horse for the first time, try to find out what it is like to clip, prior to starting. Before clipping begins, you need to have a suitable place to do it in. This needs to be an enclosed area, preferably a special stall. There needs to be a nonslip floor – rubber matting is ideal. You need to have good light so you can see what you are doing, and you must be out of wind and rain.

HORSE FACT:

William F. Cody, otherwise known as Buffalo Bill, was given a snow-white horse called Isham by the painter Rosa Bonheur, who also painted their picture together. Isham was reputed to be one of Buffalo Bill's favorite horses, and repeatedly performed in his travelling 'Wild West Show.' When, due to bankruptcy, the show was forced to close, a friend bought Isham at auction, and gave him back to Buffalo Bill.

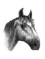

Most clippers are electric, although there are some that run on a battery pack. If you are using electric clippers you must have a power point handy and a circuit breaker; it is also useful to have a hook on the ceiling through which you can thread the cable to keep it out of the way. You should always have a helper when clipping to hold the horse for you and offer it reassurance. Both you and the helper ideally need to be wearing protective clothing of some form, such as boiler suits. You should wear rubber boots, a hat, and should use a dust mask as well.

Check your clippers before starting to clip. The blades need to be sharp and should be sent off for sharpening after every full clip, or two partial clips. At the end of every winter the clippers should be sent for servicing to keep them working efficiently. You should clean your clippers thoroughly after every use so that there is no hair clogging up the vents and mechanisms. Before starting to clip, add a drop of clipper oil to the blades, and check the blade tension, which will vary with different clippers. During clipping the blades will heat up, and it is very important to keep checking that they are not getting too hot. There are various cooling liquids on the market, which can be used or you can alternate with two pairs of clippers, using one while the other cools down.

HOW TO CLIP
THE HORSE NEEDS to be absolutely dry and clean before starting to clip. It is also a good idea to bandage the tail out of the way. A full clip can take quite some time, although the experienced clipper will do one in roughly 45 minutes. Make sure you have enough time to complete the clip in one session. Start on the shoulder, and lay the clipper blades smooth against the coat, then using long, clean strokes work against the hair. Work as quickly and efficiently as you can, and take particular care in the inaccessible regions,

such as between the front legs and behind the elbows. Stretch the skin smooth where necessary with your free hand. With each stroke of the clippers, you need to slightly overlap the stroke before so that you do not leave any ridges of hair showing. Be careful not to clip away any bits of the mane or tail, but above the top of the tail leave a small triangle to finish off nicely. Have a stool nearby in case you need one to reach the top of the back and the head. Take great care around the head region, as this is the area that a horse is most likely to object to. As you clip the hair away from the body, put a blanket over the quarters to prevent the horse getting chilled.

Top
These clippers are being tightened before use.

Bottom
Clipper oil should be added to the blades to ensure that they work efficiently and smoothly.

DIFFERENT TYPES OF CLIP

IT IS NOT ALWAYS necessary, or a good idea, to remove all of the hair when clipping, and there are different types of clip that you may choose.

Full Clip:
This is where all of the hair is removed from the body, head, and legs. It is very important that a fully clipped horse is rugged sufficiently to compensate for removing its coat.

Top Right and Right
A horse with a blanket clip; a fully clipped horse must be rugged.

Center Right
A trace clip leaves the coat above the shoulder.

Bottom and Bottom Right
Horses with a hunter clip and a chaser clip.

Hunter Clip: A popular type of clip that involves clipping the hair from the head and body, but leaving the legs and a saddle patch. By leaving the hair on the legs, the horse has some protection from thorns when hunting and also from the cold. The hair on the legs can be trimmed to make it appear tidier (see trimming).

Blanket Clip:
The hair is removed from the head, the neck, and the belly, leaving a blanket shape of hair on the body. Removing the hair from the head is optional, and sometimes just half the hair is removed, leaving hair on the front of the face round to the cheekbones.

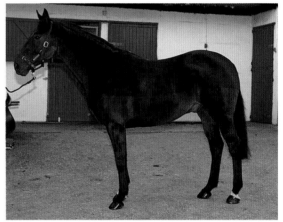

Trace Clip: There are different variations of this clip, which involves removing the hair from under the neck, and along a horizontal line starting from half-way up the shoulder, and running back to a point below the point of buttock. There are high and low trace clips, which simply involve taking off more, or less, hair in the same pattern.

Chaser Clip:
This a variation of the trace clip, when the hair is removed from the head and a line is drawn from the poll sloping to stifle. All the hair on the back and legs is left on, and the rest is removed.

Belly and Neck Clip: This just removes the hair from under the neck and the underneath of the belly.

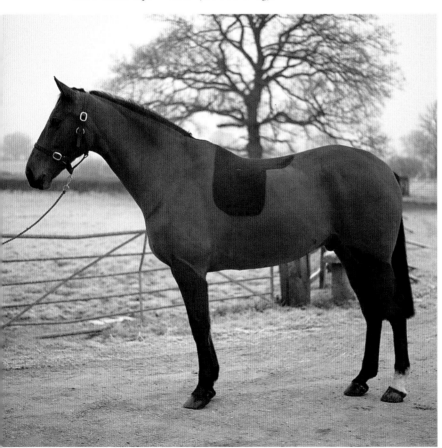

TRIMMING

TRIMMING IS a basic tidying up, which requires a pair of round-ended scissors and a comb. It can greatly enhance the look of a horse and is a necessary process if you wish to enter a showring at any time.

Start by trimming round the head region, and carefully cut a narrow bridle path, making the cut no larger than 1½ in (38 mm).

Before cutting the bridle path, take the comb and make a neat parting between the mane and forelock. Very often horses have great tufts growing out of their ears and trimming these away improves the look of the head. Very carefully take the ear in one hand and press the two sides together, then trim along the edge. Never actually trim inside the ear itself, and be very careful when trimming around the ear.

Many horses grow long whiskery hair under the lower jaw and this can be trimmed away to make the whole head appear more attractive. Long whiskers also grow on muzzles and chins, and often one or two long whiskers grow around the eyes. Some people trim these all off, though they may be left on.

Moving from the head to the mane, it is a good idea to keep the mane pulled; this is a necessity if you are showing and need to braid the mane. Pulling involves shortening and thinning the mane. First thoroughly comb the mane out then, starting at the poll end, separate a few hairs; take the pulling comb and push the shorter hairs up; wrap the longer hairs around the comb and quickly pull them out. Try to pull the mane after the horse has exercised and is hot, as the pores will then be open and the mane will come out more easily. Only pull a few hairs out at a time and if the mane is very long and thick, pull it over several days. Never use scissors to cut the length off the mane. There are several special mane pulling combs available now that have a cutting edge to them; they are rather more difficult than they

look to use, and the traditional mane pulling method produces the best results. After the mane has been pulled, you can carefully trim any straggly mane that may be growing over the withers and which gets in the way of the saddle and numnah.

Manes can also be hogged, which involves clipping the entire mane off – start at the withers and clip up the mane towards the poll. This is most effectively done when someone is holding the horse's head down, so that the crest is stretched. Hogging will need to be redone every three weeks or so to keep it neat, and is most commonly seen on cobs.

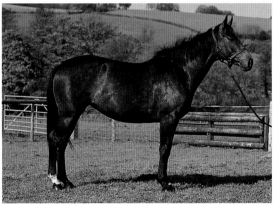

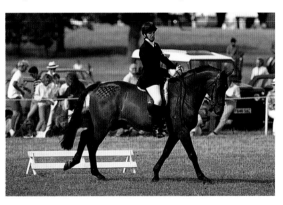

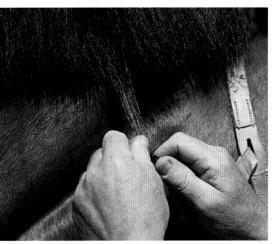

Top Left
This horse is having its tail pulled and trimmed; when finished it is known as a banged tail.

Top Right
A well-groomed horse looks elegant and smart.

Center Right
To enter a horse in dressage competitions, it should be groomed to an extremely high standard.

Right
This horse is having its mane pulled, which involves trimming and thinning the hair.

The end of the tail should be kept trimmed and is known as a banged tail. Standing to one side of the horse gently lift the tail under one arm to the height at which the horse normally carries it when working. Then trim the end of the tail so that it falls approximately 4 in (10 cm) below the point of hock. It should be trimmed absolutely dead straight across the bottom. A well-pulled tail is extremely attractive, but pulling a tail well is a real art. Always be very careful when commencing to pull a tail; not all horses appreciate it. Begin at the dock and taking a few hairs at a time, start to

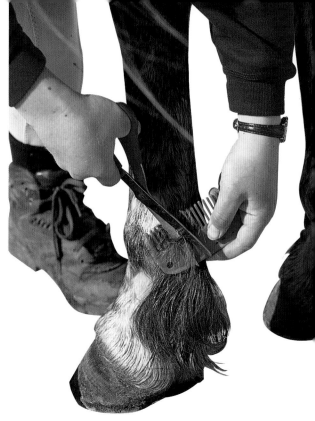

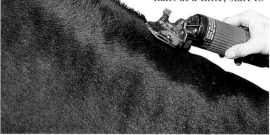

HORSE FACT:
The first American-bred and -owned racehorse to win the Grand National was Battleship, son of Man O'War, who won the legendary race in 1938 while being ridden by a 17 year old jockey.

remove them from the underneath of the sides, shaping as you go. Never use scissors or clippers to do this as it looks dreadful! Pull the tail to approximately 7 in (18 cm) from the top, and then dampen it and put on a tail bandage.

To trim all the longer unsightly hair from the legs, you will need a comb and a pair of scissors. Comb the hair against the direction of growth, and holding the comb in one hand, trim the hair level to the comb. You can work around the fetlock and

heels, and then up the leg taking off all the coarse hair. It is harder than it looks to do a good job, and the hair should end up appearing smooth with no scissor marks.

BRAIDING

BRAIDED MANES ARE required for most show classes and competitive sports with a few notable exceptions. Braiding greatly improves the look of the horse, showing off the crest and the neck. Tails can either be pulled or plaited, both of which look good and complement the shape of the hindquarters.

THE MANE

THE MANE NEEDS to have been thinned and pulled short before braiding. Brush the mane thoroughly and dampen it down so that it is lying flat. Take some rubber bands and divide the mane into bunches ready for braiding; as a rough guide, each bunch should be approximately the width of the mane comb. You need to try to work it out so that there is an uneven number of braids down the mane.

Once the mane has been divided up, start at the poll, dampen the section down again, divide it into three and start to braid pulling the hair

Top Right
This horse is having the hairs on its legs trimmed with scissors and a comb.

Bottom Left
Braiding makes a mane look much smarter and is often a standard requirement for show classes and other competitions.

Bottom Left
This tail has been pulled to give a neat appearance.

together tightly. Fasten the end, preferably with thread or a band, and then either roll, or fold, the braid up. Stitch the roll and secure by winding the thread around the braid and then down and through from top to bottom. Trim away any thread that is left hanging, but do not cut off any wispy bits of mane. If you have to braid up the evening before, take a stocking, lay it along the braided mane and secure it over each plait with a rubber band. This will help to keep the braids clean and secure.

BRAIDING THE TAIL

BRUSH THE TAIL through and then dampen the hair. Take a small section of hair from either side and one from the middle, and start to braid. With each cross over, take a small section of hair from either side adding it into the plait as you work down the tail. Keep adding sections until you reach the end of the dock, then continue braiding down to the end of the section of hair that you have in your hand. Secure the very end, then fold it up behind and

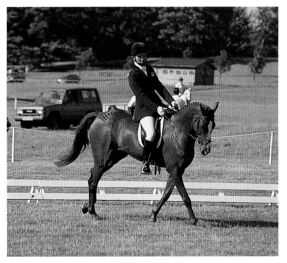

attach to the braid at the end of the dock in a loop. The trick with braiding tails is to keep the braid as tight as possible, and to keep the hair you are working with quite damp.

TIPS ON PRESENTATION

CAKED WHITE CHALK is very good for covering up last minute stains on horses with white markings. Baby oil rubbed around the muzzle and eyes looks attractive and gives the skin a gloss and shine. Paint the hooves with hoof oil just before entering the showring to make the feet shine.

Use hair gel to keep the mane and tail flat; egg white is a good alternative. Brush quarter markings on by brushing the hair in the direction of growth, placing a stencil over the quarters and then brushing the hair downward. Remove the stencil and the pattern is left; this can also be done without a stencil.

Left

Pulling manes can be time-consuming but it is vital before braiding to thin and neaten the thick, coarse hair.

Below

Tails look smart and tidy after braiding, which is easiest when the hair is slightly damp and therefore more manageable.

Bottom Right

Appearance of both horse and rider is of paramount importance in shows, and especially in dressage.

Traveling with a Horse

THERE ARE several things that you should do before traveling with your horse and, as with all aspects of good stable management, these are based on common sense. Whether you will be using a horse-box or a trailer, you must make thorough checks that the vehicle is safe. The flooring particularly is an area to keep a weather eye on to make sure that it is sound and there is no indication of rotting.

Top Right
The inside of a motortruck showing the partitions that separate the horses.

Below
This horse is being loaded into a horse box.

PRACTICALITIES

MOST HORSE VEHICLES will have drainage holes along the sides in the floor and these should always be kept clean and free from blockage. Both the floor and the ramp needs to have a nonslip surface such as rubber matting which can be removed to be cleaned, but is heavy. Straw can be used too, but must be cleaned out every time the vehicle is used. Make sure that the tie-up rings have string on them to tie the horse to – never tie the lead rope directly to the tie-up ring. Ensure that all the partitions are in good working order, and that their fastenings and hinges are well oiled to allow you to manoeuvre them with minimum fuss.

Check that all the lights on the vehicle are working; this is especially relevant with trailers which sometimes have problems with the electrical sockets. It is also worth checking that the internal lights are working. If you are driving a horse-box, make sure that its plating is up to date, and if it weighs over seven and a half tons, ensure you have a HGV licence. It is a good idea to fill your vehicle with fuel before loading and embarking on the journey, especially if you are traveling with an anxious or impatient horse that would be disturbed by long waits. Whenever you are traveling with horses, always have a first-aid kit – equine and human – and buckets and water stored away.

DRIVING WITH YOUR HORSE

WHEN DRIVING a trailer or a horse-box, always be aware of the animal on board and drive accordingly. Take corners and roundabouts slowly so as not to throw the horse off balance, and allow plenty of time for braking; the smoother the ride the horse is given, the better. Keep your speed down and be aware of branches, etc. that will make a frightening noise on the roof, startling the horse. Also take note of the weather conditions – if possible high winds are best avoided. Horses get warm when traveling, through excitement or nerves, and if there is more than one horse in the box they generate heat, so keep the vents open and rug them accordingly.

EQUIPMENT

IT IS VITAL to use appropriate protective clothing when traveling and there is a vast range available on the market today. Basic traveling equipment that needs to be provided is as follows:

Leg protection is extremely important. Bandaging is very good if done by someone experienced; it provides good protection and also support, but is quite time consuming. There are numerous leg protectors available which are shaped to protect the knees, hocks, and lower leg down to the feet. They generally fasten with Velcro and also provide good protection. They are quick and easy to put on, but have the disadvantage of sometimes coming undone, especially if the Velcro has aged. They do not provide any support, and are standard sizes, so sometimes they do not provide a very satisfactory fit.

Knee and hock boots are essential if you are using bandages rather than leg protectors. The best knee and hock boots are leather with felt surround; they are expensive to buy, but will, with care, last a lifetime. Large horses often try to 'lean' on the ramp when traveling, and examination of hock boots that have been used may show scratches and wear, which is why it is important to protect the horse's hocks. Some people use overreach boots while traveling which is also a good idea.

The tail is another vulnerable area as horses tend to 'sit' on the ramp. The tail should be protected by a tail bandage underneath a tail guard. There are different types of tail guard, but the leather ones afford the greatest protection and are very durable.

It is a good idea to travel horses when they are wearing a poll guard, although this is not so necessary with small ponies. Poll guards come in a variety of different styles but all afford good protection to this sensitive area.

Rugging a horse for traveling depends entirely on the weather and how many other horses are traveling in the same vehicle. Whatever type of rug is used, make sure that it is securely fastened and there is nothing flapping or trailing which could get caught up or cause alarm.

Top Left
This horse is dressed for traveling with its leg guards, tail bandage, and a rug.

Above
The inside of this double trailer shows straw bedding that should be moved after every journey.

Bottom
A horse being unloaded from a horse trailer.

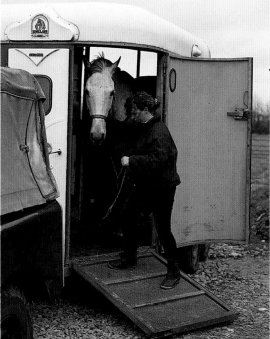

HORSE FACT:
The Celts regarded the horse as a sacred animal in their beliefs.

Health and Breeding

THE AVERAGE GESTATION period for the horse is 340 days, although it is not uncommon for mares to foal early or late. Thoroughbred mares are often bred early so that their foals, which are destined for racing, are born early in the year. However, the most common time for mares to foal is from March onward. By then, the weather is improving and the grass growing, factors which contribute to the well-being of both the mare and the foal.

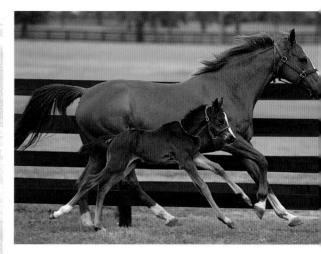

Top Right
This young foal is already running with this mare; unlike humans horses can stand from birth.

Center
The foetus of a foal in the womb.

Bottom
This foal has quite strong legs, which enables it to stand and walk from such an early age.

LIFECYCLE OF THE HORSE

UNLIKE HUMANS, foals are able to stand and move around, if a little shakily, almost immediately after birth. They are usually born with just their temporary premolar teeth, but by ten days old, they should have their central two incisors. They suckle from their mother and start picking at solid foods from about six weeks. Generally they will try grazing by copying their mother, and will also try putting their heads into their mother's feed bucket.

Foals have very long legs in proportion to their size and often when trying to graze they will have to bend their knees in order for their noses to reach the ground. They are weaned from their mothers at about six months old, and colts tend to be castrated at around this age too, although it is not always advisable to do both these processes at the same time, due to the trauma involved.

YEARLING TO FOUR YEARS

THOROUGHBREDS ARE FOALED early and mature quickly so that they are ready to be raced on the flat as two year olds. As such, all Thoroughbreds officially change their age on January 1, and non-Thoroughbred horses change their age on May 1, regardless of their actual date of birth. Yearlings are very often characteristically ungainly, and are still leggy in comparison to their overall size. They will tend to go through growth spurts, and their appearance and shape can often change dramatically as they mature.

During growth spurts the croup is often higher than the withers, although this should even itself out as the young horse grows. Some of the 'epiphyses,' growth plates on the long bones of the legs, do not stop growing until the young horse is between two and two-and-a-half years old, and it is therefore not advisable to overwork youngsters. This can result in irreversible damage to the leg bones, and for this reason, racing two year olds is a somewhat controversial subject. As well as maturing physically, the young horse needs to mature mentally, and this process happens more quickly with some horses than with others – indeed it is not infrequently that the irate rider is still waiting for their 13-year-old horse to mature mentally!

Every trainer has a different approach, but it is usual for a two or three year old to be 'backed' and 'turned away.' This process involves introducing the young horse to the saddle and rider, teaching walk, trot, and canter under saddle, and simple school exercises, and then turning the horse back out to grass for a few months. He then starts his training in earnest at either three or four years old, when he has both physically and mentally matured.

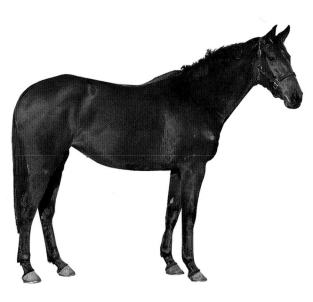

FOUR TO TEN YEARS

EACH INDIVIDUAL HORSE will mature mentally and physically at a different rate, as well as some breeds naturally maturing at different rates. The Thoroughbred, for example, tends to mature quite quickly, as does the Suffolk Punch, whereas the Lipizzaner, by contrast, is thought to mature quite slowly, but equally is long-lived, and can carry on athletic work into its twenties. However, by five years the physical proportions of the horse should be established and, varying of course from horse to horse, the best and most productive years of his working life should be from between five to 12 years old.

FIFTEEN AND BEYOND

ROUGHLY FROM FIFTEEN YEARS onward, the majority of horses will start to stiffen up, just as we do, as we get older. Some horses, of course, continue to compete at the highest levels up to 20 years old or so, and much of this is directly related to the care they have had throughout their life.

The appearance of the horse will alter as he approaches his late teenage years. They often appear to have a 'sway' back, when the back dips in the middle; the muscles largely disappear and the backbone becomes prominent. The abdomen will sag, hollows above the eyes may develop, and their teeth will become worn. The digestive system becomes less efficient, and it is hard to keep them in good condition. Horses do live from between 20 to 30 year, ponies longer and donkeys outlive both.

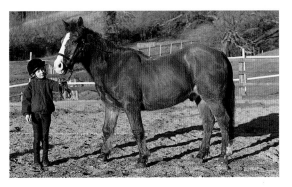

HORSE FACT

Horses' hooves grow approximately 0.25 in (6 mm) a month, and take nearly a year to grow from coronet band to the ground.

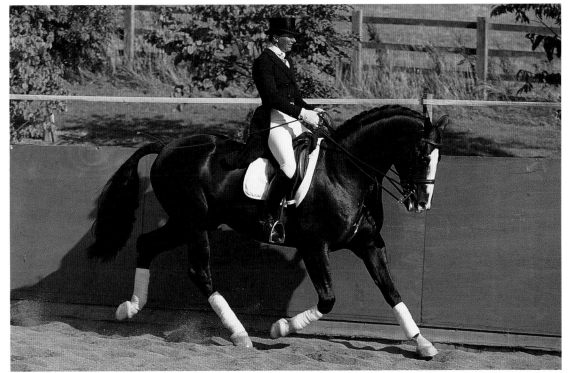

Top Left
This three-year-old will have started his training but will be 'backed away' until he mentally matures.

Center
This 28-year-old pony shows signs of ageing; he has a sway back and the backbone is prominent.

Bottom
This seven-year-old Hanoverian horse is in its prime.

 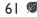

The Health of a Horse

YOU SHOULD observe your horse regularly throughout the day, regardless of whether it is kept out at grass or in the stable. The first inspection you make in the morning is the most important as your horse will have been on its own all night, and you need to observe it to ensure it is healthy. You should learn to notice indications of a problem very quickly and also recognize what is normal behavior for individual horses, so that what may be normal for one horse, could indicate a problem in another.

TEMPERATURE, PULSE AND RESPIRATION

THE NORMAL TEMPERATURE of a horse should be 100.5–101°F, or 38°C at rest. To take the temperature, shake the mercury down in the thermometer and grease the bulb end with a small amount of vaseline. Have a helper hold the horse,

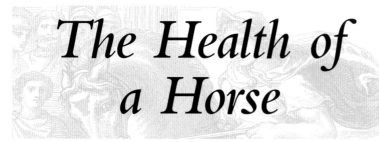

HORSE FACT:
In the state of Arizona, it is illegal for cowboys to walk through a hotel lobby wearing their spurs!

SIGNS OF ILL HEALTH

• Head hanging low, unresponsive ears.

• Sunken eyes, discharge from the eyes or the nostrils, eyes not fully open, or third eyelid showing.

• Skin taut, and slow to recoil in a recoil test.

• Coat dull and staring, or evidence of profuse sweating that may or may not have dried.

• Not eating or drinking.

• Abnormal droppings; very loose, very hard, or not passing at all.

• Discolored urine – black, brown, or red.

• Yellow, pale, or blue mucus membranes, which indicate jaundice, anemia, or lack of oxygen (in that order).

• Resting a front leg, or slow uneven steps.

• Abnormal behavior and signs of discomfort such as kicking at belly, pacing the stall, pawing the ground, frantic rolling.

• Blood slow to return to capillaries after a capillary test.

• Shallow or rapid breathing.

• Raised or lowered temperature by 1° F or 0.5° C.

• Abnormal pulse rate.

• Excessively over- or under-weight.

• Pungent smelling feet.

Top Right
One of the signs of colic is frantic rolling.

Bottom
This foal displays typical signs of ill health; its head is carried low, and the eyes are sunken and not fully open.

SIGNS OF GOOD HEALTH

• Alert, with pricked mobile ears and clear bright eyes.

• Smooth, glossy coat that is lying flat.

• Salmon-pink mucus membranes.

• The skin should move over the underlying frame easily and smoothly.

• The droppings should be normal, greenish brown depending on what it has eaten, and there should be a normal amount, roughly 15 during a 24-hour period.

• Urinating normally with colorless or pale yellow urine.

• Standing with weight on all four feet; some horses rest a hind leg, but should never rest a front leg.

• No heat, swelling, injuries, or abnormalities.

• Eating and drinking a normal amount, which varies from horse to horse.

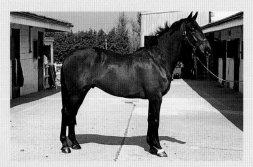

• Normal pulse, temperature, and respiration.

• The skin should be elastic and should respond to a skin recoil test. (A piece of skin is pinched between thumb and finger and, on its release, the skin should immediately recoil.)

• There should be normal response to a capillary refill test. (The thumb applies pressure to the gum to restrict the blood flow. When the pressure is removed, the capillaries should immediately refill with blood.)

• The horse should not be excessively over- or under-weight.

• There should be no signs of undue disturbance in the stall and bedding over night.

and then, standing to one side of the hindquarters, hold the tail up, and using a rotating movement insert the thermometer, bulb end first, into the rectum. The thermometer should be inserted so that the bulb end is resting against the rectal wall. Keep a tight hold on the thermometer to prevent it from being drawn completely into the rectum. Remove after one minute, wipe clean, and read.

The normal pulse for a horse at rest should be 35–42 beats per minute, slightly higher for foals.

To take the pulse, find the artery inside the foreleg in front of the elbow, or the artery on the lower jaw, and gently press your fingers against it. Count the number of pulse beats in 30 seconds, and double this for your reading.

The normal respiration rate for a horse should be 8–12 in and out breaths per minute at rest. Watch the horse's flanks and count the inhalation and exhalation movement as one.

Top
This horse is in excellent health, it is alert with a glossy coat and standing with a good profile on all four feet.

Bottom
This Hanoverian Belucci displays typical signs of good health, his ears are pricked, eyes are bright, and the coat is smooth and glossy.

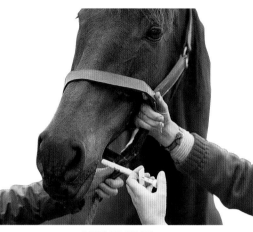

WORMING

THERE ARE SOME steps that you should routinely take to keep your horse in good health and one of these is to ensure a program of regular worming. All horses naturally carry a worm burden, but if this should become too great, then there can be serious consequences such as damage to the internal organs and even death. Horses should be wormed at least every six to eight weeks, and this should begin with foals at six weeks of age. There are different types of wormer, which target different worms and you need to start a program that is effective in controlling them all; this means using several different types of wormers.

VACCINATIONS

IT IS ESSENTIAL THAT your horse is given regular vaccinations against tetanus and equine influenza, which are often combined in one injection. It is compulsory for horses competing in affiliated competitions to have had equine influenza vaccinations.

TEETH

THE HORSE'S top jaw is wider than the bottom jaw. When the horse chews, it wears down its teeth, and due to the difference in size of the jaws, sharp edges often develop on the outside of the molars on the top jaw, and on the inside of the molars on the bottom jaw. You should arrange for a horse dentist, or a vet, to rasp the horse's teeth every six months to keep them level.

Top

This horse is being wormed; adult horses should be wormed every six to eight weeks.

Bottom

The symptoms of an ill horse should be noted to inform the vet. This Cleveland Bay lacks a healthy appearance.

WHEN TO CALL THE VET

• If your horse has injured itself and is bleeding profusely, stem the bleeding. Do not put any creams or powders on the wound until the vet arrives.

• If your horse shows signs of colic, seek professional help.

• If your horse has a puncture wound, call the vet; such wounds often become infected and are require a course of antibiotics.

• If your horse is lame, and you do not have the experience to know why or how to treat it.

• If your horse's temperature is raised by more then one degree farenheight.

• If your horse is coughing, has thick yellow mucus and is generally off color.

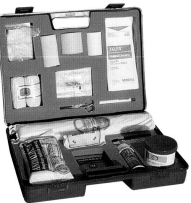

FIRST AID KIT

WITH MINOR WOUNDS it is often not necessary to call the vet, and treatment is a case of common sense. Every stable yard should have a first aid kit, which should be kept out of reach of both animals and children; some of the main components of this should be:

Veterinary bandages, vet wrap,
 crepe and stable bandages
Gamgee
Sterile dressing
Surgical tape
Antibiotic powder, spray, and cream
Cotton wool
Animalintex poultices
Kaolin paste for poulticing
Epsom salts
Scissors
Thermometer
Vaseline
Surgical spirit or witch hazel for galls
Stockholm tar

Whenever traveling with horses you must take a first aid kit with you; it is best to keep one in your vehicle, but be sure to replace anything you use. The main items needed are bandages, gamgee, cotton wool, antibiotic powder, surgical tape, scissors, antiseptic dressing, and animalintex poultices.

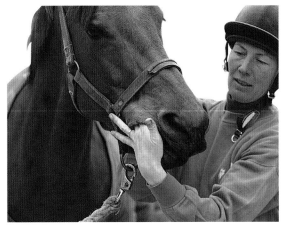

Always have the telephone number of your vet pinned up in your tack room or next to your telephone so that in cases of emergency it is easily accessible.

Top Left
This owner is checking her horse's teeth to feel whether they need rasping to prevent sharp edges.

Left
This horse is having its feet soaked to ease the pain on the sole.

Above and Bottom
An equine first aid kit should be taken whenever you are traveling. Rug a horse up when traveling in a box.

Top Left
This horse is being cold hosed, which reduces heat and swelling on an injured leg.

Top Right
A bran and Epsom salts poultice is good for hooves that have had their shoes removed.

Below
After cold hosing hot water can be applied to ease pain and draw wounds.

Bottom Right
A poultice kit.

COMMON TREATMENT TERMS

THERE ARE SOME procedures that are often used in the treatment of minor wounds, and it is helpful to familiarize oneself with these terms:

Cold hosing: This is most commonly used to reduce heat and swelling on the legs. First grease the heels with some vaseline to prevent them getting sore, then start the hose as a trickle in order not to frighten the horse, and move it gradually from the foot up the leg to the site of injury. Once the horse is used to the hose, you can increase the pressure, and this is a good way to remove dirt from an open wound as well as reducing bruising. Hose above an open wound, and not directly into it.

For hosing to be beneficial, it needs to be done for roughly twenty minutes, twice a day. After hosing, carefully, dry the heels and smear on more grease to prevent them from cracking open.

Hot fomentation: This can be used after cold hosing, and is useful in the treatment of pain and swelling, and also to draw wounds. You need to use a bucket of hot water (not uncomfortably hot) with some Epsom salts in it, soak a towel in the water, wring it out, and apply it to the damaged area. Keep applying the hot towel to the area, and keep the water in the bucket hot by topping it up from a kettle. This needs to be done for at least 20 minutes to be effective, and is useful to use on areas that can not be poulticed.

Poulticing: This is an excellent method of cleaning a dirty wound, drawing out an infection, and protecting the wound. There are several different types of poultice, but the most commonly used are Animalintex and Kaolin. Animalintex is a sterile dressing, which can be applied wet or dry. For dry use, apply as a sterile dressing, bandaging over the top. For wet use, trickle boiled and cooled water over the untreated side of the dressing. Making sure it is not too hot, place over the wound with the treated side facing in to the damaged area, cover with a layer of plastic and then bandage.

Kaolin is very effective in the treatment of bruising and swelling. Heat the Kaolin up and spread on a piece of cloth, making sure it is not too hot, and apply to the wound and bandage over the top. It can be applied cold; keep it in the fridge, then mould it to the leg and bandage over the top. Bran and epsom salts poultice is an effective one to use on the foot after the shoe has been removed, but has the disadvantage that many horses will try and eat it! Make a small bran mash with some Epsom salts added to it.

Bandage the leg, and grease the heels to protect them. Take a strong plastic bag and empty the bran mash into it to a depth of approximately 2 in (5 cm). Place the foot in the bag and press the bran around the sole of the foot and the site of injury. Either put a poultice boot on over the top to secure it, or bandage over it to secure it. All poultices and bandages should be removed and replaced at least every 12 hours.

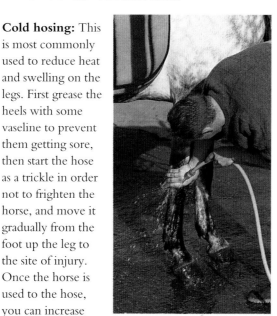

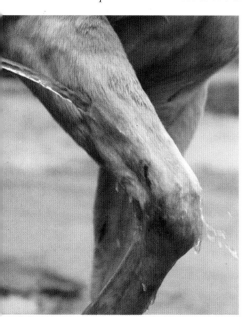

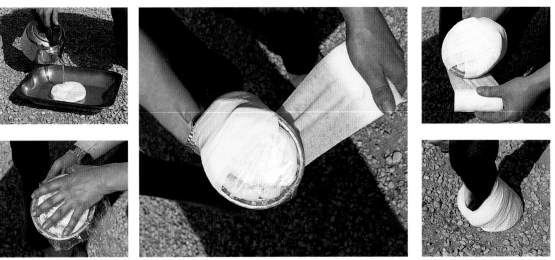

Below
This owner is cleaning the leg wound of this horse.

Tubbing: This is an effective way of cleaning a wound, drawing out infection, and reducing bruising in the foot area. Using a shallow plastic bucket and warm water, mix a saturated solution of salt or Epsom salts. Place the foot in the bucket and soak for at least 15 minutes, twice a day. Remove the foot and poultice or bandage to keep the wound clean.

When bandaging, it is very important to use gamgee or fybagee underneath to distribute pressure evenly. Make sure the bandage is put on firmly to prevent it from slipping, but be careful not to make it too tight. Always bandage the legs in pairs so that both legs are supported.

TREATMENT OF A MINOR WOUND

STEM THE BLEEDING by direct, firm pressure to the wound with a clean pad. Only do this if you are sure there are no foreign objects in the wound. Once the bleeding has stopped, carefully trim any hair overlapping the wound with round-ended scissors to allow you to assess the extent of damage. Using warm water (which has been boiled and allowed to cool), with either salt or antiseptic in it, clean the wound using a cotton pad working from the middle of the wound outward. Use a fresh pad for each wipe, and be careful not to rub any grit or debris into the wound. Once the wound is clean, dry the area and apply either wound powder, spray, or cream.

If you think that you may have to call a vet to look at the horse, do not apply any treatment powders or creams before hand because these will mask the extent of the damage to the animal. Leave evaluation of the problem to an expert who can to make an instant and informed decision about the injury and its treatment.

OTHER WOUNDS

THERE ARE FOUR MAIN types of wound that you may come across; these are contusion (bruising), laceration, incision, and puncture.

Contusion: This can be caused by a kick or a blow resulting in bruising, swelling, heat, and pain. Best methods of treatment are cold hosing, poulticing, or hot fomentations.

Laceration: This is the most common type of wound and is basically a tear wound with a jagged edge. Depending on the severity of the wound, you can either treat it yourself or call the vet. It may need to be cleaned by hosing or poulticing, and could possibly need stitching.

Incision: This is not as common, and is a clean cut from a sharp object such as glass. Incisions often bleed profusely, and will probably need to be seen by a vet and stitched. They tend to heal quite quickly.

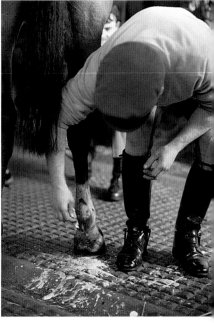

Puncture: This is a wound often seen in the foot, and is caused by stepping on a nail or a sharp object. These can be dangerous because the surface puncture wound is small, but the object could have pierced quite deep inside. The risk of infection is high with these types of wound and it is very important to check that your horse's tetanus vaccination is up to date. The wound will need to be poulticed to draw out any infection, and the surface of the wound must be kept open until it has healed from the inside out.

HORSE FACT:
The WAHO is the World Arabian Horse Organization, which approves the Arabian studbooks worldwide.

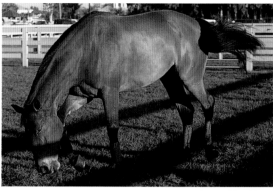

RECOGNIZING LAMENESS

WHEN THE HORSE is lame in a front foot or leg, it will be reluctant to put any weight on it. If the lameness is severe, you may observe the horse resting a front leg as it is standing still. When the horse moves off, it will have pronounced head bobbing, with the head rising up as the sore leg hits the ground and lowering as the sound leg hits the ground. The extent of the head bobbing is an indication of the severity of the lameness. Lameness in the hindquarters is harder to spot. As the horse walks away from you, it will drop one quarter lower, the sound leg, and raise one higher (the lame leg).

Top Right
When a horse is showing signs of agitation like these, it is sensible to call a vet at once.

Top Left
This horse has swollen fetlock joints.

Center
This injury to the fetlock and heel should be cleaned and bandaged to avoid infection.

RECOGNIZING COLIC

COLIC IS A GENERAL term covering any type of abdominal pain. It can be caused by a number of factors such as feeding too soon before or after exercise, worm damage to the gut, eating too much, or eating poor quality food, or distress brought on by a change in environment, going to a show, and so on.

The symptoms vary from horse to horse depending on the severity of the pain. The horse shows visible signs of distress such as lying down and getting up frequently, frantic rolling, kicking at the belly, and turning round to look at the belly. Its respiration rate may increase, it may start sweating, it will probably be off its food, and it is likely that it will not have passed any droppings. The symptoms sometimes come and go, but if they persist for more than 10–15 minutes, you must call the vet.

Remove any food from the stall, and other items such as mangers that the horse might damage itself on while in a distressed state. Keep a constant watch on the horse; if the symptoms are mild, you can walk it gently in hand on a soft surface; if they are severe leave it in its stall. Try and ensure the horse has a good, thick, deep bed and is free from drafts. The vet may give it a muscle relaxant; he may use a stomach tube and administer liquid paraffin to help remove the blockage; if a twisted gut is suspected, an operation may be needed.

The best prevention for colic is good stable management.

CARE OF THE SICK HORSE

ALWAYS ERR ON the side of caution and consult the vet if you are worried in any way about your horse. If illnesses and injuries are treated immediately they stand a much better chance of full recovery. Before your vet arrives, take your horse's temperature, pulse, and respiration, and be ready to explain to the vet the symptoms the horse has been exhibiting. Obviously, at the first sign that there is something wrong with your horse, stop working it.

Make the horse as comfortable as possible, ensure that it has a really good thick bed, and keep it warm with several lightweight rugs, without allowing it to become too hot. Try to disturb the horse as little as possible, pick out the dropping when you can, but start a deep litter bed so that you do not need to move it to muck out. Make sure that the horse has fresh air, but keep it free from drafts.

Try to keep the yard area outside its stall as quiet and free from activity as possible. Sometimes it is a good idea to put stable bandages on for support, but be sure to remove them morning and night, massage the legs and replace them. Monitor the horse closely, without disturbing it; if its condition deteriorates, call the vet immediately. Check how much water the horse has drunk and keep the water supply clean and fresh. Adjust feeding so that the horse is on several small feeds a day, and feed something tempting and laxative.

If the horse is really under the weather its appetite will be greatly reduced and it may go off his food entirely, so remove any uneaten food immediately. Allow the horse unlimited hay unless directed otherwise by the vet. If the horse is on medication make one person responsible for looking after it, so that there is no danger of someone either forgetting the medicine, or giving a double amount.

ISOLATION

LARGE YARDS HAVE an isolation stall for stabling horses with infectious conditions. The isolation stall must be completely separate from the other boxes and should ideally have its own tack and storage room next door. It needs to be far enough away from the rest of the yard that there is no danger of wind-born infections carrying to the other horses. The sick horse in isolation should be treated as above, but the person looking after it needs to make allowances for its contagious condition.

There should be a complete set of equipment used only for the isolation stall, including mucking-out tools, buckets, grooming kit, and rugs, all of which need to be thoroughly disinfected after the horse has left isolation. Only one person should be responsible for the care of the horse, and, before coming into contact with it, should put on protective clothing in the form of boiler suit, gloves, hat, and boots. These need to be removed before approaching any of the other horses on the yard. There needs to be a separate muck heap, which should ideally be burnt.

When the horse has been removed from isolation, all the bedding needs to be burnt and the box needs to be washed out, scrubbed, and disinfected thoroughly, including the walls.

HORSE FACT:

BSJA stands for the British Show Jumping Association; this association runs all the affiliated showjumping competitions in Great Britain, and in order to compete in one of these affiliated competitions, you must be a member of the Association.

Dealing with Lameness

THRUSH IS USUALLY the result of poor stable management, and is a disease of the frog. The foot gives off a pungent odour, and there is unpleasant black discharge from the frog. There is a general disintegration of tissue, and if untreated, infection will follow. Horses do not go lame at first, but will if it is untreated, and it can lead to an atrophied frog and contracted foot in the worst cases. Thrush can be prevented by regular cleaning out of the feet, exercise, and a clean, dry environment. Treating thrush involves reassessing your stable management, thoroughly cleaning the frog area with a solution of dilute hydrogen peroxide, spraying with an antibiotic spray, and having your farrier trim away the dead material.

BRUISED SOLE IS NOT uncommon, especially for horses with thin soles. It is a bruise to the underneath of the foot, and is generally caused by stepping on a sharp stone. The horse will go lame immediately, but may come sound briefly, before going lame again. The shoe needs to be removed, and the foot poulticed with either a bran poultice or Animalintex to draw the bruising out. Horses that are prone to bruising can be shod with full pads, or with a wide web shoe.

Corns are invariably caused from pressure due to a badly fitting shoe, or one that has been left on too long. Corns are bruises on the sole, in the heel region, at the seat of corn, and tend to form on the inside of the front feet. The farrier must be called out to remove the shoe. He will use his hoof testers to pinpoint the corn, and will then pare away the sole until the corn is reached. Exposing the bruise relieves the pressure, and the foot can then be poulticed to draw out the bruise and any infection. Unfortunately, once a horse has had corns, it is likely to be prone to them, so careful, regular shoeing is required.

Pricked foot is when the farrier accidentally drives a nail into the sensitive structure of the foot. The horse will react violently if this happens, and you will know immediately what the problem is; it will go lame straight away. Once the nail has been removed, the nail hole should be flushed with dilute hydrogen peroxide, or tincture of iodine to reduce the chance of any infection. If bruising occurs, the foot will need to be poulticed, and should not be reshod until the horse is sound.

Nail bind is similar but is the result of the farrier driving a nail too close to the sensitive structures resulting in uncomfortable pressure. The horse will probably not go immediately lame, but will become lame a short time after being shod. The wall of the hoof will be painful if it is tapped over the site of the bind, and there will be heat in the foot. The shoe needs to be removed, and the foot should be poulticed to relieve the bruising.

Laminitis is a highly complex disease causing inflammation of the sensitive laminae tissues of the foot. The inflammation causes great pain and in severe cases the laminae will tear, followed by rotation and dropping of the pedal bone on, or through,

Top
This horse is in superb condition; thrush in the frog, however, may lead to temporary lameness.

Bottom
In order to treat bruising on the sole the shoe must be removed before a poultice is applied.

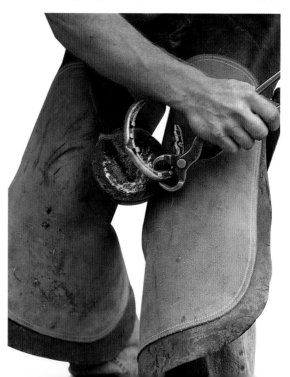

heat in the feet and a strong digital pulse. Treatment involves restricting the diet, administering painkillers such as phenylbutazone, therapeutic shoeing, including the use of a heart bar shoe to support the pedal bone, and/or cutting away the dead tissue at the front of the foot to rebalance it. Gentle exercise helps the blood circulation. Once an animal has had laminitis, it will be prone to it.

Navicular is a very complex disease about which little is known. Narrow and very concave feet may contribute to it, as may concussion, but it results in a reduced blood supply to the navicular bone, which deteriorates and roughens. It is not a curable disease, but is treatable. Frequent tripping is an early symptom, as is a reluctance to jump and a shortening of the stride, which may become pottering. Once diagnosed using X-rays and nerve blocking, treatment can begin, and good shoeing can be of great benefit.

The heel needs to be supported, usually with a bar shoe, and a rolled toe can aid the breakover. Keeping the horse in modified work helps the blood circulation, and it is likely that the vet will prescribe phenylbutazone for the pain and either Isoxuprine or Warfarin to help the blood circulation.

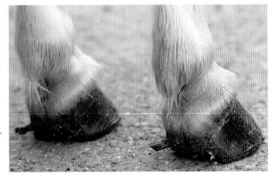

the sole.
Overfeeding, lack of exercise, and concussion are all contributors to laminitis. It is more commonly seen in ponies, and normally affects the front feet, although can be present in all four feet. Laminitic animals adopt a backward leaning stance to relieve the pressure and to take weight off the feet. They do not want to move, may have an increased respiration rate, have

Above
Narrow or concave feet can contribute towards the onset of navicular.

Top
The dead material on the foot is being removed by the farrier.

Left
This horse is being prepared for X-ray.

Fitness Procedures

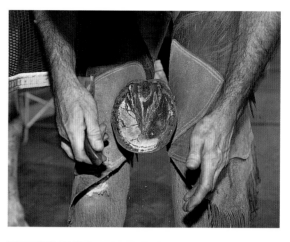

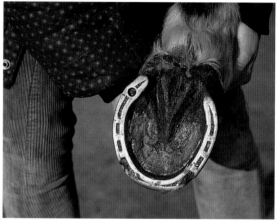

BEFORE STARTING A FITNESS program, there are several factors that you should take into consideration and some preparations that you need to do. Your fitness program will very much depend on how long your horse has been out of work, if it has been resting due to an injury, or simply on holiday, and the time of year that it has been off. If you are starting a fitness program with a particular end date in mind, such as the first event of the season, always allow yourself at least two weeks longer than you think it is going to take to get your horse fit. By doing this you give yourself enough time should anything affect your plans.

Top

Stud holes are visible on this horse's hoof.

Center

The farrier is trimming the frog and sole of foot of the horse to ensure it is in perfect condition for exercise.

Bottom

The fitness programme should always be extended by two weeks longer than first planned to account for any problems that may occur.

THE PREPARATION STAGE

IF YOUR HORSE HAS been out at grass on a summer holiday, you need to start bringing it into the stable for short periods of time to reaccustom it to life indoors. You also need to gradually introduce concentrates and hay if it has been eating just grass all summer. If your horse has been resting during the winter, it is likely that it will already have been in at night and should have been on some hay. It needs to be shod, and be sure to ask for stud holes if you think you will need them. Check its teeth, and arrange to have them rasped if necessary, also

check that it is up to date on all its vaccinations, and arrange to have these done if needed. It is also a good idea to worm it, although it should have been on a regular six to eight week worming schedule anyway.

Start grooming your horse to get the grease out of its coat and gradually introduce some lightweight rugs. Do not clip your horse at the start of the fitness programme as it will be doing a lot of work in walk and may catch a chill so it is best not to clip until the horse has started to trot. You can, however, pull its mane and/or tail and trim the worst of its feathers and whiskers. It is a good idea to rub surgical spirit into the girth, saddle, and bridle areas which may help prevent the soft skin from chaffing when the horse is tacked up.

THE WALKING STAGE

IF A HORSE HAS been recovering from an injury, especially to the tendons or ligaments, it will require a long period of walking, probably from six to eight weeks, although the vet should recommend a period for you. Similarly, horses that are being prepared for racing or long distance riding will also require a lengthy walking period, from between four to six

HORSE FACT:
Han Kan was a famous artist of the T'ang Dynasty, 618–906 AD and was the court and horse painter to the Emperor Hsuan-Tsung who is believed to have owned approximately 40,000 horses.

THE TROT STAGE

WHEN YOU FEEL your horse is ready, and without rushing the walk stage, you can gradually start to introduce trot. For the hunter or novice eventer, this is likely to be around Week Three. Start with approximately one minute of trot at a time, and complete three or four of these trots throughout your one-and-a-half hours work. Gradually increase the length of time you remain in trot. If you can, start to introduce hill work, trotting up an incline reduces concussion of the front legs and strengthens the muscles through the back and quarters.

Start by walking most of the way up the hill, finishing off in trot, and gradually increase the distance up the hill that you are trotting. Try not to do your trot work on the roads, which create too much concussion – firm, even tracks are ideal, but watch for ruts and avoid deep mud. Monitor your horse's breathing rate carefully, if its respiration does not return to normal quickly after exertion, you are pushing it too hard. Over approximately two to three weeks, increase your trot work until your horse is trotting quite happily for long periods without tiring.

> **HORSE FACT:**
> Horses with lop ears are often said to have a kind temperament, but beware of the exception to the rule.

weeks. Novice event horses and hunters will require at least two to three weeks walking, and horses being prepared for light riding will need between one and two weeks. I can not stress strongly enough how important the initial walking stage is; by rushing, it can, and invariably will, lead to injury later on in the season.

Walking needs to be done a firm surface, such as the road, and the horse needs to be walked in an outline, and not allowed to slop along. You should start with half an hour a day, and gradually increase the period until you are walking for one and a half hours a day. This early stage helps to harden the tendons, ligaments and muscles preparing them for the harder work to follow. It will also encourage the bones to increase in strength and density, and the heart and lungs will become more efficient.

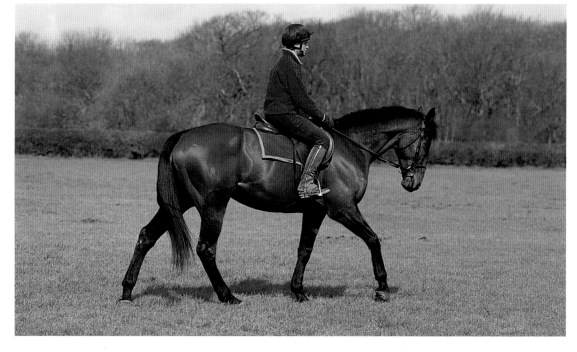

Top Left
These horses are being gently exercised; a walking period can last up to eight weeks.

Above
More advanced steps, such as the paso fino, should not be attempted until the horse is fit.

Bottom
The walking stage should not be rushed as this will inevitably lead to injury.

THE CANTER STAGE

NEXT YOU CAN introduce canter, in a similar way to the introduction of the trot. By now, for the hunter or novice eventer is probably at Week Six or Seven of the fitness programme. Find a nice straight stretch of good ground for your canter and be prepared for your horse to throw a buck or two. Keep your horse in an outline and, once it has settled, take your weight off its back.

Always ensure that your horse is properly warmed up before asking for canter. Gradually increase the length and amount of canter work, always monitoring the respiration rate. It is generally a good idea to introduce some school work now and to split the work into two sessions.

Start the school work gradually, using large circles and simple exercises and beginning with roughly 20 minutes work. Once the school work has been established you can introduce some jumping, and also lunging. It may be that if your horse is particularly excitable, you may have to lunge it early on in your programme before you ride it, but bear in mind that working on the lunge is very intensive work, and be careful not to overdo it. By now the horse should be working between one and a half and two hours a day, preferably in two sessions, depending on the type of exercise you are giving it. By Week Eight or Nine, it should be jumping, and schooling cross-country.

Top Left
The horse should only be asked to canter after it has had a warm up.

Top Right
Different disciplines require different amounts of training, however, the gallop should only be undertaken after a considerable period.

Bottom
Horses that are to be entered into cross-country competitions will need a longer and more strenuous training programme.

INTRODUCING FAST WORK

FAST WORK SHOULD

always be introduced gradually. Thoroughly warm the horse up then ask it for canter and establish a brisk pace. Ask your horse for full speed for a short distance, and then return to the canter, gradually winding down through trot and walk. This is sometimes called a pipe-opener, and should only be done approximately two or three times a week at the very end of the fitness program, which for novice event horses will be about Week Ten to 12.

The length of time spent fitness training, and the type of training, will vary from discipline to discipline, and the horse required for hacking will not need to undergo the same procedures as the novice eventer, while the three-day eventer requires an even more rigorous approach.

HORSE FACT:
At one time it was a Japanese custom to hang the head of a horse at the entrance to a farmhouse to act as a goodluck talisman.

INTERVAL TRAINING

THIS IS DIFFERENT from fitness training and can be started during the trot stage. It involves a set pattern of work, alternating with periods of rest at walk. The walk delays the build up of lactic acid which causes muscle fatigue; the second pattern of work is somewhat harder than the first, and this increases the horse's ability to cope with stress. Everybody establishes their own routines, but as a rough guide, an interval training format could be as follows:

First, mark out a set distance of 428 ft (400 m), which is your measure. Warm your horse up thoroughly, then canter the marked distance at a steady pace which should take just over a minute to cover. Return to walk for three minutes. Monitor the respiration and pulse, and when they return to normal repeat the exercise. After the second canter, take the respiration and pulse rate again, walk the horse for ten minutes, and check the pulse and respiration again. If the horse's readings have now returned to normal, then it is ready to increase the amount of work. Do this by gradually working up to five sessions of three minute canters with walk periods in between; by now the canter should be a fairly spanking pace. This should take between four to five weeks to achieve, and by this time, the horse should be novice eventing fit. This approach to fitness is excellent for some horses, but others will find it boring and will tend to go stale. Interval training should only be done twice a week.

A FEW POINTS

• Keep a close eye on your horse for any signs of stress or injury. Make sure there is no heat in the legs or feet, and be careful not to rush any of the stages.

• You will need to regulate and adjust your feeding program as you increase the workload on the horse.

• Try to continue turning your horse out in the field as much as you can, which will keep it relaxed and prevent it from stiffening up.

• You should work your horse in appropriate protective boots: brushing boots and knee boots for road work; and over-reach boots for jumping.

• Keep the fitness program as interesting and varied as possible to prevent the horse from becoming stale and bored.

• On the horse's weekly day off, make sure that it is turned out for quite some time, and is not left in the stable for 24 hours.

Center Right
The horse's feeding program may need to be altered during training.

Bottom
The horse should be turned out in to its field on any days off from the training program.

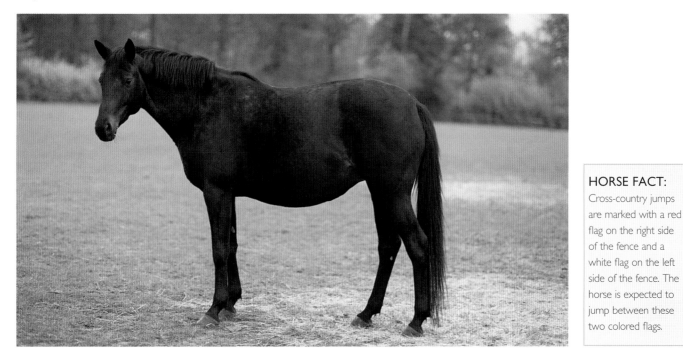

HORSE FACT:
Cross-country jumps are marked with a red flag on the right side of the fence and a white flag on the left side of the fence. The horse is expected to jump between these two colored flags.

Breeding from a Horse

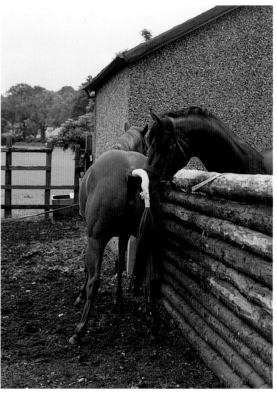

MARES AND STALLIONS should only be used for breeding if they have excellent conformation, temperaments, and proven ability. Too many people breed for the sake of it, often simply because the mare is no longer able to be ridden. There are too many unwanted horses in the world as a direct result of inexperienced people insisting on breeding from totally unsuitable mares.

THE BREEDING PROCESS

HORSES REACH PUBERTY at around two years, but it is advisable not to breed from either males or females until at least three years old. There is, in fact, no need to breed from a very young horse; they have a long fertile life and can be bred from right up to their late teens. There is also the consideration that a very young horse has not proved whether it has any ability or aptitudes and you are then effectively breeding from an unknown source.

The main breeding season is between February and August, with a high point through April, May, and June. Lengthened daylight hours and an increase in temperature will tend to stimulate the mare's estrous cycle. This cycle lasts for around 21 days, five being in estrous and 16 days of diestrus. During the estrous, the mare is commonly referred to as being 'in season,' and this is when she is receptive to the stallion. Thoroughbreds are often artificially brought into estrous as early as January by being kept in specially heated and lit stalls. In this way, they can be bred to foal early in the year. All thoroughbred foals officially have their birthday on January 1, so it is beneficial for them to be born as early as possible. However, for the rest of the equine world it is best not to plan to have foals too early in the year, while the weather is still bad and before the grass has started to grow.

Generally when the mare is in season, she is tested to see if she will be receptive to the stallion, before she is covered. This is done by either a stallion being led past the field she is in, to see if she responds to him, or she is led to a 'teasing board;' where a stallion on the other side is allowed to nuzzle her to see how she responds. The board is kept between the stallion and mare to prevent injury through kicking. If the mare is thought to be ready, she will be covered every two days until she no longer appears to be in season. If she does not come back into season in approximately three weeks, then it is likely she is pregnant. The gestation period is approximately 11 months and 10 days, although foals can be born early or late.

Top
This mare is being introduced to the stallion, who is on the other side of the teasing board, in order to establish whether she is receptive.

Above and Bottom
These Arab and Hanoverian stallions have reached an age from which their breed characteristics can be determined.

THE YOUNG FOAL

ONCE THE FOAL has been born it is very important to spend as much time as possible handling it. You must ensure that the foal is feeding properly and that the mare is allowing it to feed; in some cases it is necessary to restrain the mare to familiarize her with allowing the foal to suckle. It is a good idea, if you are able, to turn sev-

eral mares and foals out to pasture together, allowing the foals to play and give the mares a break while the foals amuse themselves.

It is very important that you have a suitable field to turn them into. You need to have secure fencing, preferably either special stud fencing, or post and rail with a nonpoisonous hedge. You also need to make sure there are no small holes where they can catch their feet, or any obstacles or protrusions that they may run in to. It is a good idea to fit a foal slip (halter) as soon as you can, but be very careful about checking its fit as the foal grows. Accustom the foal to being handled and moved around. A good way to start is to place a soft cloth around the base of the neck which you hold in one hand.

When the foal is a little larger, you can modify this by using a length of soft rope in a figure of eight formation. Start in the middle of the back and take the rope around the base of the neck, back to the middle of the back, and around the quarters. You should then hold the rope in the middle of the back and guide them like this.

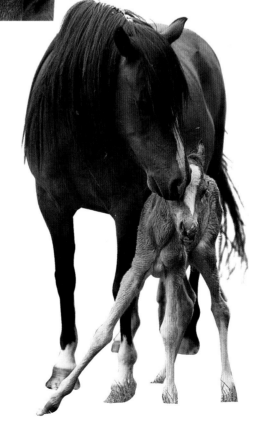

Top
This foal is being introduced to being handled and moved, the owner has place a soft cloth around the neck to aid movement.

Bottom
It is important that the newborn foal is handled and is feeding properly.

Choosing a Stallion

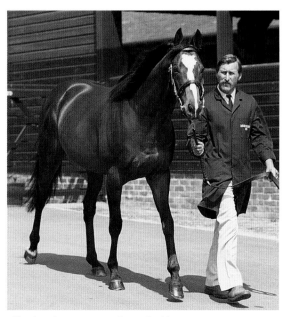

Top Right
The owner of a mare should observe the stallion and find out its history prior to breeding.

Bottom
Breeding from this Holstein stallion will produce a horse which will have specific characteristics.

BOTH THE CHOICE of a stallion and the type of mare you are breeding from is extremely important. You must have an idea of what type of horse you are trying to produce: for example, an eventer; a dressage horse; a horse for driving; a children's pony etc. These are all very important things to consider, because they should affect your choice of stallion. The other point to consider is that you need to find a stallion that excels in any areas that your mare may be weak in, and vice versa, so that the two are complementary.

COMPLEMENTARY PAIRING

IF YOUR MARE, for example, has a slightly restricted movement from the shoulder, you need a stallion that has a particularly good, free-flowing movement. The stallion should have excellent conformation, suitable for the job his progeny is to do. It is important to assess his temperament, although you must make some allowance for him being a stallion. Observe him in the stable, and his attitude towards his handler, and also where his stable is.

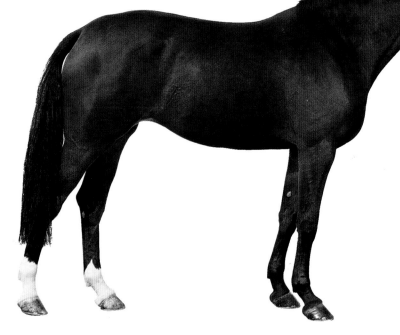

If he has been secreted in a hidden corner somewhere and is in a darkened environment with grills on the door and the handler enters the stable with a broom, it is a fair indication that he is not particularly affable. You should choose a stallion that has a proven track record in the area of work you are intending for his progeny.

An exception to this rule is, if you are wishing to breed an eventer and are using a mare with a very good performance record, it is possible to use a stallion who has proved himself on the race track. This is sticking to the complementary rule, where the mare or the stallion must excel in areas the other lacks. You need to find out about the progeny of the particular stallion you are interested in and to establish if they have proved themselves: it can be interesting actually to see some of his progeny in action. The stallion should come from a good breeding line himself, and should be approved by the breed society he is registered with. Before sending your mare to a stallion, make sure he has a good fertility rate, and if you are trying to breed a colored horse, check on the percentage of colored offspring he has thrown.

For those people who wish to try to breed a horse suitable for eventing, a good tip is to scan the programmes from the various larger two- and three-day events. Invariably they list the sires of the various horses competing and, by reading through these, you will see the same sires' names cropping up again and again, proof indeed of their excellence.

SPORT HORSE BREEDING OF GREAT BRITAIN

UP UNTIL THIS YEAR, there has been a very good scheme in operation in England called the National Light Horse Breeding Society (HIS). The HIS was strongly supported by the Horserace Betting Levy Board, whose contributions allowed them to stand top class stallions at a reduced stud fee for members, thus greatly improving breeding stock in England. There have been some changes in 1998, and the HIS has become the Sport Horse Breeding of Great Britain, aiming to further advance Britain in the world rankings of producers of first class competition horses. They operate a system of grading of both stallions and mares, which are required to meet certain stipulations and pass tests. They are a very good place to start, when looking for a stallion.

CHOOSING A MARE

SIMILAR POINTS should be at the forefront of your mind when considering your mare, as when considering a stallion. Temperament, ability, and conformation are all important aspects. Before breeding from a mare try to find out if she has been bred from before, and if she has, what kind of a broodmare she was, and how did she manage during foaling. Breeding is an expensive project and one at which it is very difficult to make money. Bear this in mind and question your motives for wanting to breed.

Invariably it is not the stud fee that is the costly part, but the cost of sending the mare to stud, foaling her (whether at home or back at stud), aftercare, and care of the foal. It is very difficult to sell foals well, and yearlings also tend not to command good prices. If you are breeding with selling in mind, consider that you will probably be keeping the foal for at least two or maybe three years before you are likely to see a return.

HORSE FACT:
Lord and Lady Henniker are currently restoring an old animal cemetery in the grounds of Thornham Magna estate in Suffolk, England. The cemetery includes the grave of the horse Morac, who was ridden in the Boer War by Lord Henniker's uncle, a general with the Coldstream Guards. Morac was shipped to South Africa with the General, and, after his military service, was retired to grass on the Thornham Magna Estate.

Top and Bottom
All stallions, no matter what their breed, should be approved by an appropriate breeding society.

HORSE FACT:
During Oliver Cromwell's reign in England (1649–58) , racing was illegal.

Sending a Horse to Stud

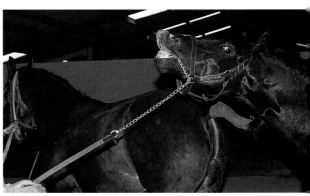

THERE ARE TWO OPTIONS when sending a mare to a stallion. Either you can take the mare on a daily basis to be covered, hence saving yourself the cost of keeping her at the stud. Or you can send her to the stud, where they can carefully monitor her and have her covered when ready.

CHOOSING THE STUD

IF YOU WISH to send her to the stud, make sure you look carefully, note the state of the stalls, the fencing, the grass, and the appearance of the other horses. Make sure you are happy with the standard of care you think your mare will receive.

BEFORE GOING TO STUD

THE MARE MUST BE in good condition, neither too fat nor too thin, which will improve her chances of becoming pregnant. She must also have her hind shoes removed and her feet trimmed. She needs to be seen by your vet, who must take a clitoral swab to test for contagious equine metritis (CEM), and you need to present a certificate proving she is clear of CEM when she arrives at the stud.

When she comes into season, the vet will take a cervical swab to ensure she is clear of any uterine infections. She should, of course, have been regularly wormed but on arrival at the stud they will probably worm her again and she must be up to date with her tetanus and equine influenza jabs. Most people keep their mares out at grass when at stud, and this greatly reduces the cost. You need to fill out a nomination form on arrival at the stud, which is basically an agreement between you and the stud, detailing that the mare has had all the appropriate preparations and meets other conditions regarding the stud fee.

Top Right
A stallion often has to be encouraged to show interest in the mare it is required to cover.

Center Right
Two employees at this stud farm ensure that the mare is covered.

Below
It is usual that the horse is wormed on arrival at the stud.

Bottom Right
Scanning machines are now used to monitor the progress of the pregnancy.

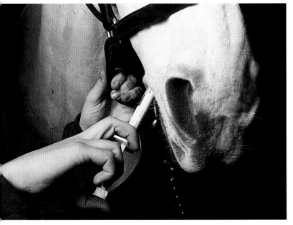

AT STUD

WHEN SHE IS AT the stud she will be tested regularly to ascertain when she is receptive to the stallion. Before being covered by the stallion, she will have felt kicking boots placed on the hind feet to protect the stallion from kicks; her tail will be bandaged to keep it out of the way, and she will be washed down around the vulva. Studs should have special covering areas which need to have a nonslip floor and the handlers should be wearing protective clothing in the form of hard hats, nonslip boots, and gloves.

If she does not come into season approximately three weeks after she was last covered, it is likely that

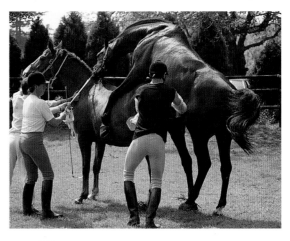

she is in foal. Ultrasound scanners are a very effective method of determining whether she is pregnant or not, and can be used as early as 15 days after the last covering date. Often the vet will do a manual test at around six weeks after the last covering date. Blood tests will show pregnancy from between 50 and 90 days after the last covering, and if gonadotrophin is present in the blood, it indicates that she is in foal. Urine tests from 100 days on will show high levels of estrogen if she is pregnant.

DURING PREGNANCY

ONCE THE MARE has been tested in foal, she can return home and can be exercised gently until about the seventh month of pregnancy. Most broodmares are kept at grass which should be sufficient feed for them until the winter months; from then on, they need feeding, but should not be allowed to get too fat. Most studs work on a 'no foal, no fee' or 'no foal, free return' basis and this is good until October 1. It is sensible therefore to have her scanned again before October 1, to ensure she is still in foal and has not reabsorbed. If she has, you will need a veterinary certificate stating this is the case to present to the stud to get your fee, or free return. The last three months of the pregnancy are extremely important, and this is when the foal increases most in size. The mare should be on special stud mix or nuts by now to ensure she receives the right quantities of protein and other essential nutrients in her diet. During the last month of the pregnancy, she will begin to form colostrum, which is the first milk that contains all the antibodies to help protect the foal in its first weeks of life. It is therefore a good idea to give the mare a flu and tetanus injection at this point, so that the foal can benefit from them. She should have remained on a regular worming program throughout the pregnancy, but be careful that the wormer is safe for pregnant mares.

Top
A mare will be watched closely for the first signs of a successful mating.

Top Left
This vet scans the mare to check the foal is healthy.

Bottom
Most pregnant mares can be put out to pasture until the winter, when they will also need extra vitamins and minerals.

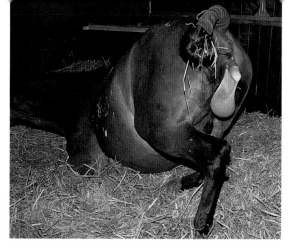

Foaling

A LTHOUGH IT IS expensive, it is a good idea for the novice owner to send the mare back to stud for the foaling; this needs to be done in enough time to allow the mare to settle before she foals, which should be a minimum of one week. If you wish to breed from her again, obviously she needs to be sent to the stud where the stallion is standing.

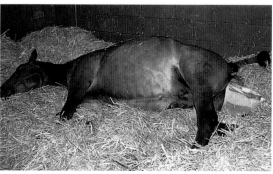

THE FOALING PROCESS

IF YOU WISH TO FOAL her at home, you must ensure that you have suitable facilities. You will need a large foaling stall, with a really good, deep, straw bed. In fact, the ideal foaling stall is a circular one, although you rarely see these. Invariably the mare will try to foal when jammed in a corner, and a circular stall eliminates this problem. Closed-circuit TV is ideal – you can watch the mare without disturbing her. If you do not have one of these, there is a device known as a foaling alarm. This is a heat detector which is attached to the mare via a roller; her temperature will rise as she is about to foal and the alarm responds to this. If you do not have either of these, it is essential to make checks on the mare at least every 20 minutes, causing as little disturbance as possible, once she starts signs of foaling. You need to have your vet's phone number accessible in case she has problems, and should also have string, towels, iodine spray, rugs, tail bandage, and in addition, frozen colostrum or milk replacement.

An early sign that the mare is preparing to foal is when she 'waxes up.' This is when a waxy substance appears on the end of the teats, and it generally means she should foal quite soon; however some mares will wax up as early as two to three weeks before foaling. Her udders will by now have become heavy and full of milk and she will be large and cumbersome. Another indication is when the vulva seems to slacken, and the muscles over the hindquarters become soft, jelly-like and appear to dip away. As she actually starts to foal, the mare will show some

Above
This owner prepares the bedding in the foaling stall.

Top Right to Bottom
The various stages of foaling are shown.

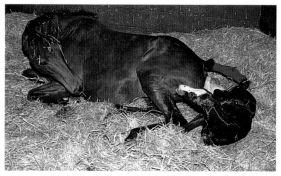

colic-like signs, staring at her belly, becoming restless and starting to sweat. The pelvis will rotate to accommodate the passage of the foal and the waters will break.

Once the waters have broken, the foal should be born within approximately half an hour. A whitish sac will appear at the opening of the vulva, followed by the first, and then the second, front foot, and the

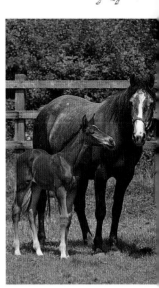

head. The white sac, which is the amnion, needs to rupture to allow the foal to breathe, and if it does not rupture naturally, then someone must break it open. While this is happening, the mare will continue to move around, getting up and lying down, which helps to ensure that the foal is kept in the right position for birthing.

THE BIRTH

SOMETIMES, ONCE THE head and shoulders are out, the mare will rest for a short while before the foal is totally clear of the vulva. As the foal comes clear of the mare and the hind legs come out, the umbilical cord will usually break naturally, and it is important to spray the stump with the iodine to prevent infection. If, after the foal is born, the mare does not expel the afterbirth straight away, tie the visible afterbirth up, and then when it is all expelled, check that it is complete. It should be cleansed within five or six hours, and if she does not cleanse it all, ring the vet immediately. Make sure the mare and foal have bonded, and possibly rub the foal down with some towels. You need to ensure that the foal learns to

suckle within a few hours, and may need to guide it to the teat.

It is very important to ensure that the foal passes meconium within 24 hours. This is the waste material that has collected in the bowels before the foal is born. If there are problems during the foaling, and the mare or foal dies, you need to call the National Foaling Bank. This center is famous for its experience with foster mares and orphan foals.

AFTER FOALING

THE MARE WILL come back into season approximately seven to ten days after foaling, and can at this point be covered, although it is generally better to allow her time to fully recover and to wait until the following estrous period. It is important to handle the mare and foal as much as possible. and to keep a careful eye on them in the first few weeks after foaling. Foals are generally not weaned until about six months of age and following weaning, the mare's food should be reduced to help her milk dry up.

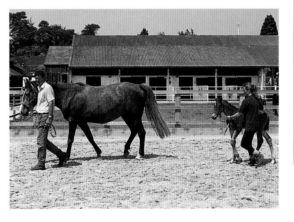

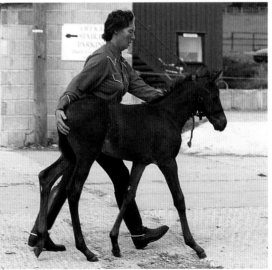

HORSE FACT:

The Veterinary College of London was founded in 1791 specifically to study treatment methods for diseases in the horse. It was not until 1872 that this institution expanded to cover all animals and was then renamed as the Royal Veterinary College.

Top Left and Center Left
The initial contact between the mare and foal is important to establish a bond and to ensure that the foal feeds properly.

Bottom Left
Occasionally foals need guiding to the teat.

Center Right and Bottom Right
Foals and mares should both be handled frequently so that they are familiarized with human contact.

Basic Tack

CERTAIN ESSENTIAL items of tack are vital for horse riding, for the comfort and safety of both horse and rider. Leather saddles and bridles are designed for the comfort and control of the animal, and hard hats for the rider are an absolutely essential safety must. Other items of tack and harness are more a matter of choice for the rider, depending on the nature of the horse being ridden, and also what is required of the horse.

Top Right

The knee-rolls on this general-purpose saddle are smaller in comparison with the jumping saddle.

Center Right

This modern jumping saddle with large knee-rolls is based on the equestrian ideas propounded by Frederico Caprilli at the turn of the century.

SADDLES

THE DEVELOPMENT of the saddle began with the use of a blanket secured with a girth-like strap, and then with breast straps, and occasionally a crupper, to hold the blanket in place. During the first five centuries of this millennium, the most significant developments in the saddle were made by the Scythians and also the Sarmartians.

EARLY SADDLES

THE SCYTHIANS USED a thick felt saddle cloth, similar to our modern numnah in concept, and over this placed two leather and felt cushions joined by leather straps and stuffed with deer hair, placed one on either side of the spine. The weight of the rider was kept clear of the sensitive spine area, which is the same principle in saddle fitting used today. The Sarmartians built their saddles around a wooden structure known today as the 'tree.' They still had no stirrups, but they had a high cantle designed to help keep the soldiers in the saddle during conflict in battle. It is believed that the stirrup was first developed around the fifth century AD in Mongolia and greatly assisted the mounted soldier during battle, and extended the distances the cavalry could travel.

THE GENERAL-PURPOSE SADDLE

THIS IS THE MOST popular and widely used saddle, which is suitable for jumping, hacking, hunting, and schooling. The general-purpose saddle evolved from the jumping saddle; they still have knee rolls, although these are smaller; the panels and flaps are somewhat straighter, and the stirrup bars are positioned further back. The waist is wider to allow the rider's weight to be distributed evenly over a greater area and therefore reduce pressure points. The majority of saddles are made from leather, although it is possible to buy synthetic saddles.

THE JUMPING SADDLE

AT THE BEGINNING of the 20th century, an Italian cavalry officer called Frederico Caprilli put into effect his then-revolutionary theories on riding. He propounded the idea of the forward seat, arguing that if one should be in balance with the horse at slow paces, then one should also be balanced when galloping and jumping. He taught his pupils to shorten their stirrup leathers, and to adopt a forward raised seat over fences, which placed their weight over the horse's center of balance, hence aiding the horse as much as possible.

Roughly 50 years after Caprilli's death, the blueprint for the modern jumping saddle evolved. Credit for this goes to the Spanish nobleman Count Illias Toptani. He developed the jumping saddle with the stirrup bars placed forward to assist the rider to achieve the forward seat. Large knee rolls were added under forward-cut flaps and panels, and the waist of the saddle was narrowed.

THE DRESSAGE SADDLE

THIS HAS BEEN designed to help the rider adopt the most centrally balanced seat while performing the movements of dressage. It has straight flaps, which are generally longer than those of the general-purpose saddle. Beneath the flaps, the panels have

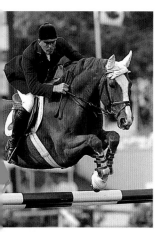

slight rolls to help position the leg, and long girth straps onto which a special dressage girth, known as a lonsdale, attaches. The stirrup bars are further back and extended to allow the stirrup leather to lie down the center of the flap. The seat of the saddle is dipped, and is made by some manufacturers to be somewhat deeper than the seat of the general-purpose saddle. The saddle should sit absolutely level on the horse's back so that it does not tip the rider out of balance.

THE SIDE-SADDLE

THIS ORIGINATED in Europe in the 14th century, but has changed quite significantly since then. The seat is level and the fixed head and leaping head are situated on the left hand side. The rider's right leg sits over the fixed head, and the left leg sits under the leaping head. The side-saddle must be fitted to the individual horse that it is to be used on. It must lie absolutely straight, and cannot be allowed to be crooked, which would damage the horse's spine. Side-saddles are fitted with a balancing strap, which runs from the nearside front of the saddle to the offside rear of the saddle, and helps to prevent lateral movement and the saddle slipping. They are also fitted with safety stirrup leathers that have a quick release device to prevent the rider becoming entangled in the case of a fall.

THE RACING SADDLE

ONE OF THE MAIN priorities with the racing saddle is its weight, and some saddles used for flat racing can weigh as little as 8 oz (0.2 kg). Racing saddles have a virtually flat seat, not having been designed for sitting in. The saddle flaps are cut forward to allow for the extremely short stirrup leathers that jockeys use. They were originally made using a wooden tree, but are often now made with a fiberglass one that is very light. Steeplechasing saddles are slightly more robust and heavier.

Top Left
This dressage saddle is different in shape to the general purpose saddle; its design aids balance and dressage movements.

Top Right
The side-saddle is a different shape to the other saddles; it has a smaller surface area and a clearly visible balancing strap.

Bottom Right
This rider demonstrates the side-saddle position.

THE WESTERN SADDLE

THE WESTERN SADDLE developed in America from Spanish saddles taken over there by the Spanish conquistadores in the 16th century. The original saddles were designed for battle; the high pommel and cantel, and the long stirrup leathers helped to keep the soldier secure in the saddle during conflict. Early Mexican ranchers, however, took this form and evolved it to produce a working cowboy saddle suitable for the rigors of ranch work. The seat of the saddle is very broad, and is designed to be comfortable for long hours of riding.

The Western saddle is very heavy, but the weight is spread over a large area by the design of the extended skirts. The stirrup leathers are called fenders, and are very wide, which makes them more comfortable and protects the rider's leg from the sweaty sides of the horse. The stirrups are generally made of wood and rawhide, and are also quite wide. The saddles have a saddle horn and swells at the front, which have evolved to aid the cowboy in roping cows. Once roped, the rope is dallied around the horn, that is wrapped around, to prevent the cow from escaping. Western saddles have two girths, which are called cinches. The front cinch should lie behind the elbow, while the back cinch, or flank strap, should lie behind the rider's leg. The back cinch prevents the saddle from being pulled up, and out of place, when an animal has been lassoed and dallied on to the horn. The front and the back cinch are connected by a strap under the belly.

Most Western saddles fit most horses and have been specifically designed to be like this so that the working cowboy can use his saddle on many different horses. One or two thick folded blankets or felt saddle pads are used under the saddle to provide added protection for the horse. Often Western saddles are quite decorative with intricate patterns carved into the leather, and many Western saddles used for showing have a large quantity of silver ornamentation.

GIRTHS

THERE ARE THREE main groups of girth, which are leather, webbing, and nylon, although there are other types of synthetic girths. Of the leather girths, which are undoubtedly the best quality, there are three main designs – the three-fold, the Balding, and the Atherstone.

The three-fold: As its name suggests, this is a piece of soft leather folded into three, with the folded edge lying toward the front of the horse. It is a good idea to keep a piece of cloth soaked in neatsfoot oil between the folds to help keep the girth soft and

Above
The Western saddle is larger and heavier than other saddles, and the seat is broad for comfort.

Top Right
The underside of a general-purpose saddle.

Right
A variety of different girths.

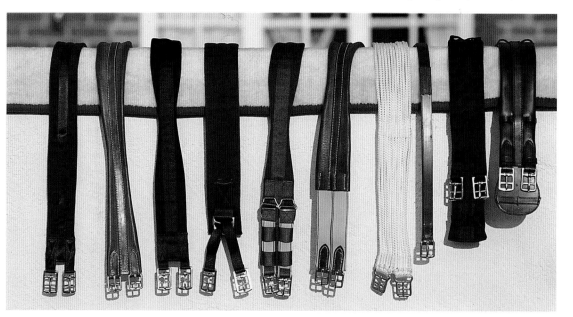

supple. If buying a three-fold, check that the folded edge is soft and rounded; if it is sharp it will chaff and cause soreness to the horse.

The Balding girth: This has its central section divided into three, which are crossed over and stitched together in the middle. This creates a shape that narrows in the elbow area and hence reduces the risk of girth galls.

The Atherstone: works on the same principle and is a shaped girth made from a single piece of soft leather that is folded and stitched together to maintain its shape.

Webbing girths are on the whole not very popular as they do not last well and need to be washed very regularly to prevent chaffing. Racing girths are often made of webbing, and are worn with a surcingle that passes over the top of the saddle and is an added preventative measure against slipping. Lampwick girths are quite old fashioned, but fairly good if looked after properly. They are made from a cotton and wool tubular web and are very soft, and so are good for using on horses that chaff easily.

Nylon girths are made of single nylon cords knotted together with woven string. They must be kept clean or they will cause chaffing and can trap skin in between the cords, which is uncomfortable for the horse.

STIRRUPS

STIRRUPS SHOULD be made out of steel; nickel irons are best avoided as they can snap under pressure and are not safe. Most modern irons are used with rubber treads that fit in the bottom of the stirrup and aid grip and insulation. Stirrups must be large enough to allow at least a 0.5 in (12 mm) gap on either side of the foot. There are various designs of safety stirrup, one of which has a thick rubber band in place of the outside edge of the stirrup iron. The band must be on the outside of the stirrup furthest from the horse and must be checked regularly to ensure the rubber is not perishing. There are also shaped safety stirrups where the outside arm of the stirrup bulges forward, allowing the foot to slip out in emergencies.

HORSE FACT:
The sculptor Korczak Ziolkowski began work on the mammoth carving of Crazy Horse in 1948. This is the image of the famous Native American Indian astride his horse which is being carved to appear to be galloping out of the side of Thunderhead mountain in South Dakota. Ziolkowski died in 1974, but the work continues, and an estimated date of completion is the year 2000. So far more than eight million tons of rock have been removed from the massive mountain.

Top and Bottom
Riders out enjoying a ride and wearing casual riding gear.

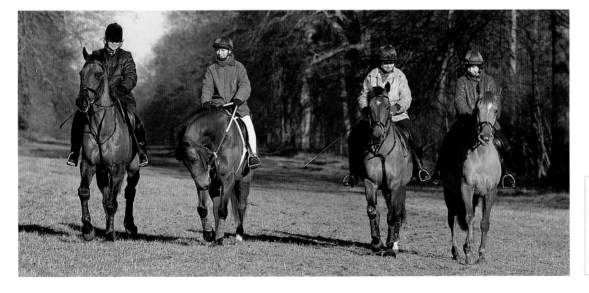

HORSE FACT:
When riding on roads it is a good idea to wear some form of reflective clothing.

Bridles and Bits

Right
The most common bridle is the snaffle; this is a bar snaffle.

Bottom
A fulmar snaffle with a flash noseband.

THE STANDARD BRIDLE, which is the one most commonly used, is known as the snaffle bridle. It consists of a headpiece, which usually incorporates the throatlatch; cheek pieces attach to the headpiece on either side, and the bit is attached to the bottom of the cheek pieces. The browband fastens to the headpiece and helps to prevent the bridle from slipping back. There is a wide range of nosebands, although the basic one is the cavesson. The noseband is run through the loops in the browband underneath the headpiece.

TYPES OF BRIDLE

THERE ARE SEVERAL variations – for instance, the American western bridle sometimes has a split ear form rather than employing a browband. In this case, the headpiece has a split running through the top which either one or both ears are placed through, depending on the style. Many western bridles do not incorporate the use of a noseband and some do not have a throatlatch.

FITTING THE SNAFFLE BRIDLE

IT IS VERY IMPORTANT to ensure that the bridle fits correctly. They are made in three standard sizes: pony, cob, and full size, in various styles with different widths of leather. Generally horses with bigger, heavier heads look best in wider leather, whereas show ponies, for example, can wear a finer, lighter type of leather. The browband acts to prevent the bridle slipping back, and also to keep the noseband in place. Make sure that it is not too tight, in which case it will pull the headpiece forward and cause discomfort and rubbing.

The throatlatch must not be fastened too tightly otherwise it will be uncomfortable when the horse flexes from the poll – as a rough guide, you should be able to fit a hand's width between the horse's cheek and the throatlatch. The cheekpieces need to be adjusted to allow the bit to be positioned in the correct place. The snaffle bit needs to be high enough to produce slight wrinkles at the corner of the mouth, and should not protrude more than ¼ in (6mm) on either side of the mouth. If the bit is too big, it will pull from side to side, and if too small it will pinch the corner of the mouth.

The cavesson noseband has the chief function of providing a point of attachment for a standing martingale, but they are often worn simply to make the bridle appear complete. The cavesson should be fitted so that it sits approximately two fingers below the cheekbone projections, and you should be able to fit two fingers' width between the front of the nose and the noseband. The reins need to be a sensible length; if they are too long there is a danger of getting your feet caught in them, and if they are too short, they can be snatched out of your hands if the horse moves its head suddenly.

HORSE FACT:

The Vale of the White Horse is found at Uffingham, Berkshire, and is home to an ancient white chalk horse that is carved into the hillside. The stylised horse is 114 m (374 ft) long and is something of a mystery. Neither the date of origin nor the exact purpose of the carving is known, although it is thought that it may be connected to a possible Celtic burial mound known as Dragon's Hill which is located on the West side of the horse.

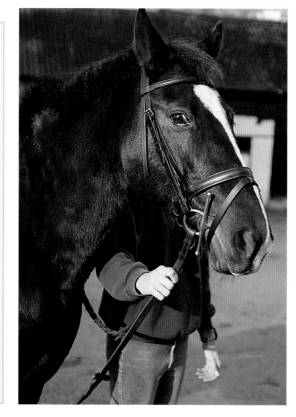

Top Left
The double bridle should only be used by experienced riders.

Top Right
This horse is wearing a grackle noseband, which is excellent for strong horses that are working at speed as it does not restrict their respiration.

Bottom Right
The drop noseband encourages this pony to keep its head tucked in.

THE DOUBLE BRIDLE

THE DOUBLE BRIDLE IS a more complex arrangement, which should only be used by experienced riders. It has the same basic arrangement as the snaffle bridle, but also has a sliphead on to which the bridoon bit fits. The sliphead passes through the loops of the browband, which hold it in place, and fastens on the offside of the head, so that the buckle of the sliphead matches the buckle of the noseband on the nearside. It is necessary to use two pairs of reins with the double bridle, one pair attached to the bridoon, and one pair attached to the curb; curb reins are always narrower than those of the bridoon. There should also be a lip strap to hold the curb chain in place.

TYPES OF NOSEBANDS

THERE IS A WIDE range of different types of noseband that have different functions and effects, but the basic ones are the cavesson (as already discussed), the drop noseband, the grackle, the flash, the kineton, and the Australian cheeker.

The drop noseband: This keeps the bit in a central position in the mouth and prevents the horse from opening its mouth, crossing its jaw, and evading the bit. It should be fitted so that it lies approximately 4 in (10 cm) above the nostrils, and then buckles tightly below the bit in the chin groove. In this position it should not restrict the horse's breathing, but will apply pressure to the nose and should cause the horse to lower its head.

The grackle: This works on a similar principle to the drop noseband. The top strap is fitted above the bit, while the bottom strap fastens below the bit; the two straps should be fastened firmly to prevent the horse from crossing its jaw and opening its mouth. Pressure is applied to the nose in the central point where the two straps cross. The grackle is considered to have a less restrictive action on respiration than the drop noseband, and for this reason is more suitable for strong horses working at speed.

The flash: This is based on the caves-son design with an additional strap that fastens under the bit. The caves-son part of the noseband should sit two fingers' width below the cheekbones and needs to be fastened securely. The bottom strap also needs to be securely fastened and should prevent the horse from opening its mouth in order to evade the action of the bit. It is possible to use a standing martingale with this type of noseband.

The Kineton, or Puckle noseband: This is one of the more severe nosebands. It is similar to the drop noseband at the front, but then is attached to two metal loops that fit behind the bit. It obviously has no mouth-closing function at all, but when pressure is applied to the reins, it is converted to quite extreme pressure on the nose. The nosepiece is made of leather, but sometimes has a metal core to make it even more effective.

The Australian cheeker: This is a rubber noseband that attaches to the middle of the headpiece, runs down the center of the face, and splits to attach to the bit in the form of two rubber rings. It is commonly used in the racing industry, and holds the bit up in the corners of the mouth, preventing the horse from getting its tongue over the bit, and it also exerts some degree of pressure to the nose.

Top Left
This horse is wearing an American gag bit and a grackle noseband, which restrict head movement.

Right
Snaffle bits.

Bottom
This horse wears a snaffle bridle with metal cheeks and a flash noseband.

DIFFERENT TYPES OF BIT

THERE ARE MANY different types of bits available, but they can be categorised into five main groups: the snaffle, pelham, curb, gag, and bitless. Bits work by applying pressure to different areas of the mouth and head of the horse such as the tongue, bars of the mouth, lips and corners of the mouth, chin groove, nose, poll, and the roof of the mouth (which is not an area that modern bits concentrate on).

The snaffle bit: This works in three basic areas, the lips, the tongue, and the bars of the mouth, and can have a slight head-raising action. There are numerous different types of snaffle, which produce different effects, some being more severe than others.

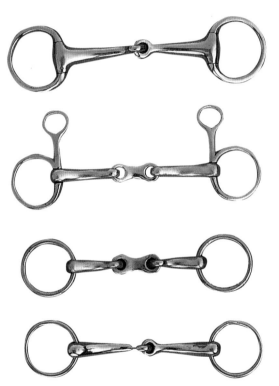

The pelham: This should be ridden with two reins to make it effective, although it is possible to buy roundings that allow just one rein to be used. When using two reins, the top rein should be the riding rein, with the bottom rein attached to the ring at the end of the shank and ridden with a light contact that is employed only when needed. The pelham effectively tries to produce in one bit the same results as the combination of the double bridle's bridoon and curb and for this reason is considered to have a confusing action, although many horses ride extremely well in pelhams.

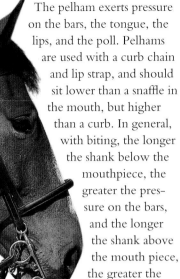

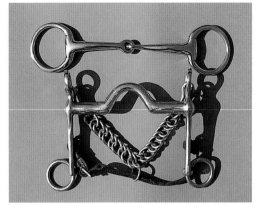

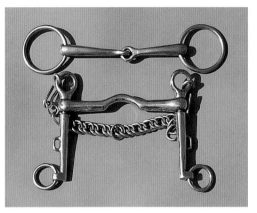

The pelham exerts pressure on the bars, the tongue, the lips, and the poll. Pelhams are used with a curb chain and lip strap, and should sit lower than a snaffle in the mouth, but higher than a curb. In general, with biting, the longer the shank below the mouthpiece, the greater the pressure on the bars, and the longer the shank above the mouth piece, the greater the pressure on the poll.

The curb bit: This is one of the bits used in the double bridle; the other is the bridoon, which is a type of snaffle with a thin mouthpiece and small rings. There are different designs of curb bit, but one of the most popular is the Weymouth, which has either a fixed or a sliding cheek piece. All curb bits are used with a curb chain, which should come into action when the shanks of the bit are drawn back to an angle of approximately 45–50 degrees. The bit exerts pressure on the tongue and bars of the mouth, and also on the poll.

The gag: This is basically a snaffle bit with a hole in the top and bottom of the bit rings. Either rounded leather or cord runs from the cheekpieces, through these rings, and attaches to the reins. The gag should also be ridden using two reins, one attached as normal to the snaffle bit ring, and the other attached to the gag. In this way the rider can mainly use just the snaffle rein, only taking on the gag rein when necessary. It has a head-raising effect and exerts pressure on the tongue, bars, lips, and poll.

The bitless bridle: This is commonly referred to as the hackamore, and works by exerting pressure on the nose, the chin groove, and the poll. There are many different designs of bitless bridle, some more severe than others, but they should not be used by inexperienced riders. They can, however, be very useful to use on a horse which has a sore mouth or bitting difficulties.

Top Left
Pelham bits exert pressure in different areas and should be used with a curb chain and lip strap.

Above
These bits are used for double bridles, two reins are attached to each loop.

Bottom
An American gag bit restricts a horse's head movement.

HORSE FACT:
'You can lead a horse to water, but you can't make it drink!'

91

Martingales

MARTINGALES ARE USED to prevent a horse raising its head above a certain point, and are therefore a form of restraining mechanism. The most widely used martingale is the running martingale. This consists of a strap attached to the girth running up between the front legs and splitting into two. Each split has a ring on the end, through which the reins are threaded. A neck keeps it in place. Running martingales should be used with rubber or leather stops that prevent the martingale rings becoming entangled with the bit.

Top Right
A running martingale is the most commonly used controlling mechanism.

Bottom Left
The standing martingale exerts pressure on the horse's nose preventing, it from raising its head in the air.

THE RUNNING MARTINGALE

WHEN THE HORSE raises its head, the running martingale exerts pressure on the reins, which is transferred via the bit to pressure on the bars of the lower jaw. In some cases, the two splits are made as one piece of leather called a bib. This has the same action, but prevents excitable horses getting their noses caught up between the straps. It should be possible to fit a hand's width between the neck and the neck strap, and then, with the martingale attached to the girth, the martingale rings should reach up the shoulders to approximately 6–8 in (15–20 cm) below the withers for the martingale to be fitting correctly.

THE STANDING MARTINGALE

STANDING MARTINGALES WORK by exerting pressure on the nose when the horse tries to raise its head beyond a certain point. They consist of a single leather strap attached to the girth at one end, which runs up between the front legs, and attaches to the back of a cavesson noseband. As with running martingales, standing martingales also have a neck strap to hold them in place. The fitting of the neck strap for the standing martingale is the same as for the running martingale; the martingale itself should then be attached to the girth, drawn up through the front legs, followingthe underside of the neck to the throat, and down to the chin groove to get the correct length for it to fit properly.

THE IRISH MARTINGALE

THERE IS A DEVICE called an Irish martingale, which, in fact, is not a martingale at all. The Irish martingale is a leather strap with a ring at either end. The reins are threaded through each ring to prevent the reins coming right over the head in the event of a fall. It also gives direction to the pull on the reins and for both these reasons is most commonly seen on racehorses.

Reins

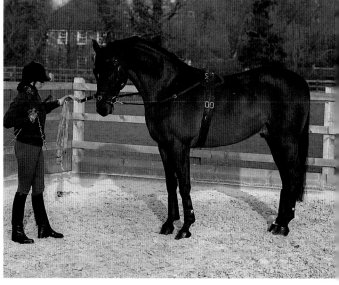

THERE ARE MANY different training aids on the market today, all of which are primarily concerned with improving the way the horse goes; and they achieve, or do not achieve, this end by employing different methods and techniques. Any training aid in the wrong hands can do infinitely more damage than good, and only experienced riders, or riders under tuition, should use them.

SIDE REINS

SIDE REINS are one of the most simple of the training aids and consist of two straps that attach from either the girth, or from a lunging roller, to the bit rings. There are three basic different types of side rein in both leather and nylon, and they are all adjustable. The first is a simple leather or webbing strap, and the second and third incorporate either a thick rubber ring or an elastic inset. The inclusion of the rubber ring or elastic inset is thought by some people to encourage a more flexible head carriage, but in many cases simply causes the horse to either become unsteady in the head, or to lean on the reins. The simple strap, on the other hand, acts as a steady contact for the horse. Side reins should only be used on the lunge and should only be attached once the horse has warmed up.

DRAW REINS

DRAW REINS ARE also a simple form of training aid and can be used as running reins. These reins attach to the girth and run up between the front legs, through the bit rings and into the rider's hands, so that the rider is then holding two pairs of reins. The draw rein is an effective method for drawing the head down and in to achieve a collected outline. The common fault using draw reins is to produce a stiff head carriage, behind the bit and lacking in impulsion from behind, and for this reason, they should only be used by experienced riders. Running reins are attached to the girth straps, and run through the bit rings, and into the hand. They have a very similar action to the draw rein, but tend to draw the head into a higher outline than that produced by the draw reins.

> **HORSE FACT:**
> A healthy adult horse should have a pulse of between 36 and 40 beats per minute when at rest.

Above
This rider has attached side reins in order to lunge the horse.

Left
Draw reins are a simple training aid running from the girth strap through the bit and used as reins.

> **HORSE FACT:**
> 'Ride a cock horse to Banbury Cross,
> To see a fine lady upon a white horse,
> With rings on her fingers and bells on her toes,
> She shall have music where ever she goes.'
> *Nursery Rhyme*

Lunging and Leading Reins

LUNGING AND LEADING REINS are invaluable tools for training both horse and rider. Unbroken horses are often schooled on the lunging rein, while nervous or novice riders can be taught the basics of riding on the leading rein.

THE CHAMBON

THE CHAMBON is a training aid that acts on the whole body not just the forehand of the horse. The Chambon should only be used when loose schooling or lunging without a rider. The device runs from the bit rings up to the poll, where it passes through rings attached to a special poll pad. It then runs from these to a split strap that goes between the front legs and attaches to a lunging roller. It encourages the horse to travel in a long, low outline, to lift from the shoulder, and round through the back achieving an overall excellent outline. It is especially useful for horses that need to build up their back muscles, and can help to improve the horse's entire way of going.

THE DE GOGUE

THE DE GOGUE is somewhat similar to the Chambon, but has the advantage of being suitable for use during ridden work. The de Gogue can be adjusted into two different positions: one for ridden work, and one for lunging. For ridden work, it runs from an attachment to the girth, up between the front legs to rings on the poll pad, then down to the bit rings, and into the rider's hand.

For lunging, instead of the reins running into the rider's hand, they pass from the bit ring back down to the girth attachment. It is possible to ride with the de Gogue in this position by attaching the reins to the bit ring.

THE MARKET HARBOROUGH

THE MARKET HARBOROUGH, or German rein, is a training aid based on a sophisticated martingale design. It appears very similar to a running martingale, but the splits of the martingale pass through the bit rings and attach to rings on the reins, which allow it to be shortened or lengthened. When fitted properly, the Market Harborough should not come into action until the horse tries to raise its head, or pulls, when the device exerts a downward and backward pull on the bit.

Top and Bottom
These horse wear Chambons, which will encourage them to raise their heads from the shoulder, improving their general outline.

Boots

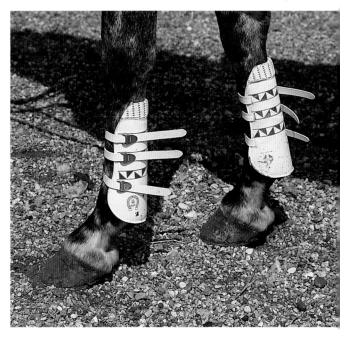

THERE ARE MANY different styles, types, and designs of boots, but their basic function is protection and support of different parts of the leg. They come in various different materials — leather, felt, and a wide range of synthetic fabrics that are becoming increasingly popular. Some of the main types of boot are:

Brushing boots: These have been designed to protect horses from knocking one leg against the other during work. They are one of the most common types of boot, and provide protection of the lower leg region.

Fetlock boots: Protect the horse from brushing but only in the fetlock region. The Yorkshire boot is a type of fetlock boot and is made largely out of felt. There are other different designs of fetlock boot, and these are more commonly produced in synthetic fabrics, which are easier to clean and more durable than felt.

Tendon boots: Designed to provide support in the tendon region, they can either be open-fronted or closed at the front and provide all-round protection and support.

Polo boots: These are designed to provide maximum protection and support to polo ponies whose legs are particularly vulnerable; polo boots are often made from thick felt and leather.

Overreach boots: Bell-shaped rubber boots that are designed to protect the heels of the front feet from overreach wounds caused by the toe of the hind feet striking into the front feet.

Sausage boots: These are a rubber ring that fits above the coronet band to protect it from injury during work. Sometimes they are worn in the stable to prevent capped elbows when the horse lies down.

The majority of boots are designed to fasten from the front to the back, with the exception of the hock boot. Boots should always have their fastenings on the outside of the leg to prevent them damaging the opposite limb. As with all horse tack and equipment, it is important that boots fit properly and securely — badly fitting equipment of any kind can cause injury and accidents.

Top
Tendon or jumping boots provide all-round protection of the tendon area.

Far Left
Brushing boots protect the horse's lower leg.

Center
This horse wears rubber overreach boots to prevent the hind feet from hitting out and injuring the front legs when moving fast.

Bottom
The Yorkshire boot is a fetlock boot and is made out of felt.

HORSE FACT:

'Don't lock the stable door after the horse has bolted' is an old saying meaning that once the damage has been done it is too late to take precautions against it.

Rugs

THERE IS AN ENORMOUS range of rugs on the market today, and their design and the material they are made from is becoming more and more sophisticated. There are several main groups of rugs with different functions, and these are as follows:

Above

This horse is wearing a modern night blanket that is made of a synthetic, quilted material.

Top

This horse is wearing a light day rug.

HORSE FACT:

In France, the first public transport vehicles were called *diligences*, and were usually pulled by a team of four horses.

NIGHT RUGS

DESIGNED TO KEEP the stabled horse warm at night, the traditional type of night rug was commonly called a jute rug, and was made from hemp or jute lined with a grey woollen lining. It was fastened by a buckle at the front and a roller, with a fillet string to keep the back of the rug in place. Under blankets are often required and one of the best of these is the striped woollen Witney blanket. They are placed on the horse first, followed by the jute rug with the top of the under blanket folded back over the jute rug and secured under the roller.

In recent years, there has been a move away from the jute rug and many people now prefer the padded and quilted synthetic rug that is rather like a horse duvet. Most modern rugs are equipped with surcingles that cross under the belly and fasten at the sides, taking pressure off the back. When using a rug with cross straps, it is necessary to use a different type of under blanket, which has its own fastenings to compensate for the lack of roller.

DAY RUGS

DAY RUGS ARE MADE to keep the stabled horse warm during the day. Traditional day rugs were always rather smart, made from wool with colored trim, and fastened with a buckle at the front and a roller. These rugs were often also used for traveling. Rugging a horse is very much a matter of common sense, and in reality a day rug simply needs to be a somewhat lighter-weight rug than the night rug.

SWEAT RUGS

SWEAT RUGS ARE designed to help dry a wet horse without allowing it to become chilled and they have really improved in recent years. The traditional large-mesh sweat rug must always be worn underneath another blanket, otherwise it has no function at all. When worn under another blanket, the holes in the sweat rug help trap and circulate a layer of warm air between the top blanket and the horse, and help to dry it off. There are many rugs on the market today known as coolers. These are thicker than the mesh sweat rug, and should be worn on their own, next to the skin. They draw the moisture from the sweating horse through the fabric of the rug and on to the surface where it evaporates away. These rugs are extremely effective in drying the horse while preventing chills.

NEW ZEALAND RUGS

THESE WATERPROOF turnout rugs can be used for the grass-kept horse that is out all the time but needs some added warmth in the winter, or they can be used on the stable-kept horse when it is turned out. Traditionally the New Zealand rug was a heavy-duty canvas, although now they come in various man-made fibers. Different weights are available and many manufacturers produce rugs that have attachable liners for extremely cold weather, as well as

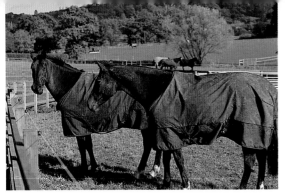

neck covers that attach to the front of the rug. Most modern New Zealand rugs fasten at the front, have surcingles, and hind leg straps. It is important that rugs fit well, and this is particularly relevant with the New Zealand rug, in which the horse is likely to roll, buck, and charge round the field.

SUMMER SHEETS

THESE ARE lightweight cotton rugs that are useful for keeping dust and flies off the horse in the summer, and can also be used to provide extra under blanket layers in the winter. They have a buckle fastening at the front, a fillet string, and often cross straps too.

CARE OF EQUIPMENT

IT IS EXTREMELY important to keep all your equipment clean, whether your tack or your rugs. Leather needs to be kept clean, soft, and supple to prevent it from causing chaffing and rubs, and to prevent it from splitting, cracking, and becoming dangerous. While cleaning your tack, check all the stitching and buckle holes to ensure that they are in good repair, and check the webbing under the saddle flaps that attaches to the girth straps. Similarly, when washing your rugs or sending them to the dry cleaners, be sure to check the washing instructions, and check all the fastenings and straps to ensure that they are secure.

THOROUGH WEEKLY TACK CLEAN

• Undo all buckles and take tack completely apart.

• Soak bit, stirrups, and rubber stirrup treads in water.

• Using warm water, wash all leather and buckles.

• With a clean sponge work in a layer of saddle soap.

• Using a tooth pick, clean grease out of buckle holes.

• Polish the buckles and stirrup irons with metal polish.

• Rinse the bit off before re-assembling the bridle.

• Wash numnahs and brushing boots.

DAILY CLEANING

• Wash the bit.

• Wash and then saddle soap the leather without taking it completely apart.

• Dry and air the numnah and boots.

Top
These horses have been turned out in New Zealand rugs, which give them added protection against the elements.

Center
This light rug is designed to keep dirt and flies off the horse.

Bottom
Woollen day rugs are often used to cover a horse when traveling.

Riding and Training

THE ART OF RIDING is one that can take years of practice, work, and dedication to acquire. This section of the book is aimed at the total novice in order to explain the very basic principles and ideas behind safe, enjoyable, and productive horse riding.

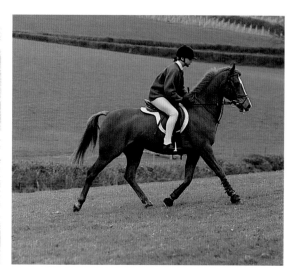

THE PACES

Top Right

As this horse is trotting uphill, the off fore-leg is leading.

Bottom Right

When walking, a horse will always have at least two hooves on the ground.

THE MAJORITY of horses naturally have four paces – walk, trot, canter, and gallop – although there are some breeds of horse that also have a natural 'pacing' gait. The horse should execute all these paces with balance, rhythm, and impulsion. Impulsion is defined as a forward-going acceptance of the pace without backing off. When describing the paces, the left-hand side of the horse is referred to as the 'near' side, and the right-hand side is the 'off' side, the legs are referred to as the near hind and near fore, and the off hind and the off fore.

THE WALK

THE WALK is a four-beat pace, with regular and even beats, so that you are able to count, 1, 2, 3, 4 as you are riding. The sequence of the legs is: near hind, near fore, off hind, and off fore, and in the walk the horse always has at least two feet on the ground at the same time. There are different types of walk – the medium walk, the collected walk, the extended walk, and the free walk, but they all have the same foot sequence. In medium walk, the hind feet should touch the ground in front of the tracks made by the front feet. Collected walk has shorter more elevated steps, with the hind hooves touching the ground behind the tracks made by the front feet. In extended walk the steps are longer, and the hind hooves touch the ground in front of the tracks made by the front feet. The horse is encouraged to relax and lengthen through his body and stride in a free walk.

HORSE FACT:

The fastest horse ever recorded was Big Racket, who reached an amazing 43.26 mph in a quarter of a mile race in Mexico City on 5 February 1945. *Guinness Book of Records.*

THE TROT

THE TROT IS a two-beat pace, with the horse springing from one diagonal pair of legs to the other, with a moment of suspension inbetween. For example, the near fore and off hind touch the ground, followed by the off fore and near hind, with a moment of suspension in between. There are different types of trot – working trot, medium trot, collected trot, and extended trot. The sequence of footfalls remains the same, while the degree of collection and the length of the stride alters, depending on which type of trot you are executing.

THE CANTER

THE CANTER is a three-beat pace, and the sequence of footfalls alters depending on which rein the horse is cantering on. If the horse is cantering to the left, the sequence is off hind, near hind, and off fore together, near fore, which is called the 'leading leg.' If he is cantering to the right, the sequence is near hind, off hind, and near fore together,

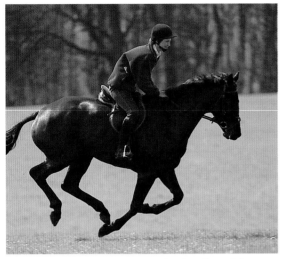

all four feet are off the ground at once. When the near fore is leading, the sequence is off hind, near hind, off fore, near fore. In the gallop the horse should lengthen its whole outline, lowering the head and neck, and often appearing to lower its whole frame towards the ground. A galloping Thoroughbred can exceed speeds of thirty miles an hour.

PACING

SOME HORSES, such as the American Standardbred, have the ability to pace, which is a two-beat gait, where the legs move in lateral pairs – for example, near fore and near hind, followed by off fore and off hind. By employing this particular gait called pacing, the horse is able to travel faster than at the normal trot, and give a smoother ride. Horses that pace are excellent for covering long distances in comfort. There are many different gaits specific to certain breeds, mostly found in America, South America, and Asia, although there is also the Icelandic pony which has several gaits including the full-speed-ahead *tölt*, which is a very fast, four-beat running walk. Lateral gaits are believed to have been inherited in the modern breeds through the influence of the old Spanish Horses, especially that of the now extinct Spanish Jennet.

and off fore, which is then the leading leg. If the horse adopts the sequence for the left rein when he is on the right rein, then it is termed as a 'wrong lead,' or as being on the 'wrong leg,' in this instance the horse will feel unbalanced. There is an exception to this rule, and this is called 'counter canter.' This is a dressage movement for the experienced horse, where he is required to canter, in balance, on the 'left leg' while on the right rein, and vice versa. Within the canter, there is again the medium, working, collected, and extended canter, and like the trot, these are achieved by varying degrees of collection and length of stride.

THE GALLOP

THE GALLOP IS a four-beat pace, and is the fastest of the four paces. The sequence of the footfalls with the off fore leading is near hind, off hind, near fore, off fore, followed by a moment of suspension when

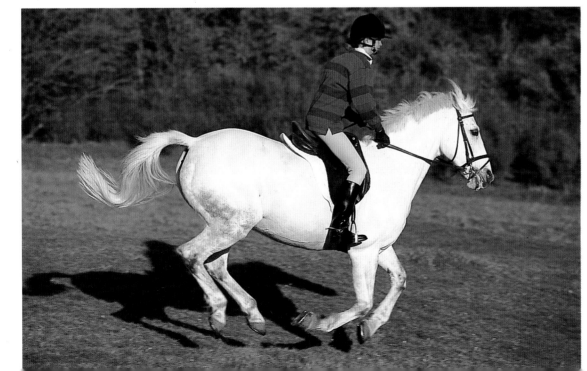

Top Left
The canter is a step that contains three beats.

Center
The Icelandic pony has several gaits, including a fast movement called the tölt.

Bottom
When a horse gallops, there is a moment when all four legs are off the ground completely.

Learning the Basics

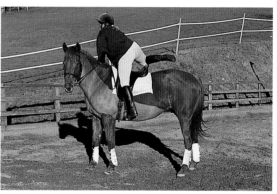

GOOD HORSEMANSHIP IS based on common sense and tact, and whenever you are around horses, you need to exercise both. Before attempting to mount your horse, you must get into the habit of checking all your tack to see that it is secure and safe, and that your girth is sufficiently tight. If you are taking riding lessons, and your horse has already been tacked up for you, you must still check that everything is secure; do not rely on someone else having done this for you.

Top and Center Right
The correct way to mount a horse: grasp the reins in the left hand and place the left foot in the stirrup. Hop round gently and swing yourself up gently on to the horse.

Right
With the weight on your left leg, swing the right leg up and across without touching the horse's back.

Bottom Right
A leg up from a helper can often help!

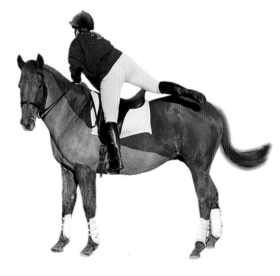

MOUNTING

YOU NEED TO SEE that the saddle has been placed on the horse in the correct position, and is neither too far forward nor too far back. Make sure that the numnah is not wrinkled up under the saddle and has not become too tight over the withers. Look at the bridle to make sure it is securely fastened, and that everything appears as it should. Be sure to look to see that your girth is done up properly, not too tight or too loose, and that it is not pinching any skin. When you are sure that your tack is fitted properly, (the more experienced you become, the quicker these tasks will take), run both the stirrups down. You can estimate the approximate length of your stirrups by holding the leather out and measuring the length of

your arm, so that your hand touches the stirrup bar, and the stirrup iron comes to just under your armpit. You should be able to tell by looking at the stirrups whether they will be roughly the right length for you or not.

Now you are ready to mount, standing on the left side, nearside, of the horse, take your reins, and whip if you have one, into your left hand. The reins need to be sufficiently short to prevent the horse from walking off, but should not be too short to encourage the horse to step backward. Place your left hand near the withers, and using your right hand to turn the stirrup clockwise, guide your left foot into it. Pivot round so that you are facing the horse, place your right hand either over the waist of the saddle or on the front of the saddle, and by hopping with the

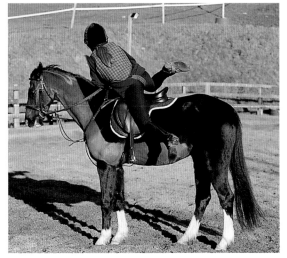

right leg, spring lightly and carefully into the saddle. Be careful not to boot the horse in the back or quarters as you bring your right leg over, and be sure to ease your weight into the saddle with care and tact. Slip your right foot into the right stirrup.

There are two alternatives to this method of mounting; the first is to be given a 'leg up.' This is when someone else helps to lift you into the saddle, which takes the strain off the left hand side of the horse's back, and prevents the left stirrup leather from being stretched longer than the right. Stand facing the horse on the nearside, take the reins into the left hand, and place the right hand over the waist of the saddle. Bend your left knee up, and this is what the helper will hold to push the left leg up. Leg-ups need careful action between rider and helper.

The second alternative is to use a mounting block. This is a specially designed, raised block on which you can stand, having positioned the horse alongside the mounting block.

THE RIGHT EQUIPMENT

BEFORE STARTING TO ride, it is vital that you have the correct equipment, and the most important item is the hat. Ensure that your hat is of the current safety approved status, which is PAS 015 or BS EN1384, although these do change quite often, and buy your own which has been fitted to your head. You also need to have a pair of riding boots which have a heel to prevent your foot from slipping through the stirrup. You can start off riding in jeans or ordinary trousers, but jodhpurs have been specifically designed for the job, and are well worth wearing. Try to avoid wearing voluminous flapping garments that could scare the horse, and always remove your jewelry, specially earrings.

DISMOUNTING

TAKE YOUR FEET out of both stirrups, put the reins and your whip into your left hand, which you can then lean gently on the horse's neck for support if you need to. Lean forward slightly, put your right hand on the pommel of the saddle, and quietly swing your right leg over the back of the horse so that you land squarely on your feet on the nearside of the horse. Be careful that you do not kick the horse in the quarters with your right leg, and also that you do not lose your balance and lurch backwards when you put your foot on the ground.

It is useful to learn how to mount and dismount from both sides of the horse.

Top Right
This horse and rider are turned out correctly for hacking. The rider is wearing the obligatory hard hat.

Center Left
As the rider starts to dismount, her feet have already been removed from both stirrups.

Bottom Left and Right
Holding on to the pommel, the rider slides down the horse to the ground.

Right
The correct sitting position is in the deepest part of the saddle with a straight back.

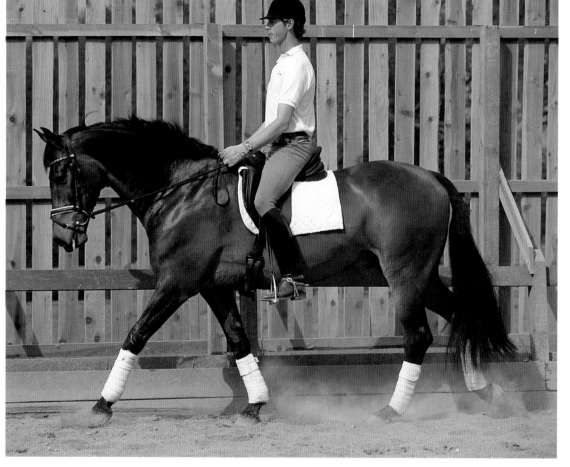

THE CORRECT SEAT

RIDING IS ABOUT balance, lightness, and suppleness, and none of these will be achieved if the rider starts out with a poor position. Once you have mounted, you need to check your girth again, and also the length of your stirrups. As a rough guide for the rider starting out, take both feet out of the stirrups and allow the legs to hang down. The bars of the stirrup iron should come to the ankle bone, or just above; this is a suitable length for the novice rider to begin flatwork. You must ensure that your leathers are the same length on both sides, and if you are having a lesson, your riding instructor should look at this for you. If your leathers are not the same length, you will be out of balance before you set off.

ADOPTING THE CORRECT SITTING POSITION

ONCE YOUR STIRRUPS are level, you need to make sure you are sitting in the correct position. You should be seated in the deepest part of the saddle, with your weight evenly distributed over both seat bones, and your hips square with the hips of the horse. It is very important that you are not crooked in the saddle. Your body needs to be straight and upright without becoming tense or rigid, and your legs need to hang in an effective but relaxed manner. Your elbows need to be bent, with slightly rounded wrists and your thumbs on top, and pointing toward the horse's ears. You should be able to draw an imaginary line from your elbow through your hand, down the rein, to the bit.

The lower leg needs to be in a relaxed contact with the horse – a common fault with novice riders is to grip with the knees. The calves and lower leg should rest on, or slightly behind, the girth, and you should be able to draw an imaginary straight line from the rider's ear, through the shoulders and hip to the back of the heel. You need to keep your elbows soft and relaxed, which in turn will keep your hands soft and able to move with the horse. A common fault with novice riders is to be very stiff and tense and it is immesely important to learn to relax and move fluidly with your mount.

Left
The correct way to hold the reins prevents them from slipping between the fingers.

Below
The reins should not be pulled down excessively but the rider should be able to feel a contact with the horse.

HOLDING THE REINS

THE REINS MUST PASS between the little finger and third finger, across the palm of the hand, and out over the top of the index finger. The thumbs are then placed on the top of the reins. The reins must be held securely to prevent them slipping through the fingers, but there should not be any tension in the hand.

Some show classes, and more advanced dressage, call for the use of a double bridle; with two reins, the curb rein is held between the little finger and third finger, and the bridoon rein passes around the outside, with the little finger dividing the two reins.

THE CONTACT

THE CONTACT IS the feeling you have once you pick the reins up, and is very important. The contact should remain constant through all the paces, and the horse needs to accept it and work into it without resistance. The contact should never be too heavy, or too light, but should give the horse a secure feeling to work to.

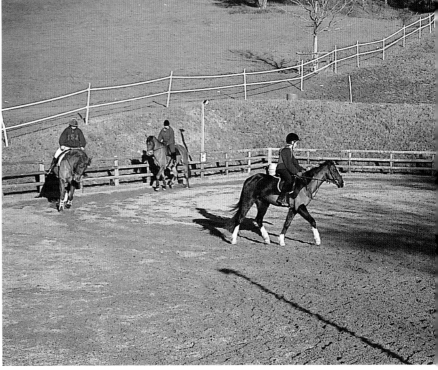

Right
This rider is using her body position to encourage the horse to trot.

Bottom right
The rider uses her hands, knees, and position in the saddle to communicate with the horse.

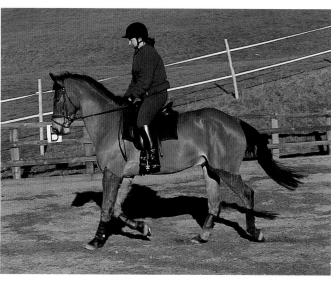

COMMUNICATING WITH THE HORSE

TO COMMUNICATE with the horse, we use aids to let it know how and what to do. It is very important to be tactful when applying the aids, so that the horse learns to respond quickly and efficiently to the lightest application of them. It is also important to apply the aids clearly so that there is no confusion as to what the horse should do. All too often, it seems that people demonstrate their ignorance by sawing on the horse's mouth with the reins, and then whacking it with a stick, effectively telling the horse, 'slow down, slow down, go faster, go faster.' This is neither pleasant nor effective riding. There are two groups of aids, natural and artificial.

NATURAL AIDS

THE NATURAL AIDS consist of the legs, the seat, and use of bodyweight, the hands, the voice, and thought. Thought can be looked upon as an aid, because basically when you think about the next movement you are about to take, you subconsciously will begin to use the other aids without even realizing it. Thought is fundamental to all the aids, and interestingly, when working with the same horse over a period of time, they seem to 'tune' their sixth sense in to you, and will respond almost before you apply your aids. The legs are incredi-

bly important as an aid and are used basically as the driving force, to create impulsion in the hindquarters and convert it to a free-flowing forward motion. The legs can be used separately to ask the horse to move in different directions, to give the aids for canter transitions, and to ask the horse to bend correctly.

Horses will move away from leg pressure; if you use just your right leg, it encourages him to move to the left, and vice versa. This is important to remember when moving on to lateral work. The seat and bodyweight is a very effective aid, which is sometimes difficult for the novice rider to grasp, but which becomes easier with experience. The seat is a useful aid to use in conjunction with the legs to encourage the horse to move forward, and is also important during lateral work, when one seat bone may carry more weight than the other, to influence the direction of the horse.

The rider's bodyweight should remain in balance with the horse, so that the center of gravity will alter slightly depending on what speed you are going, or whether you are jumping. The bodyweight should also be used in downward transitions, especially to halt, and is again used during lateral work. The hands should always be used with tact, and should never be used roughly. They are used in conjunction with the legs, and other aids, and help to regulate the forward-going motion, and the direction of travel. The hands can be used independently of one another, and should always remain soft and flexible. The voice is a useful aid, especially when lunging or working with the young horse, and he should learn to respond to the voice before learning the other aids. Once he is in ridden work, the use of the voice should be limited, and it should never be used during a dressage test.

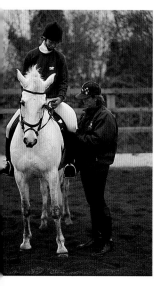

ARTIFICIAL AIDS

THE ARTIFICIAL AIDS consist of the whip and spurs, both of which obviously need to be used sensitively. The long schooling whip can be a useful addition to the leg aid, especially when training young horses in lateral work. It is used behind the leg. There is also a shorter, thicker whip which can be used in conjunction with the legs, when jumping, and should again be used behind the leg. Spurs should not be used by novice or inexperienced riders, although they can be a useful aid in more advanced dressage. They should be used extremely carefully, and should never be jabbed into the horse's side.

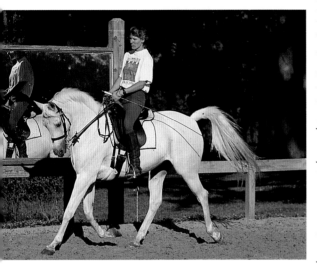

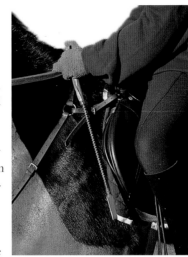

Top Right
The hands of the rider should be used to direct the horse and in conjunction with the legs.

Top Left
This Arab is being schooled by the rider, who is gently using a long schooling whip.

Bottom Left
Novice riders can learn some basic maneuver, such as changing direction, at equestrian schools.

THE SCHOOL

THE SCHOOL, menage or arena is the name given to the enclosed area in which the horse is worked when 'schooling'. These areas are usually standard sizes, and are either 131.3 x 65.6 ft (40 x 20 m) or, for higher levels of dressage, 197 x 65.6 ft (60 x 20 m). The area is marked out by standard letters and are always positioned in the same place. When talking about schooling, I will refer to the school using the relevant letters, and it is a good idea to learn where these letters are so you are familiar with them when your riding instructor is directing you.

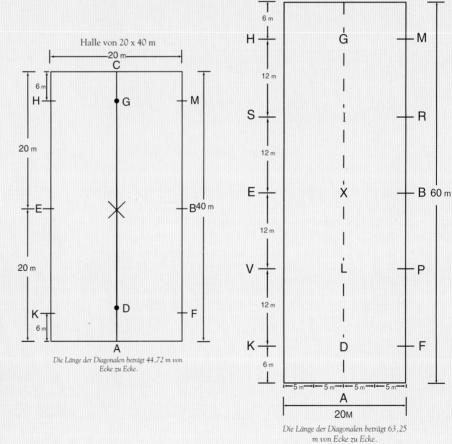

Halle von 20 x 40 m

Die Länge der Diagonalen beträgt 44,72 m von Ecke zu Ecke.

Halle von 20 x 60 m

Die Länge der Diagonalen beträgt 63,25 m von Ecke zu Ecke.

Movement

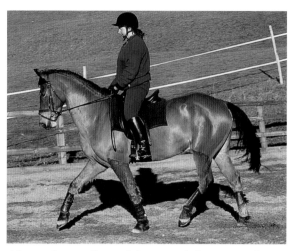

ONCE YOU HAVE achieved the perfect position at halt, and fully understand all the aids, it is time to move off. The most important thing to remember about your position is to remain relaxed and to try and move with the horse. You need to maintain your basic balanced seat without sitting absolutely rigid.

Top Left
The rider is sitting in the lowest part of the saddle and is moving with the horse.

Right
The sitting trot.

Bottom
The rising trot.

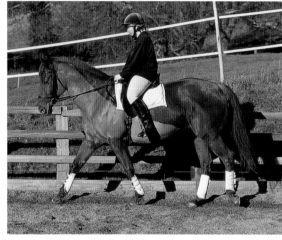

MOVING OFF, THE WALK

YOUR SHOULDERS, elbows, and hands need to stay particularly supple to allow the movement of the horse, but without setting up a 'swinging' movement yourself. If you are riding in a school, do not assume that your horse will follow on around the track; make sure that you are in control and are guiding him, and not the other way around.

FORWARD TO TROT RISING

THE RISING TROT CAN sometimes be difficult for the beginner to establish, but once you have, it is a very easy pace for both the rider and the horse. The trot is a two-time pace, with the horse moving his legs in diagonal pairs, with a moment of suspension inbetween. The rider is on the 'right diagonal' when his seat is in the saddle as the near hind and off foreleg hit the ground, and on the 'left diagonal' when the off hind and near foreleg hits the ground. For the

rider to change diagonal, he must sit for an extra beat before rising again. The natural two-time beat of the trot helps the rider to stay in rising trot. The rider should change the diagonal every time he changes the rein; he should sit on the left diagonal when going on the right rein, and on the right diagonal when travelling on the left rein. An easier way to remember is that the rider should sit as the outside front leg comes back, and rise as it goes forward, and this rule applies to both reins. (The outside leg is the leg nearest to the wall of the arena.)

The rider needs to maintain a balanced seat and position through the trot, staying in harmony with the movement of the horse. The rising and sitting of the trot should be controlled and should not be a collapse back into the saddle. The body needs to stay supple and fluid to accommodate the movement of the trot. The hands should remain steady, not lurching up and down with the rise, and should maintain a steady contact. The head needs to stay up, with the shoulders back, and not hunched, and the rider should be looking forward to see where he is going.

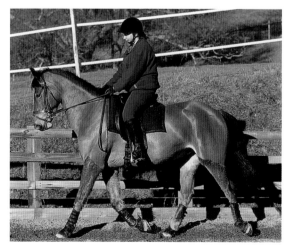

HORSE FACT:
Arabians have one less rib, one less lumbar bone, and one less tail vertebrae than other breeds of horse, which accounts for their compact conformation through the back and characteristic high tail carriage.

Sitting trot is an excellent pace for the slightly more experienced rider to gain a greater degree of collection, and to help the horse to work through his back. As in all paces, the position of the rider must remain in balance with the horse; the body needs to be upright and straight, with a deep seat and a long lower leg. You must not sit very heavily or sloppily, but should keep a light and sympathetic seat to allow the horse to work his back. If the horse hollows away from the sitting trot, it is an indication that either the horse is not ready for this or that the rider is sitting badly.

FORWARD TO CANTER

YOU MUST STAY in harmony with the movement of the horse and should be careful that you do not become either 'behind the movement,' which is when your bodyweight is behind the horse's center of gravity, or 'in front of the movement,' which is when you are tipping forward. You need to remain sitting tall, with no hunched shoulders, and your seat should stay in contact with the saddle at all times. There is nothing worse than someone bumping up and down on a horse's back, which can only cause the horse to hollow away. Your body needs to stay supple, especially through the hips, shoulders, and elbows, and your hands need to maintain a steady contact.

ON TO GALLOP

GALLOP IS THE horse's fastest pace, and once he is up to speed, the rider should adopt a forward seat, with the weight off the back. By coming forward, you keep your center of gravity over that of the horse, which increases his ability to stretch and extend into a full pace. Remember to keep looking where you are going. You need to shorten your stirrups to allow your body to come forward and should only attempt this pace once you have established balance and control at the other paces.

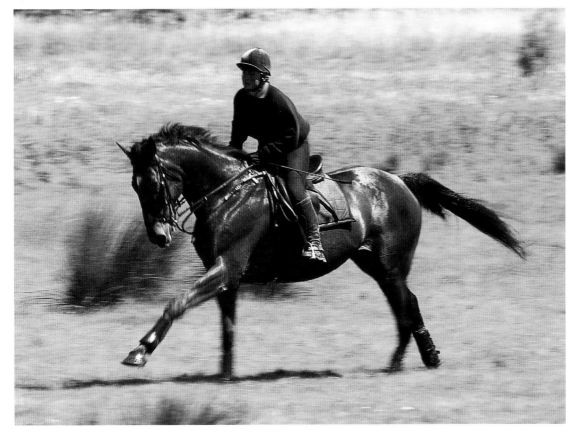

Top
The rider leans forward to encourage the horse to extend its pace at the gallop.

Bottom
When cantering, the rider should sit tall and be in contact with the saddle at all times.

HORSE FACT:
'Piaffe' is a dressage movement requiring the utmost collection and engagement of the horse so that it appears to perform a trot on the spot. This movement is only executed at the highest levels of dressage.

Aids to Movement

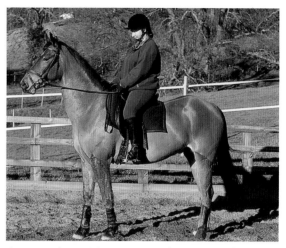

THE AIDS TO MOVE forward from halt to walk, and from walk to trot, are very simple, and involve the use of slight leg pressure; if the horse does not respond to the initial aid, apply the aid slightly more strongly. Never take your legs from the side of the horse and 'flap', or kick. All this does is 'deaden' the sides of the horse, so that he basically stops responding.

> **HORSE FACT:**
> The term 'hold hard', is a hunting command meaning 'stop immediately.'

AIDS FOR WALK, TROT, CANTER, AND GALLOP

TO ASK FOR CANTER if you are on the left rein, draw your outside (right) leg back behind the girth and, keeping your inside leg to the girth, apply leg pressure. To canter on the right rein, draw your left leg back behind the girth, keep your right leg to the girth, and apply leg pressure.

Be very careful not to lose balance when making either upward or downward transitions. To ask the horse to gallop, establish the canter, then using equal leg pressure and allowing the hands to come forward a short way, ask for gallop. Downward transitions, that is when moving from a faster pace to a slower one, require tactful use of the seat, the legs, and the hands. Before making either upward or

Top Right
This is a bad halt; the rider has pulled too hard on the horse's reins.

downward transitions, you need to prepare for the transition – plan where you wish to make it, set the horse up for it, and then ask for it.

The aim is for the horse to remain constant throughout his paces and his transitions in a steady, balanced rhythm. Most novice riders, and novice horses, tend to lose balance through the transitions. Common faults are rushing when the rider over-asks for the transition, so that the horse hurries into the pace; and 'collapsing,' when the rider over-asks with the hands for a downward transition and the horse collapses into the pace. To avoid losing all forward momentum, you must keep your legs backing up the use of your hands when decreasing the pace.

THE HALF-HALT

THE HALF-HALT is a very useful aid, which involves a slight checking of the horse in a forward pace; it is an excellent way of bringing the hindquarters in underneath him, raising the forehand, putting him together into a more collected outline, and as preparing for transitions. The half-halt is often used just before a lateral movement. To ask for half-halt, sit tall, take a small check with the reins, think of your weight sinking down, and be very careful to back your aids up with the leg, otherwise the horse will simply drop down a gear.

THE HALT

THE HALT IS OFTEN forgotten about by many people, but is in fact an important movement to practise. The novice rider should go into a halt from a walk, being the most simple maneuver, but as you and/or the horse gain in experience, you can make a downward transition to halt from both trot and canter. The aids for halt are a gentle squeeze of the reins backed with the leg to prevent the horse stopping

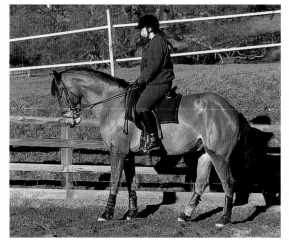

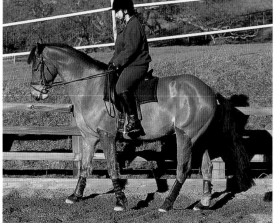

too abruptly. Think halt and sit tall. The horse should stop squarely, with his front and back legs in line, and should keep a steady outline through the transition and in the halt. The horse must learn to stand in halt in a steady outline without fidgeting, and must not be allowed to throw his head or take steps sideways or backward.

REIN BACK

THIS MOVEMENT involves the horse moving with calm, level steps backward from the halt but is not generally tackled by the novice rider. The horse should remain as balanced and as receptive in the rein back as he is when going forward. The pace is a two-time pace with the legs moving in diagonal pairs, i.e. left hind and right fore together, and right hind and left fore together. To ask for rein back, apply both legs to create forward movement, and keep a slightly restrictive hand to ask the horse to move back instead of forward. Once he has moved back the required amount of steps, you must send him forward straight away.

Top Left and Right
In the back rein, the horse should remain as receptive as when going forward.

Bottom
A square halt; all of the horse's legs are level and the rider is balanced centrally on its back.

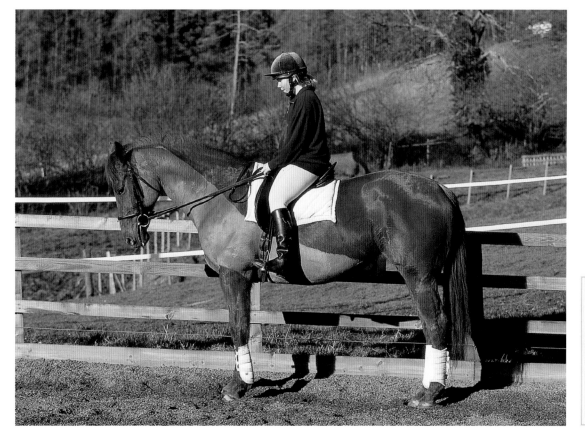

Changing Direction

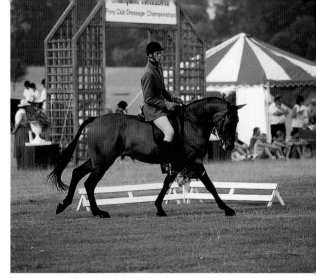

WHEN WORKING in the school, you need to carry out a variety of exercises to maintain and improve the horse's way of going. For the novice rider there are some basic maneuvers that you will be required to do when having riding lessons.

Top Right
The rider's inside leg should support this horse as it turns a corner.

Bottom Right
This horse is being turned on a circle.

CIRCLES AND CHANGING THE REIN

CIRCLING IS ONE of these, and the novice rider usually starts with 66-ft (20-m) circles, either at point A, C, B, or E. It is important to ride an actual circle, and a common fault is for people to ride a circle with a square end where they are still on the track. For example, if you are asked for a 66-ft (20-m) circle at A, you should ride your route off the track between K and A, and A and F.

The 66-ft (20-m) circle ridden correctly from either A or C means that you are crossing the center line at X. The 66-ft (20-meter) circles ridden in the middle of the school should again be round, and not, as they often tend to be, oval. Circles can be reduced to 50 ft or 33 ft (15 m or 10 m), and should be ridden so that the horse actually bends his body to encompass the turn and does not go round 'plank-sided.' The curve his body makes should be uniform from poll to tail, and so the tighter the circle, the greater he has to bend his body. He must retain his balance and rhythm when circling, and this requires the rider to maintain theirs. You should keep your hips square with the horse's hips, and your shoulders square with the horse's shoulders. To ask for a circle, use your inside hand to give direction, backed by your outside hand to prevent over-bending the neck. Support the horse with your inside leg as he turns, and stay on the girth, with the outside leg behind the girth preventing the horse from 'falling out.'

CHANGING REIN

CHANGING THE REIN, or changing your direction, can be as simple or as complicated as you make it. A simple change of rein across the diagonal means riding from either K to X to M, or vice versa, or

from F to X to H, or vice versa. When riding across the diagonal, make sure you ride into your corners well, so that you make a good positive turn at the letter, and then ride straight across the school to the next letter. Riding into your corners is a habit you should practice when riding large around the school.

Another simple change of rein is a figure of eight, which is a 66-ft (20-metre) circle at one end of the school, and as you cross X, change direction to start a 66-ft (20-metre) circle at the opposite end of the school. It is useful to practice changing the rein by making a turn up the center line. Be sure to ride a dead straight line from A to C, and make good turns into, and out of, the maneuver. When you are changing rein in the rising trot, remember to change your diagonal, and if you are carrying a schooling stick, you should change this so that it is held in your inside hand.

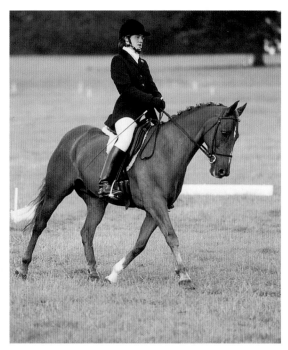

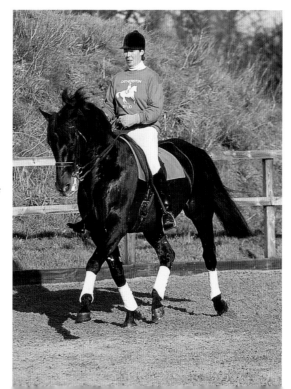

Top
This horse has a good outline; he is accepting the bit and working hard, with a supple back and neck, and a swinging tail.

OUTLINE AND THE CORRECT WAY OF GOING

ONCE YOU ARE FAMILIAR with the paces and simple maneuvers such as circling and changing the rein, and are riding in balance and harmony with the horse, it is time to consider the horse's way of going and his outline. The outline is the overall shape that the horse is in as he is working, and he can either be in a good outline or a bad one. People often refer to this as the horse being 'on the bit,' but I think this is a confusing term, especially for the novice, in that it implies something from the front end only. Horses can technically be 'on the bit,' without being in a good outline, and a prime example of this is the horse that is restricted by the hand in front, and has no impulsion coming through from behind, leaving the hocks trailing.

To be in a good outline, the horse must be soft and supple through his back and neck, his hindquarters need to be active and underneath him, and he needs to be carrying himself and accepting the bit without resistance. From a side view, the horse in a good outline has its poll as the highest point, the head held vertically, being neither behind the vertical nor in front, the jaw relaxed, and a gentle curve from the withers to the poll, the back should be supple, the tail swinging, the quarters active and underneath him, and the shoulders moving forward freely. The outline of the horse should remain constant and should not alter through any of the paces or transitions.

To maintain a good outline, the rider needs to have a steady contact and to encourage the horse forward into this by using the legs. The rider needs to be balanced, supple, and in total harmony with the movement of the horse. A good outline should be maintained in a steady, calm, rhythmic manner, with the horse being responsive, attentive, and moving forward with impulsion, which should not be confused with speed. Once a good outline and a correct way of going have been established, the rider is ready to move on to more complicated exercises, to start shortening and lengthening the stride, and to begin lateral work.

Learning to Jump

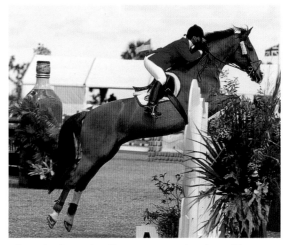

JUMPING IS EXCELLENT FUN and extremely rewarding, but should only be tackled by the rider who has developed a secure seat on the flat. You need to be fully in balance and able to direct accurately and control your horse, as well as being competent at riding turns and circles.

BASIC JUMPING

Bottom
The first stage of the jump is the approach; it is important that the beginner jumps on the straight.

LEARNING TO JUMP can initially be quite difficult, and you may find that you lose your balance as the horse takes off. This can lead to a common fault that you must try to avoid called neck-leaning. When the horse takes off over the fence, the rider props him or her self up by leaning the thumbs or hands on the base of the neck. Not only can this result in broken thumbs, but it is also very restrictive for the horse, especially as you move on to larger fences.

FIVE PHASES OF JUMPING

Top Right
In the take-off, the horse's neck should be raised and shortened.

JUMPING CAN BE SPLIT into five phases, all of which need to be ridden correctly to produce a good jump. The phases are the approach, the take off, the flight, the landing, and the recovery.

THE APPROACH

Bottom Right
The rider's weight should be forward over the horse's neck and out of the saddle.

THE APPROACH RELIES on a number of things, the first of which is the line you choose to take to the fence, and in basic jumping for the novice, this must be a straight line aiming for the middle of the fence. More experienced riders are able to jump off tight turns and at angles, but the novice needs to stay on the straight. You must be looking where you are going toward the jump and make a good turn into it so that the horse is balanced. You need to stay straight, guiding the horse with your legs. His approach needs to be balanced and rhythmic, with no last minute rushing into the bottom of the fence. The very best show jumping is that

when the horse hardly appears to alter its stride through all five phases of the jump. As you are on your approach, you need to see your stride and judge where your take-off will be. The horse lengthens its neck as it assesses the fence. You should have adopted a slightly, but not overly, forward seat with your weight off the back, pushing into the balls of your heels. The approach is extremely important, and invariably a bad approach leads to a bad jump.

THE TAKE-OFF

THE TAKE-OFF SHOULD have been set up by a good approach and, as the horse takes off, the head and neck are raised and shortened to help him lift the forehand. His hind legs come well under him to push the forehand up, and his hocks propel him into the air. You need to adopt the jumping position at this point to help him become airborn.

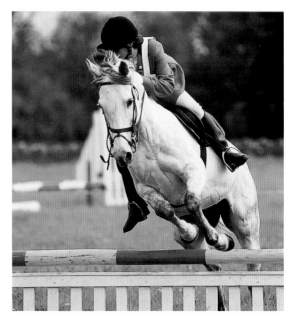

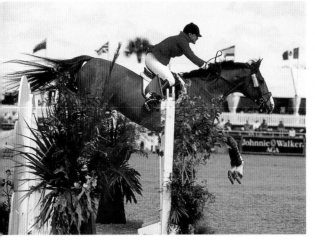

THE LANDING

AS HE PREPARES to land, the horse's front legs stretch out and down, with one meeting the ground fractionally before the other; the head and neck rise again to balance him and the hindquarters follow through. As the horse lands, the rider should gradually straighten his body while still keeping the weight off the back. A common fault is when the rider is out of balance and lurches forwards, or to the side, both of which put the horse off balance.

THE RECOVERY

THE RECOVERY is very important and in many competitions, the getaway actually turns into the

Top Left
In flight, the rider should look forwards.

Center Left
The horse raises his head on landing in order to regain balance.

Center Right
The final stage of the jump is the recovery, which can be the start of the next approach.

Bottom
If the approach is wrong, the horse will probably refuse to jump.

Two common faults often occur at this point, the first of which is taking off before the horse. That is when the rider launches his or her self into the jumping position before the horse has taken off, leading to a lack of balance, and adding extra weight to his forehand as he is trying to lift. The second common fault is being left behind; this is when the horse takes off and the rider's weight is behind the movement, which often results in the horse getting jabbed in the mouth. Timing is absolutely everything in good showjumping.

next approach. As the horse lands, his hocks come underneath him, and as he strides away from the fence, it is important to establish a balanced stride as quickly as possible. The rider needs to have straightened their position somewhat so that they have resumed the position for the approach.

THE FLIGHT

AS THE HORSE takes off, he enters the third stage of the jump, the flight – the period when he is actually in the air. He rounds his back, stretches his head and neck forward and down, and tucks his forelegs and hindlegs under him. When the horse makes a good shape over the fence it is described as a 'bascule', meaning an arc. It is very important for the rider to keep a still seat, and look up and ahead while the horse is in flight.

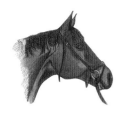

Bottom
This rider demonstrates the forwards riding position, allowing their center of gravity to remain with that of the horse.

Top Right
Pole work is an excellent method for the novice to learn to jump.

THE JUMPING POSITION

BEFORE STARTING to jump it is necessary to shorten your stirrup leathers to allow your knees to bend in order to achieve the forward seat. The jumping position needs to remain in balance and harmony with the horse in movement just as during the flat work. The forward jumping seat allows the rider's center of gravity to remain in line with that of the horse. The rider must bend at the hip, not the waist, and come forward in the saddle with the seat out behind.

You need to keep a straight back, and keep looking forward to the next jump. The lower leg stays in contact with the horse, and the weight is transferred to the balls of the feet. The reins need to be shorter than normal, and the hands should travel up the neck as he stretches forward, whilst maintaining a contact. It is a good idea for the novice rider to practise the jumping position at a halt, and then at walk, trot and canter to get used to the feel of it.

DEVELOPING AN EYE AND SEEING A STRIDE

SEEING A STRIDE is extremely difficult for the novice and indeed they should not try. Developing an eye comes with experience: on the approach to a fence, you are able to judge exactly where the horse needs to take off, and so can tell if you need to alter his stride. This can be very useful when tackling different fences, such as uprights, spreads and water jumps, all of which require a slightly different approach. For

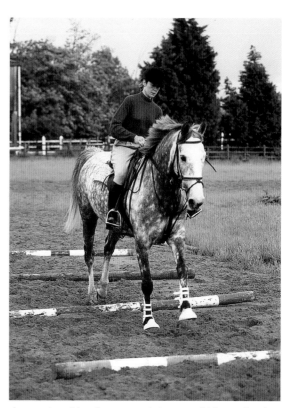

the novice rider, however, it is a good idea to let the horse sort it out, bow out to their greater experience and learn from them how to see a stride.

POLE WORK

ANOTHER VERY GOOD way of learning how to see a stride, and in fact the way that every novice should begin jumping is by the use of trotting poles. If you have never worked with poles before, start off by walking over a series of three or four poles on the ground, which have been regularly spaced to suit the length of stride of your horse. Once you are familiar with the exercise, move the poles further apart, and trot over them. Once you are quite happy with this, place three poles at a good trot distance from each other, and measure out a distance of approximately nine foot to a small cross pole jump. The distances vary from horse to horse, but should be one good stride before the fence.

Using the poles method helps not only the jump itself, but also the approach to the jump. As you become more confident, you can remove two of the trotting poles, so that you are left with just one placing pole. When you do this, remember still to look for your approach stride. Always start jumping in trot until you are quite happy and secure in your seat. When you progress to jumping out of canter, keep the placing pole to help you see your stride, but be

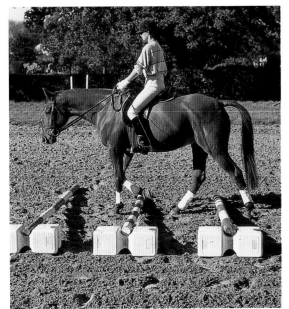

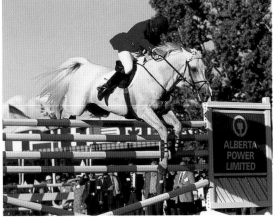

Top Left and Right
In order to jump in com-
petitions, the rider needs
to have the experience to
be able to judge the
obstacles quickly.

Below and Bottom
For both horse and rider
to jump well they need to
train well.

sure to move it back to approximately 18 ft from the jump. Initially work with cross poles, which are inviting and help you to aim for the middle of the fence; when you wish to progress to a larger fence, place a straight pole behind the cross poles. This keeps the fence looking inviting, and is an easier fence to jump than a straight upright.

Once you have established jumping in canter, move on to jumping a simple combination, or two jumps. The most simple combination consists of two jumps, called a 'double'. First approach the double from trot, adjusting your placing pole if necessary, and positioning the two jumps approximately 5.5 m (18 ft) apart. You may need to alter the distance depending on the length of stride of your horse.

It is very important to ride directly straight into the first part of your double, to ensure that your horse does not miss the second part. You need to be thinking about the second jump as you are going over the first. Obviously you have to keep a very balanced seat, so that you can recover quickly from the first jump and prepare for the second. When you start to jump the double from canter, adjust your placing pole accordingly, and move your two jumps so that they are approximately 7.3 m (24 ft) apart.

To start jumping two fences which are unrelated, position one on one side of the school, and the one on the other. Use your placing poles if you still feel you need them. Approach your first fence as normal but as you are jumping it be thinking about your second fence. Establish a balanced stride as quickly as you can on landing after the first fence, and prepare for your turn into the second fence, looking towards it. Once you are on the approach to the fence, ride as normal. Gradually, as you gain confidence and experience, you can increase the number and difficulty of the fences you are jumping.

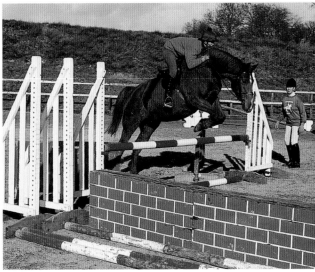

Jumping, as with dressage, is a precision sport, and requires quick thinking, good judgement and common sense. The best advice for a novice is to take every step of equitation slowly and look upon it as laying foundations on which to build your skill. With jumping especially, do not rush into it, make sure you have built your foundations in your flat work, and you will find that you progress much more easily.

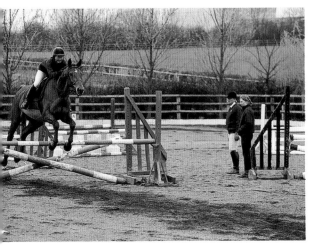

HORSE FACT:
'Green' is the term used in reference to a young, inexperienced horse and has nothing to do with its color.

Training a Young Horse

I T IS GENERALLY BEST to approach the training of a young horse in two phases: backing, followed by a period of rest, before training in earnest begins. Most horses are backed at either two or three years old during the summer months, they can then be turned away to grass over the winter months before being brought back into work in the spring. It is extremely important that when backing a two year old, that it is turned away to grow and mature both physically and mentally.

horses; they tire quickly, and invariably throw tantrums, much like a young child. It is important to treat young horses, indeed all horses, with a firm yet understanding attitude – they need to learn the difference between what is and what is not acceptable in all areas of their life.

STARTING OUT

BASIC TRAINING STARTS the moment the is born and includes learning manners, and learning to be handled. The young foal needs to get used to being touched and led as soon as possible. Make a point of running your hands all over him every day, making sure you feel under his stomach, between his legs, his tail, head and legs. As soon as possible, pick his feet up, and as you are holding the foot up, bang on the sole of the foot with the flat of your hand to accustom him to motion in this area. You should not creep around young horses trying not to startle them, but should behave as you normally would to accustom them to every day living in a noisy human world.

Try to get them used to as much as you possibly can – leading them past cars, the noise of doors bang-

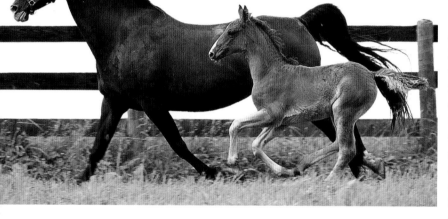

Top Right
Young horses tire easily and show signs of temper; they should be treated with understanding and a degree of discipline.

Above
Foals should be accustomed to being handled from birth.

Bottom Right
It is better if young horses have a wealth of experiences from a young age as it will make them easier to train when older.

WITH THREE YEAR OLDS, depending on the breed and the individual, it can be possible to bypass the turning away period, and continue with their training. Obviously there are some variations to these principles, namely in the flat racing world, where horses are raced as two year olds, and have therefore begun training exceptionally young. It is important, as always, to use common sense and to assess each individual horse. General rules are just that, and are not hard and fast. Many different breeds naturally develop at different speeds, as well as the individual, and in some cases it is better to leave the horse until he is either three or four, rather than rushing him.

When dealing with young horses, try to remember that they are still babies, and have a whole life ahead of them to learn. Young horses naturally react very differently from mature

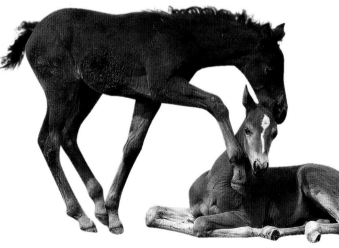

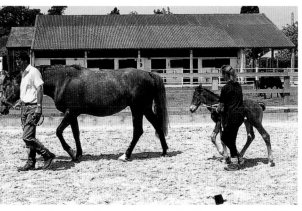

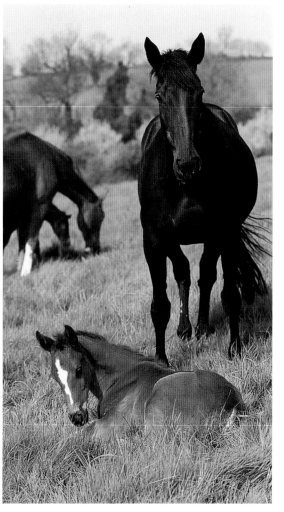

Top Left
This mare and foal are being led together to accustom the young horse to being handled.

Left
This foal, like all horses, should be brought in to shelter if the weather turns cold to prevent it from catching a chill.

Below
The foals are being trained with older horses in order so that they learn to behave in company.

ing shut, a radio, washing on the line, dogs and children. If your young horse is able to cope with these kind of stimuli before you get on him, your job is going to be that much easier. It is a good idea to work with yearlings in a stable. Lead them into the stable or feed them in there in the evenings to get them used to being enclosed. Once they are in the box, start to teach commands such move over, back up and so on to teach the manners of a stabled horse. Practise leading them as much as you can and if you are showing in hand, teach them to lead up and trot up, as well as standing properly.

STIMULI FOR THE YOUNG HORSE

ALTHOUGH TAKING YEARLINGS to shows can be a hair-raising experience for all concerned, it is excellent training for them. They learn to behave in company, which is extremely exciting for them on their first time out and they also meet all kinds of stimuli which you cannot create at home. Always travel with a helper, and accustom your horse to having bandages on his legs before your first trip in the lorry to avoid unnecessary worry for him. Putting rugs on foals or yearlings has advantages and disadvantages. It is a good idea to get them used to wearing a rug, so they become desensitised to having something large and flappy on their back. However, unless it is absolutely necessary, do not start turning your youngsters out in rugs.

It is a good idea for them to winter out and providing it is well fed and has shelter there is no reason why a youngster should be rugged, or any other horse for that matter, providing it is not clipped and has grown a decent winter coat. You must not over-cosset them and the only time you need to be careful is if it has been raining constantly accompanied by a strong wind. This type of weather condition can chill any horse, youngster or not, and the best approach is to bring them in and dry them off.

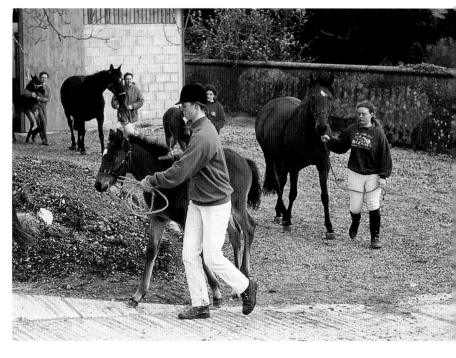

PREPARING A YOUNG HORSE

THERE IS NO SUBSTITUTE for good groundwork and preparation when dealing with young horses, and if they are used to being handled, and have learnt trust and respect, then your job becomes much easier. Very early lessons should take place in an enclosed area, preferably a round pen of approximately 20 m (65.6 ft) in diameter, or slightly larger, or you can use one end of a school, dividing it up using barrels and poles. Lead your horse into the middle of the round pen, and reassure him. Release him and send him away from you so that he is travelling around the outside track of the pen.

It is a good idea when working horses, especially young horses, to put on either brushing boots or bandages. You initially want to teach your horse basic voice commands, so that he learns to respond to you and your directions. It is usually not necessary in this early stage to use a lunge whip – use your voice and body language to keep him moving. Fix your eye on his and tell him to trot; repeat the command if it is not heeded; if it is still not heeded you can click and stride purposefully towards his quarters, while still looking him in the eye. Keep him trotting round until he shows signs of relaxing when his tail should start to swing, his stride becomes steady, he lowers his head and neck, starts to lick and chew and

Above
This British Warmblood foal should first be schooled within an enclosed area.

Bottom
Lunging a horse in a circle is an excellent form of exercise and training.

starts to decrease the size of his circle. Ask for walk, and slide your eyes back towards his shoulders. Repeat your commands, asking the horse to trot and walk, and to stop. Remember to change directions and work him on both reins. Once he has learnt what the voice commands are, you can move on.

The next step is to introduce the lunging roller and breast plate, placing the roller over a western-style saddle blanket. As the horse moves, he will feel the blanket moving against his sides which can help when first putting a saddle on. Once he is accustomed to this, you can introduce the bridle and bit, which should be a snaffle, and the lunge cavesson. Before putting the bridle on, roughly measure the size against the side of his head, so that it will fit, and warm the bit in your hands. Once the bridle is on, make any adjustment that you need to carefully and without alarming him.

LUNGING

LUNGING SHOULD eventually be carried out using side reins but at first I prefer to leave them off and continue working the horse on a loose school basis. This allows the horse to become accustomed to the bit and bridle without any form of distraction. With young horses, it is best to use a lunge cavesson, and attach the line to this. When you do attach your side reins, be very careful that they are long and in no way restrictive. It is very important for the young horse to learn to go forward, and to want to go forward. Side reins should be attached so that they

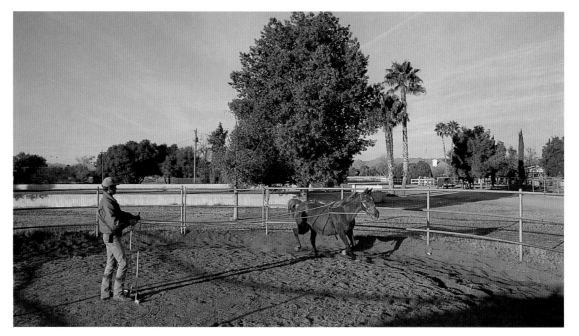

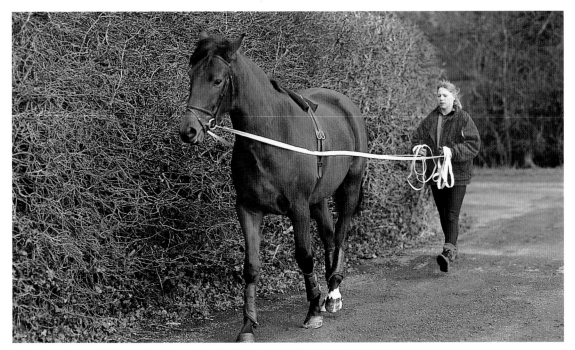

HORSE FACT:
A saddle should always initially be fitted on a horse without a numnah; to properly fit a saddle, it should be seen with a rider on as well to check the clearance over the withers and spine and also for any uncomfortable pressure points.

encourage the horse to work in a long, low outline, using his back and staying relaxed and supple.

When you start lunging, you will need to carry a lunge whip. As you attach the lunge line, be sure to allow the horse to sniff it, and look at it. Lunging can be an excellent form of exercise if done by someone competent. It helps to teach the young horse a good way of going, before he has the rider on his back. When you are lunging be sure that the horse is bending and using his body, and is not falling out through the quarters or shoulders. Lunging is very hard, intensive work, so be aware of this, and do not lunge the youngster for too long.

LONG REINING

LONG-REIGNING IS an excellent way of teaching the horse to accept wearing the bit before you actually mount. It is often easier to long-rein with two people, with the second person walking alongside the horse's head in the initial lessons to help direct him and calm him if he appears nervous. Before long-reining, you should get your horse used to having a line trailed over his back so that he is not scared by the sensation, then with your lines attached to the bit rings and through the roller rings you can set off. Keep your lines long enough so that there is a reasonable distance between you and the back of the horse, and send him forwards. You need to keep a respectable distance in case the horse is nervous or startled and decides to lash out, either with teeth or hooves. Start off in an enclosed area but then you can take him outside and long-rein him up and down tracks, and around farmyards, etc. You can also lunge your horse on long reins. In your enclosed area, send him in a circle around you, keeping a steady contact with both reins, but be careful that your line does not creep up and become wedged under his tail, as this may cause an explosion.

Top
This horse is being long-reined, it is a good way to accustom the horse to the feel of the bit and reins.

Bottom
When the horse is accustomed to the feeling of the long rein, take him out of the enclosed area. As his confidence increases, take him out on a quiet road.

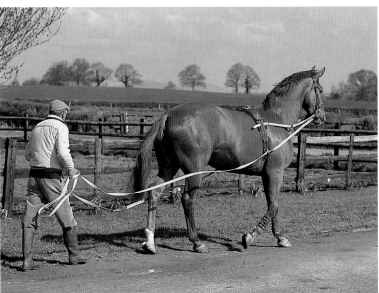

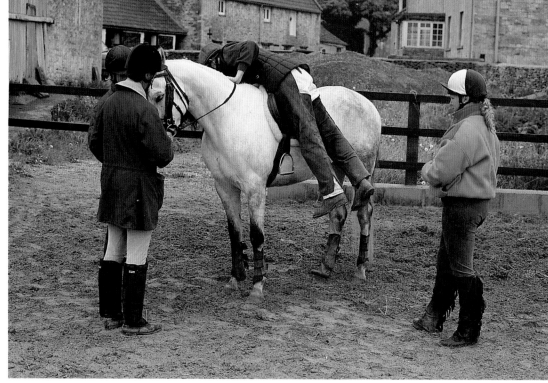

Top

The rider is familiarising the young horse to being ridden, by laying across his back at first it is preventing the horse from being startled.

Bottom Right

A second person holds the head of the horse as the rider carefully introduces it to being mounted.

MOUNTING

ONCE YOUR HORSE has been lunged and long-reined, he should be ready to be mounted. Ground work is very important, and should not be stinted; you need your horse to be as educated from the ground as possible, before getting on. Introduce the saddle quietly and carefully. When the saddle is on send him away, with the stirrups dangling to trot round the pen. Let him become accustomed to the stirrups banging his sides. Once he has relaxed, put his bridle on and have someone very carefully give you a leg up, so that you are lying across the saddle. Once this has been established, have another leg up, and very quietly mount. Some people prefer to do this on a lunge rein but I think it is safer for the rider to be in command; this is a personal preference.

Once on, take things very easily and very slowly. If you are backing a horse, you should be experienced enough to be able to 'read' the horse and act accordingly. Try to walk him around until he settles, but be warned, invariably he will not blow up on this first occasion, but will try to misbehave on the third or fourth ride, when he feels more confident in himself. By the third ride or so, you should be able to walk, trot and halt, and should be starting to establish steering which is helped by your long-reining.

Try to be tactful and light in the hand, and back up any hand aids with the use of the legs. Once you have established walk, trot, canter and halt, you can leave the school and venture out. The best way is to be accompanied by an older, bomb-proof horse to give your horse reassurance.

Stay off the roads at this very early stage, but try to hack around tracks, woods and fields. The horse needs to learn to go forward, to meet obstacles and react sensibly, and most importantly, not to become stale or bored.

Once he has been doing this, and doing it well, it is time to turn him away to let him grow up, even if this is only for a few months. It is a very important part of training a young horse. If he is three or four, and suitably mentally and physically mature, you can then start his training in earnest and including more school work and exercises, and subjecting him to different stimuli.

SIMPLE EXERCISES

HERE ARE SOME EXAMPLES of simple school exercises you can do, all of which are excellent ways to improve any horse's way of going. Circling and serpentines are really self explanatory. Leg yielding is a very good lateral movement to increase suppleness, but try not to 'over ask' in the initial stages.

• Come off the track on the three-quarter line, and then ask the horse to leg yield back to the track. It is very good for teaching them to move away from the leg, but be sure to keep your outside leg there for support so they do not fall out through the shoulder.

• Quarter turns on the forehand again are very good for teaching horses to move away from the leg; start with a quarter turn before progressing to a half turn.

• Trotting poles, and raised trotting poles, are excellent for teaching the horse to pick his feet up neatly, and are a good exercise for keeping the back supple.

• Rein back is quite a tricky movement and some horses find it difficult so start teaching it using an assistant to gently push him backwards as you apply the aids.

PERSONAL SAFETY

THIS IS a highly condensed account of mounting and dismounting, and is merely designed to give you an idea of what they entail. There are a vast number of exercises, both on the ground and on horseback, which are very useful but have not been covered here. Mounting and dismounting should not be done alone by the novice rider.

Top and Bottom
This horse is lunged over jumps, which is an excellent way of keeping his back supple and teaching him to tuck in his feet.

Competitions

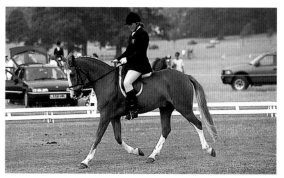

THERE ARE A HUGE number of competitions tailored to appeal to people from all areas of equestrian life, and this section will provide you with just an idea of the main competitions there are available; it is by no means a comprehensive guide. As well as ridden competitions, there are a wide range of driven competitions from harness racing to cross-country driving and dressage driving. Every discipline has its own set of stringent rules, and if you are considering competing within one of these, it is of paramount importance that you study the rule book. Competitions are not just geared for the professional horseman or woman – there are numerous different competitions for all the disciplines, which are aimed at all levels of riding competence, allowing everyone the chance to enjoy competitive riding.

book and runs showjumping in Britain to the highest level and with the greatest degree of efficiency. All the major showjumping shows are affiliated and to compete in these you must be a member of the BSJA. Unaffiliated showjumping can be run by anyone, such as any riding establishment, riding club or group of individuals. These shows are open to anyone, and are generally based on the same rules applied by the BSJA.

Unaffiliated shows are an excellent place for the novice rider or novice horse to begin showjumping competitively. They are of a much lower standard than the BSJA shows and are a good introduction to showjumping. The BSJA does, however, hold classes aimed at all levels of ability, from novice through to the very highest levels, and the lowest BSJA classes are a good to progress to once you are finding that the unaffiliated classes become too small and undemanding for your level of skill.

THE COURSE

SHOW JUMPS ARE brightly colored, usually wooden, moveable fences that are arranged into a course that usually consists of between eight to fourteen or so jumps. There are a variety of different types of obstacle such as a wall, planks, parallels, water jump, gates, stiles, triple bars, etc., but all of these can be divided into two groups: uprights and

Top, Center, and Bottom Right
There are a variety of different types of competitions that you can enter from rodeo to dressage (see top right) and showjumping.

Bottom
Showjumping is one of the fairest competitions as the horse and rider are judged purely on speed and clearing the jumps.

SHOWJUMPING

SHOWJUMPING HAS already been partially discussed in 'Horses in the Human World', but from a more historical angle. Here I would like to try to provide an idea of what showjumping is all about.

Firstly, showjumping is basically divided into two branches. There is affiliated and unaffiliated showjumping. Affiliated showjumping shows are run by the British Show Jumping Association (BSJA), which has a comprehensive rule

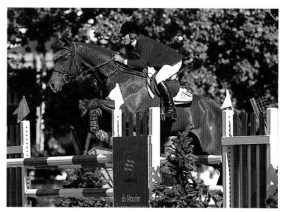

spreads. The design of fences is quite an art, and they are often beautifully presented with flower boxes and shrubbery around them.

A course of show jumps will usually comprise at least one combination fence. In the easier classes, this will be a double, which is two fences in a row with only one stride in between them. As the classes get harder, so do the combinations, and they often comprise three jumps in a row with a difficult striding in between. Course building is a highly skilled job. Although to the untrained eye, the course may appear to comprise of randomly placed jumps, they are in fact all carefully worked out by the course builder, who measures the striding in between fences to an exact degree.

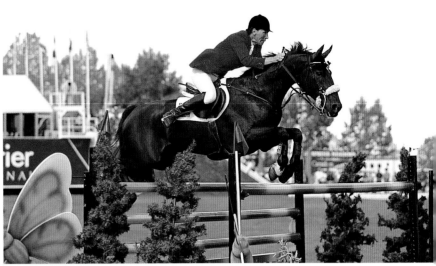

THE COMPETITION

SHOWJUMPING IS considered one of the fairest of equine competitions because it is judged purely on whether the horse clears the obstacles or not, and how fast it does so; the style that the rider and horse adopt is of no consequence. Some classes are judged on style, but on the whole this does not count. There are many different classes of showjumping that take a slightly different format but the basic procedure is the same. Before the class begins, the riders are invited to 'walk the course' which is a very important part of showjumping. The experienced rider is able to walk, on foot, around the course and calculate how many strides his horse needs to take and at what angle each fence can be jumped.

Once the course has been walked, the class begins. This normally consists of two rounds of jumping. The first round is not timed, but requires the horse and rider to complete the course with a clear round, having neither refused, nor knocked a fence down. Everyone who rides a clear round in the first round is then eligible to ride in the second round which is called the 'jump off.' The jump off is a shorter course than the first round, and the fences are raised. The round is timed and the person with the fastest clear round wins. This is a very simplified synopsis of showjumping. There are in fact many different classes run under different BSJA rules which take varying formats, but this should give you the general idea.

Top
Showjumping courses are designed to test horse and rider by varying the combinations and the striding needed.

Center
Before the competition begins, the rider will have walked the course in order to establish the striding needed for each jump.

Bottom
This jump will be raised for the 'jump off' part of a competition.

Eventing

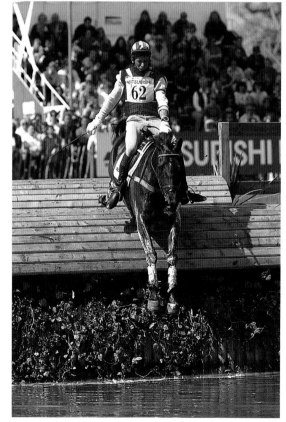

THIS IS A HIGHLY demanding competitive sport that combines three disciplines of riding, showjumping, dressage, and cross-country jumping, and demands a highly trained and responsive horse with great stamina and speed. Similar to showjumping, there is both affiliated and unaffiliated eventing; the affiliated is run by the British Horse Trials Association (BHTA).

Top

The horse has to have a variety of skills and abilities to be able to compete successfully in events.

Bottom

Eventing is more suitable for the experienced rider, although the standard of competitions can vary.

CHOOSING EVENTS

IT IS ADVISABLE to begin eventing on an unaffiliated basis until you have got to grips with the basic elements involved. There is usually quite a considerable difference in the size of the cross-country fences between the largest of the unaffiliated and the smallest of the affiliated, with the smallest affiliated courses

being larger and more solidly built.

Eventing is an excellent sport which tests the horse and rider and that requires a great deal of groundwork and training, not least in getting the horse suitably fit. Affiliated eventing, is however, an expensive sport, even at the lowest levels, which is worth remembering.

LEVELS OF COMPETITION

EVENTING IS SPLIT into different levels of competence, whether this is of the horse or the rider. The lowest level is pre-novice, then novice, open novice, intermediate, open intermediate, and advanced. Advanced eventing is not for the faint-hearted. Events may be run over one day, two days, or three days. The majority, though not all, of pre-novice, novice, and intermediate events are one day events, and consist of a dressage test, a showjumping round, and a cross-country round, in that order. All three-day events include a speed and endurance section that comprises roads and tracks, a steeplechase course, and another roads and tracks section, all to be ridden before starting the cross-country course. The dressage test is ridden on the first day; the roads and tracks, steeplechase and cross-country course on the second, the showjumping is the final test on the last day.

STAGES OF THE COMPETITION

DRESSAGE TESTS in horse trials are difficult but not as testing as the tests used in pure dressage competitions. They are designed to show that the horse which has the courage, stamina, and speed to tackle the big cross-country fences is also disciplined enough to perform calmly and obediently in the dressage arena. The showjumping phase consists of a single round that is not ridden against the clock but does have a maximum time limit. Errors in the showjumping ring are marked differently from those in pure showjumping.

In eventing, a knock-down results in five penalties, the first refusal is 10 penalties, the second is 20 penalties, and the third results in elimination. If the rider or horse falls, 30 penalties are given and the second fall results in elimination. Elimination is also given for an error on the course. The cross-country

HORSE FACT:

The first female rider to compete in the Grand National was Charlotte Brew in 1977; the first female jockey to complete the gruelling course was Geraldine Rees in the 1982 race.

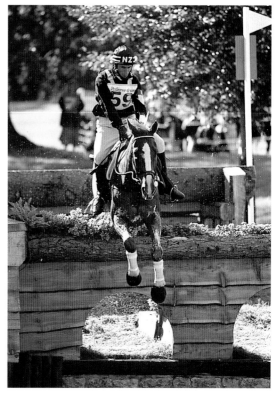

course is the most testing of the three elements. The size of the fences, the length of the course, and the speed it needs to be ridden at escalate from novice to advanced level.

THE COURSE

THE FENCES ARE all solid, immovable natural fences including logs, ditches, hedges, water, drops, steps, and combinations. The cross-country fences are carefully designed and built to be as testing as they can, and in many cases are built as 'rider frighteners.' These fences look daunting to the rider, but often will not worry the horses, who will jump them well. There are usually a number of fences with options to go a slightly easier, but longer, route. The cross-country course is not about pointing and going as fast as possible. The course should be walked several times before being ridden, and requires much

thought and planning as on how to approach and jump the different types of fences.

The course needs to be ridden at a good speed; however, there are penalties awarded if you complete it too fast (which indicates you have not ridden safely), and also penalties if you ride it too slow and exceed the maximum time allowed. On the cross-country course, the first refusal results in 20 penalties, the second in 40 penalties, and the third in elimination. A fall gets 60 penalties and the second fall results in elimination, as does error of the course.

JUDGING

THE 'FAULTS' SYSTEM is straightforward: every time a horse knocks a fence down, he is given four faults that accumulate. For the first refusal he gets three faults, for the second refusal he gets six faults, but if he refuses a third time he is eliminated. If a water jump is being used in a course, and the horse trails a foot in it, he gets four faults. If a horse or rider falls, they are eliminated. Faults or elimination are awarded for other errors, such as jumping the fences in the wrong order, starting before the bell, not crossing the finishing line, and turning in circles, among others.

The fences themselves, as already mentioned, generally fall into two groups, uprights and spreads. An upright fence is the more difficult of the two to jump, because they give the horse a difficult ground line from which to judge the take-off distance. Spread fences have a better ground line, which gives the horse an easier tool to judge take-off. One of the hardest fences is a parallel bars. This consists of two upright fences of the same height placed together, to form a spread fence, thus combining two types of fence in one. Upright fences can include gates, planks, walls, poles, etc, while a spread fence can be a triple bar, a double oxer, two upright fences with a hedge in between, or a water jump, and so on.

Top

The cross-country fences are designed to be solid and immovable.

Top Left

Eventing comprises of different competitions that the horse and rider are required to take part in; dressage is one of these.

Bottom

A horse that makes an excellent showjumper may not have the stamina for cross-country competing, but both these qualities are tested in eventing.

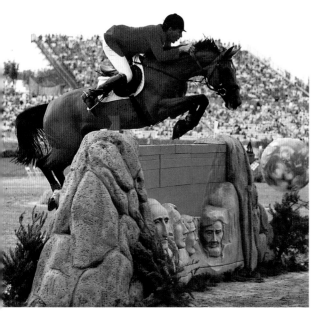

Hunter Trials and Other Events

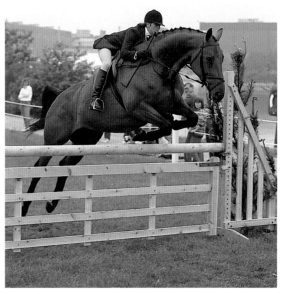

HUNTER TRIALS ARE effectively the cross-country phase of eventing. They are usually run by the Pony Club or by riding clubs, and are excellent to gain experience before tackling eventing. They are run through the autumn and winter, and consist of a course of cross-country fences usually on a scaled-down version from those found in eventing. There are different classes in hunter trials and variously sized courses from minimus, through novice, intermediate, and open, and sometimes a pairs class too.

Top
The fences in hunter trials are generally smaller than those found in eventing.

Center
Some hunter trials are judged against the clock; others on riding a clear round in the optimum time for the course.

Bottom
Two competitors take part in a team chase.

too often riders hare round these smaller courses at breakneck speeds, and then when they start to tackle bigger fences, they invariably come to grief.

Another method of judging is to have a timed gate section. The mounted competitor has to open and shut a gate, in the middle of the course, as quickly as possible. The fastest clear timed round wins.

TEAM CHASING
SIMILAR IN ESSENCE to hunter trialing, team chasing involves teams of four competitors riding round a cross-country course together. The courses can be quite large, especially the open competitions, and are mostly judged on a fastest time basis. Most courses include at least one 'dressing' fence, at which at least three of the four competitors must jump side-by-

HORSE FACT:
HRH Queen Elizabeth II was given a black mare called Burmese by the Royal Canadian Mounted Police, which was the Queen's favorite ceremonial mount through the 1970s.

HUNTER TRIALS
MOST HUNTER TRIALS judge their classes based on an optimum time. This is a set time which is worked out so that the horse and rider have to ride at a forward going, but sensible speed. The winner of the class is the competitor who rides a clear round closest to the optimum time. A few classes, normally open ones that are judged against the clock, which is not a good idea for the less experienced horse or rider. All

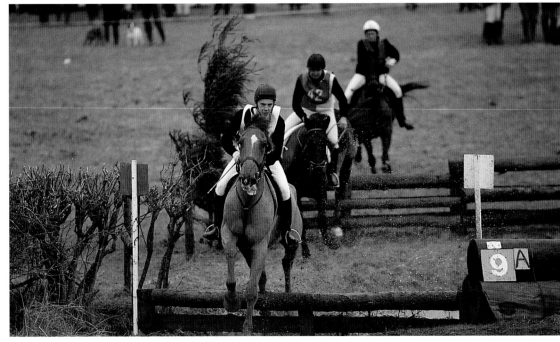

HORSE FACT:
One of General George Washington's chargers was called Nelson, and he rode him throughout the American Revolution. When Washington retired to Mount Vernon, he retired Nelson there too.

side. The courses are often between 2 and 3 miles (3.2 and 4.8 km) long and are usually run by individual hunt clubs, under their own rules. Open team chases are invariably fast and furious affairs that are great fun, but only for the brave and bold.

SHOWING

HORSE SHOWS have numerous different classes and, like all competitions, differ in the standards set from your average riding club show to the prestigious Horse of the Year Show. Many shows hold a large number of classes for children, some of which are leading rein classes, first pony off the leading rein, family pony, working hunter pony, handy pony, Pony Club pony, and riding pony.

Working hunter pony is a very good class to demonstrate the all-round pony. The classes are split by the height of the pony and each class has to jump a round of natural fences, which usually includes a rustic gate, a stile, a brush fence, and various pole fences. The ponies are judged on the way they jump, and then once all competitors have jumped their round, they come back into the ring and show walk, trot, and canter all together. They are then lined up, and each child rides a small 'show' to demonstrate the pony's way of going. They may also be required to remove the saddle and trot the pony up and down for the judge.

The exact format of the class varies from show to show. Pony Club pony is another all-round class, where the ponies are required to jump and do a small

show, handy pony classes invariably make excellent and amusing ringside watching. Someone inventive creates a course of hazards, such as washing lines with washing attached, umbrellas, road cones, etc., and the hapless pony is required to negotiate these obstacles, usually in the fastest time possible. Riding pony and show pony classes are basically pony versions of the riding horse class. The ponies should be exquisite to look at, go like a dream, and have perfect manners.

Left
Point-to-points races are run over a course with low brush or wooden fences,.

Bottom
Junior shows are an excellent way of introducing children to competitions; this young rider trots her pony for the judges.

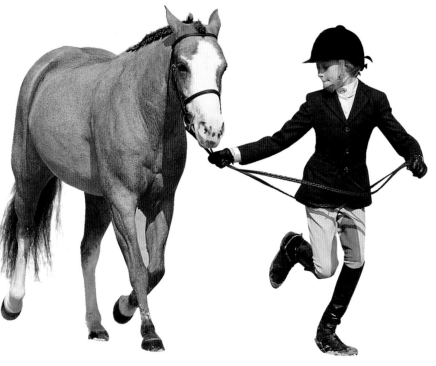

Dressage

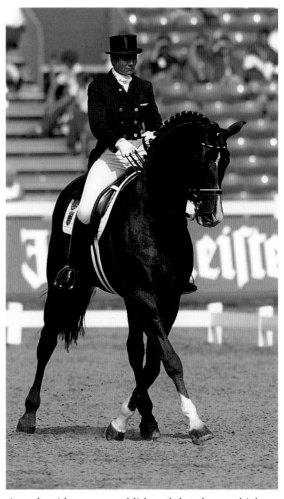

THE WORD DRESSAGE comes from the French verb dresser meaning 'to train' which is basically what dressage is. It is the training of the horse to an exceptionally high level, and includes the art of classical riding, and airs above the ground demonstrated so well by the Spanish Riding School. For our purposes here however, we shall consider the modern competitive school of dressage.

Top and Bottom
Dressage competitions test the schooling of the horse and whether animal and rider can execute steps with precision.

RIDING STANDARDS

DRESSAGE COVERS ALL standards of riding from the most simple tests to the most demanding. The structure of the dressage world is rather complex, but in simple terms, a dressage competition involves riding a set series of movements, although in a free-style competition, the rider is required to devise his or her own pattern which must include a certain number of required movements. Before entering a competition, the rider must establish and then learn which particular set test is being used. Sometimes a caller is allowed to call the test out for you, but this can be distracting.

THE COMPETITION

ONCE THE TEST is learnt, and you enter the competition, you will work your horse around the outside of the arena before commencing your test. The judge, sitting at the C end of the arena, indicates when you may start to ride your test by ringing a bell. You enter the arena at A, and proceed to ride the test. The judge awards you marks for each movement you execute, and will also judge you on overall style, technique, position, the freedom and suppleness of the horse, and so on. In more advanced dressage tests, there is more than one judge to ensure a fair score. One of the most important things to demonstrate is accuracy and obedience.

JUDGING

THE DRESSAGE ARENA is marked with letters around it and the movements you are required to do are related to the letters. Therefore, if you are expected to go forward into trot at A, by trotting accurately at A, you can gain yourself a few extra points. Each movement is marked from zero to ten with zero being on the low end. It is very rare for a ten to be awarded. Your horse needs to be totally obedient and responsive, as well as moving forward in a good outline, having the quarters underneath it, and moving with freedom, impulsion, and suppleness. Dressage should be the building block for jumping, because, until you have achieved the correct way of going on the flat, and the required obedience and attentiveness, you should not be tackling jumps.

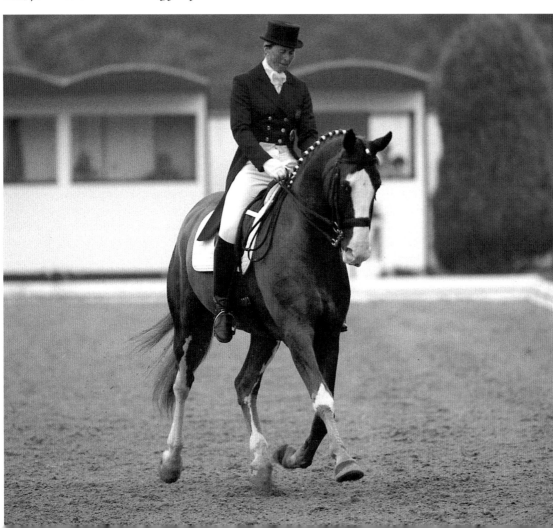

HORSE FACT:
Genghis Khan, 1162–1227, was one of the most powerful nomadic warriors of all time and was also an accomplished horseman, fighting all his battles on horseback,, and having a highly trained army.

Top
The judge not only awards points on each movement but also on the general appearance of the horse and rider.

Bottom
Discipline is important if the horse is to execute the positions with accuracy.

HORSE FACT:
Hemlock, deadly nightshade, ragwort and yew, are just a few of the many extremely poisonous plants that should never be seen in any pasture in which horses are grazing.

Different Horses, Different Classes

THERE ARE NUMEROUS horse classes that are similar to the pony classes, such as working hunter, show hunter, riding horse, riding club horse, and various in-hand classes for mares and foals and young stock. The working hunter class follows similar lines to the pony classes, except the fences are much bigger and the judge rides each horse. The rider also gives a small show and trots the horse up in-hand. These are fun classes to compete in, but they often take a very long time. Riding club horse is designed for horses that are all-round types and capable of all riding club activities. The riding horse is a finer show horse of greater quality.

Center Right
A proud youngster wins a class with her smartly turned-out pony.

Top and Right
Mounted games are part of children's gymkhanas, they involve team work and a lot of athleticism.

Center Far Right
The sport of kings', polo remains a sport of the rich as riders need several highly trained horses.

Bottom
Polo originated in Persia but is now played in Britain, the United States, and Argentina.

GYMKHANAS

SOME HORSE SHOWS also run gymkhanas and if you are planning to take an excitable horse to a show it is worth finding out if there is also a gymkhana taking place. Gymkhanas are synonymous with lots of children having fun, but they are not such fun if you are an adult on young horse. Gymkhana games require a great deal of skill from children, resulting in the Pony Club's mounted games competition. A combination of skill, speed, athleticism, and teamwork is needed in events including bending races, moving objects such as flags from one site to another, sack races, egg and spoon and numerous others. The ponies need a lot of training to respond quickly and

neatly. The Pony Club's mounted games competition is a fiercely contested team event that culminates in an annual final held at the Horse of the Year Show.

POLO

POLO IS AN ANCIENT team game that is believed to have been played in Persia 2500 years ago. It is an enormously popular and expensive game that is played in various forms and has either three or four members to a team, depending whether it is arena polo or standard polo. The game is played using mallets to hit a small ball, and the object is for each team to try to score as many goals against the opposite team as possible.

The game is divided into a series of periods of play, called 'chukkas.' The majority of games have six chukkas that usually last for seven and a half minutes each, although they can be up to ten minutes each. There is a rest between chukkas which usually lasts about three to five minutes. The players have specific roles: Numbers One and Two are forwards, or attacking players; Number Three has an attacking and defensive role and hence is a half-back; and Number Four is the main defence and backs up Number Three. The goal posts are at either end of the field, and after a goal is scored the teams change ends. Polo is a fast and furious game which requires highly trained and skilled ponies.

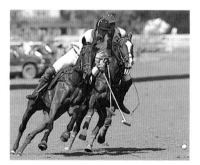

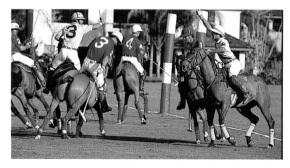

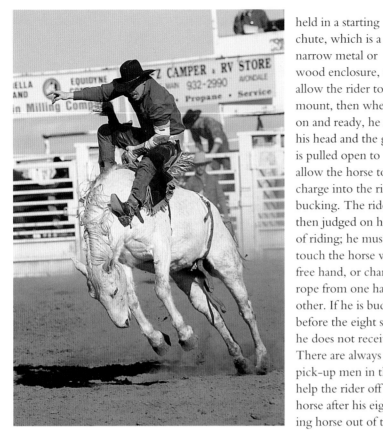

held in a starting chute, which is a narrow metal or wood enclosure, to allow the rider to mount, then when he is on and ready, he nods his head and the gate is pulled open to allow the horse to charge into the ring bucking. The rider is then judged on his style of riding; he must not touch the horse with his free hand, or change the rope from one hand to the other. If he is bucked off before the eight seconds is up, he does not receive a score. There are always two mounted pick-up men in the arena to help the rider off the bucking horse after his eight seconds, and to guide the bucking horse out of the arena.

Top and Top Left
Rodeo competitions have developed from the cattle ranches in the western United States.

Bottom
Saddle bronc-riding has become the archetypal sport of the western cowboy.

RODEO

RODEO RIDING IS FOUND mainly in the western states of America where it has a huge following. There are several main events in a rodeo: saddle bronc-riding; steer-wrestling; team-roping; calf-roping; bareback bronc-riding; bull-riding; and barrel-racing. All aspects of the rodeo have arisen as a natural extension of ranch work, and the horses that compete in rodeos are highly trained and skilled athletes, and can sometimes be worth huge amounts of money.

SADDLE BRONC-RIDING

SADDLE BRONC-RIDING IS where the competitor has to ride a bucking horse for a period of eight seconds without being bucked. The horses wear a special saddle, which consists of a modified stock saddle, minus the horn, and a halter that has a single length of rope onto which the competitor can hold with one hand. The horse is

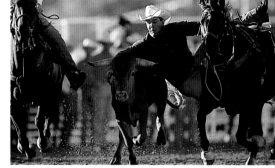

This Page
The rodeo is also comprised of other competitions, including steer-wrestling, a sport for which strength and quick thinking are essential.

BAREBACK BRONC-RIDING

BAREBACK BRONC-RIDING is similar to the saddle bronc event, but the rider does not have a saddle. He has a rigging, which is rather like a roller with a suitcase-like handle attached to it made from leather and rawhide, and he secures one hand under this. When he is ready, the horse is released from the pen and the rider is judged on the style of his riding. He must stay on the bucking horse for eight seconds to get a score, and there are two pick-up men in the arena with him.

STEER-WRESTLING

STEER-WRESTLING INVOLVES a steer being released from a chute and the competitor on his horse catching it up; he then lowers himself from the horse, which is galloping, on to the ground to catch the steer. A second person on horseback called a hazer gallops on the other side of the steer to keep it running in a straight line. Once the competitor has caught the steer, he must pull it to the ground so that all four feet are in the air for a split second. This is a timed event, and the time is taken from when the steer leaves the pen until it has all four feet in the air.

TEAM-ROPING

TEAM-ROPING FOR TWO competitors is a timed event. A steer is released from a pen and the first competitor, called the header, must lasso the animal around the horns; once he has done this, the heeler then must lasso the animal around the two back legs. If only one back leg is caught, then the competitors receive a five-second penalty. Roping horses have to be carefully trained to become accustomed to having a rope whirled around them while the rider tries to lasso the animal.

BULL-RIDING

BULL-RIDING IS A VERY dangerous competition in which the competitor has to ride a bull for a period of eight seconds, and is judged on the style of his ride. The bulls have a rope similar to that used on the bareback horses, and the rider secures his hand under this. Usually if a bull bucks the rider off, it will turn and attack, and for this reason there are always either one or two 'clowns' in the arena with the competitor. The clowns are on foot but are extremely athletic and divert the bull's attention away from the fallen rider.

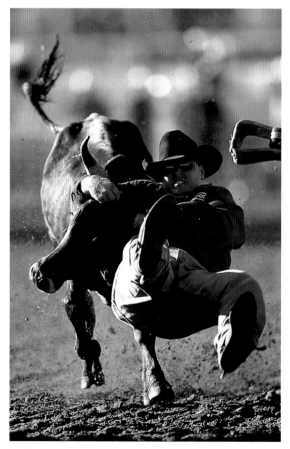

CALF-ROPING

CALF-ROPING CALLS FOR one competitor to rope a calf from his horse. Once the calf is caught the horse stops dead. The competitor then jumps off his horse, runs to the calf, lays it on its back, and ties three of the legs together. During this, the horse has been keeping the rope pulled tight, once the calf is tied, the competitor re-mounts his horse and allows the rope to slacken. After the competitor is back on his horse, the calf must remain tied for six seconds. The competitor is timed at how quickly he ropes and ties the calf, but if it unties itself during the six seconds he does not get a score.

BARREL-RACING

BARREL-RACING IS A TIMED event. Three barrels are arranged in a triangular formation and the competitor has to race around them in a clover-leaf formation without knocking any of them over. The horses that compete are extremely fast and athletic.

CUTTING COMPETITIONS

THIS IS ANOTHER mostly western sport, which requires extremely well-trained horses. Quarter Horses were originally used exclusively for this event and they appear to have a natural affiliation for it. The event requires them to cut a steer out from a herd, and then keep it away from the rest of the herd. To do this the horse basically has a to twist and turn, anticipating the steer's every move. The powerful hindquarters of the Quarter Horse and its tremendous turn of speed make it eminently suitable for all cow work.

ENDURANCE RIDING

THIS IS A TOUGH SPORT that requires great stamina, both from the horse and from the rider. Endurance riding has a huge following in America, and is becoming increasingly more popular in England. There are two separate authorities in England: the British Endurance Riding Association and the Endurance Horse and Pony Society. Both these bodies run competitive rides, using slightly different rules. Like all competitions, there are different levels of events run, from relatively short distances to the 100 mile (160.9 km) tests.

The horse and rider has to complete the course within a minimum speed, and in the Bronze series or Novice classes, within a maximum speed. The horses are regularly vetted and have to pass sound, and with a pulse of 64 beats a minute or less. If the horse fails the vetting it is eliminated at the end of the ride. The horses also have their shoes checked by a farrier before starting the course and have to undergo a tack inspection. There are rules for endurance riding covering qualifying for different classes.

One of the easier classes is the Bronze Buckle Qualifier, which is set over a 20 mile (32.2 km) course, and should be ridden at a speed of between 6 ½–8 mph (10.5 km/h and 12.8 km/h). For anyone wishing to compete in classes above this level, they need to have a log book for the horse. The log book catalogues a complete record of the horse's competitive endurance riding career, and must be presented at the time of the competition. Horses and ponies must be five years old and over to compete, and must be seven years old or older to compete in the Gold series rides or Endurance rides, which are the toughest. Horses need to qualify to compete in the next level up and all the competitions are rigorously monitored by veterinary inspections.

One of the most well known endurance competitions is the Golden Horseshoe event in Exmoor, which is extremely tough, covering a distance of 100 miles (160.9 km) to be ridden in two days.

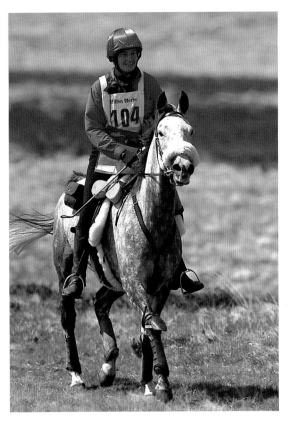

Top Left
Another western traditional sport is barrel racing, in which women compete on athletic horses.

Top and Bottom
Endurance riding is judged on speed, and the physical state of the horses is regularly checked.

Horses in the Human World

THE HISTORY OF the horse as an instrument of work and leisure goes back to the very beginnings of man's relationship with the animal, and continues, indeed florishes, to this day.

WAR

THE WARHORSE was of great importance to early warriors; one shining example was Alexander the Great's charger, Bucephalus. When Bucephalus died in 326 BC, Alexander the Great buried him and named the city near his grave, Bucephala. The earliest battles were probably carried out from horsedrawn chariots, and then, from approximately 500 BC, the warring Greeks employed the services of mounted archers. At this time there were no saddles with stirrups, which must have made mounted warfare something of a feat. It is likely that during the Roman Empire horses were used to transport soldiers to and from the scenes of battle, but that once there, the fighting took place largely on foot.

Until the 15th century, horses in Britain were small by today's standards, being more pony, than horse, size. Henry VIII made a conscious effort to increase the height of the British horse by decreeing that stallions kept on common land had to be over 15 hh, and also that landowners had to own at least two mares that were over 13 hh. Horses on the continent were larger, and

Britain started to import these to increase the size and stockiness of the British horse. It was an obvious advantage to have a larger horse for use in warfare.

ALL SIZES, ALL USES

DURING THE MIDDLE AGES, the light draft horse was the favored mount of the knights. One knight's armour could weigh up to 420 lb, so horses needed to be large and strong enough. They were, however, still considerably smaller than the draft horse of today. In 1651, Oliver Cromwell began to disperse the heavier horse from the cavalry and to import Arabians to produce a lighter, faster, more agile warhorse. However, the victory of the British against Napoleon in the Battle of Waterloo in 1815 was in part due to the superior, and heavier, British horses,

Above
Bucephalus was Alexander the Great's favorite horse; he even named a city after him.

Top Right
A re-enactment of the knights of the Middle Ages, whose horses partook in jousts and battles.

Bottom Right
These Norman knights went into battle on horseback, giving them an advantage over their contemporaries.

compared with the lightweight French ones. The early years of the First World War were the last time that horses played a major role in British warfare. There were approximately one million horses and mules employed by the British army, but from then on they started to be replaced by mechanization. Today in Britain the Household Cavalry, which consists of the Blues and Royals and the Life Guards, can be seen on guard duty outside Buckingham Palace, and the King's Troop of the Royal Horse Artillery frequently puts on impressive displays at shows.

TRANSPORTATION

THE HORSE as a means of transport has been invaluable since the it was first domesticated. There is great debate as to when exactly man began to first ride and use the horse in harness. Evidence of wear on the teeth caused by a bit can be dated to approximately 2000-1900 BC from remains at Malyan in Iran, and from the remains at Dereivka in Ukraine to approximately 4200-3750 BC. Although horses were controlled from an early time using bridles and bits, the development of the saddle and stirrups did not appear until much later.

It is probable that oxen and asses were widely used as draft animals before horses were used in harnesses. Very early vehicles were made entirely from wood, including the wheels, and would had a central pole to which two animals were harnessed, one on either side. Early roads were rather different from ours today and pulling vehicles would have been heavy and strenuous work. The earliest types of harness were in the form of a yoke, which was attached to an ox's horns or withers. This method of harnessing was very effective with oxen, but when a yoke such as this was placed over the horse's withers, it would have a constricting effect on the throat; and the 'modern' horse collar was invented during early medieval times.

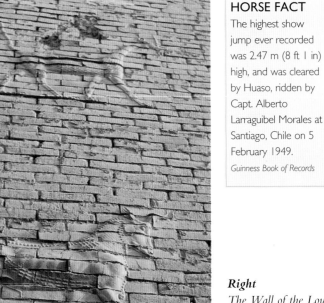

Right

The Wall of the Lower Ishtar in Babylon features the relief of a horse.

Bottom

This bronze model of a chariot was found near Ziteli Zkaro, Georgia and dates back to circa eighth century BC.

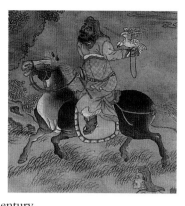

TRAVEL BY COACH

THE EARLY 'people-carrying' coaches would have been big heavy vehicles which often did not have any form of suspension or springs. These vehicles required large strong draft horses to pull them over the uneven roads, often through deep mud. The first British public transport coach was the stagecoach, which was developed in the 16th century. They were usually pulled by four horses and were meant to run along set routes to a timetable. As the standard of the roads improved, so did the coaches, and they could be drawn by a lighter, faster breed of horse. Holland was one of the first countries to show noticeable improvements in the quality of the roads, many of which were built alongside the canals. Springs were introduced to vehicles making them more comfortable, and the wealthy started to buy their own private carriages for jaunts to the countryside.

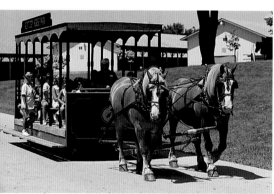

By the end of the 19th century, horsedrawn trams had been developed as an efficient means of public transport, as had the horsedrawn omnibus. Trams were usually drawn by from one to four horses and could travel at speeds averaging seven miles per hour (10 kmh).

On the continent, the most popular carriage horses were the Oldenburgh, Hanoverian, and Holstein, while in England, the Cleveland Bay and the Thoroughbred were in great demand. It is interesting to note how many of the breeds that were once sought after as carriage horses are now successful as ridden competition horses.

INDUSTRY AND COMMERCE

THE HORSE HAS PLAYED a powerful part in industry over the years, and the development of the horse as a draft animal must have contributed greatly to early trading. For the first time, people were able to travel and carry their wares with them in order to trade with neighbouring communities. The Great Khan, grandson of Ghengis Khan, had the foresight to establish a messenger service all over his empire, which relied on delivering messages on horseback. This was in a way a prelude to the modern postal service. Horsedrawn mail coaches were developed as the roads improved through the 19th century.

They kept to a strict timetable and maintained a hard and fast pace that took quite a toll on the horses involved – most mail horses did not last for more than four years on the job. Deliveries of all kind were made by horsedrawn vehicles, and it is still possible to see brewery drays delivering beer in some towns today. Horses were still employed by the railroad companies, long after the advent of the railroad, for use in the freight yards and for moving rolling stock.

It was also a common sight to see horses pulling barges up the canals, being able to move loads of 60 or 70 tons at a time in this way. Mining has had a long relationship with the horse, with thousands of 'pit ponies' used in the mines, many of whom spent their whole lives underground. Miners also used horses to turn the windlass of the hoist at the pitheads and to pull the coal wagons. These are just a few of the many examples of the importance the horse has played in industry over the centuries.

PACKHORSES

PACK ANIMALS are animals that are used to carry and transport goods on their backs, usually in special 'pack' saddles, or pannier baskets, one on either side of the back. Pack-

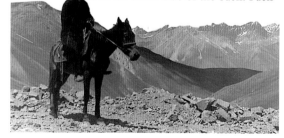

Top Left
These two Belgian horses pull a coach of tourists at Kentucky Horse Park.

Center
Horses were used to deliver beer around towns in Britain; these two gray Shire horses are continuing the custom.

Bottom
Hoses were traditionally used as pack animals in areas of rugged and inaccessible terrain.

ponies or horses are useful for transporting goods in areas where it is not possible to take a vehicle. In many mountainous countries, like Tibet and Mongolia, the pony is still used primarily as a means of transporting goods in steep and rocky areas. They are still used on hunting expeditions, especially in America. Once the hunter has stalked and claimed his deer, the animal is cut up and carried out of the inaccessible area by pack horses.

Packponies were commonly used in Britain until relatively recently; they were used to transport lead from the mines in the Pennine hills to the east coast, and Shetland ponies transported peat in panniers on their backs in the Shetland Isles. It is not uncommon to see pack ponies in many under-privileged countries, where the people cannot afford any other means of transportation.

AGRICULTURE

ALTHOUGH HORSES have been used in agriculture for thousands of years, their role was really developed during the 18th and 19th centuries as they were used to replace the slower oxen. Different breeds were developed, depending on the type of land and country. While it is often the Shire, Clydesdale, and Percheron that are associated with agricultural work, in hilly areas such as the highlands of Scotland, the native ponies were more suitable to cultivating the land. The horse continues to be used widely in parts of North America, South America,

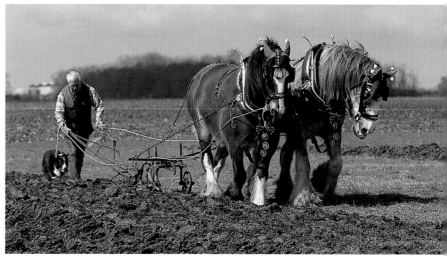

and Australia to herd cattle and sheep, and some farmers still keep a team of horses that can work in areas where a tractor would become stuck.

No matter how far technology advances, there will always be areas of work in which the horse or pony is able to perform better than their metal, motorized counterparts.

POLICE

THE FIRST mounted police division was the London Bow Street Horse Patrol which was formed in 1758, and horses continue to be used to great effect by mounted police for crowd-control purposes as well as for patrolling streets and parks. The horses have to go through intense training to prepare them for the frightening noise and atmosphere of crowd work, as well as having to learn to cope with the heavy traffic of innercity life. In countries such as India, which employs a huge number of mounted police, the police horse is frequently used for patrolling rural and inaccessible areas of the countryside.

Top Left
Shetland ponies worked as a pack animal transporting peat on the Scottish islands.

Top Right
Horses have been used by farmers for centuries to plow fields.

Bottom
In Britain horses are still employed by the police force and are especially effective on the streets of London and at football matches, where they are used for crowd control.

> **HORSE FACT**
> The Egyptians often depicted vast, stylized horses on the outside of their tombs.

Racing and Showjumping

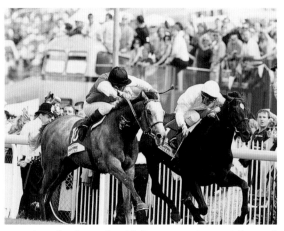

HORSE RACING has spawned a huge industry in Britain; flat races take place in the summer and steeplechases in the winter. In addition, show jumping is a popular spectator sport.

FLAT RACING

THE EARLIEST ACCOUNT of horse racing in Britain was by William Fitzstephen, who wrote about horse races taking place at Smithfield, London in 1074. The earliest racetrack was in Yorkshire and was commissioned between 208 and 211 AD by Roman Emperor Lucius Septimius Serverus.

Until the 16th century, racing was the 'sport of kings' and other wealthy nobility. Britain has a long tradition of the reigning monarch taking an active interest in racing and the English Thoroughbred. During the reign of James I, (1603–25), official race meetings were established near Richmond in Yorkshire, Croydon, and Enfield Chase. He built a hunting lodge in Newmarket, Suffolk, which became the seat of international horse racing. King Charles I (1625–49) financed the first Gold Cup race at Newmarket in 1634, and from 1667, annual races have been held there.

RACING IS AS A SPORT

OLIVER CROMWELL BANNED racing in 1654 and 1655, and it was the efforts of King Charles II, (1660–85), that re-established the sport. He increased the prize money and the number of races at Newmarket, and

introduced rules and guidelines covering weights and distances. The racecourse at Epsom opened during his reign, which is home to the famous Epsom Derby.

Queen Anne, (1702–14), and her consort, Prince George of Denmark, were highly influential in the formation of the modern Thoroughbred racehorse. They were enthusiastic racegoers, and improved the racehorse stock by importing Arabians, including the famous Darley Arabian, one of the forefathers of the modern Thoroughbred. During her reign, racecourses were opened in 1711 at Ascot, home to the prestigious Royal Ascot meeting, at Doncaster, and at York.

THE JOCKEY CLUB

THE JOCKEY CLUB is the governing body of British racing, and was established in the 1750s. Originally covering racing at Newmarket, it quickly extended to cover all racing in Britain. It still lays down the rules of racing, regulating courses, races, breeding, and licensing. In 1773, James Weatherby was appointed Keeper to the Match Book to the Jockey Club, responsible for all course records, and in 1813, Weatherby's issued the first General Stud Book, back to which all Thoroughbreds can be traced.

Top

Willie Tyan wins the 1997 Epsom Derby, it was under King Charles II that this racecourse was first opened.

Center

The first account of a racecourse in Britain dates back to the third century.

Bottom

One of the most fashionable and prestigious British racecourses is Ascot, which hosts the prestigious three-day Royal Ascot meeting every year.

Richard Tattersall formed Tattersall's in 1766 as a centre for betting and horse sales at Hyde Park Corner, where it remained until 1865; today Tattersall's is still synonymous with racing.

Until 1744, most horses running in races were over five years old, but the age has gradually decreased. One race was set up for four-year-olds in 1744, followed by two races in 1756 for three-year-olds, and in 1786 a race was established at Newmarket for two-year-olds.

One of the most famous British group of races are the British Classics, for three-year-olds which are highly prestigious. Five races make up this group: the St. Leger, run at Doncaster during September; the 2,000 Guineas, and the 1,000 Guineas, both run at Newmarket during April; and the Derby and the Oaks, both run at Epsom during June. The ultimate aim is to win the Triple Crown – winning the 2,000 Guineas, the Derby, and the St Leger.

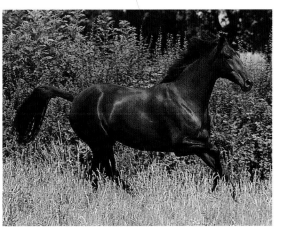

Left
This black Thoroughbred horse could have been racing since it was a two-year old, racing such young horses has become a controversial issue.

Center
These horses are racing at Cheltenham racecourse.

STEEPLECHASING AND POINT-TO-POINTING

STEEPLECHASING is not a sport for the faint-hearted. It is associated with England and Ireland, although some races do take place in other countries. These races were originally run between one church steeple and the next, jumping any obstacles in the way. Steeplechasing developed as an extension from early foxhunting, and a competitive edge developed as natural obstacles and fences were jumped.

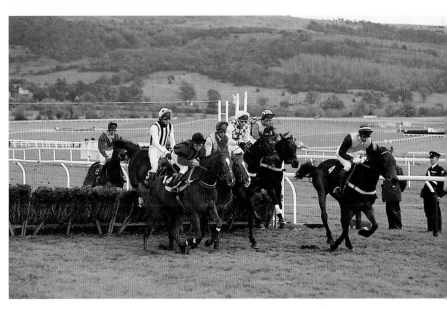

EARLY STEEPLECHASING

ONE OF THE EARLIEST recorded steeplechases took place in 1752 in County Cork, Ireland. There were only two competitors, Cornelius O'Callaghan and Edmund Blake, and the race was run along a four-mile stretch between Buttevant Church and the St. Ledger steeple. Blake won and was awarded large quantities of Jamaican rum, port, and claret for his efforts.

The first official steeplechase in England was held in 1830 at St Albans, and was run for a sweepstake of twenty-five sovereigns.

Bottom
Jockey Darryl Holland pulls away from the group (see far left) to win at the 1994 Lincoln Handicap at Doncaster.

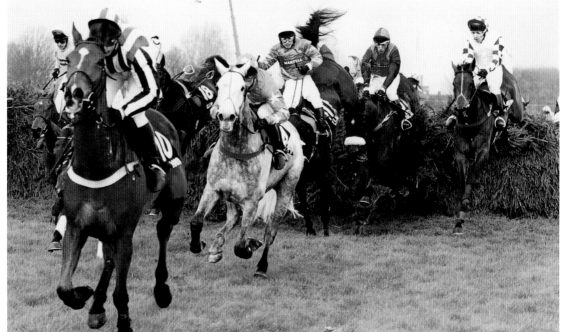

Top
The most famous British steeplechase is called the Grand National.

Below
Red Rum competed in the Grand National a record five times during the 1970s, winning three of the races.

THE GRAND NATIONAL

AROUND 1850, steeplechasing split into two types; National Hunt racing for professional jockeys, and races for amateurs called point-to-points. One of the most famous steeplechases is the Grand National at Aintree, Liverpool, England. The first one was held in 1839 over a four-mile course with 29 fences. Captain Becher, riding a horse called Conrad, came to grief at a large jump with a ditch, and since then the infamous fence has been known as Becher's Brook. The race was won by a horse called Lottery in a time of 14 minutes and 53 seconds. Today, the Grand National course is four-and-a-half miles long, comprising 30 fences, and on average is run five minutes faster than Lottery did.

One of the bestknown steeplechasers of all time was Red Rum. He ran in the Grand National five years in a row between 1973 and 1977, with the

Right
Flat racing makes millions of pounds in revenue for Britain each year,

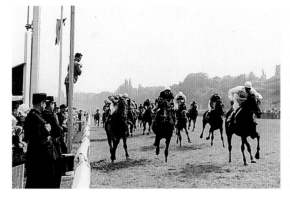

incredible record of three wins and two seconds. Two other great steeplechasing horses were Golden Miller, who won the Cheltenham Gold Cup five years in a row, and the Grand National in 1934, and Arkle, who won 27, including three Cheltenham Gold Cups.

FAMOUS RACES

THE MOST NOTABLE steeplechases run abroad are probably the French Grand Steeplechase de Paris, and the hair-raising Czechoslovakian Grand Pardubice. Fred Winter proved what a truly great horseman he was in 1962 when his bridle broke before the fourth fence in the French Grand Steeplechase de Paris. He carried on with the race, and won on a horse called Mandarin. The Grand Pardubice is a notoriously dangerous race where many riders fall off, some remounting and proceeding.

POINT-TO-POINTS

POINT-TO-POINTS are only open to amateur riders, and are run by individual hunts, under Jockey Club regulations. Courses are set across fields incorporating natural fences and hedges as well as specially built obstacles. Horses that compete in point-to-points must have a certificate from a master of foxhounds stating that they have been hunting a minimum of seven times during the season. Most meetings have five or six races, and of these there is usually a race for ladies only. The quality and standard of point-to-point horses is mostly high, and

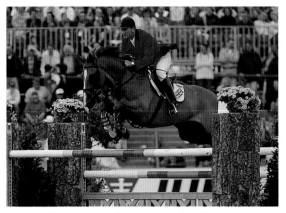

many either go on to become National Hunt steeplechasers or are older horses that have been National Hunt horses and have downgraded.

SHOWJUMPING

ONE OF THE earliest recorded show jumping competitions was held at the Royal Dublin Horse Show in 1865. The competition was based on a 'high and wide' leap and is believed to have been mainly to test the ability of potential hunters. In its beginnings, show jumping was basically practised only by the military, who adopted the traditional hunting style of jumping – leaning forward over the fence and back on landing. Frederico Caprilli, an Italian cavalry officer, was largely responsible for our modern style of jumping. At the turn of the 20th century, he introduced the forward-balanced seat, and his principles on riding and jumping are still practiced today.

DEVELOPMENT OF SHOWJUMPING

ANOTHER HIGHLY influential figure in the development of showjumping was Colonel Paul Rodzianko, an officer in the Russian Imperial Guard. He studied classical equitation in Russia with James Fillis, and then worked with Caprilli at the Italian Cavalry School in the early 1900s. In 1929, he was asked to train the Irish Army's show-jumping team, which blossomed under his tuition and became one of the leading teams in Europe. One of his

pupils in England was Mike Ansell, who went on to become Chairman of the British Show Jumping Association in 1944.

The first international horse show held in Britain was in 1907, at Olympia, and in 1912, equestrian events were included for the first time at the Stockholm Olympics. After the First World War, an effort was made to regulate and organize showjumping on a more universal scale, and in 1921 the Fédération Equestre Internationale (FEI) was formed. The FEI was established as the governing body for all types of equestrian sport, laying down rules for international level competitions. Individual countries formed their own governing bodies affiliated to the FEI.

BRITISH SHOWJUMPING ASSOCIATION

IN ENGLAND, the British Show Jumping Association (BSJA) was formed, and set its own rules for showjumping competitions based largely on those of the FEI. Soon after this, two important events occurred within show jumping. First, it ceased to be a military preserve, and second, for the first time, women were allowed to compete in the sport. Two of the great early women competitors were Lady Wright, who was the first woman to jump a clear round at Olympia, and who went on to win the *Puissance* (high jump) competition at Olympia, the Daily Mail Cup at Olympia, and the championship at the Bath and West Show. The second great lady of showjumping was Pat Symthe, the first woman to be in the British Olympic team, in 1956 in Stockholm, and who remained one of the top riders throughout her career.

SHOWJUMPING TODAY

TODAY, SHOWJUMPING competitions are ever more challenging, with fences getting bigger and courses trickier. Prize money at the top competitions is large, but the cost of getting to the top is huge. Most riders have sponsorship of some kind from companies, and without this, it is virtually impossible to compete at the top. There are many smaller competitions run by the BSJA and these are excellent experience for those starting out in the world of showjumping. All shows run by the BSJA are 'affiliated' and run under their rules; to compete in them it is necessary to be a member of the BSJA.

There are also numerous other showjumping competitions classed as 'unaffiliated,' are open to anyone meeting the requirements of the class. It is not necessary to be a member of the BSJA for these.

Top and Bottom
Historically showjumping was the preserve of the military, however, now most showjumpers are professional and civilian.

Center
Britain's Pat Smythe and her horse Flanagan competing in the 1956 Equestrian Olympics.

Bottom Right
Over the years the fences have increased in height so that now both jockey and horse have to be fearless competitors.

The Leisure Horse

Top
The rugged countryside of an Arizona dude ranch are ideal for trekking Western-style.

THE VAST MAJORITY of the horse population today is kept on a leisure basis. There are endless opportunities for both horse owners, and nonowners to take part in a variety of 'horsey' pursuits. There are riding holidays organised in areas of outstanding natural beauty, often using ponies native to the surroundings. Scotland is a classic pony-trekking area, where tough native ponies will carry both beginners and accomplished riders alike safely across the hilly terrain.

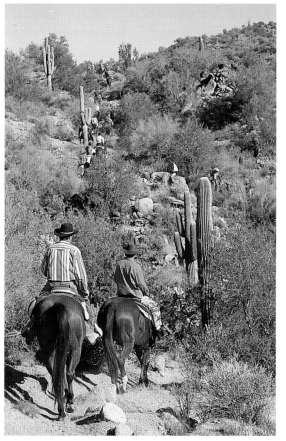

HORSE HOLIDAYS

AN INTERESTING type of 'horse holiday,' and one that appeals to those who do not ride, is the horse caravan holiday. Traditional gypsy-type caravans can be hired, complete with traffic-safe horse. Riding holidays are offered virtually world-wide, with, to name a few, trekking in Iceland, Austria, Spain, horseback safaris in Africa, and the increasingly popular chance to stay at 'dude' ranches and become a cowboy for a week in America.

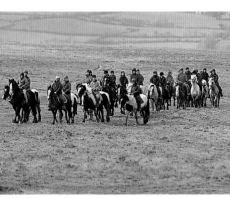

Center
Trekking is a popular way for tourists to see the countryside, these riders explore the haunting beauty of Dartmoor.

Bottom
An alternative holiday to trekking is hiring a gypsy-style caravan and pony.

For those who have their own horse, and wish to take him on holiday too, in England there are now various hotels and bed and breakfast venues which will cater to your equine's every need and offer mapped-out rides to follow.

Hunting holidays are also very popular, especially in Ireland, where it is possible to hire horses which are, on the whole, excellent mannered hunters. Hunting still has a following as a recreational sport in England, although in recent years it has received a bad press. Contrary to popular belief, there are different types of hunting, not all of which involve killing. There are of course the traditional fox- and staghunting, but also draghunting, which is where the hounds follow an artificial trail, often aniseed. There is also bloodhunting, and in this case the hounds follow the scent of a human runner who runs the trail prior to the hounds setting off. All of these provide an excellent, fun, and exhilarating day out.

RIDING SCHOOLS

THERE ARE innumerable riding schools, where one can go for riding instruction either with, or without, owning a horse. Some of these establishments offer residential courses over several days for all levels of riding competence. It is important to check that the riding school has been approved for safety

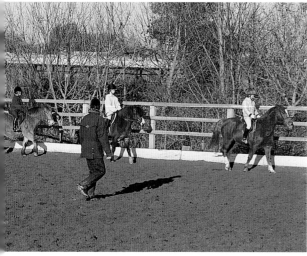

and racing. All of these competitions can be as much fun for the spectator as for the competitor, and it is not necessary to have your own horse to derive enjoyment from watching these events.

The big three-day events have become a real crowd puller. Spectators are required to pay an entrance fee and can then watch the competition unfold, as well as walking the cross-country course. These events have more and more stands selling anything from country-type clothing to home-made foods, as well as every possible equestrian accessory. There may also be other equestrian activities going on, such as Western riding, trick riding, or dressage demonstrations, which occur throughout the day.

Top
Enthusiastic riders can take advantage of intensive weekend courses.

and competence by the Association of British Riding Schools (ABRS) or the British Horse Society (BHS) before booking a course.

As well as live-in courses, there are hundreds of riding schools across the country where one can take lessons. Again it is important to always check that the riding school has been approved by the ABRS or the BHS. For the more ambitious rider, there are numerous 'clinics' on offer. These are usually held over one or two days and are run by some of the leading dressage, event, and showjumping riders. Clinics such as these are an excellent opportunity to get top-level tuition from world-class professionals. Generally they are for the horse owner and tend not to provide horses. One of the best places to find out information about such clinics is in the leading horse magazines.

OTHER HORSE EVENTS

IN ADDITION to horse holidays and lessons, there are hundreds of competitions, aimed at all levels of riders, which take place very often. There are local shows and gymkhanas, all levels of show jumping, eventing, hunter trials, endurance riding, driving, polo, Western riding, showing, team chasing, point-to-pointing,

RIDING CLUBS

ENGLAND HAS a very good network of riding clubs, as well as the famous Pony Club. It is not necessary to have your own horse to join either, although it can be an advantage. The Pony Club is a great way for children to learn about horses and have fun at the same time, while riding clubs offer all sorts of instruction and competitions. There are riding clubs and the Pony Club in other countries and it is worth finding out about these if you intend to move or travel abroad.

Center
Badminton is one of the main three-day events in Britain; the crowd can walk the course and buy equine equipment from hundreds of stalls.

Bottom
Polo is a sport often played by the rich, but everybody can go and watch the competitions.

The Relationship with Man

AROUND 12,000 YEARS AGO, the human population of Western Europe was steadily growing, and wild horses would have provided a good source of food and hides. There is great debate about the actual beginnings of man's relationship with the horse in a domesticated situation. Some of the best and earliest archeological findings which indicate an answer to this were excavated during the 1960s and 1980s at a late Neolithic settlement known as Dereivka on the river Dnieper in Scythia. The bones of approximately fifty-two horse remains were found on this site, including the skull and limb bones of a stallion that was buried with two dogs in a seemingly ritualistic manner.

ANCIENT HORSE CULTURE OF KAZAKSTAN

ANOTHER SITE that has yielded a great number of horse bones is in the east of North Kazakhstan at the site of Botai. The site has evidence of ancient dwellings and over 300,000 animal bones, most of which are equine. These date from between 3500 BC and 2500 BC, and indicate a culture that revolved around the horse. Interestingly, areas of Kazakhstan are today inhabited by the primitive Kazakh people, who lead a simple, seminomadic life, at the core of which is the horse. Their whole culture involves horses although in recent years they too have been somewhat affected by 'progress.'

THE DOMESTIC HORSE

BY 2000 BC, the domestic horse had become widespread through the Old World, with finds becoming common on late-Neolithic sites across Western Asia, Europe and the British Isles. The development of the horse as a domestic animal had a huge

Top
The horse is fundamental to the lives of the indigenous people of Kirghizia; this woman prepares the horse for a race.

Center
Horses have had an integral role in the human world for centuries; this is illustrated in the decoration of the Isthar Gate in ancient Babylon in present day Iraq.

Bottom Right
The image of horse and rider was transformed by Greek mythology into the centaur, this bowl is from the sixth century BC.

STUDIES OF this skull have shown abnormal wear on the premolar teeth, which would indicate that primitive bits had been used. Several perforated tines of red deer antler were also recovered, and these are thought to be cheek pieces from primitive bridles. This evidence suggests that horses were first ridden around 6,000 years ago, which was approximately 500 years before the invention of the wheel. There is great scientific debate surrounding the precise origins of horse riding, and it is wise to keep an open mind.

their hands free for using their archery skills. These carvings indicate how the horse also played a role in the pursuit of pleasure, and was not used solely for military means.

GREEKS AND ROMANS

THE GREEKS and Romans developed chariot racing and other equine pursuits – the first four-horse chariot race to be included in the Olympics was in 684 BC, and by 648 BC, mounted horsemen were competing in the Games. One of the most famous early horsemen was the Greek cavalry officer, Xenophon, who wrote the earliest surviving books on the art of equitation and training, and some of whose methods are related to equitation principles today. It is interesting to note, however, that the Hittites from Asia Minor are credited with being the first to write comprehensively about 'stable management,' and this was as far back as 1360 BC. Evidence from their texts shows how they realised the importance of feeding grain and alfalfa to horses, and more importantly that there was a direct relationship between feeding and exercise.

impact on the development, progress and civilization of man. Suddenly, there was a means of transport which allowed for travel over great distances, and which led to the birth of trade and commerce. The horse became a draft animal, able to transport a large number of people at one time, as well as being used in the fields. Horses were highly efficient as tools of war, and the impact on people who had not encountered the domestic horse must have been enormous when they saw someone riding toward them. It is thought that this is how the Greek myth of the Centaur, which was half-man and half-horse, originated.

ASSYRIAN RIDERS

EARLY DEPICTIONS of man on horses show him adopting a curious seat far back on the loins. This is also believed to be how the early donkeys were ridden, and hence it is called the 'donkey position.' There are depictions dating back to the eighth century BC of Assyrians riding in the 'modern' position behind the withers, which is probably when this seat was developed. There are wonderfully detailed carved *bas reliefs* surviving from the ancient Assyrian palaces of Nineveh and Numrud. These carvings show Assyrian nobility hunting from horseback in elaborate detail. They had not yet developed the saddle, but had devised a unique bridle where the reins were attached via a neck roller to the rider's feet, keeping

Top
This seventh-century BC bas-relief from the palace of Ashurbanipal in Nineveh depicts a war chariot pulled by horses

Center
In this ancient frieze, horses are shown being ridden in to battle by archers.

Bottom
As this ancient Greek vase shows, horse were used to pull carriages over 2,000 years ago.

HORSE PAGEANTRY

THE HORSE also played a major part in ancient pageantry and in some countries continues to do so today. Ancient processions always featured elaborate chariots and carriages pulled by highly groomed horses, and the horse became synonymous with the nobility, and was seen as a sign of wealth. Even among the poorer nomadic tribes, such as the Scythian people, the horse was a sign of prestige. There are a lot of archeological findings which have provided us with an insight into the Scythian culture.

Treasures of gold and precious materials have been found, many of which had depictions of horses on them, and there is evidence of horse sacrifice in some of the burial chambers, indicates the prestigious role that the horse played in their society. The Scythian's whole culture revolved around the horse, and they were undoubtedly among the most skilled horsemen of that time, from around the first millennium BC to the Middle Ages.

THE PAZYRYK TOMBS

ANOTHER FASCINATING insight into the role of the horse in ancient societies was provided by the discovery of the Pazyryk tombs. These were a group of five large tombs excavated between 1929 and 1949, situated close to the river Ob in Siberia. The tombs date back to the late fourth and early third centuries BC, and contained the remains of approximately 14 horses each. By a remarkable twist of nature, water had seeped into the tombs and frozen the remains, preserving the bridles, saddle cloths, harness, and decorative head-dresses to a very high degree. The remains were detailed enough to show how the horses had had their manes trimmed, their tails braided, their ears notched, and how they had been dressed. This provided information on the type of horses that were being used, how they were being looked after, what they were fed, and how big they were.

HORSES IN ANCIENT CHINA

THE EMPERORS of China have left us with the extraordinary evidence of the role the horse played in their culture. Sacrificial sites from the Shang Dynasty, dating back to around 1400 BC, have produced the remains of the early chariots and horses of the time. Approximately 100 horse skeletons have been recovered, and these show that the horses would probably have been similar in appearance to the Przewalski Horse. However, probably the most famous archeological evidence from China was discovered in the tomb of Qin Shi Huang, the first emperor of the Qin dynasty who died in 210 BC.

He was buried in one of the most incredible mausoleums, which must have been a testament to his extraordinary power and money. Discovered in the mausoleum, buried with him, were life-size terracotta figures of roughly 500 chariot horses, 116 cavalry horses, 130 battle chariots, and 7,000 soldiers, as well as various weapons and other accessories. This provides us with a view of what the horses of the time were actually like – it appears from their terracotta counterparts

Top

An Etruscan statue of a horse and rider is over 2,000 years old and is made of buchero *ware.*

Bottom

Horses have been essential to Chinese life for thousands of years, this terracotta statue is from the T'ang Dynasty.

Top
When the tomb of the ancient Chinese emperor Qin Shi Huang was discovered, the archeologists also found terracotta figures of 500 horses.

Bottom
This scene from the Battle of Hastings illustrates how horses were used by the Norman soldiers to beat the English.

that they were surprisingly large. They had an average height of around 17 hh and to have had a build similar to the modern Thoroughbred – their manes were carefully trimmed to stand upright and their tails were braided or tied up.

THE ENGLISH HORSE

STRANGELY, HOWEVER, it would seem that the English horse remained relatively small until well into the Middle Ages. Henry VIII, (1491–1547), laid down several laws restricting the use of stallions under 15 hh to try to increase the size of the British horse, and during the 15th and 16th centuries, many larger horses were imported from Spain, France, Denmark, and Hungary. The knights, in their armour, needed an animal large and strong enough to carry them into battle, so some draft blood was introduced in to the cavalry horses to increase the size of the animals.

The importance of the horse as a tool of war was quickly learned, but it would seem that the English learned it the hard way. The Battle of Hastings (1066) was a shining example with the Norman invaders shipping their battle horses over with them and then riding them to war against the English, as has been so well documented in the Bayeux Tapestry. The English at this time still adopted the battle procedure of riding to the site of attack, dismounting and fighting on foot. This lost them the life of their leader, King Harold II, (1020–66), and gave them the need to turn around their battle maneuvers.

There is little doubt of the major role the horse played in the life of ancient man, contributing significantly to all areas of his life, from trade, transport, war, agriculture and in many cases, spirituality. With the dual relationship of man and horse, whole new worlds, literally, were opened up.

Myths and Legends

THE HORSE FEATURES widely in a number of ancient myths and legends, some of which are better known than others, and this section deals mostly with those of Greek or Roman origins, although there are some other examples included too for good measure.

HORSE FACT:
Minerva, the Goddess of Wisdom, and Neptune, God of the Seas, took part in a contest to win the city of Athens. It was decreed that whoever produced the most useful gift for mortals should claim the city. Minerva produced the olive and Neptune, the horse. The olive was deemed more useful, and Minerva won Athens.

THE UNICORN

PERHAPS ONE of the most romantized mythical figures is the unicorn, which has different forms, names, and attributes in different cultures. One of the popular 'types' of unicorn in modern Western society is that of the elegant white horse with a twisted horn, often made of gold, projecting from the center of its forehead. However, the unicorn of the Orient is portrayed as a cross between a horse and a goat, with cloven hooves and a beard under its chin. The Japanese unicorn goes by the name of 'Kirin' and in China it is called the 'Ki-lin'. Both words derive from the Hebrew word, 're'em,' which translates roughly as, 'one horn.'

Top
In the West the archetypal unicorn is white with a gold horn; here it is depicted on a fifteenth-century Dutch tapestry.

Center and Bottom
The different world mythologies surrounding the unicorn has created a variety of embodiments, this Chinese wooden statue resembles a goat.

The Greek historian Ctesias wrote about the unicorn, which he thought resided in India, in 398 BC, and gave a vivid description of it. He believed it to be similar in appearance to a wild ass, but as big as a horse, with a white body, dark red head, and blue eyes, with the characteristic single horn. It is likely that this description came from the tales of wide-eyed travelers, and was probably based on a mix between the wild ass, the Himalayan antelope, and the Indian rhinoceros.

THE UNICORN'S HORN

THE HORN itself is thought to have had, (or have?), a range of properties, including the power to heal and the power to resurrect the dead. Some descriptions of the horns tell of them being white at the base, black in the middle, and having a sharp, red tip. There is a medieval tale of how a unicorn dipped its magic horn into a pond of poisoned water, hence cleansing the water and providing the animals with a drinking hole. This may have led to the custom of the nobility and royalty to drink from a cup fashioned from the horn of the unicorn, and so protecting themselves from poison attempts. The unicorn was considered in Western society to be an unapproachable wild animal, while in Eastern cultures it was thought to be tame and gentle.

Another medieval story tells the rather tragic story of how the unicorn was captured. No man was able to get near to the unicorn, but it could be tamed by a young maiden. The tale goes that the

lonely maiden would sit under a tree in the woods, the unicorn would approach her, drawn to her scent of purity, and would lay down with its head in her lap, and fall asleep. She would then cut off his horn, and leave him to the mercy of the hunters and their dogs. This could imply that the unicorn had a somewhat impaired sense of smell. A similar beast to the unicorn is the indrik of Russian folklore. The indrik had two horns, and was the king of all animals and ruler of the water. He lived on the Saint Mountain, and according to legend, made the earth tremble when he moved.

PEGASUS

ONE OF THE other great mythical horse characters was Pegasus. Pegasus was the offspring of the notoriously badly behaved Poseidon and the intolerably ugly Medusa. There are two different versions of how Pegasus actually arrived into the world – one is that when Perseus cut off Medusa's head, Pegasus sprang from her pregnant body; the other is that when her head was cut off and her blood seeped into the ground, Pegasus sprang forth.

However he began, Pegasus was the winged horse who led a long and colorful life. It was believed that when he galloped, he created the well of Hippocrene on the mountain of Helicon. The mountain of Helicon belonged to the Muses, and Pegasus was given to them by Minerva (Athena) after she had managed to capture and tame him. Being the horse of the Muses, Pegasus has often been used by

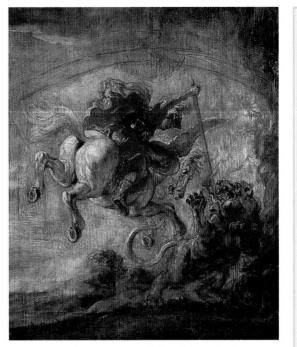

poets as good writing material, and has also become the hero of various stories surrounding needy and starving writers.

PEGASUS AND BELLEROPHON

ANOTHER STORY INVOLVING Pegasus tells how Bellerophon managed to capture him, using a golden bridle given to him by Athena, while he was drinking from a well. He managed to ride Pegasus in pursuit of the Chimera, a deadly monster who was causing all sorts of problems for the townsfolk of Lycia. Bellerophon captured and killed the Chimera, and went on, with the help of Pegasus, to undertake many horrible tasks. Due to his great successes, Bellerophon decided to ride up Mount Olympus and ask the gods for help in a love matter. The gods were so enraged at his presumption that they sent a gadfly that stung Pegasus, who threw Bellerophon to the ground.

Some versions of the story tell how Bellerophon was lamed and blinded in his fall, and spent the rest of his life wandering around lonely and miserable in the hope that Pegasus would return to him. Another version of the tale is that Bellerophon was never able to mount Pegasus, who threw him when he attempted to, and flew off into the heavens where he became a constellation. Pegasus was also employed by the mighty Zeus, and was responsible for carrying his thunderbolt.

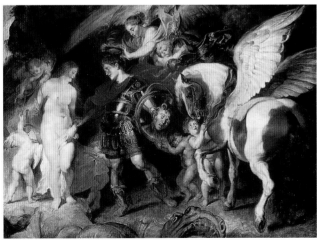

HORSE FACT:
Buzkashi, which in Turkish means 'to steal the goat' is a fast, dangerous game played on horseback. It is believed that the game originated with the Scythians and was played throughout Central Asia. The game involves a headless goat or calf skin filled with sand and soaked in water. The object is for one rider to seize the skin from the 'circle of justice,' ride around a post and return to the 'circle of justice' before another rider can seize it. Any number can play from ten to over 1000, and the rules allow for the riders to attack each other with the whip. Serious injury often results. Buzkashi is mainly played in Afghanistan today, and Buzkashi horses are considered highly valuable.

Top
The winged-horse, Pegasus, is painted here by Rubens being ridden by Bellarophon.

Bottom
A favorite subject of Rubens, Pegasus is the hero of starving writers.

One of the most admirable Centaurs was Chiron, who was taught by Apollo and Diana and was a skilled hunter, musician, physician, and prophet. He was held in high esteem by the gods and, on his death, Jupiter placed him among the stars, making him the constellation of Sagittarius.

POSEIDON, GOD OF HORSES

POSEIDON (NEPTUNE) was one of the more powerful gods and was the ruler of the sea, as well as the god of earthquakes, and the god of horses. He is the patron saint of horse races, and is said to have had horses with brazen hooves and golden manes that

drew his chariot over a sea which became smooth before him. As with many of the gods, Poseidon was a man of few morals and was responsible for the rape of his sister Demeter. In her efforts to avoid the ardent Poseidon, she turned herself into a mare but, unfortunately, Poseidon was able to transform himself into a stallion, whereupon he had his wicked way with her. The result of their coupling was a horse called Arion.

Poseidon (Neptune) also features in the story of the city of Athens. The goddess Minerva (Athena) and Poseidon each wanted the city of Athens for themselves, and it was decided that whoever produced a gift most useful to mortals would win the city. Poseidon donated a horse and Minerva donated the olive. It was decreed that the olive was the more useful of the two, and so Minerva was awarded the city. In some versions, Poseidon's gift was the spring at the Acropolis.

Xanthus and Balius were the two immortal horses that Poseidon gave to Peleus as a wedding

THE CENTAUR

THE CENTAUR is another famous mythical creature, which took the form of a man from the head to the loins, while the rest of the body was a horse. The Centaur was considered by the ancients to be one of the better-behaved monsters of the time, and is often portrayed in a kindly light. Having said that, the example of the battle of the Lapithae and the Centaurs was the exception to the rule. Several Centaurs were invited to the feast of Eurytion, where they became inebriated on the free-flowing wine. They began to get rowdy, and then started to insult the bride. A dreadful battle followed and many of the Centaurs were slain.

Center

A nineteenth-century painting of Neptune's steeds; this God of the sea is often surrounded with horses in the mythologies.

Bottom

This Roman mural depicts Chiron, the creator of the constellation Sagittarius, with Achilles.

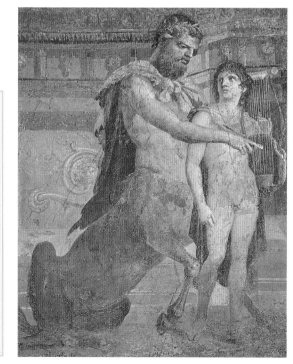

HORSE FACT:

Pliny, the Roman naturalist, described the unicorn as a fierce beast with the body of a horse, the head of a deer, feet of an elephant, tail of a boar, a bellowing voice, and a single black horn in the middle of its forehead. He also told how the unicorn could never be captured alive.

THE TROJAN HORSE

THE TROJAN HORSE was a large, hollow, wooden horse which played an instrumental part in the ransacking of the city of Troy. The Trojan prince, Paris, had fallen madly in love with the beautiful Helen and had whisked her away from her husband Menelaus into the city of Troy. For ten years Greek warriors fought outside the walls of the city in an effort to return Helen to her husband. Finally, they hid themselves inside a huge wooden horse that the Trojans, believing it to be a present, wheeled into their city. In the middle of the night, the soldiers crept out from the horse and opened the city gates, allowing in the other Greek soldiers. The city was burned down and Helen was subsequently returned to her husband.

present. The horses were later used by Achilles to pull his chariot during the Trojan war, and when Achilles scolded the horses for allowing Patroclus to be killed, Xanthus replied that it had happened at the hands of a god, and that soon he too would be killed by a god. After his prophesy, the unfortunate horse was struck dumb by the Erinyes.

THE VALKYRIORS

THRE ARE ALL sorts of wonderful legends from all over the world that are not just about the Greeks. One particularly interesting tale is that of the Valkyriors from northern mythology. Their name means 'choosers of the slain,' and they were fierce female warriors who allegedly were also virgins, and the messengers of the omnipotent Odin. They would ride around in their armor with their shields and spears, and as they covered the ground, flickering light would flash from their armor up into the northern skies, and this became the Aurora Borealis, or the Northern Lights.

Odin was one of the main gods of Norse mythology and was responsible for placing the sun and moon in the sky. He was also the god of war, poetry, wisdom, and death and among his most prized possessions was Sleipnir, an eight-legged horse who could travel through air as well as to the underworld.

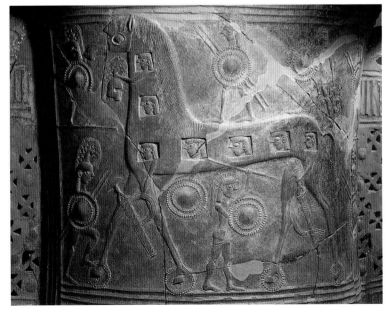

Top
This illumination from a fifteenth-century book illustrates the story of the Trojan horse.

Center
Odin, the Norse God who placed the moon and sun in the sky, rode an eight-legged horse.

Bottom
A Trojan horse is here depicted with the soldiers in this Greek terracotta relief from circa 670 BC.

Horses and British Royalty

THE RELATIONSHIP BETWEEN horses and royalty is one that goes back in time to the very beginnings of hierarchical society. There is perhaps no better person to demonstrate this than our present Royal family, led by H.R.H. Queen Elizabeth II. The British Royal family is tightly bound to the tradition of horses, which for Queen Elizabeth began at the age of four when she was given a Shetland pony called Peggy. She has ridden throughout her life, and continues to ride in the grounds of Windsor Castle and Balmoral. In 1982, she was seen riding around the estate of Windsor with Ronald Reagan, the former president.

home of the annual Royal Ascot meet. It was during the reign of Queen Anne that the famous Darley Arabian stallion was imported from Aleppo, and there was the dawn of a new chapter of high class horse breeding.

ROYAL PATRONAGE

THE QUEEN and Queen Mother are ardent supporters of the racing industry and keep approximately 25 horses in training every year. Both are highly respected for their knowledge and expertise in the world of racing. Royal patronage of the racecourse and the racing world is a tradition that goes back many hundreds of years, and has helped in the development of flat racing as a recognized and highly structured sport.

Charles II,(1660–85), greatly promoted the sport of racing, and established the many different races at Newmarket, increasing the prize money and laying down a set of official rules. It was during his reign that the course at Epsom, now home to the famous Epsom Derby, was opened. Queen Anne (1702–14) was another fan of the sport, and set up the course at Ascot in 1711, which is now the

ROYAL STUDS

THE PRESENT QUEEN keeps her racehorses at three studs, at Sandringham, Wolferton, and Polhampton, which was purchased by the Queen in 1972. The Sandringham and Wolferton studs were established in 1886, although the very first royal stud was begun in the 16th century at Hampton Court. The Queen stands two Thoroughbred stallions, Bustino and Ezzoud, and keeps her own broodmares. She takes a keen interest in all aspects of her horses, from their breeding to their training and competing. The Queen's horses have an excellent track record, winning all the English Classics except for the Derby, and notching up over six hundred wins between them since 1949.

Top
The Queen and Prince Edward enjoy riding in the Windsor grounds here in 1983.

Bottom
One of the Queen Mother's horses, Devon Loch, competes in the 1956 Grand National.

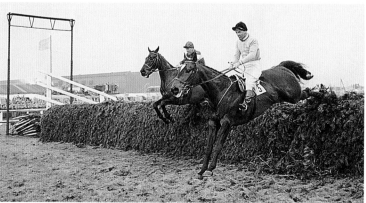

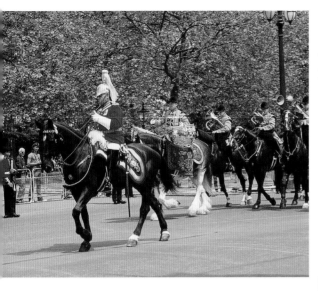

The Royal Mews on Buckingham Palace Road were commissioned in 1820 by George IV (1820–30), and were built to the designs of John Nash. Today, the Royal Mews, which is open to the public, houses the Queen's carriage horses, the wonderfully ornate carriages, the State Coaches, a collection of the Queen's cars and is also home to the Mews staff. George I (1714–27) introduced the cream horse in 1714, and this became the traditional type of royal horse. More recently however, the royal horses are predominantly Cleveland Bays, with some Dutch bay horses such as Oldenburghs and Holsteiners. There are also the famous Windsor Grays, and these are the only horses which pull the Queen's carriages. They derive their name from Windsor Castle, where, during Victorian

times, they were kept for drawing the private carriages. The Windsor Gray is not a breed, but the horses are bred to a very similar type.

A ROYAL HORSEMANSHIP

THE QUEEN'S INTEREST in horses is by no means restricted to the racing world, and has had something of an effect on her children. The Princess Royal is an extremely accomplished horsewoman, having competed very successfully at the highest levels of horse trials, and having ridden in races as well. In 1976, she was a member of the Olympic Three-Day Event Team, competing at the Montreal Olympics, and in 1986, was elected the president of the FEI (The International Equestrian Federation).

The Duke of Edinburgh has competed successfully in many driving competitions, and some of his driving ponies are bred and reared at Balmoral, along with Haflinger, Fell, and Highland ponies. Much of the Queen's horsebreeding takes place at the Hampton Court Stud, and this revolves around the production of carriage horses for the Royal Mews, and the Household Cavalry horses, including the drum horses.

TROOPING THE COLOR

ENGLAND is one of the few countries where the horse and carriage still plays a major role in royal pageantry. One such ceremonial occasion is Trooping the Color, and the Queen always rode at this occasion. From 1969 to 1986, she rode a black mare called Burmese, which was a gift to the Queen from the Royal Canadian Mounted Police. In 1986, Burmese was retired from duty, and from then on, the Queen has ridden in her carriage.

Top
A British tradition that continues to this day is the Trooping the Color in which the horses have an integral role.

Center
Hundreds of people gather outside Buckingham Palace and along the Mall to watch the troops of the Life Guards ride past in neat lines.

Bottom
The Queen previously rode in the ceremony, now she celebrates her official birthday from a horse-drawn carriage.

Horses in Literature

THROUGH THE AGES the horse has played a significant role in the life and times of man and this is reflected within the literary world. From the very earliest relationship with man the horse has been a romantic and fanciful figure, inspiring sentiment and poetry from some of the greatest writers the world has known.

THE HERO: THE HORSE

THE HORSE IN the 'hero' role features largely in children's fiction, not least in the famous story of *Black Beauty*, written by Anna Sewell, that addresses cruelty to animals in the 19th century. *The Black Stallion* series by Walter Farley is an inspiring group of children's books about the adventures of Alec Ramsey and his black stallion. Mary O'Hara's books about a horse called Flicka show how the devotion of a young boy to an animal helps him to understand his difficult father.

One of the great children's classics is *National Velvet*, which was written by Enid Bagnold. This book, which has also reached the big screen and stars Elizabeth Taylor, tells of a young girl winning a horse at a raffle, and riding him to fame in the Grand National. Dick Francis is one of the most widely read in adult horse fiction. A former jockey, Francis writes suspense novels about racing, full of intrigue and colorful characters.

Top
Horses featured in a variety of Greek stories and myths; a Greek text on horsemanship dates to the fourth century BC.

Center
Horses have been the protagonists in a variety of children's fiction; Black Beauty is one of the most famous.

Bottom
The famous horse author Dick Francis was also a champion jockey.

HORSEMANSHIP MANUALS

HORSES FEATURE in a huge range of literature, not least in the numerous riding and training books. Many manuals were written hundreds of years ago and provide a fascinating insight into early training methods and ideas. One of the very earliest surviving manuals on horsemanship was written around 1360 BC by Kikkulis the Mittanian. Kikkulis was the Master of the Horse to the Hittite King Sepululiamas, and what is so extraordinary is that the manual discusses the relationship of feeding and exercise along very modern lines. It promotes feeding grain and outlines the benefits of alfalfa and chaff in ways that are similar to modern feeding theories.

The other, more famous, early writer on equitation was the Greek general Xenophon, 427–354 BC. He wrote extensively on the art of horsemanship covering all aspects from training, feeding, and choosing a horse, to the correct apparel for the horse

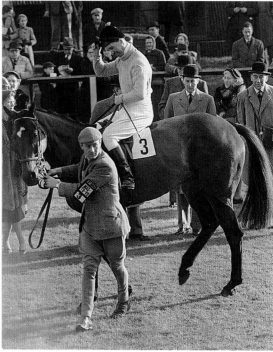

and cavalryman, and expressed concern for the well-being of the animal itself. Even by today's standards theories on the care of the horse were incredibly sound and showed a genuine equine understanding. His theories on riding and equitation in *Peri Hippikes* are considered to be the basic rules of the classical art of Renaissance riding.

'THE RULES OF RIDING'

THE ITALIAN NOBLEMAN Frederico Grisone expanded on the fundamental ideas of Xenophon and expanded them. In 1550, he published the book, *Gli Ordini di Cavalcare* (*The Rules of Riding*) which became enormously popular at the time, but he sadly propounded the use of pain and fear in the training of his horses, thus diverging from the humane tactics employed by Xenophon. Although his methods were questionable, Grisone understood the principles of balance, rhythm, and fluidity, and achieved significant results.

THE FRENCH SCHOOL

IN 1593 the Frenchman Saloman La Broue published the first French manual on equitation called *La Cavalerie Françoys*, which helped to make the French School of Riding one of the major influences on the classical style in Europe. Another Frenchman, Antoine de Pluvinel, as the first Master of the French School, was responsible for one of the most influential books of the time, *L'Instruction du Roy en l'Exercise de Monter à Cheval*, which was published in 1625, five years after his death. He advocated the use of ground exercises to increase suppleness, used a more humane approach, and is believed to have been one of the first people to use pillars to help collection and levade, the first step of 'airs above the ground.'

The eighteenth century saw the age of François Robichon de la Guérinière, who published *Ecole de Cavalerie* in 1733, the most important equestrian book of the time. He readvocated the use of humane methods of training and did away with painful curb bits that were so popular. He established the position of the rider with the thighs held close to the horse and used for guidance, similar to the modern position. He is responsible for modern dressage, and his methods were developed to form the basis for the Spanish Riding School in Vienna.

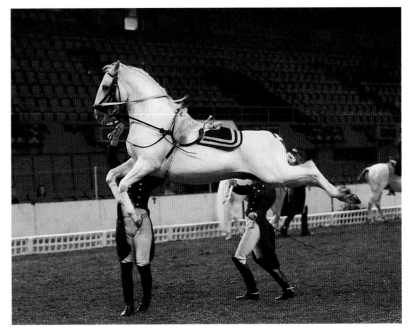

ENGLISH EQUITATION LITERATURE

THROUGHOUT THIS time, the English were far too busy racing or tearing after hounds to publish many treaties on equitation. There was, however, one exception. William Cavendish, Duke of Newcastle, (1592–1676), was exiled to Antwerp in 1658 and during his exile he published his theories in French, and then an expanded tome on his return to England in 1660. His methods were dubious and he advised the use of a harsh regime with peculiar, unnatural exercises for the horse.

These are just a few examples of the huge field of horse literature at both ends of the spectrum – fiction and classical theory.

HORSE FACT:
The most famous equine bronzes are the four horses in St Marks, Venice, Italy.

Top
The Spanish Riding School in Vienna took as a basis the humane methods of training developed by François Robichon de la Guérinière in the eighteenth century.

Bottom
Modern dressage methods were first propounded by the Frenchman Robichon de la Guérinière.

Horses in Art

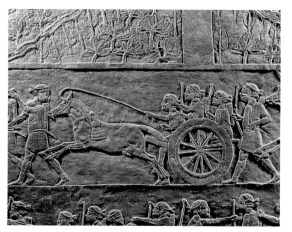

THE HISTORY of the horse in art is one that spans many thousands of years, and goes back to before the horse was a domesticated animal. The discoveries of cave paintings at Lascaux and Avignon in France have provided us with an insight, not only into the very early 'artists,' but also of the physical appearance of the primitive horse. That these paintings have survived at all is unbelievable, but when you consider their date of approximately 20,000 BC, and compare this to the condition they are in, it is quite astonishing.

Top and Bottom
These seventh century stone reliefs are from the palace in Nineveh and depict the battle against the king of Elam.

Center
Horses have featured in art since prehistoric times; this cave painting was found in the Grotte de Niaux in France.

SIGNIFICANCE OF CAVE PAINTINGS

BOTH THE SITES at Lascaux and Avignon are buried in deep underground caves, and perhaps this has largely contributed to their preservation. It is interesting to consider why these pictures were done in such inaccessible places and whether they were depictions of what early man considered to be spiritual or godlike animals. Alternatively, they could simply have been portrayals in admiration of the fierce and wild spirit of the early horses. One vivid drawing is the picture of a horse at Niaux, in the mid-Pyrenees. Carefully drawn with a heavy black outline, it bears a striking resemblance to Przewalski's horse. Others, at the site at Vallon-Pont-d'Arc, are depicted with flowing lines and bold color and are so detailed that it is possible to pick out spotted markings similar to the Appaloosa. The horses here

appear to have a finer head than that of the Niaux horses and show some resemblance to the Arab.

CARVINGS OF NINEVEH AND NIMRUD

PICTURES OF the horse through the centuries provide us with a tremendous amount of information, ranging from the role of the horse in society, to how the horse developed. Another great source of pictures comes from the Assyrian people of the Middle East, and the best of these are in the form of *bas-reliefs* carvings in the palaces of Nineveh and Nimrud. The reliefs from Nineveh date back approximately to 645 BC and give a vivid portrayal of the times. They include carvings of an exotic lion hunt, with the King in his chariot. Standing alongside are the beautifully and evocatively displayed horses, tense with the excitement of the chase. They even show the harnessing and tack that was being used on the horses. The horses appear muscular and in good condition, obviously well looked after, but are depicted with a typical 'straight leg' movement – it was many years before horses were shown with a more natural carriage.

The reliefs at Nimrud, which date to approximately 865–860 BC, are equally as vivid as those at Nineveh. They show archers riding barback on

have been even more magnificent. They still retain some of the gold leaf and this is probably because they were originally covered with many layers. The Greek sculptor Phidias also had a great understanding of the horse and the sculptures he made, that form part of the frieze around the Parthenon in Athens, are testament to his talent. They are believed to date to approximately 447 BC and show the Greek ideal of perfection. Young men are riding bareback on beautifully proportioned and collected horses, which are shown in various stages of movement.

Top
Classical statues of ranks of war horses in San Marco, Venice.

Bottom Right
This bronze statue represents the Roman emperor Marcus Aurelius Antonius; the presence of a horse adds to his majesty and power.

Bottom Left
A Mongolian terracotta funeral statuette is of a horse and rider, and dates to the fifth century.

powerful-looking stallions, while aiming their bows. Again, the reliefs show the elaborate bridles that were in use and a type of decorative neck-hanging with tassles.

HORSE SCULPTURES

PERHAPS SOME of the most amazing early horse sculptures are the four figures of the gilded copper horses which reside in the Basilica San Marco in Venice, Italy. These horses date back to the third or fourth century BC and stand larger than life size. They are believed to have been produced by the Greek sculptor Lysippus and are wonderfully proud and muscular. They are fairly anatomically correct, very lifelike, and appear to be about to move off at any minute. Originally these horses would have appeared a brilliant, burnished gold color, and must

TERRACOTTA WARRIORS

THE HORSE was a very important part of life in early Chinese societies too, and were very much a sign of wealth and power. There is perhaps no better example of this than the tomb of Emperor Qin Shi Huang, which dates to the third century BC. His whole tomb has yet to be excavated, but what has been unearthed already is an extraordinary display of power. He was buried alongside approximately 7,000 life-sized soldiers, 600 life-size terracotta horses, and various carriages and weaponry. The figures of the horses are superbly detailed with individual characteristics. Compared to the horses of the Basilica San Marco, or the huge bronze of Marcus Aurelius on horseback, AD 160–180, the Chinese horses are rather less realistic and somewhat stiffer in appearance. What is interesting, however, is that there is a clear difference in the breeds between those seen in China, and those of the Greeks and Romans.

HORSE AS A SUBJECT IN PAINTING

THROUGH THE Middle Ages, the horse became less important in the works of many artists, existing as a sub-theme, or disappearing altogether. There was an increase in religious subject matter, which became central to the majority of artists' work, and it was not until the 18th century that the horse again became popular. The following examples are some rare exceptions to the rule.

DE LIMBOURG AND GOZZOLI

TWO EXQUISITELY painted pictures of the 15th century that feature horses include Paul and Jean de Limbourgs' *May* (1410) and Benozzo Gozzoli's *Journey of the Magi to Bethlehem* (1459). *May* was commissioned by the Duke of Berry from the Limbourg brothers' workshop, and was a page from a Book of Hours that was attached to a calendar to illustrate the changes associated with the different seasons. This particular painting is very much in the Gothic International style and is incredibly finely detailed, probably having been painted with the use of a magnifying glass. It is a beautiful piece depicting the carefree atmosphere of the courtiers during their annual festival. The horses have been carefully drawn with attention to beauty rather than anatomical correctness. The movement can still be seen to be rather stiff and unnatural, although this in no way detracts from reputation of the painting as a masterpiece.

Gozzoli's *Journey*, although painted some years later, retains the International style. This again has a great degree of detail, especially evident in the ornamental trappings of the horses, which have been drawn in a similar way to those in the Limbourg piece and appear as heroic powerful steeds. It is interesting how Gozzoli has tackled the 'head on' angle of the horse on the right of the picture. He is obviously unsure of the sequence of

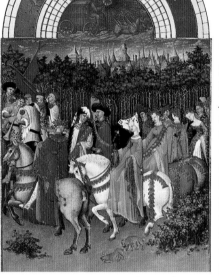

Top
Journey of the Magi to Bethlehem *features horses that are intricately painted but less realistic than in later works.*

Center
Detail of fifteenth-century manuscript showing courtly figures on horseback.

Bottom
Paolo Uccello's Rout of San Romano *is battling with problems of perspective.*

legs in movement as he portrays the horse standing on two legs on one side. The gray horse to the left of the picture, however, does appear to be moving forward, and this is due to the way he has painted the hindlegs with a forward, thrusting motion.

UCCELLO

ANOTHER INTERESTING picture of around this time is Paolo Uccello's *Rout of San Romano*, (c.1450). This is really an extraordinary picture for a number of reasons, though on first glance it appears to be a rather wooden depiction of both horses and man. Uccello was grappling with theories on perspective, and this picture is laid out specifically to demonstrate his ideas. Each figure is supposed to be standing in its own space and, through the use of the lances and spears creating planes of vision, he has tried to draw the eye back and into the painting.

He has been partially effective, although in this particular painting there is a rather peculiar jump from foreground to background, with a diagonal

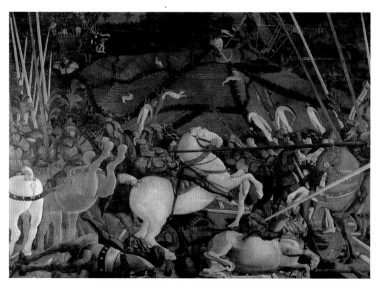

move from the front right corner to the left rear corner, and the landscape on the right appears somewhat unrelated to the rest of the picture. The horses themselves are very wooden and really do not seem realistic, but the explosion of color and pattern compensates for the picture's anatomical failings. In fact, it almost has a modern feel to it and appears like a study in the pursuit of pattern and color.

VAN DYCK AND VELAZQUEZ

TWO GREAT PORTRAIT artists of the early 17th century were Anthony van Dyck and Diego Velazquez. Van Dyck was one of Rubens' pupils, and went on to become the Court Painter to Charles I in 1632, whereupon his name was changed to Sir Anthony Vandyke. His paintings have left us with a concise view of aristocratic society and dress, complete with all their foibles. Perhaps two of his most famous pictures are *Equestrian Portrait of Charles I*, (c.1638), and *Charles I of England*,

Top
The position of the horse in this picture, with its bowed head, emphasizes Charles I's power.

Bottom
Sir Anthony van Dyck's portrait of Charles I depicts him on horseback; the addition of the horse lends magnificence to the depiction of the monarch.

(c.1635). *The Equestrian Portrait* is indeed an artistic feat. The horse itself is central to the picture and captures the eye far more so than the rather vacant looking Charles I. However, by painting such a magnificent and powerful beast, Vandyke managed to make this appear as a reflection of the King's own qualities. The horse is in fact totally out of proportion, with a small head set to a body of elephantine dimensions; but it nevertheless remains a pleasing painting to view. Note the long shanks on the curb bit that the horse is wearing, and understand the set and carriage of the neck.

The second portrait mentioned shows the King in his flamboyant style, having just dismounted from a fine gray horse. Although only the front half of the horse is depicted, enough is shown to recognize that it is a powerful and muscular animal. The horse has lowered its head and raises its front foot, while appearing to look toward the King, a humbling gesture before the mighty Charles.

HORSE FACT:
Hippology is the study of the genus *equus* (horses, zebras, asses, and onagers), including breeds, genetics, history, and geographical distribution.

Velázquez (1590–1660) worked at the Court of King Philip IV of Madrid in a similar capacity to Vandyke.

Velázquez was very involved with the ideas of 'naturalism,' wishing to depict nature as it appeared, and in great detail. His main job was to paint the King and his family, which meant in the most flattering way possible.

It is believed that neither King Philip IV nor Charles I was particularly attractive or charismatic in any way, making the job of the artist very difficult. Velázquez excelled himself with the *Equestrian Portrait of Philip IV* (c.1636). The picture depicts the King in fine detail astride a powerful animal in a semi-rearing posture. The background of the painting, while attractively painted, is fairly devoid of detail, throwing the central horse and rider into silhouette. All attention is focused on the pair, and like Vandyke, Velázquez makes the King appear more heroic by placing him on such a proud horse. The detail on the tack and costume of the King is very finely painted, and takes the eye away from the slight anatomical abnormalities of the horse.

Top
The atmospheric *Arabian Fantasy* *was painted by Delacroix in 1834.*

Above
King Philip IV of Spain *by Velázquez.*

Right
George Stubbs painted Whistlejacket *in 1762.*

Bottom
The stance of the horses in Géricault's picture Horse Racing at Epsom *(1820) is unrealistic.*

DELACROIX AND GÉRICAULT
GÉRICAULT (1791–1824) SPENT much time studying the work of Rubens and Vandyke, and worked towards realism and accuracy in his depictions of horses. He was a passionate horseman and was tragically killed falling from a horse. It is interesting to study his painting *Horse Racing at Epsom* (1820) and compare this to paintings executed after Eadweard Muybridge's studies of the horse in motion, executed during the 1880s. Delacroix (1798–1863),

too, was an avid fan of horses, and was one of the founding members of the French Jockey Club.

Delacroix's style can only be described as opulent – he painted with vigor, energy, and color to depict wild, frenzied scenes of blood, lust, and passion. He traveled to Morocco which had a profound effect on him, and further increased his use of exotic color and subjects. By looking at his painting *Arabic Fantasy* (1834) you can see how his use of color and movement created the atmosphere, and his work shows early leanings towards the impressionism that was to evolve and dominate the painting style of this period.

GEORGE STUBBS
GEORGE STUBBS (1724–1806) is known as one of the first great English equestrian painters and there is no better picture to emphasis this than his painting of *Whistlejacket* (1762). This was one of his earlier commissioned pieces and is a stunning achievement. The painting stands at over nine feet (3 m) high and focuses on the form of the exquisite horse, with no background painting to distract the eye. Stubbs spent

HORSE FACT:
White horses are always referred to as being 'gray.'

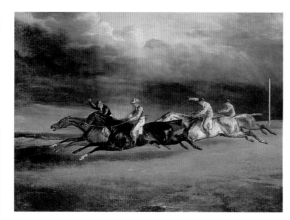

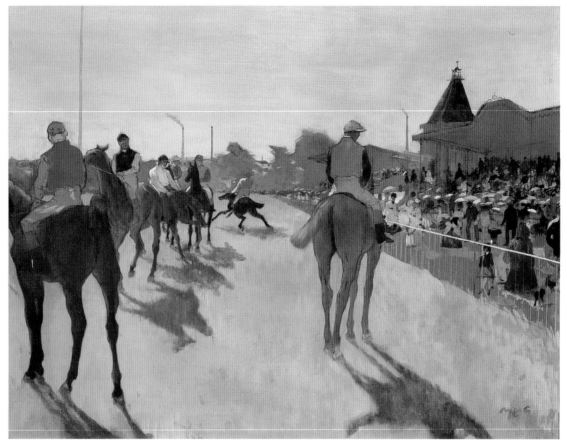

two years in the 1760s working on anatomical drawings of the horse, which were finally published around 1766 as a book of engravings. The detail, and the extraordinary lengths to which he went to produce this, speak of his devotion to his work. His depictions of horses all have great animation, accuracy, elegance, and feeling to them, which places him at the height of English equestrian art.

DEGAS

DEGAS TOO WAS a great painter of the racehorse and all the ceremony attached to the race meet. He was concerned with using unusual view points and organization of space in his works, which make them both varied and interesting. His evocative painting *Racehorses in Front of the Grandstand* (c.1866–68), for example, is viewed from behind the horses, which is unusual in itself. There is an air of calm, the lull before the storm, as the horses mill round before the start of the race. Degas was greatly affected by the publication of Muybridge's photographs of the horse in motion, and made several drawings from them. His pictures showed a greater understanding of the sequence of the legs after exposure to Muybridge's discoveries.

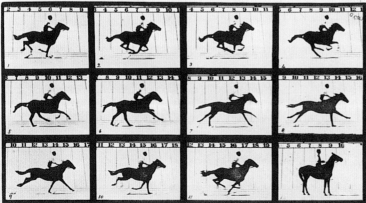

MUNNINGS

ALFRED MUNNINGS, (1878–1959), was another English painter famous for his paintings of horses. He was a great enthusiast of hunting and many of his pictures reflect this, not least the picture of *Huntsman with Hounds*, Zennor Hill, Cornwall, (1914). It is a superbly crafted picture showing great movement and stillness at the same time. The horse appears transfixed, rooted to the spot, peering at some distant point as if it would never move again, while the busy hounds and the bay horse create activity and excitement spiralling outward from the stillness of the horse.

Munnings went on to travel to France as a war artist with the Canadian cavalry and depicted life of the cavalry on the road. His paintings of this period housed in the Canadian War Museum in Ottawa, provide great documentation and are proof of his position within the ranks of the very greatest of the 20th century equestrian artists.

Top
La Defile (Racehorses in Front of the Grandstand) *by Degas.*

Center
Munnings was famous for his life-like and striking hunting paintings.

Bottom
Muybridge's photographs of horses in motion influenced artists like Degas.

Classifying Horses

FOR MANY YEARS, the evolution of the horse was considered to have taken place in a straight line, with a clear and simple move from the earliest fossil horses found to modern day *Equus*. However, through the continuing discovery of fossils, it is now apparent that the evolution of the horse was far from being that simple. Different horse species evolved at different rates, sometimes showing dramatic changes while at other times exhibiting gradual changes, with many species living alongside one another at the same time.

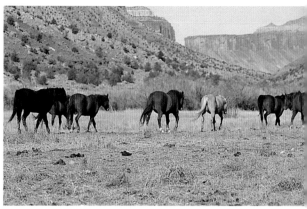

EVOLUTION OF THE HORSE

THE EARLIEST EQUID FOSSIL dates back approximately 60 million years to the Eocene period, when *Eohippus hyracotherium* inhabited the forest regions of North America. *Eohippus* was a small browsing mammal that looked nothing like the modern horse. They were about the size of a fox, with four toes on the front feet and three on the hind, and probably lived on a diet of fruit and soft foliage. They are classified as an ungulate – a herbivorous-hoofed mammal that walks on its toes, and has the toe bone increased in length to enable them to move quickly to escape predators.

Eohippus spread widely throughout North America, and also reached western Europe via a landbridge. At the end of the Eocene period, as a result of continental drift, the landbridge was lost between North America and Europe, and from then on Eohippus developed in quite different ways in the two places. In Europe and Asia, *Eohippus* split into a number of divergent species, all of which became extinct in the early Oligocene period, which was about 35 million years ago.

In North America, *Eohippus* developed via *Orohippus* and *Epihippus* through the Eocene period, with the most notable changes occurring in their dentition with the development of molars more suited to chewing tougher plants and foliage. Approaching the Oligocene period, approximately 24 to 34 million years ago, there was a climatic change in North America which caused the huge forests to start receding and the emergence of great areas of grasslands. As a product of this, the horse species of the Eocene period began to develop tougher teeth, which were more suited to chewing grass, and to become somewhat larger and longer in the leg to move faster in the open country.

HAPLOHIPPUS, MESOHIPPUS, AND MIOHIPPUS

AT THE BEGINNING of the late Eocene period, about 37 million years ago, there emerged three new types of horse; *Haplohippus*, *Mesohippus*, and *Miohippus*. The latter two were the most advanced, and demonstrated the most horselike features. *Mesohippus* was slightly larger than *Epihippus*, with longer legs and a longer neck. They had three toes on the hind and front feet, and the dentition was to become more suitable for grazing. *Miohippus* was similar to *Mesohippus* but larger, had a longer skull and was developed a leg movement that was closer to that of the modern horse.

In the early Miocene period, approximately 24 million years ago, the horse family split into at least two main branches, with a smaller third branch. The

Top
In these Colorado plains the Eohippus grazed 60 million years ago.

Center
The skeleton of a Eohippus, a prehistoric mammal that was the size of the fox.

Bottom
The Mesohippus had a long neck and legs; its teeth were designed for grazing.

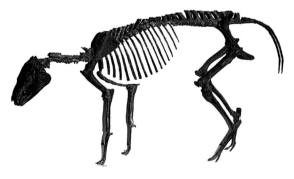

first branch was seen in *Anchitiheres,* which was similar to *Miohippus* but had increased in size. They were three-toed browsers, and diversified into several species such as *Hypohippus* and *Megahippus,* which became widespread across Eurasia and North America, and are thought to have become extinct about nine million years ago, probably due to climatic changes.

The smaller third branch was a line of pygmy horses called *Archeohippus,* but this particular branch did not survive very long.

The second and main branch of horses began to show some significant changes. The teeth, again, had become much better equipped for chewing and grinding, and had become longer and able to grow continuously from the gum as they were worn down

by grinding up the coarse grasses. These early horses also became more suited to running, with an increase in body size, length of the leg and length of the face. The fleshy pads on the feet disappeared and they started to stand just on the third toe, which was another adaptation for speed and running. They also had lengthened muzzles like modern horses, and an increased distance between the eyes and the mouth, which allowed them to watch for predators at the same time as eating. These changes were seen through *Parahippus,* which evolved around 23 million years ago during the early Miocene period. *Parahippus* evolved rapidly, in evolutionary terms, into a grazing horse called *Merychippus gunteri.*

MERYCHIPPUS

MERYCHIPPUS EMERGED approximately 17 million years ago, and would have been recognizable as a 'horse' as we know them today. They were much

larger, standing at around 10 hh, had a larger brain, a more elongated muzzle, and teeth further developed for grazing. They still had three toes, but the middle toe was much more pronounced with the lateral toes decreasing in size. The middle toe developed into a convex hoof similar to that of a modern horse, and the leg movement was now just forward and backward, adapted for running, with no rotation.

Around 15 million years ago, during the late Miocene period, the *Merychippus* rapidly gave rise to as many as 19 new horse species that can be grouped under the following three headings. The first were the *Hipparions,* which were very successful and crossed to Asia, Europe, and Africa, becoming extinct here approximately 400,000 years ago. The second group were the *Protohippines,* which included *Protohippus* and *Calippus,* and which were significantly smaller. The third group evolved from *Merychippus primus* in a gradual process to eventually become the true early equine.

By 10 million years ago there was a huge diversity of species in the horse family, with *Hipparions,* *Protohippines* and true equines effectively living side by side. From the *Merychippus* line evolved the *Pliohippus,* which is a relative of the modern horse but probably did not directly give rise to it. Shortly after *Pliohippus* arose *Astrohippus,* and then came the emergence of *Dinohippus.* The earliest of the *Dinohippus* show definite *Equus* characteristics, especially in the structure of the foot and the dentition. It is thought that *Dinohippus* directly gave rise to *Equus.*

Top
This reconstruction of the prehistoric Merychippus *illustrates the similar appearance the species had with the modern horse.*

Center
Dartmoor ponies still roam free on the moors.

Bottom
The Pliohippus *is a relative of the modern horse.*

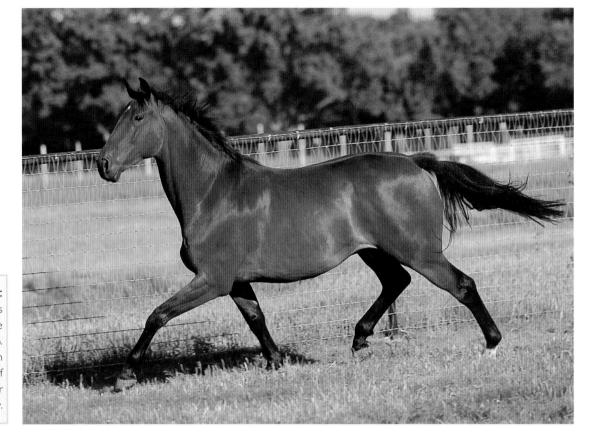

HORSE FACT:

The cowboy hat was invented during the 1860s by John B. Stetson, and Stetson hats remain one of the most popular Western hats today.

Top

This bay is a descendant of the horse that first appeared in Europe, Asia, and the Middle East around two million years ago.

Bottom

The Arab is one of the finest modern horses.

EQUUS

EQUUS EVENTUALLY evolved around four million years ago. They were approximately 13.2 hh, and had classic horse features and physiology. During the late Pliocene period, around two-and-a-half million years ago, some *Equus* species crossed to the Old World. Those that entered central Africa developed into the zebra, while others entered into North Africa and Asia and evolved into onagers and asses. Those that spread into Europe, Asia, and the Middle East eventually became the *Equus caballus*, or the modern horse. Horses became extinct in North and South America approximately 10,000 years ago, probably due to climatic changes and excessive hunting by man. There were no equids in America until they were reintroduced by the Spanish conquistadores in the 16th century.

The process of evolution of the modern horse from *Eohippus hyracotherium* is extremely complex and has been greatly sim-plified in this text. For the enthusiast, there are many fascinating books which deal with evolution as it should be dealt with, in great depth and detail.

EVOLUTION OF THE MODERN HORSE

THE HORSE BECAME EXTINCT in America approximately 10,000 years ago, but it continued to evolve in Europe and Asia. It is possible to establish the development of four primitive breeds, each of which became adapted to its own particular environment.

PRZEWALSKI'S HORSE
(Equus przewalski przewalski poliakov)

ORIGINALLY FROM the steppe areas of Asia, the Asian wild horses are no longer seen in the wild. They are being bred in captivity with the plan to reintroduce them to their natural habitat in Mongolia in the near future. This incredibly primitive breed was rediscovered by, and named after, a Polish colonel called N. M. Przewalski, in Mongolia in 1879. They characteristically have a heavy and long head, with small eyes set high on the face, and a straight or convex profile. They are a typically primitive dun coloring with a dark dorsal stripe, and sometimes have zebra markings on the legs. They have a coarse upright mane, and differ from modern horse in their chromosome count, which is 66 as opposed to 64.

TARPAN
(Equus przewalski gmelini antonius)

ORIGINALLY FROM Poland, the Tarpan is lighter in build and faster than Przewalski's Horse. They have the same primitive dun coat coloring, which turns white in winter, and also have a dark dorsal stripe and, often, zebra markings on the legs. The Tarpan is technically extinct, although a 'modern' version of the breed has been reconstructed and lives in a maintained herd at Popielno, Poland. It is believed that the Tarpan played a significant role in the development of many of the light breeds of horses in the world today.

FOREST HORSE
(Equus przewalski silvaticus)

ORIGINALLY FROM Northern Europe, the Forest, or Diluvial, Horse was a large-boned, slow-moving, heavy horse believed to be the ancestor of the draft breeds of Europe. Although now extinct, the Forest Horse was well adapted to its environment, developing broad hooves, which enabled it to live in the widespread swampy areas, and also a thick and wiry coat which may have been dappled to provide the horse with camouflage.

TUNDRA HORSE

ORIGINALLY FROM Northeast Siberia, the now-extinct Tundra Horse is likely to be the ancestor of the local Yakut ponies, characterized by their thick, white coats. However, it is unlikely that the Tundra Horse played a significant role in the development of any other domestic equine breeds. Based on detailed studies of early equine bone structure, it has been concluded that these four primitive horses gave rise to a further four 'types' of equine which are directly traceable to modern horse.

HORSE FACT:
'The good horseman is not so much a part of the horse as he is part of the horse's movements'.
Alessandro Alvisi, 1939.

Top
The Tarpan is one of the oldest breeds of horses that has influenced the development of many other modern species.

Bottom
Przewalski's horse has been breed in captivity to ensure its survival.

PONY TYPE 1

Modern equivalent is the Exmoor pony

PONY TYPE 1 derived from northwest Europe and was a small, but very tough and hardy pony that probably stood between 12 hh and 12.2 hh. They lived in harsh conditions and were seemingly resistant to wet and cold, qualities that are still retained in the Exmoor pony and other native British pony breeds. Pony Type 1 typically had a small head with a straight profile, broad forehead, and small ears, as well as having a particular jaw formation which bears a striking similarity to the modern Exmoor pony.

Top Left
The Exmoor pony has retained the hardy qualities of Pony Type 1.

Bottom Left
This Highland pony is similar to the original Pony Type 2, one of the earliest breeds of Equus.

Top and Bottom Right
Resistant to the extreme climate of desert, the Akhal-Teke has descended from Horse Type 3, Type 4 is small and finely built, coming from western Asia.

PONY TYPE 2

Modern equivalent is the Highland pony

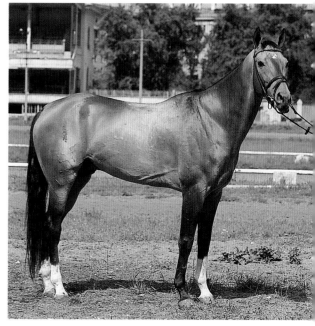

HORSE TYPE 3

Modern equivalent is the Akhal-Teke

HORSE TYPE 3 derived from Central Asia and would have been highly resistant to the extreme heat and cold of the desert climate. They were a larger breed, probably standing between 14.2 hh and 14.3 hh, but were of a much lighter build, being fine-boned and fine-skinned with a long and narrow body. These characteristics are clearly seen in the Akhal-Teke of today.

HORSE TYPE 4

Modern equivalent is the Caspian Miniature Horse

HORSE TYPE 4 derived from western Asia and was a small, finely built horse, probably standing between 10 hh and 12 hh. They would have been extremely resistant to heat, fine-boned, and refined, with a small head, concave profile, and a highset tail. Horse Type 4 is thought to have contributed a great deal to the development of the Arabian, and their characteristics can be seen in today's attractive Caspian Miniature Horse.

PONY TYPE 2 derived from Northern Eurasia and again was highly resistant to the cold. They were slightly larger than Pony Type 1, and probably stood between 14 hh and 14.2 hh. They had a heavy build and would have been more stocky than Pony Type 1, exhibiting primitive features similar to Pzewalski's Horse. The features and characteristics of Pony Type 2 can be seen today in the Highland pony.

THE MODERN HORSE

THE PROCESS OF EVOLUTION from the very first *Eohippus* to the modern horse is one that has taken millions and millions of years. Horses today continue to develop and change, although mostly now by man's selective breeding, rather than by natural selection. The influence of the Arabian, Barb, and Spanish Horse is paramount in the development of the modern horse.

INFLUENTIAL BREEDS

THE ARABIAN and the Barb horse have greatly affected many modern breeds, not least the English Thoroughbred, through whose stud book all modern Thoroughbreds can be traced back to two Arabian stallions and a Barb stallion. In a similar way, the Spanish Horse dominated Europe between the 16th and 18th centuries, and then, following their introduction to America in the early 16th century, they became responsible for founding the American breeds we see today. In many cases, the obvious influence of the Spanish Horse can be seen through certain characteristics in many modern breeds.

ADAPTING THE ENVIRONMENT

IT IS INTERESTING to look at the impact of the environment and climate on the early development of different breeds. As can be seen from the primitive pony and horse types discussed previously, these breeds exhibited characteristics which enabled them to cope with their surroundings. The Akhal-Teke from Turkmenistan is one of the most highly adapted breeds to their harsh desert climate, able to cope with extremes of both heat and cold. The Basque pony of Spain will grow thick whiskers on its top lip

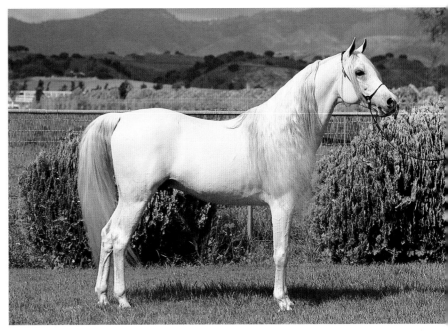

to protect it from the spiney plants it has to eat in the winter, due to a shortage of other food. When the grass starts to grow again, the whiskers are shed until the following winter.

BREEDING TECHNIQUES

THERE ARE HUNDREDS of examples of breeds that have become specifically adapted to their habitat, and it is worth considering what effect modern high-tech breeding programs are having on the natural development of breeds. Breeding is indeed a science and never more so than within the racing industry. However, it is interesting to note that there has not been a significant increase in speed over the past fifty years in racehorses, which raises Darwin's question as to whether the ultimate improvement in the Thoroughbred has already been reached. Gaffney and Cunningham (1988) maintain that the modern Thoroughbred still has the potential to be bred to run faster, which puts into words the dream of every racehorse owner.

Top
Arabs such as this stallion have influenced many modern breeds.

Below
All English Thoroughbreds are descended from two horses, one of which was a Barb.

Above
The Basque pony is influenced by its surrounding environment; during the winter months they grow whiskers on their top lip.

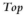

Wild and Feral Horses

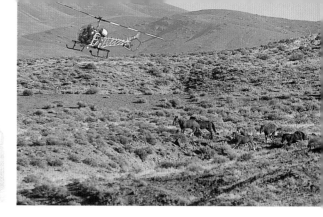

FERAL IS THE NAME given to animals that were once domesticated, but have either escaped or were released, and have since established themselves in the wild. Some examples of feral horses are the Mustang of America, the Sable Island pony of Canada, the Brumby of Australia and the Sorraia of Portugal. Some feral horses can be successfully trained to make useful riding or pack animals. With increasing human populations on a worldwide scale, the habitat of the feral horse has become threatened.

THE AMERICAN MUSTANG

A POIGNANT EXAMPLE of this is the Mustang of America. These feral horses developed from horses that were brought over to America during the 16th century by the Spanish conquistadores, some of which subsequently escaped, forming herds in the wild. At the beginning of the 20th century there were between one and two million Mustangs living in the wild in the Western states of America, but by the 1970s only a few thousand remained, having been hunted down to provide more grazing for cattle. The Mustangs are now under Federal protection, and their welfare is looked after by the Bureau of Land Management (BLM).

The BLM has started an adoption program that has caused some controversy. Periodically the horses are rounded up and sold at very low prices for one year. After the year, the owner has to provide a certificate from an appropriate authority stating that the animal has been well cared for. If this meets with the approval of the BLM, the horse is officially recognized as belonging to the owner. Some consider that many people who take on Mustangs are ill-prepared and ill-equipped to do so, resulting in accidents and injuries to both horses and owners. However, the BLM is largely credited with helping the numbers and the quality of the Mustang.

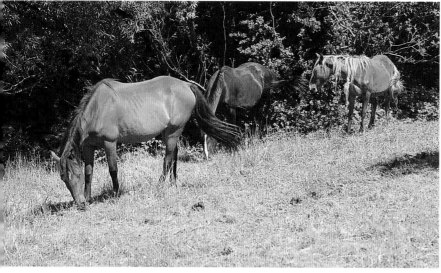

Top
These wild mustangs are being round up in Nevada to be sold.

Center
Brumbies are feral horses from Australia.

Bottom
Horses that range wild are always found in herds for reasons of sociability and security.

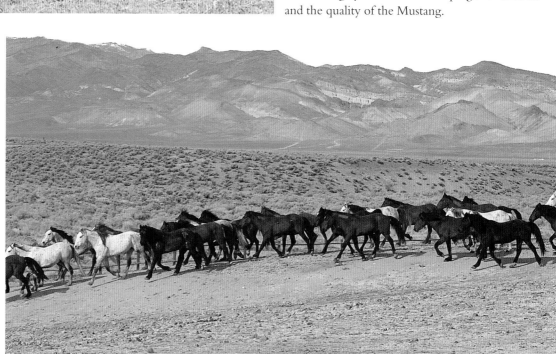

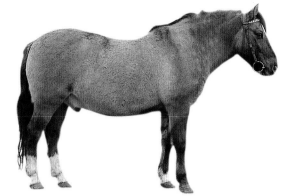

WILD HORSES IN DECLINE

THE DECLINE of the wild horse can be traced back as far as 15,000 years ago. As the human population grew, the wild horse was widely hunted to provide meat and hides, and this, combined with a change in climatic conditions, greatly affected the wild horse population of the northern hemisphere. As the climate became warmer, forests replaced the widespread grassland areas, which the wild horse grazed on, and by 10,000 years ago the wild horse was extinct in North and South America. In Europe, cultivation of the land pushed the wild horses towards the steppes of Central Asia, and by 7,000 years ago it would have been rare to see a wild horse in the West.

There were, however, two subspecies of wild horse left until the end of the 19th century and these were the Tarpan, *Equus przewalskii gmelini*, of Eastern Europe and the Russian steppes, and the Mongolian, or Przewalksi's horse, *Equus przewalski przewalski* poliakov, in Mongolia.

THE TARPAN

THE FACT that the Tarpan existed in the wild until the end of the 19th century is indisputable, but there is some debate as to whether or not the Tarpan was originally wild or feral. Tarpan is something of an umbrella name and it is very probable that all the feral or wild ponies of the steppes area were, at that time, collectively called Tarpans. Little evidence remains of the original Tarpans – there are only two skeletal specimens remaining of Tarpan ponies that died in captivity.

During the Middle Ages the ponies were hunted as game animals, and the meat was a delicacy among the aristocracy. Tarpans remained in the forests of Poland until the 1820s, when the last remaining few were captured and given to local farmers. Today the Konik pony of Poland greatly resembles historical

descriptions of the Tarpan. The last actual Tarpan died in captivity in Munich in 1887; there have been efforts to breed it back, and, using selective breeding with Koniks and other pony breeds, the new Tarpan has been established.

THE PRZEWALSKI

THE LAST REPORTED sighting of a Przewalski's Horse in the wild was in 1968. The breed has been maintained in zoos and parks around the world, however, and they have recently been re-introduced into the wild in a special reserve in Mongolia. The horse first described by the explorer Przewalski in 1876 and was found in the Gobi desert and the steppes of Mongolia. They exhibit truly primitive characteristics and have a different chromosome count than that of modern horse, possessing 66 as opposed to 64.

The modern Przewalski is descended from just eleven Przewalskis that were captured and bred in captivity. With such a small gene pool, it is highly likely that the Przewalski of today is somewhat different from the ancient Przewalski. Studies of blood typing indicate that the earliest domesticated horses would have appeared very similar to the Przewalski, but research into mitochondrial DNA suggests that the ancestors of the modern horse and the ancestors of the Przewalski were different.

HORSE FACT:
The first documented race at Newmarket took place in 1622; and there are to this day still two separate courses there, the Rowley Mile and the July Course, both owned by the Jockey Club.

Top
The Tarpan is officially extinct; scientists, however, have successfully bred Tarpans from Koniks.

Bottom
The Przewalski was on the verge of extinction before human intervention reestablished the breed.

HORSE FACT:
The smallest horse to win the Grand National was 15.2 hh. Battleship was ridden by Bruce Hobbs, who, at 17 years old and 6 ft 3 in (1.9 m), was both the youngest and the tallest jockey to do so.

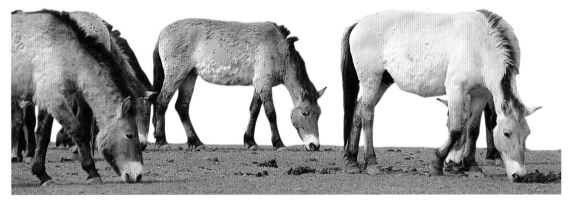

The Equus Family

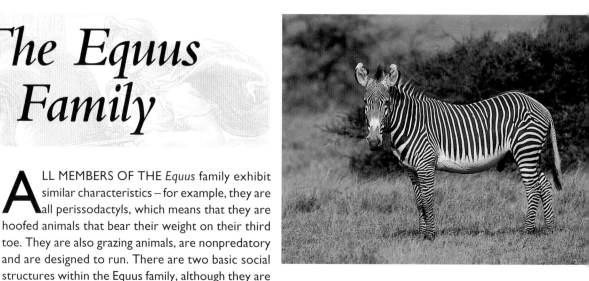

ALL MEMBERS OF THE *Equus* family exhibit similar characteristics – for example, they are all perissodactyls, which means that they are hoofed animals that bear their weight on their third toe. They are also grazing animals, are nonpredatory and are designed to run. There are two basic social structures within the Equus family, although they are all essentially gregarious creatures.

HORSE FACT:
Horses should have their teeth checked twice a year by a horse dentist or a veterinarian, who will rasp the teeth to ensure there are no sharp edges, and also check for loose or infected teeth.

HERDS
THE WILD OR FERAL horse demonstrates the first system, where they live in small herds or harems, consisting of a mature stallion with several mares and their young offspring. They form lasting bonds, and the harem remains for the most part a secure social structure. The mountain zebra and the plains zebra also exhibit this behavior.

TERRITORIES
THE SECOND SYSTEM is a territorial one, which is especially evident during the breeding season. The stallions defend a territory with a water supply and good forage, and mares enter into the territory to breed and raise their foals. The stallions are fiercely protective and immediately chase away any rival stallions.

All equids reproduce slowly; the gestation period ranges from eleven to thirteen months and they usually have only one baby at a time. Females are not sexually mature until they are two years old, and the males tend not to mature until they are at least three years old. Most equids can live to be twenty or more years old.

ZEBRAS
ZEBRAS ARE A member of the Equus family and can be divided into three separate species: Grevy's zebra, the plains zebra, and the mountain zebra. They all live in Africa.

GREVY'S ZEBRA
MOSTLY FOUND IN the semi-desert of Northern Kenya, Grevy's zebra is the largest of the zebra family, and typically has very narrow and closely spaced black and white stripes that extend all over the body and down to the hooves, with a white belly. They also have a black dorsal stripe with a small amount of white on either side. They have long legs, a large head, a long, upstanding mane with a black tip, their ears are large and rounded, and they bray like a donkey.

Top
This Grevy's zebra is the largest member of the zebra family.

Bottom
The zebra shares similar characteristics to the horse; they both are hoofed and bear their weight on the third toe.

The gestation period for the Grevy's zebra is 13 months and, once born, the mother and foal will stay close to the territorial stallion and a water supply. The foals will not drink water until they are three months old, and while the mothers go to the watering hole, the foals will remain with the territorial stallion who acts as the nanny. This is the only equid that displays this unusual type of behavior. The foals start to forage earlier than most equids, and consequently become more independent from their mothers at a younger age. The Grevy's zebra is continually under threat from human encroachment on their habitat.

THE PLAINS ZEBRA

THESE ARE FOUND mostly in Eastern and Southern Africa and are the most common of the zebra family. Smaller and sturdier than the Grevy's zebra, they have broader black and white stripes that cover the entire body and meet under the belly. They also have an upstanding striped mane and a unique call that is more bark-like. In some areas, the habitat of the plains zebra and Grevy's zebra overlaps and the two can be seen in mixed herds, although it is believed that they do not interbreed.

The plains zebra has several subspecies, of which the Grant's zebra is the most common and the best studied. The Chapman's zebra, one of the subspecies of the plains zebra, has distinctive markings of wide black stripes alternating with thinner, lighter ones – there are no stripes at all on the legs and over the hindquarters the stripes fade to a solid brown color.

Two other subspecies of the plains zebra, the Burchell's zebra and the quagga zebra, are now extinct. The pattern of stripes on each zebra is different, and this has allowed researchers to identify and study certain animals over a long period of time.

THE MOUNTAIN ZEBRA

THERE ARE TWO subspecies of the mountain zebra – the Hartmann's zebra and the Cape mountain zebra. They do not form large herds but do maintain the harem type social structure. Both species of the mountain zebras have been widely hunted and are now considered to be endangered species. They have a distinctive feature called the dewlap, which is a square flap of skin seen on the throat, most noticeable on the males.

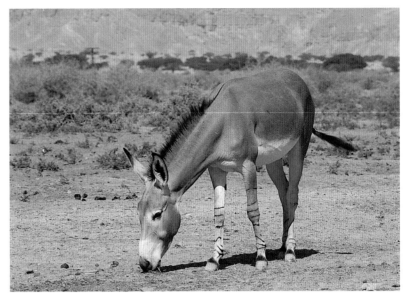

THE AFRICAN WILD ASS

THE AFRICAN WILD Ass is a greatly endangered species, with the only surviving subspecies being the Somali Ass, which lives in two small areas of Somalia and Ethiopia. The Somali Ass stands at approximately 51 inches high, its head is quite large in proportion to its body, and it is a uniform light gray color. It has a white muzzle, white rings around the eyes, and is white under the belly. It has an upright black mane, long black tipped ears, black rings around the lower parts of the leg, and occasionally a black dorsal stripe. The second subspecies of the African Wild Ass was the Nubian Ass, thought to have become extinct during the 1950s. The Nubian Ass is largely thought to have been the ancestor of the domestic donkey.

Top
The Somali wild ass is an endangered species.

Bottom
These Cape mountain zebra have maintained the traditional harem structure; one stallion will stay with several females, creating a secure and stable group.

ONAGERS AND KIANGS

BOTH ONAGERS AND Kiangs are asslike equids that live in Tibet, Mongolia, and across Asia, and can be classed as Asiatic asses. Kiangs grow thick long coats in the winter to protect them against the extreme cold of the high altitudes of their habitats. Their winter coats are brown, but when their summer coats come through they are a lighter, more chestnut-brown color with a dark dorsal stripe, and their bellies, lower legs, and muzzle area is generally pale. There are two subspecies of Kiang.

Onagers appear fairly similar to Kiangs, but are smaller and finer with a lighter colored coat. They have a donkey-type head with long ears and a short upright mane. There are approximately five subspecies of Onager.

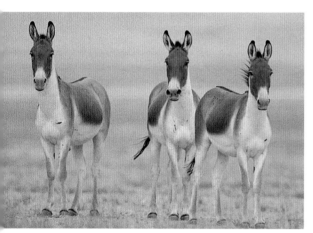

It is thought that the donkey reached Europe by 2000 BC, and that Christopher Columbus introduced the first donkeys to the New World in 1495. All over the world, the donkey became a popular work animal. They are low cost, low maintenance, and exhibit great endurance and stamina, consequently they are still widely used in poorer countries. Over the years donkeys have been bred for specific reasons – to improve the breeding of mules and for use as show animals and pets. They come in all shapes, colors, and sizes although the most common type of donkey is a gray dun color, with a light belly, muzzle and eye rings, a dark dorsal and shoulder stripe, and dark tips to the very long ears. The donkey has a characteristic very loud bray. Male donkeys are referred to as jacks and females are called jennets.

DOMESTIC ASS, DONKEY

THE DONKEY is thought to have been domesticated since at least 4000 BC in Egypt and became the Egyptians' and Africans' chief beast of burden. Highly versatile they played a significant role in the development of long distance trade, and were both easily trained and a useful food source. Their milk was commonly used for consumption as well as for a cosmetic product to promote white skin and they were also trained to tread seeds into the ground and to thresh the harvest.

Top and Center
Onagers (see top) originate in Tibet and Mongolia, and are similar in appearance to the Asiatic ass (see above).

Center Right
The ancestors of this miniature donkey have been used for a variety of draft and farm work.

Bottom
Donkeys have been domesticated for over 6000 years.

high-stepping action similar to the African Wild Ass. Generally, they are gray in color, with white bellies, muzzles, and eye rings, dark dorsal and shoulder stripes, and dark rings on the legs. There are also instances of brown, black, white, red, or spotted burros.

MULES AND HINNIES

A MULE IS THE off-spring of a cross between a male donkey and a female horse, and a hinny of a cross between a female donkey and a male horse. As a general rule, a mule has the front end of a donkey and the back end of horse – they have a donkey head, with long ears, an upright mane, strong legs, and horse-like hindquarters with a long tail. A hinny has the front end of a horse and the back end of a donkey. Mules and hinnies are nearly always sterile and it is generally easier to breed mules rather than hinnies.

Mules are more popular and are more commonly seen. They are exceptionally strong and have good stamina and, usually, a good, quiet temperament. Over the years, mules have been used for a variety of different jobs ranging from being the preferred mount of the clergy, pulling fire-fighting equipment, being used by the army for pulling the artillery and removing the wounded from the battlefield, working at the mines, and for agricultural work. Although the numbers of mules declined rapidly during the 1940s and 1950s, they are now enjoying a revival in America where they are used for pleasure riding and even jumping competitions. It is possible to breed mules of different sizes and weight, producing large and heavy-weight ones for draft work and lighter, more refined types for riding.

BURROS

BURRO IS THE Spanish name that is given to feral donkeys in the United States. The burros of today are most probably descendants of donkeys that were abandoned at the end of the mining era in the late 19th century. They are often smaller than the domestic donkey and have become adapted to living in the wild by becoming sleeker and quicker, with a

HORSE FACT:

Secretariat, nick-named Big Red, was one of the most famous American racehorses of all time. Born in 1970, out of Something royal and by Bold Ruler, Secretariat was voted Horse of the Year in America in 1972 and won the Triple Crown in 1973. He won at nine different racetracks, and out of his 21 starts, lost only five races.

Top Left
This burro is a feral donkey found in the United States.

Top Right
This mule is descended from a male donkey and a female horse; mules are invariably sterile.

Bottom
Donkeys are still used as light draft animals.

What is a Horse Breed?

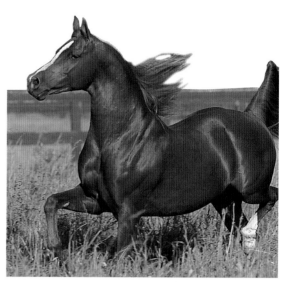

ALL HORSES are members of the *Equidae* family, belonging to the modern genus *Equus*; within this they are classified as *Equus caballus*. Under the heading of *Equus caballus*, the horse is further categorized into different breeds. The term 'breed' describes a group of animals that share distinctive inherited characteristics. Each breed has common ancestors, and therefore has a similar genetic makeup. There are natural breeds and artificial breeds.

NATURAL BREEDS

NATURAL BREEDS are animals that, through natural selection, have evolved characteristics specific to their survival within their differing habitats, and have passed these down to the next generations. An example of this is the Basque or Pottock pony, which grows thick whiskers on its top lip during the winter, protecting them from the prickly plants they live off when food is short. The Tarpan which, although a reconstructed breed, still retains the ancient characteristic of its winter coat turning white, which would have been a camouflage measure to protect against predators.

ARTIFICIAL BREEDS

MANY MODERN breeds, however, are largely artificial – man has selected certain characteristics from different individuals, and through a process of crossbreeding, has created horses with qualities suitable for specific purposes.

THE STUDBOOK

BREED SOCIETIES regulate the breeding process requirements and keep the studbook. The breed society has requirements in respect of size, conformation, action, and in some cases color, that need to be exhibited for a horse to be recognized as part of that breed. There are two types of studbook – open and closed. An open studbook allows a horse bred from parents of a different registered breed to be eligible for a particular breed, providing it meets the requirements. A closed studbook only allows a horse to be registered if both its parents are registered. This type of studbook keeps a breed much purer, and a good example of this is the Arabian studbook.

DEVELOPMENT OF HORSE BREEDS

HORSE BREEDS developed into groups as people bred animals to perform fundamental tasks. The heavy draft horse was developed for agricultural work, and became highly specialized in this field. An offshoot from this was the light draft horse, which was suitable for both light agricultural work and draft work. The harness, or carriage, horse evolved as a lighter, faster breed suitable for harness work and light haulage. The saddle horse, as its name suggests, was the ideal riding horse.

Today, there has been much interbreeding between the different main groups as the emphasis

Top

This Arab stallion comes from one of the most pure breeds as the stud book has discouraged breeding with other breeds.

Center

An example of a natural breed is the Pottock pony because it has developed in response to its environment.

Bottom

Crossbreeding has created horses that have qualities that are specific for certain competitions, this Hanoverian is excellent for dressage.

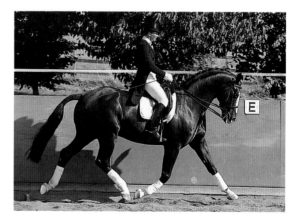

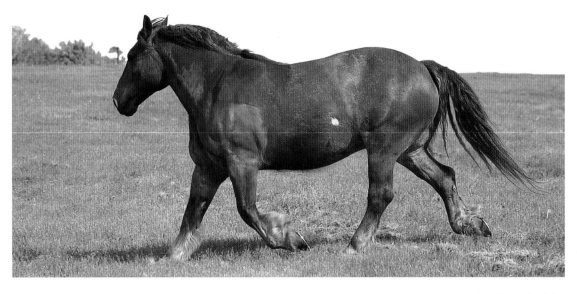

now is on producing good riding horses. Mechanization has largely done away with the need for draft and carriage horses, but these heavier breeds are often crossed with lighter breeds to produce excellent middleweight riding horses. There are also different pony breeds, and these too fall into different groups, with some breeds being more suitable for riding and some for driving, while many are 'ride and drive' breeds, such as the Welsh ponies, which excel at both.

The increased crossbreeding that is carried out today has led to the decline of many genetically isolated breeds. An example of this is the Strelets Arabian, which was absorbed in the development of the Tersk breed in the former U.S.S.R., and now does not exist as a breed in its own right. There are many young new breeds that have been developed, especially in the United States, and one of these is the American Walking Pony, which had its register established in 1968.

BLOOD TYPES

THERE ARE three different blood types that a horse may be described as having – hot, cold, or warm. The hotblooded horse is typified by the Arab or the Akhal-Teke. This is a fine-boned and fast horse, often with a fiery

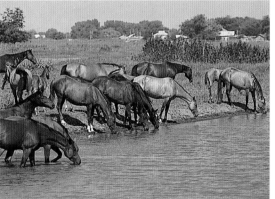

temperament. Having originated in desert climates, they are resistant to extreme heat and commonly have a very thin skin and coat. The coldblooded horse originated in Northern Europe and is typified by heavy draft horses such as the Suffolk Punch or the Shire. They are big, strong-bodied horses with a calm and docile temperament. The warmblood is a mixture of the two, with ancestors from both the hot and cold blood types, and is typified by the Trakehner and the Danish Warmblood.

DEFINITION OF A TYPE

THERE ARE various types of horse or pony that are not breeds, but do have specific characteristics. A 'type' is a horse or pony that is suitable for a particular job, but can in fact be of any breed. For example, a hack can be any well-proportioned horse with quality, often with a high degree of Thoroughbred blood. Similarly a hunter can be any horse that hunts, although they do uniformly need the qualities of stamina and bravery. Often when assessing a horse, it is quite straightforward to say what type it is without knowing its specific breed.

Top
Certain breeds, such as this Suffolk Punch, were developed for heavy agricultural work and are coldblooded.

Center
These Akhal-Teke horses are hotblooded, having originated from a desert climate.

Bottom
This Dutch warmblood is a mixture of the hot- and coldblooded breeds.

The Cob

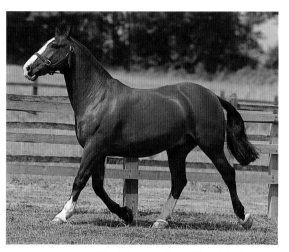

THERE ARE TWO breeds of cob, the Welsh Cob and the Norman Cob, but there is also a type of horse called a cob, and they mainly come from Ireland and England. These types do not have a set breeding pattern, and can be produced by various different crosses; they do, however, have similar characteristics. The cob is quite unmistakable and is easily spotted and there are classes at many of the top shows in England, specifically for the cob, divided into lightweight, heavyweight and working cob. Generally, a cob is the result of an Irish Draft cross, although some cobs are pure Irish Draft, some are bred from Welsh Cobs, and some are derived from a heavy horse crossed with a Thoroughbred or a Cleveland Bay.

This page
These horses all display archetypal cob qualities, such as an attractive face and short, arched necks.

APPEARANCE

IN APPEARANCE, the cob should have an attractive and quality head. The cob often exhibits a very sensible and honest facial expression, and indeed these are qualities much sought after. They tend to have short, arched necks which should be in proportion to the body, and invariably have their mane hogged, which is when the hair is clipped completely off. This enhances their attractive topline. Cobs are of a sturdy and solid build, and have a broad and deep chest with good spacing between the front legs.

They should be compact through the barrel, with wellsprung ribs and great depth of girth, which can make their short legs appear even shorter. The hindquarters are muscular, broad, and well rounded, and the legs, although short, have very good bone and large flat joints. Cobs often used to have their tails docked, which was was common practice on horses that were used in harness to prevent the tail from becoming entangled, but it was also used for

cosmetic reasons. Docking has been illegal in the U.K. since 1948.

Sometimes, a horse that is not actually a cob is described as having 'cobby' conformation, meaning that it is thickset and powerful-looking, with a compact body and short legs. Generally, cobs are upright in the shoulder, which gives rise to a relatively short, high stride. They usually average in height approximately 15 hh but can sometimes be larger, although for entry into showclasses they must be under 15.1 hh, and they can be any color.

QUALITIES OF THE COB

COBS ARE GREAT weight carriers, and in spite of their relatively small size, a good cob should be able to carry a man riding all day. They are built as 'power houses,' and have conformation resembling the heavy horse breeds more than the light horse breeds. They are built for strength rather than speed, but like an old Rolls Royce, once a cob is in full throttle, it can go surprisingly fast. They are extremely versatile and often make excellent 'family' horses, having the calm and kind temperament to allow children and adults alike to ride them.

They are still frequently used in harness, and a good cob in harness is a highly attractive sight. Cobs can jump, and will jump out hunting all day. They usually have sensible and calm personalities and gentle temperaments.

HORSE FACT:

Weaving is the name given to a particular type of stable vice, where the horse stands in its box and sways rhythmically from side to side. Stress, boredom, tension and excitement are often triggers for weaving, and once a horse has learnt to weave it is difficult to completely break the habit.

The Hack

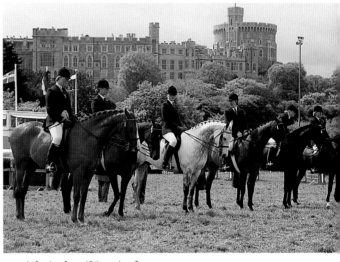

A HACK IS a supremely elegant type of showhorse. The majority of hacks are actually Thoroughbreds, or Thoroughbreds crossed with Anglo-Arabs, and are therefore mostly hot-blooded. However, a hack must not show overtly Arabian characteristics, which are frowned on in the ring. They are generally between 14.2 hh and 15.3 hh, and can be any solid colour. The hack is the epitome of good breeding, perfect conformation, and manners – the aristocrat of the equine world!

APPEARANCE

IN APPEARANCE, it should have a head of exceptional quality, with a straight profile, no convexity or concavity. The neck should have 'good length of rein' and should be elegant and well defined. They should be sufficiently broad and deep through the chest, but not too broad, and should have perfect conformation of the shoulders. The shoulders need to be nicely sloping to allow for the distinctive free flowing, low, graceful action that is synonymous with the hack. They should be neither too long, nor too short through the back, being perfectly proportioned, and should have a good depth of girth and a wellsprung rib cage. The hindquarters should be nicely rounded, but not excessively heavy.

They should have good, clean leg, free from any bumps or scarring. The legs should not be too fine, and should have at least eight inches (20 cm) of bone below the knee. The hind legs are notably straight with a prominent second thigh. In the showring, the hack is expected to perform calmly with great presence and poise.

QUALITIES OF THE HACK

DURING THE 19th century there were two types of hack: the covert hack and the park hack. They were quite different. The covert hack was used to ride to the hunt meets and would have been a Thoroughbred type with elegance and quality. They needed good manners and good smooth paces. Not used for hunting, however, they did not need to have stamina, strength, or be able to gallop. The covert hack no longer exists, but the closest show class for it would be the riding horse class. While these horses are truly admirable, they do not have to exhibit quite the same elegance and grace of the show hack. The park hack was the horse that socialites would ride in fashionable places like Rotten Row in London. They had to be supremely well mannered, with a presence and a 'look at me' quality, to best show off their riders.

The modern equivalent of the park hack is the show hack and there are different show classes for these horses. The show hack can be displayed individually or in pairs, which is particularly impressive. For the single hack, the classes are divided into small hack, which is 14.2 hh to 15 hh; large hack, which is 15 hh to 15.3 hh; and lady's hack, which is 14.2 hh to 15.3 hh, and is ridden sidesaddle. The hacks are expected to show walk, trot, and canter, an individual demonstration, and to be ridden by the judge.

HORSE FACT:
Most horses should be reshod every four to six weeks, although factors such as the amount of road-work the horse is doing, and hoof growth rate, which will vary from horse to horse, affects this.

This page
The hack is considered the most majestic of horses for its excellent character, disposition, and conformation.

The Hunter

HUNTERS VARY QUITE considerably in appearance but they do all need common characteristics such as stamina, athletic ability, courage, and sense. It is widely considered that many of the best hunters are produced in Ireland. They are likely to be Irish Draft crossed with Thoroughbred or Cleveland Bay and may even have some pony blood. Hunters vary from region to region, depending on the countryside in which they are ridden. In largely flat, grassy areas the hunter needs to have a higher proportion of Thoroughbred because the speed of the hunt is that much faster. In areas of heavy clay ground, or rough land, more of a half-breed is required.

QUALITIES OF THE HUNTER

A HUNTER needs to be a good weight; that is, he needs to have plenty of bone and be strong and sturdy. However, he also needs to be built for speed and should have powerful hindquarters. A major criterion for a hunter is stamina. Many enthusiasts hunt at least once or twice a week throughout the winter and often in bad weather. The hunter needs to be a horse that copes with this workload, which is considerable when bearing in mind the long days and fast galloping that go with hunting. They need to be particularly sound in

HORSE FACT:

'If wishes were horses, then beggars would ride,' is an old saying meaning that if wishes came true, then even the poorest would have everything they wanted.

This Page
This hunter is typically athletic and courageous.

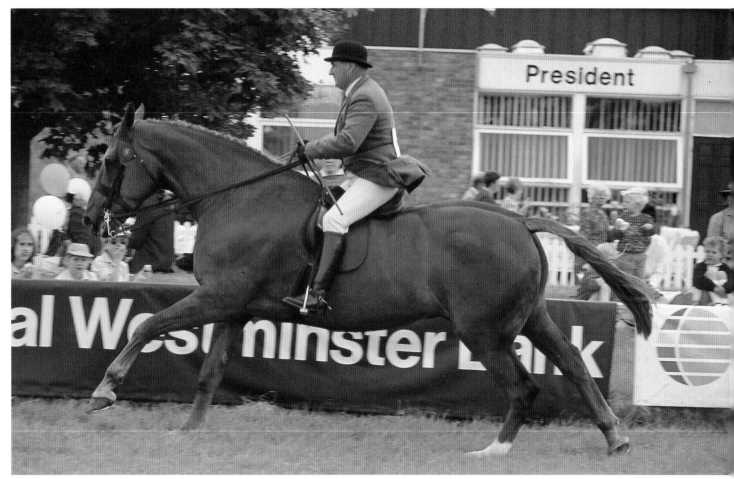

wind and limb to stand up to the rigors of the job. Sometimes people take two horses to a meet and swap horses halfway through the day – this is especially useful when hunting over thick and heavy ground, which tires even the fittest horse.

APPEARANCE

HUNTERS SHOULD have an attractive head with an intelligent, bold eye. The perfect hunter has a head that shows the quality of the Thoroughbred, with the sense of the Irish horse.

The ideal hunter should have a long neck, to give good length of rein, and a broad and deep chest. The body should be compact and deep through the girth with wellsprung ribs. Conformation of the shoulders needs to be good to allow for a long, ground-covering stride. The hindquarters should be muscular and reasonably broad and the hind legs need to have a well-muscled second thigh. They need to have strong, tough legs which stand up to galloping and jumping. The hunter needs to be athletic and bold to cope with the fences it may meet – this is very true of the Galway Blazers, an Irish hunt

which is famed for its daredevil jumping. It is very important for the good hunter to have excellent manners, to stand when asked, open and shut gates, and stop quickly if need be. They range in height from 15 hh to 17 hh to suit their rider and there are also many ponies that hunt admirably.

THE SHOW HUNTER

IN THE SHOWING world, there are show classes for light-, middle- and heavyweight hunters, as well as for working hunters. The light-, middle- and heavyweight show hunter classes are for horses that are full of qualities, similar to those of the hack class, but with more substance and bone. The working hunter class is aimed for horses that actually hunt. They are required to jump a course of fences as part of the competition and may be of a lower quality than the show hunter with more substance and bone. There are also show classes for working hunter ponies, generally divided by height. Working hunter show ponies have, like the horses, extreme quality, but, of course, many ponies of all shapes and sizes can be seen out on the hunting field.

Above
The powerful hindquarters of this hunter powers it forward, making it a fast and strong breed.

HORSE FACT:
Horses, like humans, have the five main senses, hearing, seeing, smelling, tasting and feeling; but it is generally considered that they also have a 'sixth' sense. This is their ability to sense imminent weather changes, danger, and also to pick-up on human feelings.

The Polo Pony

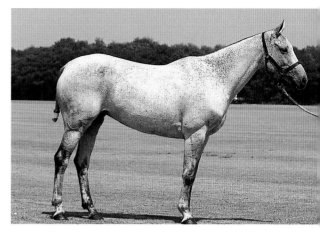

ALTHOUGH THE POLO PONY is not a breed, it is characterized by specific qualities suitable for playing the game of polo: stamina, courage, agility, speed, balance, and responsiveness. Officially the polo pony is actually often no longer a pony; since the abolishment of the height restriction laws at the end of the First World War, the polo pony has become larger, and now averages around 15.1 hh. They are extremely tough, fast, and dexterous, and are usually a Thoroughbred cross, sometimes with Quarter Horse or Criollo blood.

HORSE FACT:
The first road-coaches were designed by Hungarian craftsmen in the late 15th century in the village of Kocs, and these coaches were subsequently called Koksi.

This Page
Although the polo pony is not a specific breed, they display similar characteristics that make them excellent players on the pitch.

THE GAME OF POLO

POLO IS an ancient game, being documented as far back as 525 BC, when it is thought to have been developed by Darius I, the third King of Persia who used his greatly admired Persian horses for the game. Polo was introduced to India by Muslims from the northwest and quickly became popular. The British became acquainted with the game in India, and in 1859 the Silchar Club was formed which is now the oldest polo club in the world. The original ponies used for the sport in India were the Manipuri ponies which were very small, around 12 hh on average, but incredibly tough. The British introduced the game to Europe and the Americas, and it is now the Argentinians who are famous for their skill at both the game, and at producing top-class polo ponies, which can change hands for huge sums of money.

HORSE FACT:
The adult male horse has 40 teeth with the possible addition of wolf teeth; the adult female horse has 36 teeth, again with the possible addition of wolf teeth.

QUALITIES OF THE POLO PONY

ALTHOUGH THE PONIES are now larger than they once were, it is still important for them to retain the short and quick stride of a pony. They need to turn quickly and be very responsive – these qualities are often displayed in the American Quarter Horse, which is why they have started to be used in pony breeding. Extremely tough, wiry, intelligent, and a good polo pony can anticipate its next move on the pitch.

APPEARANCE

IN APPEARANCE, they often have a head which reflects the Thoroughbred in them, with a lean and muscular neck, and the mane always hogged to prevent it getting tangled with the polo stick. Often they have prominent withers, and are lean and wiry through the body. The quarters are muscular, and the legs straight and tough. They tend to be short in the cannons with good bone and excellent hard feet. They can be any color.

The Riding Pony

THE RIDING PONY is the pony equivalent of the hack. In appearance and conformation, they should appear as a scaled-down hack, but should also retain some pony characteristics, and should be simply a small horse. The breeding of top-rate riding ponies has become something of a science, to produce the right combination of grace, quality, and freedom of movement, combined with pony features. The riding pony is a result of a cross between native pony mares such as the Welsh, Dartmoor, or sometimes Exmoor breeds with a small Thoroughbred, or Arab stallion. One notable Arab stallion, called Naseel, has contributed significantly to the development of the riding pony.

APPEARANCE

THEY SHOULD be very elegant and graceful and have perfect manners. The ponies are typically beautiful in appearance with correct and proportioned conformation and small intelligent heads, with large, wide-spaced eyes. The head must retain pony characteristics. They should be deep through the girth, compact and well-muscled quarters. The legs should be clean and strong with short cannons. They should have freeflowing action from the shoulder with well-

engaged hocks behind. They are divided into three categories based on their height: 12.2 hh and under, up to 13.2 hh and up to 14.2 hh, and can be any whole colour. The French also produce a riding pony, called the Poney Français de Selle, although it does not have quite the same quality and refinement as the English riding pony. The French riding pony is currently being produced as more of an all-round pony club pony, and is a very useful type.

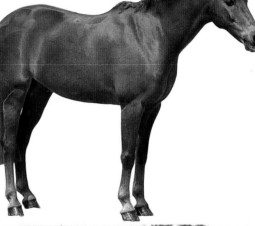

HORSE FACT:
A 'dark horse' is the name given to an unexpected winner; this is especially relevant in politics when a 'dark horse' is a candidate considered unlikely to be nominated by their party, but who might be chosen if the party leaders cannot agree on a better candidate.

This Page
The riding pony is a beautiful-looking pony which has been influenced, in particular, by the Arab.

HORSE FACT:
The infamous jump at Aintree called Becher's Brook was named after Captain Becher, who fell at the jump during the inaugural Grand National.

The Pony

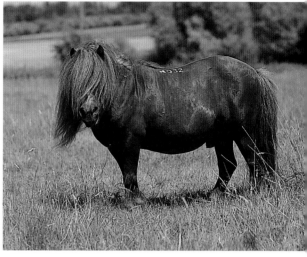

PONIES ARE DEFINED in two ways — either by height alone, or by height, conformation, and characteristics typical of a pony. Horses and ponies are measured in hands, each hand being equivalent to 4 in (10 cm). A pony can be classified as any equine that stands under 14.2 hh (hands high). A height of 14.2 hh or over indicates a horse. However, it is advisable to take into account conformation and characteristics when looking at horses and ponies. In some cases a small horse that measures under 14.2 hh is still very much a horse, and not a pony. Regardless of their size, for example, the Arabian is nearly always considered to be a horse, partly due to their fiery temperament and horselike conformation.

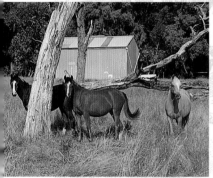

GROWTH OF PONIES

BREEDS FROM PARTICULARLY poor environments, where there is a harsh climate and low-grade fodder, can exhibit stunted growth and there are some which although very small in height, would grow considerably under more favorable conditions. Some breeds feature in this section on account of their height only. The Caspian, for example, which does not exceed 12 hh, but is in fact a miniature horse.

Ponies have distinctive conformation and are generally deeper through the body in relation to their height and of a more stocky build. They often have rounded withers and a short, strong back. They are mostly short in the leg, with the cannon bone, in particular, being

Top

The growth of the Shetland pony is stunted because it originally came from a very harsh environment.

Above and Right
Ponies still roam wild in herds in Australia and on the island of Chincoteague, off the coast of Virginia, U.S.A.

short and dense, and this, combined with the sturdiness of their build, makes them able to carry considerable weight compared to their size.

Most ponies have distinctive heads, being usually wide through the forehead with a tapering muzzle and small, alert ears. In winter a pony grows an exceptionally thick coat and most have a thick protective mane and tail. Ponies are singularly sure-footed with a highly developed sense of self-preservation and often appear to have more personality than many horses. They tend to have a higher knee action than a horse and generally have a placid temperament, which makes them very suitable for children.

Over the centuries, ponies have been used for a huge variety of jobs from pulling Roman chariots, to working in the mines, going to war, joining the circus, driving and driving competitions, and, of course, for riding. The pony is highly adaptable and throughout history has done it all.

American Shetland

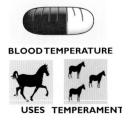

BLOOD TEMPERATURE

USES TEMPERAMENT

THE FIRST SCOTTISH Shetland ponies arrived in America in 1885, when 75 of them were imported by Eli Elliot. These ponies formed the basis for the development of the American Shetland, which now bears little resemblance to the original Shetland pony. Breeding of the American Shetland centers on the state of Indiana, although the ponies quickly grew in popularity and can now be widely found all over the United States.

By crossbreeding the Shetland pony with Hackney ponies, and later with small Arabians and small Thoroughbreds, a new and distinct type began to emerge. In 1888, the American Shetland Pony Club was formed and the club now keeps two studbooks – Division A and Division B. Division A is maintained to register pure Shetlands, while Division B is open to ponies with one parent from Division A and the other parent being either a Hackney pony, Welsh pony or a Harness show pony. Typically these small ponies are full of quality and character, resembling the Hackney pony in build and stance while maintaining the Shetland pony's endurance and toughness as well as their luxurious mane and tail. They are extremely versatile ponies and, although they are ideally suited to harness work, they also make excellent children's ponies.

The American Shetland can be seen competing in any manner of competitive fields, including show classes under both English and Western saddle, jumping, dressage, gymkhana, harness racing and various driving competitions. The breed is now extremely popular in the United States and top class ponies will sell for phenomenal amounts of money.

HORSE FACT

Four-horse chariot races were first introduced to the Olympic Games in 684 B.C.

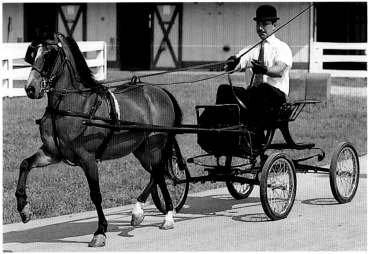

In appearance, the American Shetland pony has an intelligent and fine head, which is often long and not of typical pony character. They have muscular arched necks that are set and carried in a similar way to the Hackney pony. They tend to be quite long and narrow through the back, with broad muscular hindquarters, and unusually high withers for a pony breed. The shoulders have a good slope, which allows for their extravagant action of a similar nature to the Hackney pony. Often they are long and fine in the leg, with long cannon bones, and retain the Hackney pony stance with the hind legs stretched out behind the body. Any solid color is acceptable within the breed and they stand at anything up to 11.2 hh.

Top

The American Shetland bears little resemblance to its hardy ancestor from the Shetland Islands in Scotland.

Center and Bottom

Often used in driving competitions, the American Shetland has the stance and gait of a Hackney pony.

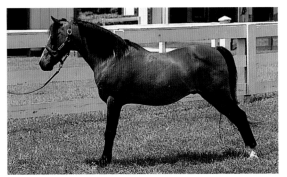

183

BLOOD TEMPERATURE

USES TEMPERAMENT

American Walking Pony

┌───┐
│ BREED INFORMATION │
│ NAME American Walking Pony │
│ APPROXIMATE SIZE Up to 14 hh │
│ COLOR VARIATIONS Any solid color │
│ PLACE OF ORIGIN United States │
└───┘

THE AMERICAN Walking Pony, which has often been described as a 'dream walking,' is a highly attractive larger pony of Arab type. Joan Hudson founded the registry of this breed in 1968. Although the breed exhibits a fixed type and characteristics, it took nearly 14 years of crossbreeding to come up with the right combination. The principal aim was to produce a larger pony with great quality and beauty for performance in the showring.

The eventual foundation cross was a registered Tennessee Walking Horse and a registered Welsh pony. The Welsh mare, Browntree's Flicka, was highly influential in the early development of the breed and is Number 1 on the breed register. Her son, BT Golden Splendor, who is an excellent example of the type's finest qualities, is listed as Number 5 on the register, and is the first registered stallion. The American Walking Pony combines the best features of both parent lines – they are born with natural gaits, inherited from the Tennessee Walking Horse and the excellent qualities of the Welsh pony. The American Walking Pony has unique gaits which include the Pleasure Walk,

Merry Walk and Canter, although they are seven gaited and are worth comparing to the champion Walking Horse, Roan Allen. The Pleasure Walk is a four-beat gait, faster than a normal walk, but slower than a trot. The Merry Walk is a four-beat gait, but much faster and accompanied by a head-nodding movement, with the pony nicely together with its hocks under it and its head carried well. The canter is smooth and collected, and all the paces are unhurried and comfortable to sit to.

The American Walking Pony is highly versatile and has proved its mettle in jumping, dressage, showing and pleasure riding, as well as driving. They have very attractive and fine heads, which do not have particular pony characteristics. The neck should be of good length, muscular, and set and carried well. The shoulders are nicely sloping allowing for good freedom of movement, the chest should be broad and deep, the back compact, and the quarters muscular. Typically, they have great presence and quality, they can be any solid color, and have a height limit of 14 hh.

HORSE FACT:

An act was passed in 1739, during the reign of George II, banning weak horses and ponies from races.

Top

The American Walking Pony looks similar to an Arab, with a fine and delicate head.

Left

These ponies have a very similar gait to the Tennessee Walking Horse.

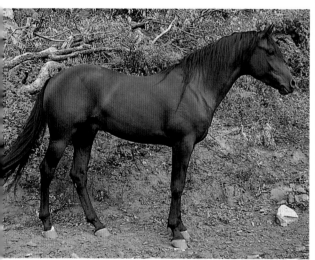

BLOOD TEMPERATURE

USES TEMPERAMENT

BREED INFORMATION

NAME	Ariègeois
APPROXIMATE SIZE	13.1–14.3 hh
COLOR VARIATIONS	Always black
PLACE OF ORIGIN	France

Ariègeois

ALSO KNOWN as Cheval de Mérens, this breed originates in the mountainous region of France along the Eastern Pyrenees and takes its name from the river Ariège. A very ancient breed, it could possibly be a direct descendent of the horses depicted in the wall paintings of Ariège some 30,000 years ago. The Ariègeois have been influenced by infusions of oriental blood, which has contributed towards their spirit, stamina, and energy. They have been selectively bred since 1908 in an effort to maintain their true qualities, and in 1948 their studbook was opened by the Syndicat d'Elevage du Cheval de Mérens. As recently as 1971 there were infusions of Arab blood to improve and upgrade the quality of the stock, which is regulated by the French National Stud at Tarbes.

Incredibly tough ponies, they are very well-suited to the mountainous region of their homeland. They are seemingly totally resistant to cold, although suffer in the heat, and are able to traverse the most slippery and treacherous of mountain paths with ease. They are rarely shod, having hard hooves with dense horn and are extremely frugal feeders, surviving on minimal rations. They are popular as pack, riding, draft, and farm workers in the mountainous, steep areas, where tractors and vehicles are unable to function, and they are also increasingly being used for pony trekking. They have very kind and forgiving temperaments and are suitable for children and novices.

In appearance, the Ariègeois is very similar to the English Dales and English Fell pony, while also bearing a resemblance to the black Friesian horses. They have an attractive head, with small alert ears, an expressive face and an abundance of thick coarse forelock and mane. The neck is short and muscular but carried well. They are stocky through the body with a deep and wide chest, reasonably straight shoulders, a long and muscular back, flat withers, a sloping croup, and a low-set, thick tail. The legs are short and muscular, and they are often cowhocked behind, which is a feature of mountainbred horses and ponies. The coat is always black, usually without any white markings, and the hair is thick and coarse. They stand at between 13.1 hh and 14.3 hh.

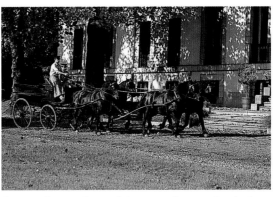

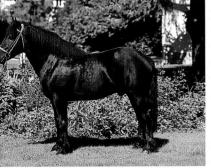

HORSE FACT:
In 1875, 1,000 tones of horse manure was being removed from the streets of London every day.

Top and Center
These hardy little black ponies work very well in teams and are extremely agile.

Left
The Ariègeois pony has a heavy forelock and mane, and a short, strong neck.

BLOOD TEMPERATURE

USES TEMPERAMENT

HORSE FACT:
Crossbreeding often helps to improve or eradicate a known weakness in a breed.

Assateague and Chincoteague

BREED INFORMATION	
NAME	Assateague and Chincoteague
APPROXIMATE SIZE	12 hh
COLOR VARIATIONS	Any color, often pinto
PLACE OF ORIGIN	United States

THE ASSATEAGUE and Chincoteague are effectively the same pony, found mainly on the Island of Assateague, and on the neighbouring Island of Chincoteague, off the coast of Virginia, America. The ponies live a feral existence, and there is some mystery surrounding how they came to be there. One interesting theory is that they are descendants of horses that survived a shipwreck during

the 16th century and swam ashore to the islands. It is more likely that they are the result of Spanish and North African horses that escaped, or were abandoned, in early colonial times, or that they were deliberately taken out to the islands by the colonials after the introduction of horse taxes on the mainland in 1669.

Although the ponies are small in stature, standing at an average of 12 hh, they do bear some horse-like characteristics, especially in the head and in the length of cannon bone, which suggests that they are descendants of early horses. Their existence did not become widely known until the 1920s, but now the ponies fall under the protection of the Chincoteague Fire Department, which is responsible for managing the islands. They gained in popularity in 1947 with Marguerite

Henry's classic children's book, *Misty of Chincoteague*. In 1961, Twentieth Century Fox made the film, *Misty*, and ever since, the ponies have received a steady stream of visitors to their island. To keep the numbers of ponies at a manageable level, every year the Fire Department organizes a four-day pony penning festival. The mares and foals are swum across the water from Assateague to Chincoteague and are auctioned off to the public. Money raised is then plowed back into the welfare of the ponies.

Until the 1920s, the ponies were in a poor state due to both interbreeding and the harsh environment. Notable conformational defects included extreme narrowness through the chest and body, large heads, and deformed legs. More recently, the introduction of Shetland and Welsh Pony blood, as well as Pinto blood has had an overall improving effect. In appearance, the Assateague pony has a long head, a long, poor neck, a long and narrow back, and a sloping croup. The shoulder is straight but the legs tend to be sturdy and strong. They can be any color, and are often pinto.

Top
Shetland and Welsh pony blood has been introduced to improve these two little-known breeds.

Right
The ponies are feral and their numbers are carefully maintained at a sustainable level.

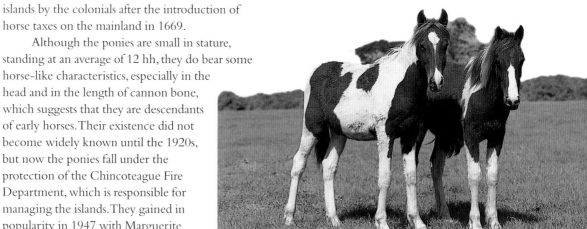

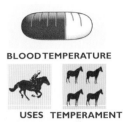

BLOOD TEMPERATURE

USES TEMPERATURE

BREED INFORMATION	
NAME	Australian Pony
APPROXIMATE SIZE	12–14 hh
COLOR VARIATIONS	Mostly gray, can be any solid color
PLACE OF ORIGIN	Australia

Australian Pony

AUSTRALIA HAS no indigenous breeds of horse or pony, so development of their breeds relied on importing from other countries. The first horses and ponies to arrive in Australia were on the ship First Fleet which arrived at Sydney in 1788 from South Africa. From 1803 onward, the increasing importation of the hardy Timor pony from Indonesia followed. This provided the basis of the breed, which was then subjected to a diverse range of sources through its development. Most notable influences on the breed were those of the Welsh Mountain pony, the Hackney pony, Arabian, small Thoroughbreds, the Timor, Shetland, Highland and Irish Connemara. Two Exmoor ponies feature in the development of the breed – Sir Thomas and Dennington Court – and during the mid-1800s a Hungarian stallion called Bonnie Charlie was used to progress the breed.

The Australian Pony of today clearly shows how early breeders concentrated on using native British stock, as well as maintaining the quality of the Arab. The influence of the Welsh Mountain pony is particularly evident, and the Welsh Mountain, Dyoll Greylight, is generally considered to be the founding sire. Dyoll Greylight arrived in Australia in 1911 and passed on his incredible beauty and conformation to his progeny. The Australian Pony Stud Book Society formed in 1931 and there are now over 27,000 ponies registered.

The Australian Pony is a first-class children's pony with quality, presence and ability. They generally have excellent conformation and a good length of stride for a pony breed. They excel in all areas of riding, including dressage, jumping, pony club eventing, gymkhana and mounted games, showing, and competitive driving. They have remarkable temperaments and are ideal for children, small adults, and novices alike.

In appearance, they have a quality pony head and large, kind eyes. The neck should be well set and arched, with very well conformed sloping shoulders, and a short, straight back. The chest should be deep and well developed, the barrel round, and the quarters sloping. The legs are short, with a strong and dense cannon bone, and are mostly well put together. Typically most Australian ponies are gray although any color is allowed, apart from skewbald and piebald, and they usually stand between 12 hh to 14 hh.

Left
The Australian Pony is a mixture of many breeds, including the Welsh Mountain Pony.

Bottom
Gentle in temperament, these ponies make ideal rides for children and nervous novices.

BLOOD TEMPERATURE

USES TEMPERAMENT

Avelignese

BREED INFORMATION

NAME	Avelignese
APPROXIMATE SIZE	Up to 14.3 hh
COLOR VARIATIONS	Always chestnut, flaxen mane and tail
PLACE OF ORIGIN	Italy

THE AVELIGNESE TAKES its name from Avelengo, an area of the Alto Adige, which has been an Italian region since 1918. The Avelignese is Italy's version of the Haflinger, and the two breeds bear a striking resemblance to each other. They are both believed to be related to the ancient Avellinum-Haflinger and are also both traceable to the stallion El Bedavi. El Bedavi was an oriental stallion bought by the Austrian Commission in Arabia, and although the Avelignese is considered a coldblood, and exhibits many coldblood characteristics, they do owe a debt to oriental influences.

The Avelignese is widely bred through Tuscany, Emilia, and Central Southern Italy, although it is found throughout Italy and is considered to be the most prolific Italian breed. They are extremely tough and enduring, due in part to the rocky, mountainous environments in which they have developed. They are larger than the Haflinger, both in height and stature, and are a good middleweight type. The Avelignese is very versatile, and used in harness for working the land in regions inaccessible to motorized vehicles. They are very surefooted over rough country, and have exceptionally hard and well-formed feet. They are often used both for pack purposes and for pony trekking.

Their quiet, unflappable temperament, typical of the coldblood, makes them ideal for children, novice, or nervous riders. Their extremely muscular frame makes them capable of carrying adults, and they make an ideal family pony. Although they have a fairly massive build, they are not unattractive and generally have good conformation.

In appearance, the head is fine with quality; they are broad across the forehead, with the head tapering to a fine muzzle. They are thick through the neck, which is short and very muscular. The shoulders are powerful and are built to be suitable for carrying a harness collar. The shoulder is quite upright, and the stride fairly short. They are broad through the chest and have a compact and wide back. The hindquarters are muscular and rounded. Conformation of the legs is generally good and they have hard dense bone, well-formed joints, and some fine feathering around the fetlocks. They are chestnut with a flaxen mane and tail in color and can stand at up to 14.3 hh.

HORSE FACT:
The first equid was *Hyracotherium*, also known as *Eohippus*, which translates as 'dawn horse'.

Top and Center
Avelignese ponies have powerful shoulders and muscular frames, which makes them ideal for farm work.

Right
With their calm nature, these versatile ponies are well-suited to carrying children on gentle rides.

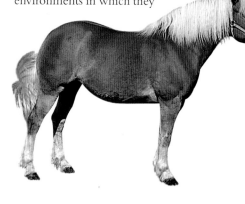

```
 o o o o o o o o o o o o o o o o o o o o o o o o
           B R E E D   I N F O R M A T I O N
```

NAME	Bali
APPROXIMATE SIZE	12–13 hh
COLOR VARIATIONS	Mostly dun
PLACE OF ORIGIN	Indonesia

Bali

BLOOD TEMPERATURE

USES TEMPERAMENT

THE BALI PONY is based on very ancient stock although there is little known about their ancestry. Various theories regarding their background include one put forward by Groenveld in 1916, which concludes that the ponies probably developed from ancient stock, taken to Indonesia by the Chinese as early as the sixth century. If this was the case, the Mongolian horse would be largely responsible for the early characteristics of the breed and there are present, even now, some indications of Mongolian blood in their background.

Some breeds of Indian horse were taken to Indonesia but the exact breeds are unknown; then, during the 18th century, the Dutch were responsible for importing various oriental strains to Indonesia. Although rather vague, this combination of oriental and Mongolian blood is generally considered to be the most likely base for the Bali pony.

The Bali pony, which lives on the island of Bali, has not been selectively or consistently bred to produce any kind of aesthetic or athletic qualities. They do, however, perform the necessary functions of life required by the local people, and they are used in the transportation of stones and coral from the beaches, to be used as building materials. They are extremely strong in comparison to their size and are also used for riding, and for trekking and sightseeing by tourists.

They are very self-sufficient, probably through necessity, and can survive on minimum rations, with minimum care. They also have notably hard, tough and sound legs and feet, are rarely shod, and rarely go lame. Their appearance is primitive and often dun-colored with a dorsal stripe, wither stripes, and zebra stripes – all indications of their ancient roots. They invariably have an upstanding black mane of coarse hair reminiscent of the Mongolian pony.

Their appearance has often been likened to that of *Equus Przewalskii Przevalskii* Poljakoff. The Bali pony generally does not have the best conformation as its head is often large and rather coarse, though nonetheless full of pony character. The neck is of a reasonable length, the shoulders are rather upright lending to a short stride. They are not particularly wide in the chest or the back, which is quite short, and they have a sloping croup. They tend to range in height from 12 hh and 13 hh.

HORSE FACT:

*My horse be swift in flight.
Even like a bird;
My horse be swift in flight.
Bear me now in safety.
Far from the enemy arrows,
And you shall be rewarded
With streamers and ribbons red.*
Sioux warrior's song to his horse.

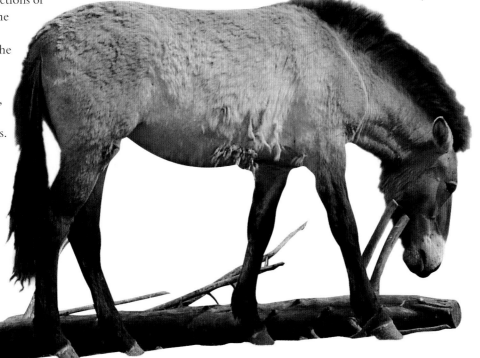

Left
The Bali pony is very similar in appearance to the Przewalski Horse, and may also have Mongolian blood.

BLOOD TEMPERATURE

USES TEMPERAMENT

Bardigiano

THE BARDIGIANO IS based on ancient stock and is probably related to the Abellinum breed of Roman times, to which the Haflinger and Avelignese can also be attributed. The Bardigiano developed over the years in the Northern Appenine region of Italy, and is especially adapted to its rough mountainous habitat. The Bardigiano has much in common with both the Avelignese and the Haflinger, although it is the least publicized of the trio, but is likely that the Bardigiano has been influenced at some point by the Avelignese which, in turn, is traced back to the oriental stallion El Badavi. The Bardigiano has a notably oriental type head, but also appears to have similarities to the native English breeds of the Exmoor and Dales ponies and the Asturcon pony of Northern Spain.

During the First and Second World Wars, Bardigiano mares were widely used in the production of first-class mules, and this actually had the effect of reducing the numbers of pure-bred Bardigianos. A number of stallions from a diverse range of breeds were introduced to the stock after 1945, but this is now considered to have been a mistake. The breed began to deteriorate and lose some of its defining characteristics. In 1972, a committee was formed to try and re-establish the old breed and this was successfully done.

Bardigianos are useful and attractive ponies and, as with all mountain breeds, they are very tough and enduring, as well as being extremely surefooted. They have very good, quiet temperaments, making them excellent for trekking, and as children's ponies. Due to their robust frame and build, they are also suitable for farm work, light draft work and for pack work.

In appearance, they have fine pony heads of oriental type, with intelligent eyes and small, pricked ears. They are extremely muscular through the neck, which is thickset and arched, and has an abundance of mane. The shoulders can be upright, but are immensely powerful; they are short through the back, with a rounded barrel and rounded and muscular hindquarters. The legs are generally short and strong with broad joints, short cannon bones, and hard hooves. They can be bay, brown, or black, with minimal white markings, and can stand up to 13 hh.

Top
The Bardigiano has been the subject of recent efforts to improve the purity of the breed.

Right
Often used for farm and light draft work, Bardigianos are also excellent riding and trekking ponies.

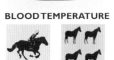

BLOOD TEMPERATURE

USES TEMPERAMENT

HORSE FACT:
As of January 1, 1999, all Thoroughbred foals need to have a micro chip implant for breed identification purposes.

BREED INFORMATION

NAME:	Bashkir
APPROXIMATE SIZE	13–14 hh
COLOR VARIATIONS	Bay, chestnut, or palomino
PLACE OF ORIGIN	Russian Federation

Bashkir

THE BASHKIR IS an ancient breed that has lived in the inhospitable regions of the Ural mountains in the former U.S.S.R. for thousands of years. They are probably related to the steppe horses of Western Asia and may contain other blood of Turkish origin. They have developed to become a quite remarkable pony breed, highly adapted to their harsh environment and a central part of the local steppe people's lives.

They are incredibly enduring, living and flourishing in the type of extreme cold where many other breeds perish. Possessing great stamina and speed for their size, they are frequently used for pulling the traditional *troikas*. They live out at pasture in large herds, all year round, and are employed for draft, farm work, riding, and milk and meat production. Bashkir mares are commonly milked for eight months a year and are renowned for their extraordinarily high milk production. It is not uncommon for a mare to produce upward of 350 gallons of milk during the lactation period. The milk is subjected to a fermentation process to produce the highly prized koumiss, which forms a staple part of the local people's diet. Foals were once tethered away from their mothers for most of the day, only being allowed to feed at night, to allow most of the mare's milk to be siphoned off. The quality of the foals rapidly deteriorated, which, in turn, began to effect the entire stock. This has since been rectified.

There are two distinct types of Bashkir: the mountain type, which is smaller, lighter and more of a riding pony, and the steppe type, which is larger, heavier and more often used for pulling the troikas. That said, both types of pony are suitable for riding and light draft work. They are typically strong and hardy, with a quiet and docile temperament.

They have a heavy head with a straight profile, lively eyes, a full forelock, and small alert ears. They have short, strong necks, are deep chested with sloping shoulders, low withers, and a long, sometimes dipped back, with a low-set tail. Their legs are short and strong, and they have very hard hooves. They are usually bay, chestnut, or palomino in color, and have a prolific mane and tail. Heights vary between 13 hh and 14 hh.

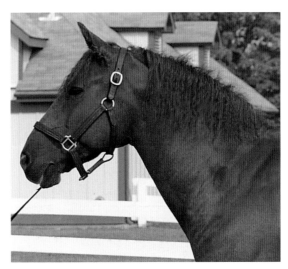

Top
The Bashkir is an ancient breed and has adapted well to its remote environment.

Left
Usually bay, chestnut, or palomino, the pony has a heavy head and a short, strong neck.

BLOOD TEMPERATURE

USES TEMPERAMENT

Basque or Pottock

○○○○○○○○○○○○○○○○○○○○○○○○○○○

BREED INFORMATION

NAME	Basque or Pottock
APPROXIMATE SIZE	11.1–14.2 hh
COLOR VARIATIONS	Chestnut, brown, bay, pinto
PLACE OF ORIGIN	France and Spain

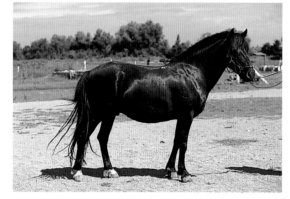

HORSE FACT:
Gentle hands in training make gentle horses to ride.

Top and Center
Basque ponies have a natural jumping ability and make good competition animals.

Bottom
Some of the ponies live a semi-feral existence in remote areas of the Basque region of northern Spain.

THE BASQUE PONY, or the Pottock, which in Spanish means 'small horse,' is a breed with ancient origins. They are a mountain breed from the Basque provinces, Navarra, and Southwest France, although they are now found throughout France. It is believed that the Pottock descended from the prehistoric horse of Solutré and it also exhibits an Arab influence.

Many of the ponies live in a wild or semi-wild fashion in the inhospitable areas of the Basque provinces and are extremely tough and hardy, having adapted well to their environment. During the winter they often resort to grazing on the prickly, spiny plants of the area, and grow thick whiskers on their upper lip to protect them from the spikes. In the summer months, when food is again plentiful, they shed the whiskers. As the qualities of the breed have been appreciated, it is likely that fewer of them exist in the wild now and they are more commonly tamed and trained for riding, pack,

and draft work. Their powers of endurance are legendary and their relative lightness of frame and stature belies their strength.

There are three groups recognized within the Pottock breed – the Standard Pottock, which varies from 11.1 hh to 13 hh; the Double Pottock, which varies from 12.3 hh to 14.2 hh; and the Pinto Pottock, which has the same height limits as the Standard. They were typically used for pack and light draft purposes but more recently have become valued as children's riding ponies. Those of superior conformation make very good, small competition ponies; they have a natural jumping ability. They have excellent temperaments, being gentle, quiet and

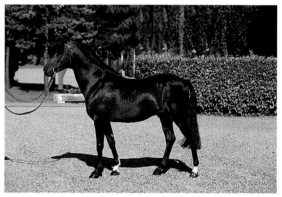

willing, which again makes them suitable for children. Recent infusions of Arab and Welsh blood have improved their quality and conformation.

In appearance, the head is in proportion to the body with a straight profile, or sometimes a concavity through the forehead, long ears, large eyes, and an occasional overhanging upper lip. They may be ewenecked, with a straight shoulder, long, straight back, wide chest, and rounded ribcage. The legs tend to be clean and fine in bone, with small strong hooves, although they are sometimes cowhocked behind. Typically, they are bay, brown, chestnut or pinto, and stand between 11.1 hh and 14.2 hh.

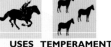

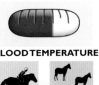

BREED INFORMATION

NAME:	Basuto
APPROXIMATE SIZE	Up to 14.2 hh
COLOR VARIATIONS	Chestnut, brown, bay, or gray
PLACE OF ORIGIN	Kingdom of Lesotho, and South Africa

Basuto

HORSE FACT:
Dressage was first introduced as one of the official sporting events at the 1912 Olympics in Stockholm.

THE BASUTO IS one of the best-known pony breeds of South Africa, although not indigenous to the country. It achieved its fame during the 19th century as a warhorse. Although the Basuto is small in size, it is considered a small horse, possessing horselike characteristics, such as a particularly long stride.

The first horses arrived in South Africa in 1653, when four horses were introduced to the Cape area by the Dutch East India Trading Company. The exact breed of these horses is unknown but they may have been Arabian and Persian. What is likely is that they were similar to the Java pony, and that they were upgraded with Arabian and Persian blood at a later date. These original imports became the founders of the Cape Horse, which became extremely popular and especially gained an admirable reputation during the Boer War. The Cape Horse and the Basuto probably started as one, and then with continual Thoroughbred and Arab blood, the Cape Horse evolved into a larger more quality animal, while the Basuto remained smaller and stockier.

Former Basutoland, now Lesotho, acquired the Cape Horse as spoils of war between the Zulus and the settlers. As a result of the harsh conditions and interbreeding with local ponies, the Cape Horse lost some of its height and nobility and the Basuto pony largely took its place. Due to the rocky and hilly terrain that the ponies were continually ridden over, often at great speed, they developed into tough, surefooted animals with incredible stamina and bravery, and these excellent qualities were nearly the undoing of the breed. They became so popular that many thousands were exported and then many of the best specimens were killed in action during the Boer War at the end of the 19th century. There is now a concerted effort to re-establish this commendable breed and they are often now used for racing or polo.

In appearance, they have a rather heavy head, a long neck, a long straight back, a rather straight shoulder, and a sloping but muscular croup. Their legs are usually very tough and sound and they have incredibly hard hooves. They stand at anything up to 14.2 hh, but rarely higher, and can be chestnut, brown, bay or gray, and have white markings.

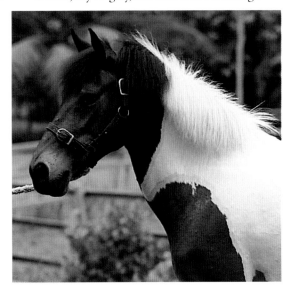

Top and Left
Basuto ponies may share their origins with the Java pony, which is pictured here.

BLOOD TEMPERATURE

USES TEMPERAMENT

Batak

THE BATAK is an Indonesian breed of pony, which originates in Central Sumatra and is probably descended from ancient stock. Similar to other Indonesian breeds such as the Sandalwood and Bali, the Batak probably has Mongolian and Arab blood in its ancestry, and has for many years been regularly improved by infusions of Arab blood. The Batak is highly regarded among the Indonesian people and is selectively bred and used to upgrade stock from neighboring islands.

The Batak has long been a central part of life for the local people and at one time was commonly used for sacrificial ceremonies to the gods. Today's Batak is a popular riding pony, of some class and spirit. It clearly owes a debt to the Arab, and exhibits fewer Mongolian features than some of the other Indonesian breeds. It has an excellent temperament and is docile and quiet, thus suitable for children, while it can be lively and energetic on request. They are strong and sturdy, but often slender in frame. They are attractive ponies of reasonable conformation and their shortcomings and faults are probably largely due to the difficult and poor environment in which they are raised. They are second only to the Sandalwood among the Indonesian breeds in terms of quality, conformation, and ability. The Batak is an obliging pony, economical to feed, and easy to keep. They are very popular among the local people as they are capable of an admirable turn of speed and are commonly used for local races. The other pony breed found in Sumatra is the Gayoe. The Gayoe is probably a strain of the Batak and the two have similarities, although in general the Gayoe is a more stocky pony with less spirit and quality.

Top and Top Right
Bataks are popular as riding ponies and are also often used for light draft work.

Right
The breed boasts a fine head and slender frame, with an obvious Arab influence.

In appearance, the Batak has a fine head with either a straight or slightly convex profile. Often the neck is short, thin and weak, and runs into fairly prominent withers for a pony breed. They are lightly built, slender, having a narrow chest and frame, and often a long back, and sloping quarters. The tail is usually set and carried high, which gives the pony an attractive look. Conformation of the legs is not great and they are often long with poor muscle development and long, fine, cannon bones. The hooves are mostly hard, the breed can be any color, and they can stand at up to 13 hh.

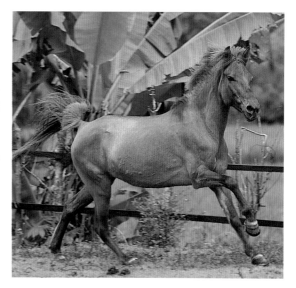

BLOOD TEMPERATURE

USES TEMPERAMENT

HORSE FACT:
The small intestine
of a horse is about
75.5 ft (23 m) long.

Bhutia and Spiti

<table>
<tr><td colspan="2" align="center">BREED INFORMATION</td></tr>
<tr><td>NAME:</td><td>Bhutia and Spiti</td></tr>
<tr><td>APPROXIMATE SIZE</td><td>Up to 13.2 hh</td></tr>
<tr><td>COLOR VARIATIONS</td><td>Mostly gray; can be chestnut or roan</td></tr>
<tr><td>PLACE OF ORIGIN</td><td>India</td></tr>
</table>

THE BHUTIA and Spiti are very similar and originate in the Himalaya region of India. The native Tibetan pony also shares very similar characteristics with both the Bhutia and Spiti, probably as a result of interbreeding between the three breeds over the years, and it is not uncommon for all these Indian breeds to be referred to simply as, 'Indian Country Bred.' This is an umbrella name to cover the various breeds in India, many of which have interbred so extensively that some of the individual breed characteristics have been lost.

Both the Bhutia and Spiti are basically suited to mountainous regions, both in terrain and climate, finding the humidity and warmer temperature of the flats hard to endure. India is not a great horse breeding country – the climate is not suitable for many breeds and there is always a shortage of good fodder, which affects their growth and development. The horses, therefore, have naturally become extremely tough and self-sufficient, and are, by necessity, frugal feeders and economical to keep.

The Bhutia and Spiti are working ponies and are largely kept in the mountainous regions for purely functional reasons. They are not widely used for leisure. They have great stamina and endurance and are very willing and quiet to be around. They make excellent pack ponies, as well as being suitable for riding, although the occasional one can have an unreliable temperament.

In appearance, their conformation is not always great and they do exhibit some faults. They have a large head with a pronounced jaw and a straight profile. They tend to have a short neck, with low withers, a straight back, sloping quarters, deep chest, straight shoulder, and a well-set tail. The legs are short, but strong, and they vary in height from between 12 hh and 13.2 hh.

The Spiti is essentially a smaller version of the Bhutia, and is primarily found in the Spiti Valley of Himachal Pradesh. The Spiti range in color from gray to dun, but can be any solid color, and rarely stand above 12 hh.

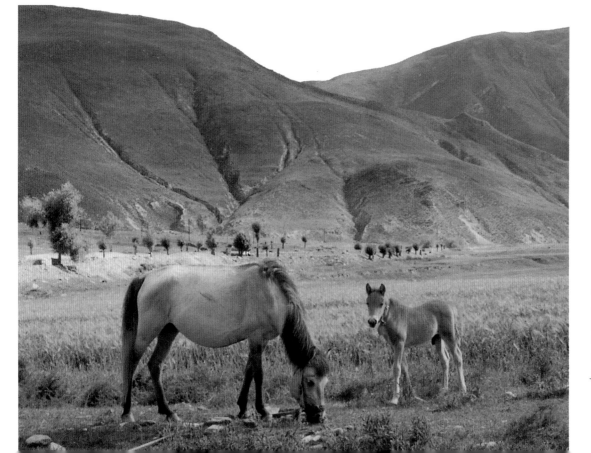

Left
Bhutia and Spiti ponies share many of the characteristics of the Tibetan mare and foal pictured here.

BLOOD TEMPERATURE

USES TEMPERAMENT

Bosnian

○○○○○○○○○○○○○○○○○○○○○○○○○○○○○

BREED INFORMATION

NAME	Bosnian
APPROXIMATE SIZE	13–14.2 hh
COLOR VARIATIONS	Any solid color
PLACE OF ORIGIN	Former Yugoslavia

THE BOSNIAN PONY, which originates in the former Yugoslavia, bears many similarities to both the Hucul and the Konik breeds of pony, with which they are collectively known as the Balkan breeds. They are all ancient breeds and the Bosnian pony is considered to have developed through a cross between the Tarpan and the Asian Wild Horse, also known as Przewalski's horse. Further infusions of oriental stock probably would have been introduced to the breed by the Turks during the Ottoman Empire, and this led to a deterioration within the breed, which was rectified by repeated introductions of Tarpan blood.

The Bosnian pony has been prized in its area for many centuries and, since the 1900s, has been selectively bred. For many years, the principal center of breeding was at the Borike Stud in Bosnia, where stallions were strictly controlled by the state, while mares were under private ownership. The use of three stallions – Agan, Barat and Misco – during the 1940s had an important overall improving effect on the stock. The former two were of a type similar to the Asian Wild Horse, and stocky in build, while Misco had a lighter, better-quality appearance. Until the recent troubles, there was a very strict standard set for stallions to ensure that only the strongest specimens were allowed to breed and they were required to compete in performance tests.

Due to the careful controls imposed, the Bosnian pony is an extremely useful and functional animal, quite capable of light farm work, light draft, pack, and riding. They are frequently used for pack purposes, being very surefooted over terrain unsuitable for motorized vehicles. They are hardy and tough, with a docile temperament, which makes them easy to handle and good to ride.

In appearance, the ponies retain a fairly primitive look, which is in line with the Asian Wild Horse, but with greater quality and refinement due to the infusions of oriental blood. They have a heavy head with a straight profile, full forelock, and small ears. They have a short muscular neck, with long sloping shoulders, a straight back, sloping quarters, and a wide and deep chest. They are often bay, brown, black or palomino in color, and stand between 13 hh and 14.2 hh.

Right
Bosnian ponies are surefooted, with docile temperaments, and are a pleasure to ride.

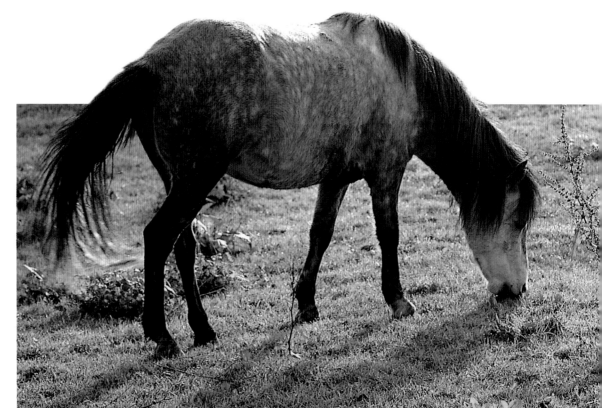

Burmese

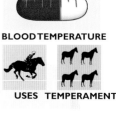

BLOOD TEMPERATURE

USES TEMPERAMENT

THE BURMESE, or Shan Pony as the breed is also known, is another mountain breed of pony, and is primarily bred in the Shan state of Eastern Burma by the local hill tribes. The Burmese pony shows many similarities to the Manipuri, and the Bhutia and Spiti ponies of the Himalayas, and it is likely that these breeds are all of similar origin. They are all ancient breeds, which probably developed from the Mongolian pony, and had other oriental influences over the centuries.

The Burmese pony, however, has probably had less benefit from Arab blood than the Manipuri, which is a far superior, more elegant, and faster breed. However, the Burmese is extremely well adapted to its environment and lifestyle, and makes an excellent working pony. They are extremely surefooted and ideally suited to mountainous areas, making them excellent pack and trekking ponies, and they are quite able to traverse areas not suitable for vehicles. Their quiet and willing temperament makes them ideal for tourist trekking, children, and novices alike. They are sturdy and tough, with good stamina,

and are resistant to the harsh climate of their environment. At one time they were used by the British colonials as polo ponies, but it is generally thought that this was through a shortage of other, better breeds. Although they are reliable, especially for mountain work, they are not particularly fast or athletic, and the Manipuri is considered a much better polo prospect.

In appearance, the Burmese is a rather unstartling pony to look at, being of a more functional than aesthetic type. They generally have a fine head with a straight profile and a good width through the forehead. The neck is muscular and in proportion to the body, and is set to a muscular, but sometimes long, back. The withers are not pronounced, and the shoulders are quite straight, producing a short stride, which is nonetheless useful in mountainous terrain. They are deep and wide through the chest, and have a strong, sloping croup. Their legs are strong, but fine, and the hooves are small and hard. They are brown, bay, black, chestnut or gray in color, and stand approximately 13 hh.

Left
Burmese ponies were sometimes used as polo ponies by the British living in the colonies.

BLOOD TEMPERATURE

USES TEMPERAMENT

Camargue

○ ○

BREED INFORMATION

NAME	Camargue
APPROXIMATE SIZE	Up to 14 hh
COLOR VARIATIONS	Gray
PLACE OF ORIGIN	France

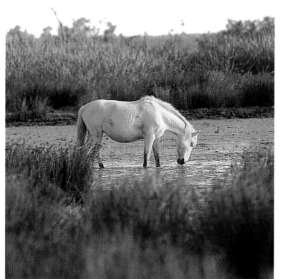

***Right and
Bottom Right***
*Ponies have lived wild
in the Camargue region
of southwest France for
thousands of years.*

Bottom Left
*Their temperaments
make the ponies useful
trekking animals.*

THE CAMARGUE ponies are indigenous to the Rhone delta of Southern France and are a ancient breed, thought to be descendants of the prehistoric Solutré horse. They display some characteristics of the horses depicted in the Lascaux cave drawings dating back to 15,000 B.C., especially in the shape of the head. They were influenced by the Barb horses brought over during Moorish invasions in the 7th to 8th centuries, but have since remained unchanged due to the geographical isolation of their habitat.

They live in semiwild herds on the swampy marshland of the Rhone delta, where they have a harsh existence. They survive on salty reeds and rough grass and are rarely given supplementary food. The area is subjected to extremes of climate, and these environmental factors have contributed toward their extreme toughness and hardiness.

They are mostly used by the Camargue cowboys, also known as guardians, for working the wild, black bulls of the area, which are commonly used in local bull fights. The horses are also used as pack ponies and, as tourism in the area increases, they make excellent trekking ponies. In spite of the breed's history, they did not receive official recognition until 1968 when their association was formed. Since that time there have been regular stallion inspections.

They characteristically have a large and heavy head with pronounced jaws, an extremely short neck, and an upright shoulder. The conformation of the shoulder allows for a good highstepping walk, but the trot is very stilted and rarely used. They have a good free-flowing canter and gallop. Often they have a short, strong back, with a sloping croup and a low-set tail. Their legs are strong and muscular with very hard hooves. They are quite heavy in the frame with a good depth of girth and a very powerful build. Agile and athletic, they have a good temperament, and are extremely bold. The Camargue is slow to develop, not reaching maturity until five or six years of age, but is also very longlived. The foals are born dark and lighten with age – nearly all adult Camargue ponies are gray and are branded with the breed brand of a 'C' in a shield. They can stand up to approximately 14 hh.

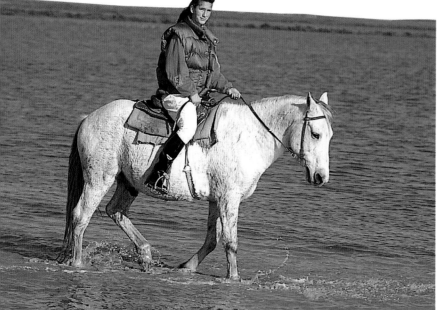

BREED INFORMATION

NAME	Caspian
APPROXIMATE SIZE	10–12 hh
COLOR VARIATIONS	Mostly bay or brown
PLACE OF ORIGIN	Iran

Caspian

BLOOD TEMPERATURE

USES TEMPERAMENT

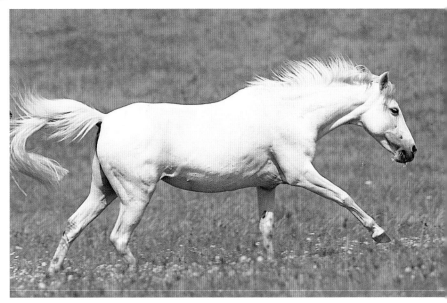

THE CASPIAN IS an important breed that was rediscovered in Iran in 1965 by an American lady called Louise Firouz. The Caspian is a miniature horse although it is referred to as a pony breed; it can be almost directly related back to the postulated Horse Type 4, and is widely believed to be, along with the Asian Wild Horse, the oldest breed of horse/pony in the world today. It may be related to the miniature horse of Mesopotamia, and to have existed there from *c.*3,000 B.C. until the seventh century AD, when they disappeared from records.

There are exciting studies currently being carried out to determine whether the Caspian is the ancestor of all modern hotblooded breeds, including the Arabian. Studies on the skeleton of an adult Caspian in 1969 demonstrated how the Caspian has several skeletal anomalies from other breeds of horse. These were primarily seen in the structure of the skull, the length of the lower leg bones in relation to overall size, the structure of the withers and the foot. When the breed was discovered in 1965, their numbers were small and they were widely dispersed.

Luckily, the breed has been re-established, first at the Norouzabad Stud in Iran, and then in 1976, when the Caspian Stud was founded in England. The horses have greatly benefited from careful breeding

and management and are now much improved. The Caspian is a quite remarkable creature and has a truly wonderful temperament, so much so that the stallions are frequently handled by children; several can even be turned out together. They make excellent children's riding ponies and have beautiful movement, making them desirable show ponies. Adaptable driving ponies, they adjust to harness quickly. Their particular slope of the shoulder and length of leg contributes toward their exceptionally long free-flowing stride that is rare in an animal of this size.

In appearance, they have the proportions and conformation of a miniature horse of great quality. They have an attractive head with an Arab look, very small ears, a muscular neck, a narrow back, and strong quarters. Their legs are strong, and the hooves incredibly hard – they rarely require shoes. They are mostly bay or brown, and stand from between 10 hh and 12 hh.

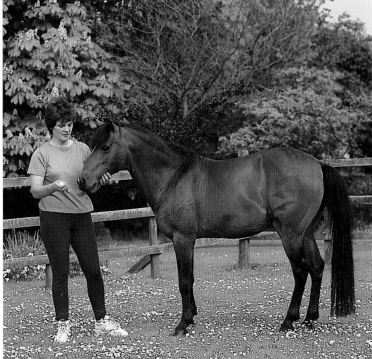

Top and Bottom
Careful breeding methods have recently improved the standard of Caspian ponies.

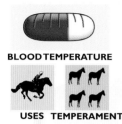

BLOOD TEMPERATURE

USES TEMPERAMENT

Chinese Guoxia

BREED INFORMATION	
NAME	Chinese Guoxia
APPROXIMATE SIZE	Up to 11 hh
COLOR VARIATIONS	Bay, roan and gray
PLACE OF ORIGIN	China

THERE ARE many different breeds of horse in China, most of which are ancient and descended from the Mongolian. Although many of the breeds are small in stature, they are considered to be small horses not ponies, and will often, when provided with good care and food, grow considerably in height. There is one breed that is thought to be an actual pony breed and this is the little-known Guoxia, found in the southwest of China. Many of the breeds within China bear distinct regional differences, so although they may have descended from common ancestors, they have developed differently according to their habitat and climate. The Guoxia is no exception.

There is little information available regarding the breed's roots or heritage, except that it is likely to be extremely old and to have developed through the centuries. A bronze statue has been recovered of a Guoxia, dated approximately 2,000 years old, which is an indication of the age of the breed. Their name translated means 'under fruit tree horse,' which is probably indicative of one of their early uses. Very small in height, only reaching a maximum of 11 hh and often smaller than this, they would, therefore, have been useful for working among the fruit trees, collecting fruit. The breed was largely forgotten and considered extinct until it was rediscovered in 1981 and now there is a breed association.

They make very good children's ponies and are useful in harness, in spite of their small size. Generally they have good temperaments, being quiet and willing, and are also tough and enduring. In appearance, they are not very refined, and bear some primitive horse features. They tend to have a small, but heavy head with small alert ears. The neck is short, and the back is straight and short. The shoulders are also quite straight, but the legs are well formed and strong with good hard feet. They are usually bay, roan, or gray in color.

Top
Guoxia make very good children's ponies as they have quiet and willing temperaments.

Bottom
The ponies have straight shoulders and short, strong necks.

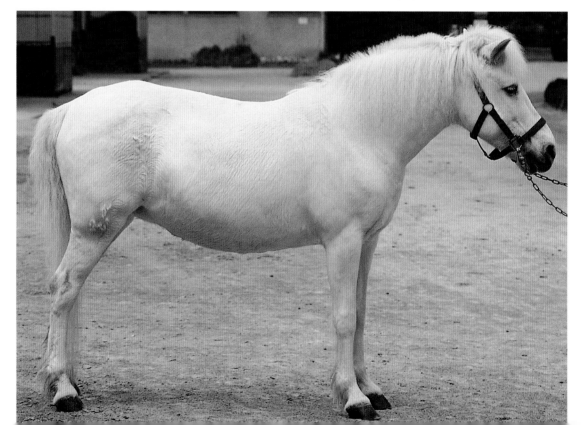

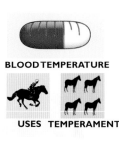

BLOOD TEMPERATURE

USES TEMPERATURE

BREED INFORMATION

NAME	Connemara
APPROXIMATE SIZE	Up to 14.2 hh
COLOR VARIATIONS	Gray, bay, brown, dun, occasionally chestnut or roan
PLACE OF ORIGIN	Ireland

Connemara

THE CONNEMARA IS an old breed native to the Connaught region of Ireland and is a descendant of the Celtic pony, one of the early primitive breeds of Europe. The Connemara has, over the years, been exposed to a diverse range of

breeds, including the Spanish Jennet, as well as Arab and Barb blood. They have been influenced by Thoroughbred, Hackney, and most significantly, Welsh blood, and have absorbed the best qualities of all these breeds.

Important stallions used were Golden Glen, foaled 1932, Rebel, foaled 1922, and Cannon Ball, foaled 1904. Cannon Ball was of Welsh and Connemara origin and became the first stallion to be entered in the Connemara studbook in 1926. More recent influences have been by the stallion Carna Dun, foaled in 1948 by the Thoroughbred Little Heaven, the Irish Draft stallion,

Mayboy, the Arabian, Clonkeehan Auratum, foaled 1954, and the Welsh stallion Dynamite. From such a diverse range of influences it is strange that a fixed type has been maintained, but the Connemara has proved itself to be one of the best pony breeds in the world.

They have been shaped by their environment, which is wild, boggy, and very wet. This has instilled in them a great resistance to the elements and has produced an extremely hardy pony. The Breeders Society was formed in 1923 and since that time has worked hard to maintain the commendable characteristics of the breed. They have a wonderful temperament and are the ideal child's pony. They are very talented and compete at the highest levels in showjumping, dressage, eventing and competitive driving. They are naturally athletic and agile, but quiet and calm to ride.

In appearance, they are highly attractive with a fine head set on a well-arched neck. They have well-conformed shoulders, allowing for a good length of stride, a deep and broad chest, and powerful muscular quarters. They have a compact body and are tough and intelligent, with great stamina. They have well-made legs with good bone, and hard feet. Originally they were characterized by their dun color with a black dorsal stripe and black points. Nowadays, however, they are often gray, and occasionally bay or brown, and range in height from between 13 hh and 14.2 hh.

Top

Known for their wonderful temperaments and jumping ability, Connemaras make excellent competition ponies for novices.

Bottom Right and Left

Connemara ponies used to have a distinctive dun color, but now are just as often bay or gray.

BLOOD TEMPERATURE

USES TEMPERAMENT

Dales

BREED INFORMATION	
NAME	Dales
APPROXIMATE SIZE	Up to 14.2 hh
COLOR VARIATIONS	Mostly black, dark brown, or bay
PLACE OF ORIGIN	England

THE DALES and the Fell ponies are very similar and are probably both descended from the same ancestors, but have developed slightly differently. They are native to England, and hail from the northern counties, the Dales from the east Pennines, and the Fells from the north and west Pennines. The Dales is an old breed, most probably descended from the old Friesian horse of Europe, that was itself a descendent of the primitive Forest Horse. However, the Dales pony has been subjected to influences from other breeds, nearly all of which have been successful, with the exception of Clydesdale blood, introduced during the early 20th century.

The Dales pony is most famous for its great strength and endurance and its ability to carry huge weights. It was widely used for transporting loads of lead ore from the mines of Northumberland and Durham to the smelt mills. The breed was also popular with Dales farmers, who used the ponies for tasks around the farm, such as plowing. On small hill farms, the Dales was ideally suited to the terrain and climate.

The Dales pony is a very versatile breed, being eminently suitable for riding and driving, as well as working on the land, and even with the advent of mechanization, the Dales pony can still perform better in some areas than a tractor. They are notable for their excellence in harness and are able to transport heavy loads very quickly. Approximately 100 years ago, a Welsh stallion called Comet was introduced into a breeding program with some Dales mares and many of his characteristics were passed on, most notably a more free-flowing action in the trot, which has made the Dales more popular as a riding pony. They have a very good temperament and are increasingly used in the tourist industry for trekking holidays.

In appearance, the Dales pony often has a neat head with a fine jaw and throat, set onto a shortish, thickset neck. They have a strong muscular body with plenty of bone, well-sprung ribs, and strong hooves. They should have luxurious manes and tails and copious feathering on the lower leg. They are usually dark brown or black in color and stand at approximately 14.2 hh.

Top
Dales ponies originate from the north of England and are known for their strength and endurance.

Bottom
With their biddable temperaments, these ponies are well-suited to use on trekking holidays with novice riders.

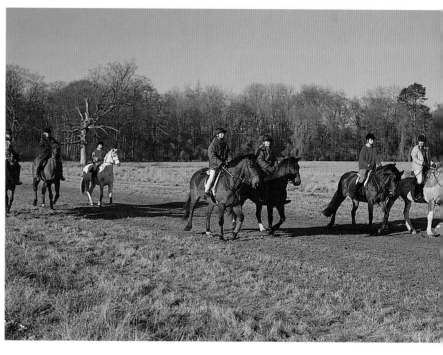

Dartmoor

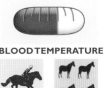

BLOOD TEMPERATURE

USES **TEMPERAMENT**

Left
Although most Dartmoor ponies are now privately owned, some still are allowed to roam free in Devon.

Bottom
These tiny ponies have heavy manes and forelocks, and should not ever exceed 12.2 hh.

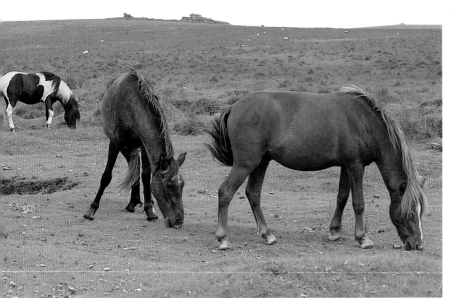

THE DARTMOOR has ancient roots and has had a very checkered past, which nearly resulted in the extinction of the breed several times. The Dartmoor is one of England's native pony breeds and for centuries it lived in a semiwild state in the open moorlands of Dartmoor in Devon. Although they are still to be seen there, the majority of them are now kept and bred in private stables.

Through time, the Dartmoor pony has always been noted for its excellent qualities and abilities, including a natural jump and good movement, and has benefited further during the 20th century from infusions of blood from other breeds. Significant contributions to the modern Dartmoor pony came from the Arab stallion Dwarka, foaled in 1922, and his son, The Leat, as well as the Welsh Mountain pony, Dinarth Spark. The Dartmoor suffered severely in the years from 1789 to 1832, which saw the birth of the Industrial Revolution. The breed was greatly infiltrated by Shetland blood to produce suitable pit ponies, resulting in a decrease of good, pure-bred stock. Revived through the use of Welsh Mountain pony and Fell stallions, it again suffered large losses during the First World War. The Second World War almost saw the end of the breed as its natural habitat was taken over by the army for training exercises. Luckily it was saved, and today good-quality Dartmoor ponies are in great demand for children's ponies and show ponies. They have excellent dispositions, being sweet tempered, willing, and naturally athletic. They jump very well, move very well, and are often used as foundation stock for the breeding of Riding ponies, with studs in France as well as Britain.

In appearance, the Dartmoor pony is a quality riding pony, also suitable for use in harness. They are nicely proportioned and put together, with good conformation. They have fine attractive heads, a muscular neck, a compact back, and strong legs with short cannon bones. They have a very full mane and tail, and should be muscular through the neck, back, and loins. The most preferable colors are brown, bay, or black, with minimal white markings. Skewbald and piebald coloring is not accepted into the breed register at all. The ponies do not exceed 12.2 hh in height.

BLOOD TEMPERATURE

USES TEMPERAMENT

Dulmen

○○○○○○○○○○○○○○○○○○○○○○○○○○

BREED INFORMATION

NAME	Dulmen
APPROXIMATE SIZE	12–13 hh
COLOR VARIATIONS	Dun, black, brown, or chestnut
PLACE OF ORIGIN	Germany

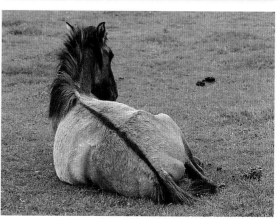

GERMANY IS more famous for its excellent production of warmblood horses than for its pony breeds, and only has one native pony breed remaining – the Dulmen. The Senner pony of the Teutoburg Forest was the only other German pony breed and is now considered extinct. The Dulmen is a very old breed found near the town of Dulmen in the Meerfelder Bruch, an area where ponies have been documented since the early 1300s. The exact origins of the breed are not known although it is likely to have developed from ancient primitive horse types, and still has some primitive characteristics.

The ponies used to live in large wild herds all across Westphalia, but during the 19th century, as land was increasingly divided up and separated, the ponies began to lose their natural habitat. Today there is only one wild herd left, owned by the Duke of Croy, which roams approximately 860 acres of the Meerfelder Bruch. The Dukes of Croy have had a long relationship with the Dulmen pony and first helped the herd back in the mid-1800s. Within the Meerfelder Bruch acreage, there is a wide diversity of small habitats, ranging from woodland to open moorland, which provide the ponies with every environment they may need. They are left to lead a wild lifestyle and must find their own food and shelter, and cope with illness and death. Those members of the herd that survive are subsequently the strongest and, therefore, as a breed, they are particularly tough and

resistant to disease. Once a year, on the last Saturday of May, the ponies are rounded up and the colts separated off. The colts are then sold at public auction and the mares are returned to the Meerfelder Bruch with one or two stallions.

Dulmen ponies that are tamed and trained make good children's ponies and adapt to civilized life well. They are also useful driving ponies and were used for working the land, maintaining their inordinate hardiness, even in captivity. In appearance, they are quite primitive looking with coarse features. Some of them retain the dun coat coloring, while others exhibit brown, black, or chestnut coats, which indicates infusions of foreign blood throughout the breed's history. They usually stand between 12 hh and 13 hh.

Top and Bottom
The breed often still exhibits its traditional dun color and may have a characteristic dorsal stripe.

Center
The Dulmen is the only pony breed that is native to Germany.

Exmoor

BLOOD TEMPERATURE

USES TEMPERAMENT

THE EXMOOR PONY is found mainly in Exmoor, in the southwest of Devon, living a semiwild existence. Although it was once prolific, the breed is now greatly reduced and there are ongoing, strictly monitored breeding program to ensure its continuation. The Exmoor pony is one of the better known feral ponies in Europe and they run free over the moorlands, although some are bred at private studs. They are a truly primitive breed with dun coloring with mealy muzzle and belly.

Comparisons of the Exmoor pony to Pleistocene cave paintings of wild horses from France and Spain, and the similarity of the Exmoor to the Tarpan and Przewalski's horse, suggest that the Exmoor pony could be a relic of the wild horse. The Exmoor largely retained their original features and have not been overinfluenced by other breeds, due to the relative geographical isolation of their moorland habitat. They are extremely hardy and resistant to many equine diseases, as well as harsh weather conditions.

The Exmoor pony has several distinctive features, most of which have evolved from environmental conditions. They have a highly waterproof winter coat, composed of a double layer; the under layer is short and woolly, with the top layer being longer and greasy. This keeps the rain and cold out, and the heat in. Their eyes have a heavy top lid known as a 'toad eye,' and their tails have a fanlike growth of bushy hair at the top. They have great stamina, strength, and durability, and make good children's ponies. Once a year, the Exmoors are roundedup, inspected, branded with a star and the number of their herd on the near shoulder, and the pony's number on the left hindquarter. Colts considered below standard are gelded.

In appearance, the ponies have primitive characteristics, including their dun coloring with black points. They have attractive heads which are wide across the forehead and have lighter markings around the eyes. The shoulders are reasonably sloping, they should be deep and wide through the chest, have a compact frame, which is deep through the girth, and have short strong legs, and hard hooves. The Exmoor mares have a height limit of 12.2 hh, and stallions and geldings of 12.3 hh.

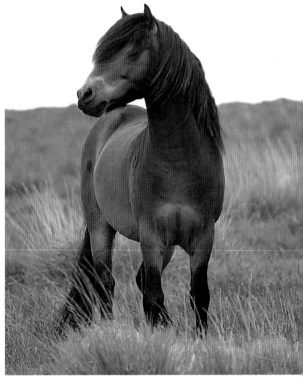

Top Right
The breed has a waterproof winter coat to ward off the cold, and a heavy top lid to the eye.

Bottom
The Exmoor has faced extinction in the wild, and is now the subject of careful breeding controls.

BLOOD TEMPERATURE

USES TEMPERAMENT

Falabella

○○○○○○○○○○○○○○○○○○○○○○○○○○○○○○

BREED INFORMATION

NAME	Falabella
APPROXIMATE SIZE	Under 9 hh
COLOR VARIATIONS	All colors
PLACE OF ORIGIN	Argentina

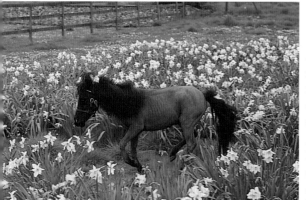

THE FALABELLA developed during the 19th century in Argentina. The breed takes its name the Falabella family, who spent years establishing the breed at their ranch outside Buenos Aires. Although the Falabella family developed the breed, the initial idea of producing a miniature horse came from an Irish man living in Argentina, Patrick Newtall. He spent years forming a herd of small 'horses' that stand under 9 hh, and he passed his knowledge and expertise to his son-in-law, Juan Falabella, in 1879.

This was the beginning of the Falabella which was produced by crossing Shetland ponies with the herd established by Newtall. There were then further infusions by a very small English Thoroughbred and a small Criollo. To keep reducing the size of the Falabella, the smallest and best of the progeny were repeatedly inbred until the average size was below 30 inches at the withers. There is, interestingly, a degree of Spanish blood in the Falabella, since Newtall's original herd would have been largely founded on small Spanish horses, and then the later infusion of Criollo would have added to this.

The original intentions were to produce a tiny, miniature horse and not a small pony. It is hard to tell quite what the perceived function for developing this breed was, when considering how tiny and inbred they are. However, the Falabella is extremely strong for its size and has been used in a light harness capacity, and has been ridden by small children. The conformation of the breed, with its straight shoulder and tiny size, does not put it among the great ranks of children's ponies. They do have very good temperaments, are intelligent and friendly, and perhaps their best role is as an ornamental and unique pet.

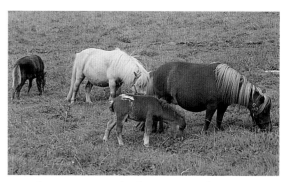

In appearance, the better examples are quite attractive small horses but, due to inbreeding, they invariably have a head that is proportionally too big for the body, and various other defects of conformation, mainly in the legs and hind quarters. Interestingly, it has been discovered that the Falabella has one or two fewer ribs than other equine breeds. They have a wide range of coat colors and will often be spotted or pinto, which is a throwback to their Spanish blood. They are exceptionally longlived, and can continue past 40 years.

Top and Center
The Falabella is the smallest horse in the world, standing under 9 hh. They come in a variety of colors.

Right
Selective breeding has produced a tendency in the Falabella to an over-large head.

Fell

<table>
<tr><td colspan="2">○○○○○○○○○○○○○○○○○○○○○○○○○○</td></tr>
<tr><td colspan="2">BREED INFORMATION</td></tr>
<tr><td>NAME</td><td>Fell</td></tr>
<tr><td>APPROXIMATE SIZE</td><td>Up to 14 hh</td></tr>
<tr><td>COLOR VARIATIONS</td><td>Black, dark brown, and bay</td></tr>
<tr><td>PLACE OF ORIGIN</td><td>England</td></tr>
</table>

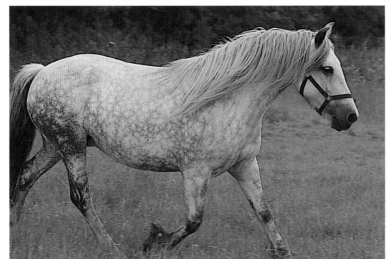

They are excellent ponies and are very tough and strong for their size. Like the Dales, the Fell was also used for transporting lead to the docks and was widely used as a pack animal, as well as in harness. They are very good trotters and can cover a large amount of ground in a short time. They are now frequently used both as ride and drive horses, and excel in both capacities. They are extremely versatile and surefooted, and tend to have a sensible disposition making them ideal as children's ponies and useful for nervous adults.

In appearance, they should have a small neat pony head, set on to a well-crested and longish neck. They should be strong through the body with well-sprung ribs, and muscular quarters with the hocks well let down. They should have good legs with short cannon bones and well-developed knees. Fells usually have an abundance of mane and tail, and a fair amount of feathering on the legs. Typically, they are black, dark brown, or bay, although grays are allowed and they should have minimal white markings. An abundance of white markings indicates a crossbred pony which would not be allowed entry in the studbook. They are usually between 13 hh and 14 hh. The Fell is a smaller and lighter build than the Dales, with a less massive body frame, and both breeds are highly commendable.

THE FELL PONY is mainly found on the northern and western sides of the Pennines and in Cumbria, and is very similar in many ways to the Dales pony, which is its geographical neighbor. The two breeds probably arose from the same source and then developed regional differences which were later concentrated on by breeders, so that two variations emerged. The Fell is thought to be a descendent of the old Galloway pony, now extinct, and the Old Friesian horse of Europe. The Galloway pony was a tough Scottish breed that had many admirable qualities and was probably instrumental in the development of both the Fell and Dales pony, as well as the English Thoroughbred. The Fell has been kept very pure as a breed and this is something the Fell Pony Society, which was formed in 1912, strives to maintain.

Top

Fell ponies tend to be black, brown, or bay, but grays are allowed in the breed specifications.

Bottom Right and Left

A Fell pony has a small, neat head and a long mane and forelock.

BLOOD TEMPERATURE

USES TEMPERAMENT

French Saddle Pony

○○○○○○○○○○○○○○○○○○○○○○○○○○

BREED INFORMATION

NAME	French Saddle Pony
APPROXIMATE SIZE	12.2–14.2 hh
COLOR VARIATIONS	Any color
PLACE OF ORIGIN	France

THE FRENCH Saddle pony, also called the Poney Français de Selle, is a relatively new breed, created to fulfil the same role as the British Riding pony. The breeding process has included crossbreeding native pony mares with Welsh, New Forest, Arab and Connemara stallions, as well as taking Mérens, Basque, and Landais mares and crossbreeding these with New Forest, Selle Français, and Connemara stallions.

They are versatile and make excellent children's ponies. They have a quiet but lively temperament and are highly attractive. The French Saddle pony has a small, fine head with kind eyes and alert ears. The neck should be of good length and nicely set on, the chest deep and wide, the shoulders sloping, and the legs strong with well-formed joints and hard hooves. The back is straight, the withers developed, and the croup sloping, with a well-set tail. They can be any color and tend to stand at between 12.2 hh and 14.2 hh.

Top and Right

These ponies are a relatively new breed and have native pony blood in them.

BLOOD TEMPERATURE

USES TEMPERAMENT

Galician and Asturian

○○○○○○○○○○○○○○○○○○○○○○○○○○

BREED INFORMATION

NAME	Galician and Asturian
APPROXIMATE SIZE	11.2–12.2 hh
COLOR VARIATIONS	Brown or black
PLACE OF ORIGIN	Northern Spain

THE ASTURIAN IS an ancient breed of pony from the Asturias region of Northern Spain, along with the Galicia, from the province of Galicia. Sadly, the Galicia has now become extinct.

The exact ancestry of the Asturian is not known but it probably developed through crosses between the Sorraia of Spain and the Garrano of Portugal, while also tracing back to the ancient Celtic pony. They are hardy and frugal, able to survive in areas where other breeds of horse would perish. Over the years the breed has faced possible extinction. Recently, their plight came to light and societies have been formed to help protect them.

The Asturian ponies have a quiet and biddable temperament and are useful for riding, driving, pack, and trekking. In appearance, they tend to have a small, but heavy head, a thin neck with an abundance of mane, low withers, a deep chest, straight shoulders, and sturdy legs with strong joints and hard hooves. Generally they have a straight back, are rounded through the barrel, and have a sloping croup with a low-set tail. Usually they are brown or black in color with minimal white markings and they stand between 11.2 hh and 12.2. hh.

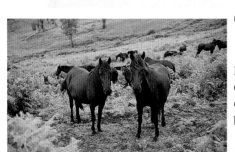

Above and Right

Along with the Galicia, Asturian ponies faced extinction but are now protected.

Galiceño

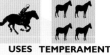
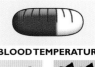
BREED INFORMATION

NAME	Galiceño
APPROXIMATE SIZE	Up to 14 hh
COLOR VARIATIONS	Any solid color
PLACE OF ORIGIN	Mexico

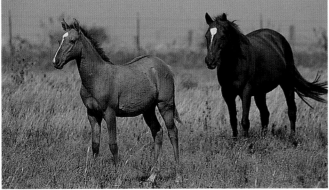

THE GALICEÑO DEVELOPED in Mexico in the early 16th century from horses shipped to South America by Hernando Cortés, who invaded Mexico from Cuba in 1519. The pony is believed to have developed from the Galician pony from Spain, the Garrano of Portugal, and with a debt to the Spanish Sorraia. This pony is highly prized in Mexico due to its excellent qualities of soundness, toughness, endurance and stamina.

The breed was not introduced to the United States until 1958, and in 1959, the Breeders' Association was formed to maintain the breed. They are popular in America, although their numbers are still relatively small. The Galiceño is suitable for riding, pack, draft and farmwork, and they make excellent children's ponies. They are quick, athletic, biddable, and intelligent, as well has having good stamina. Many of the ponies are notable for their peculiar, fast running walk, which is a very smooth gait, and they are therefore very comfortable to ride. The smoothness of their gait is probably due to their Spanish ancestry.

Due to their small size, they are often only thought of as children's ponies, but they have been used for years by the Mexican cowboys and can easily carry a man all day in the heat over rough terrain. In fact, the Galiceño is often considered to be a small horse and not a pony breed at all, despite its diminutive size. The ponies are brave and intelligent in nature and are easy to train, due to the quickness with which they learn.

In appearance, they are attractive animals and have a nicely proportioned head, with a kind eye and alert ears, but which does not show overtly pony characteristics. The neck is usually short and muscular and slightly arched from withers to poll. They tend to be narrow through the chest and body and finely built, although remaining very strong and powerful. The shoulders are reasonably sloped, the back short and compact; the croup is sloping and the legs tough, hard and well formed. The hooves may be small, and the breed's natural stance is not always correct. They can be any solid color and stand at between 12.2 hh to 14 hh.

Left
The Galiceño are calm and easy to train, with a fast walking gait that is very smooth for the rider.

Center and Bottom
This breed is often considered to be a small horse, not a pony; their well-proportioned head is horse-like.

BLOOD TEMPERATURE

USES TEMPERAMENT

Garrano

```
BREED INFORMATION
NAME              Garrano
APPROXIMATE SIZE  10–14 hh
COLOR VARIATIONS  Bay, brown, or chestnut
PLACE OF ORIGIN   Portugal
```

BOTH THE GARRANO and the more famous Sorraia are ancient breeds that have descended from the same stock and have developed along different lines according to their habitat. The Sorraia lives in Spain, mostly between the rivers Sor and Raia, and the Garrano lives in neighboring Portugal. The Garrano, or Minho, as the breed is sometimes called, mainly lives in the fertile regions of Minho and Tras os Montes, and has probably been more subjected to outside infusions of blood than the Sorraia.

There are similarities between primitive cave paintings of the Paleolithic era and the Garrano, which indicate the breed's antiquity, and it is generally considered that the Garrano is one of the ancestors of both the Andalusian and the little-heard Galician. In recent years, the Garrano has had fairly frequent infusions of Arab blood, a procedure implemented by the Portuguese Ministry of Agriculture. This has had the effect of greatly refining the breed, but losing some of its primitive features.

The Garrano are strong and hardy ponies, with a quiet temperament. They have been used for riding, and for light farm work, and were widely employed in the past for pack purposes. They are very surefooted and can travel easily and smoothly over the difficult, steep and densely wooded terrain of their homeland and, as such, perform much better in this area than a motorized vehicle. They were also used by the military for pack purposes and are very useful driving horses in harness. For their size, they have a remarkable turn of speed and are used for competing in the traditional trotting races of the region.

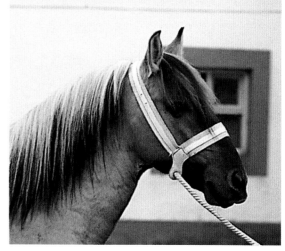

In appearance, the Garrano is now an attractive pony of some quality, bearing some Arab- type traits. This is especially seen in the head, which is fine, pretty, and often has a concave profile, although it can also sometimes be slightly heavy. They tend to have small ears, lively large eyes, and a long neck set to a straight shoulder. The back is short and compact, with sloping muscular quarters, and a low-set tail. They are deep and wide through the chest, and have short, strong legs with hard, broad joints, and well-formed hard hooves. They are mostly bay or chestnut in color, and stand at between 10 hh and 14 hh.

Top and Center
The Sorraia are an ancient breed and are usually dun in color.

Bottom
Arab blood has been introduced into the Garrano, which now has a fine head and slightly concave profile.

Gotland 'Skogsruss'

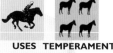
BREED INFORMATION

NAME	Gotland or Skogsruss
APPROXIMATE SIZE	12–12.2 hh
COLOR VARIATIONS	Any solid color
PLACE OF ORIGIN	Sweden

THE GOTLAND, or Skogsruss, meaning either, 'little horse of the woods,' or 'little goat,' is an ancient breed which still maintains many of its primitive characteristics. For centuries they were found mainly on the Island of Gotland in the Baltic sea, or in the forest of Lojsta on the Swedish mainland, although they are now bred all over Sweden.

By 1,800 B.C., the Goths had established themselves on the Island of Gotland, and existing sculpture from 1,000 B.C. shows them using Gotland-type ponies in harness. The Gotland pony of today developed from these ancient equines and is probably descended from the Tarpan. The Gotland, Hucul, and Konik all bear distinct similarities and probably originated from the same ancient stock. The Gotland is extremely hardy, tough, and surefooted, with very good stamina. The ponies were used in harness, for pack purposes and farm work, although their main function today is as a child's pony.

They have an athletic jump, are extremely speedy and are popularly used in trotting races. Both these abilities are surprising as they are often poor in the hindquarters. They have good temperaments, being quiet and calm, but lively when required, but they can be obstinate. Significant influences on the Gotland were the stallion Olle, which was a Gotland/Syrian Arabian cross and is generally responsible for the popular yellow dun coloring. The other primary influence was from the oriental stallion, Khedivan, that introduced the gray coat coloring.

In appearance, they have a typical pony head with small alert ears, lively eyes, and a straight profile. The neck is nearly always short and quite muscular and is set to reasonable

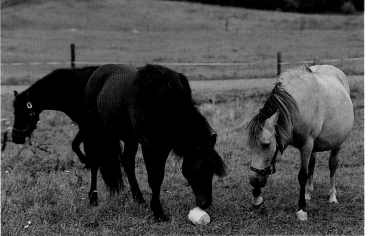

withers for a pony breed. The back is long and straight with a sloping croup and weak, unstartling quarters. The shoulder has quite a good slope to it for a primitive type pony breed and this helps explain their prowess at trotting races, although they are unable to extend in gallop. The legs are strong and tough with good joints, but the hind legs often lack muscle development and can be poorly conformed. The feet are very tough and are a good shape. The coat can be a variety of colors, although usually dun and gray. They stand between 12 hh and 12.2 hh.

HORSE FACT:
Epona is the mythological goddess of the horse, the ass, and the mule. Her name is derived from the word *epo*, which is the gallic equivalent of *equus*, and hence the origin for the word 'pony.' Her image is often depicted as the bodyguard of the horse, and she is generally shown seated with her hand resting on the head of either a horse, an ass or a mule.

Top
This ancient pony developed in a harsh environment in northern Sweden and is very hardy.

Left
Gotland ponies have lively eyes, a straight profile and a short neck.

BLOOD TEMPERATURE

USES TEMPERAMENT

HORSE FACT:

'Eventing' is the international magazine for horse trials. Launched in 1983 it continues today as a successful monthly publication.

Pindos

BREED INFORMATION	
NAME	Pindos
APPROXIMATE SIZE	Up to 13 hh
COLOR VARIATIONS	Mostly bay, black, dark brown, or dark gray
PLACE OF ORIGIN	Greece

THE PINDOS PONY, also known as the Thessalonian, is an ancient breed that was traditionally raised in the Thessaly and Epirus regions of Ancient Greece where it continues to be bred today. Greece is not an ideal climate or environment for raising horses, having harsh weather conditions and a consequently fairly infertile and poor soil. However, these environmental factors have produced an inordinately hardy and enduring pony, whose functional abilities make up for a lack of aesthetic beauty. They are mountainbred ponies, and have all the accompanying qualities, including noteworthy climbing abilities.

The Pindos pony is now probably somewhat different from its ancestors, who are believed to have been largely oriental types and horses brought from the Scythian people, who were well-known for their horsemanship. The Pindos pony is probably a direct descendent of the old Thessalonian breed which was developed by the Greeks and was noted for its courage and beauty.

They are typically very surefooted and are still used to perform many of the tasks around the local people's small holdings. These may range from agricultural work, plowing the land, working in harness to transport goods, as a pack pony, and also

for riding. They have great endurance and stamina and have an extremely sound constitution. The ponies are frugal and can live on minimal rations, are extremely long lived and have very sound legs and feet, rarely going lame. Pindos mares are often used to breed a good stamp of working mule.

In appearance, the Pindos has a rather coarse head with an unattractive small eye. The neck and back are of reasonable length. They are light and narrow through the frame, with poor and underdeveloped quarters, and a high-set tail of seemingly oriental influence. The legs are fine in bone, with small joints, but they are strong and the hooves are very tough. The Pindos has a reputation for being difficult and stubborn. The coat colors are mostly dark, such as, bay, black, and dark gray and they stand at up to 13 hh.

Top

Pindos ponies have a reputation for being difficult to train but are extremely strong.

Right

Harsh climatic factors and little natural vegetation for food has made the Pindos an exceptionally tough pony.

Peneia

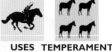

BLOOD TEMPERATURE

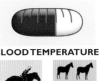

USES TEMPERAMENT

Left
Peneia ponies have a surprising natural jumping ability and are very surefooted.

HORSE FACT:
King Alexander III of Scotland, 1249–86, died when he rode his horse over a cliff in the middle of the night.

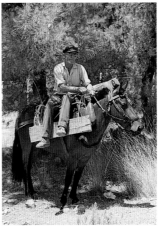

THE PENEIA is an old breed found in the semi-mountainous regions of Eleia in the Peloponnese. They are probably related to the Pindos pony of Greece, but are rarer and exist in very few numbers. They are heavier than the Pindos and are used for all forms of work, including agriculture, harness, pack, and riding, they have very amenable temperaments. Their conformation is not exemplary but they are very functional animals and have a sound constitution. They are extremely tough and hardy with great stamina and endurance and are very surefooted across rough terrain.

The Peneia is useful and capable animal and surprisingly makes a good, natural jumping horse. The Peneia stallions are often used for breeding hinnies. Though they possess a rather stilted stride they are taught a form of gait called the *aravani*, which produces a smoother action than their natural one. In appearance, they are heavily framed, with a coarse head and a very muscular neck. They have a broad, strong back but weak and underdeveloped hindquarters. Their legs are typically very sound and strong although they frequently have cow or sickle hocks. They are mostly roan, chestnut, or black in color and range in height from 10 hh to 14 hh.

Skyros

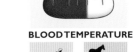

BLOOD TEMPERATURE

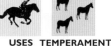

USES TEMPERAMENT

Left
Now extremely rare, the Skyros pony are small at 11 hh, and make excellent companions for young children.

THE SKYRIAN IS the third of the Greek pony groups and, like the Peneia, is now extremely rare. They are found on the island of Skyros and are an ancient breed. There is no documentation as to how they came to be on the island and this is now a matter of conjecture. They used to live a mostly semiwild life, roaming in herds across the island but they are now mainly kept by individuals for riding and light harness work.

They have the same qualities as the other Greek breeds, being extremely tough, hardy, enduring, surefooted, and sound in wind and limb. Their conformation is not very good but this does not seem to affect their work unduly. In appearance, they are small, fine-boned and light-framed ponies, with an attractive head, short neck, compact back, and weak quarters. They have exceptionally hard feet and rarely require shoeing. Their temperaments are good and they make good ponies for children. They are mostly brown, bay, or grey in color and stand up to 11 hh.

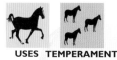

BLOOD TEMPERATURE

USES TEMPERAMENT

Top
The Hackney has a small, fine head, pricked ears and intelligent eyes.

Bottom
Hackney ponies have a very exaggerated gait and carry their tails very high.

Hackney

BREED INFORMATION	
NAME	Hackney Pony
APPROXIMATE SIZE	12.2–14 hh
COLOR VARIATIONS	Black, bay, chestnut, or brown
PLACE OF ORIGIN	England

THE HACKNEY PONY was developed in the 19th century, primarily by one man, Christopher Wilson of Westmorland. He used his stallion, St. George, foaled 1866, who was a Norfolk Roadster and Yorkshire Trotter cross, and mated him with Fell mares. He took the progeny and interbred the best of them to produce a fixed type. The Hackney pony also probably contains Welsh blood which would help to retain the pony characteristics of the breed.

The first ponies were known as Wilson ponies, and it was not until later that they became known as Hackney ponies. Wilson commonly kept his ponies out all year, wintering them on the inhospitable fells, and providing them with little extra food or care. This practice helped to develop the breed's extraordinary toughness and their powers of endurance. The Hackney pony does not have its own stud book, but shares that of the Hackney Horse. By the 1880s the breed was established and its outstanding trotting abilities, its class and exuberance, made the ponies a great success.

The Hackney pony must be under 14 hh and should exhibit true pony characteristics, not simply appearing as a scaled-down version of the Hackney horse. Generally, the Hackney pony has an even more exaggerated action than that of the Hackney horse, with the knees rising as high as possible and the hocks coming right under the body. The action should be spectacular, fluid and energetic, with the pony carrying its head and tail high with an arched neck to produce an effect of display and sportsmanship.

In appearance, the Hackney pony should have a small, quality pony head with alert, pricked ears, and large intelligent eyes. The neck should be muscular and arched, carried proudly. They have good, powerful shoulders and quarters, with a compact back and a light frame. The legs should be very strong with good joints, although the bone is often quite fine. Their feet should be exceptionally hard and it is common practice to allow the toes to grow longer than normal in order to accentuate the snappy action. The tail is always set and carried high. They are generally black, bay, chestnut, or brown and may have some white markings. Their height ranges from 12.2 hh to 14 hh.

HORSE FACT:
The ancient Przewalski horse of Mongolia is also called the Takhi, which means 'spirit', a reference to its independent and unmanageable nature.

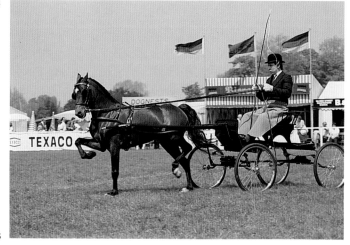

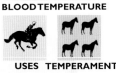

BLOOD TEMPERATURE

USES TEMPERAMENT

Haflinger

<table>
<tr><th colspan="2">BREED INFORMATION</th></tr>
<tr><td>NAME</td><td>Haflinger</td></tr>
<tr><td>APPROXIMATE SIZE</td><td>Up to 14 hh</td></tr>
<tr><td>COLOR VARIATIONS</td><td>Chestnut with flaxen mane and tail</td></tr>
<tr><td>PLACE OF ORIGIN</td><td>Austria</td></tr>
</table>

HORSE FACT:
Linseed must be cooked before it is fed to horses. This process kills an enzyme that produces poisonous cyanide.

THE HAFLINGER is a breed with ancient roots which, due to its geographical isolation, has remained very true to type. They originated around the village of Hafling in the Etschlander Mountains of the southern Austrian Tyrol, and are now bred widely in Bavaria and all over Europe. The breed can be traced back to Arabian bloodlines and a variety of coldblooded lines, a combination which makes them ideal for both riding and light draft work.

The early roots of the Haflinger are not known, but from 1868, their history has been well documented. The prepotent Arabian stallion El Bedavi XXII, was introduced to the breed in 1868, and his son, Follie, foaled 1874, is generally considered the breed's founding sire. Today, four of the five main bloodlines can still be traced back to El Bedavi's offspring. This very pure heritage accounts for the distinct look and characteristics of the Haflinger, which show little variation from horse to horse.

The main centre of breeding for the Haflinger in Austria is the Jenesien Stud Farm where the state controls the stallions to allow careful monitoring of the breeding stock. Colts undergo a rigorous examination and only the very best are allowed to stand at stud. The Haflinger breed also enjoys great popularity in Bavaria, where it is often crossed with Arabian blood. The progeny are then bred back to Haflingers to produce a very nice, quality horse but this system is not practised in Austria.

The Haflinger pony is a typical tough mountain breed and they are strong and sturdy, surefooted, and intelligent. They have a very biddable temperament, making them useful pack ponies, as well as excellent ponies for children and adults alike. They have an attractive head, which is heavy but not coarse, a large, kind eye, and small alert ears. They are typically short in the leg with a broad, strong back and muscled quarters. They should be powerful through the shoulder and deep through the chest. They are nearly always chestnut in color, ranging from light gold to rust and have a flaxen mane and tail. The breed has been described as being a 'prince in front and a peasant behind.' They should not exceed 14 hh, and are often slightly smaller.

Top and Center
With their gentle nature, Haflinger ponies are ideal first rides for children.

Left
Haflingers were carefully bred to exacting specifications, so there are few variations to their distinctive chestnut color.

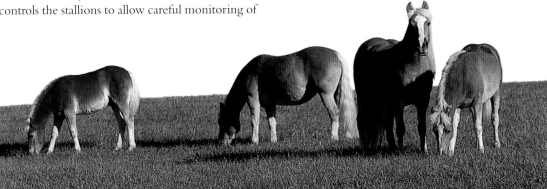

BLOOD TEMPERATURE

USES TEMPERAMENT

Highland

○○○○○○○○○○○○○○○○○○○○○○○○○○○○○

BREED INFORMATION

NAME	Highland
APPROXIMATE SIZE	Up to 14.2 hh
COLOR VARIATIONS	Dun, gray, bay, and black
PLACE OF ORIGIN	Scotland

THE HIGHLAND PONY bears similarities to the postulated Horse Type 2 and the Asian Wild Horse, although, as a breed, it has been subjected to a number of outside influences over the years and has probably changed somewhat in appearance. During the 16th century, French ponies and Spanish horses were taken to the highlands of Scotland, and during the 19th century a Hackney type, and various Fells and Dales ponies, were introduced to the breed. Over the years there has been substantial use of oriental and Arabian stock in the upgrading of the Highland. There were originally two types of Highland – the smaller-framed pony from the Western Isles, and the larger mainland pony. Both types have mostly integrated now, however, and there is less obvious distinction.

Top
The wide nostrils and large eyes of the Highland pony reflects the influence of its Arab blood.

Center and Bottom
Highland ponies are extremely versatile; crofters used them to work on the land and as pack and driving animals.

> **HORSE FACT:**
> In its natural habitat, the horse will eat for approximately 20–22 hours a day, and sleep for two to four hours.

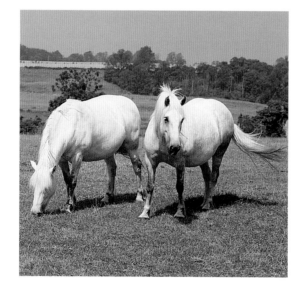

The Highland pony is another breed that has been greatly shaped by its harsh environment producing ponies of extremely tough and hardy nature, with great endurance, and tolerance to bad weather. The Highland pony was used by the Scottish crofters for anything from riding, driving, packing and working the land, and they proved themselves to be highly versatile and biddable. They are known for their ability to cross and wet land and will pass through an area they consider too deep.

The ponies were, and still are, frequently used by hunters for carrying deer and stag carcasses, which demonstrates their extreme strength in relation to their size,

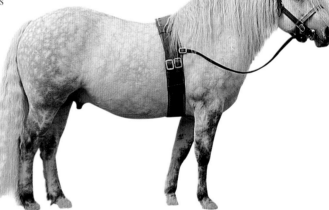

and also their calm temperament – many horses would fiercely object to having a dead animal on their back. Now they are most commonly used for pony trekking and as family ponies, able to carry adults as well as children.

In appearance, they are strong and sturdy, but usually have attractive heads that indicate the influence of Arab blood. They should have small ears and large eyes, with wide nostrils capable of dilation. The neck should be quite long and crested, the back short and strong, the chest deep and powerful, and the quarters muscular. They usually have short legs with flat bone and broad knees. In color they vary from dun with dorsal stripe to bay, brown, chestnut, and gray. White markings should be minimal and they do not exceed 14.2 hh.

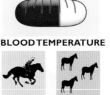

BLOOD TEMPERATURE

USES TEMPERAMENT

Hucul

THE HUCUL PONY is native to the Carpathian Mountains and is considered one of the oldest breeds of native pony in Europe. They are thought to be closely related to the Tarpan, which they resemble, especially in the shape of their short head and the predominant dun colorings. It is likely that they evolved as a result of a cross between the Tarpan and Mongolian horses and, therefore, have a largely oriental background.

One of the first stud farms for the Hucul was established in 1856 at Radauti, Romania, and they were selectively bred there for some years to keep them as true as true to the original type as possible. During the Second World War the breed had its numbers severely reduced and it was not until 1972, with the foundation of the Hucul Club, that efforts were made to re-establish them. The move paid off and, by 1982, a studbook had been established.

Like all mountain breeds, the Hucul is exceptionally tough and hardy, and able to survive terrible climatic conditions. They are extremely surefooted to this day are used for carrying goods across the treacherous mountain paths. They are also widely employed in harness, at which they are very good, and can be used as children's riding ponies. They have traditionally always been used on the remote hill farms for all farm work, and have proved themselves to be extremely versatile. Their harsh environment has made them highly resistant to many forms of equine illness and they are exceptionally sound in wind and limb. Their feet are well formed and

HORSE FACT:
The first 'modern' style of shoeing involving nailing the shoe on, is recorded as having occurred in Europe at the end of the ninth century.

very tough so that they rarely require shoes, even over difficult ground. They have very good temperaments and are both docile and willing, making them suitable for children. They also have a good natural jump and great powers of endurance.

In appearance, the Hucul has a small primitive type head with small alert ears and lively eyes. The neck is short, strong and muscular, and the back is compact and strong with low withers. The shoulders are quite upright and produce a short high action. The chest is usually wide and deep, and the quarters are sloping. Their legs are strong, but often cowhocked. Their color varies from dun to bay, black and chestnut, and their height ranges from 12.1 hh to 13.1 hh.

Top
The head of the Hucul pony is traditionally small, with a short, strong neck.

Left
Huculs were originally mountain ponies, and have been used for many years as pack animals on remote hill farms in Eastern Europe.

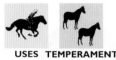

BLOOD TEMPERATURE

USES TEMPERAMENT

Icelandic

○○○○○○○○○○○○○○○○○○○○○○○○○

BREED INFORMATION

NAME	Icelandic
APPROXIMATE SIZE	12.3–13.2 hh
COLOR VARIATIONS	Any color
PLACE OF ORIGIN	Iceland

types more suited to draft work and lighter saddlehorse types. There are frequent horse shows held on the island and racing over short distances is virtually a weekly occurrence.

The Icelandic horse has five natural gaits – the walk, the trot, the fast gallop, the pace, and the *tölt*. The *tölt* is a very fast four-beat running walk and the pace is a flat out two-beat lateral gait, which can only

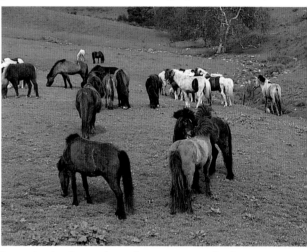

THE ICELANDIC pony is not indigenous to Iceland, but is believed to descend from the North European Forest pony and the Celtic pony. The original settlers in Iceland were two Norwegian chiefs called Ingolfur and Leifur, who moved there with their livestock in A.D. 871. Other settlers from Norway and the Western Isles of Britain also took livestock with them, hence the birth of the Icelandic pony.

The Icelandic pony is actually a small horse, with horselike characteristics. They represent a unique position in modern breeds in that the Icelandic has been uninfluenced by outside blood for over 800 years and is, therefore, one of the most pure breeds in existence. Approximately 900 years ago oriental blood was used on the breed to such disastrous effect that a law was passed banning the importation of foreign equines. This remains in effect today and any exported Icelandic horse is not allowed back into the country.

The Icelandic horse occupies a central part of Icelandic life and has for centuries been heralded by the local people. For many years, they were the only form of transport and today are still widely used to traverse areas not suitable for motor vehicles. They have played an important role in island life from being used to work the land, for transporting goods, riding and for sporting events, which are gaining in popularity. There are various different types of Icelandic horse which have been developed to suit certain functions. Within the breed there are heavier

be maintained over short distances. Typically the Icelandic horse is strong, sturdy, and stocky with a large head, intelligent eyes, a short thick neck, strong legs and a heavy, thick mane and forelock. Interestingly, they also have excellent sight and an uncanny homing instinct. They normally stand at between 12.3 hh and 13.2 hh, and although predominantly gray or dun, or chestnut, they are found in any color.

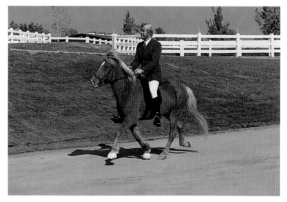

HORSE FACT:
Arkle was the famous Irish-bred steeplechaser who won the Cheltenham Gold Cup for three years running from 1964 to 1966.

Top and Center
The Icelandic pony is one of the purest breeds still in existence today, which is due to its geographical isolation.

Right
A central part of the life of Icelanders, the ponies still work inaccessible farm land but are increasingly used for riding.

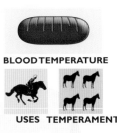

BLOOD TEMPERATURE

USES TEMPERAMENT

Java

THE JAVA, or Kumingan pony, originated on the Indonesian island of Java, probably during the 17th century. The Dutch East India Company was instrumental in the development of many of the Indonesian breeds through their introduction of oriental horses. Their first factory was established on Java

during the late 1500s and from that time on, they imported horses to work in harness and for pack. Local stock was crossed with Arabian and Barb imports and this largely gave rise to the Java pony.

The Java pony of today does not bear startling similarities to the Arabian in conformation, but it has seemingly absorbed the Arab horse's desert nature and is highly resistant to heat. It has also inherited the Arab's endurance and stamina and, in spite of its small and weak-looking frame, works relentlessly all day in the heat. One of the Java's prime jobs is pulling the *sados*, which is a type of horse-drawn Indonesian taxi. The *sados* are often piled high with both people and goods, but the Javas pull them with little effort or sign of distress.

They are useful pack and riding ponies, and are used in both these ways on the island. Unlike other Indonesian breeds, the Java is commonly ridden with a covered wooden saddle that has extraordinary toe stirrups. They involve a piece of rope with a loop in the end through which the rider puts his toe. The Java has a very good temperament, being quiet and extremely willing. They are tough, wiry and light-framed, which may be due to deficient and poor diets.

In appearance, the Java is unremarkable, with a not-unattractive head with quite long ears, and lively expressive eyes. Usually, the neck is quite short and very muscular and leads into pronounced withers. The shoulders are reasonably sloping allowing for a good free stride and the chest is deep, but not very wide. They tend to be long in the back and have a slightly sloping croup. The tail is set and carried high, reminiscent perhaps of the Arab. Their legs are poorly conformed, but surprisingly strong. They are fine in bone, with poorly developed joints, and long cannon bones. The feet are hard and tough. Their coats can be any color and they stand at between 11.2 hh and 12.2 hh.

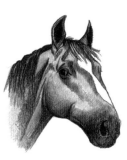

Top
Javanese ponies have a long muzzle, prominent ears and a very short, sturdy neck.

Left
The ponies are commonly used on Java to pull sados, *which are the local traditional horse-drawn taxis.*

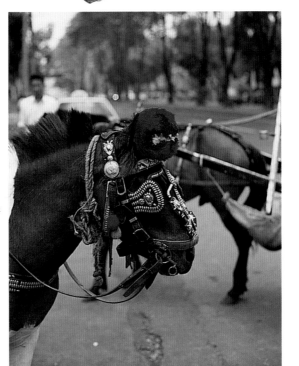

BLOOD TEMPERATURE

USES TEMPERAMENT

Kazakh

○○○○○○○○○○○○○○○○○○○○○○○○○○○○○

BREED INFORMATION

NAME	Kazakh
APPROXIMATE SIZE	Up to 14.2 hh
COLOR VARIATIONS	Chestnut, gray, palomino, or bay
PLACE OF ORIGIN	Kazakhstan, Russian Federation (CIS)

THE KAZAKH is an ancient breed believed to be a descendent of the Asiatic Wild Horse and originating in Kazakhstan of the former U. S.S.R. The breed has been subjected to a wide range of influences from other breeds, most notably, the Mongolian, Arab, Karabair, Akhal-Teke, and more recent infusions of Thoroughbred, Orlov Trotter, and Don blood.

Within the Kazakh breed there are two distinct types which are the Adaev and the Dzhabe, or Jabe. The Adaev is more suitable as a saddle horse, although it can be used in harness, and has evolved as lighter in frame and more lively. The Adaev has benefited from a greater use of Thoroughbred, Don, and Orlov blood than the Dzhabe, and this has created a better quality type, which is, however, less able to cope with the extremely harsh climate.

In appearance, the Adaev is quite fine, with a small head and a long neck. They have a straight back and quite sloping quarters, and are narrow through the chest and frame. They are often criticized as having insufficient bone. Their coats can be chestnut, gray, palomino, or bay, and they generally do not exceed 14.1 hh. The Dzhabe is an extremely tough little pony able to survive in the harshest conditions, finding food in apparently barren areas and being highly resistant to fatigue. They have had large infiltrations of Don blood over the years, which has given them a certain refinement, although they are for the most part fairly massive in build. They are useful draft and working animals, although they can be ridden. Most commonly, however, they are used for the meat and milk industry and are particularly productive in this area.

In appearance, they tend to have a heavy head set to a short but incredibly thick and muscular neck. They are compact through the body with straightish shoulders and muscular, hard legs. The Dzhabe is generally brown, bay, liver chestnut, or mouse dun in color, and tends not to exceed 14 hh. Both types of Kazakh have a very thick and waterproof coat in the winter and are well adapted to harsh and poor surroundings, although the Dzhabe thrives better like this than the Adaev. Neither is particularly astounding as a performance horse, and they tend to have a short and choppy stride.

Top
Kazakh ponies are traditionally working animals rather than riding ponies; they have an uncomfortable, choppy action.

Right
Dzhabe ponies are short and sturdy, with thick waterproof coats to protect the against the extreme cold of Kazakhstan.

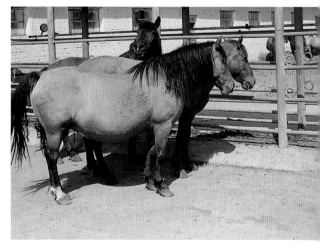

BREED INFORMATION

NAME	Konik
APPROXIMATE SIZE	Up to 13 hh
COLOR VARIATIONS	Mainly mouse dun with dorsal stripe
PLACE OF ORIGIN	Poland

Konik

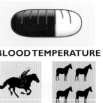

BLOOD TEMPERATURE

USES TEMPERAMENT

Top

Like their ancestor, the Tarpan, Konik ponies are nearly always dun in color with a dorsal stripe.

Bottom

Herds of semi-wild Tarpans are largely made-up of Konik blood.

THE KONIK, which means 'little horse' in Polish, is a breed of ancient descent found mainly in the lowland farm areas of Poland, East of the San river, and also in other parts of Eastern Europe, to where it has been exported. The Konik is mainly bred at the state stud of Jezewice and at Popielno, where it is selectively bred to maintain the breed characteristics. The Konik resembles the Hucul, its close neighbour, and both are believed to be descended from the Tarpan. The Konik has been instrumental in re-establishing the 'new Tarpan' and the wild herd at Popielno is largely made up of Konik blood.

The Konik was a central part of local life and was used in all areas of agriculture, especially at market gardening farms, where they are still employed. Although many Koniks are privately owned by small farmers, during the early 20th century the breed began to decline as larger draft animals were used instead. Numbers have since recovered and it has started to gain in popularity. They make excellent children's ponies due to their very docile and willing temperament, and this is now their main use. They are also good light draft animals. They have had some infusions of Arab blood over the years which has given the Konik a certain refinement, attractiveness and presence. They are typically tough and hardy, economical to feed, long lived, and fertile – all qualities which make them highly attractive within the local community and also across Europe.

In appearance, they retain some primitive characteristics associated with the Tarpan and are nearly always the primitive mouse dun color, with a dark dorsal stripe and wither stripes. They have a nicely proportioned head of a workmanlike character, small ears and lively eyes. The neck is short and muscular and runs into low withers. The shoulders are rather upright which accounts for their poor action, but makes them useful in harness. They are compact and strong through the back and body, with a good depth of girth, and sloping quarters with a reasonably low-set tail. The legs are sturdy and strong with good bone density and hard feet. Occasionally they may exhibit sickle hocks. They tend not to exceed 13 hh.

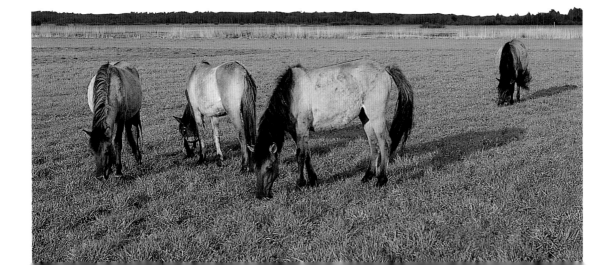

HORSE FACT:

When out hunting, your horse must never step on or kick a hound; this is considered extremely bad form and you may even be asked to leave.

BLOOD TEMPERATURE

USES TEMPERAMENT

Landais

○○○○○○○○○○○○○○○○○○○○○○○○○○

BREED INFORMATION

NAME	Landais
APPROXIMATE SIZE	11.3–13.1 hh
COLOR VARIATIONS	Black, bay, brown, chestnut
PLACE OF ORIGIN	France

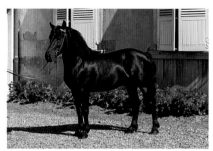

THE LANDAIS is a very old breed that has been heavily infiltrated by foreign blood. A high infusion of Arab blood was introduced around the time of the Battle of Poitiers, A.D. 732, and again in the early 1900s. More recently they were crossed with heavier breeds to increase their build. Originally from the Landes region of Southwest France, they make useful riding and light draft types.

The breed suffered a dramatic reduction in numbers after the Second World War, and Arab and Welsh Section B stallions were used to boost the stock, whose characteristics they now bear. They are exceedingly hardy and an attractive children's pony being naturally intelligent, quiet, and kind.

Top and Right
The Landais has Arab and Welsh blood; they are attractive and biddable ponies.

In appearance, they have a small head with a broad forehead and a straight profile. They have shaped necks that are muscular, and have nicely sloping shoulders. The chest can be under-developed, the withers are pronounced, and they have a short, wide back with sloping quarters. Invariably they are bay, chestnut, black, or brown, and usually stand between 11.3 hh and 13.1 hh.

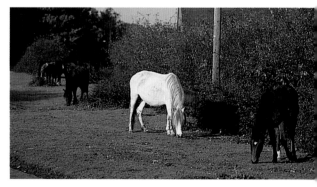

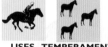

BLOOD TEMPERATURE

USES TEMPERAMENT

Lundy

○○○○○○○○○○○○○○○○○○○○○○○○○○

BREED INFORMATION

NAME	Lundy
APPROXIMATE SIZE	Up to 13.2 hh
COLOR VARIATIONS	Dun, roan, palomino, bay, liver chestnut
PLACE OF ORIGIN	Lundy Island, England

HORSE FACT:
Hades, God of the Underworld, had a chariot pulled by four jet-black horses.

THE LUNDY PONY is a recent breed that was developed on the island of Lundy by using New Forest mares and an Arab stallion. Other influences have been a Connemara stallion and Welsh Mountain stallions but the pony has remained free from other influences. In 1980, the pony herd was moved from the island to Cornwall, where it continued to breed, and then also to North Devon.

The breed society was formed in 1984 and subsequently some mares and foals have been returned to the island. The island provides a very harsh and unfriendly environment, with extreme weather and poor grass. This has made the Lundy pony very hardy and tough, and an economical feeder. They are excellent children's ponies and are highly attractive with good conformation and natural jumping ability.

Right
A new breed, the Lundy pony is a mixture of New Forest, Arab, Connemara and Welsh Mountain genes.

They have fine heads with a well set and muscular neck. They are nicely proportioned with a compact strong back and good hindquarters. The chest is wide and deep, the shoulders sloping, and the legs hard and sound. They are mostly dun, roan, bay, palomino or, liver chestnut, and do not exceed 13.2 hh.

Manipuri

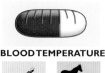

BLOOD TEMPERATURE

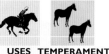

USES TEMPERAMENT

HORSE FACT:

All *equids* are *perissodactyls*, which means that they are hoofed animals that bear weight on their central 'third toe.'

THE MANIPURI FROM INDIA is a breed with ancient roots and is believed to be a descendent of the Mongolian Wild Horse crossed with oriental and Arab stock. The Manipuri is a small animal, rarely exceeding 13 hh, but is extremely quick, agile, tough, and enduring – qualities that must have led it to become one of the original polo ponies.

Ancient manuscripts show that the ruling King of Manipur introduced the fast-moving game in the seventh century using the ponies bred in the state. The British did not discovered polo until the 19th century, when they saw it for the first time and probably played the game using Manipuri ponies. They took the game to Europe and America where it has become phenomenally popular and expensive. The Manipuri pony is ideal for the game possessing all the necessary qualities, but over the years the height limit for the game has been continually raised and in 1919 it was abolished altogether, resulting unfortunately in the Manipuri being passed over in favor of larger polo ponies.

The Manipuri were also great war ponies and were used by the indomitable Manipur cavalry, which was feared throughout Upper Burma in the 17th century. They were still being used in the Second World War, when they were used as transport ponies to accompany the British 14th Army into Burma in 1945. The Manipuri is used today in India for polo and racing, as well as by the military. They are known for their stamina, speed, and intelligence.

In appearance, they should have an attractive head with a straight profile, alert ears, and oriental shaped, intelligent eyes. The muzzle is broad with nostrils that dilate. The neck is muscular and nicely shaped with a good length of rein, and copious mane. They should be broad through the chest, with a compact body and well-sprung ribs. The shoulder is sloping and allows for a fast, long and low action. The quarters are muscular with the croup slightly sloping and the tail set and carried high. The legs are in proportion to the body and should have strong knees and hocks, with good density of bone, and very tough feet. They range in color from mostly bay, to chestnut, gray, brown, and occasionally pinto, and they rarely stand higher than 13 hh.

Left
Manipuri ponies were the original polo ponies, but are now considered too short for the game.

BLOOD TEMPERATURE

USES TEMPERAMENT

Mongolian

○ ○

BREED INFORMATION

NAME	Mongolian
APPROXIMATE SIZE	12–14 hh
COLOR VARIATIONS	Dun, black, bay, brown, chestnut, palomino
PLACE OF ORIGIN	Mongolia

HORSE FACT:
At one time it was a Japanese custom to hang the head of a horse at the entrance to a farmhouse to act as a good luck talisman.

THE MONGOLIAN PONY is perhaps one of the oldest breeds and also one of the most influential, along with the Arabian and Iberian Horse. They originated in Mongolia and descended from Przewalski's Horse, also known as the Asian Wild Horse. As the Mongolians invaded their surrounding countries their influence spread across Asia and Europe; they were probably once the mount of Genghis Khan and his feared warriors. The Mongolian has remained somewhat unchanged and, true to its original form, retains many primitive characteristics.

Largely due to environmental conditions several different types have emerged under the Mongolian heading. There are four main groups, commonly described as the forest, mountain, steppe, and Gobi types. The forest type of pony is the largest and reaches heights of approximately 13.2 hh. They also have the heaviest body frame and are most suitable for draft and pack work. The mountain type is smaller and stands at approximately 13 hh, often with pinto coat coloring. The steppes type is about the same size as the mountain type and is conformationally more suitable for ridden work. The Gobi, or desert type, is the smallest, usually with a pale coat coloring, and is never used for milk production.

All of the types, however, are rather coarse in appearance but they have excellent stamina and are able to work hard and long with little care. They are extremely tough and live out in the open all year round, usually with no extra food and little shelter. The ponies have amazing endurance and will often travel distances of between 60 to 120 miles a day – a feat rarely achieved by any other breed of horse. Some of them also have lateral gaits, which are very smooth and which further enhance their usefulness as long distance mounts. They are used for draft, pack, and riding, but they are also raised for milk and meat production, and are selectively bred for this purpose.

In appearance, they are not particularly attractive and often have a coarse, primitive type head. They are short and stocky through their muscular neck, have a wide and strong frame, and a short compact back with powerful quarters. Their legs are short and strong, and they have very hard feet.

Top
The Mongolian is a primitive breed with dun coloring.

Bottom
The ponies were originally feral and found in great numbers on the steppes.

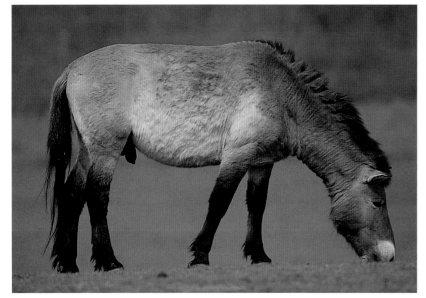

BLOOD TEMPERATURE

USES TEMPERAMENT

BREED INFORMATION

NAME	New Forest
APPROXIMATE SIZE	12–14.2 hh
COLOR VARIATIONS	Mostly bay or brown
PLACE OF ORIGIN	England

New Forest

HORSE FACT:
Riding hats of an approved standard should always be worn when riding.

THE NEW FOREST pony has lived in a semiwild state in the New Forest of Hampshire since the 10th century and has had a varied, but well documented history.

Descended from ancient stock, they have been subjected to various influences, the first recorded one being that of 18 Welsh mares, introduced to the herd in 1208. One of the most interesting influences, however, was provided by the famous small Thoroughbred horse, Marsk.

Marsk was the sire of the indomitable Eclipse, one of the greatest racehorses of all time, and was introduced to the New Forest herd in 1765. His influence was quite considerable and the New Forest pony still retains a largely horse-type head, and an extremely long, low stride aided by good conformation of the shoulders. In spite of Marsk's influence, by the 19th century the quality of the ponies had diminished considerably. In 1852, the Arabian stallion Zorah was used to improve them and then in 1889, another Arabian stallion, Abeyan, and a barb stallion Yirrassan, were lent to the New Forest by Queen Victoria.

In 1891, the Society for the Improvement of the New Forest Ponies was founded, which set up a stallion premium plan for stallions which were suitable to run in the herd. The subsequent introduction of various native ponies, including the Fell, Dales, Highlands, Welsh, Dartmoor, and Exmoor which had an improving effect on the New Forest ponies. Due to these influences, there is a range of characteristics within the New Forest breed and the height can range from 12 hh to 14.2 hh. The New Forest pony is an excellent children's pony, and excels at dressage, jumping, mounted games, and cross country, as well as in harness. The New Forest is now widely bred throughout the UK, although a herd does still remain in the New Forest. They are tough and hardy, have good stamina and endurance, and have very good temperaments.

In appearance, they usually have an attractive head which lacks pony characteristics. They have well-proportioned conformation, a muscular neck and quarters, short and compact back, and often excellent conformation of the shoulder. Their legs are typically quite fine boned, but are strong and tough, with good feet. They are mostly bay or brown in color, but can be any color.

Top
The numbers of New Forest ponies are now increasing again.

Left
Although some ponies still live in the New Forest, they are now bred all over the country.

BLOOD TEMPERATURE

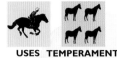

USES TEMPERAMENT

Nigerian

BREED INFORMATION

NAME	Nigerian
APPROXIMATE SIZE	14–14.2 hh
COLOR VARIATIONS	Any color
PLACE OF ORIGIN	Nigeria

THE NIGERIAN originates in Nigeria and is believed to be related to the Barb. Barbs, brought to Nigeria by nomadic peoples, were crossbred with the local ponies, resulting in the Nigerian. The Nigerian may have similar ancestors to the little known Poney Mousseye of Cameroon.

The Nigerian is a large pony breed, although they are sometimes referred to as small horses. Often in poorer environments the growth of a horse or pony is limited due to insufficient food and this can be misleading when categorizing them. However, the Nigerian is a pony, although it exhibits some horselike features. They are very versatile and are used in a light draft and pack capacity, as well as being ridden. Typically they have good stamina and endurance, and a quiet and biddable temperament. They are tough and hardy, and resistant to the heat of their climate.

In appearance, they have a plain head with a straight profile and small, alert ears. They have a short neck, nicely sloping shoulders, a deep chest, prominent withers, a short back, and the characteristic sloping croup of the Barb horse. On the whole they are attractive ponies, compact through the body with strong legs, although sometimes the quarters are poorly developed. They can be any color and stand at between 14 hh and 14.2 hh.

Top
The genes of the Nigerian pony may contain Barb blood.

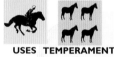

BLOOD TEMPERATURE

USES TEMPERAMENT

Poney Mousseye

BREED INFORMATION

NAME	Poney Mousseye
APPROXIMATE SIZE	Up to 12 hh
COLOR VARIATIONS	Any color
PLACE OF ORIGIN	Cameroon

THE EXACT heritage of the Poney Mousseye is not known although it is thought they may have some common roots with the Nigerian. They are small ponies, which also exhibit some horse-like characteristics, and, like the Nigerian, the Poney Mousseye has been described as a 'degenerate Barb.'

Interestingly, the fairly rare Poney Mousseye mainly lives in the area around the river Logone, notorious for the tsetse fly that produces sleeping sickness. The Poney Mousseye, however, appears to be resistant to this, while other breeds of equine are not. They live a very geographically isolated existence and have been largely unaffected by other breeds.

The ponies make good riding ponies and, in appearance, have a large and heavy head, a short thick neck, and long back. The legs are short and strong and the breed possesses great stamina and endurance.

They can be any color, but are mostly gray or chestnut, and stand under 12 hh.

Right
The Poney Mousseye appears to be resistant to the tsetse fly which causes sleeping sickness.

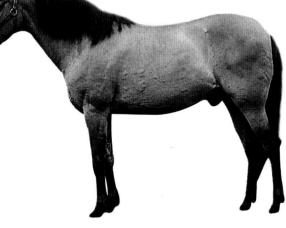

Northlands

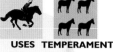

BLOOD TEMPERATURE

USES TEMPERAMENT

THE NORTHLANDS PONY is an extremely old breed that originates in Norway. It is generally considered to be a descendant of the Asiatic Wild Horse and the Tarpan, from which the Baltic pony, or Konik, and the Celtic ponies, the Icelandic, Shetland and Exmoor, also derived. The Northlands, therefore, have much in common with the breeds mentioned above and comparisons between them are worth making.

The Northlands pony developed slightly differently in different regions of Norway and, although now the differences are less obvious, there is one type called the Lyngen that does sometimes reappear. The Lyngen pony developed in Lyngen in Northern Troms and is generally larger than the Nordland type and is mostly chestnut in color. The Northlands was traditionally the pony of the Norweigan farmers and as such was used for riding, light draft and farm work – all areas in which these excellent, strong ponies excel. Until the 20th century there was no real selective breeding occurring and the numbers of the Northlands pony steadily declined.

After the First World War, there was an effort made to preserve the breed and regulate the standard of ponies being bred, although by 1944 there were in fact only 43 registered ponies left. Since then there has been another conscious effort to re-establish them, and numbers have improved, mainly due to the stallion Rimfakse.

Typically, the Northlands has a good temperament, being docile, yet energetic. They are tough and hardy, and very well adapted to the harsh climate of their environment; they are also very long lived, and have a long working life, as well as remaining fertile longer than many other breeds. They make good ponies for children and have a naturally athletic jump.

In appearance, they should be sturdily built with an attractive head and small, pricked ears, a shortish and thick neck, nicely sloping shoulders, a deep and wide chest, flat withers, a long back, and well-made hindquarters with a tail set and carried correctly. The legs are typically very hard and strong with hard hooves. The Northlands is an attractive and well-made pony with good workmanlike conformation. They are generally bay or brown, but can also be chestnut or gray, and stand at between 12 hh and14 hh.

HORSE FACT:
The Duke of Wellington's favourite horse was a charger called Copenhagen that carried the Duke during the Battle of Waterloo.

Left
Northlands ponies are the subject of an intensive breeding programme which has led to an increase in their numbers.

HORSE BREEDS

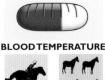

BLOOD TEMPERATURE

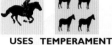

USES TEMPERAMENT

Norwegian Fjord

Right and Far Right
The Norwegian Fjord is an ancient breed with an upright, two-tone mane and short legs with feathering.

HORSE FACT:
The mythical Hippopod was a creature with the body of a man, and the legs and feet of a horse.

BREED INFORMATION

NAME	Norwegian Fjord
APPROXIMATE SIZE	13–14 hh
COLOR VARIATIONS	Dun with dark dorsal and zebra stripes
PLACE OF ORIGIN	Norway

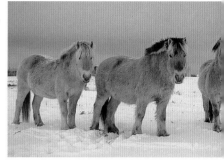

THE NORWEGIAN FJORD pony is an ancient breed, with strikingly primitive characteristics, resembling the Asian Wild Horse. Once the mount of the Vikings, the Norwegian Fjord's popularity spread across Scandinavia, and they are now found worldwide. Since the beginning of the 20th century, the Fjord has remained pure and is often regarded one of the ancestors of all modern European draft breeds. They are incredibly versatile, making excellent riding ponies, as well as being used for farm work and driving; they are tireless workers with a very kind and biddable temperament.

They are characterized by their distinctive dun coloring with upright two-tone mane, which is dark in the centre and light cream or silvery on the outside. They are stocky with a neat head, wide forehead and a very powerful neck with little or no wither. The legs are short and strong with some feathering and the feet exceptionally hard. They differ in weight and size, some being almost light draft, while others are more refined and used mostly for riding. Their height varies from 13 hh to 14 hh.

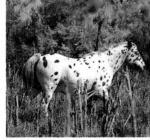

BLOOD TEMPERATURE

USES TEMPERAMENT

Pony of the Americas

BREED INFORMATION

NAME	Pony of the Americas
APPROXIMATE SIZE	11.2–14 hh
COLOR VARIATIONS	Spotted coat
PLACE OF ORIGIN	United States

THIS IS a new breed founded during the 1950s and developed through an Appaloosa mare crossed with a Shetland stallion. The first foal of this cross was called Black Hand 1, and is the foundation sire. The breed has since benefited from Quarter Horse, Welsh and Arab blood, as well as further infusions of Shetland and Appaloosa. The resultant Pony of the Americas combines the best features of all these breeds and has quickly developed into a very popular and versatile children's pony.

Their conformation resembles the Quarter Horse and Appaloosa and they have the presence of the Arabian and superb temperaments. In appearance they have an attractive fine head with a slightly dished profile. They are compact with well-sprung ribs and muscled quarters. The chest is wide and deep and the shoulders are sloping. The tail is carried high and the action is free-flowing and balanced. For registration with their breed society, they must have one of the accepted Appaloosa coat patterns. They stand at between 11.2 hh and 14 hh.

Right and Far Right
This new breed has a fine, slightly dished head, which shows its Arab heritage.

Przewalski's Horse

BLOOD TEMPERATURE

USES TEMPERAMENT

HORSE FACT:
A horse called Sultan, also known as Ivan, was the favourite mount of Buffalo Bill Cody and featured in his Wild West Shows.

BREED INFORMATION

NAME	Przewalski's Horse or Asian Wild Horse
APPROXIMATE SIZE	Up to 13 hh
COLOR VARIATIONS	Sand dun with dark dorsal, wither, and zebra stripes
PLACE OF ORIGIN	Asia

THE REDISCOVERY of the Asian Wild Horse is attributed to the Russian Colonel Nikolai Przewalski in 1881. However, it has recently come to light that this extraordinary breed had been spotted many years earlier by various explorers.

Przewalski found the horses in the Dzungarian region of Western Mongolia and in prehistoric times they would have lived in a wide area covering the European and Central Asian Steppes. They are the only known breed of true wild horse in the world and represent a direct link between early and modern horse. They have some differences from domestic horse, primarily the presence of 66 chromosomes in the Asian Wild Horse, and only 64 in the domestic horse. Some people contend that the Asian Wild Horse is a different species, while others maintain that they are the same, but have developed a chromosome mutation. They also have some asinine features, but this reflects the early roots of the horse and the donkey.

Sadly, the Asian Wild Horse was hunted to virtual extinction in the wild and has for years existed at zoos and research stations where it has been the subject detailed study. Recently a herd was released back into their natural habitat in Mongolia and is being carefully watched over and protected. The Asian Wild Horse is almost impossible to tame in any way and even when living in the domestic

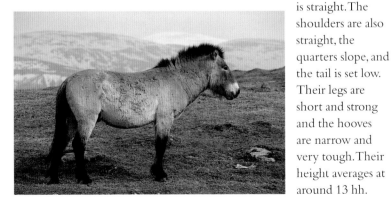

surroundings of zoos, they retain their wild and aggressive nature.

In appearance, they are truly primitive and are characterized by their dun coloring with lighter belly and muzzle. They have dark points, often with zebra stripes on the forearms, hocks and gaskins, and a dark dorsal stripe. The mane is coarse and stands upright, the forelock is sparse, and the tail is similar to that of a donkey, with short coarse hair at the top, growing longer at the bottom. They have large, heavy heads with a convex profile, small, high set eyes, and a heavy jaw. The neck is short and muscular, the withers are flat, and the back is straight. The shoulders are also straight, the quarters slope, and the tail is set low. Their legs are short and strong and the hooves are narrow and very tough. Their height averages at around 13 hh.

Top
The Asian Wild Horse is the only truly wild horse left in the world.

Left and Far Left
The pony can be very difficult to tame, with a stubborn and aggressive nature.

BLOOD TEMPERATURE

USES TEMPERAMENT

Sable Island

○○○○○○○○○○○○○○○○○○○○○○○○
BREED INFORMATION

NAME	Sable Island
APPROXIMATE SIZE	Up to 14 hh
COLOR VARIATIONS	Dark colors
PLACE OF ORIGIN	Sable Island

LITTLE IS known of the first horses on Sable Island, off the coast of Nova Scotia, Canada. The ponies now on the island rarely stand over 14 hh, but are descended from horses, and owe their small height to their environment.

One of the first horses on the island was the stallion, Jolly, who was taken there in 1801, but there were already horses there and it is thought they may have arrived as early as the 16th century. The ancestry of the ponies is unknown, but they owe some debt to the Spanish horse.

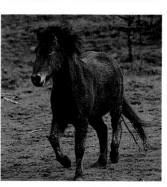

The majority of the ponies are feral, but some have been tamed to ride, and are said to be excellent, tough and enduring, and able to travel with ease over any terrain. The ponies are all very hardy and thrive in an inhospitable environment. The herds are not managed and so exhibit a range of characteristics. In general, they have nice heads with a straight or convex profile and are short, stocky and muscular in frame. Their coats are mostly dark colors and they do exhibit white markings.

Right and Far Right
These ponies are actually small horses; their height was dictated by their environment.

BLOOD TEMPERATURE

USES TEMPERAMENT

Sandalwood

○○○○○○○○○○○○○○○○○○○○○○○○
BREED INFORMATION

NAME	Sandalwood
APPROXIMATE SIZE	Up to 13 hh
COLOR VARIATIONS	Any color
PLACE OF ORIGIN	Indonesia

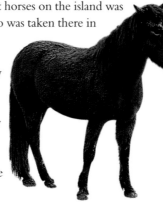

THIS BREED originated in Indonesia on the islands of Sumba and Sumbawa, and takes its name from the export of sandalwood, one of Indonesia's main crops. The Sandalwood is the best of the Indonesian breeds and owes this to the high percentage of Arab blood they contain. The Sandalwood is a highly versatile pony and is used for riding, pack, farm, and draft work, as well as for racing and harness racing. They are extremely quick and agile and are used for local bareback races over three miles on the islands.

They make excellent children's ponies, and many have been exported to Australia for this reason; they are also exported to other Southeast Asian countries as racing ponies. They have great stamina and endurance and are quiet and easy to manage. In appearance, they have a nicely proportioned head with small alert ears and intelligent eyes. They generally have a short and muscular neck, a deep chest, sloping shoulders, a long, straight back, and a sloping croup. They can be any color, and stand at between 12 hh and 13 hh.

Above and Right
Sandalwood ponies are quick and agile; they are often used as racing ponies.

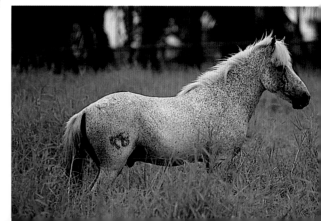

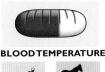

Sardinian

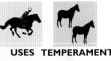

BLOOD TEMPERATURE

USES TEMPERAMENT

THERE IS little hard fact surrounding the development of the Sardinian pony, which is now quite rare, but there are far more records about the Sardinian horse, also known as the Sardinian Anglo-Arab. The Sardinian pony is an ancient breed developed from early imports of Barb and Arabian stock to the island, as well as probably containing some Spanish blood. The first documented mention of the pony was not until 1845, and even since then they have remained largely unrecorded.

What is interesting is that the Sardinian pony, although small in size, does have some horselike characteristics, and this is especially seen in the conformation of the foals. It is worth considering that this is another pony breed descended from horses and shaped accordingly by their wild environment. Many of the ponies live in a feral state on a harsh plateau approximately two thousand feet above sea level. The living conditions are poor and food is sparse. This has made the ponies extremely tough and hardy, resistant to the weather, and economical feeders.

The domesticated Sardinian pony is suitable for riding, light draft, and light farm work. They are very surefooted over rough terrain which makes them useful for pack and trekking. Generally, they have a quiet temperament but there are instances of the Sardinian exhibiting a difficult streak and being somewhat stubborn.

In appearance, they have a heavy head, with a straight or convex profile, small alert ears, and large intelligent eyes. The neck is in proportion to the body, and is muscular with a good arch from withers to poll. The back is short and compact, but inclined to be hollow, and the croup is sloping with a low-set tail. Mostly the conformation of the shoulders is good, having a nice slope, and being powerful. They are deep and wide through the chest, and have long legs which are strong but fine in bone. The hooves are tough, and they do not generally exhibit lameness in the legs or feet, although they do have the conformational defect of cow hocks. Generally, they are brown, black, bay, or liver chestnut and stand between 12 hh and 13 hh.

HORSE FACT:
The Hansom cab, a two-wheel buggy drawn by one horse, was introduced to London in 1834 by J A Hansom.

Top
Little is known about this rare breed, which may have developed from a mixture of Barb and Arab blood.

Left
The Sardinian pony may have a slightly convex profile, alert ears and an arched neck.

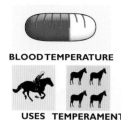

BLOOD TEMPERATURE

USES TEMPERAMENT

Shetland

BREED INFORMATION	
NAME	Shetland
APPROXIMATE SIZE	Up to 42 in (10.2 hh)
COLOR VARIATIONS	Mostly black, chestnut, brown, gray, and pinto
PLACE OF ORIGIN	Scotland

NATIVE TO the Shetland Islands off Scotland, the Shetland pony's roots are unknown, although they are an ancient breed. They probably have strong ties to the ancient ponies from Scandinavia and may have reached the Shetland Isles before the lands were separated by water in approximately 8,000 B.C. They would have been influenced by the Celtic pony, taken to Scotland by the Celts in the second and third centuries A.D. The Shetland pony is one of the oldest surviving breeds and has probably not changed dramatically in appearance.

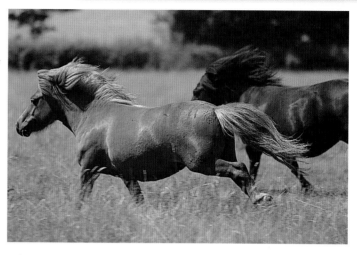

Possibly the strongest of all breeds in relation to its size, the Shetland pony was commonly used for all farm tasks, as well as working extensively in the mines as pit ponies. They would have been used in all areas of the early crofters' lives and were commonly used for transporting peat for fuel, which was incredibly heavy. Due to its harsh living conditions, the Shetland is extremely hardy, resistant to difficult climatic conditions, with an extremely waterproof winter coat. They are very surefooted, have excellent eyesight, and are long lived.

Shetland ponies are found worldwide, most notably in America, which has bred a larger, flashier Shetland known as the American Shetland. The American Shetland is most commonly used for showing and carriage driving and has some Hackney pony infusions in the bloodline. The English Shetland pony is now generally used as a children's pony and as a pet, due to its diminutive size. They are very good starter ponies for children, but must not be spoilt or they will develop a difficult temperament. They are measured in inches or centimetres rather than in hands and a Shetland at three years old should not exceed 40 inches, while at four years and over they can be up to 42 inches.

In appearance, they have a small attractive head with wide spacing between the eyes. The ears are small and alert, and the neck short and muscular. The back is short with well-defined withers, deep through the girth, and with well-sprung ribs. The legs are short and strong, being long through the forearm and short in the cannon. They have copious mane and tail growth and exceptionally thick winter coats. They can be any color including skewbald and piebald, but should not be spotted.

Top

Shetlands survived in extremely harsh conditions, and in consequence they are very hardy ponies.

Center and Right

Shetland ponies make ideal children's ponies, but their temperaments can be easily spoilt.

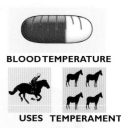

BLOOD TEMPERATURE

USES **TEMPERAMENT**

BREED INFORMATION

NAME	Sorraia
APPROXIMATE SIZE	Up to 13 hh
COLOR VARIATIONS	Dun, grullo, dark palomino
PLACE OF ORIGIN	Spain, Portugal

Sorraia

THE SORRAIA is descended from very ancient stock and is related to the Tarpan, as well as possibly the Asian Wild Horse. The Sorraia influenced the development of many breeds, including the indomitable Spanish Horses – the Andalusian, Lusitano and Alter Real – and is in many ways a mini version of these breeds of horse. They originated in the western region of the Iberian Peninsular and can be traced to the area between the Sor and Raia rivers, which is in both Spain and Portugal and from whence they derive their name.

Spanish conquistadores took numbers of the Sorraia with them to America and their influence is seen in many American breeds. Over the centuries, the Sorraia has undoubtedly been subject to man's selective breeding but it still retains some of its primitive characteristics and bears a striking resemblance to many of the prehistoric cave paintings that have been discovered. They are extremely tough and hardy, with great powers of endurance and stamina, and have a long working life.

Traditionally, the Sorraia would have been used for working the land, and in light harness, as well as being ridden. For years they were associated with the cowboys of the region and make excellent cow horses. The Sorraia is known for its calm and gentle temperament, a trait which is seen in many of the Spanish horse breeds. They are also intelligent, easy to train, and naturally very willing. Sadly the breed now exists in very few numbers and has been maintained largely by the efforts of the d'Andrade family in Portugal, which keeps a small Sorraia herd in a wild state.

In appearance, the Sorraia has typical Spanish characteristics. They have a heavy head with a convex profile and quite large ears. The

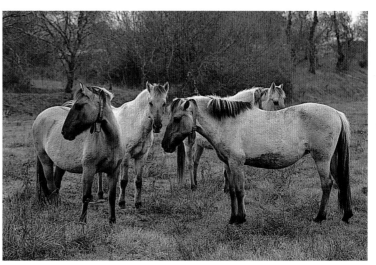

neck is elegant and muscular, and arches nicely from the withers to the poll. They are compact through the back with well-defined withers, and sloping quarters with a low-set tail. They have a deep, but often narrow, chest, and a reasonably straight shoulder. The legs are short and strong with good joints and hard hooves. They are always primitive colors: dun with dorsal stripe, a dark palomino, or grullo. Grullo is a slate gray with a brown tinge over the body and darker head and legs. They tend not to exceed 13 hh.

Top
Sorraia ponies are always dun, dark palomino or slate gray touched with brown, and have dorsal stripes.

Left
The head is heavy, with a muscular neck and large pricked ears.

233

BLOOD TEMPERATURE

USES **TEMPERAMENT**

Sumba and Sumbawa

BREED INFORMATION	
NAME	Sumba and Sumbawa
APPROXIMATE SIZE	Up to 12.2 hh
COLOR VARIATIONS	Mostly dun with dark dorsal stripe
PLACE OF ORIGIN	Indonesia

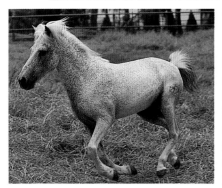

Top and Right
These Indonesian ponies are fast and agile; they are used in fast horseback games and in traditional ceremonies.

THESE PONIES ARE effectively the same, and are named after the islands of Sumba and Sumbawa where they live. They are descended from ancient stock and have both Chinese and Mongolian blood in them. They are widely used on the islands for a variety of jobs, including pack, riding and light draft, and exhibit extraordinary strength. They are frequently ridden by men, and are used in the fast and furious game of Lance Throwing. They are also used in traditional Indonesian dancing competitions. Young boys ride the ponies bareback in patterns dictated by the dance master, and the ponies are decorated with bells attached to their knees and move in time to a rhythm beaten on a drum.

They are typically quiet and willing with good stamina and endurance and are fast and agile. In appearance, they have primitive characteristics, with a heavy head, a short muscular neck, a deep chest, straight shoulders, and flat withers. They are often long in the back, which is very strong, and have a sloping croup. The legs are fine but strong with well-formed hooves. They may be any color although are often dun with a dark dorsal stripe and black points, and do not generally exceed 12.2 hh.

BLOOD TEMPERATURE

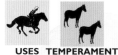

USES **TEMPERAMENT**

Syrian

BREED INFORMATION	
NAME	Syrian
APPROXIMATE SIZE	Up to 15.1 hh
COLOR VARIATIONS	Chestnut or gray
PLACE OF ORIGIN	Syria

ORIGINALLY FROM SYRIA, the Syrian or Syrian Arab is an ancient breed that is closely related to the Arabian. It is often considered that the Syrian Arabian is of purely Arabian blood, but has developed and named according to its region. The Syrian is actually a small horse, with horselike characteristics and conformation, but is included in this section due to its height!

They bear all the virtues of the Arabian, and are extremely hardy, tough, and frugal. They are superbly adapted to a desert climate and cope with both heat and cold, as well as poor nutrition; they make excellent riding horses. In appearance, they resemble the Arabian, but are generally a little larger, both in height and frame, and are somewhat less attractive; they have the same spirit, presence, and bearing. The coat can be gray or chestnut, and they stand at between 14.2 hh to 15.1 hh.

Right
The Syrian is related to the Arab, and has the same elegant bearing and presence.

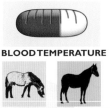

Tarpan

○ ○

BREED INFORMATION

NAME	Tarpan
APPROXIMATE SIZE	Average of 13 hh
COLOR VARIATIONS	Dun
PLACE OF ORIGIN	Eastern Europe, Western Russia

THE TARPAN was for many years confused with the Asian Wild Horse and no distinction was made between the two. More recently, the two breeds have been recognized as quite significantly different, and while the Asian Wild Horse is believed to be the ancestor of the Mongolian pony and other heavy-headed breeds, the Tarpan has been attributed with the development of the light horse breeds such as the Trakehner and possibly even the Arabian. The importance of the Tarpan is key to understanding the

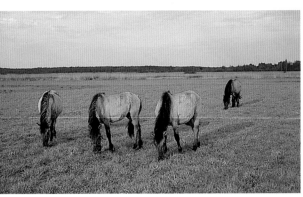

development of the modern horse breeds and it is tragic that the breed was allowed to become extinct. The last wild Tarpan died in 1879, while an attempt was being made to capture it, and the last Tarpan in captivity died in 1887 in Munich Zoo.

The modern Tarpan is a reconstructed breed based on the Tarpan's close relatives, the Konik and Hucul. The most primitive examples of the Hucul and Konik were collected by the Polish government as these specimens were considered likely to contain a high percentage of Tarpan blood. They were then crossbred and the progeny interbred to establish a fixed type. The modern Tarpan does greatly resemble the original breed but, of course, can never be the same. Now they are selectively bred in the Polish forests of Bialowieza and Popielno and they have retained some of the inherently wild characteristics of the old Tarpan. They are very hardy and tough, economical feeders, longlived and resistant to many equine diseases, and highly fertile. They have been ridden and used for light draft, but are now primarily kept in feral herds.

The old Tarpans were captured by the local farmers and kept and tamed for work because of their formidable strength and toughness. These captured Tarpans would have bred with the domestic Hucul and Konik. The fate of the old Tarpan is thought to be almost directly a product of hunting for meat.

In appearance, the Tarpan has a long head with a slightly convex profile, longish ears, a short, thick neck, powerful shoulders, a long back, and sloping quarters. They are mouse or brown dun, with dorsal stripe and two-tone mane and tail. Sometimes they have zebra stripes on the legs and their coats change in winter to white. They stand at approximately 13 hh.

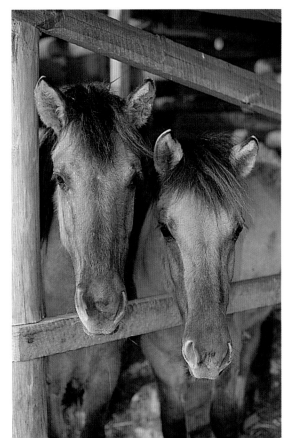

Top and Center
The Tarpan has been recently re-introduced after becoming extinct in the 19th century.

Left
The Tarpan has a long face and convex profile, with long ears and a powerful, short neck.

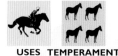

BLOOD TEMPERATURE

USES TEMPERAMENT

Tibetan

⊙⊙⊙⊙⊙⊙⊙⊙⊙⊙⊙⊙⊙⊙⊙⊙⊙⊙⊙⊙⊙⊙⊙⊙⊙
BREED INFORMATION

NAME	Tibetan
APPROXIMATE SIZE	Up to 12.2 hh
COLOR VARIATIONS	Mostly bay or gray
PLACE OF ORIGIN	Tibet, China

THE TIBETAN PONY is found in Tibet and is descended from ancient stock. They have some similarities to the Mongolian pony and to other Chinese breeds, but have remained largely pure for many years. They are famous for their incredible strength and endurance in relation to their size. The Tibetan pony is held in high regard among the local people and has traditionally always been kept by wealthy Tibetans and by the Dalai Lama, as well as by the local farmers. Tibetan ponies were often sent as gifts to the Emperors of China, especially during the Tang and Ming dynasties. They are excellent workers and are employed in light draft,

Right

The hardy Tibetan ponies are extremely agile and surefooted, with short, solid legs.

riding, and pack. They are extremely surefooted and are very resilient and energetic.

In appearance, their heads have a pronounced jaw line with a straight profile and small eyes and ears. The neck is muscular and shortish, the chest deep and the shoulders straight. The back is short with flat withers and broad, powerful hindquarters, the legs are short and strong with solid joints. They are mostly bay or gray, but can be any color, and stand at approximately 12.2 hh.

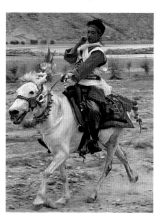

BLOOD TEMPERATURE

USES TEMPERAMENT

Timor

○○○○○○○○○○○○○○○○○○○○○○○○○○
BREED INFORMATION

NAME	Timor
APPROXIMATE SIZE	10–12 hh
COLOR VARIATIONS	Mostly bay, brown, or black
PLACE OF ORIGIN	Indonesia

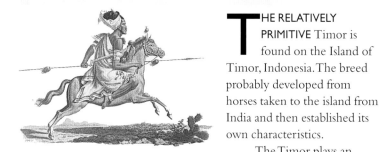

THE RELATIVELY PRIMITIVE Timor is found on the Island of Timor, Indonesia. The breed probably developed from horses taken to the island from India and then established its own characteristics.

The Timor plays an important role on the island, and is used for riding, driving, light farm work, and working the cows. This tiny pony shows remarkable strength and endurance and works with cattle very well. Characteristically they are quiet and biddable as well as being strong, frugal and quick. Large numbers of Timor ponies have been exported to Australia where they have been instrumental in developing the Australian pony.

Above and Right

Timor ponies have long been part of Indonesian culture, and are used for riding, driving and working cows.

In appearance, they have large and heavy heads for their narrow frame, a short muscular neck, a short back, prominent withers, and a sloping croup, with a high-set tail. The shoulders are often quite straight and the legs are tough with small hard feet. They are generally brown, black, or bay, and stand between 10 hh and 12 hh.

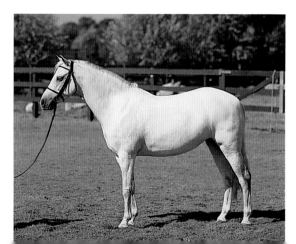

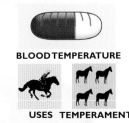

BLOOD TEMPERATURE

USES TEMPERAMENT

Viatka

THE VIATKA is a rarely heard of breed that has been in danger of extinction for several years. They originated in the areas around Viatka and Obva river basins of the former U.S.S.R. and have probably been influenced by both the Klepper and Konik ponies, while almost certainly being a descendent of the Tarpan.

They are extremely useful and versatile ponies and have stamina, hardiness, and endurance. They are used for riding and driving and are commonly used for pulling the traditional *troikas*; they are also useful for light agricultural work. They have an excellent willing and honest temperament, which makes them easy to handle.

In appearance, they have a small head, set on to a strong, thick neck. They are very powerful through the shoulders, deep through the girth and have muscular quarters. Invariably the Viatka has a luxurious mane and tail, and in winter grows an incredibly thick coat. Characteristically they are chestnut or bay roan, or dun-colored with a dorsal stripe and sometimes zebra markings on the legs, although occasionally bay and roans are seen. Their height ranges from 13 hh to 14.2 hh.

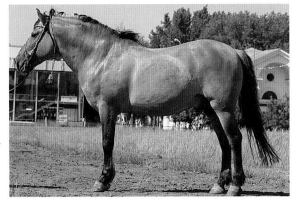

Top and Left
The Viatka is probably descended from the Tarpan and is now extremely rare.

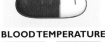

BLOOD TEMPERATURE

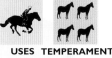

USES TEMPERAMENT

Welara

HORSE FACT:
Grass grows best in soil with a pH value of 6.5.

THE WELARA is a new breed that was developed in the United States and established in 1981. The Welara comes from Southern California where the first person to breed a Welara pony was Lady Wentworth. The breed was first introduced by using the stallion Skowronek on Welsh mares imported from the Coed Coch stud farm in North Wales. These ponies are highly attractive and excellent performers, making superb children's ponies. They combine the best features of both the Arab and Welsh pony, and have an enormous presence and carriage, while also moving extremely well for a pony breed. They have good temperaments, being calm, yet also lively and energetic when required, and are kind and intelligent.

In appearance, the Welara has a fine and attractive head set to a muscular and gently arched neck. The back is short and compact with good powerful quarters, and nicely sloping shoulders. Their legs are very tough and strong with hard hooves. Any color is accepted into the registry, apart from appaloosa, and they stand at between 11.2 hh and 14.2 hh.

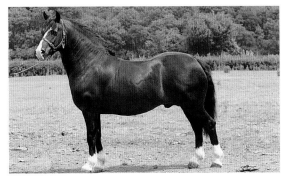

Left
Welara ponies are a new American breed combining the well-known strengths of Arabs and Welsh ponies.

BLOOD TEMPERATURE

USES TEMPERAMENT

Welsh Mountain

BREED INFORMATION	
NAME	Welsh Mountain
APPROXIMATE SIZE	Up to 12 hh
COLOR VARIATIONS	Often gray, can be any color except piebald and skewbald
PLACE OF ORIGIN	Wales

THE WELSH MOUNTAIN pony is the oldest recorded native British pony breed, and it is believed that Julius Caesar founded a stud of the ponies on the shores of Lake Bala. It is likely that he introduced some oriental blood to the line and, until the beginning of the 20th century there were periodic infusions from other breeds, most notably Arab, Thoroughbred, and Hackney. One important early influence on the breed was the Thoroughbred stallion, Merlin, and occasionally, Welsh ponies are still referred to as merlins.

The Welsh studbook is divided into four sections according to conformation and height, and the Welsh Mountain pony comes under Section A. These are the smallest of the four sections, and their height must not exceed 12 hh. They are also the oldest, and were the foundation stock from which the other three types arose. The Welsh pony has had a huge effect on the development of numerous other breeds and, in almost all cases, passes on its quality and talents. It has been used in the development of the Riding pony, to great effect. The studbook was established in 1902 and a great effort has been made to maintain fixed types since then.

One of the most important stallions in the breed since the 1900s was Dyoll Starlight, who is credited as the foundation sire of the modern breed. He was a combination of Welsh and Arab. Typically, they have excellent temperaments and make first-class children's ponies. They are enormously talented and are as useful in harness as they are under saddle. Early practices of keeping Welsh ponies out on the hills and uplands of Wales were crucial to the characteristics of endurance and resilience that these ponies now have. They have a particularly sound constitution and are very economical feeders.

In appearance, the Welsh pony should have a pretty Arablike head with kind, wide set eyes, and small alert ears. The neck should have good length and be arched, and they should have a sloping shoulder, deep chest, short strong back, and fine legs with good hocks. They should have a good depth of girth with a rounded rib cage and muscular quarters. The legs have particularly dense bone and short, strong cannons. They can be any color except skewbald or piebald.

Top
Welsh Mountain ponies have attractive Arab-like heads with slightly convex profiles.

Bottom
This is a versatile and tough breed, with a calm temperament, which makes for excellent riding ponies.

HORSE FACT:
The first documented horse race in Australia took place in Sydney in 1821.

Welsh Pony Section B

BLOOD TEMPERATURE

USES TEMPERAMENT

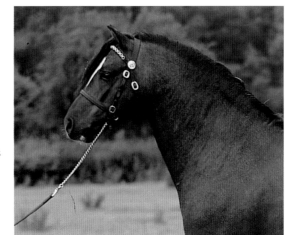

THE WELSH SECTION B PONY developed through a cross between the Welsh Mountain pony and the heavier small Welsh cob, known as Section C. The Section B pony also contains Arab, Thoroughbred, and Hackney blood and is full of quality. Many of them are shown as Riding ponies but their essential Welshness and true pony characteristics, seen in the Welsh Mountain pony should shine through. Some Section B ponies are criticized for being too fine and light weight.

There are three foundation sires for the Section B: firstly, Tan-y-Bwlch Berwyn, who was himself sired by a barb stallion out of a Welsh mare from the famous Dyoll Starlight line. The second stallion was Criban Victor of Welsh descent, and the third was Solway Master Bronze, who sired a terrific number of first-class foals. The early Arab bloodlines are often quite evident in the Section B, especially in the head, and also in their flamboyant action. They have excellent conformation of the shoulder, producing good free-flowing movement, which is particularly eye-catching in the show ring.

The Section B, like the Mountain pony, has a superb temperament and disposition, and is an excellent children's pony. The Section B is a first-class performer, having a good natural jump, and also the balance and rhythm required for dressage. They are also very good in harness and make the all-around perfect ride and drive pony.

In appearance, they should retain some characteristics of the Mountain pony but are lighter in frame. The head is highly attractive, broad across the forehead and tapering to a fine muzzle. The eyes are large, expressive and intelligent. They should have a well-conformed neck in proportion to the body, muscular and gently arched from withers to poll. They are deep and wide through the chest and have a compact and strong back. They should have good depth of girth and well-made muscular quarters. The tail is set and carried high and they typically have great presence. The legs are very correct with good bone measurement, well-made joints and tough hooves. They can be any color except skewbald or piebald, and must not exceed 13.2 hh.

Top
The Arab blood can easily be seen in the strong conformation of the Welsh pony.

Bottom
These ponies are very handsome, with tapering heads and fine muzzles.

BLOOD TEMPERATURE

USES TEMPERAMENT

Welsh Sections C and D

○ ○

BREED INFORMATION

NAME	Welsh Sections C and D
APPROXIMATE SIZE	Up to 13.2 hh for Section C, no height limit for Section D
COLOR VARIATIONS	Any color except skewbald or piebald
PLACE OF ORIGIN	Wales

HORSE FACT:

The first Grand National Steeplechase at Aintree took place in 1839 and was won by a horse called Lottery.

THE WELSH PONY of cob type, Section C, is the smaller of the two Welsh cob types. The Section C has a height limit of 13.2 hh, and is similar to the Welsh Mountain pony, except that it has a heavier frame and is more coblike. Both the Section C and the Section D, the Welsh Cob, probably developed through a cross with the Mountain pony and horses brought by the Romans when they went to Wales.

There were later crosses with Spanish horses, which led to the development of the Powys horse. The Powys horse was the foundation stock from which the Section C and Section D developed. Much later in the development of the breed was influence by the indomitable Norfolk Roadster and early Hackney types, as well as the Yorkshire Coach Horse.

Both Section C and D are excellent in harness and the recent revival in competitive driving has increased the use of the Welsh cobs. Four very influential stallions on both Sections were: Trotting Comet, foaled 1840 from a long line of formidable trotting horses; True Briton, foaled 1830, by a trotting sire out of an Arabian dam; Cymro Llwyd, foaled 1850, by an Arabian stallion out of a trotting mare;

and lastly Alonzo the Brave, foaled 1866, whose ancestry traced back through Hackney heritage to the Darley Arabian. The heritage of these four sires clearly shows both the trotting and the Arabian influence and these characteristics are present in both Sections today. The Arabian debt is seen in the presence, bearing, and carriage of these two types, and also sometimes in the head and expression of the face. Both Sections are versatile animals with great talent and scope. They have very good temperaments, stamina and endurance, and are easy to keep.

In appearance, the Section C is a smaller version of the D, which has no height limit. They have attractive heads, a good muscular and arched neck, a deep and wide chest, good depth of girth, and a rounded barrel, a compact back, and muscular powerful quarters. The legs are well made, sturdy and strong, and the Section D may have light feathering around the fetlock. They can be any color except piebald or skewbald.

Top and Right
The Welsh Cob has a pony-like head on a muscular neck and a strong, sloping body.

Far Right
Section D ponies have handsome heads and sweeping manes and forelocks.

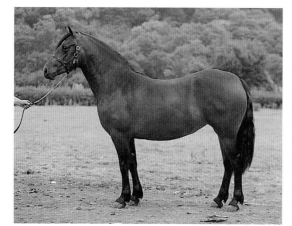

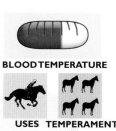

BLOOD TEMPERATURE

USES TEMPERAMENT

Zemaituka

HORSE FACT:
The Velka Pardubicka Steeplechase Cross Country, also called the Grand Pardubice, was first held in 1874 in Czechoslovakia..

THE ZEMAITUKA, or Zhumd, is an ancient breed originally from Lithuania and now existing in very few numbers. The exact history of the Zemaituka is not known but they are believed to be closely related to the Konik of Poland and are probably descended from the Tarpan. However, over the years, the Zemaituka has been influenced by other breeds, namely those of native Russian origins, and also the light horse breeds of Poland.

More recently, during the 19th century, the Zemaituka had infusions of Arab blood and this Arab ancestry can often be seen in their head. With the influence of the Arab blood, two different types of Zemaituka emerged – one of better quality, finer, saddle type, and the other, having less Arabian blood, more suitable for draft work. Now there is less distinction between the two since, following the Second World War, there was a conscious effort to try to increase the size and bulk of the breed and they are now suitable for both riding and draft.

They live in extremely harsh climates, with poor forage and freezing temperatures, which have greatly contributed to their development. Consequently, they are frugal feeders, possessed of enormous stamina and endurance and seemingly unaffected by fatigue. The Zemaituka generally has a quiet and biddable temperament and is suitable and widely used for riding, light draft, and farm work. In spite of their fairly massive frame, they are surprisingly agile and athletic and, for these reasons, when crossed with a lighter, larger breed, they produce excellent sports horses.

In appearance, they have an attractive head with a large kind eye, and mobile ears. The neck is broad and muscular, and they are deep through the chest. The shoulders can be rather straight, they have a compact, short, straight back, a sloping croup, and a low-set tail. Their legs tend to be short and muscular, but can have poor hocks although the feet are well formed with hard horn. In terms of color, they are often mouse dun, or dun with a dorsal stripe and black points, which is a clear indication of their ancient origins, but can also be brown, black, bay, or palomino. They stand at between 13.2 hh and 14.2 hh.

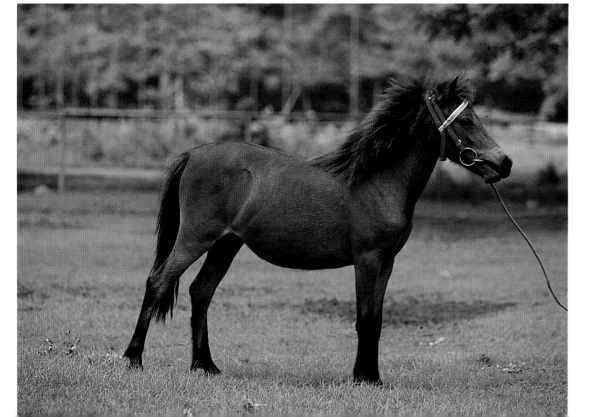

Left
Like this Indonesian pony and the Tarpan, the strength and size of the Zemaituka has been shaped by its harsh environment.

The Heavy Horse

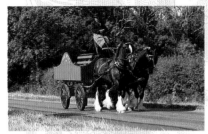

HEAVY, OR DRAFT, describes the horse breeds that are the most suited to heavy draft and farm work, and they differ in conformation and temperament to the light horse. For centuries the draft horse was indispensable to farming and industry and is still used in some countries today. However, since the arrival of mechanization many of these breeds are in danger of disappearing.

THERE ARE AREAS where the horse is able to perform more efficiently than a vehicle; the North Swedish Horse, for example, is still used for forestry work, being more agile through the trees than a large vehicle, and the Comtois of France is employed in vineyards and forests. Often a draft horse is better able to cope with uneven, rocky, hilly, or boggy terrain than a tractor. The big brewery companies are great supporters and there are show classes held for these breeds in particular, Trade and Turnout classes are spectacular to watch.

Many of these horses are now bred for the meat industry, particularly in France and the former USSR. This can lead to a deterioration in conformation as they are selectively bred for body mass. Many lighter drafts are crossed with light horse breeds, especially the Thoroughbred. The Irish Draft and Thoroughbred is an excellent combination but has become so popular that numbers of pure-bred Irish Drafts have diminished.

In general, draft breeds have a large, dense skeletal frame, with legs short in proportion to body mass; the one notable exception is the long-legged Clydesdale. Typically, they have a very muscular, thick neck, a broad, deep chest, and a short, wide back. The withers are mostly rounded, and the shoulders are usually quite upright, contributing to a short stride and high knee action. Characteristically they have superb temperaments, being willing and docile, although there is always the odd exception. Temperament is important when considering their size and bulk. Most, but not all, draft breeds have feathering, which can be a disadvantage when working in muddy, wet conditions, since the hair retains moisture and can cause skin problems. The Suffolk Punch does not have feathering and this was due to the heavy clay soils in which the Suffolks had to work.

Although most commonly associated with working in the fields, forests, and transporting heavy goods, the draft horse has, through time, had a variety of jobs, including carrying knights into battle, and drawing the early stagecoaches.

Top
Jutland horses can be traced back to the 12th century.

Right
Shire horses still pull drays for various breweries while heavy horses still work on some farms.

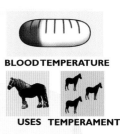

Ardennes

BLOOD TEMPERATURE

USES TEMPERAMENT

<table>
<tr><td colspan="2">BREED INFORMATION</td></tr>
</table>

BREED INFORMATION	
NAME	Ardennes/Ardennais
APPROXIMATE SIZE	14.3–16 hh
COLOR VARIATIONS	Roan, bay, iron gray or chestnut; black and dappled gray are not allowed
PLACE OF ORIGIN	France and Belgium

THE FRENCH ARDENNES originates from the mountainous region of the Ardennes bordering France and Belgium, although there is a Swedish Ardennes and a Belgium Ardennes. The original Ardennes, that of France, is the oldest, and can be traced back to accounts by Julius Caesar in his *De Bello Gallico* about his conquest of Gaul. They are an ancient cob-type draft horse, very similar to the remains of the ancient horse found at Solutré, suggesting a direct descendancy.

The old type of Ardennes was somewhat lighter than the massive form of the modern type and would have been suitable for riding as well as draft work. They were widely used during the French Revolution (1789) and after by the French military. During the Napoleonic Wars they excelled themselves with their amazing stamina, endurance and ability to survive amid the harshest conditions. It is likely that the Russian Ardennes developed from the French Ardennes left behind in Russia during the French retreat.

The more modern type was developed during the 19th century and is a larger type of draft horse. They were crossed with Boulonnais, Percheron, Thoroughbred and Arabian blood and were bred for greater strength to cope with very heavy types of draft work. They are particularly good in rough and hilly areas, where they are extremely surefooted and have a kind, but lively temperament. The Ardennes are also being bred in Belgium and Sweden, where they have often been crossed with other breeds of draft horses. The Ardennes is closely related to the Auxois and to the Trait du Nord draft breeds.

The conformation is coblike, with a strong, compact body, muscled quarters, a thickset neck, and a well-shaped head. They tend to have a good sloping shoulder which allows for a freedom of movement not usually associated with the draft horse. They are particularly thickset and are built as power houses, with a huge pulling capacity. They are used as draft animals in France, but are also raised for the meat industry. They are usually roan in color, but can be bay or chestnut, and stand between 14.3 hh and 16 hh.

HORSE FACT:
Charles Pahud de Mortanges (Netherlands) holds the record for winning four Olympic gold medals for three-day eventing in 1924 (team), 1928 (team and individual), and 1932 (individual).
Guinness Book of Records.

Top and Center
The Ardennes has a strong body with thickset shoulders and a short head.

Left
Ardennes horses are still used as dray animals in France as they are immensely powerful.

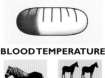

BLOOD TEMPERATURE

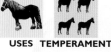

USES TEMPERAMENT

Auxois

```
○○○○○○○○○○○○○○○○○○○○○○○○○○○○○○
         BREED INFORMATION
NAME                Auxois
APPROXIMATE SIZE    15–16.2 hh
COLOR VARIATIONS    Bay, roan, sometimes chestnut
PLACE OF ORIGIN     France
```

ORIGINALLY FROM the Cote d'Or and Yonne region of France, the Auxois breed is a descendant of the old Burgundian horse, dating back to the Middle Ages. There are very few left, although efforts are being made to maintain the breed, particularly around the Cluny Stud and the fertile areas of Yonne and Saône-et-Loire.

HORSE FACT:
Mark Todd (New Zealand) won individual Olympic gold medals in 1984 and 1988 for three-day eventing.
Guinness Book of Records.

In the 19th century there was an infusion of Boulonnais and Percheron blood, as well as Ardennais and Trait du Nord, which increased the overall size of the Auxois. They are closely related to the Ardennes, and since the beginning of the 20th century, only Ardennais blood has been used to improve the Auxois. They are now somewhat larger in height than the Ardennes and both breeds are selectively bred for the meat market due to their mass. The Auxois were widely used in the transport industry and, with the advent of mechanization, suffered dramatically in numbers.

Today they are strictly protected and monitored by the Syndicat du Cheval de Trait Ardennais de L'Auxois which is based in Dijon, and has kept the breed's studbook since 1913. They have kind, quiet, and biddable temperaments, which combined with their endurance, makes them highly suitable for heavy draft and farm work.

In appearance, they are typically either bay or roan in color, although can sometimes be red roan or chestnut. They usually have a smallish head in comparison to body size, which is broad across the forehead and has small alert ears. They are very stoutly built, having a short, thickset neck, flattish withers, and a wide and deep chest, characteristics also associated with the Ardennes. Generally they are broad through the back, which is also straight, and have a long, sloping, muscular croup with a low-set tail. The shoulders are also reasonably sloping which allows for good freedom of movement. They have particularly powerful legs, which are slender in proportion to the body, with a very muscular forearm and short dense cannon bones.

Compared to the Ardennais, the Auxois is finer in the legs and has smaller hindquarters, though this is relative. They are not heavily feathered and can move surprisingly freely and fast for their bulk. They are well built and, like the Ardennes, have an enormous pulling capacity. They stand between 15 hh and 16.2 hh.

Top
Normally bay or roan in color, the Auxois is stoutly built with long, sloping shoulders.

Right
The Auxois has a broad head, which is small in relation to its vast body size.

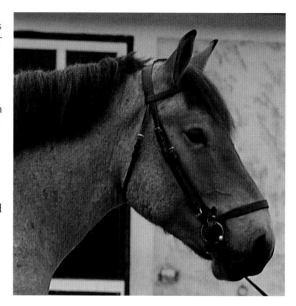

Boulonnais

BLOOD TEMPERATURE

USES TEMPERAMENT

BREED INFORMATION

NAME	Boulonnais
APPROXIMATE SIZE	15–17 hh
COLOR VARIATIONS	Mostly gray, but also bay and chestnut
PLACE OF ORIGIN	France

HORSE FACT:
The longest jump over water ever recorded was 27ft 6 in (48 m) and was made by Something, ridden by Andre Ferreira in Johannesburg, South Africa on April 25, 1975.
Guinness Book of Records.

THE BOULONNAIS originates in the North-West of France and is a very ancient breed, although it was not officially recognized until the 17th century. The Boulonnais developed from heavy draft horses of pre-Christian times and owes its quality and spirit to early infusions of Arab and Barb blood during the 16th century.

The Boulonnais is often described as the Thoroughbred of the heavy horse – they have an exceptionally fine head for a horse of their size, combined with an excellent free-flowing action. In fact, the Boulonnais have such an admirable turn of speed that they were commonly used as carriage horses. They also have very fine skin with delicate veins, which has led to their being compared to polished marble.

As well as the large Boulonnais there was the Mareyeuses, or the 'Petite Boulonnais,' which was a smaller build, standing at between 15 hh and 15.2 hh. This swifter animal was used to transport fish from coastal regions to Paris quickly. The Mareyeuse has virtually disappeared and the numbers of the Boulonnais itself were greatly depleted during the Second World War. They are noted for their stamina and endurance and are able to maintain a steady speed over great distances. Due to their quality they are often used to improve other draft bloodlines in much the same way as the Thoroughbred is used to

improve riding stock. Sadly, their use is somewhat limited now, although the preservation of the breed is ensured by the vigilance of the French National Studs and the larger types are bred widely for use in the French meat industry.

In appearance, the Boulonnais is a very large and heavy horse, standing up to 17 hh. They have a fine head as noted, with expressive eyes. The neck is nearly always gently curved and very well set to a nicely sloping shoulder which allows for their action. They have a broad chest, powerful quarters with clean legs, and often have flat hooves. The legs are very powerful and have very well-made large joints. A peculiar feature they tend to have is a bushy tail, which could be a throwback to their eastern influence. The predominant color is gray, although bay and chestnut are not uncommon.

Top
With an Arablike head, the Boulonnais has a curved neck and sloping shoulders.

Left
The Boulonnais is the aristocrat of heavy horses, with an ancient lineage and Arab blood.

BLOOD TEMPERATURE

USES TEMPERAMENT

Top
The strength of the Brabant and the willingness of their temperament makes them ideal working horses.

Bottom
The Brabant has huge shoulders, an arched neck and a relatively short head.

HORSE FACT:

Dick Turpin the legendary English Highwayman was publicly hanged in York in 1739 for robbery and horse theft. Before his capture he lived with his parents near the village of Shenton and kept his horse, Black Bess, in a clearing in Lindley Wood.

Brabant

BREED INFORMATION

NAME	Brabant
APPROXIMATE SIZE	15.3–17 hh
COLOR VARIATIONS	Roan
PLACE OF ORIGIN	Belgium

THE BRABANT is an extremely old breed of horse which can be traced to the prehistoric horses of the alluvial period and is likely to be related to the Ardennes. Also called the Belgium

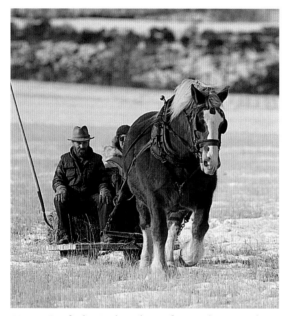

Heavy Draft, the Brabant has influenced many other breeds of draft horse. During the Middle Ages, the Brabant was also known as Flanders Horse, and played a major role in the development of the heavy English breeds – the Shire, Clydesdale, and Suffolk Punch – and may have contributed toward the early Irish Draft horses.

Until the beginning of this century, there were three different types, which were bloodline related. The first was the Colossal Horse of Mehaigne, for which the stallion Jean I was responsible; the second was the Big Horse of the Dendre, which was founded by the stallion Orange I; and the last group was the Grey Horse of Nivelles, which was based on the stock produced by the stallion Bayard. The progeny of the great stallion Orange I were noted for their success in the show ring during the 1800s.

By the 20th century however, the three groups had become indistinguishable. The studbook for the Brabant in Belgium was started in 1855 by the

Société Royale Le Cheval de Trait Belge, numbers since have dropped quite significantly in England. They are, however, popular in America, and the American studbook for the breed was started in 1887. The breed in America has changed from the original Belgium Brabant, having become more refined and more stylish. They are one of the heaviest draft horses and combine their incredible strength with an extremely willing and generous temperament, making them an ideal heavy work horse.

Typically, they have a small head on a thick and muscular neck, huge powerful shoulders and quarters, and short legs with a small amount of feathering around the fetlock. Their stride is quite short and choppy, typical of the draft action, but they do have a good

walk. Before mechanization, the Brabant was exported all over Europe and to America due to their excellent pulling efficiency but, since the end of the Second World War, their numbers have declined, although they are still bred for the meat industry. The Brabant is predominantly chestnut or red roan in color, and can stand up to 17 hh.

BREED INFORMATION

NAME	Breton
APPROXIMATE SIZE	15–16 hh
COLOR VARIATIONS	Chestnut, chestnut roan, flaxen mane and tail
PLACE OF ORIGIN	France

Breton

BLOOD TEMPERATURE

USES TEMPERAMENT

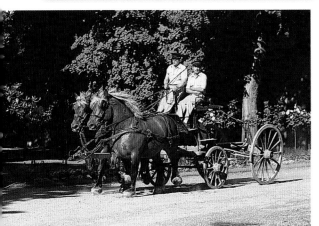

ORIGINALLY FROM Brittany, France, the Breton horse has an interesting history. The breed originally developed from horses kept by Celtic warriors, and then remained largely unchanged until an infusion of oriental blood during the Crusades. This led to the development of the Bidet Breton and, by the end of the Middle Ages, two different strains of Breton had evolved. These were the Sommier Breton and the Rossier. The Sommier was heavier, being suitable for pack, draft, and farm work, while the Rossier was a lighter-gaited animal with a very comfortable stride. The Rossier became popular among the military, being able to travel long distances at its brisk ambling gait, which was somewhere between a walk and a trot. During the 17th century, many were exported to Canada and their influence is still evident there today.

By the end of the 19th century, the breed had developed again, due to crosses with Percheron, Ardennes, and Boulonnais. This led to the Draft Breton, a heavy draft animal of tremendous power. Another type of Breton horse came about during the

middle of the 19th century which was the versatile Postier Breton horse. The Postier had large infusions of Norfolk Roadster blood and was a lighter, more refined horse, still with great strength. They are lively and energetic and the pride of Brittany. There is a third type of Breton horse called the Breton Corlay, which is built more along mountain pony lines, and is very rare and seldom seen today. Both the Postier and Draft Breton horses have had a joint studbook since 1926, which has been closed since 1951 to maintain the breeds' characteristics.

The Postier are invariably very compact with an attractive head on a crested neck. They should be clean in the leg and have a positive action. They generally have an excellent temperament making them a highly versatile and useful horse. Predominantly chestnut or chestnut roan in color, they often have a flaxen mane and tail, and sometimes a dark cross is evident on the withers, indicating their primitive ancestry. They tend to stand at between 15 hh and 16 hh. The Draft Breton is similar to the Postier Breton in many ways except that they are heavier and tend to stand between 15 hh and 15.2 hh.

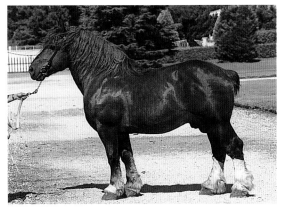

HORSE FACT:
America's first rodeo bucking horse was called Steamboat. He was born just before the turn of the century in Wyoming and started his long bucking career in 1901 at the Wyoming Frontier Day festival. He bucked for 13 years, and in all that time only one person, Dick Stanley, ever stayed on him for the compulsory eight seconds.

Top
The Breton is still frequently used in driving competitions.

Center and Right
The horse has a heavy body with an arched neck and attractive flowing mane and forelock.

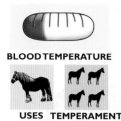

BLOOD TEMPERATURE

USES TEMPERAMENT

Clydesdale

○ ○

BREED INFORMATION

NAME	Clydesdale
APPROXIMATE SIZE	16–18 hh
COLOR VARIATIONS	Mostly bay
PLACE OF ORIGIN	Scotland

THE CLYDESDALE originated in the Clyde region of Scotland during the mid-18th century and replaced the use of the Shire in Scotland. It developed from a tough and hardy native breed and, with the introduction of Belgian Draft and Flemish stallions, started to gain size and bulk. One of the early influential stallions was a horse called Blaze, a native stallion. This laid the roots for the breed and then, during the 1720s, the 6th Duke of Hamilton imported six Flemish Great Horses to further improve the Clydesdale.

The early Clydesdales were referred to as the Clydesman's Horses by local people and they gained recognition and admiration for their enormous pulling power. Infusions of Shire blood added to their bulk, especially during the latter stages of the 19th century, when Lawrence Drew and David Riddell introduced the use of Shire mares. Interestingly these two breeders were convinced that the Shire and the Clydesdale were two branches of one breed. The Clydesdales were widely used throughout Lanarkshire for hauling loads of coal, and they began to be used throughout England. Several early influential stallions were Glancer, who foaled 1806, and Broomfield Champion. Broomfield Champion is often credited with stamping his mark on the modern Clydesdale and this was partly through the influence of his son, Clyde.

The Clydesdale Horse Society was formed in 1877 – the Clydesdale was the first draft horse in Britain to have its own society. The Clydesdale has several characteristics which breeders have sought to maintain, namely, their exceptionally tough and hard legs and feet and the activity and energy of their stride. They have one of the most extravagant strides seen in the draft breeds.

The Clydesdale has an attractive head with a straight profile, large intelligent eyes, and a broad forehead. The neck should be curved and well set to slightly sloping shoulders. They should be quite compact through the back, with well-sprung ribs, and muscular hindquarters. They should have broad strong joints and feathering. The modern Clydesdale is smaller than the original type, and is usually around 16.2 hh.

As with all draft breeds, they suffered a decline in numbers after the beginnings of mechanization, but have recently again increased in numbers. The Clydesdale is very popular in America, and is famously represented by the Budweiser Clydesdale team.

HORSE FACT:
Gene Autry with Champion, and Roy Rogers with Trigger, are perhaps the most famous man-and-horse combinations ever seen on television and the big screen.

Top and Bottom
Clydesdales pull wedding carts in Hawaii and are often used in driving competitions.

Center
The Clydesdale has one of the most extreme actions of any of the draft breeds.

Comtois

BLOOD TEMPERATURE

USES TEMPERAMENT

BREED INFORMATION

NAME	Comtois
APPROXIMATE SIZE	14–15 hh
COLOR VARIATIONS	Dark chestnut, flaxen mane and tail
PLACE OF ORIGIN	France

THIS ANCIENT BREED is thought to have existed in the French-Comte region of France as early as the fourth century, when they were mentioned by Publius Vegese. They probably originated from German horses imported by the Burgundians and it seems that their appearance has not altered dramatically over the years.

During the 16th century, they were used to improve the Burgundy Horse, and were themselves improved during the 19th century by Norman, Percheron and Boulonnais blood. More recently there have been infusions of Ardennes blood into the breed which has greatly improved their strength and soundness. They are versatile horses and were favored by the military in France. They were used by Louis XIV for both the cavalry and the artillery, and in Russia during Napoleon's attacks. They are suitable for draft, farm, and riding, and are surefooted and tough. They are a mountain type, and are now bred widely in the mountainous areas of the Alps, Pyrenées, and Massif Central. They are ideally suited to the climate and environment of mountain work. However, they are also used for work in the forests and, interestingly, for working in the vineyards.

In appearance, they tend to have cobby characteristics with a large head, a straight profile, and small, alert ears. The neck should be very muscular and is often quite short. They are broad and deep through the chest, with a rounded ribcage, short, strong legs and powerful quarters. The legs have good strong joints and hard hooves, and are generally quite clean, with minimal feathering. Occasionally they will have the conformational defect of sickle hocks. They have a distinctive, often very dark, chestnut coloring and a lighter mane and tail, and generally stand at under 15 hh.

They are still used in France for working in steep and rough areas, and are also, sadly, bred for the meat industry. The breed remains fairly prolific and has not become dramatically reduced in numbers as many draft breeds have since the use of motorised machinery. In part, the meat trade of France strangely helps to maintain the heavy horse breed numbers although horses being bred solely for the meat industry tend to suffer a deterioration in characteristics, as the emphasis is placed on producing bulk and meat.

Center
The distinctive dark chestnut coloring of the Comtois highlights the paler shade of the mane and tail.

Bottom Left
Comtois horses have short, sturdy legs which makes them ideal for working in inaccessible, rugged terrain.

Bottom
The head of the Comtois is large and the breed has a prolific mane and forelock.

HORSE FACT:
A horse's appetite should be approximately equivalent to two and a half percent of its total body weight.

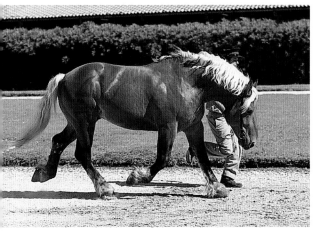

BLOOD TEMPERATURE

USES TEMPERAMENT

Dole Gudbrandsdal

○ ○

BREED INFORMATION	
NAME	Dole Gudbrandsdal
APPROXIMATE SIZE	14.2–15.2 hh
COLOR VARIATIONS	Black, brown, or bay
PLACE OF ORIGIN	Norway

Top
Dole Trotters have powerful hindquarters and shoulders, with long backs and arched necks.

Bottom
Both Dole horse types have a luxurious mane and tail and are usually black or dark brown.

HORSE FACT:
Racing at Ascot in Berkshire, England was started in 1711 by Queen Anne; the first Royal Ascot meeting was on 11 August 1711.

THE NATIONAL DOLEHORSE Association was only established in 1967. The foundations of the breed are ancient, however, and they originated in the Gudbrandsdal Valley in Norway, probably descended from Dutch Friesan horses. They have similarities to the native British Fells and Dales and it is likely that they all originated from related prehistoric stock. There are two distinct types of Dole horse – the heavier Dole Gudbrandsdal and the lighter Dole Trotter – although the two types are commonly interbred today.

The Dole Gudbrandsdal owes much of its present characteristics to a stallion called Brimen, and was widely used for agricultural and pack work. With the advent of mechanization, numbers declined, but in 1967 with the establishment of their association, and a state breeding center, their numbers started to increase. Both the draft type and the Trotter have to undergo tests and grading and the draft type is judged on its pulling power and its trot. The lower legs and feet are x-rayed and if weaknesses show up the animal cannot be used for breeding purposes. The trotting horses have to have performed well on the racetrack to be used for breeding.

The trotting strain developed through experimenting with different breed crosses. One of the more successful ones was with the English horse Odin, who has been described as both a Thoroughbred and a Norfolk Trotter. He produced a lighter type of horse with a better trot stride, while maintaining the power of the hindquarters. Odin is present in all modern Dole pedigrees. Other stallions to influence the trotter were, Balder (4), grandson of Odin, the Arabian Mazarin, Toftebrun and Dovre, who is registered as being the foundation sire of the trotting Dole. The Dole Trotter is slightly larger than the Gudbrandsdal and has a more refined head but both types appear similar.

Typically they have a crested neck, strong, powerful shoulders and quarters, and are inclined to be slightly long backed. The Dole Gudbrandsdal has short legs with very short, dense cannon bones with some feathering. Both types have a luxurious mane and tail and are nearly always black or dark brown in color. They stand at between 14.3 hh and 15.2 hh. The Dole Trotter tends to have less feathering of the legs and is notable for its endurance and stamina.

Dutch Heavy Draft

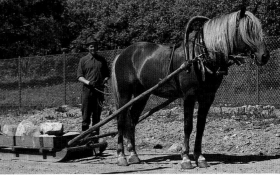

BLOOD TEMPERATURE

USES TEMPERAMENT

THIS IS A relatively young breed which was developed in Holland after 1918. The Dutch Draft is massive and is the heaviest of the Dutch horses. They developed from crossbreeding between the Brabant, Zeeland-type Dutch mares and the Belgian Ardennais, and still bear a resemblance to the Brabant.

Traditionally, the Dutch Draft was used for agricultural purposes throughout Holland, especially on heavy clay soils which tire many other breeds out. Before mechanization, they were popular agricultural horses through Gelderland, North Brabant and

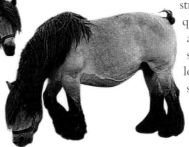

Limburg, because of their phenomenal strength and willing temperament. They are generally intelligent, good 'doers,' and economical to keep. Surprisingly for their size, they are very active and tend to have a long working life.

They are of a massive build, although the head should not be too coarse. They have a short neck, often set on to loaded shoulders, with a wide and strong back. The quarters are muscular and powerful, with a sloping croup and a low-set tail. They stand at about 16.3 hh and are generally chestnut, bay, or gray.

Left
These phenomenally strong horses reach up to 16.3 hh and have black feathering on their legs.

HORSE FACT:
Riding hats became compulsory in racing in 1923 after the death of jockey Captain Bennett at Aintree.

Finnish Draft

BLOOD TEMPERATURE

USES TEMPERAMENT

THERE WERE originally two types of Finnish horse – the Finnhorse Draft and the Finnish Universal (see the Light Horse section). Over the years, the two breeds have been widely interbred, and the heavier draft has largely disappeared. The Finnish Draft was bred on a purely functional and practical basis and was rather common in appearance.

They were a comparatively small draft horse, standing at about 15.2 hh, but were incredibly strong and capable of the hardest agricultural tasks. They were kind and willing, with a fast-stepping, naturally active stride. The horses developed from crossbreeding between the native ponies from countries along the Baltic coastline and imported foreign breeds, and so exhibit both coldblood and warmblood characteristics. They are of a medium weight for a draft, averaging 1,270 lb (576 kg), and

should have an attractive head that is not too large, a strong neck, and powerful shoulders and quarters. Their legs should be clean and well muscled, without much feather. Generally

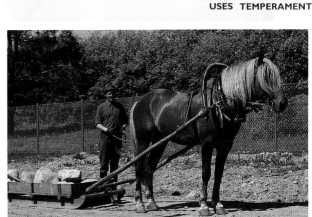

they are chestnut, gray or bay, and occasionally black or brown – white markings are acceptable. Their studbook was opened in 1907 and they have to undergo quite stringent performance testing which is designed to keep the breed clean.

Above
The Finnish Draft has a fast-stepping stride and is well-suited to hard agricultural work.

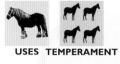

BLOOD TEMPERATURE

USES TEMPERAMENT

Freiberger

┌───┐
│ BREED INFORMATION │
├───┤
│ NAME Freiberger │
│ APPROXIMATE SIZE 14.3–15.3 hh │
│ COLOR VARIATIONS Bay or chestnut │
│ PLACE OF ORIGIN Switzerland │
└───┘

Top

With a calm and easy disposition, Freibergers are often still used as dray horses.

Bottom

The breeding of Freibergers is strictly monitored and they can only be bay or chestnut in color.

ALSO KNOWN as the Franches-Montagnes, the Freiberger originated in Switzerland in the Jura region at the end of the 19th century. The breed developed by crossing the native Bernese Jura horse with the English Thoroughbred and Anglo-Norman, and also with the Ardennais and the Arab. There are two distinct types within the Freiberger breed: a broader, heavier stamp of horse with more muscle development and a lighter, finer type. Nowadays there is a trend towards breeding the lighter type, as interest in competitive riding and leisure riding increases. However, the importance of the old type of Freiberger should not be overlooked, and this is why the Freiberger is included in the Draft section rather than the Light Horse section.

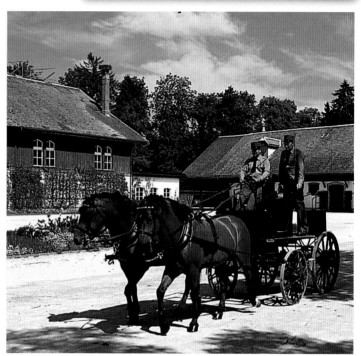

These days found in Italy as well as all over Europe, the Freiberger is a highly versatile horse, used for light draft, farm work, riding, and competitive riding. They are a mountain horse and do very well in hilly and mountainous areas, being naturally surefooted and tough and, in many cases, far better equipped for working this type of land than a tractor. They were widely used by the upland farmers of the Jura region and are also popular with the Swiss Army, who favour them as pack animals and for use during patrols. Many Freibergers trace back to one stallion, called Valliant, who had a mix of Norfolk Roadster, Anglo-Norman, and English Hunter blood in him. Another influential stallion was Urus, who also contained Norman blood. They are bred at the Avenches stud, the Federal stud, where their breeding is strictly regulated. They mature quickly into well-balanced, active, and calm animals making them easy work companions.

Typically, they have a heavy, although small, head with a pronounced jaw line and a broad forehead. The neck should be arched and muscular, with a good sloping shoulder, broad and pronounced withers, and a straight and powerful back. They invariably have good clean legs, strong joints, and hard feet. Traditionally, they had a very small amount of feathering at the fetlock, although modern breeding has largely bred this out, and they also have a somewhat finer head now, which sometimes shows Arab character in the facial expressions. Characteristically they are only bay or chestnut in color and stand at between 14.3 hh and 15.3 hh.

HORSE FACT:

'Man has to learn how to walk; the horse walks naturally'.

Alessandro Alvisi.

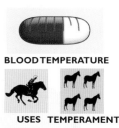

Irish Draft

BREED INFORMATION

NAME	Irish Draft
APPROXIMATE SIZE	15.3–17 hh
COLOR VARIATIONS	Bay, chestnut, or gray
PLACE OF ORIGIN	Ireland

BLOOD TEMPERATURE

USES TEMPERAMENT

THE IRISH DRAFT horse is a wonderfully versatile horse but the term draft can be confusing because, although they were used on the land they are, in fact, generally lighter than true draft horses. As with many breeds, there was an old type and there is now a newer type. The original Irish Draft was a smaller animal, standing at

approximately 15 hh to 15.3 hh, and had a more draft-like conformation.

These horses were probably descended from the Great Horses of Flanders, which were imported after the Anglo-Norman invasion of A.D. 1172. They had infusions of Andalusion blood over the years, as well as that of the Connemara pony. At the end of the 19th century, Clydesdale blood was introduced to the breed to improve its draft qualities but this crossbreeding caused some consternation within the Irish Draft world. The Clydesdale was blamed for poor conformation below the knee and lack of stamina. These traits have been largely bred out and infusions of Thoroughbred blood have added greater refinement, better conformation of the shoulder and greater endurance.

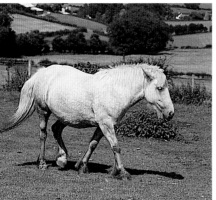

The Irish Draft of today is larger than it was and more of a riding horse, losing some of its draft characteristics. They are versatile horses and often appear to have a high degree of common sense. In appearance they should have an intelligent head, which sometimes has a roman nose on a well-set neck. The shoulders should be powerful and the barrel and quarters muscular. The legs should be clean, with a short cannon bone, and muscular second thigh and forearm. The Irish Draft combines quality, weight and natural athleticism. They are widely used for crossbreeding with Thoroughbreds to produce top-class competition horses. This cross-breeding has led to a decline in the breeding of pure Draft foals, although steps are being taken by the breeders to counteract this process.

The Irish Draft Society in Ireland was formed in 1976 and the English Irish Draft Horse Society in 1979. Both societies are very active in promoting the Irish Draft and there are various program to grade top quality mares, stallions and foals. The Irish Draft is usually bay, chestnut, or gray and tends to stand at between 15.3 hh and 17 hh.

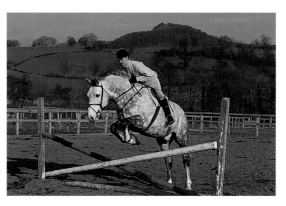

HORSE FACT:

In 1931 a brown mule called Pal saved his owner from an attack by an enraged bull in Oregon, U.S.A., and was subsequently awarded the Latham Foundation's Gold Medal which is for animal heroes.

Top and Far Left
The Irish Draft is today lighter than its predecessors; it is normally used as a riding horse.

Left
This is now a very versatile breed and is often crossed with Thoroughbreds to produce good competition horses.

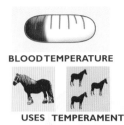

BLOOD TEMPERATURE

USES TEMPERAMENT

Italian Heavy Draft

BREED INFORMATION	
NAME	Italian Heavy Draft
APPROXIMATE SIZE	15–16 hh
COLOR VARIATIONS	Chestnut or roan
PLACE OF ORIGIN	Italy

THE ITALIAN HEAVY DRAFT horse originates in the northern regions of Italy and is very popular throughout the country. The breed began with rather experimental beginnings – native horses were crossed with the Brabant, the Percheron and the Boulonnais, with fairly unsuccessful results. Finally, the Breton horse was crossed with Italian mares and this provided the base for the Italian Heavy Draft.

Their studbook began in 1926, and they were bred specifically for draft and agricultural purposes, although they were also used by the Italian military to transport artillery. They are now also widely bred for the meat industry, which has led to some deterioration in conformation as breeders concentrate on producing maximum body mass and weight. They resemble the Breton quite strongly, but also the Avelignese.

The Italian Heavy Draft typically has an excellent temperament, as indeed many draft breeds do. They are quiet and biddable, as well as being economical feeders and easy to keep. They also mature quickly which is an advantage both for the meat market and for working.

In appearance, the Italian Draft is a highly attractive, cobby-type horse with a quality head for a horse of its weight. They are of medium size, standing at between 15 hh and 16 hh, and have a compact and muscular body with well-sprung ribs and a strong back. The shoulders are generally good and very powerful, they are deep through the girth and have rounded, muscular quarters. They tend to have a shortish neck, which is often very thick through the jowl, and is thickset and very powerful. The legs can have rather poor conformation, being light in bone compared to their size, and having small joints. They also have a tendency toward boxy feet, which is an undesirable feature. Down the back of the legs there is some feathering, which is not seen in either the Avelignese or the Breton.

Their attitude is coblike, being energetic and willing, and they have an excellent fast, energetic action, probably inherited from the swift moving Breton horse. In fact, their action is so good that they are commonly referred to as *Tiro Pesante Rapido* or Quick Heavy Draft by the local people. Typically they are a deep chestnut color with a flaxen mane and tail, though they can also be chestnut or roan.

Top

Despite their bulk, Italian Heavy Drafts have a fast, energetic action.

Right

The neck of the horse is thickset and powerful, but short and arched, with a thick jowl.

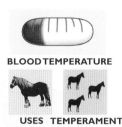

Jutland

BREED INFORMATION

NAME	Jutland
APPROXIMATE SIZE	15.3 hh
COLOR VARIATIONS	Mainly chestnut, black, or brown
PLACE OF ORIGIN	Denmark

HORSE FACT:

Voltage is a combination of gymnastics and equestrian skills and is considered to be one of the fastest growing equestrian sports for the young and nimble. The 1990, Stockholm Olympics saw the first official UK Vaulting team competing.

THE JUTLAND HORSE can be traced back to the 12th century, although ninth century pictures of Danish warriors show them riding horses

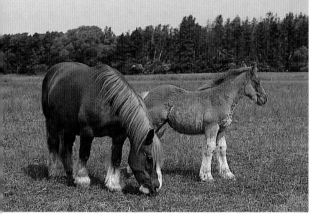

which appear quite similar to the modern Jutland. The Jutland was used not only in a draft capacity but was also a popular mount for the knights of medieval times. They had both the strength and the stamina to excel at carrying the heavy armor, although now they are not commonly used as riding horses. There is a theory that the Vikings took Danish horses into England and that the Suffolk Punch developed from these, and there are certainly similarities between the modern Jutland and the Suffolk. During the 18th century, Frederiksborg blood was introduced to the breed which was responsible for improving their paces.

However, it was a Suffolk Punch stallion that was to have a major influence on the development of the modern Jutland. The stallion was Oppenheim LXII who was imported to the region in 1860 by the well-known horse trader, Oppenheimer of Hamburg, who specialized in Suffolk Punches. The Jutland is also believed to have Cleveland Bay and Yorkshire Coach Horse blood, which is the combination that gives rise to its heavy, but attractive, draft appearance. The Jutland is closely related to the Schleswig Heavy draft horse of North Germany which can also be traced back to Oppenheim.

The Jutland is a compact, heavy horse with short, stocky legs, and feathering, which breeders are trying to eliminate from the breed. In the past they have been criticised as having weak joints, which again, breeders have been trying to improve. They have quite similar conformation to the Suffolk Punch but are generally considered to have a less-refined head than the Suffolk. The neck is carried high, and is typically thick and muscular, set to quite upright shoulders. They are very broad and deep through the chest and have a rounded barrel and short back.

Typically they are chestnut in color, although they were originally black or brown, and stand at around 15.3 hh, weighing approximately 1,500 to 1,800 lbs. The Jutland is used by the Carlsberg brewery for pulling their drays and they travel to many shows and festivals competing and putting on demonstrations. Sadly they are rarely used in the agricultural fields for which they were bred.

Top
The Jutland horse has recently been the object of crossbreeding to improve the quality of the breed.

Left
Usually chestnut in color, Jutlands are now more often bred as show than working horses.

255

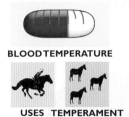

BLOOD TEMPERATURE

USES TEMPERAMENT

Latvian Harness Horse

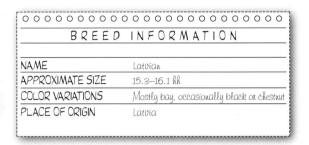

BREED INFORMATION	
NAME	Latvian
APPROXIMATE SIZE	15.3–16.1 hh
COLOR VARIATIONS	Mostly bay, occasionally black or chestnut
PLACE OF ORIGIN	Latvia

which became the base for developing the breed. There were then crosses made using Hanoverian, Norfolk Roadster, Oldenburg part-breds, East Friesian, and Ardennes.

There are three basic types of Latvian horse: the heavy draft horse, which is the closest to the original type, and a horse of great strength and pulling power; secondly, the Latvian harness horse, which is particularly suited to light draft work, but also makes a good riding horse; and lastly the most modern type – the Latvian riding horse which has developed through the introduction of English Thoroughbred blood, as well as Arab blood, and is a much finer, lighter type of riding horse. The riding horse type is becoming the most popular and the old heavy draft type is now rarely seen. However, the modern riding type is still able to perform admirably in harness, although not having the same draft strength. The Latvian as a breed is particularly versatile and the modern riding horse type has become extremely successful in the competition world, competing at dressage and showjumping.

In appearance, the Latvian tend to have a large, but attractive, head, with small alert ears and expressive eyes. The neck is long and muscular and is set to quite high withers. The shoulders are sloping and the chest is deep and broad. They have a straight back with muscular legs and good, hard joints. Conformational problems that may be seen are cow hocks and a predisposition to ringbone. In general they have good musculature and good stamina and endurance.

Typically they are bay in color, although occasionally black or chestnut, and stand between 15.3 hh and 16.1 hh.

THE LATVIAN BREED has only been established since 1952 but is believed to have descended from ancient roots. It is likely that the Latvian was closely related to the Dole Gudbrandsdal, the North Swedish Horse and other heavy European draft breeds, originally dating back to the prehistoric Forest Horse of Northern Europe. During the 17th century, the breed had German riding horse, English Thoroughbred and Arab blood introduced to it, but the most influential infusion was that from the Oldenburg, Hanoverian, and Holstein. During the early half of the 20th century, 65 Oldenburg stallions and 42 Oldenburg mares were imported from the Netherlands

Top

The Latvian was only officially established in 1952 but the breed may have ancient roots.

Right

The horse has a large, handsome head and an arched neck with long, sloping shoulders.

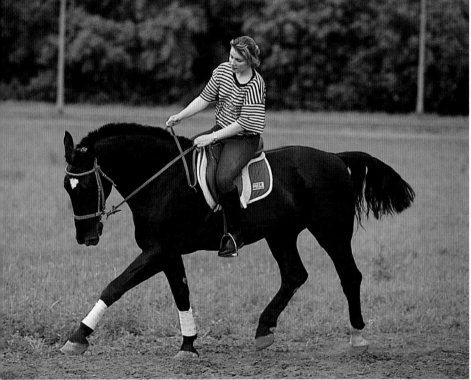

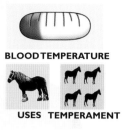

Lithuanian Heavy Draft

BLOOD TEMPERATURE

USES TEMPERAMENT

BREED INFORMATION	
NAME	Lithuanian Heavy Draft
APPROXIMATE SIZE	15–16 hh
COLOR VARIATIONS	Bay, black, gray, chestnut, or roan
PLACE OF ORIGIN	Lithuania, Russia

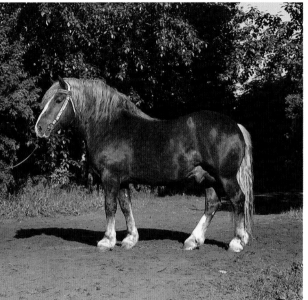

In appearance, they have a nicely proportioned head, which tends to be on the coarse side, and a muscular and arched neck with a flowing mane. The chest is wide and deep, the withers are fairly pronounced, and the back is short and powerful, with a rounded croup and high-set tail. Occasionally they will have the defect of a dipped back, which can be a sign of weakness, but there are current efforts to selectively breed this out. Their frame could be described as massive, and appears more so due to the size of the body compared to the length of leg. Their legs are generally short and strong with good joints and well-formed feet, although they do occasionally have the conformational defects of cow hocks and pin toes. They stand at between 15 hh to 16 hh, and can be bay, black, grey, chestnut or roan in color.

There are some similarities between the Lithuanian Heavy Draft and the heavier of the Latvian Harness Horses, namely in their conformation and paces. They are still used for agricultural work in some areas and are also used for crossbreeding with the native Altai horse to improve their meat and milk production.

Top
The Lithuanian is extremely strong and excels in agricultural and heavy draft work.

Bottom
The breed's flowing mane and forelock complements the high, arched neck.

THE LITHUANIAN HEAVY Draft originated in Russia at the end of the 19th century and has only been registered since 1963. However, it is a breed that has become hugely popular and by 1964 there were 62,000 Lithuanian Heavy Draft horses in Lithuania, which speaks both of their demand and their fertility. The Lithuanian Heavy Draft came about through a combination of the local Zhmud horses being crossed with Swedish Ardennes and the Finnish horse. The breed is preserved through a process whereby potential stallions have to pass a series of performance tests before being allowed to be used as breeding stock.

The Lithuanian has an excellent quiet temperament and is extremely strong and durable making them suitable for heavy draft and agricultural work. They are very long lived and have a high fertility rate, which has ensured the breed's continuance. They also cope very well in harsh and extreme climates and are seemingly resistant to the cold. They are also notable for their particularly good walking and trotting gait – which is unusual in a heavy draft breed.

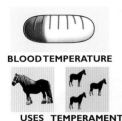

BLOOD TEMPERATURE

USES TEMPERAMENT

Muräkozi

BREED INFORMATION	
NAME	Muräkozi
APPROXIMATE SIZE	16 hh
COLOR VARIATIONS	Liver chestnut, flaxen mane and tail
PLACE OF ORIGIN	Hungary and Former Yugoslavia

THE MURÄKOZI ORIGINATED around the area of the river Mura in Southern Hungary and continues to be bred there today, as well as in Poland and the countries formerly belonging to Yugoslavia. The breed developed as a result of crossing native Hungarian and Polish mares with Percheron, Ardennais and Noriker stallions. Considerable Arabian blood was introduced to the breed at the beginning of the 20th century and, although the Muräkozi is technically called a coldblood, they do have quality from their Eastern influence which is not seen in the majority of coldbloods. This combination has produced a useful, quality draft horse that is extremely strong and fast for a heavy horse. In the years between the two World Wars, the Muräkozi was extremely popular in Hungary and was employed extensively in an agricultural capacity.

However, as with many breeds, the Second World War took a dramatic toll on the numbers of the Muräkozi and, after the war, new blood had to be introduced to boost the numbers again. The Ardennes was primarily used and the Muräkozi probably owes some of its great power and strength to them. The Muräkozi is an economical animal to keep due to its ability to survive on frugal pickings. It also matures very young and is quite capable of beginning to work at two years old. They are excellent agricultural workers and, being generally possessed of a willing and biddable temperament, are an easy horse to handle. There are two types within the breed – a more massive built horse and a finer one, that is suitable for riding as well as draft and farm work.

In appearance, they tend to have a plain head with a large kind eye. The neck is short and muscular, being typical of the draft horse, and is set to very powerful shoulders. They are compact through the body, with a well-sprung rib cage, and with short, strong legs, which are occasionally light in bone when compared to the size of the horse. The croup tends to be quite sloping with a low-set tail. They generally do not have a great deal of feather on the legs, and are mostly liver chestnut with a flaxen mane and tail, and stand at approximately 16 hh.

Top

Muräkozi horses have compact bodies with short, strong legs and are ideal for heavy agricultural work.

Right

This breed has a willing temper and so is easy to train and handle.

Noriker

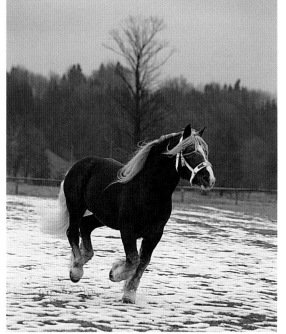

BREED INFORMATION

NAME	Noriker
APPROXIMATE SIZE	15.2–17 hh
COLOR VARIATIONS	Liver chestnut with flaxen mane and tail, or bay, dun, spotted, or skewbald
PLACE OF ORIGIN	Austria

BLOOD TEMPERATURE

USES TEMPERAMENT

conditions with little or no shelter. The heading of Noriker now also covers the Pinzgauer, which was once a separate breed. The Pinzgauer is of similar type to the Noriker but is a spotted horse. Both the Noriker and Pinzgauer are versatile farm workers, being surefooted, and a lighter type of draft, which makes them useful for working in the mountainous regions of Austria.

As well as being known for their excellent temperament and willing attitude, they are also strong and sturdy, qualities that are maintained in the breed by the process of stallion testing before they are allowed to stand at stud. Norikers are important in the breeding of Central and Eastern European draft horses. They tend to have a head bordering on the heavy side, set on to a short, thick neck with loaded shoulders, a deep chest and well-sprung ribs.

The quarters should be round and muscular, often with a broad cleft, and a low-set tail. They should have good strong legs with feathering at the pasterns, and hard hooves. They usually have an excellent forward-going stride especially at the trot.

Typically they are bay and chestnut, although also sometimes dun, spotted, and skewbald. In height they average from between 15.2 hh to 17 hh.

Top
The Noriker came from Austria originally but is now also bred widely in southern Germany.

Bottom
The breed is known for having heavy heads, short necks and deep, broad chests.

HORSE FACT:
It is often said that a horse with long ears is likely to have a good turn of speed, but this is something of an old wives' tale.

THE NORIKER ORIGINATED in the Alpine regions of Austria in what was the ancient Roman state of Noricum. The Romans established studs and it is likely that the Noriker developed from the heavy warhorse that was being selectively bred in the Salzburg region. During the Middle Ages, the Noriker continued to be bred but by then in studs attached to monasteries. Today it is widely bred throughout Southern Germany as well as Austria and is also known as the South German Coldblood. It is likely that Haflinger and also Spanish, Neapolitan, and Burgundian blood are responsible in part for the Noriker's ancestry.

Although extremely popular as an agricultural worker, in 1729 the breed was modified by the infusion of a number of warmblood stallions to make them suitable for the army. The areas where the Noriker are bred are naturally rough and harsh, which has imbued the Noriker with incredible toughness, able to survive in extremely harsh weather

BLOOD TEMPERATURE

USES TEMPERAMENT

Normandy Cob

○○○○○○○○○○○○○○○○○○○○○○○○○○

BREED INFORMATION

NAME	Normandy Cob
APPROXIMATE SIZE	15.2–16.3 hh
COLOR VARIATIONS	Chestnut or bay
PLACE OF ORIGIN	France

THE NORMANDY COB has a long history dating back to the small, tough Bidet horse which was around before the Roman Empire. During the Roman Empire, the Romans crossed the Bidet, which was essentially an Eastern horse, with their heavyweight pack mares, to produce a very serviceable horse for the military. The Normandy Cob was developed to meet the needs of the military, both as a remount, and as a light draft horse. During the 18th and 19th centuries, two Royal studs were established – one at Le Pin in 1728 and the other at Saint Lo in 1806. The Saint Lo stud became known as the centre for breeding of the Normandy Cob and by 1976 was standing 60 Normandy Cob stallions.

Gradually, through the 19th and early 20th century, the Normandy Cob began to develop into two types. There was a lighter version, with a larger infusion of Thoroughbred and Norfolk Roadster blood, which was suitable as a riding horse, and was employed by the military for use as cavalry remounts. The second type which is more common today, was the stockier and heavier variety suitable for light draft, carriage, and farm work. Interestingly, despite being recognized as a breed, there is no studbook for the Normandy Cob, although their breeding is documented, and in some cases performance testing is carried out.

The Normandy Cob of today is a versatile and classy horse with great presence and an extravagant stride. They are similar in conformation to the classic English cob, although they are of a heavier build and more suited to draft work. They have very good temperaments and are docile and gentle, while also being lively and energetic when required. They have a plain but sensible head, a short and muscular neck set to good shoulders, and a wide and deep chest. Typically they have a short back and are compact through the body, the croup is rounded, and the legs extremely sturdy and strong. They have a very powerful build and frame, but are not classed among the heavyweights of the draft category. Generally they have minimal feathering on the legs and have a characteristic energetic and free-flowing trot. The Normandy Cob is always chestnut or bay, and stands at between 15.2 hh to 16.3 hh.

HORSE FACT:

A lorimer or a loriner is the old name for a craftsman who made bits, bridles, spurs and the metal parts of horse harnesses.

Top

The Normandy Cob has a powerful frame with a short back and compact body.

Right

Always chestnut or bay, this breed can reach up to 16.3 hh.

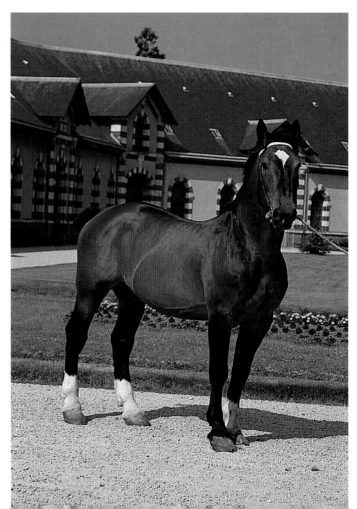

North Swedish Horse

BLOOD TEMPERATURE

USES TEMPERAMENT

BREED INFORMATION

NAME	North Swedish Horse
APPROXIMATE SIZE	15–15.3 hh
COLOR VARIATIONS	Mostly brown, chestnut or dun
PLACE OF ORIGIN	Sweden

THE NORTH SWEDISH Horse is a relatively young breed, with its studbook being established in 1909. They are related to the

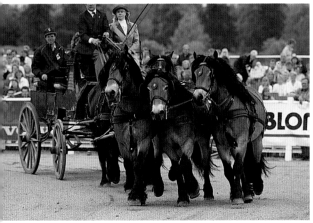

Dole Gudbrandsdal, having both developed from the ancient native horses of the area. There have been infusions of Friesian and Oldenburgh into the North Swedish breed, as well as some crossings with the heavy European draft breeds. Since 1903, there have been very strict regulations for the breeding of the North Swedish in an effort to continue their particular admirable characteristics. Foremost in this has been the Stallion Rearing Institute of Wangen in Jamtland which is now one of the principal North Swedish studs.

One of the most remarkable things about the North Swedish is their incredible

strength, draft capabilities and endurance when compared to the relative smallness of their frame. They are not a heavy draft horse in terms of the Clydesdale and Percheron, but are ideally suited for the forest and lumber work for which they have been principally bred. They are one of the most rigorously tested breeds in the world, and have to undergo testing on their pulling powers, fertility, and have X-rays of their lower legs done. Annually there is a County Horse Days event, where stallions and mares are examined in a number of different situations, and particular attention is paid to temperament. There has developed a second type of North Swedish horse, which is a finer lighter animal, and which has been produced with harness racing in mind. It is called the North Swedish Trotter.

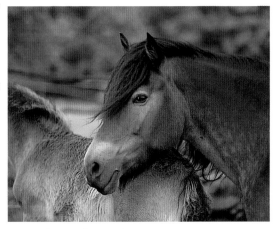

They are willing and cooperative workers and were used extensively for farm and forest work in Sweden, being more efficient in these conditions than machinery. They are also notably long lived and seem to be relatively immune to many equine diseases. They have excellent temperaments and are very obliging – their temperament is greatly valued and is a careful consideration when breeding.

In appearance, they have a slightly heavy pony-type head set to a shortish, but muscular and crested neck. They are often quite long in the body, and have well-constructed and reasonably sloping shoulders, which allow for their excellent active long-striding paces. The legs should be short and strong, with some feathering. Generally they are brown, chestnut, or dun with black points, and stand at between 15 hh and 15.3 hh.

Top Left
As well as competition driving, these horses are used for farm and forest work in Sweden.

Center and Left
The North Swedish Horse has heavy head with a mealy muzzle and ponylike features.

BLOOD TEMPERATURE

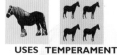

USES TEMPERAMENT

Percheron

○ ○

BREED INFORMATION

NAME	Percheron
APPROXIMATE SIZE	15.2–17 hh
COLOR VARIATIONS	Mostly black or gray
PLACE OF ORIGIN	France

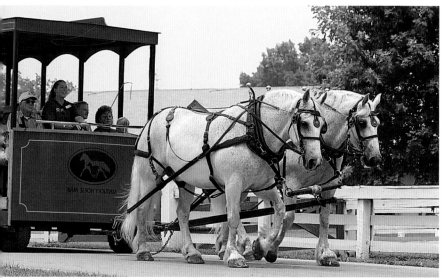

ORIGINALLY FROM THE La Perche district of Northern France, the Percheron is one of the most popular draft horses and is found worldwide. As with many breeds of horse, the exact roots of the Percheron are not known although they are a breed of great antiquity. There has been evidence recovered of a type of horse, very similar to the Percheron, having existed in the La Perche area since the Ice Age.

It is likely that Arab stallions were crossed with the local native mares during the eighth century A.D. to lay down the foundations for the breed. Arab blood has been repeatedly introduced to the

Percheron over the years and it is one of the most elegant of the heavy horses. The influence of the Arab can be seen particularly in their unusually free-flowing and active stride. The famous Le Pin stud in France was a central breeding area for the Percheron, and in 1760 was responsible for importing several Arabian stallions to the stud to cross with the Percherons. Two very influential Arab stallions were Godolphin and Gallipoly. Gallipoly sired one of the most famous Percheron stallions, Jean le Blanc, who foaled in 1830. Breeders of the Percheron have, over the years, been able to alter the breed according to requirements, which is a testament to their successful breeding.

The Percheron has been used for farm and draft work, artillery work, as a warhorse, and riding horse. Depending on demand, the Percheron has been bred to be either lighter and more suited to ridden work, or heavier and more suited to draft work. Currently, the Percheron is bred primarily as a draft and farm worker and, due to its outstanding qualities, is often used on other breeds to improve their stock. For a heavy horse, they have grace and freedom of movement, and amazing stamina, being able to travel in trot, on average, an incredible 35 miles a day!

Characteristically they have a very fine head which is attributed to their Arab blood. They have a well-made neck set onto a good wither, a deep chest, muscled quarters, and a strong back. Their legs tend to be short and clean with minimal feather, and hard bone. Typically they are black or gray, and stand between 15.2 hh to 17 hh.

Top
The versatile Percheron has been used as a warhorse, for draft and agricultural work and also as a riding horse.

Right and Far Right
Arab influence can be seen in the slightly concave profile of the Percheron's fine head.

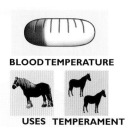

Poitevin

BLOOD TEMPERATURE

USES TEMPERAMENT

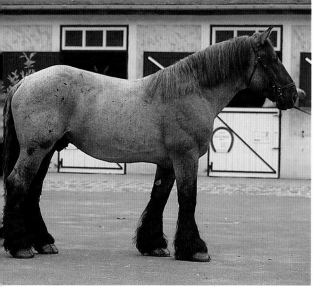

THE POITEVIN, OR Mulassier, originates in the Poitou region of France and is believed to be related to the ancient primitive Forest Horse of Northern Europe. The Poitevin is a singularly unprepossessing animal, which does not perform particularly well, has poor conformation and is rather unattractive. Having said that, however, they are widely used in the production of excellent mules, at which they excel! The Poitevin is believed to have descended from various Danish and Norwegian Heavy horses that were probably imported to the region during the land reclamation work of the seventeenth century. They can be used in draft capacity, and for working the land, but are also used in the meat industry.

In appearance, the Poitevin has a heavy and coarse head with a straight or convex profile, set onto a very short and muscular neck. The shoulders are quite straight and are poorly put together. They are generally long through the body with a straight back and sloping croup. The legs are very short in comparison to the bulk of the body and are also very thick

with coarse feathering. Their feet are large and flat, and their body hair is coarse. They tend to be dun, a throwback to primitive roots, but can be gray, bay, black, or palomino, and stand at between 16 hh to 16.2 hh. Having more or less written the Poitevin off, they have recently undergone a revival in popularity as they are being crossed with Baudet de Poitou jackasses to produce first rate working mules, called Poitevin mules.

The Baudet de Poitou is an extraordinary breed. It is a donkey, but can stand at up to 16 hh, and are extremely hardy and tough. They have the characteristic straight donkey back but have an amazingly quick and energetic stride for a donkey. They have been carefully bred over the years to maintain these admirable donkey traits and share their studbook, which was started in 1885, with the Poitevin horse. Breeding Baudet de Poitou jackasses with Poitevin mares produces the Poitevin mule. These are strong, tough and enduring animals with a long working life and a good disposition and constitution. Since 1950, there had been a reduction in the demand for mules but recently there has been a mule revival and Poitevin mules are again very much in demand.

HORSE FACT:

B.H.T.A. is the British Horse Trials Association, which runs affiliated horse trials events throughout the country. Currently there are 160 one-, two- and three-day events organized by the association. The B.H.T.A. has about 8,890 members, a number which is increasing rapidly.

Top
Considered rather plain, the Poitevin has a heavy, coarse head and a very short neck.

Right
Poitevins are often crossed with Baudet de Poitou jackasses to produce strong and hardworking mules.

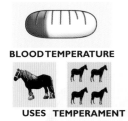

BLOOD TEMPERATURE

USES TEMPERAMENT

Rhineland Heavy Draft

BREED INFORMATION

NAME	Rhineland Heavy Draft
APPROXIMATE SIZE	16–17 hh
COLOR VARIATIONS	Chestnut, chestnut roan, red roan, bay
PLACE OF ORIGIN	Germany

developed largely from the Belgian Draft horse, with infusions from the Ardennes, Clydesdale, Percheron, and Boulonnais, to produce a heavyweight but attractive animal of great power. They were excellent farm and draft horses, and highly efficient in both these capacities. The prime center for breeding was the Wickrath regional stud in Rhineland. In appearance, they are a very four square horse, and massively built.

For their size, they tend to have a small, but well-shaped head with a heavy jaw. The neck is extremely powerful, well arched, and has a pronounced crest. The shoulders are likely to be massive, as are the rounded quarters. They are generally low in the withers, with a short and wide back. The chest is very broad and deep, and the quarters extremely muscular. They have strong, short legs with good sound joints, short cannon bones, and very hard feet. They tend to have some feathering and appear low to the ground, due to the shortness of the leg in comparison to the bulk of the body. They have an excellent temperament being quiet, yet willing and energetic when required. Their coloring varies from chestnut, sorrel, and chestnut roan and red roan, and they vary in height from between approximately 16 hh to 17 hh.

HORSE FACT:
Horses walk at an average of 4 miles (6km) per hour, and trot at between 6–7 miles (9–11 km) per hour.

THE RHINELAND HEAVY Draft, often called the Rheinish German Heavy Draft, tends to appear in many different forms and under different names all over Western and Eastern Germany. It is not uncommon for the breed to be referred to as the German Coldblood, Rheinish-Belgian, Niedersachsen Heavy Draft, or the Rheinish-Westphalian. The breed was developed during the last half of the 19th century, with the studbook being started in 1876, for agricultural and draft purposes, and enjoyed a fairly brief period of popularity.

Since the age of mechanization, however, the numbers of the Rhineland Heavy Draft have dramatically decreased, like many of the draft breeds, and it is now quite rare to see one. They were at one time the most prolific horse breed in Germany but numbers have dropped to such an extent that now only approximately two percent of the horse population in Germany are draft breeds. They were

Top
Once prolific in Germany, Rhineland Draft horses have become quite rare since mechanization.

Right
Massive in size and weight, the Rhineland were excellent farm and draft workers.

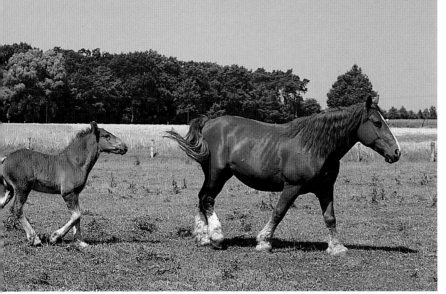

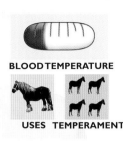

BLOOD TEMPERATURE

USES TEMPERAMENT

BREED INFORMATION

NAME	Russian Heavy Draft
APPROXIMATE SIZE	14.2–14.3 hh
COLOR VARIATIONS	Mostly chestnut, strawberry roan, or bay
PLACE OF ORIGIN	Ukraine

Russian Heavy Draft

HORSE FACT:
For a horse to be eligible to run in a point-to-point, it must have been hunting with a recognised pack of hounds a minimum of seven times during the season.

1952, the Russian Heavy Draft was registered as a breed. There are different types within the one breed which range from the massive draft build to a lighter type which is suitable for draft and ridden work.

Although solid and powerful, they are fairly small in height, averaging 14.2 hh to 14.3 hh. This has increased their popularity because they are able to perform agricultural chores and yet are economical to feed and keep. They mature quickly and are able to work by the age of two years; they have a long working life and a high fertility rate. They have rather more presence and quality,

THE RUSSIAN HEAVY Draft horse is a relatively young breed which started around the 1860s in Ukraine. The two main centers of breeding were the State studs of Khrenov and Derkul where local Ukraine mares were crossed with imported Ardennes stallions. After these initial crosses, there were infusions of Belgian Heavy Draft, Percheron and Orlov blood, followed by interbreeding to create a distinct type. The Orlov has been credited for the active and energetic stride of the Russian Heavy Draft and also its rather refined head.

Due to the influence of the Ardennes blood until the 1920s, the Russian Heavy Draft was referred to as the Russian Ardennes. The breed was greatly affected both by the First World War and the Civil War and was virtually eliminated. After the wars, efforts were made to re-establish the breed and in

probably due to the Orlov blood, than many draft horses which makes them highly attractive. They are known for their excellent temperament, their extraordinary pulling power, and their fast gait at the walk and trot.

In appearance, they are of cobby type, and have a very strong frame, carrying themselves with presence. The head is often quite classy for a draft horse, and is set to a muscular and crested neck. The shoulders are strong, and the chest is broad and deep. They can be quite long in the back, which can be a weakness, and have a long and sloping croup. The legs are relatively short and the front pasterns can be prone to ringbone, while the knee joints are sometimes set too far back. The legs carry some feather. They are mostly chestnut, strawberry roan, or bay in color.

Top
Almost eliminated in the First World War, the Russian Heavy Draft has since been re-established as a breed.

Center and Left
With their kind temperament and fast walking and trotting gait, these horses are popular riding animals.

BLOOD TEMPERATURE

USES TEMPERAMENT

Schleswig Heavy Draft

BREED INFORMATION

NAME	Schleswig Heavy Draft
APPROXIMATE SIZE	15.2–16 hh
COLOR VARIATIONS	Mostly chestnut, flaxen mane and tail
PLACE OF ORIGIN	Germany

THE SCHLESWIG HEAVY Draft takes its name from the Schleswig Holstein region of Northern Germany where it originated. It is a relatively young breed, and the Society of Schleswig Horse Breeding Clubs was not formed until 1891. The breed developed from Jutland horses, and then further developed through crosses between Danish horses, Yorkshire Coach Horses and the English Thoroughbred. The breed can be traced back to one Jutland stallion called Munkedal, and his descendants, Hovding, and Prins of Jylland. However, selective breeding to improve the stock was not started until the 1860s, when the Suffolk Punch stallion Oppenheim LXII was used, and there are traces of his influence in the modern Schleswig. After the Second World War, infusions of Boulonnais and Breton were used.

Although the Schleswig is a young breed, its ancestors were commonly used to carry knights in their heavy armor. Later on, Cleveland Bay and Thoroughbred blood was added to make them more suitable as artillery horses. During the end of the 19th century, the Schleswig was in popular demand for pulling trams and buses and proved to be a very versatile breed, also excelling at working the land.

As with many of the draft breeds, the Schleswig has dramatically reduced in numbers and it is believed that there are only approximately 10 pure-bred stallions left. This is a great shame because they are a useful type of horse with a particularly good temperament, being docile, and yet also active and willing. They are a medium-sized draft horse, and in some instances a second type has developed of a mediumweight horse also suitable for riding.

In appearance, they have a cobby type build and are one of the lighter draft horses. They have an attractive head, which has become more refined over the years, and has an honest coblike outlook. The neck is short and muscular, typical of the draft animal, and is set to very powerful and muscular shoulders. They are broad and deep through the chest, have a rather long body which can have a flattish rib cage, and rounded quarters. They have short legs with good strong joints and quite heavy feathering. They invariably have rather soft, flat feet. Predominantly chestnut in color, they stand at between 15.2 hh and 16 hh.

HORSE FACT:

The Riding for the Disabled Association is an excellent charity that gives disabled people the chance to both ride and drive. The R.D.A. was formed in 1969 and there are currently nearly 700 groups with 25,000 riders and drivers.

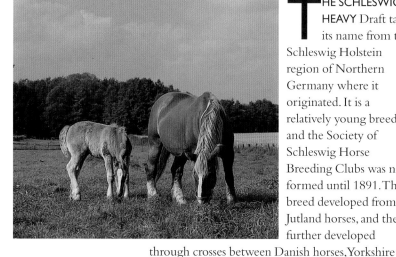

Top
The ancestry of the Schleswig can be traced back to one Jutland stallion.

Right
As one of the lighter draft breeds, the Schleswig is cobby in conformation, with a handsome head.

Shire

BREED INFORMATION

NAME	Shire
APPROXIMATE SIZE	Over 17 hh
COLOR VARIATIONS	Bay, chestnut, gray, or brown
PLACE OF ORIGIN	England

THE SHIRE HORSE developed in the U.K. Fen counties, as well as in Derbyshire, Leicestershire, and Staffordshire, and can be traced back to the English Great Horse of the Middle Ages and the primitive Forest Horse. During the

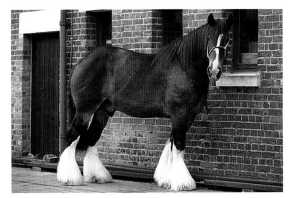

17th century, large numbers of Flanders Horse and the Friesian were brought over to England by the Dutch contractors employed to work on the land reclamation taking place in the Fens. Both these breeds had a considerable effect on the development of the Shire horse.

Interbreeding between the Great Horse, the Friesian, and the Flanders horse, led to the English Black, named by Oliver Cromwell. The English Black was a much bigger animal than the Great Horse and exhibited many of the features of the Flanders Horse, as well as the predominantly black coloring of the Friesian. The foundation sire of the Shire horse is believed to be a black horse called Packington Blind Horse who sired the first Shires to appear in the studbook of 1878. In 1884 the Shire Horse Society was formed, and from then until the Second World War a vast number of Shires were registered every year. They became extremely popular due to their

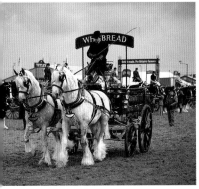

incredible pulling power, which has not been surpassed by any other breed of horse, and were used for all agricultural uses. After the Second World War the numbers of Shires decreased dramatically, but the breed has seen a revival in interest, partly due to the support of the breweries, who continue to use the Shire throughout the country for demonstrations and shows. The Shire horse is known for its docile and gentle temperament, making them easy to handle in spite of their size.

In appearance, they are big-barreled horses with long legs that carry a lot of feather. They usually have an attractive head, which often has a Roman type nose, and a very honest outlook. They have wide spacing between intelligent and kind eyes, and fairly small, alert ears. The neck is often longish and slightly arched, they have a good, powerful, sloping shoulder and rounded muscular quarters. Generally they are black, bay, chestnut, gray or brown, often with white markings on the legs. They can stand up to 18 hh, and there have been cases where they have even exceeded this.

HORSE FACT:
The record for the fastest time for completing the Grand Pardubice race is held by the Czech-bred horse, Cipisek, who won in 1996, in a time of nine minutes and 35 seconds.

Top and Bottom
Even though Shires stand up to 18 hh and more, the breed is known for its docile nature.

Left
The Shire is a rather glamorous breed with heavy white feathering on their legs and a showy action.

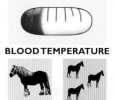

BLOOD TEMPERATURE

USES TEMPERAMENT

HORSE FACT:
Nez Percé and Umatilla warriors would record their exploits in battle by painting images on their horses.

Right and Far Right
The Sokolsky developed through crossbreeding with other heavy horses, and has a kind head and disposition.

Sokolsky

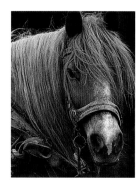

```
oooooooooooooooooooooooo
       BREED  INFORMATION
NAME                    Sokolsky
APPROXIMATE SIZE        15–16 hh
COLOR VARIATIONS        Chestnut, bay, or brown
PLACE OF ORIGIN         Poland
```

THE SOKOLSKY, OR Sokolka, originated in Poland, and is a relatively young breed, having been established for approximately 100 years. The Sokolsky developed through crosses between Belgian Heavy Draft, Belgian Ardennes, Norfolk, Dole Gudbrandsdal, and Anglo-Norman stock. The result is a versatile draft and farm animal of great strength but without being excessively heavy. They are tough, with great stamina, and an excellent forward-going gait – characteristics which have ensured their popularity. In appearance, the Sokolsky has a slightly heavy head, with a straight profile, large kind eyes, and alert ears. The neck is quite long for a draft horse, and is very muscular and broad at the base. The shoulders are well put together and reasonably sloping for a draft animal, which accounts for their free action. They should have a deep chest, pronounced withers, a short and straight back, and a sloping, muscular croup. Their legs should be strong with short cannon bones, well-defined tendons and well-formed, hard hooves. Generally they are either chestnut, bay, or brown, and stand at between 15 hh to 16hh.

BLOOD TEMPERATURE

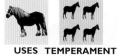

USES TEMPERAMENT

HORSE FACT:
The last race over fences at Windsor race course was run on December 3, 1998.

Right
The Soviet is a very heavy horse, but through selective breeding is surprisingly agile.

Soviet Heavy Draft

```
oooooooooooooooooooooooo
       BREED  INFORMATION
NAME                    Soviet Heavy Draft
APPROXIMATE SIZE        15–15.3 hh
COLOR VARIATIONS        Chestnut, bay, or roan
PLACE OF ORIGIN         Russia
```

THE SOVIET HEAVY DRAFT originated in Russia at the end of the 19th century, becoming established by the 1940s. They evolved through crossing native mares with imported Percheron and Belgian stallions and interbreeding the progeny. This resulted in a heavy draft horse of massive build, but with surprisingly free move-ment at walk and trot. They are one of the most common draft horses in the Soviet Union and are frequently used to improve other heavy draft breeds. They mature quickly, but are less resistant to disease than some other breeds.

They have a well-proportioned head with a pronounced jaw and straight or convex profile. The neck is usually very short and muscular, the chest broad and deep, the shoulders straight and strong, the back short, and very strong, very muscular quarters, and a rounded abdomen.

Their legs are very strong and sturdy with good solid joints, and broad, rounded hooves. Conform-ational faults that they are prone to are pigeon toes in the front feet and sickle hocks behind. Generally they are chestnut, but can be bay or roan in color, and stand at approximately 15 hh to 15.3 hh.

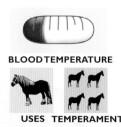

BREED INFORMATION

NAME	Suffolk Punch
APPROXIMATE SIZE	16–16.3 hh
COLOR VARIATIONS	Chestnut
PLACE OF ORIGIN	Great Britain

Suffolk Punch

BLOOD TEMPERATURE

USES TEMPERAMENT

THE SUFFOLK PUNCH originated in East Anglia where it remained largely pure and true to its original form. Today, the Suffolk is bred in other parts of England, as well as abroad, most notably in America. The breed can be traced back to 1506, when writers referred to them as the Old Breed. All Suffolk Punches today can be traced back down the male line to one stallion called Crisp's Horse of Ufford, who foaled in 1760. The Suffolk Punch is one of the three heavy horses of England – the other two being the Shire and the Clydesdale. However, the Suffolk differs significantly from these two, being both shorter and more massively built, and also having only minimal feathering of the legs. Traditionally the Suffolk was used for agricultural purposes, being immensely powerful and very willing. They were developed for the East Anglian terrain, which was mainly heavy clay soil, and, therefore, the lack of feathering was a distinct advantage. One gentleman credited with establishing the breed was Herman Biddell. He was the first secretary of the Suffolk Horse Society and published an extensive history of the breed as well as the first studbook in 1880.

The Suffolk has tremendous stamina and can work for long hours on minimal fodder rations. Traditionally they were entered in strength contests, where they would be required to pull huge logs. They were judged by the amount of effort they put in and it would not be uncommon to see a Suffolk get down on its knees in an attempt to unique in appearance, wcomparison to the massive build of taand kind eyes, a thick and powerful neck, low sloping muscular shoulders, with a deep and broad chest, and wide powerful quarters. They are short in the legs, which are, nonetheless, very strong, and have good joints and short cannon bones. Typically the Suffolk matures young and is long-lived, as well as being an economical feeder. They are always chestnut in color – the breed society recognizes seven different shades of chestnut – and white markings are discouraged. They stand at approximately 16 hh to 16.3 hh.

HORSE FACT:
The International Museum of the Horse at Kentucky Horse Park, Lexington, U.S.A., is the largest and most comprehensive horse museum in the world.

Top
With a very powerful build and tremendous stamina, the Suffolk Punch was used for agricultural purposes.

Center and Bottom
Although the Suffolk has a large head, it has extremely short legs in comparison with the heavy build of its body.

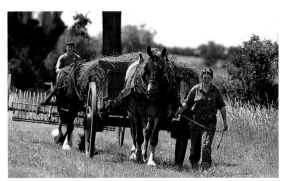

BLOOD TEMPERATURE

USES TEMPERAMENT

Toric

Below and Right
The Toric is an attractive horse with considerable jumping ability.

THE TORIC, OR TORI, originated in Estonia during the 19th century and is a relatively young breed. The breed developed by crossing the Klepper with Arab, Hackney, East Friesian, Ardennais, Hanover, Thoroughbred, Orlov, and Trakehner blood. It is sometimes called the Estonian Klepper or the Double Klepper. It is a draft horse of great quality which is suitable for farm and agricultural work, and in some strains as a riding horse. The foundation sire is considered to be the stallion Hetman, who had Norfolk Trotter and Anglo-Norman roots. They have a medium- to large-sized head with a straight profile, a long and muscular neck, a massive shoulder, and a broad and deep chest. The back can be long, but is wide with muscular quarters and a well-set tail. The legs are short and strong, with good joints and strong tendons. Usually they are either chestnut, gray, brown, or bay with white markings, and stand around 15 hh. They are in general an attractive horse and show a natural ability for jumping.

BLOOD TEMPERATURE

USES TEMPERAMENT

Trait du Nord

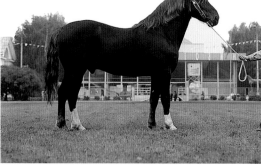

Right
With a calm disposition and great hardiness, the Trait du Nord works well on hilly and rough terrain in remote areas.

THE TRAIT DU NORD originated in France and is still bred in the areas around Lille, the Somme, the Aisne and the Pas-de-Calais, although its numbers are in decline. The Trait du Nord owes much to the influence of the Belgian Draft, the Boulonnais and mostly to the Ardennais, and is sometimes, incorrectly, referred to as a branch of the Ardennais breed. The studbook for the Trait du Nord was established in 1919, and the breed enjoyed a brief period of popularity before its declined. The Trait du Nord is incredibly strong with great pulling power and hardiness, as well as having a calm disposition. They are ideally suited to draft and farm work in hilly and rough terrain

They have a heavy head set on a short and muscular neck. The chest is broad and deep, the shoulders sloping and muscular, flattish withers, a short and straight back and extremely muscular hindquarters. The legs are short and strong with well-formed joints, good feet, and feathering. They are bay or roan in color, and stand at between 15.2 hh to 16.2 hh.

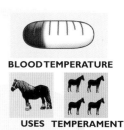

Vladimir Heavy Draft

BLOOD TEMPERATURE

USES TEMPERAMENT

THE VLADIMIR HEAVY DRAFT is a young breed of horse, having only been recognized as an official breed since 1946. The breed was developed in the late 1800s at the collective and state breeding establishments in the Vladimir and Ivanovo regions of Russia. The state stables of Gavrilovo-Posadsk also played

quite a role in the development of the Vladimir in the late 1800s. The breed was established primarily through crosses between Clydesdale, Shire and local mares, and was developed with the aim of producing a middleweight draft horse with good pulling power, but also with some speed. The foundation sires can be traced back to three Clydesdales called Lord James, Border Brand, and Glen Albin – the first two foaled in 1910 and the latter in 1923. There were also infusions of Cleveland Bay, Percheron and Suffolk Punch blood, as well as some contribution from the Ardennais. From 1925 onward no new blood was allowed to be introduced, and the breed was further evolved by taking the best of the progeny and interbreeding to produce the standard Vladimir of today.

The Vladimir is an attractive and useful stamp of horse, which has great strength, without being too massive. They clearly show the influence of the Clydesdale especially in their free-flowing action. They have a presence and quality to them, especially in the head region, which is particularly unusual for a draft breed. They have, like many draft horses, a gentle and willing temperament, making them easy to handle. They mature early and are in work by the age of three, and they are valued for pulling the traditional Russian *troika*, which they do with elegance, hitched three abreast.

In appearance, their head is quite large with a straight or convex profile. They have a nicely proportioned neck which is very muscular and is set to powerful shoulders. The chest is more developed than that of the Clydesdale and is very broad. The withers are quite pronounced and the back sometimes rather long, and can be weak. They are tremendously deep through the girth and have sloping muscular quarters. They are short in the leg, which often have plenty of feathering, and white markings. All whole colors are allowed, and they stand at approximately 16 hh.

HORSE FACT:

Crazy Horse (1842–77) was an excellent Native American horseman and warrior, who was an inspiration to his people. Leader of the Oglala Lakota Indians, Crazy Horse fought against Lieutenant Colonel Custer and the 7th Cavalry in the 1876 Battle of Little Bighorn, Wyoming.

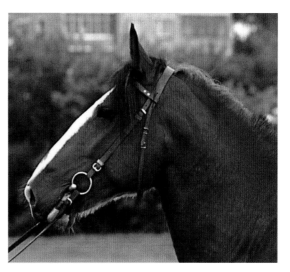

Top
At about 16 hh, the elegant Vladimir is very strong without being too massive.

Left
The Vladimir's head is large and straight, with a muscular neck leading to powerful shoulders and a deep chest.

The Light Horse

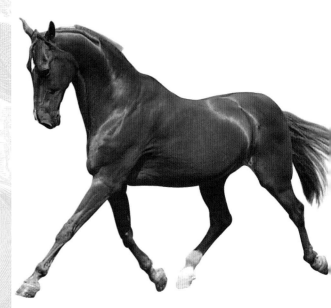

THE TERM LIGHT horse really is a very broad label covering those breeds of horse that are suitable to be ridden. Within this group, there are breeds that are naturally much finer and of lighter bone than others, as well as many breeds that are suitable for both riding and driving. There is some overlap between the light horse and draft breeds, a notable one being the Irish Draft, which is featured under Heavy Horses, but which also makes an excellent middle/heavyweight riding horse.

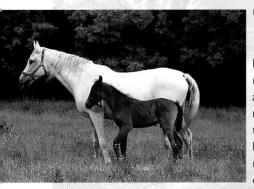

Top Right and Left
There are an enormous number of different breeds of light horse.

Bottom
Light horses are used throughout the world as riding animals.

HORSE FACT:

Steeplechasing got its name from cross-country races being held from one church steeple to the next, with the horses jumping any obstacles encountered in between.

TYPES OF LIGHT HORSE

THE LIGHT HORSE has a much lighter skeletal frame than the heavy draft horse, as well as having different conformational characteristics which make them suitable for riding. They have well-defined withers with a back that is not excessively broad. Their first eight ribs, the 'true' ribs, tend to be flattish to allow the saddle to sit easily and securely on the back. The last ten ribs, the 'false' ribs, should be well-sprung so that the horse appears attractively rounded through the barrel.

The riding horse should have a broad and deep chest, allowing maximum room for the heart and lungs, and a nicely sloping shoulder that allows free-flowing movement. The majority of the light horse breeds have a long and low movement without excessive bend in the knee. This makes the

horse appear to float, covering a lot of ground with each stride. This does not of course apply to all breeds — the Hackney for example, which is a light horse, has a very fine and typically high knee action.

Most light horse breeds are built to be naturally athletic and fast through their proportions and should have clean legs with the hocks set low to the ground. Often a horse is referred to as being light of bone, or with good bone, and this refers to the circumference of the leg bone just below the knee. It is not desirable for this measurement to be too small and many breed societies set a standard that is required by the breed. As a rule, a measurement of anything over eight inches is good.

Many light horse breeds are extremely versatile and perform as well in light harness as they do under saddle. Interestingly, as modern trends have changed, many breeds that were originally destined as carriage horses now make excellent riding horses; good examples of this are both the Hanoverian and the Oldenburgh.

BREED INFORMATION

NAME	Akhal-Teke
APPROXIMATE SIZE	14.2–15.2 hh
COLOR VARIATIONS	Dun, palomino, bay, chestnut, or gray
PLACE OF ORIGIN	Turkmenistan

Akhal-Teke

BLOOD TEMPERATURE

USES TEMPERAMENT

HORSE FACT:
One of the earliest documented steeplechases was held in Co. Cork, Ireland, in 1752, and was between Cornelius O'Callaghan and Edmund Blake. Blake won the four-mile chase, and was rewarded with large quantities of Jamaican rum, claret, and port.

THE AKHAL-TEKE is a very old breed, related to the ancient Turkoman horse that was the preferred mount of Eastern warriors some 2,500 years ago. Horses of a very similar type, probably the ancestors of the modern Akhal-Teke, were bred in Ashkhabad as long ago as 1,000 B.C.

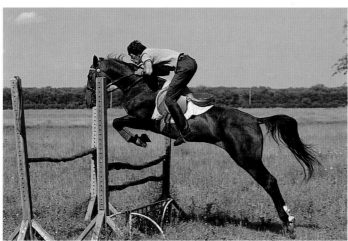

They were bred primarily as racehorses, and this is a pursuit the modern Akhal-Teke is still used for and at which it excels. Interestingly, it is also widely believed that the famous Bucephalus, favored mount of Alexander the Great, was of Turkmenian blood and, therefore, closely related to the Akhal-Teke.

The Akhal-Teke is something of a unique breed bearing many of the characteristics associated with the postulated Horse Type 3, which again points to its very early development. Found mainly in the Turkmenistan area of Central Asia, the Akhal-Teke was developed by the Turkoman tribes as a horse capable of great endurance and stamina, and able to cope with the extremes of heat and cold

associated with that area. They are unrivalled in their powers of endurance, having famously travelled in 1935 from Ashkhabad to Moscow, a distance of 2,500 miles (4,000 km), which included crossing 235 miles (376 km) of desert in three days with no water.

The Akhal-Teke is believed to be related to the Arabian breed and bears a distinct similarity to the Munaghi Arabian, which is also bred for racing. The similarities between these ancient breeds have raised the question as to which influenced the other and, therefore, which one came first. The Akhal-Teke does not have good conformation in the Western sense, but is possessed of an extraordinary elegance and beauty.

They are characteristically very long and slender through the frame, giving them the appearance of an equine greyhound. They have a finely modelled head and an unusually long and muscular neck, which is set very upright onto the shoulders. The shoulders are sloping allowing for a particularly soft gait, possibly developed through years of working on the sandy terrain of their homeland. They are deep through the chest, but are very narrow, and this narrowness continues back through the frame. The withers are high, and the back is long with a shallow rib cage. The croup is often slightly sloping, and is muscular and powerful. They are long in the leg and have fine bone. The hind legs particularly have a long and thin thigh, and are occasionally sickle hocked. The legs are extremely tough and hard with well-defined tendons and well-formed hard feet.

Top
The Akhal-Teke is a good riding horse with a brave temperament.

Bottom
These horses have great strength and endurance but they are known to be wilful at times.

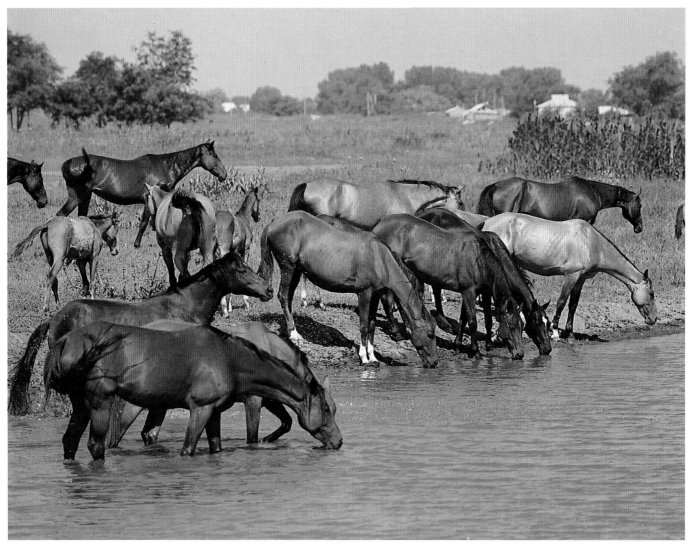

Top
The Akhal-Tekes traditionally roamed in herds in the wild.

Their coat colors vary from a golden dun, through palomino, chestnut, bay, and gray, and have an unusual metallic sheen. Often the mane and tail hair is sparse.

The Akhal-Teke was traditionally, and continues to be, used for racing and is also a useful riding horse, able to compete in both dressage and jumping competitions. An interesting point to note regarding the Akhal-Teke is that they invariably move 'above the bit,' which means that their mouth is above the level of the rider's hands. This is mainly due to their very upright conformation through the neck and head. Akhal-Tekes used in the dressage world have to be trained to carry their head and necks lower to ensure they are not 'above the bit' and moving in a technically incorrect manner. The Akhal-Teke is often used for crossbreeding with and recently Thoroughbred blood was introduced to increase their racing speeds. Although the Thoroughbred cross produces an attractive and workable horse, much of the Akhal-Teke's great

natural endurance is lost. There are now efforts being made to keep the pureness of the Akhal-Teke and they are being bred at Lugov in Kazakhstan, Gubden in Dagestan, and at the Komosomol Stud at Ashkhabad.

The Akhal-Teke has always been prized by the Turkoman people who care for them in an unusual way, when compared with Western practices. The horses are maintained in hard condition with good, muscular development and not an ounce of fat on them. Traditionally, they would rug them in thick felt blankets, both to ward off the cold of the desert nights, and also to produce sweating during the intense heat of the day to prevent any surplus fat. They were also traditionally fed on a diet of alfalfa, corn, bread, and animal protein in the form of boiled chicken, eggs, or mutton fat. They are relatively small horses, standing from between 14.2 hh and 15.2 hh, and are lively, alert, courageous, and occasionally rebellious.

Albino or American Cream

BREED INFORMATION

NAME	Albino or American Cream
APPROXIMATE SIZE	15 hh
COLOR VARIATIONS	White
PLACE OF ORIGIN	United States

BLOOD TEMPERATURE

USES TEMPERAMENT

THE ALBINO, or American Cream, originated in Nebraska in America in 1937 and can be credited to the efforts of Caleb and Hudson Thompson. The foundation sire was a stallion called Old King, of Arab/Morgan stock, who was purchased by the Thompsons in 1918.

Old King produced mainly pink-skinned, white-colored foals from a variety of whole-colored mares and the Thompsons used him on a herd of Morgan mares to create a breed of white-colored horses. Within the breed there are a wide range of differences in conformation, with the influence of the American Quarter Horse, the Morgan, English Thoroughbred, and Arab showing in varying degrees from horse to horse.

Perhaps the Albino is less of a breed of horse and more of a color definition, although American Cream horses do all have similar characteristics, such as an excellent learning and training ability. There is now more distinction between the two, the American Albino Horse Club has changed its name to the American White Horse Club, and the breed has

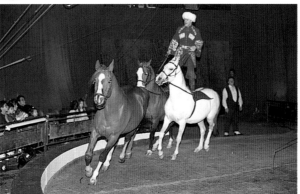

changed its name to that of American Cream. Despite the lack of conformity regarding their conformation, the American Cream seems universally to be an intelligent horse, that is quick to learn with an excellent temperament, making them a very nice riding horse. These qualities have also led to them being widely used in the film industry and also in the circus. Traditionally, white horses were considered one of the most beautiful and desirable horses, being ridden by kings and queens and great Generals, while also featuring in folk stories and legends as having magical powers. More recently their color has been considered a a sign of weakness, which is of course a myth.

Breeding the American Cream can be difficult because not all white horses produce white offspring. Within the breed there are four color combinations that are acceptable: an ivory white body with a lighter mane, blue eyes and pink skin; a cream body with a darker mane, cinnamon-colored skin, and dark eyes; both body and mane the same color cream, pink skin and blue eyes; and both body and mane the same darker cream, pink skin and blue eyes. On average, the American Cream horse stands at approximately 15.1 hh.

Left
These biddable horses are easily trained and so can be used in circus and novelty acts.

Bottom
With mixed blood, the American Cream was originally bred from a series of albino foals.

HORSE FACT:
The game of polo is thought to have been developed during the reign of Darius I, the third King of Persia, 522–486 B.C.

BLOOD TEMPERATURE

USES TEMPERAMENT

Alter-Real

BREED INFORMATION	
NAME	Alter-Real
APPROXIMATE SIZE	15.1–16.1 hh
COLOR VARIATIONS	Mostly bay, but can be chestnut, gray, or brown
PLACE OF ORIGIN	Portugal

THE ALTER-REAL has had a very checkered past and is lucky to be in existence today. The word *real* in Portuguese means royal, and the breed was established by the Braganza royal family in

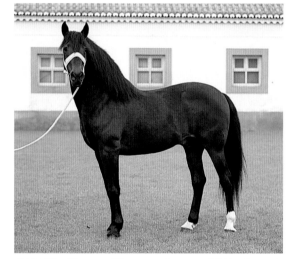

1747. The House of Braganza imported 300 selected Andalusian mares from the Jérez region of Spain, to form a national stud in Alter do Chao, from which the Alter-Real derives its name. The principal reason for establishing the stud was to provide the royal family with suitable High School and carriage horses for the royal stables at Lisbon. During the 18th century, the Alter-Real became extremely popular for their ability at High School exercises, which was in part due to their association with the Marquis of Marialva (1713–99), who was the Master of the Horse at that time.

During the Napoleonic invasion, the breed suffered a setback and was contaminated by infusions of English Thoroughbred, Arab, Norman, and Hanoverian blood. Following this, a great deal of Arab blood was introduced to the breed to try to

re-establish it, but this did not produce the desired results. Finally, Andalusian blood was reintroduced which restored the Alter-Real back to its former glory. Another setback was suffered during the early 20th century when, as a result of the dissolution of the Portuguese monarchy, the Alter-Real stud was closed down and most of the stud records burnt. Luckily, a leading equestrian figure of the time, Dr. Ruy d'Andrade, salvaged two stallions and some mares from the stud and set about re-establishing the breed again. Due to his efforts the breed did survive and continues to be bred in Portugal.

The Alter-Real is intelligent and a quick learner, and as such needs to be handled by experienced and knowledgeable horsemen. They tend to have an average-sized head, with a pronounced jaw, and a straight or convex profile. They should have a short and muscular neck that is nicely arched, pronounced withers, a compact frame with a short back, and muscular quarters with a well-set tail. The shoulders should be sloping, and they should have strong legs with slender, but sturdy cannon bones and pasterns. Typically they are bay, but can be chestnut, gray, or brown in color, and tend to stand between 15.1 hh and 16.1 hh.

Top
Alter-Real horses are handsome and showy, with an arched neck and slightly convex profile.

Bottom
These horses have a lively nature and can be temperamental.

American Bashkir Curly

THE AMERICAN BASHKIR CURLY is an extraordinary breed which has many unique qualities. There is some mystery surrounding their origins and to list the United States as country of origin is not strictly correct. They have very ancient origins and two of the only other breeds to have a curly coat similar to theirs are the Lokai and Bashkir of the former U.S.S.R.

Whatever their origins, the Curly was first discovered in America in 1898 in the Peter Hanson mountain range of Central Nevada. Two horseback riders spotted three curly-coated horses living in the wild and now many of the Curlys can be traced back to that original herd. In 1971, the American Bashkir Curly Registry was established in an effort to promote the breed and it is now enjoying increasing popularity. They are inordinately tough and enduring, and able to withstand the most extreme climatic conditions. Those that are captured from the wild herds are reasonably easy to tame and train, and those raised in captivity exhibit an extraordinarily friendly and tractable temperament. They perform in any sphere and have so far proved their worth in the showring in both Western and English classes, at jumping, dressage, pleasure riding, endurance riding and all forms of ranch work.

Their most striking feature is their coat, which is extremely curly in the winter but often less so in the summer. The curly gene is fairly dominant and Curlys crossed with a flatcoated horse often produce a curlycoated foal. One unique aspect is the way in which they shed their mane and sometimes their tail hair in the summer, growing it back for the winter. Strangely too, many Curlys do not have ergots and will only have very small, soft chestnuts. Another anomaly is that in many cases people who are allergic to horse hair are not allergic to the Curly's coat.

In appearance, they have a fairly heavy head, often with oriental type eyes, and great width across the forehead. The neck is quite short and muscular, and they are stoutly built and muscular through the body frame. Generally they are nicely proportioned horses and move with an active action, sometimes having a natural foxtrot, or running-walk gait. They vary in height, but average between 14.3 hh and 15 hh.

Top
These unusual horses have curly coats similar to two of the ancient Russian breeds.

Bottom
With their gentle nature, the horses make excellent riding animals.

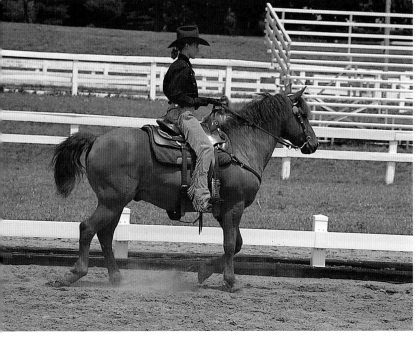

HORSE FACT:
Racing colors are the hat cover and shirt which the jockey wears when racing. The colors, are individual to each owner, who must register the color and pattern of the shirt and hat cover with Weatherby and Sons. Every set of colors is different to allow easy distinction to be made between the different owner's of horses.

HORSE BREEDS

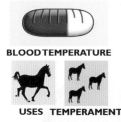

BLOOD TEMPERATURE

USES TEMPERAMENT

HORSE FACT:

Both the B.H.S. (British Horse Society) and the A.B.R. (Association of British Riding Schools) can approve riding establishments and you should only use a riding center that has been approved by either of the above.

American Saddlebred

BREED INFORMATION	
NAME	American Saddlebred
APPROXIMATE SIZE	15–16 hh
COLOR VARIATIONS	Chestnut, but can be any solid color
PLACE OF ORIGIN	United States

THE AMERICAN SADDLEBRED, or Kentucky Saddler as the breed was traditionally called, originated in the areas around Kentucky during the 19th century. They were originally developed as an all-around versatile utility horse by the pioneers of Kentucky, using a cross primarily of Narragansett Pacer and Canadian pacer, both of which are now extinct. There was also the introduction of Morgan, Hackney, and Thoroughbred blood, and the American Saddlebred exhibits traits from all of these breeds. They are perhaps the most famous of the American gaited horses and have acquired much of their reputation through their exhibitions in the showring.

They are judged under two groupings – one for three-gaited horses and one for five-gaited horses. In both instances, the gaits are very exaggerated and flashy which, combined with the artificial tail-nicking to produce the very high tail carriage, have in some cases deflected from the versatility of the Saddlebred. For showing purposes they have their feet shod in a particular manner, with heavy shoes and overgrown horn to accentuate the action, and this, combined with some of the training methods used on these horses, has caused concern in some circles. The Saddlebred is in fact an incredibly useful and versatile horse. They have excellent temperaments being very willing and calm, as well as energetic, and have good stamina and endurance. They make very good riding horses, are used for pleasure and trail riding, for hunting with hounds, for farm and ranch work, and go very well in harness.

Typically the American Saddlebred has great presence and spirit, with an extravagant action. Some are trained to acquire five gaits: walk, trot, canter, slow gait, and the rack, which is an impressive 'full speed ahead' movement. Generally they have small, quality heads, a muscular neck set high onto the shoulders aiding the elevated action, a broad chest, a well-sprung rib cage, and a level croup with the tail well-set and nicked to produce an excessively high carriage. They tend to stand with the front thrust forward and straight-hocked behind. The legs are slender and long with well-defined tendons and sloping pasterns. Any solid color is permissible, although chestnut is predominant, and they stand at between 15 hh and 16 hh.

Top
Some of American Saddlebred horses have five gaits, others three; these are very showy.

Bottom
These horses are spirited but have a calm disposition.

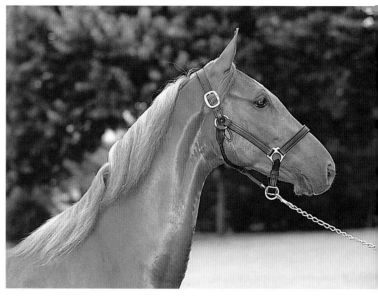

278

Andalusian

BLOOD TEMPERATURE

USES TEMPERAMENT

THE ANDALUSIAN, one of Spain's most famous horses, has a past somewhat veiled in mystery. There are three explanations of the origin of the Andalusian horse, but whichever you believe, there is no denying that the breed is ancient. Firstly, and most likely, it is thought that during the Moorish invasions of the eighth century A.D., the Barbs and the Arab horses belonging to the Moors crossed with the native Spanish stock to produce the Andalusian horse. There is also the theory that the Andalusian is a descendant of the 2,000 Numidian mares that were shipped to Spain by the Carthaginian general, Hasdrubal. Lastly, there is debate over whether or not the Andalusian is descended from *Equus ibericus*, which was also influential in the development of the Barb.

Whichever you choose to believe, there is no doubt about the influence the Andalusian has had on a tremendous number of breeds. In Europe their influence is seen in the Holstein, the Oldenburg, the Frederiksborg, the Kladruber, the Lipizzaner, the Hackney, the Frisian, the Old Norman Horse, and the Orlov, and in America, in the Quarter Horse and the Criollo.

In appearance, the Andalusian has an attractive head with a broad forehead, a straight or convex profile, and large, kind eyes. The neck is often quite thick, nicely arched, and set well onto good, sloping shoulders. The chest should be broad and deep, the barrel rounded, the back short and compact and the quarters muscular, with a tail that is low set and thick. Typically, they have tremendous presence and a spectacular action, which includes the *gait paso de andatura* – a high-stepping movement that was used in parades. They have excellent temperaments, being docile and quiet but also energetic and brave; qualities that have led to their use in the bullring. They are mostly gray, bay, black, chestnut, or roan in color, and stand at between 15 hh and 16 hh.

The breed commonly referred to as Andalusian is in fact now called by the Spanish Breeders Association *Pura Raza Española*, which means 'the pure Spanish breed.' A range of breeds, including the Alter-Real, Luistano, Peninsular, Zapatero, and Andalusian, can all be referred to under the common heading of Iberian Horse, since all are closely related, and bear similar characteristics.

> **HORSE FACT:**
> A 'drugstore cowboy' is someone who dresses up as a cowboy, but has had no ranch experience and has never worked with cattle or horses.

Top
These spirited and energetic horses have an unusual high-stepping gait and great presence.

Above
The Andalusian is an attractive breed with a noble head and long mane and forelock.

BLOOD TEMPERATURE

USES TEMPERAMENT

Anglo-Arab

```
○ ○ ○ ○ ○ ○ ○ ○ ○ ○ ○ ○ ○ ○ ○ ○ ○ ○ ○ ○ ○ ○ ○ ○ ○
```

BREED INFORMATION

NAME	Anglo-Arab
APPROXIMATE SIZE	15.2–16.3 hh
COLOR VARIATIONS	Bay, brown, chestnut, or gray
PLACE OF ORIGIN	Britain

THE ANGLO-ARAB is bred throughout Europe, with France being one of the foremost breeding centers. The French national studs have been breeding the Anglo-Arab since the middle of the 19th century and have established themselves as the most successful breeding center. However, the breed originated in the UK in the 18th and 19th centuries and came about through a cross between the Thoroughbred and the Arab. In England one of the most successful crosses is between an Arabian stallion and a Thoroughbred mare since this combination tends to produce larger and better offspring than that between a Thoroughbred stallion and an Arabian mare.

The breeding of the Anglo-Arab is quite a science and is achieved through knowledgeable selective breeding. Anglo-Arabs must have at least 25 percent of Arab blood in them and the usual method of crossing is to use a pure-bred Arab stallion on a Thoroughbred, or Anglo-Arab mare. The Anglo-Arab should combine the best features of the Arab and the Thoroughbred, without displaying either breed's characteristics too obviously. They should show the speed and class of both breeds, while having the stamina and toughness of the Arab. The Anglo-Arab is a natural athlete with great jumping ability which, combined with speed, produces excellent event horses. They are often bigger than the pure-bred Arabs and heights vary between 15.2 hh and 16.3 hh.

In appearance, they should be a quality horse with a sensible outlook. They have finely modelled heads, which have a look of the Arab about them, but should not be overly dished in profile. The general outline is similar to the Thoroughbred but they should have more substance. The neck should be of good length and nicely curved from withers to poll. The shoulders are very powerful and should slope to allow for speed and free movement. They are deep in the chest and compact through the body with powerful quarters. The legs should be well-conformed with strong tendons, good bone, and tough joints — the feet are well-formed and hard.

Naturally good movers, with a free-flowing and long-striding action, they make excellent saddle horses and jumpers. In color, they are generally bay, brown or chestnut, but can be any color, and have white markings.

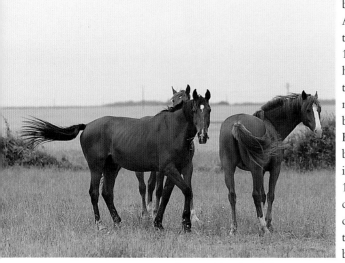

Top

The Anglo-Arab is bred throughout Europe and is one of the most popular riding horses.

Bottom

The horses have a fine head that has some similarities to the Arab.

Appaloosa

BLOOD TEMPERATURE

USES TEMPERAMENT

THE APPALOOSA IS descended from horses imported to America by the Spanish conquistadores in the 16th century. The breed was developed by the Nez Percé Indians of Northwest America and the name, Appaloosa, is derived from the Palouse river which ran through the Indians' territory. The Nez Percé were one of the first and certainly the most skillful Indian peoples to begin selective breeding. They established herds and by gelding or trading any horses that were not of the highest quality, maintained a standard. By the mid-1700s, the Nez Percé had established their herds and gained considerable reputation for their horses. They bred the Appaloosa not only for its attractive spotted markings, which were excellent camouflage, but also for its qualities of stamina, endurance, speed, and athleticism.

During the late 1800s, the Appaloosa was virtually eradicated when the U.S. army captured the Nez Percé Indians and slaughtered nearly all of their horses. In 1938, a group of breeders revived the breed using some of the descendants of the Indians' horses, and managed to re-establish the breed. The Appaloosa is closely related to the American Quarter Horse, both historically and genetically, and both breeds reflect similar influences. The Appaloosa Horse Club boasts over 400,000 registered horses and continues to grow in popularity.

The Appaloosa is characterized by its spotted coat, of which there are six acceptable configurations. These are known as: snowflake, leopard, frost, marble, spotted blanket, and white blanket. The basic coat color is mostly roan, apart from the leopard pattern, although any color is allowed as long as it displays one of the six spot patterns. The Appaloosa has mottled skin around the nose, lips, and genitals, and often has white sclera round the eyes. They generally have a sparse mane and tail, and the hooves tend to display black and white vertical stripes. In conformation, the Appaloosa has a smallish head with a straight profile. They are long in the neck, which is muscular and set on to a deep chest with a sloping shoulder. The withers are moderately pronounced, the quarters rounded and muscular, and the back short and compact. The Appaloosa makes an excellent riding horse, being both docile and quiet, but also energetic. They have good stamina, and are naturally athletic. They stand at between 14 hh and 15.2 hh.

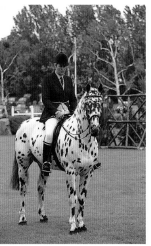

Top
The Appaloosa is a popular riding horse in the USA.

Center and Bottom
The distinctive markings of this breed are very carefully maintained; the skin must display one of six patterns.

HORSE FACT:
Year of the Horse is not, as one might think, a film about horses, but is a documentary film about the relationship between the rock icon, Neil Young, and the band 'Crazy Horse.'

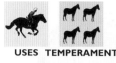

BLOOD TEMPERATURE

USES TEMPERAMENT

Arab

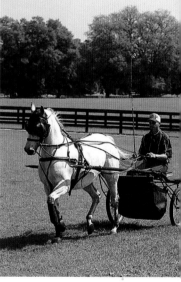
BREED INFORMATION	
NAME	Arab
APPROXIMATE SIZE	15 hh
COLOR VARIATIONS	Bay, gray, or chestnut
PLACE OF ORIGIN	Middle East

TO THE ARAB PEOPLE, the Arabian horse is called *keheilan*, meaning 'pure blood, through and through,' which is probably the best and most accurate way to describe the Arab horse.

One of the oldest pure breeds in the world, the Arab has stayed free of foreign blood and has thus maintained its distinctive

characteristics. Although ancient drawings and carvings record the Arab's existence long before the Christian era, little hard fact is known about their origins, except that they came from Western Asia. They may have originated in Saudi Arabia, but it seems likely that they also had strong ties to Iran, Iraq, Syria, and Turkey. The fact that they are one of the most ancient pure breeds is indisputable, and they are probably descended from the primitive postulated Horse Type 4.

> **HORSE FACT:**
> A horse shoeing forge can heat metal to over 2,500 degrees.

The first Arab horse in Britain was in A.D. 1121 when Alexander I, King of Scotland, presented an Arabian horse to the Church of St. Andrews. From that time on, Arabs were occasionally introduced to British ponies to improve their speed; in 1616 James I bought a celebrated Arabian horse from a Mr. Markham. The Arab's popularity in England did not begin until Charles II sent his Master of the Horse to the Levant to purchase stallions and brood mares and from then their reputation became established.

The purity of the Arab is maintained today by the Arab Horse Societies, and the World Arab Horse Organization, which lay down strict pedigree standards that must be met in order to register as pure-breds. There are several offshoots from the Arab, which, while being based on pure stock, do not conform to the pedigree strictures. There is also, of course, the Barb horse, which is a very important breed in its own right, and is further discussed under Barb. The role the Arab horse has played in the development of nearly all modern breeds of horse cannot be underestimated. They are perhaps the singularly most influential breed, not least in the development of the English Thoroughbred.

For centuries, the Arab has been used to improve and refine other breeds, and is still widely used to this effect. The Arab's popularity is firmly established throughout the world, and this must be in part due to its huge versatility. Not only is the Arab one of the most beautiful horses to look at, in terms of symmetry and conformation, but also they are one of the toughest and most enduring breeds, a fact that is belied by their looks. They are famous for their

Top and Center
Perhaps the most famous horse breed in the world, the Arab is a versatile animal.

Bottom
The horses can be of any color with a fine head and arched neck.

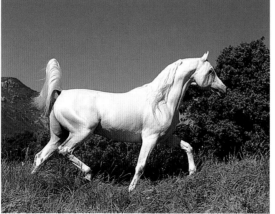

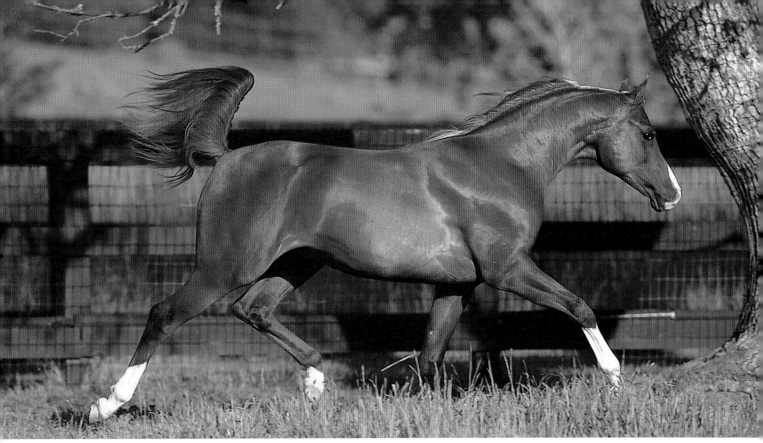

stamina and endurance, have an incredible turn of speed, and make an excellent light, balanced riding horse.

The Arab is quite unique in its conformation and appearance; one of its notable differences from other breeds is the number of vertebrae it possesses. They have 17 ribs, five lumbar vertebrae, and 16 tail bones, whereas other equine breeds have 18 ribs, six lumbar vertebrae and 18 tail bones. This unusual skeleton of the Arab accounts for their compact back and high tail

carriage. They also have a very distinctive head, which is small and refined with a dished profile. They have a wide forehead, with a distinctive shield-shaped bulge which is known as the *jibbah*. The head tapers to a small muzzle, with very large nostrils capable of great dilation. Their eyes are always very large, expressive, and beautiful. The ears are usually small and alert, and curve in towards each other. They have another unique feature called the *mitbah*, which is the angle where the head meets the neck. It results in a curved arch that allows the head to be particularly mobile and move in almost any direction. The neck should be arched, muscular, and elegant, and is set onto a strong, very well-made shoulder with a deep broad chest. The back should be strong and level, with broad quarters, the croup is characteristically long and level, and the tail is set and carried high. They are clean legged with, typically, very hard tendons and good feet.

The Arab has an excellent action, being free-flowing and straight, and fast at all paces — they have a floating action, and appear to glide effortlessly over the ground. They also have a particularly fine skin through which their veining is quite visible. Traditionally they are a small horse, standing at approximately 15 hh, although they have been bred to be larger, though they can lose some of their quality. Generally the Arab horse is bay, gray, or chestnut in color.

Top
The horses tend to carry their tails very high and have a showy gait.

Bottom
The head meets the neck of an Arab at an odd angle, a feature called the mitbah. *This gives raise to the distinctive arched neck.*

HORSE FACT:
Year of the Horse is not, as one might think, a film about horses, but is a documentary film about the relationship between the rock icon, Neil Young, and the band 'Crazy Horse'.

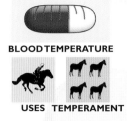

BLOOD TEMPERATURE

USES TEMPERAMENT

Australian Stock Horse

○○○○○○○○○○○○○○○○○○○○○○○○○○○○

BREED INFORMATION

NAME	Australian Stock Horse – Waler
APPROXIMATE SIZE	14.2–16.2 hh
COLOR VARIATIONS	Bay, but can be any whole color
PLACE OF ORIGIN	Australia

Top

These horses have long been used by Australian cowboys in the outback.

Center and Bottom

The Stock Horse still exists in herds and is somewhat similar to the Thoroughbred in appearance.

THE FIRST HORSES WERE taken to Australia in 1788 by Governor Arthur Phillip and were imported from the South African Cape. From that time on, an increasing number of horses were imported, mainly Thoroughbreds and Arabians, and these were selectively bred in the New South Wales area for ranch work on the huge sheep stations. The tough and enduring horse that evolved was called a Waler, after the region, but was never registered as a breed.

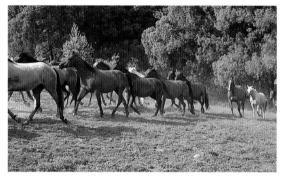

The early Walers were highly regarded both as working ranch horses and as cavalry remounts, and were used extensively by the Indian cavalry, and then later, during the First World War, they were used in huge numbers by the allied forces. In fact, during this time so many Walers were exported that numbers were severely depleted and by the end of the Second World War they had largely disappeared. The Australian Stock Horse

developed from the Waler and was based on a largely Anglo-Arab type, having evolved through crosses between Arabians and Thoroughbreds. In 1954, there were large infusions of American Quarter Horse blood into the breed and four Quarter Horse stallions – Vaquero, Jackeroo, Risbon, and Gold Standard – were to have an important effect on the Stock Horse breed. There is probably also Percheron blood in the breed, which may account for their substance. In 1971, the Australian Stock Horse Society was formed and continues to promote and regulate the breed. They are an excellent versatile horse and have good temperaments, being willing, lively, quick, and possessed of good stamina.

In appearance, the Stock Horse is a quality animal rather similar to the Thoroughbred, but with more bone and substance. They should have an attractive and fine head with a broad forehead and large, kind eyes. The neck should be in proportion to the body, and should be well-set onto good, sloping shoulders. They are deep through the chest, though not excessively wide, and should have a strong back and rounded ribcage. The quarters are very powerful and muscular, and the legs strong and tough with well-formed feet.

They can be any whole color, although are often bay, and stand at between 14.2 hh and 16.2 hh.

HORSE FACT:
A horse shoeing forge can heat metal to over 2,500 degrees.

Azteca

BREED INFORMATION

NAME	Azteca
APPROXIMATE SIZE	14.3–15.2 hh
COLOR VARIATIONS	Any whole color
PLACE OF ORIGIN	Mexico

HORSE FACT:
The first civilian showjumping competition was held at the Royal Dublin Society's annual show, in 1865, although the sport dates back to around the beginning of the 18th century.

THE AZTECA is a very modern breed which was developed in Mexico in 1972 through the combined efforts of several Mexican organizations, namely, La Secretaria de Agriculturea y Recursos Hidraulicos, Asociacion Mexicana de Criadores de Caballos de Raza Azteca, Centro de Reproduccion Caballar Domecq, and Casa Pedro Domecq. The Azteca has developed to challenge the place of the Native Mexican, or Mexican Criollo, and is rapidly growing in popularity. They have been rigorously selectively bred since 1972 and there are strict breeding codes enforced to ensure the continued success of the breed. They have evolved through crossbreeding Andalusian stallions with Quarter Horse mares, or vice versa, or by crossing Andalusian stallions with approved Criollo mares.

currently approximately 1,000 Aztecas registered with the International Association, and this figure is increasing daily. They are elegant, attractive, versatile, and athletic horses combining the best qualities from the Quarter Horse and the Andalusian. They are suitable for all types of riding, including competitive fields, and also for light draft and light farm work. In general, the Azteca has an excellent temperament, being calm-minded, energetic, intelligent, and willing.

In appearance, they have attractive Spanish type heads with lively eyes, and small alert ears. The neck should be muscular, well set on, and gently arched, the shoulders are nicely sloping, they should be deep and wide through the chest, have prominent withers, a straight back, and muscular hindquarters. The legs should be strong and sturdy with good joints, long cannon bones, and well-formed feet. They can be any whole color, and in size, females must exceed 14.3 hh and males 15 hh.

The crossbreeding has been very scientifically researched in order to cement the best qualities of a combination of the three different breeds in one horse. The most common cross is that of an Andalusian stallion with a Quarter Horse mare. Subsequent generations can then be bred back and forth. The offspring must always be six-eighths or less of any of the individual breeds. In 1992, the International Azteca Horse Association was set up to oversee the continued success and development of the breed and, at the same time, affiliated associations in America and Canada were formed. There are

Top
The Azteca is a modern breed that is often used in dressage competitions.

Center and Bottom
The horses have elegant heads and strong legs with good movement.

BLOOD TEMPERATURE

USES TEMPERAMENT

Barb

BREED INFORMATION	
NAME	Barb
APPROXIMATE SIZE	14–15 hh
COLOR VARIATIONS	Mostly gray, can be bay, brown, or chestnut
PLACE OF ORIGIN	North Africa

THE BARB comes from the coastal belt of Northwest Africa, countries such as Morocco, Algeria, and Tunisia and, like the Arab, have

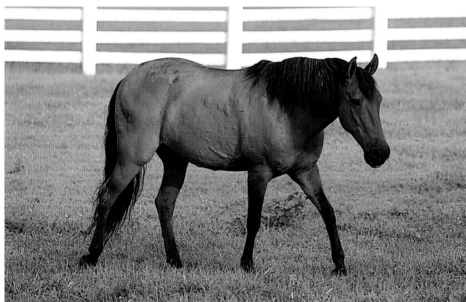

Top

The Barb is an ancient North African breed that has influenced many others over the years.

Bottom

The horses are quite similar to small Arabs but have a heavier head.

had a tremendous effect on many breeds of horse that we see today. They are an extremely ancient breed, and little is known about their exact origins, although they do bear some similarities to the postulated primitive Horse Type 3. It has been the subject of great debate as to whether the Barb or the Arabian came first. It is likely that the Barb contains some Arabian blood, and it is testament to the dominance of the Barb's genes that they have maintained their characteristics. Having said that, however, the Barb has been extensively crossbred in recent years and exists in slightly varying types across North Africa.

The Barb and the Arab are both typical desert horses with fine skin and great endurance. However, the two breeds should not, be confused. The Barb has very distinctive characteristics, such as their convex or Roman profile that is seen in many of the Iberian horses influenced by the Barb.

In appearance, the Barb has a fairly narrow head, that tapers from the forehead to fine nostrils. They have curved ears, which are also seen in the Arab, and expressive oriental type eyes. They tend to have a muscular neck which curves gently from prominent withers to the poll. Often the shoulders are rather flat and straight, which is strange considering their speed and agility. The chest is deep, but can be quite narrow. They tend to be slender through the frame, but have a good depth of girth, and have sloping quarters with a low-set tail. Their legs are slender but extremely tough and strong, and the feet, although somewhat boxy, are very hard and rarely prone to lameness. Conformational faults appearing in the legs are sometimes cowhocks, and forelegs too close together; neither seems to affect their soundness.

Typically they are quite small, like the Arabian, and their height ranges from 14 hh to 15 hh. They are now generally gray, although this may be due to Arab influence, but they can also be bay, brown, or chestnut, and were probably originally mostly dark colors. They are incredibly hardy small horses with

HORSE FACT:
The horse's stifle joint is roughly equivalent to the human knee joint.

have great powers of endurance and stamina, as well as being resistant to extreme climate conditions. They lack the natural grace of the Arabian and do not move as freely but are equally fast, if not faster, over short distances. Barbs today are still very much in evidence in North Africa, especially in Tunisia, Algeria, and Morocco, and are often clothed in decorative tack with semiprecious jewels as a demonstration of the owner's wealth.

The Barb had a considerable effect on the Spanish horses, and is indeed believed to be a direct ancestor of the Spanish horse. Barbs were introduced to Spain during the Moorish invasions and influenced the Andalusian and Spanish horse, and through them, many other breeds of horse in Europe and America. Perhaps, however, the singularly most important effect of the Barb horse was in the development of the English Thoroughbred. One of the three founding stallions of the Thoroughbred was a Barb horse called the Godolphin Arabian. The Godolphin Arabian has a fascinating history: a small 15 hh bay with a beautiful head, but unnaturally high crest, he was spotted pulling a cart in Paris by a Mr.

Coke. Mr. Coke purchased the horse, took him to England and gave him to a Mr. Williams, who passed him on to the Earl of Godolphin. In 1731, he was being used as a teaser on a mare called Roxana, who was to be mated by a stallion called Hobgoblin. When the time came, Hobgoblin would have nothing to do with Roxana, and so the Godolphin Arabian was allowed to mate with her instead. The resulting foal, Lath, became one of the most famous racehorses of the day, second only to Flying Childers, and founded one of the most successful dynasties of racing. However, the history of the Barb horse in England is one that far precedes the Godolphin Arabian, and it is known that Barbs were being imported to England for use in the royal studs as long ago as the reign of King Richard II (1377–99) and were at that time being used for racing too.

As well as the Thoroughbred, the Barb is also credited with having had a profound influence on the development of the Camargue horse of France to which it bears a striking resemblance, the Irish Connemara, and various French breeds including the Limousin.

> **HORSE FACT:**
> The earliest methods of harnessing animals always involved two animals, one on either side of a central shaft. The idea of harnessing one animal between two shafts did not appear to develop until the second century in China.

Left
Barbs can be any of a range of colors but are most often gray; they are known to be lively and temperamental.

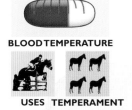

BLOOD TEMPERATURE

USES TEMPERAMENT

Belgian Warmblood

○ ○

BREED INFORMATION

NAME	Belgian Warmblood
APPROXIMATE SIZE	16.2 hh
COLOR VARIATIONS	Mostly bay, can be any solid color
PLACE OF ORIGIN	Belgium

HORSE FACT:

Monty Roberts, 'the man who listens to horses,' is a highly respected horse trainer based in California who is gaining worldwide recognition for his humane methods of 'starting' horses. He frequently travels abroad giving demonstrations and clinics, and has worked with, among others, Queen Elizabeth II of England's cavalry horses.

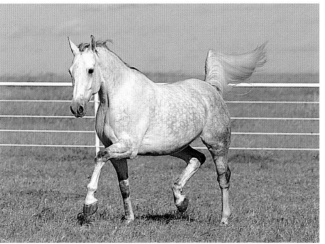

THE BELGIAN WARMBLOOD is a relatively new breed, developed especially for competitive and performance purposes. Belgium has most commonly been associated with the production of the heavier draft horse, such as the Brabant, but since the development of the Belgian Warmblood in the 1950s, Belgium is now recognized as a country of importance in the production of quality competition horses and produces approximately 5,000 Belgian Warmblood foals a year. Belgian Warmbloods have become popular all over Europe and in America due to their versatility, athleticism, and superb demeanor.

The Belgian Warmblood initially evolved as a result of a cross between the lighter agricultural horses and the Gelderland horse. This produced a nice, but heavy, stamp of riding horse that lacked the movement and agility required for competitive work. The breed was then further developed by using Holsteiner, Selle Français, and Hanoverian blood which produced a lighter and more active type. However, the breed was still lacking the speed and finesse that was necessary and so there was a very successful introduction of Thoroughbred

and Anglo-Arab stallions, as well as some Dutch Warmblood stallions, and this produced the excellent all-around sports horse now called the Belgian Warmblood.

The Belgian Warmblood is a horse of great quality and power with good free-flowing movement and an excellent, calm temperament. They have become more and more popular and excel at the highest levels of competitive pursuits, especially in showjumping and dressage. In appearance, the head often shows the influence of their Thoroughbred and Anglo-Arab ancestors and is refined and attractive with a sensible eye. They have a well-set muscular neck, a broad chest, and good sloping shoulders, allowing for their free forward-going movement. The back should be short and compact with muscular quarters and well-placed withers. Typically they have very good, sound, clean legs, and hard hooves. They should have excellent conformation, and appear balanced and in proportion. Generally bay in color, although all solid colors are acceptable, they stand at approximately 16.2 hh.

Top
Belgian Warmbloods are powerful animals who have free movement.

Bottom
This breed has excellent conformation and are generally bay.

BREED INFORMATION

NAME	Brumby
APPROXIMATE SIZE	14–15 hh
COLOR VARIATIONS	Any color
PLACE OF ORIGIN	Australia

Brumby

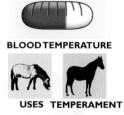

BLOOD TEMPERATURE

USES TEMPERAMENT

BRUMBIES ARE Australian feral horses that developed from domestic horses that either escaped or were abandoned around the time of the gold rush in 1851. Brumby is really a heading for a number of different types of horse, all of which are feral, and it is likely to include descendants of both Walers, Stock Horses, Anglo-Arabs, Percherons and some pony breed, all of which have interbred. They, therefore, do not have any startlingly uniform characteristics and can vary quite considerably in appearance. They naturally formed into herds, and through prolific breeding, and interbreeding, their numbers dramatically increased with detrimental effect to farming and agriculture.

The Brumby had become so well adapted to the harsh, arid climate and environment of Australia, that they were surviving and thriving at the expense of many native Australian flora and fauna. This was especially evident during drought season. Finally during the 1960s, systematic and excessive culling was introduced, forcing the Brumby into virtual extinction. The barbaric culling, which took place using rifles from helicopters and often resulted in horrific injuries rather than immediate

death, provoked an international outcry. Now the numbers of Brumby are greatly reduced, but it is still necessary to control their numbers and methods for doing this have been the subject of great debate.

Unfortunately, the Brumby has little value as a riding horse. They are, like any feral animal, extremely difficult to capture and tame, and have rebellious and wilful natures. There is also no shortage of excellent riding horses in the form of the Stock Horse, making it unnecessary to use the Brumby. As they became feral in the 19th century their physical characteristics altered as they adapted to life in the wild. They became smaller, faster, and more cunning than the domestic horse, as well as enduring and extremely tough.

The Brumby varies in conformation but generally has a heavy head with a short neck and back, straight shoulders, sloping quarters, and strong legs. Their shape is generally poor although the occasional one has a throwback to Thoroughbred ancestry and will have some quality, especially in the head region. They can be any color and their height varies but they tend to be small – although the odd horse will exceed 15 hh.

Top
Brumbies were once so prolific in Australia that they were threatening indigenous species.

Bottom
Although some Brumbies show signs of Thoroughbred blood, they are generally plain in appearance.

HORSE FACT:
Due to the position of the horse's eyes on the side of the head, they have almost 360 degree vision, having a small 'blind spot' directly in front of their nose, and just behind the rump.

BLOOD TEMPERATURE

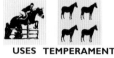

USES TEMPERAMENT

Budyonny

HORSE FACT:
The ABRS is the Association of British Riding Schools, established in 1954; it is the only organisation to solely represent professional riding school proprietors.

THE BUDYONNY is a relatively new breed which was named after the famous Russian cavalry commander of the Civil War (1918–20), Marshal Budyonny. The breed was developed in the Rostov region during the period between 1921 and 1949 primarily as a cavalry horse and is now bred in the Ukraine and the southern areas of the former U.S.S.R. The Russian cavalry sustained huge losses through the First World War and decided to try to recoup these losses by breeding a new type of top-grade horse.

Carefully selected Don and Chernomor mares were crossed with Thoroughbred stallions, which gave rise to a type known as Anglo-Don. Early crosses were also made using the Kirghiz and Kazakh breeds, but this proved to be an unsatisfactory cross, with the offspring inheriting the worst traits from both. The best of the initial progeny interbred to establish a fixed type. The continued use of Thoroughbred stallions improved the stock and by 1949 the breed was officially recognized. Budyonny youngsters are performance-tested, both on the racetrack and in equitation tests, to ensure the continued excellence of the breed.

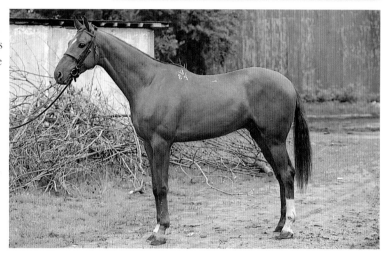

The Budyonny has a natural free action, with a very good gallop and an athletic jump, making them an all-around sporting horse. They are used in steeplechases, including the daunting Czechoslovakian Gran Pardubice Chase but do not match the Thoroughbred in speed. They are increasingly being used for competitive jumping and dressage, and are good in endurance competitions. They have a docile and quiet temperament, although are energetic and lively when called upon and are very tough and enduring.

In appearance, they are generally well-proportioned, with an attractive head on a well-formed and muscular neck. The back is long and straight, the shoulders and quarters sloping, the chest wide and deep, and the tail well set. Typically, they have strong legs with plenty of bone and solid joints. Conformational problems that may occur are excessive straightness through the hind legs and poor conformation of the lower front legs, and these faults are believed to be a throwback to the early infusions of Kirghiz and Kazakh blood. They are mostly chestnut in color, with a metallic sheen inherited from the Don, but can be bay, gray, brown, or black. They stand at approximately 16 hh.

Top
Budyonny horses are attractive animals with a docile nature, which makes them ideal for showing.

Bottom
This breed has a good, strong action with a strong gallup.

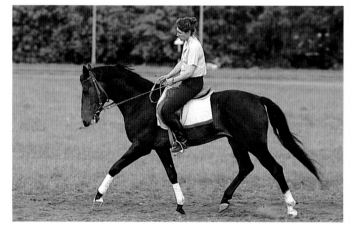

BLOOD TEMPERATURE

USES TEMPERAMENT

Calabrese

BREED INFORMATION

NAME	Calabrese
APPROXIMATE SIZE	15.3–16.2 hh
COLOR VARIATIONS	Gray, bay, chestnut, brown, or black
PLACE OF ORIGIN	Italy

THE CALABRESE has a long and varied history, being a descendent of horses bred in Italy prior to the founding of Rome. However, the breed's characteristics started to evolve through the crossing of Arab blood from the Bourbon period with Andalusian stock. The breed originated in the region of Calabria in Southern Spain, from where it derives its name. During the Middle Ages, the Calabrese became a popular mount for the knights and the continued infusions of Andalusian blood created a spirited horse that was still strong enough to cope with the weight of armor.

From the Middle Ages to the early 1700s, there was a decline in the breed as interest was focused on the breeding of mules in the area, which were considered able to cope with the terrain and workload better than the Calabrese. The mid-1700s to the mid-1800s saw a revival in the breeding of the Calabrese with the introduction of new Arabian and Andalusian blood. In 1874, however, the breed was again set back when many of the studs were closed by a decree and much of the breeding stock was split up. It was not until the 1900s that breeding of the Calabrese began again and there was the introduction of English Thoroughbred, Arabian, Andalusian, and Hackney blood. The Thoroughbred blood has improved the breed adding quality and refinement, while the Arabian blood maintains the breed's characteristics and toughness. They are a useful general-purpose riding horse with good temperaments, being active and energetic while remaining calm and manageable.

In appearance, they have a refined head with a straight, or sometimes convex profile. The neck is in proportion to the body, and is well shaped and muscular. The chest should be broad and deep, and the shoulder should be sloping to allow for good action. They are generally compact through the body, with a short and strong back and a muscular and sloping croup. They have good muscular legs with strong, well-defined tendons, and naturally well-formed, hard feet. The Calabrese is usually gray, bay, chestnut, brown, or black, and stands at between 15.3 hh and 16.2 hh.

Top
An ancestor of the Calabrese was bred in Italy before the beginning of the Roman Empire.

Bottom
Recent uses of Arab and Hackney blood in breeding these horses has improved their stock.

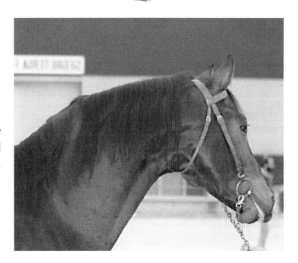

HORSE FACT:
Horses walk at an average of 4 miles (6k) per hour, and trot at between approximately 6–7 miles (9–11 km) per hour.

BLOOD TEMPERATURE

USES TEMPERAMENT

HORSE FACT:
Robert Bakewell,
1725–95, was
instrumental in the
improvement of
various farm animals
through selective
breeding. He is famous
for the experiments he
carried out on the
Black Horse of
Leicestershire, which
eventually gave rise to
the Midlands type of
Shire horse.

Canadian Cutting Horse

BREED INFORMATION	
NAME	Canadian Cutting Horse
APPROXIMATE SIZE	15—16 hh
COLOR VARIATIONS	Any whole color
PLACE OF ORIGIN	Canada

THE CANADIAN CUTTING HORSE was developed in Canada and is largely based on the American Quarter Horse, which they resemble in appearance, temperament, and aptitude.

They have been selectively bred to be extremely quick, agile, and athletic, as well as being intelligent, calm, and willing. These are all qualities that they need to carry out their principal job, the working of cows on the ranch.

The breed is largely based on the Spanish horse, which are renown for their 'cow sense;' this is a vital element of both the Canadian Cutting Horse and the American Quarter Horse. Basically, the horse naturally out-thinks and out-maneuvers cattle. They are widely used, as is the American Quarter Horse, for all types of ranch and cow work, as well as being used for cutting competitions. These competitions involve the horse having to separate a marked cow from a herd with speed and grace. Once the cow has been separated, the horse then has to mark the cow by mirroring its movements to keep it from returning to the herd. Once the cow has been cut from the

herd, the rider holds onto the saddle horn, and the horse is left to mark the cow on its own. These competitions demonstrate the agility of the horse and also its intelligence and training and the prize money can be extremely large.

In appearance, the Canadian Cutting Horse has a well-proportioned head with a straight or slightly convex profile which is a throwback to its Spanish ancestry. The eyes are intelligent and kind, and the ears are mobile and alert. The neck should be muscular and well set on. The shoulders are nicely sloping and powerful, the chest should be broad and deep, the back straight, and the hindquarters immensely powerful and muscular. The legs are short and strong with hard tendons and good feet. The overall appearance is of a well-proportioned, powerful animal, which appears close to the ground, due to the shortness in the leg. They can be chestnut, bay, brown or gray in color, and stand between 15 hh and 16 hh.

Top
This breed has two influences: the American Quarter Horse and the original Spanish Horse.

Bottom
Canadian Cutting Horses have great power, with strong hindquarters and short legs.

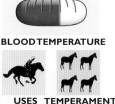

Carthusian

BREED INFORMATION

NAME	Carthusian
APPROXIMATE SIZE	15–16 hh
COLOR VARIATIONS	Mostly gray, can be chestnut, or black
PLACE OF ORIGIN	Spain

BLOOD TEMPERATURE

USES TEMPERAMENT

Top
The Carthusian is one of Spain's oldest breeds and is usually gray..

Bottom
This breed has a kind and lively disposition, with a strong back and hindquarters.

THE CARTHUSIAN HORSE is now classed as a distinctive side-branch of the Andalusian family, rather than a breed on its own, although it has remained true to its original form and has not been totally absorbed into the Andalusian. The Carthusian has a long, colorful, well-documented history, and is one of Spain's oldest and purest breeds.

Their story began with two brothers called the Zamora brothers, who owned several Spanish mares. One of the brothers, Andrés, one day recognized an old stallion pulling a cart as a horse he had ridden in the cavalry. He bought the horse, called El Soldado, and bred him to two of his Spanish mares. One of the mares produced a colt and this colt was called Esclavo, who was to become the foundation sire of the Carthusian. Esclavo was considered the perfect horse in temperament and conformation and sired many outstanding foals. One day, when Andrés was away, his brother sold Esclavo in Portugal for a huge sum of money. Andrés was so grief stricken that he died soon after.

Some of Esclavo's offspring were sold around 1736 to Don Pedro, who, in turn, gave some of the mares to the Carthusian monks. The Carthusian monks were responsible for developing and furthering the Carthusian strain and, more importantly, kept the breed pure. Now the Carthusian horse is bred, maintained, and monitored in the state owned studs of Cordoba, Jérez de la Frontera, and Badajoz. Esclavo passed his conformation and traits on through his progeny, which still largely retains his form. He had several peculiar traits, including warts under his tail, which have been passed on in many cases, and also strange bony growths on the forehead, which resemble tiny horns. At one time, if a horse did not have the warts under its tail it was not considered a descendent of Esclavo. He also passed on his dark gray coloring and now gray is the dominant color within the breed, although they can be chestnut or black.

In appearance, the Carthusian has a fine head, well set to an arched and muscular neck, nicely sloping shoulders, a deep chest, and a well-proportioned back and hindquarters. In general, the Carthusian has good conformation, being uniformly in proportion and balance. They stand at between 15 hh and 16 hh.

BLOOD TEMPERATURE

USES TEMPERAMENT

Cleveland Bay

○○○○○○○○○○○○○○○○○○○○○○○○○○○○

BREED INFORMATION

NAME	Cleveland Bay
APPROXIMATE SIZE	16.2 hh
COLOR VARIATIONS	Bay with black points
PLACE OF ORIGIN	Britain

THE CLEVELAND BAY is one of the oldest of the indigenous British breeds of horse, dating back to the Middle Ages. They originated in the Cleveland district of Yorkshire and developed from the Chapman Horse, named after the Chapmen

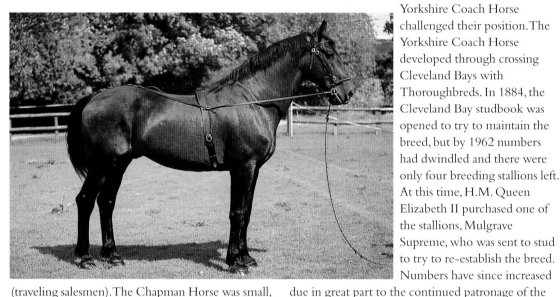

(traveling salesmen). The Chapman Horse was small, sturdily built, and had great pulling power. One important feature of the Chapman Horse was its clean legs with no feathering which made them ideal for working on the heavy clay areas of Cleveland. The Cleveland Bay undoubtedly developed from the Chapman Horse, and it likely that Barb blood was introduced to the breed during the 17th century. They owe some debt to horses of a Thoroughbred type. Two such stallions were Jalep, who was a grandson of the famous Godolphin Arabian, and Manica, son of the Darley Arabian.

During the 17th and 18th centuries the Cleveland was popular as a carriage horse. However, as the faster Yorkshire Coach Horse developed, the Cleveland was criticized as being too slow and the Yorkshire Coach Horse challenged their position. The Yorkshire Coach Horse developed through crossing Cleveland Bays with Thoroughbreds. In 1884, the Cleveland Bay studbook was opened to try to maintain the breed, but by 1962 numbers had dwindled and there were only four breeding stallions left. At this time, H.M. Queen Elizabeth II purchased one of the stallions, Mulgrave Supreme, who was sent to stud to try to re-establish the breed. Numbers have since increased due in great part to the continued patronage of the royal family. The Clevelands are used by the royal stables as carriage horses. Clevelands make very good heavyweight hunters and riding horses and have been widely used to improve other breeds. The Cleveland Bay has a remarkable calm and sensible temperament, yet is lively when required.

In appearance, they are a large, powerful horse of quality. They have quite a large, Spanish-type head with a muscular, arched neck. The shoulders and chest are very muscular and strong – typical of a carriage horse. They have a longish and straight back with very powerful quarters. They are short in the leg and have no feathering. Bay is the only acceptable color, and the only white marking allowed is a small star on the face. They stand at approximately 16.2 hh.

Top

This is one of the oldest breeds indigenous to Britain, dating back to the Middle Ages.

Bottom

Bay is the only acceptable color for this horse, but a small white star on the face is permissible.

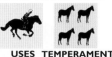

Colorado Ranger

BLOOD TEMPERATURE

USES TEMPERAMENT

Top
There are many different coat colorings for this breed, many of which are spotted.

Bottom
These horses have gentle dispositions, making first-class riding animals and often working with cows on ranches.

THE COLORADO RANGER, or Rangerbred Horse, has a well-documented and interesting history, dating back to 1878 when General U.S. Grant made a visit to Turkey. He was presented with two first-class stallions – one Arabian called Leopard and one Barb called Linden Tree. They were shipped to Virginia, America and lent to one of the great horsemen of the time, Randolph Huntingdon. Huntingdon had developed a type of light harness trotting horse and believed the stallions would improve his stock. Huntingdon used Leopard and Linden Tree for 14 years, creating the Americo-Arab, but sadly, in 1906, due to financial ruin, his stock was broken up and sold.

The next chapter in Linden Tree and Leopard's life began in 1894 when they went to General Colby's ranch in Nebraska. Here the two elderly stallions stood at stud for one season and gave rise to a crop of foals with distinct characteristics. The stallions were used on various local mares and the progeny proved its worth in a ranch and cow-working capacity. The new breed became known as the Colorado Ranger. In 1918, a spotted Barb stallion called Spotte was introduced to the breed and many Colorado Rangers today can be traced back to him. Another important early stallion was Max, also spotted, and he left his mark on all his progeny.

There are many different coat colors exhibited within the breed, many of which are spotted, and coat coloring is not restricted by the breed association. To be registered, the Colorado Ranger has to meet specific conformation and pedigree requirements, and the only outside blood that is allowed to be used is Thoroughbred, Quarter Horse, Arab, Appaloosa, and Luistano. Typically, the Ranger has an excellent temperament and disposition, and, as well as being very good cow-workers, also make first-class riding horses.

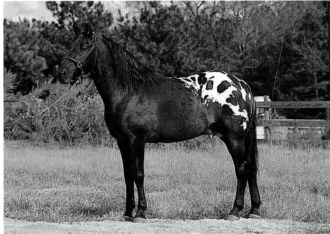

In appearance, they have attractive heads with alert and mobile ears. The neck should be of good length and very muscular, they are deep and wide through the chest, have a rounded barrel, and a compact back. The hindquarters are extremely powerful and the overall impression of the breed is a solid, muscular, small, 'power house' type. They stand at between 14.2 hh and 16 hh.

HORSE FACT:
Horse and Hound is the world's best selling equestrian magazine; begun in 1884, Horse and Hound is a weekly magazine full of information, articles, educational features and classifieds.

BLOOD TEMPERATURE

USES TEMPERAMENT

Criollo

○ ○

BREED INFORMATION

NAME	Criollo
APPROXIMATE SIZE	14–15 hh
COLOR VARIATIONS	Mostly dun, can be any whole color or roan
PLACE OF ORIGIN	Argentina

THE ARGENTINE CRIOLLO dates back to the 16th century when the founder of Buenos Aires, Pedro de Mendoza, shipped 100 Spanish horses to Rio de la Plata. Although many of these horses died in transit, a few survived and went on to form the basis for the Argentine Criollo. The word *criollo* means 'Spanish horse' and it is likely that the original Spanish horses taken to South America were a mixture of Sorraia, Garrano, and Andalusian. The Criollo developed from interbreeding between these and possibly Arab and Barb stock. In approximately 1540, when the Indians sacked Buenos Aires, many of the Spanish horses were released or escaped and through breeding in the wild the Criollo developed. The Criollo is perhaps one of the toughest and most enduring horses in the world having been hugely influenced by the environmental factors

present during the formation of the breed.

The Argentine climate experiences both extremes of heat and cold and the Criollo is able to survive these, as well as lack of food or water. They are extremely hardy and frugal eaters, thriving on the little grass they are able to find. The Criollo breed society was formed in 1918, and this sets rigorous endurance tests to select the best horses for breeding. The tests are run over a 465 mile course, which must be completed in a maximum of 75 hours split over 14 days. During this time, the horses are allowed no extra food rations, eating only the grass at the side of

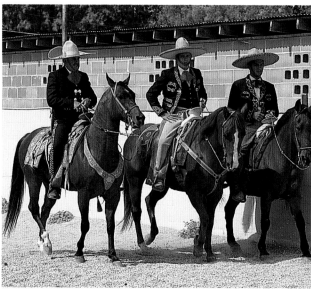

the road, and are inspected at the end of each day by a veterinarian. They also have good resistance to disease and are long-lived and resourceful. They are widely used as the cowboy's favorite mount, and have contributed to the Argentinian polo pony.

In appearance, they look like a small horse standing between 14 hh and 15 hh, they have a long head which shows their Spanish influence, a long muscular neck, a sloping shoulder, and a broad chest. Generally, they have a short compact back, with muscular quarters and well-defined withers. The legs are strong and solid with good bone and very hard hooves. Typically they are dun in color, but can be any color, and have a willing, biddable temperament.

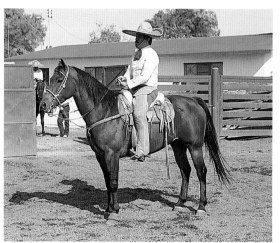

Top
The Criollo has a long head which shows the influence of the Spanish Horse on the breed.

Center and Bottom
The horses are used by gauchos and in traditional ceremonies.

Danish Warmblood

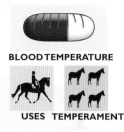

BLOOD TEMPERATURE

USES TEMPERAMENT

```
○○○○○○○○○○○○○○○○○○○○○○○○
        B R E E D   I N F O R M A T I O N
```
NAME	Danish Warmblood
APPROXIMATE SIZE	16.2 hh
COLOR VARIATIONS	Mostly bay, can be any whole color
PLACE OF ORIGIN	Denmark

ALTHOUGH DENMARK has a long history of horse breeding dating back to the 14th century, it is only comparatively recently that they have come to the forefront of the international

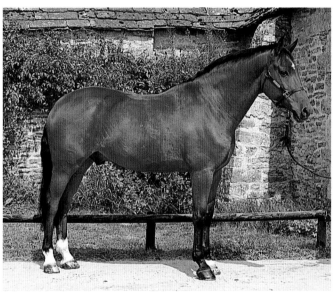

market for breeding first-class competition horses. The early monastic studs at Holstein, and later the Royal Stud of Frederiksborg, which produced the Holsteiner and Frederiksborg breeds respectively, are responsible for the base stock of the Danish Warmblood. The Danish Warmblood, or Danish Sports Horse as it was formerly known, evolved through careful, open-minded selective breeding, employing many different breeds until the right combination was achieved.

The studbook for the Danish Warmblood was opened during the 1960s, and the Danish Warmblood Society carefully promotes and maintains the breed. The Frederiksborg crossed with the Thoroughbred produced a good quality but slightly heavyweight riding horse, which was then improved further by infusions of Trakehner, Wielkopolski, Selle Français, and more

Thoroughbred blood. Through selective breeding a distinct type emerged and this became the Danish Warmblood of today. The absence of Hanoverian blood in the breed may account for its particular characteristics when compared to other Warmblood breeds. The Danish Warmblood stallions have to undergo rigorous testing called the '100 day test' and are carefully selected before they are approved. This maintains the extraordinarily high standard of the breed.

Typically, the Danish Warmblood is a horse of great quality, with a Thoroughbred look, but more weight and substance than the Thoroughbred. They have good stamina, speed, and jumping ability, as well as often having excellent natural elevation through their paces. The Danish Warmblood excels at both dressage and jumping, and has forged a name for itself in both these spheres.

In appearance, they have a finely-made attractive head, a muscular, and well-set neck with a good length of rein, a broad and deep chest, and sloping shoulders. The back should be compact and strong, the tail well set, and the legs muscular and clean. The joints should be strong, with the hock joints particularly well made and the hooves correctly formed. They have an exceptional temperament, are highly amenable, tough and bold, and have excellent free-flowing movement. The Danish Warmblood can be any whole color, although they are usually bay, and stand at approximately 16.2 hh.

HORSE FACT:

The horse was highly prized by many of the Native American Indian tribes; the Wishram people would commonly kill a man's favorite horses when he died, as a mark of respect.

Top
Danish Warmblood horses have the look of a Thoroughbred but carry more weight.

Bottom
The horses have fine heads with long, muscular necks and sloping shoulders.

BLOOD TEMPERATURE

USES TEMPERAMENT

Don

BREED INFORMATION	
NAME	Don
APPROXIMATE SIZE	15.2–16.2 hh
COLOR VARIATIONS	Mostly chestnut or brown
PLACE OF ORIGIN	Former USSR

THE DON DERIVES ITS name from the Steppes region of Russia across which the Don River flows. This region is naturally exposed to severe weather conditions and, as such, the Don horse is incredibly hardy and tough, surviving where many other breeds of horse would perish. They evolved through the 18th and 19th centuries, and are probably descended from a cross between the steppe-bred Mongolian horses and Turkemene, Karabakh, Akhal-Tekes, and Orlov stallions. The Don achieved considerable fame during the military campaigns of 1812–14 when the Cossacks fought the French. Many of the French horses were unable to cope with the extreme cold and harsh winters and died, whereas the Dons survived and thrived. After these events, the importance of the Don was realized and selective breeding began in earnest during the 1830s.

They were primarily being bred for use in the cavalry – both to be ridden and to be used in harness. More recently, at the beginning of the 20th century, Thoroughbred and Arabian blood was introduced to the breed but since then they have remained largely untouched by outside blood. The Don has some fairly major conformational faults, which breeders are trying to eradicate, but they are nevertheless extremely useful for their tough and enduring qualities. In the former Soviet Union the Don is frequently introduced to other Soviet breeds, most notably the Budyonny. They are suitable for riding and light draft work, and tend towards a quiet, but energetic temperament.

In appearance, the Don has an eastern-type head of average size. Generally, the neck is well formed and muscular, the shoulders are often quite upright which lends to a choppy and restricted stride, the chest is deep and broad, and the back long and straight. The quarters can be weak, with the croup rather straight and the tail low set. They can be upright in the pastern but the hooves are usually very hard. They have a tendency to be long in the leg and often have conformational defects such as calf knees in the front and sickle hocks behind. Generally the Don is chestnut or brown in color, sometimes with a metallic sheen reminiscent of their Akhal-Teke ancestry, and stand at between 15.2 hh and 16.2 hh.

Top
The Don is a product of an extremely harsh environment and is consequently very hardy.

Bottom
They are biddable horses with even temperaments and are useful jumpers.

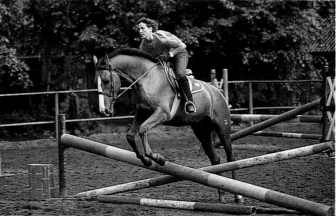

Dutch Warmblood

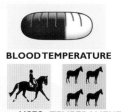

BLOOD TEMPERATURE

USES TEMPERAMENT

Top
The Dutch Warmblood is an excellent show horse with particular jumping skills.

Bottom
The horse has a well-shaped head and deep chest with sloping shoulders and clean legs.

THE DUTCH WARMBLOOD is a relatively young breed that has developed into an extremely successful and versatile stamp. The Netherlands has always had an excellent reputation for husbandry skills, in the breeding of animals and plants, and this includes the breeding of top-rate competition horses. With the advent of mechanization there has been a move away from the harness and draft horse towards the lighter riding horse. The Dutch Warmblood combines the best elements of both the Groningen and the Gelderland, together with Thoroughbred, Trakehner, and Oldenburgh blood.

The Thoroughbred was introduced to the breed to add quality, refinement, speed and courage, and yet breeders have been careful to maintain the fundamental sensibility and calm temperament of the Warmblood. Although Dutch Warmblood stallions are owned by individuals, the breeding of the Warmblood is monitored by the state-aided Warmbloed Paardenstamboek Nederland. Stallions may only be used for breeding if they pass the rigorous testing process which maintains a very high standard of

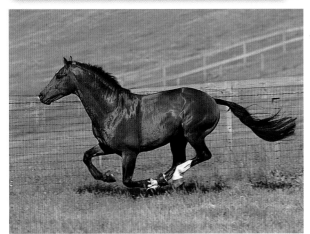

selective breeding. All aspects of the stallion are judged, from temperament to athletic ability, aptitudes, and intelligence, as well as conformation and movement. The horses also have their lower legs and feet X-rayed to eliminate the possibility of hereditary faults. Mares are also tested and the resulting progeny are closely monitored to track their successes or failures. This process of testing is one of the most sophisticated approaches used in the world and has led to the quick growth and success of this young breed. They are often extremely attractive, with a free-flowing and extravagant movement that has seen the breed make its name within the dressage world. The Dutch Warmblood is also very athletic with an excellent natural jump and many of these horses are used for jumping competitions of the highest caliber.

Typically, the Dutch Warmblood has a well-proportioned head with a wide forehead; the neck is in proportion to the body and is muscular and well set on. They have a broad, deep chest with a sloping shoulder, a straight back, powerful quarters and a well-set tail. The legs are strong and clean, with good joints and hard, well-shaped feet. They are usually bay, gray, chestnut, or black in color, and stand at between 15.3 hh and 16.3 hh.

HORSE FACT:

To Native American Indians, the horse was commonly seen as a sign of wealth and prestige and would often be decorated with ornamental saddlery.

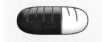

BLOOD TEMPERATURE

USES **TEMPERAMENT**

East Bulgarian

Right

The East Bulgarian is a handsome horse, useful in dressage and jumping competitions.

BREED INFORMATION	
NAME	East Bulgarian
APPROXIMATE SIZE	15–16 hh
COLOR VARIATIONS	Chestnut, bay, or black
PLACE OF ORIGIN	Bulgaria

THE EAST BULGARIAN was developed at the end of the 19th century at the Vassil Kolarov stud farm near Shumen and at Bojurishte near Sofia, in Bulgaria, by crossing local horses with Arabs, Anglo-Arabs, English Thoroughbreds, and English half-breds. Once the characteristics had been established, only English Thoroughbred blood was used to improve the quality of the stock and the breed was recognized in 1951. The East Bulgarian is a highly attractive horse of great refinement and quality that excels in all sorts of riding capacities from jumping to dressage and is also very useful as a light draft animal.

Typically, they have quiet but energetic temperaments and are nicely put together, with good conformation. In appearance, they have a fine head with a straight profile, and large, kind eyes. The head should be well set to an elegant, muscular neck which is quite long and slopes into prominent withers. They have good, powerful shoulders, a broad and deep chest, a straight, long back, a slightly sloping croup, and well-made, long, hard legs. They are mostly chestnut, bay, or black in color, and stand between 15 hh to 16 hh.

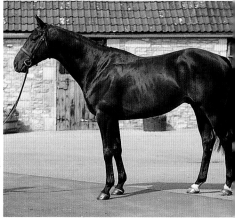

BLOOD TEMPERATURE

USES **TEMPERAMENT**

East Friesian

BREED INFORMATION	
NAME	East Friesian
APPROXIMATE SIZE	15.2–16.1 hh
COLOR VARIATIONS	Black, bay, gray, chestnut, or brown
PLACE OF ORIGIN	Germany

THE EAST FRIESIAN, found in the Federal Republic of Germany, developed along similar lines to the Oldenburgh until the political division of Germany at the end of the Second World War. The East Friesian is descended from a mix of Spanish, Neapolitan, Anglo-Arab, and Thoroughbred blood and more recently from Arab stallions from the Marbach stud and the gray Gazal from the Balbolna stud in Hungary. The breed has become more refined, aided by the influence of Hanoverian blood, which has helped to produce a more general all-around sports horse.

The East Friesian has an attractive well-proportioned head with intelligent eyes, and nostrils capable of dilation. The neck should be longish and nicely arched, the chest broad, the shoulders sloping, the back long and straight, and the quarters slightly sloping. The legs are muscular, the tendons strong and the feet hard. Generally the East Friesian has a bold and lively temperament and good free-flowing movement. They can be black, bay, gray, chestnut, or brown in color, and stand between 15.2 hh and 16.1 hh.

Right

These horses have mixed blood, including a recent introduction of Arab to improve the breed.

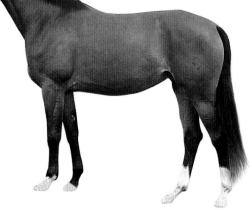

Finnish Universal

BLOOD TEMPERATURE

USES TEMPERAMENT

ORIGINALLY FROM FINLAND, there are two types of Finnish horse which have basically descended from the same stock. There is the Finnish Universal and the now quite rare Finnish Draft horse, which is discussed in the Heavy Horse Breeds section. The Finnish Universal is a descendant of a mixture of ancient warm- and coldblooded breeds. Native ponies were crossed with various other European breeds, including the Oldenburgh, of both heavy and light build, to produce the Finnish Universal. The studbook was opened in 1907 and from then on there has been a process of selective pure breeding to maintain the admirable qualities of the breed.

As their name suggests, the Finnhorse Universal is an extremely versatile small horse, capable of great pulling power with speed, endurance, and agility. They are still used in some areas for light agricultural work, especially over terrain not suitable for mechanized vehicles. They are also used in the timber trade, for working in the forests, where they cause less damage than large vehicles. As well as agricultural uses they make good riding horses, having an aptitude for jumping, and are suitable for use in riding schools and trekking, due to their calm and sensible nature. The Finnhorse Universal can also be extremely fast when required and is widely used throughout Finland in harness trotting races, at which they excel. They are known for their quiet, calm and biddable temperament, and their toughness and longevity.

In appearance, the Finnish Universal is somewhat plain, having been bred for function rather than looks. They tend to have an unremarkable, but honest type of head with small alert ears. The neck is of average length and very muscular, set to extremely powerful and muscular shoulders typical of a draft horse. The chest is broad and deep, the withers quite prominent, the back straight and quite long, the hindquarters muscular with a sloping croup, and a low set tail. The legs are short, but very correctly put together, with no feathering, good bone, strong joints and hard feet. They are mostly chestnut in color, but can be bay, gray or occasionally brown or black, and they stand at approximately 15.2 hh.

HORSE FACT:
Year of the Horse is not, as one might think, a film about horses, but is a documentary film about the relationship between the rock icon, Neil Young, and the band 'Crazy Horse'.

Top
These horses have a fast movement and are often used in trotting races.

Bottom
Many Finnish Universals have a white blaze on their faces and long, coarse forelocks and manes.

BLOOD TEMPERATURE

USES TEMPERAMENT

HORSE FACT:
When out hunting, you must never pass or overtake the field master; this is considered extremely bad form and is also dangerous.

Florida Cracker Horse

⚬⚬⚬⚬⚬⚬⚬⚬⚬⚬⚬⚬⚬⚬⚬⚬⚬⚬⚬⚬⚬⚬⚬⚬

BREED INFORMATION

NAME	Florida Cracker Horse
APPROXIMATE SIZE	14–15 hh
COLOR VARIATIONS	Solid colors and roan, but can be any color
PLACE OF ORIGIN	United States

THE FLORIDA CRACKER HORSE has very old roots but has only had its own registry since 1989. They are descendants of the original Spanish horses which were taken to the Florida area as long ago as the early 1500s by the Spanish conquistadores. The value of the Spanish horse was quickly realised and by the mid-1600s they were being bred for working on the land and for use in the cattle ranches.

The Florida Cracker Horse is a mixture of those early Iberian horses from Spain, as well as the Spanish Sorraia, Spanish Jennet, Barb, and Andalusian. They have similar characteristics to other breeds largely based on the Spanish horse, such as the Criollo and Paso Fino, but have also developed their own traits. The Indians were some of the first people to really utilize the Cracker and then later the early ranchers used them for working cattle. They have a natural 'cow sense' and their toughness and stamina made them excellent for all the ranch work. They were used for all purposes from riding to hauling loads, working the land, and drawing the early buggies.

The Cracker became the favorite mount for the early cowboys, having a tremendous turn of speed and being able to carry large men all day, in spite of their diminutive size. The Cracker derived its name from the cowboys called crackers, who used loud cracking whips to herd their wild-natured Spanish cows. The Cracker is also known as the Seminole Pony, Chickasaw Pony, Florida Horse, and Florida Cow-Pony. They are considered to be an important part of Florida's cultural heritage but sadly, over the years, their numbers have drastically reduced. With the formation of the breed society it is hoped that the breed will be preserved.

In appearance, the Cracker is a small horse standing between 14 hh and 15 hh, clearly showing its Spanish ancestry. They have a Spanish-type head with a straight or convex profile, a muscular neck, and a good shoulder. They are wide and deep through the chest and have sloping quarters with quite a low-set tail. Generally they have good temperaments are especially prized for their incredible stamina and are also very fast; many of them retain a running walk.

Right
This is an extremely showy breed with enormous stamina; many of the horses retain their unusual running walk.

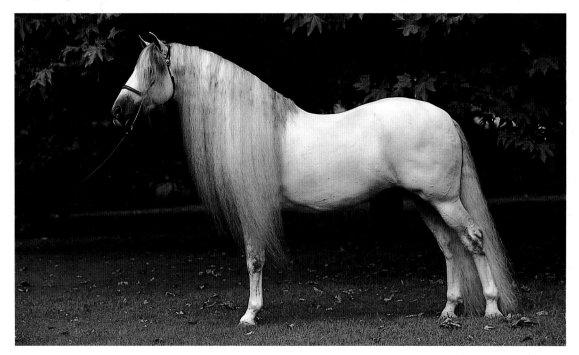

BREED INFORMATION

NAME	Frederiksborg
APPROXIMATE SIZE	16 hh
COLOR VARIATIONS	Chestnut, usually a flaxen mane and tail
PLACE OF ORIGIN	Denmark

Frederiksborg

BLOOD TEMPERATURE

USES TEMPERAMENT

I N 1562, KING FREDERICK II of Denmark established the Royal Frederiksborg Stud, which developed into the Frederiksborg breed from the base stock of Spanish and Neopolitan horses standing at the stud. The primary aim in developing the Frederiksborg was to produce a versatile horse for royal and military use, both to be ridden and driven. Until the late 1600s and early 1700s, there was no real selective breeding to improve the Frederiksborg but from the 1700s onward a selective programme was established. One famous horse to evolve from this was the white stallion, Pluto, foaled 1765, who became a foundation sire for one of the Lipizzaner lines.

The Frederiksborg had developed into a first-class quality utility horse and became increasingly popular through the 17th, 18th and 19th centuries. The breed's popularity was actually to the detriment of the continuation of the breed because so much good breeding stock was exported abroad. By 1839, the breed had diminished in numbers so greatly that the Royal Frederiksborg Stud was forced to close. Individual owners and enthusiasts kept the breed somewhat alive, although there was a tendency toward producing a heavier type more suited to draft work.

In 1939, there were renewed efforts to re-establish the breed and Friesian, Oldenburgh, Thoroughbred, and Arabian stock was used. The numbers of Frederiksborg horses are still quite low but their influence and value to other breeds should not be overlooked. They were widely used to improve the Danish Jutland and were influential in the development of the Danish Warmblood. They have an extravagant action and a lively and intelligent temperament, making them good riding horses.

In appearance, the Frederiksborg has a well-proportioned head which shows some of its Spanish ancestry, set on a muscular, though sometimes shortish neck. The neck is often rather upright in carriage, the shoulder too is quite upright, with low withers, and a long straight back. The chest should be broad and the quarters rounded with a well-set tail. The legs are muscular with well-defined tendons, strong joints, and well-shaped feet. They are always chestnut in color and stand at approximately 16 hh.

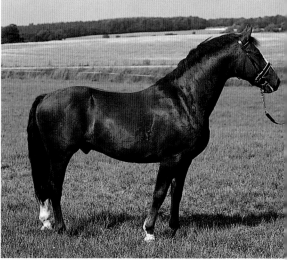

Top
This breed is always chestnut, with a tendency to a straight neck and shoulders.

Bottom
The horses have an exaggerated action and lively temperament; they are increasingly popular as riding horses.

HORSE FACT:
Year of the Horse is not, as one might think, a film about horses, but is a documentary film about the relationship between the rock icon, Neil Young, and the band 'Crazy Horse'.

BLOOD TEMPERATURE

USES TEMPERAMENT

French Anglo-Arab

BREED INFORMATION

NAME	French Anglo-Arab
APPROXIMATE SIZE	15.2–16.3 hh
COLOR VARIATIONS	Chestnut, bay, or gray
PLACE OF ORIGIN	France

Top and Center
Each French Anglo-Arab must contain at least 25 per cent Arab blood.

Bottom
The horse has a fine, attractive head with an arched, muscular neck.

ORIGINALLY FROM France, the French Anglo-Arab is an extremely important breed of horse in the world today. It is widely accepted that they can make top-class competition horses with a particular aptitude for jumping and have excellent conformation and great quality. The breed was first really established in about 1843 by a veterinarian called E. Gayot at the stud farms of Le Pin and Pompadour. Prior to his efforts, it is believed that the French Anglo-Arab descended from a group of oriental type mares left by the Moors in the A.D. 732 Battle of Poitiers. It is likely that these mares bred with local stallions to produce the Tarbes and Limousin breeds and that infusions of Arab and English Thoroughbred blood went on to provide the basic stock for the French Anglo-Arab.

The breed's characteristics and conformities were then cemented by the Arab stallion Massoud (1814–1843), the Turkish stallion Aslan, the stallion Prisme (1890–1917), and three English Thoroughbred mares – Daer, Selim Mare, and Comus Mare. There are strict requirements laid down by the French Anglo-Arab's studbook, one of these being that every horse registered must contain at least 25 percent Arab blood, and these rules continue to aid the preservation of the breed's excellent qualities. Their particular qualities of speed, endurance, and athleticism were established early in the breed's history by a rigorous programme of selective breeding where the horses had to perform a series of tests. There is also now a division of the French Anglo-Arab for racing stock and there are over 30 annual Anglo-Arab race meetings, although the Anglo-Arab does not achieve quite the speed of the Thoroughbred.

In appearance, they are highly attractive horses, with a fine, neat head of quality. The neck should be muscular and gently arched, well set to a broad, deep chest, and long sloping shoulders. The withers are quite prominent, the back straight and in proportion, the hindquarters strong and muscular with a long, flat croup and a well-set and carried tail. The legs are well made, strong and tough with good clean joints and hard hooves. They are generally chestnut in color, but can be bay or gray, and stand between 15.2 hh and 16.3 hh.

HORSE FACT:
The normal temperature for a horse is 100—101° F, 38° C; any reading over 101°F is cause for concern and can indicate infection or fever.

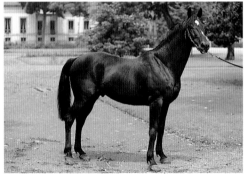

┌─────────────────────────────────────┐
○ ○

BREED INFORMATION

NAME	French Trotter
APPROXIMATE SIZE	16.2 hh
COLOR VARIATIONS	Commonly bay or chestnut, can by any solid color
PLACE OF ORIGIN	France

French Trotter

BLOOD TEMPERATURE

USES TEMPERAMENT

HORSES IN FRANCE first began to be selectively bred for trotting races in the early to mid-1800s. The French Trotter developed primarily from Norman stock which was crossed with English Thoroughbred and half-bred hunter types, Norfolk Roadster, and some American Standardbred. The French Trotter is sometimes referred to as a Norman Trotter, due to the influence of the Old Norman horse on the breed's development.

The early Trotters were rather heavier and coarser than they are now, bearing a greater resemblance to their Normandy ancestors, but infusions of Thoroughbred blood have greatly refined them. Early significant influences on the development of the breed were by the stallion Young Rattler, foaled 1811, who was by the Thoroughbred, Rattler, out of a mare with a high percentage of Norfolk Roadster blood. Eventually five impressive Trotting lines were established and these were due to the stallions Conquérant, Lavater, Normand, Phaeton, and Fuchsia. Although there have been infusions of American Standardbred blood, the French Trotter has retained its unusual habit of trotting on the diagonal, rather than adopting the lateral pacing of the Standardbred.

The French Trotter excels at both ridden and driven trotting races, and maintains a particularly balanced and level stride. Through interbreeding with the Thoroughbred, the conformation of the Trotter's shoulders has improved and become less upright, allowing for a longer stride. They also have very good stamina. The first trotting races in France took place in the 1830s at Cherbourg and since then the sport has increased rapidly in popularity, which is mirrored by the increasing production of the French Trotter.

The Trotters are bred for functional, not aesthetic purposes and there is quite some variation of physical characteristics within the breed. However, in general terms, they tend to have a slightly heavy and large head, which is plain, but not unattractive. The neck is of good proportional length, and is well set to shoulders which are becoming increasingly sloped. The withers are usually quite rounded, the back broad and strong, with extremely muscular quarters. The legs are very well conformed, being strong and muscular with good joints, hard, dense bone and very hard hooves. They tend to be chestnut or bay in color, but can be any solid color, and stand at approximately 16.2 hh.

Top
Trotters have a long, balanced stride which has improved since the conformation of their shoulders has improved.

Bottom
The horses have large heads and well-proportioned necks, and shoulders that are becoming increasingly sloped through careful breeding patterns.

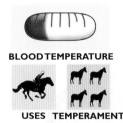

BLOOD TEMPERATURE

USES **TEMPERAMENT**

Friesian

○○○○○○○○○○○○○○○○○○○○○○○○○○○
BREED INFORMATION

NAME	Friesian
APPROXIMATE SIZE	15 hh
COLOR VARIATIONS	Black
PLACE OF ORIGIN	The Netherlands

THE FRIESIAN IS BELIEVED to be descended from the primitive Forest Horse, and originated in the Friesland region of the Netherlands. There have been references to the

HORSE FACT:
The American Saddlebred breed is often used in preference by Hollywood trainers to produce the equine stars of films; this is because they are invariably intelligent, large, and attractive.

Friesian throughout history and they were frequently painted by the Old Dutch Masters carrying knights into battle. The Friesian was a popular mount for knights — they have an exceptionally proud bearing and extravagant, high knee action, while being extremely strong for their comparatively small size. During the Spanish occupation of The Netherlands, from 1568 to 1648, the Friesian probably had infusions of Spanish blood and this influence on the breed added greater refinement.

Over the centuries the Friesian has proved its adaptability and has been used for many different purposes including farm work, draft, riding, dressage, as a warhorse, in trotting races, and for improving other breeds. The Friesian is believed to have influenced the British Fell and Dales ponies, which show clear similarities to the Friesian. They were used in the development of the Old Black Horse of the Midlands and in the development of the Shire horse. Their influence can be seen in the Dole Gudbrandsdal of Norway and they were used as base stock at the German stud of Marbach, where they contributed to the early

development of the Württemberger and Oldenburgh. During the 15th and 16th centuries the Friesian was used in the Riding Schools of France and Spain, performing the High School exercises.

Typically, the Friesian is an attractive, compact, muscular, little horse with a great presence and bearing, and a Spanish type head. They carry themselves proudly and have a high-stepping, active trot. They are unusual in that they are one of the few light horse breeds to carry feather, of which they have a large amount. They also have a long and luxurious mane and tail and these features, combined with their jet black coloring makes them an eye-catching horse in action. The Friesian has a particularly docile and kind temperament, and is an economical feeder. During the 19th century they were widely used in trotting races, which led to breeders trying to produce a lighter strain of Friesian, so that the Friesians of today are considerably lighter than they were originally. They are always black in color with minimal white markings, and stand at approximately 15 hh.

Top
Friesians have been bred to be lighter than their forebears and are always black in color.

Bottom
This is a breed that carries itself proudly, with a small, elegant head and pricked ears.

Furioso

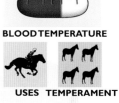

BLOOD TEMPERATURE

USES TEMPERAMENT

NAME	Furioso
APPROXIMATE SIZE	16 hh
COLOR VARIATIONS	Bay, chestnut, or black
PLACE OF ORIGIN	Hungary

THE MEZOHEGYES STUD farm was founded in 1785 by the Emperor of Austria and the King of Hungary, Joseph II, and quickly gained a reputation as one of the best breeding centers in Europe. The Furioso or Furioso-North Star developed there in the 19th century as a result of crosses between the stud's base stock, which was primarily Nonius mares and two imported English Thoroughbred stallions, Furioso and North Star. Furioso, who was imported in 1841, sired 95 stallions who were instrumental in the progression of the breed. North Star, who was imported in 1844, came from an illustrious background which included some Norfolk Roadster blood. He was the grandson of Touchstone, winner of the 1834 St. Leger, and twice winner of the Ascot Gold Cup. On his mother's side, there were connections to Waxy, winner of the 1793 Derby, and to the famous Eclipse.

At first, the two lines of Furioso and North Star were kept separate but, towards the end of the 19th century, the progeny started to be crossbred and eventually the Furioso characteristics became more prominent than those of North Star. The Furioso now bears little resemblance to its Nonius roots. Now the Furioso is bred at Apajpuszta in Hungary and also widely across Central Europe. The Furioso is

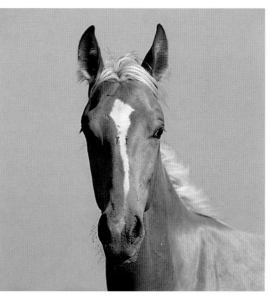

a versatile riding horse, more refined than its relative the Nonius, and is capable of competing in all major disciplines. They were also used for light farm work, at which they excelled due to their innate toughness, although now the focus is more on producing riding horses. They are strong and tough, and have a calm, but energetic temperament.

In appearance, the Furioso has a correctly proportioned head which is quite refined and has more of a Thoroughbred look than that of the Nonius. The neck is in proportion to the body and is muscular with a prolific mane. They are often described as having basic workmanlike conformation which is a debt to the Nonius. They are often long through the back, have muscular quarters, strong legs, and hocks that are well let down. They should be wide through the chest and have a sloping shoulder.

Conformational faults that may occur are pigeon toes in front and cowhocks behind. Generally they are bay, chestnut, or black, and stand at approximately 16 hh.

Top
These horses have long, intelligent heads with muscular necks and a prolific mane.

Bottom
The Furioso is now widely bred in Central Europe and is regarded as a useful riding horse.

BLOOD TEMPERATURE

USES TEMPERAMENT

Gelderlander

BREED INFORMATION	
NAME	Gelderland
APPROXIMATE SIZE	15.2–16.2 hh
COLOR VARIATIONS	Mostly chestnut
PLACE OF ORIGIN	The Netherlands

THE GELDERLANDER DEVELOPED approximately 100 years ago in the Gelderland province of the Netherlands. They were bred by the local people primarily as a versatile farm horse, able to work on the farms, but also sufficiently conformed to make a good riding horse. The breed evolved from a rather mixed gene pool. The local people bred native mares to Andalusian, Norfolk Roadster, Neapolitan, and Norman stallions. There were then further infusions of Arab, Anglo-Arab, Furioso, Holstein and Orlov blood. In the late 19th century, the breed was further improved by the introduction of English Thoroughbred, Hackney, and Oldenburgh blood. Rather remarkably, considering the diversity of influences, a fixed type did develop by crossbreeding the progeny, and this became known as the Gelderlander.

They are extremely versatile horses with an excellent quiet temperament. The infusions of Thoroughbred have lent the breed a certain amount of class and they are probably best described as eye-catching mediumweight carriage horses. The Gelderlander is increasingly being used for competitive driving, at which they are very talented many having competed at International level competitions. They also have very good stamina. They make good middleweight riding horses and are often quite athletic possessing good natural jump, but they do however lack speed. They have great presence and elegance with a free-flowing action and a particularly stylish high-stepping trot. Numbers of the Gelderlander have somewhat decreased in recent years, as they are increasingly used to breed Dutch Warmblood, which is a much higher caliber of riding horse.

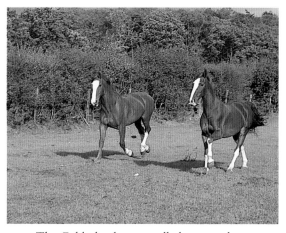

The Gelderlander generally have good conformation, with a long, sometimes plain head, and straight profile. The neck is muscular and gently curves from broad withers to the poll. The back is quite straight and long with muscular quarters, which are fairly straight from the croup. The tail is set and carried high. They are broad and deep through the chest, and have muscular shoulders which can be rather straight. The legs are muscular and quite short, while proportionally often being long in the forearm, with good, strong joints, and very hard hooves. They are mostly chestnut, but can be bay, gray, or black in color, with white markings, and stand at between 15.2 hh and 16.2 hh.

HORSE FACT:
A horse-shoeing forge can heat metal to over 2,500 degrees.

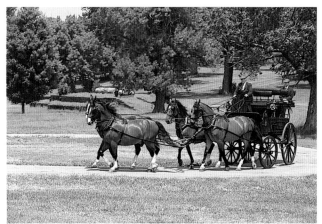

Top and Center
This breed is a good driving animal but lacks the speed of horses like the Dutch Warmblood.

Bottom
The Gelderland comes from the Netherlands and was developed about 100 years ago.

Gidran Arabian

BLOOD TEMPERATURE

USES TEMPERAMENT

HORSE FACT:
Tetanus vaccinations are just as important for a horse as they are for a person. Every horse should be be kept up-to-date on their boosters.

THE GIDRAN ARABIAN, or the Hungarian Anglo-Arab, originated at the Hungarian stud of Mezohegyes, which was founded in 1785. The breed developed during the 19th century and its history can be traced back to the stallion Siglavy Gidran, who was imported from Arabia in 1816. Gidran was from the notable Siglavy Arab strain and was an imposing chestnut horse. He was mated with a Spanish mare called Arrogante which produced a colt foal called Gidran II. Gidran II became the foundation sire of the Gidran Arabian breed.

During the early development of the breed there was a rather haphazard selection process, with a number of different mares being used, some local breeds and some Spanish. This was followed by infusions of Thoroughbred and more Arab blood and led to the fixed characteristics of the breed. The breed was originally developed for use as cavalry horses, having a larger and more weight-carrying frame than the Arab. The Gidran Arab developed along two basic lines: one heavier and suitable for light farm and draft work and the other lighter, faster and more of a saddle horse. The breed sustained substantial losses during the First World War and afterwards further Arab blood and some Kisber blood was introduced. Numbers had again dropped by 1977 and two stallions from Bulgaria were used to bring in fresh blood.

The Gidran Arabian is a large upstanding horse, solidly built, and exhibiting quality and class. It is suitable for competitive riding, being a good sports horse and is also used as a carriage horse. It has a questionable temperament, believed to have been inherited from the original Siglavy Gidran, and is not the easiest horse with which to get along with.

In appearance, they are attractive large horses, nearly always chestnut in color. The head is refined, but not as fine as the traditional Arab. The neck should be in proportion to the body and is muscular and well set on. The shoulders should have a nice slope, allowing for freedom of movement, and the chest is deep and wide. They are deep through the barrel, and have a strong, sometimes long back. The quarters are also muscular, and the legs are strong with short dense cannon bones and well-formed feet. They stand at between 16–16.2 hh, although occasionally are as big as 17 hh.

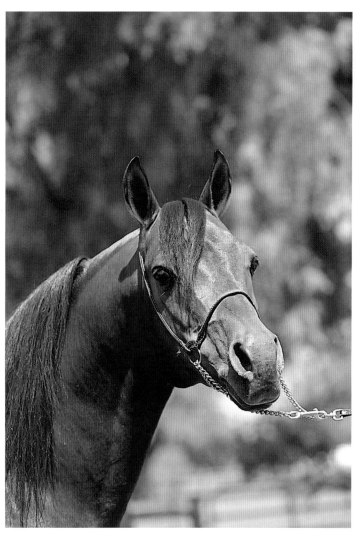

Left
These are handsome horse which are usually chestnut; they have a distinctive Arab look.

BLOOD TEMPERATURE

USES TEMPERAMENT

Groningen

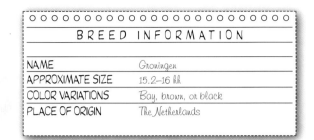

BREED INFORMATION

NAME	Groningen
APPROXIMATE SIZE	15.2–16 hh
COLOR VARIATIONS	Bay, brown, or black
PLACE OF ORIGIN	The Netherlands

Top
Another Dutch horse, the Groningen is a heavy breed that was used for draft work.

Bottom
The horse has a strong head with powerful shoulders which are becoming more sloped.

THE GRONINGEN originated in the northwestern province of Groningen in the Netherlands and was developed primarily as an all-around versatile horse for use on the farms. The breed evolved through crossing native mares with Oldenburgh, East Friesian, and Friesian stallions and is characteristically a heavy type of workman horse. They fulfilled the local people's need to carry out all light farm chores, as well as being driven, and also make a good heavyweight riding horse. They were for many years popular as a carriage horse – they were not as flashy as their neighbors the Gelderlanders, but were eminently reliable and could keep going all day.

What the Groningen lacks in looks and class, they make up for in stamina, endurance, and usefulness. They have had little influence on other breeds, but have been instrumental in the

development of the impressive Dutch Warmblood. From 1945 onward, their numbers have dwindled as the demand for good workhorses has decreased and by the 1970s they were virtually extinct, with only one pure-bred stallion remaining. Since then, there have been efforts by enthusiasts to preserve the breed, with recent infusions of Oldenburgh blood. The Groningen now has improved conformation and is more compact with a better, more sloping shoulder, mainly due to the Oldenburgh.

In appearance, the Groningen is a medium-weight stamp with quite plain features, although they have a natural presence and carriage. The head tends to be quite long and plain, with a straight profile and long ears. The neck is very muscular and wide at the base, while the withers are reasonably prominent and long. The shoulders have become more sloping in recent years, having been quite upright, which led to a short stride. They are powerfully built, with a broad and deep chest, and a good depth through the girth. The back can be quite long and the croup flat. The quarters are very muscular and the tail is set and carried high. The legs are short but strong and the hooves are hard. Typically, the Groningen has an excellent temperament, being willing and kind, and is also an economical feeder. Usually they are any whole color, bay, brown, or black, and stand at between 15.2 hh and 16 hh.

BLOOD TEMPERATURE

USES TEMPERAMENT

BREED INFORMATION

NAME	Hackney Horse
APPROXIMATE SIZE	14–15.3 hh
COLOR VARIATIONS	Any solid color
PLACE OF ORIGIN	Britain

Hackney Horse

THE HACKNEY HORSE developed in Great Britain through the 18th and 19th centuries and evolved from the two trotting breeds of that time, which were the Norfolk Roadster and the

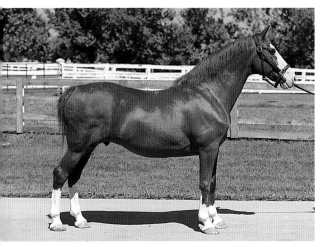

Yorkshire Roadster, also known as Trotters. Both the Norfolk and the Yorkshire were similar types of trotting horse which developed according to their region — the former being of a more cobby conformation and the latter having more quality.

The Norfolk is perhaps the better known of the two and was famous in its day for its great trotting speed. It was also highly influential in the development of many other breeds such as the Gelderland, Furioso, French Trotter, Welsh Cob, Maremmana, Orlov Trotter, American Saddlebred, and Standardbred. Both the Norfolk and the Yorkshire evolved primarily for the purpose of transportation, at which they excelled, having a tremendous turn of speed combined with great stamina and endurance. Both the Norfolk and the Yorkshire are traced to a single stallion, Original Shales, who was born in East Anglia in 1755. He was out of a hackney mare, which in those days, and when spelt with a small 'h,' simply meant a type of riding horse, and was sired by the stallion Blaze. Blaze had notable ancestry, being the

son of the famous Flying Childers, the first great racehorse of the day, and was also the grandson of the Darley Arabian, one of the founders of the Thoroughbred breed. Original Shales went on to father the two stallions, Scot Shales, and Driver, who had a great influence on the Norfolk Trotter.

The eventual emergence of the Hackney Horse through the combining of the Norfolk Roadster and Yorkshire Roadster should be largely accredited to Robert and Philip Ramsdales. This father and son team took some of the first Norfolk horses to Yorkshire, Wroot's Pretender and Phenomenon, and mated them with Yorkshire trotting mares. The resulting progeny combined the best elements of both parents and, by 1833, The Hackney Horse Society was formed in Norwich, and their studbook opened. Interestingly, one of Phenomenon's daughters, called Phenomena, who was a mere 14 hh, trotted a record 17 miles in 53 minutes in 1832.

The advent of the railroads in the 19th century and the beginnings of mechanization drastically effected the numbers of the Norfolk and the Yorkshire Trotters, both of which sadly went into decline and eventually died out altogether. The Hackney, however, managed to survive and this is largely credited to their extraordinary showiness and style, which far exceeded that of the Roadsters, and led to their use in the show ring.

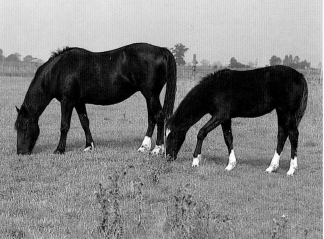

Top
The Hackney Horse has a showy movement and is used extensively in harness races.

Bottom
The breed has continued to flourish where other similar trotting horse breeds have died out.

HORSE FACT:

Hippocampus was a sea-horse in Greek mythology who had the upper body of a horse and the lower body of a fish. He was responsible for pulling Poseidon's chariot across the sea.

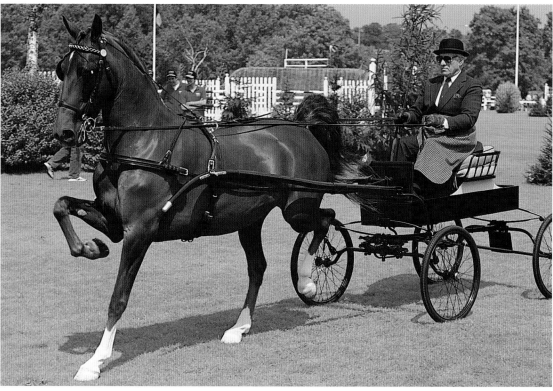

The Hackney Horse measures from 14.3 hh upward, although they are occasionally smaller, and are easily recognizable by their extravagant, flashy knee and hock action. They move very freely from the shoulder throwing the front legs forward with a distinct moment of suspension in every stride, where the horse appears to float over the ground; the hind leg action is similar, but to a slightly lesser degree. Their action is quite stunning and has been described, among other things, as spectacular, electric, and effortless in the extreme. The Hackney is unique in its appearance and carriage and should be considered the very top of its class on a world standing. Like the Hackney Pony, the Hackney Horse is used mainly for driving, both on the road and to great effect in the showring. They have also been very successfully crossed with Thoroughbreds to produce excellent riding and showjumping horses. They are generally chestnut, bay or black in color, but can be any solid color, and may carry some white markings.

In appearance, they have a small fine head with a slightly convex profile. The ears are small, alert and mobile, and the eyes should be large and kind. The neck is of reasonable length, is thick and crested, and is usually set and carried quite upright. The chest should be broad, but is not typically deep, and the shoulders should be of good harness-type conformation, as well as being extremely powerful. They are compact through the back, with the barrel running up, and the ribs are well rounded. The quarters are immensely powerful and the croup is level. They characteristically have a very high-set and carried tail, which is increased by the use of the traditional crupper and dock piece. The legs are very strong with good broad joints, with the hocks particularly low to ground, which provides the forward thrust from behind. Their hooves are also very hard and tough, and they are renowned for exceptional soundness, both in the leg and the foot.

Top and Bottom
The Hackney is very successful at shows in harness and trotting races as it has such an extreme gait.

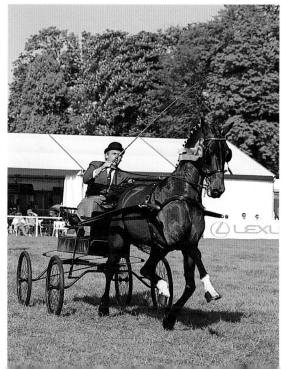

Hanoverian

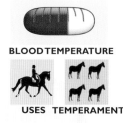

BLOOD TEMPERATURE

USES TEMPERAMENT

THE HANOVERIAN TODAY IS considerably different from the early Hanoverians and enjoys an excellent reputation in both the dressage and showjumping worlds. In 1714, George

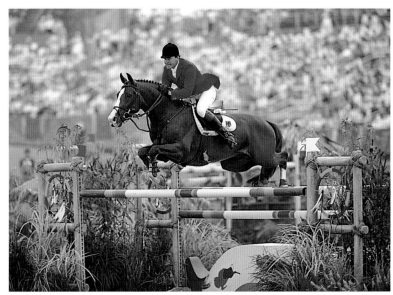

Louis, the Elector of Hanover, became King George II of England, and founded the Celle stud in Lower Saxony. Selective breeding took place there between base stock, Thoroughbred types and, most importantly, with 14 black Holstein stallions. These Holsteiners were to be the primary influence on the development of the Hanoverian for approximately 30 years.

The principal aim was to produce a quality animal, which was suitable for carriage work, riding, and most of the agricultural tasks around the farm. There were later infusions of Thoroughbred blood which slightly lightened the breed, making it more suitable for riding. The Napoleonic wars of 1812–13 had a devastating effect on the breeding program of the Hanoverian and by 1816 there were only 30 stallions remaining, where once there had been 100. At this time, large numbers of Thoroughbreds were imported to Celle until 35 percent of the stock at Celle was Thoroughbred and this had the effect of greatly lightening the Hanoverian. The Hanoverian was now too light to usefully perform the agricultural tasks required and an effort was made to increase their overall frame.

By 1924, the numbers of Hanoverians were rapidly increasing and there were now 500 stallions standing at Celle. Due to the growth in numbers, another stud was opened at Osnabrück-Eversburg, with 100 stallions. After the Second World War, there was a move towards creating a lighter type more suitable for riding and this was achieved through infusions of Trakehner and Thoroughbred blood. Now the Hanoverian is an excellent competition horse, both in dressage and jumping, and is frequently used to improve other breeds. They are noted for their excellent temperament, as well as their strength and stamina.

In appearance, they have an attractive head that is well set on, a long and well-conformed neck, a wide deep chest, nicely sloping shoulders, a long straight back, with muscular quarters and a well-set tail. The legs should be strong with broad joints and hard hooves. They have a natural presence and elegance, and move very freely and correctly, with excellent balance. They can be any solid color, and stand at approximately 16.2 hh.

Top
Hanoverians are extremely popular as show jumping horses as they are extremely agile.

Bottom
This breed has an attractive head with a muscular neck and well-sloping shoulders.

BLOOD TEMPERATURE

USES TEMPERAMENT

Hispano

BREED INFORMATION

NAME	Hispano – Spanish Anglo-Arab
APPROXIMATE SIZE	14.3–16 hh
COLOR VARIATIONS	Bay, gray, or chestnut
PLACE OF ORIGIN	Spain

THE HISPANO, also called the Spanish Anglo-Arab, originated in Spain as a result of a cross between mares of Arab and Andalusian heritage and English Thoroughbred stallions. The breed is also for this reason referred to as *trés sangres*, meaning 'three blood'– the three blood lines upon which the breed is founded. The resultant Hispano is a horse of Arabian features with the quality and stamp of the Thoroughbred and characteristics of the Andalusian. Sometimes these horses can vary quite considerably in physical appearance, with either the Arab, Thoroughbred or Andalusian becoming the dominant feature. They are characteristically extremely bold and courageous and are often used to work the young bulls in preparation for the bullring, as

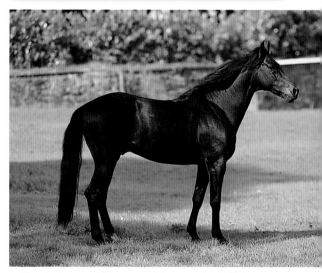

well as being used in competitions in the bullrings.

The Spanish have a long tradition of using bulls in sporting events one of which is the *acoso y derribo*. In this, the competitor on horseback has to bring a bull to the ground using a long stick. The horse has to be extremely quick and agile as well as being highly trained, because invariably the bulls will get up and charge. The Hispano have a quiet, but lively temperament and are highly versatile and talented, making very good competition horses in both dressage and jumping. For the most part, they combine all the most admirable qualities from the three breeds in one horse, making them highly desirable as riding horses.

In appearance, they have a correctly proportioned fine head usually with a straight profile, although sometimes the Arab genes come out in the shape of the head. They tend to have a light frame which belies their toughness and strength. The neck is elegant and longish, and well set on, with a gentle curve from the withers to poll. They should have a wide and deep chest with a good sloping shoulder, which allows for a nice free-flowing action. The back is straight, strong, and quite short with muscular quarters and a well-set tail. The legs should be clean and tough, with well-defined tendons and strong hooves. Generally they are bay, gray, or chestnut, and stand between 14.3 hh and 16 hh.

Top and Center
These elegant horses with Arab influence, were used in traditional Spanish sporting events against bulls.

Bottom
Hispanos are fast and agile and are popular both as riding and competition horses.

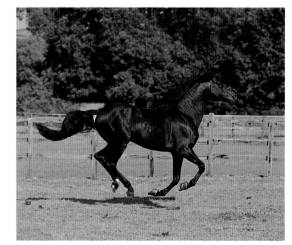

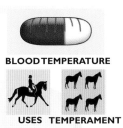

Holstein

BREED INFORMATION

NAME	Holstein
APPROXIMATE SIZE	16–17 hh
COLOR VARIATIONS	Mostly bay or chestnut, but can be any solid color
PLACE OF ORIGIN	Germany

BLOOD TEMPERATURE

USES TEMPERAMENT

Top
These horses have a good strong action and an excellent disposition; they make biddable riding animals.

Bottom
Holsteins have a strong head with an obvious Thoroughbred influence.

THE HOLSTEIN is another German Warmblood breed that has changed quite considerably throughout its history. The breed takes its name from the Schleswig–Holstein area where it originated and is generally believed to have developed through the 13th century. There is documentary evidence of Holstein type horses existing in 1285, when permission was given to a monastery at Uetersen to graze horses on private land around the cloisters. It is likely that they are descended from a mix of German, Spanish and oriental blood and that during the Middle Ages the Holstein was a heavy, but elegant warhorse, as well as being used for agricultural purposes. They were frequently used both by the cavalry and as a gun horse for pulling the heavy artillery.

During the 17th century they became more popular as carriage horses, although they were still quite coarse in appearance, with a heavy frame and a short stride. One famous Holstein of the 17th century was the gray stallion Mignon, who became the founder of the cream horses which were prized by Electors of Hanover, and were used at the British Royal Mews until 1920. During the 19th century there was an infusion of Thoroughbred blood to improve the Holstein's conformation and speed, and also of Yorkshire Coach Horse blood, which is credited with supplying the Holstein's excellent temperament and wide action.

After the Second World War, there were again infusions of Thoroughbred blood, and the Holstein became a more refined lighter type eminently suitable for competitive riding. They have a superb temperament making them very easy to get along with and are highly versatile, being talented at both dressage and jumping, which makes them popular

competition horse worldwide. They are exceptionally athletic, and number among the top show jumping horses in the world.

In appearance, they have a nicely proportioned head of a Thoroughbred type that is well set to a muscular and elegant neck. They should be broad and deep through the chest, with sloping shoulders allowing freedom of movement, a straight longish back with muscular sloping quarters, and short, strong legs. They are often long in the cannon bone with clearly defined tendons and well-shaped hooves. They can be any solid color, although they are often bay, and stand from between 16 hh and 17 hh.

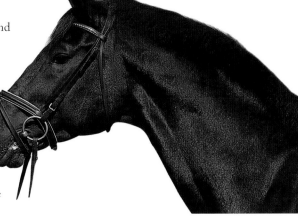

HORSE FACT:
The Jockey Club was established in Newmarket in 1752 and is responsible for the rules of racing, breeding and licensing in an effort to keep racing fair and regulated.

BLOOD TEMPERATURE

USES TEMPERAMENT

Bottom

The Indian Half-bred shows a lot of different physical characteristics; the best specimens originate from studs run by the Army in India.

Indian Half-Bred

BREED INFORMATION

NAME	Indian Half-Bred
APPROXIMATE SIZE	15–16 hh
COLOR VARIATIONS	Any color
PLACE OF ORIGIN	India

THE INDIAN HALF-BRED was developed in India primarily at the army studs to produce suitable cavalry horses. They are descended from a cross between the native Kathiawari, oriental stock, the Australian Waler and a substantial amount of English Thoroughbred. Around the beginning of the 20th century, large numbers of Walers were imported to India for use within the Indian Cavalry and remained the principal method of transport until the start of mechanization. The army had used mostly Arab, and Arab part-bred stock for their requirements, but had then started to import the larger and more suitable Australian Waler as replacements.

The Half-bred is now produced all over India especially at the army remount depot at Saharanpur and army stud at Babugarh. As well as use within the army, the Half-bred is also widely used by the police force in the towns and especially in the rural areas. There are an increasing number of horses being used in civilian riding clubs, and in more competitions, at which the Half-bred does very well. India is not the ideal horse breeding country as the climate is extremely harsh, and the soils and grasses poor. These factors have, in part, led to the tough and hardy nature of the Half-bred which has evolved to cope with both the climate and the food, or lack thereof. They can vary quite a lot in physical characteristics and generally those bred at the army studs have better conformation.

They are on the whole, however, excellent horses of some quality and substance with exceptionally calm and willing temperaments. In appearance, they are mostly attractive horses which clearly show the influence of the Thoroughbred. They have quality heads with a kind eye and alert ears. Sometimes the ears will curve in toward each other,

which is a throwback to their Kathiawari genes. The neck is of good length and muscular, the shoulder nicely sloping and ideal for a riding horse, although poor examples of the breed will be upright in the shoulder. They should be deep through the chest, which can be quite narrow, have a fairly straight and long back, rounded hindquarters and good, well-made, strong legs. They can be any color, and stand at between 15 hh and 16 hh.

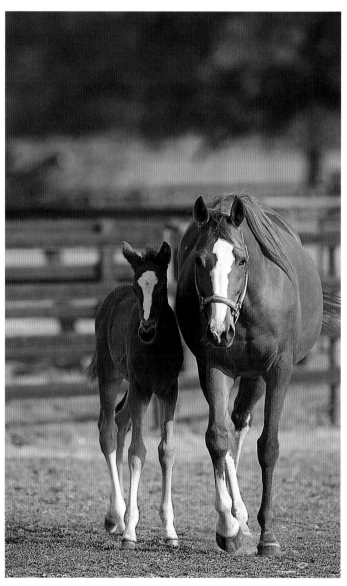

Iomud

BLOOD TEMPERATURE

USES TEMPERAMENT

THE IOMUD is an ancient breed, closely related to the Akhal-Teke, and descended from the old Turkmenian horses. The Iomud developed in Southern Tukmenia, and has over the centuries been influenced by infusions of Arab, Kazakh, Mongolian, Turkmene, and more recently Akhal-Teke blood.

The Iomuds were typically kept in herds which were run over the desert and semidesert regions, and is hence able to survive on minimal fodder and water, as well as coping in the extremes of climatic conditions. Like the Akhal-Teke, the Iomud has a toughness that is rarely equalled by any other breed and their powers of stamina and endurance are legendary. They have been developed primarily as riding horses, although are useful in harness and are very versatile. They have also been used for racing since 1925 and show a considerable turn of speed, although in the most part they do not surpass the Akhal-Teke in this capacity.

The Iomud is sadly in very real danger of extinction now, although there are efforts being made to re-establish them. According to a publication in 1989, there were only 616 pure-bred Iomuds remaining. They make excellent riding horses and have a natural jumping ability, which, combined with their speed, makes them very good competition horses. They also have a particularly sound constitution, are long-lived and have good temperaments.

In appearance, the Iomud has less of the grayhound shape of the Akhal-Teke, and is a heavier, more compact frame. They have attractive heads with an honest look, and often a slightly Roman profile. The ears are small, alert and mobile, and the eyes are large and kind. Their neck is in proportion to the body, and is muscular and well formed, with a gentle curve from withers to poll. The withers themselves are reasonably prominent, and the back is quite long, straight and muscular. The shoulders are nicely sloping, and as a result the Iomud has a particularly good, smooth,

and free-flowing stride. The quarters are muscular, and the croup slightly sloping. Their legs are exceptionally strong and sound, as are the hooves. They are usually gray, but are sometimes black or bay in color, and stand at approximately 15 hh.

Top
The Iomud is an ancient breed and has a large amount of mixed blood.

Bottom
The heads often have a slightly Roman profile and the horses have large, kind eyes..

Irish Hunter

BLOOD TEMPERATURE

USES TEMPERAMENT

BREED INFORMATION	
NAME	Irish Hunter
APPROXIMATE SIZE	15.3–17 hh
COLOR VARIATIONS	Any color except skewbald and piebald
PLACE OF ORIGIN	Ireland

THE IRISH HUNTER, or Irish Horse, originated in Ireland and is the result of a cross between the English Thoroughbred and Irish Draft. Technically, the Irish Horse is actually not a breed, but a half-bred, being half-Thoroughbred and half-Irish Draft but Irish Horses do all have very definite characteristics and so can be classed as a breed, and their universal importance and appeal deserves a mention.

The Irish Horse combines the best elements of both the Irish Draft, having their sense, honesty, and charisma, and the Thoroughbred, from whom they inherit their athletic ability, speed, and endurance. The Irish Draft had traditionally been used in Ireland for all purposes, serving as a means of transportation, working the land and for riding, but with mechanization, the Draft horse began to decline in numbers as there was a move towards the riding horse.

The development of the Irish Hunter has filled the need for a first-class riding horse of considerable talent and recently the numbers of the Irish Draft have increased. For a country of their size, Ireland produces a staggering number of top quality horses every year, many of which sell for vast amounts of money through Europe and America. Typically the Irish Horse has a wonderful temperament, perhaps one of the very best among all the breeds of horse, being innately calm, sensible, honest, and yet energetic and lively when required. They are also very tough and have good stamina. They are naturally talented jumpers –

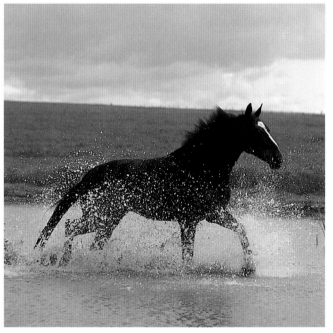

the Irish horse combines quality, ability and bravery, making them one of the most versatile and popular horses of our time. Irish Horses make first-class eventers and showjumpers, while also having the manners and sense to hunt all day.

In appearance, they tend to fall into three categories: light-, middle- and heavyweight, based on their weight-carrying ability. They have attractive heads that sometimes have a convex profile, a well-defined and muscular neck that should be slightly arched, good strong sloping shoulders, and a short, compact back with a broad and muscular croup. Their legs should be clean and well muscled, with good feet. They can be bay, gray, brown, chestnut or black, and stand at between 15.3 hh and 17 hh.

Top
The selective breeding of the Irish Hunter has produced a first-class all-round riding horse.

Bottom
The horses can be any of several colors and can vary in height from 15.3 to 17 hh.

Kabardin

BLOOD TEMPERATURE

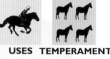

USES TEMPERAMENT

THE KABARDIN developed during the 16th century in the mountainous regions of Northern Caucasus in the former U.S.S.R. It developed through crosses between the Turkmenian, Arab, Persian, and breeds of the south Russian steppes, but perhaps one of the biggest early influences in the breed's development was their environment.

The Kabardin is commonly described as the most élite of mountain horses. They are very surefooted over rugged terrain, and can easily cross the treacherous steep mountain passes, negotiating river crossings and deep mountain snow. They are frequently used without shoes due to the extreme toughness of their feet. They have incredible stamina and endurance – a group of Kabardins in about 1935, famously travelled 1,860 miles through the Caucasian mountains, in bad weather, in just 37 days. They have an extraordinary built-in homing device and are able to find their way both in the dark and in bad weather. During the Russian Revolution of 1917, numbers were drastically reduced and by the 1920s efforts were being made to re-establish this valuable breed.

Initial breeding programmes took place at the studs at Kabardin-Balkar and Karachaev-Cherkess, and now the best Kabardins are bred at the Malokarachaev and Malkin studs. The Kabardin had always been a fairly small, wiry-framed horse, and after the Revolution, there were infusions of Turkmene, Karabakh, Persian, and Arab blood to improve the breed and to increase their size. They are agile, frugal, long-lived and enduring with a calm, but lively temperament, making them highly versatile as a riding horse, as well as being suitable for harness work.

They have an oriental appearance, with an attractive head, often with a Roman nose; the neck can be quite short and muscular and the shoulders are straight and powerful. The straightness of the shoulder creates quite a high action, but this is adequate for their mountainous terrain. They have good smooth paces in the walk, trot, and canter, and some pace naturally, but they are unable to gallop or extend. The frame of the horse is extremely strong, although not classically well put together. The legs are usually quite short, very strong but fine, and exhibit sickle hocks behind. Generally they are bay or black in color, and stand between 15 hh and 15.2 hh.

Top
Kabardin horses have an oriental appearance with a slight Roman nose when viewed in profile.

Bottom
The horses originated from the rugged region of the Northern Caucasus and are very hardy and sure-footed.

HORSE FACT:
The Roman writer, Columella, who wrote a complete treaty on the culture of gardens and agriculture during the first century A.D, described in his writings his theory that mares could be impregnated by the wind.

BLOOD TEMPERATURE

USES TEMPERAMENT

Top
The Karabakh is a mountain breed that has developed as a tough and hardy horse.

Bottom
These horses are normally chestnut or dun and may display a dorsal marking.

Karabakh

○ ○

BREED INFORMATION

NAME	Karabakh
APPROXIMATE SIZE	14–15 hh
COLOR VARIATIONS	Chestnut, bay, or dun
PLACE OF ORIGIN	Azerbaijan

THE KARABKH HORSE developed in Azerbaijan of the former U.S.S.R., in the upland area between the Araks and Kura Rivers. The Karabkh is another breed of mountain horse which has adapted well to its harsh environment. They are believed to have evolved through crossbreeding of the Akhal-Teke, the Persian, Kabardin, Turkmene, and Arabian. In more recent years, there has been a large infusion of racing Arabian blood which has helped the Karabakh's speed and agility.

Like all mountain breeds, the Karabakh is extremely surefooted and is able to travel at speed over rough terrain. They are seemingly resistant to disease and have an excellent constitution. They are a small horse with a wiry frame which belies their strength and toughness. However it would seem that their small stature has rather counted against them and the breed is now in serious decline. Numbers of the Karabakh were initially devastated in 1826 by the Iran raids and, after this, they were considered too small to make satisfactory cavalry mounts. They are currently bred at the Akdam Stud in Azerbaijan but most of the horses are Arab and Karabakh crosses, not pure Karabakh. It would be a great shame for this breed to disappear – their qualities are many and they have frequently been exported to other countries to improve various breeds. They are extremely versatile riding horses and are hardy, strong, enduring and tough. They also have very good temperaments, being calm, willing, energetic, and brave.

In appearance, they have a finely made head, broad across the forehead tapering to nostrils capable of dilation. They have nicely proportioned conformation, with a long, muscular, and elegant neck, well set to quite upright shoulders, a deep chest, a straight back, and a sloping croup. The legs are quite long and fine, but are very strong, although the joints are somewhat small. The feet are extremely tough and hard. They are invariably quite narrow through the body and not very deep through the girth, which is an indication of the influence of the Akhal-Teke. The coat coloring is often an unusual metallic type of chestnut or dun with a darker mane and tail, and a dorsal stripe. They can also be bay or gray and white markings are allowed. In height, they stand between 14 hh and 15 hh.

HORSE FACT:

Lipizzaners are born dark and lighten with age, becoming 'white' at about four years old, and sometimes not until they are as old as ten.

BLOOD TEMPERATURE

USES TEMPERAMENT

Karabair

HORSE FACT:

A 'sprinter' is a horse that can gallop extremely fast over a short distance, and a 'stayer' is a horse that can cover a much longer distance, but at a slower pace.

THE KARABAIR BREED is a very old breed based on ancient stock that has been documented as being in the Uzbekistan area before the Christian era. It is likely that the Karabair developed through a mixture of Arab and Mongol blood, later influenced by the desert horse breeds from the neighboring countries, such as the Turkmene, and further infusions of Arab blood. Uzbekistan is still populated by a vast number of nomadic peoples who have been, through the years, the principal breeders of the Karabair. Their lifestyle accounts for the number of different breeds which have gone toward the development of the Karabair. They have similarities to the Arab, especially in their innate toughness and endurance, as well as their speed and agility, although physically they are less graceful.

The horse is a fairly central element of life to the Uzbekistan people and is used for riding and driving, as well as in the ridden game of Kokpar. Kokpar is a ferocious game which centers over gaining possession of a dead goat carcass – there are few rules and many injuries, and the Karabair with its bravery and speed is used almost exclusively to play.

The Karabair had developed in three different types all of a similar height: the first type is suitable for light draft, pack, and riding, and is a heavier stamp; the second is lighter, and is mainly used for riding; and the third has conformation better adapted just to draft work. Although now there is less distinction between the three, the heavier type has almost disappeared and the other two types have more or less amalgamated.

In appearance, they have the conformation of a stocky Arab, but with less quality. They tend to have a small, but attractive head with a straight profile, and a well-muscled neck of good length. They have a wide chest which lacks in depth, but sufficiently sloping, muscular shoulders. The body frame is lean and wiry with no fleshiness, and a thin, fine skin. They have a short compact back, and quite sloping quarters. Often they will appear to be more developed in the front half than in the quarters. The legs are quite fine, but strong with very hard feet. Generally they are gray, bay, or chestnut in color, and stand between 14.2 hh and 15 hh.

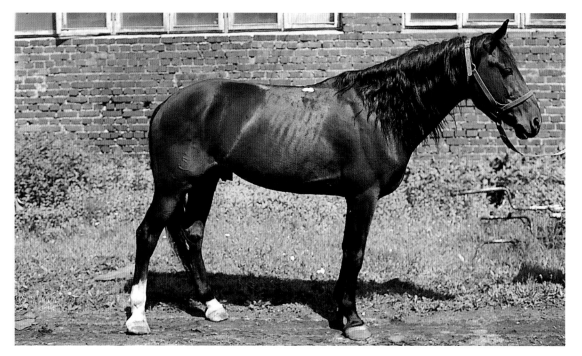

Right
These horses resemble a stocky Arab but their conformation is not as good; their chests lack depth and the body frame is light and lean.

BLOOD TEMPERATURE

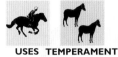

USES TEMPERAMENT

Kathiawari

○○○○○○○○○○○○○○○○○○○○○○○○○○○

BREED INFORMATION

NAME	Kathiawari
APPROXIMATE SIZE	Up to 14.3 hh
COLOR VARIATIONS	Any color except black
PLACE OF ORIGIN	India

THE KATHIAWARI is an old breed that originates in the Kathiawar peninsular from where it takes its name. Although small in stature, the Kathiawari is considered a small horse

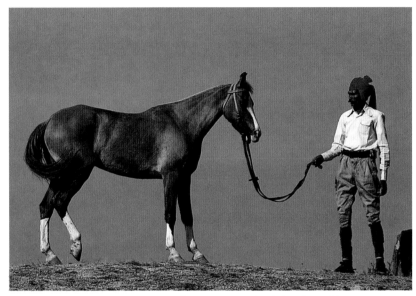

rather than a pony and exhibits horselike characteristics. Their exact roots are not known but it is thought that they date back to around the 14th century when they are believed to have evolved through crossbreeding between the local native ponies and Arabians, and other oriental strains.

One story is that some Arabians swam ashore from a shipwreck off the west coast of India and then bred at will with the local pony breeds. However, there is also the theory that Arabians and other oriental stock were shipped to India during the period of the Mongol emperors and that these were deliberately crossbred with the indigenous breeds to evolve the Kathiawari.

Whatever their exact roots may be, it is quite obvious that they are a largely oriental breed with many Arabian characteristics, especially their great stamina and endurance. The Kathiawari are highly prized as animals of great quality in the area and they are very distinctive. They were traditionally bred by wealthy families who would name the strain

after the foundation mare and are now bred chiefly at a government controlled stud at Junagadh. They are naturally tough and frugal, have great stamina and generally have a quiet temperament, although they can be unpredictable. Interestingly, many of them have a natural ability to pace, which would indicate influence from Central Asian breeds. They are used by the local Gujerat mounted police division and also make a very popular mount in the fast and furious game of tentpegging.

In appearance, they have fine heads with distinctive ears that are large and mobile, and curve inwards to touch. They have a fine and graceful neck and are generally narrow and wiry in build. The shoulders are reasonably sloping, the chest narrow but deep, the back long and straight, the croup sloping, and the tail set and carried high. Their legs tend to be slim, but strong with well-formed small, hard hooves. They invariably exhibit cow hocks, and are fine of bone by Western standards. The coat coloring varies from chestnut, bay, brown, gray, palomino, piebald, and skewbald and they stand up to 14.3 hh.

Top

Although small in size, this breed is considered to be a small horse rather than a pony.

Bottom

The horses have distinctive heads with large, mobile ears.

BREED INFORMATION

NAME	Kisber Felver
APPROXIMATE SIZE	15.2–17 hh
COLOR VARIATIONS	Mostly chestnut or bay, can be any solid color
PLACE OF ORIGIN	Hungary

Kisber Felver

BLOOD TEMPERATURE

USES TEMPERAMENT

Top
This is a relatively new breed which was developed about 100 years ago.

Bottom
The horses are handsome with strong heads and alert ears..

THE KISBER FELVER, Kisber Half-bred, is a relatively young breed having been developed over the last 100 years at the Kisber Stud in Hungary. The Kisber Stud was founded in 1853 and was primarily concerned with the breeding of

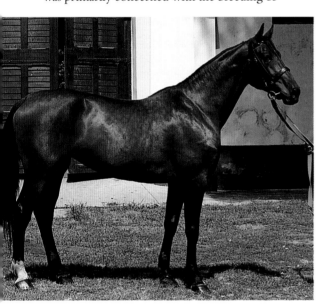

Thoroughbreds, at which it had great success, most notably with the mare Kincsem. Kincsem was unbeaten in an amazing 54 races and was entered in the *Guinness Book of World Records* as a result.

The Kisber Felver evolved through crosses between Thoroughbred, Furioso, Trakehner, Arab and Anglo-Arab, and Selle Français. They are essentially a half-breed, and as such contain a high percentage of Thoroughbred blood, combined with other breeds. It is thought that they were originally developed to be a useful sports horse, with more weight than the Thoroughbred, and also a horse capable of going in harness. Once the Kisber Felver had developed its fixed characteristics, they were commonly used for crossbreeding with local stock to improve the progeny.

They are, naturally, a highly attractive and quality horse, with a distinct Thoroughbred look to them and have made extremely successful competition horses.

The Kisber Felver has a tough and sound constitution and is energetic and lively, qualities which made them suitable for military as well as private use. They are naturally athletic, and make good jumping and eventing prospects. Sadly the breed numbers were dramatically reduced during the First and Second World Wars and in 1945 more than half of the breeding stock was taken as war damages. In 1961, the remaining breeding stock was moved to the Dalmand Stud Farm where they are still bred. The Kisber Felver is rarely heard of, a fact which belies their merits and worth as competition sports horses.

In appearance, they have attractive, fine, and quality heads with alert ears. The neck is of good proportion, and curves gently from the withers to the poll. They have well-conformed sloping shoulders, a deep chest, and well-sprung ribs.

Often the back can be long, and the croup slightly sloping. The legs are muscular, although the joints can be on the small side. They are generally chestnut or bay in color, but can be any solid color, and stand at between 15.2 hh and 17 hh.

HORSE FACT:
Great Britain has won the three-day eventing World Championships a record three times; in 1970, 1982, and 1986.
Guinness Book of Records.

BLOOD TEMPERATURE

USES TEMPERAMENT

Kladruber

HORSE FACT:

Trigger was the famous palomino horse owned by Roy Rogers. Trigger starred in 87 different western films and was also in the 'Roy Rogers Show' on television for six and a half years. He knew many different tricks and was even house trained! When Trigger died in 1965 Roy Rogers had him stuffed and put on display at the Roy Rogers-Dale Evans Museum in Victorville, California.

BREED INFORMATION	
NAME	Kladruber
APPROXIMATE SIZE	6.2–17 hh
COLOR VARIATIONS	Gray or black
PLACE OF ORIGIN	Former Czechoslovakia

THE KLADRUBER originated during the 16th and 17th centuries in the former Czechoslovakia. The breed arose primarily through a mix of Neapolitan and Andalusian blood,

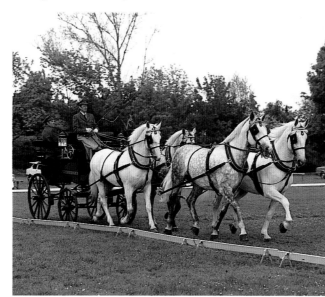

and developed along similar lines to the Lipizzaner, with which they share characteristics. The Kladruby Imperial Court Stud, founded in 1579 by the Emperor Rudolph II, became the chief breeding establishment for the Kladruber. The Kladruber was developed to be a top-class carriage horse for the Imperial Court.

The very early Kladrubers had a variety of different coat colors, from the usual solid colors to palomino and appaloosa, although now they are only bred to be black or gray (white). Sadly, approximately the first 200 years worth of Kladruber stud records were destroyed in a fire in 1757 and much of the early information surrounding them was lost. From the mid 1700s onwards the breed was developed from three stallions – the gray (white) stallion Pepoli, whose two sons Generale and Generalissimus

were also influential to the breed; and two black stallions of the same name, Sacromoso. The gray Kladrubers are still bred at the Kladruby Stud, but unfortunately the black Kladruber herd was destroyed in the 1930s, with many of the animals being sold for meat. A few of the black mares were rescued and there have since been stringent efforts to re-establish the line.

The Kladruber is strong, long-lived and kind with a calm and energetic temperament. They are principally used as draft horses, although they are often crossed with lighter breeds to produce good riding horses. They make excellent competitive driving horses, possessing speed and endurance, and have frequently been seen at world class competitions.

In appearance, they have a long head with a convex profile, and a sensible, kind eye. The mane and tail hair is prolific and luxurious. The neck should be muscular and well set on with a nice arch from withers to poll. The shoulders are reasonably sloping, the chest wide and deep, and the back quite long. The quarters should be muscular and strong, and the legs should be clean and strong with good joints, although they are sometimes long in the pastern. In height, they vary between 16.2 hh and 17 hh.

Top
These are strong, robust horses which make good draft animals.

Bottom
The Kladruber has a long head with a convex profile and prolific mane and tail.

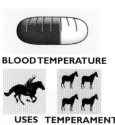

BLOOD TEMPERATURE

USES TEMPERAMENT

BREED INFORMATION	
NAME	Knabstrup
APPROXIMATE SIZE	15.2 hh
COLOR VARIATIONS	Spotted, brown or black spots on a white base
PLACE OF ORIGIN	Denmark

Knabstrup

HORSE FACT:
From the 16th century onward it became fashionable for kings and noblemen to be depicted on horseback; Van Dyck, (1599–1641), and Velasquez, (1599–1660), are noted for both their human and equine depictions.

SPOTTED COAT coloring was often seen in very primitive horse breeds and there are frequent depictions surviving from many hundreds of years ago of spotted horses. An excellent example of this is seen in the cave paintings at Vallon-Pont-d'Arc, France, which clearly show some spotted horses and,

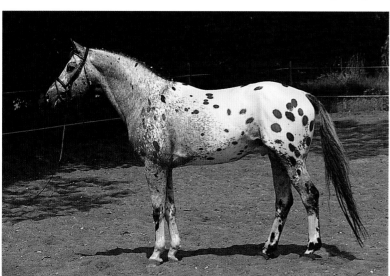

incredibly, have been dated as 20,000 years old. However, the Knabstrup breed developed in Denmark in 1808 from a spotted mare called Flaebehoppen. Flaebehoppen was of Spanish origin and the influence of the Spanish ancestry can be seen in the Knabstrup today.

Flaebehoppen was bought by Judge Lunn and taken to his Knabstrup Estate, where the breed was developed. In 1808, she was bred to a Frederiksborg stallion, and founded a line of spotted horses largely through her grandson, Mikkel. Mikkel is now credited as being one of the foundation sires of the breed. During the 1880s, the Knabstrup Estate was dissolved and the numbers of the Knabstup horse began to decline until the intervention, in 1933, of a Danish veterinarian. He founded an association for the preservation of the spotted horse which led to a revival of the Knabstrup's numbers. The association bred many notable Knabstrup

specimens, one of which was a stallion called Max, who, in 1938, famously knelt in front of Christian X, King of Denmark.

The early Knabstrup horses were tough, sturdy and workmanlike in appearance, while today the Knabstrup has quality and is similar in appearance to the Appaloosa. The Knabstrup are renowned for their intelligence and were widely used in the circus for performing tricks and, due to their broad backs, for gymnastic riding displays. They make very good riding horses, having stamina, endurance, good paces, and being quick learners, while also suitable for harness work. The early Knabstrup was particularly good in harness and had more draftlike conformation.

The modern Knabstrup has a smallish, attractive head with the typical sclera round the eyes, and mottling of the muzzle. The neck is generally short, quite thick, and slightly arched, the shoulder quite upright, the back sometimes long and straight, with good width. The quarters tend to be muscular and the legs short and strong. They are always spotted in color, and stand at approximately 15.2 hh.

Top
The Knabstrup are always spotted in color and, owing to their great stamina, are good all-round horse..

Bottom
The head is small and unusual and there is always sclera present around the eye.

BLOOD TEMPERATURE

USES TEMPERAMENT

Bottom
This is a hardy breed with great strength of endurance; some of the horses exhibit Thoroughbred characteristics.

Kustanair

BREED INFORMATION	
NAME	Kustanair
APPROXIMATE SIZE	15–15.2 hh
COLOR VARIATIONS	Any solid color
PLACE OF ORIGIN	Former U.S.S.R.

THE KUSTANAIR is a relatively young breed that was developed at the state farms and studs in the Kazakhstan region of the former U.S.S.R. The breeding process of the Kustanair was very deliberate, and they were bred to form two distinct types, each being treated in a different manner. The breed developed mainly at three state Studs at Kustanai, Turgai, and Orenburg, which were formally established in 1888, 1887, and 1890, respectively. However, it was the Kustanai Stud that had the earliest and best results and can be credited with establishing the breed, which was officially recognized in 1951.

The basic foundations for the Kustanair were laid by taking the native steppe horses and crossing them with a Don, Kazakh, Strelets (now extinct), Thoroughbred and half-bred blood. Early crosses were fairly unsuccessful, but by using

purposes, and with greater quality and presence, while the second developed into horses suitable for both saddle and harness work – a tougher, hardier, and less quality horse.

The toughness and hardiness of the two types of Kustanair is relative because both types are indeed extremely tough as are many of the Russian breeds. Typically they have great stamina and endurance, combined with a calm, quiet, and energetic disposition, making them highly versatile saddle or harness horses. They are also for the most part attractive and quality animals, some appearing to have more Thoroughbred aspects than others.

In appearance, they have a fine, light head set to a long muscular neck, which is often quite low set. The withers are often prominent, the shoulders sloping, the back straight and wide, and the croup sloping. They are deep and broad through the chest and have long muscular legs with good joints and hard hooves. They vary from chestnut, gray, bay, brown, black or roan in color, and stand at between 15 hh and 15.2 hh.

HORSE FACT:
Sir Charles Bunbury owned the winner of the first Epsom Derby, a horse called Diomed, who sped to victory in 1780. Sir Charles Bunbury tossed a coin with the Earl of Derby to decide who the famous race would be named after – the Earl of Derby won.

improved native mares, and further infusions of Thoroughbred blood, the fixed characteristics of the Kustanair started to emerge. The breed was not selectively bred into different types until the 1920s, when two groups of Kustainair were taken and raised under different conditions. The first were stabled, corn fed, and selectively bred, while the second group were kept at pasture all year around and allowed to breed freely. The results were the formation of a distinct saddle horse type, suitable for all riding

Latvian

BREED INFORMATION

NAME	Latvian
APPROXIMATE SIZE	15–16 hh
COLOR VARIATIONS	Black, bay, brown, occasionally chestnut
PLACE OF ORIGIN	Former U.S.S.R.

THE LATVIAN LIGHT Harness Horse originated in Latvia, former U.S.S.R., in the early 20th century, and can be classified into three distinct types. There is the standard Latvian Light Harness Horse and the lightweight Latvian, both of which will be discussed here; there is also a heavier version which is featured and discussed in Heavy Horse Breeds. It is generally thought that the Latvian Light Harness Horse is an ancient breed descended from the original stock that gave rise to all the heavy draft breeds in Europe. The Latvian has had infusions of Dole Gundbrandsdal, North Swedish Horse, Zemaituka, Finnish Draft, and Oldenburg blood over the years, and these breeds have evolved along similar lines.

Since the 17th century, the Latvian has had infusions of English Thoroughbred, Arab and Oldenburg, and it is this influence that has led to a greater refinement and quality within the breed. The lightweight Latvian has been subjected to greater influence from the Thoroughbred, Arab and Oldenburg than the standard Latvian. Perhaps the greatest influence on the development of the modern Latvian has been the infusions of Hanoverian, Oldenburg and Holstein blood. Between the 1920s and the 1940s, there were large infusions of Oldenburg blood, as 42 Oldenburg mares and 65 Oldenburg stallions were imported from the Groningen stud in Holland. Both the lightweight and the standard Latvian make excellent riding horses, and are also able to carry out some light draft work, although since the 1960s, there has been more emphasis on breeding the lightweight Latvian as competitive riding has become more popular. The modern Latvian, which are still periodically improved by Oldenburg, Hanoverian, and Thoroughbred blood, make first-class jumping and dressage horses. In general, the Latvian has a calm and willing temperament and is a powerful animal with good endurance.

In appearance, they are a middleweight stamp of riding horses with a rather large head set to a muscular, but elegant neck. The shoulders should be nicely sloping and powerful, the chest broad and deep, the back straight and well proportioned, muscular hindquarters, and short, strong legs with good joints and hard hooves. Conformational faults they may have are cowhocks and a tendency toward ringbone. They can be black, bay, brown, and occasionally chestnut in color, and stand at between 15 hh and 16 hh.

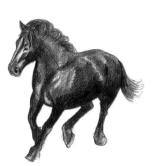

Top
There are three types of Latvian: standard, which is a heavy horse, light harness and also light-weight.

Bottom
The horses vary in color between black, bay, brown or sometimes even chestnut.

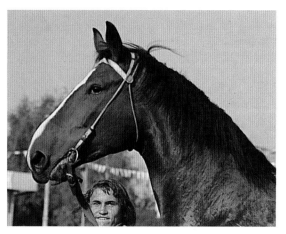

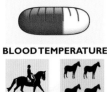

BLOOD TEMPERATURE

USES TEMPERAMENT

Lipizzaner

○○○○○○○○○○○○○○○○○○○○○○○○

BREED INFORMATION

NAME	Lipizzaner
APPROXIMATE SIZE	15.1–16.2
COLOR VARIATIONS	Mostly gray, occasionally bay
PLACE OF ORIGIN	Slovenia

THE LIPIZZANER TAKES its name from the Lipica stud in Slovenia where the breed originated. The stud was founded in 1580 by Charles II, who imported nine stallions and 24 mares from the Iberian Peninsular, to create a showy, predominantly white horse for the ducal stables at Graz and the court stables in Vienna.

The famous Spanish school was founded in 1572 to teach the nobility and was so called because it used Spanish horses. There have also been infusions of Neopolitan blood, Arab, Danish, and German, and some Thoroughbred, although the introduction of Thoroughbred to the breed was not successful.

The Lipizzaner breed is based on six foundation sires, whose lines still exist today. These stallions were Pluto, a gray Spanish stallion, foaled 1765 and bought from the Royal Danish Stud; Conversano, a black Neopolitan stallion, foaled 1767; Neapolitano, a brown Neopolitan stallion, foaled 1790; Favory, a dun stallion, foaled at the Kladruby stud in 1779; Maestoso, a gray stallion, foaled 1819 at the Hungarian stud of Mezohegyes; and Siglavy, a gray Arabian, foaled 1810. Although the Lipizzaner is assumed to be only gray, there were, until the 18th century, Lipizzaners with various coat colors, including dun, spotted, and bay.

They are now bred to be gray, although there is still the occasional bay, and it is a tradition for there to always be one bay Lipizzaner in residence at the Spanish School. The Lipizzaners have been bred for the Spanish School at Pider in Austria since 1920, although they are bred in Hungary, Romania, and the former Czechoslovakia and are often used for light draft and farm work. In general those bred for use on the land tend to be larger than those bred for the Spanish School. The Lipizzaner is a long-lived, intelligent horse, which matures late and is used into its 20s.

They have attractive heads that can show some Arab influence, but in general maintain typical Spanish characteristics. The neck is short and muscular, with flatish withers, a deep chest, sloping shoulders which are suitably conformed for riding or harness, a long back, and rounded quarters with a well-set tail. Their legs are short and muscular, and they usually have good bone. They stand between 15.1 hh and 16.2 hh.

HORSE FACT:
Among the Native American Indians the horse represents love, devotion and loyalty and also symbolizes stamina, strength and power. Artworks often show Shaman riding on a magical horse.

Top and Center
The Lipizzaner is a very striking horse that is used at the famous Spanish Riding School in Vienna.

Bottom
Although the breed is now predominantly white, bays do exist.

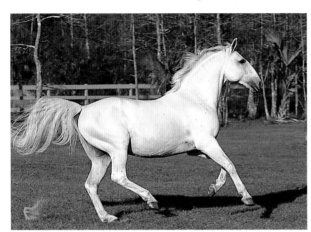

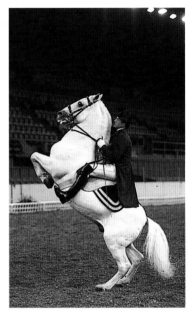

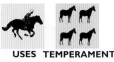

BREED INFORMATION

NAME	Lokai
APPROXIMATE SIZE	14.3 hh
COLOR VARIATIONS	Gray, bay or chestnut, often with metallic sheen
PLACE OF ORIGIN	Former U.S.S.R.

Lokai

BLOOD TEMPERATURE

USES TEMPERAMENT

Bottom
These horses are quite plain and can often have a curly coat like other ancient Russian breeds.

FOUND IN THE REGION OF Tajikistan, Russia, the Lokai falls between the definition of horse and pony. Its height averages 14.3 hh, technically putting it into the horse bracket, but invariably they are smaller than this. Their characteristics tend to be more horselike, especially around the head. They are mountain-bred from Central Asia and are exceptionally strong and sturdy; they can be used for a variety of purposes from being a pack animal, to working the land, or for riding. It is believed that they date back to around the 16th century when the breed was developed by the nomadic Uzbek-Lokai people.

The Lokai was based on the local steppe horses which were improved by infusions of Arab, Karabair and Iomud blood as well as some Akhal-Teke and Turkmene. In recent years, Thoroughbred and Tersk blood has been introduced. They are often kept in herds out at pasture all year round, which has helped develop extremely tough and enduring small horses. They are fairly quick and are regularly performance tested on the racetracks at Dushanbe and Tashkent as youngsters. They are also widely used in the hair-raising game of Kokpar, which requires speed and agility as the riders fight over possession of a dead goat carcass, as well as becoming popular horses for use in endurance riding.

Some Lokai have a particularly curly coat which can be traced to the stallion Farfor, a curly-coated sorrel who was used for breeding from

1955 to 1970. There are currently experimental breeding projects to find out more about the curly coat gene. Generally the Lokai have excellent temperaments being quiet and willing, and also have great stamina and endurance.

In appearance, they have a plain head with a straight profile set to a short and muscular neck. The shoulders are reasonably sloping, with a broad and deep chest, wide withers, a short compact back, and muscular hindquarters. They tend to have strong legs with well-defined tendons, although the legs often have conformational defects such as cowhocks and splayed front feet, which do not appear to unduly affect the horse. They vary in color from chestnut, gray, and bay, to occasionally black or palomino.

HORSE FACT:
Many horse diets can be deficient in salt, so it is a good idea to either feed salt as a supplement or to provide a salt and mineral block that the horse can access.

BLOOD TEMPERATURE

USES TEMPERAMENT

Lusitano

```
○○○○○○○○○○○○○○○○○○○○○○○○○○○○○○
     BREED   INFORMATION
NAME                  Lusitano
APPROXIMATE SIZE      15–16 hh
COLOR VARIATIONS      Gray, bay or chestnut
PLACE OF ORIGIN       Portugal
```

THE LUSITANO derives its name from the word *lusitania* which is the Latin word for Portugal, their country of origin. The Lusitano is an Iberian or Spanish horse, and is extremely similar to the Andalusian and other breeds of Spanish horse.

They have, in fact, only been called the Lusitano since 1966. Both the Lusitano and Andalusian developed from the same genetic background and have large percentages of both Barb and Sorraia blood. The two breeds do, however, have some notable conformational differences which are especially seen in the head.

The Lusitano has a pronounced Roman nose, and great width across the forehead, while the Andalusian has a more oriental head shape, with a straighter profile. This developed through infusions of Arab blood into the Andalusian, and for this reason, many consider the Lusitano to be a purer breed. The Lusitano has a more sloping croup and a lower-set tail than the Andalusian, and is often straighter through the shoulder. The Lusitano is highly prized in Portugal, and is especially valued as the mount of the *rejoneador*, the bullfighter. Portugal has a very active bullfighting circuit, where the bulls are not killed in the ring, and the Lusitano is used due to its agility, speed, and extremely calm temperament. They need to be expertly manoeuvred to prevent injury by the bulls and if a *rejoneador* allows his horse to be injured it is considered a great disgrace.

The Lusitano was originally developed for military use and as a carriage horse. Now, they are growing in popularity throughout Europe and America and increasingly are used for pleasure riding and dressage, as well as for farm work and light draft work in Portugal. They are a universally excellent riding horse, possessing a quite remarkably calm and unflappable temperament. Typically the Lusitano have great poise and balance, they are intelligent, sensible, frugal, and brave.

In appearance, they have an attractive head with a Spanish profile, a short, thick neck, powerful quite upright shoulders, a broad chest, a short, compact back with well-sprung ribs, muscular quarters, and strong long legs. They are an extremely strong and powerful horse. They can be gray, bay, or chestnut in color, and stand at between 15 hh and 16 hh.

Top Right and Left
The Lusitano is a handsome breed that resembles other Spanish horses, such as the Andalusian, closely.

Bottom
The breed has a long, flowing mane and a handsome head.

Malapolski

BREED INFORMATION

NAME	Malapolski
APPROXIMATE SIZE	15.2–16.2 hh
COLOR VARIATIONS	Bay, brown, chestnut, black, or gray
PLACE OF ORIGIN	Poland

BLOOD TEMPERATURE

USES TEMPERAMENT

THE MALAPOLSKI IS A fairly recent breed that evolved in Poland during the 19th century and could also be described as a half-bred Anglo-Arab. The breed was developed through a combination of oriental blood, Arab, Anglo-Arab, Shagya, and Gidran with some Thoroughbred, Furioso, Austrian Hungarian half-bred, and Przedswit, which is a type of Thoroughbred half-bred. There are two main strains of Malapolski which have developed: firstly, the Sadecki which has been chiefly influenced by infusions of Furioso blood; and secondly, the Darbowsko-Tarnowksi, which has been influenced by infusions of Gidran blood.

To further complicate matters, the Malapolski can vary quite considerably from region to region and, as a breed, exhibits a wide range of differing physical aspects! The Malapolski also has similarities to another Polish breed – the Wielkopolski – but the Wielkopolski generally has more conforming physical characteristics. The Malapolski is quite a common horse in Poland and is bred at five state stud farms at Stubno, Prudnik, Udorz, Walewice, and Janow Podlaski, as well as being widely bred by individuals in the southeastern and central areas of Poland.

In general, the Malapolksi is an excellent all-round versatile horse. They are still widely used in Poland for agricultural purposes and light draft, as well riding, and make very good farm horses. They are fairly athletic and are increasingly used as competition horses, having a good natural jump and a bold demeanor. They have been successfully steeplechased and are fast and agile. The Malapolski has a very good temperament, being both calm and willing, but energetic when required. They also usually have good basic conformation and nice smooth paces, making them a comfortable riding horse.

In appearance, they are a classy, quality-looking horse with an attractive and well-proportioned head. The neck is muscular, well formed, and gently curves from the withers to the poll. They have a longish back, with a nicely rounded barrel, and sloping shoulders. They are broad and deep through the chest and have a slightly sloping, muscular croup. They tend to have long, muscular legs and hard naturally well-formed hooves. Usually they are brown, bay, chestnut, black or gray in color, and stand between 15.2 hh and 16.2 hh.

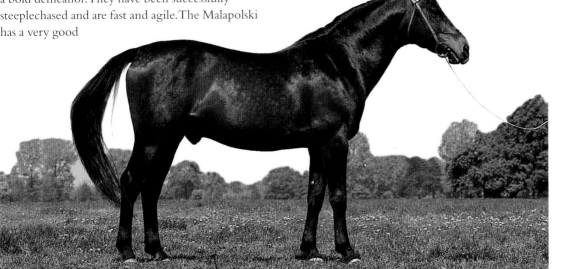

Top
This is a very versatile horse that has been used for farm and draft work as well as riding.

Bottom
The Malapolski is a good looking horse with good conformation, showing well-sloped shoulders and long legs.

331

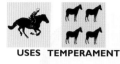

BLOOD TEMPERATURE

USES TEMPERAMENT

Mangalarga Marchador

○ ○

BREED INFORMATION

NAME	Mangalarga Marchador
APPROXIMATE SIZE	14.2–15 hh
COLOR VARIATIONS	Any solid color
PLACE OF ORIGIN	Brazil

THE MANGALARGA MARCHADOR is one of the unique breeds of horse in the world, originating in Brazil in the 1740s. A Portuguese man, João Francisco, moved to an area in Brazil south of Minas during the 1740s and formed the *hacienda* Campo Alegre. One of João's sons, the Baron of Alfenas, was presented with an Alter-Real stallion called Sublime by Dom Pedro I, Emperor of Brazil (1798–1834), which became one of the foundation sires.

Sublime was mated with mostly Spanish Jennet mares, and also with some Criollo and Andalusian mares. This formed the base for the Mangalarga Marchador, which were originally called Sublime Horses. The Mangalarga Marchador are important because they exhibit many of the traits of the Spanish Jennet, which is sadly extinct. One of these traits is a very smooth action – the Mangalarga Marchador appears to move across the ground with ease and balance, and is said to be one of the most comfortable horses to ride. They have peculiar gaits called the *marcha*

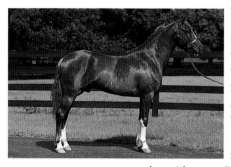

batida and the *marcha picada*, both of which are four-beat gaits allowing the horse to cover a huge amount of ground in a short time. Interestingly, the Mangalarga Marchador do not trot but move from their fast marching gait into a smooth canter.

These horses have become extremely popular in Brazil and are widely used for working cattle, for which they have a natural talent. They are very versatile, and can be used for most riding pursuits including endurance and cross-country. They also have remarkable temperaments, being very calm and kind, so much so, that they are suitable for children and novices, but can also be lively and energetic when necessary.

In appearance, the Mangalarga Marchador is an attractive lightweight horse with notable Spanish characteristics. They have a very attractive fine head with a straight profile, intelligent eyes, and ears with in-turned tips. The neck is elegant, muscular and gently curved from the withers to the poll. The withers are prominent, the chest is deep, the back is proportionate to the body and the quarters are muscular. They have a slightly sloping croup and good sloping shoulders. The legs are strong, muscular and powerful with good joints and hard feet. They can be any solid color, and stand between 14.2 hh and 15 hh.

Top
This horse is very smart in appearance, with strong legs and hard feet.

Bottom
This breed is commonly used on Brazilian ranches by the cowboys to work the cattle.

Marwari

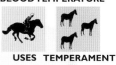

BLOOD TEMPERATURE

USES TEMPERAMENT

THE MARWARI IS AN ancient breed which, despite its small height, should not be classed as a pony breed. They evolved in the state of Marwari, and possibly in the northwest of India bordering Afghanistan. Their exact origins are not certain but it must have developed along similar lines to its neighbour the Kathiawari and it has a high percentage of Arabian blood. The Marwari also has similarities to the old Turkmenian breed.

The Marwari became the warrior horse for the Rathores, who were rulers of Marwar, and were using selective breeding as early as the 12th century. They were considered the finest horses for centuries and were highly prized. It was said that the Marwari horse, even if injured during battle, would not fall down until it had carried its rider to safety. It was also said that they would stand guard over their riders if they fell off or were injured during battle. Many legends surround the exploits of the Marwari horse and all of them demonstrate its inordinate bravery and loyalty. During the reign of the Moghul Emperor, Akbar (1542–1605), the indomitable Rajput warriors formed the Imperial Cavalry, employing over 50,000 horses, the vast majority of which were the Marwari.

They remained popular for many years and were even used during the First World War, before falling into decline. By 1930, the breed was nearly extinct and was only saved by the efforts of Maharaja Umaid Singhji, who bought some good Marwari stallions and sent them to breed with the best Marwari mares he could find. Numbers have since partially recovered and there is an ongoing effort by the Indian government and the enthusiastic Marwari Breeders Association to preserve them.

In appearance, the Marwari is quite distinctive and is a noble-looking horse of some quality. They have a slightly heavy head, topped by extremely in-turned ears that are a hallmark of the breed. They are generally well built and strong, with a muscular neck of good length. The back is compact and there is good depth through the girth. The shoulders are reasonably sloping and the chest is deep. The hindquarters are muscular, and the legs strong, and tough with dense bone and hard feet. They are occasionally cowhocked. They range in color from bay, brown, chestnut, and pinto, and are generally under 14.3 hh.

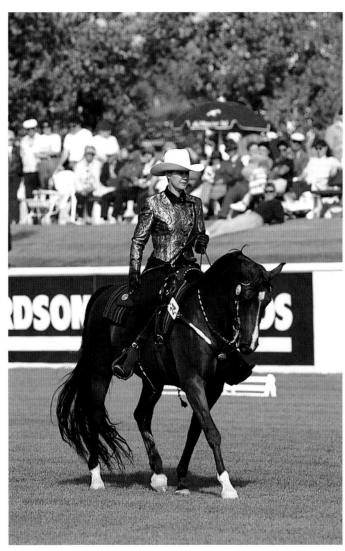

HORSE FACT:
BHS, stands for the British Horse Society, the UK's largest and most influential equestrian charity. The BHS aims to improve the quality of life of horses, and provides endless equestrian information and help to its members. The BHS relies on financial support from its members and from other donations.

Left
This is a distinctive, noble-looking horse with a high percentage of Arab blood.

BLOOD TEMPERATURE

USES TEMPERAMENT

Maremmana

○○○○○○○○○○○○○○○○○○○○○○○○○

BREED INFORMATION

NAME:	Maremmana
APPROXIMATE SIZE:	15–15.3 hh
COLOR VARIATIONS	Any solid color, often black
PLACE OF ORIGIN	Italy

THE MAREMMANA has a rather vague background but it is generally considered that the breed is based on early stock that came

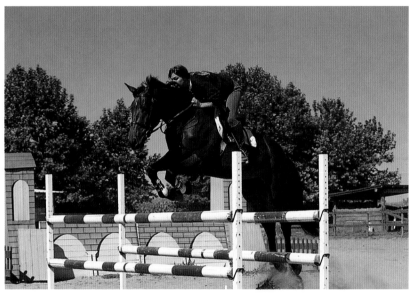

from North Africa, combined with Spanish, Barb, Neopolitan and Arabian blood. During the 19th century the breed was exposed to infiltrations of Thoroughbred blood and also probably Norfolk Roadster and some half-bred stallions. By the end of the 19th century, the Maremmana features had become fixed although it was not until 1980 that the breed's studbook was opened.

They are mainly bred in the northern regions of Maremma in Tuscany and were really established through the efforts of the stud at Grosseto, although there are still herds of Maremmana being bred in a semiwild state in some local areas. It is likely

Top

The Maremmana is of quite mixed blood, with Arab and Barb blood as well as Spanish.

Bottom

The horses are bred in the rugged Maremma region found in Northern Tuscany.

that they were originally developed for agricultural use and would have been used to work the land, as well as working in harness. They were also employed by the cavalry as troop horses and have often been used by the police force. The Maremmana excels at working cattle. They are frequently used by the Italian ranch hands and cowboys, known as *butteri*, and demonstrate an enormous amount of 'cow sense,' similar to that seen in the American Quarter Horse. 'Cow sense' is probably best described as the horse's natural instinct to follow and herd cows.

The Maremmana is a naturally highly athletic and agile animal, and is known for its considerable jumping ability. A Maremmana horse called Ursus del Laseo won the Italian Jumping Championships in 1977; they are today frequently crossed with Thoroughbreds to produce jumping horses. The Maremmana is typically an extremely tough and hardy animal with good stamina and endurance. They are resistant to fatigue and seemingly have a very sound constitution. They are also economical to keep, being frugal feeders, and in spite of quite haphazard breeding polices within the breed, they do tend

to be versatile and steady in character, which makes up for their less than perfect conformation.

Generally they have a long and rather heavy head, a good muscular neck, prominent withers, full chest with slightly sloping shoulders, a short straight back, sloping quarters, and solid legs. Usually any solid color, they stand at between 15 hh and 15.3 hh.

Missouri Fox Trotting Horse

BLOOD TEMPERATURE

USES TEMPERAMENT

THE MISSOURI FOX TROTTING HORSE originated in the Ozark mountains in Arkansas and Missouri, America, during the 1820s and, as such, is one of America's oldest breeds of horse. When Missouri officially became a State in 1821, many people started to move there from Tennessee, Kentucky and Virginia and they took with them their various saddle horses. It is likely that the breed arose through a combination of Spanish, Barb, Morgan, Arab and Thoroughbred blood, and it is known that an early breeding policy was instigated to use horses which had reached fast running speeds.

Several of the early settlers in the Ozark region were instrumental in developing the type that was to become the Missouri Fox Trotter and among these were the Alsups. The Alsups became famous for their horses which were all related to the Thoroughbred racing stallion, Brimmer, and consequently became known as Brimmers.

Another influential stallion on the development of the breed was Old Skip, who was a Morgan and Thoroughbred cross, as well as two Saddlebred stallions, Chief and Cotham Dare, who are also credited with the early development of the breed.

It is likely that the initial breeding of the Missouri Fox Trotter was based largely on producing horses for racing which was a popular pastime, until it was deemed irreligious. Attention was then focused on producing a horse suitable for traveling long distances and being comfortable to ride over the surrounding rough landscape.

One of the most distinguishing features of the Fox Trotter is its gaited fox trot, which allows it to travel with a particularly smooth and comfortable stride. They are horses with great endurance and stamina, resisting fatigue to a much greater degree than many other breeds. The fox trot is a gait where the horse walks in the front and has a sliding trot action behind. This creates little movement through the back making them extremely comfortable to ride and capable of traveling long

distances at speed. Over a long distance, the Fox Trotter can maintain speeds of approximately 7 mph, while over shorter distances this will increase to approximately 10 mph. This gaited movement is accompanied by an up and down head nodding and a rhythmic

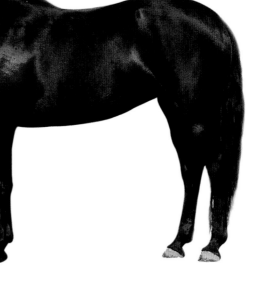

Top
This horse can maintain its unusual gait for long distances, traveling over rugged terrain.

Bottom
The horse comes from the Ozark mountains in Missouri and may have originally been bred for racing.

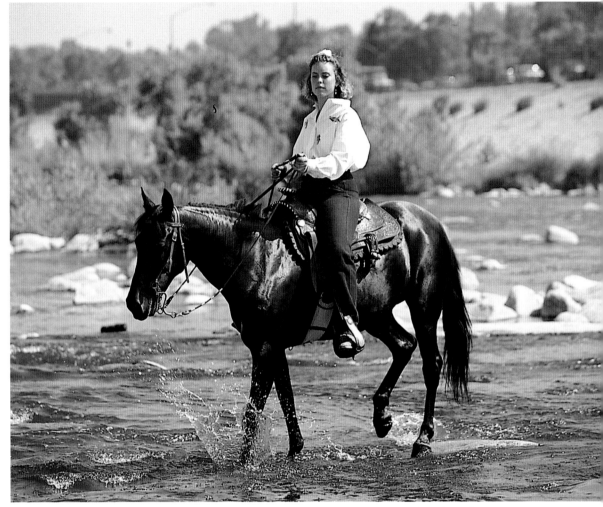

Top

The Fox Trotter has five gaits but they are not as high-stepping as the Tennessee Walker or the American Saddlebred.

tail bobbing. The Fox Trotter's other gaits are a four-beat walk, called the flat foot walk, in which the hind feet overtrack the front feet, and a very smooth canter. The paces of the Fox Trotter do not include the flashy, extravagant, high-stepping style of the Saddlebred or Tennessee Walker.

There are many shows for the Fox Trotter, but unlike other gaited breeds, the Fox Trotter is not allowed to have any artificial measures to accentuate its action such as excessively weighted shoes or show signs of having had chains round their fetlocks. They also have a natural tail set and are not allowed to be nicked. In the show ring, they are judged primarily on the quality of their fox trot stride, with other marks being awarded for the walk, canter, and conformation. Aside from the show ring, the Fox Trotter is popular throughout the States as a pleasure horse for trial riding and endurance riding, and is also an excellent 'cow' horse. In fact, when many breeds of horse suffered due to the advent of mechanization, the Fox Trotter probably survived due to the continued support and breeding by cattle men and ranchers, who recognized the breed's importance.

One of the early influential sires on the breed was Old Fox who spent most of his adult life working cows in Southern Missouri at the beginning of the 20th century. The breed was officially recognized in 1948 with the formation of its studbook, which was closed in 1982, so that only horses with both parents already registered could be registered. This keeps the breed more true to its original characteristics.

The Fox Trotter has an excellent temperament being quiet, amenable, intelligent and energetic when required and is frequently ridden by children and novices. In appearance, they are attractively put together, with good basic conformation. Generally they have a well-proportioned head with a straight profile and lively eyes and a muscular neck set onto very powerful sloping shoulders. They should be deep chested, compact through the back, and have very muscular and powerful quarters and legs. Usually they are chestnut in color, although can be any color, and stand between 14.2 hh and 16.2 hh.

Morab

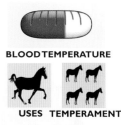

BLOOD TEMPERATURE

USES **TEMPERAMENT**

THIS BREED DEVELOPED around the early 1800s and is based on a cross between a Morgan and an Arab, rather as the breed name suggests, although it is likely that there were early influences of American Quarter Horse too.

The International Morab Registry (IMR) was not actually formed until 1992. One of the foundation sires was Golddust who foaled in 1855. Golddust was the progeny of the Morgan stallion Vermont Morgan and an Arab mare, who was the daughter of the Arab stallion Zilcaddie. Golddust was famous both as a flat-footed walker and a trotting stallion. He is reputed to have been unbeaten in the showring and at the racetrack, and famously, in 1861, beat Iron Duke for the huge sum of $10,000. Golddust was killed during the Civil War but not before he had sired 302 foals, 44 of which went on to become notable trotting horses. Today over 100 Morab horses can be traced back to Golddust.

The next major event in Morab history was not until the 1920s, and was spearheaded by William Randolph Hearst, who is credited with giving the Morab its name. Hearst had a highly acclaimed herd of Arabs which included the stallions Ghazi, Gulastra, Joon, Ksar, Sabab, and Rahas, and he used these on various Morgan mares. He also bought the Morgan stallion, Moncrest Sellman, and used him for crossbreeding with both Morab and Arab mares. Another notable Morab breeding program was run by the Swenson brothers at their Texas ranch during the 1920s, 30s and 40s. Their Morabs were particularly prized as cutting horses – one famous one being the gelding Rey Boy, foaled in 1943. Recently, the Morab has enjoyed an increased popularity and make very good riding horses. They have good temperaments and are easy going, calm, and friendly.

In appearance, they have fine heads with a straight or concave profile. They are muscular through the neck which is of good length, have nicely sloping shoulders, a deep chest, a short compact back, and a muscular croup. The tail is set and carried high, and the legs are generally strong, powerful and sound. They can be any color, as long as they do not display spots, and stand between 14.1 hh and 15.2 hh.

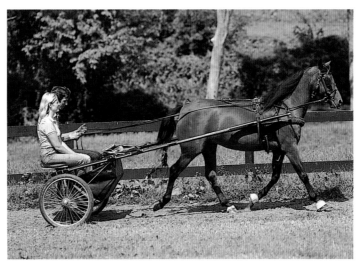

Top
The Morab has an attractive head with a concave profile like that of an Arab.

Bottom
The horse is suitable for light draft and harness work as well as trotting.

BLOOD TEMPERATURE

USES TEMPERAMENT

Morgan

○○○○○○○○○○○○○○○○○○○○○○○○○○○○
BREED INFORMATION

NAME	Morgan
APPROXIMATE SIZE	14.2–15.2 hh
COLOR VARIATIONS	Any solid color
PLACE OF ORIGIN	United States

THE MORGAN HORSE is possibly one of the most important American breeds of horse having influenced many other breeds, most notably the Tennessee Walker, Standardbred, and Saddlebred. The Morgan horse had a quite remarkable beginning and can be traced to just one incredible stallion. That stallion was called Figure; later renamed Justin Morgan after one of his owners. There are very few facts surviving about the origins of this amazing horse, but there are various theories. He is believed have been sired by the early Thoroughbred type, True Briton, while also of Arab blood, others suggest he may have been sired by a Friesian stallion, or, as the leading authority Anthony Dent proposes, by a Welsh Cob stallion. Justin Morgan had physical similarities to the Welsh Cob, while probably also containing some degree of both Arab and Thoroughbred.

Whatever his origins, Justin Morgan stamped all his progeny with his own characteristics, and virtually single-handedly gave rise to a new breed. He foaled around 1793 in Springfield, Massachusetts, and was given, as a two-year-old, to a man called Justin Morgan. Figure, as the horse was known at first, was a small bay colt, standing at only 14 hh. Justin Morgan was sceptical

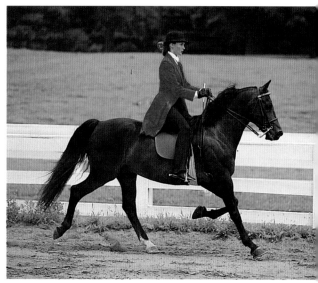

about the small horse but he quickly proved his remarkable talents at everything he was asked to do. In fact, throughout his career, he was unbeaten in saddle and harness races, and in weight pulling contests. He became extremely popular as a sire and was also worked extremely hard throughout his life. After his owner died, he was renamed Justin Morgan and went on to leave his own distinctive mark on all his progeny which became the Morgan horse breed.

Incredibly strong with great stamina, bravery and intelligence, the Morgan horse is widely used for leisure riding all over America. They have an attractive head set onto an arched and muscular neck, the shoulders are very powerful, the chest broad, and the back wide and short. The croup is often long and rounded, with a well-set tail. They have solid, strong legs that are short in the cannon, with well-made joints. The Morgan has a characteristic stance, with the front end thrust forward and the hind legs straight out behind. Any solid color is permissible, and they stand between 14.2 hh and 15.2 hh.

Top
This remarkable horse is one of the most important American breeds; they are strong, brave and versatile.

Bottom
The Morgan has a distinctive stance, with the hind legs pushed out behind them.

BREED INFORMATION

NAME	Murghese
APPROXIMATE SIZE	15–16 hh
COLOR VARIATIONS	Mostly black
PLACE OF ORIGIN	Italy

Murghese

BLOOD TEMPERATURE

USES TEMPERAMENT

Top

There is some confusion about the origins of this breed, but they may be influenced by Arab, Barb and Neopolitan stock.

Bottom

The horses have a bluff, pronounced Roman nose and a strong head.

THE MURGHESE, also known as the Murge Horse, originated in the Murge region of Southeast Italy, and dates back to the time of Spanish rule there. There is some mystery surrounding the exact heritage of the Murghese, but it is likely that the breed evolved through a combination of Neopolitan, Barb, and Arab stock, with some infusion of Avelignese, and possibly Italian Heavy Draft blood. The breed has had a rather chequered history, becoming extremely popular during the 15th and 16th centuries, especially for use by the cavalry, but then falling into a decline and becoming virtually extinct. The modern Murghese was established during the 1920s and quite possibly has evolved as a more refined type than the original Murghese.

Until 1926 there was quite a diversity of physical characteristics within the breed due to a lack of any special programs, but 1926 saw the beginnings of selective breeding at what is now known as the Regional Institute for Equine Increase. The three foundation sires used were – Nerone, Granduca, and Araldo delle Murge – which formed the principal three bloodlines. The Murghese is a versatile light draft and riding horse, which was, and still is, a popular farm horse, able to carry out the principal chores around a smallholding. They have a willing and lively temperament and are tough and hardy. Many Murghese horses are raised in a semiwild state in the forests of Murge, living out all year round and foraging for themselves. This has made them extremely enduring and seemingly resistant to many equine diseases. They are becoming increasingly popular as riding horses, and are suitable for trekking and novices due to their

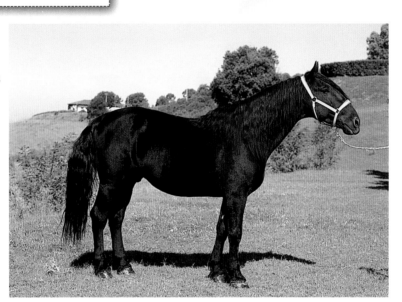

calm and forgiving nature. They are often used as a base to breed better riding stock, by crossing with Thoroughbreds or similar quality breeds.

In appearance, they tend to have a Roman nose, with a prominent jaw line and small ears. The neck is muscular with a full mane, the chest broad and deep, the shoulder quite sloping, the back short, and occasionally hollow, and the quarters sloping and sometimes under-developed. The legs can be light of bone, with the joints often small, although they are strong. Generally black in color, they stand at between 15 hh and 16 hh.

HORSE FACT:

The bridle and the bit was developed before the saddle and stirrups. Most riding was performed bareback until the Middle Ages.

BLOOD TEMPERATURE

USES TEMPERAMENT

Mustang

BREED INFORMATION	
NAME	Mustang
APPROXIMATE SIZE	14–5 hh
COLOR VARIATIONS	Any color
PLACE OF ORIGIN	United States

MUSTANG is the name given to the feral horses of America which first appeared during the 16th century. They are descended from the Spanish horses brought to America by the conquistadores. At that time, a quantity of horses escaped, or were released, and these joined together creating herds of feral horses. The name Mustang derives from the word *mesteth*, which means 'band or herd of horses.'

Throughout the centuries horses of various breed and type have either been released, or have escaped, into the wild and these would naturally form herds together. There is evidence of a heavier type that probably developed from early artillery and coach horses which escaped during battle and it is thought that these may have derived from the East Friesian Horse, known to have been popular with the military. At one time they existed in huge numbers to the point that they were damaging grazing land for domestic animals. There ensued a haphazard system of hunting with the Mustang being killed and used for pet food, or for human consumption. The widespread and indiscriminate killing led to a great reduction in their numbers and it was not until 1971 that any regulations were actually laid down regarding the culling.

They now enjoy federal protection and their welfare is over seen by the B.L.M. – Bureau of Land Management. In 1973, a controversial 'Adopt a Horse' programme was begun, which is thought by many to have helped manage numbers of the Mustang. It is considered that the general standard of the Mustang is improving through the B.L.M.'s management, by weeding out the poorer stallions and allowing the better specimens to remain.

There is a wide diversity of physical characteristics through the nature of their feral existence but many Mustangs still exhibit characteristics of the original Spanish horses. As a guide, Mustangs will often have a Spanish type head with a Roman nose; they are usually short through the neck, somewhat upright in the shoulder, flat through the withers, have a short back, and poorly conformed, but very tough legs. As with any feral animal, their temperament is rebellious and intractable although with experienced handling many Mustangs are tamed to become good riding horses. Their height ranges from 14 hh to 15 hh, and they can be any color.

Top
This name applies to the feral horse in the United States, which are given official protection.

Bottom
The features of the mustang are diverse, but the influence of the Spanish Horse can be seen in some cases.

BREED INFORMATION	
NAME	Nonius
APPROXIMATE SIZE	14.3–16.2 hh
COLOR VARIATIONS	Bay or brown
PLACE OF ORIGIN	Hungary

Nonius

BLOOD TEMPERATURE

USES TEMPERAMENT

HORSE FACT:
Mounted horsemen first competed in the Olympic Games in 648 B.C., the 33rd Olympic Games.

THE NONIUS BREED developed in Hungary during the early 19th century. The breed takes its name from the sire, Nonius Senior, who foaled in Normandy in 1810 and was taken by the Hungarian cavalry in 1813 after the defeat of Napoleon at Leipzig. Nonius Senior went to the prestigious Hungarian Stud Farm of Mezohegyes where he stood for the next 22 years, during which time the Nonius breed was established. Nonius Senior was sired by a stallion called Orion, who is known to have been an English half-bred; it is thought he had some Norfolk Roadster connections and his dam was a Norman mare. It is documented that Nonius Senior was not a particularly well-conformed, or attractive, stallion, traits that he luckily did not pass on to his progeny. It does seem strange, however, that a poor-looking stallion was used as a primary stud at the great Mezohegyes. Nonius Senior was put to a wide variety of different mares, including Andalusian, Arab, Norman, Kladruber, and English half-breds.

Later in the development of the breed, the English Thoroughbred was used to further improve the stock both from a physical aspect and in terms of ability. Nonius Senior was a prolific stallion who went on to sire 15 excellent stallions, including Nonius IX, who in turn were instrumental in fixing the breed characteristics. The Nonius breed developed into two strains: a heavier larger type, suitable for light draft and farm work, as well as being a riding horse; and a smaller lighter strain, more suited to pure riding work.

Recently very successful crosses have been made using Nonius mares and English Thoroughbred stallions to produce first-rate competition and sports horses. The Nonius is strong and tough, with an amenable and lively temperament. They tend to make useful all-around riding horses, and are generally well built and sound.

In appearance, the Nonius has a long head with a straight or convex profile; the neck is muscular, and arched in the stallions. The shoulders are powerful, but can be rather straight, the withers are often wide and rounded, and the back too is wide and quite long. They are wide and deep through the chest, and the legs solid and muscular. They are nearly always bay or brown, and their height varies from between 14.3 hh and 16.2 hh.

Bottom
The bloodline of the Nonius was improved by the introduction of the Thoroughbred.

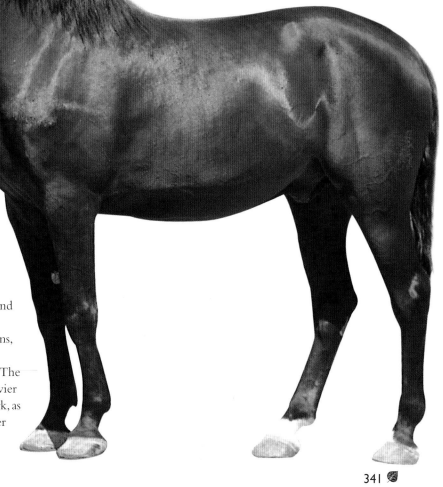

BLOOD TEMPERATURE

USES TEMPERAMENT

Novokirghiz

○○○○○○○○○○○○○○○○○○○○○○○○○○○○○

BREED INFORMATION

NAME	Novokirghiz
APPROXIMATE SIZE	14–15 hh
COLOR VARIATIONS	Bay, brown, gray, or chestnut
PLACE OF ORIGIN	Former U.S.S.R.

THE NOVOKIRGHIZ is a relatively new breed that developed in the 1930s in Kirghizia and which has largely replaced the Old Kirghiz breed from which it evolved. The Old Kirghiz was a

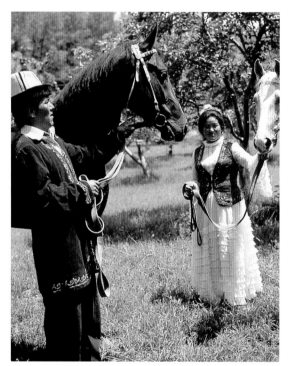

mountain breed from the high altitude areas of Kirghizia and Kazakhstan and had descended largely from Mongolian stock. The Novokirghiz has developed as a more refined and faster breed, mainly due to combinations of English Thoroughbred, Don, and half-bred Anglo/Don blood, crossed with the Old Kirghiz. By 1918, 48 Thoroughbreds had been imported to the stud of Issyk-Kul and were being bred with Old Kirghiz mares. During the 1930s and 1940s, the breed characteristics became fixed by repeated crossbreeding between Old Kirghiz, Thoroughbred, and Don, and interbreeding the best of the progeny. Three different types emerged: basic, massive, and saddle. The massive type was the most successful and the most versatile and well adapted to its environment.

They are typically tough and useful in harness, for riding, or for agricultural work. They are stout and strong and are also frequently used for pack purposes in the mountains. The basic and saddle types lacked in stamina and endurance and were less able to cope with the mountain climate. Now the three types are less distinct and there is more of a single improved type. Characteristically they are very tough and strong and are able to cope with any kind of terrain. They have great stamina and endurance, as well as having an amenable and energetic temperament, and are used as riding horses as well as for light draft and pack work. The Novokirghiz mares are used for milk production which is turned into a fermented drink koumiss, which is a major part of the local people's diet. Interestingly, the mares are fairly infertile, which has been attributed to too much Thoroughbred blood being introduced to the breed.

In appearance, they should have a small neat head, a muscular well-formed neck, good sloping shoulders, a well-developed chest, pronounced withers, a longish back, and sloping quarters. Usually they have short legs that are very strong and muscular, although they often exhibit sickle hocks. They are mostly bay, brown, gray, or chestnut in color, and stand between 14 hh and 15 hh.

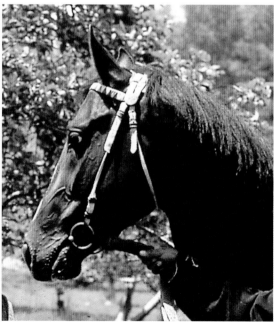

Top
This breed is relatively new, as new blood was introduced in to the stock in the 1930s.

Bottom
The horse has a neat, small head with a muscular neck and well-sloping shoulders.

Oldenburgh

BLOOD TEMPERATURE

USES TEMPERAMENT

THE OLDENBURGH has changed in appearance quite considerably since its early development in Germany during the 17th century. Count Anton Gunther, who ruled as the Count of Oldenburgh from 1603 to 1667, is largely credited with the development of the breed. His original aim was to produce a large carriage horse of quality, which was also able to work in an agricultural capacity. Gunther established stud farms in the Geest regions and also built the royal stables and riding school at Rastede. He began to import Spanish and Neopolitan horses and used these to cross with the East Friesian. One important stallion influential in the early development of the breed was the gray Kranich, who was descended from good Spanish lines.

It is likely that the early Oldenburgh was similar to the Kladruber horse which had developed in the 16th century. The early Oldenburgh would have been quite heavy-framed and somewhat coarse in appearance, and is documented as having a pronounced Roman nose. It was not until the late 18th century that there was any effort made to improve the quality of the Oldenburgh, but then began the introduction of Barb, half-bred, and Thoroughbred type blood, which would also have contained a large percentage of the indomitable Norfolk Roadster.

During the second half of the 19th century, the Oldenburgh acheived some popularity, particularly with the military, who used them as cavalry horses, and also with the postal

service who used the Oldenburgh for drawing the mail coaches.

At this time, the Oldenburgh was still a middle- to heavyweight horse and with a conformation very much in character with a light draft animal. In 1897, some English Thoroughbred blood was introduced, some of which is believed to trace back to the famous Eclipse, and around this time Cleveland Bay stallions were used.

The Cleveland Bay was a notable carriage horse of the time and also extremely useful as a riding horse with a good natural jump, which can only have improved the Oldenburgh stock. There were infusions of Hanoverian blood and use was made of the Norman Horse, most notably the stallion Normann. The Oldenburgh was used during the First World War by the cavalry but during the war, the breed suffered great losses.

Afterwards, the Oldenburgh was once again chiefly employed for harness and agricultural purposes, and it was

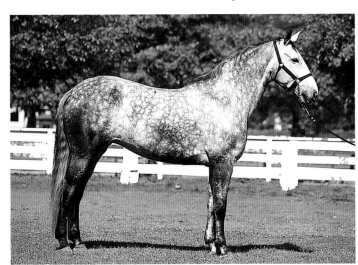

Top
The Oldenburgh was used extensively during the First World War and suffered heavy losses.

Bottom
This breed can be a variety of colors, including gray.

HORSE FACT:
The famous jockey
Bob Champion won
the 1981 Grand
National steeplechase
after recovering from
cancer. He was riding
Aldaniti who had
recovered from a
serious leg injury.

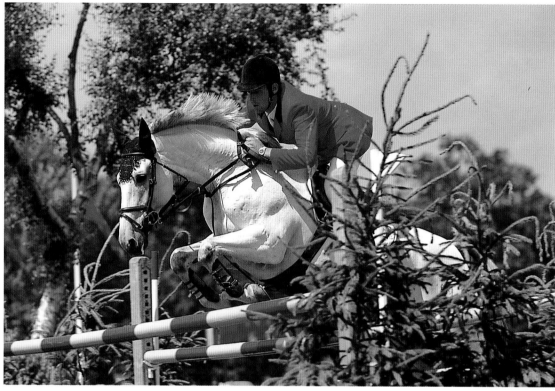

not until after the Second World War that there were further efforts to lighten and improve the breed. With the advent of mechanization and motor vehicles, the breed again fell into decline and it was at this point that the 'New Oldenburgh' was established to prevent the breed from disappearing altogether. It was realized by the Oldenburgh enthusiasts that it was necessary to focus breeding on the production of a versatile riding horse. To this end, there were further infusions of Thoroughbred blood, most notably from the stallion Lupus, and more Norman blood, especially from the stallion Condor, who had a high percentage of Thoroughbred blood in him. In order to prevent the Thoroughbred characteristics, namely their excitable temperament, from dominating, there was the continued use of Hanoverian blood, which helped to maintain the excellent Oldenburgh nature.

The Oldenburgh of today is a versatile, quality horse suitable for competitive work, especially in the dressage and show jumping worlds, as well as being popular within the competitive driving world. Originally the Oldenburgh would have had quite a high knee action in line with their role as a carriage horse, and this action, and the conformation of their

shoulder, has subtly changed through the years. They do, however, still retain a fairly high action but this in no way detracts from their use for either dressage or more importantly show jumping. The Oldenburgh is not noted for its speed, although the Thoroughbred blood in them has improved this somewhat. They are impressive and attractive, long-lived, early developers, and possessed of a calm but energetic temperament.

They are powerfully built and still retain a fairly massive body structure. They have quality heads, which occasionally exhibit a convex profile, and have large, kind eyes. The neck is of good length and muscular, and set to very powerful shoulders. They are broad and deep through the chest and are deep through the barrel which is rounded. The back is often quite long and the quarters very muscular, with a well-set tail. They have strong, solid legs, with good bone and excellent hooves. They are mostly bay, brown, black, or gray in color, and stand at between 16.2 hh and 17.2 hh.

Top
These are versatile horses which make good competitive jumpers as well as good hacks.

Bottom
The horses have good strong heads, sometimes with a convex profile.

BREED INFORMATION

NAME	Orlov Trotter
APPROXIMATE SIZE	16 hh
COLOR VARIATIONS	Mostly gray, can be bay, black, or chestnut
PLACE OF ORIGIN	Former U.S.S.R.

Orlov Trotter

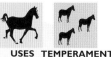

BLOOD TEMPERATURE

USES TEMPERAMENT

THE DEVELOPMENT of the Orlov Trotter can be attributed to Count Alexei Orlov at his Khrenov Stud, which he established in 1788. Due to the Count's part in the conspiracy to overthrow Peter III and win the Russian throne for the Tsarina Catherine the Great, he was made Commander of the Russian fleet. Soon after this, he beat the Turkish in an important battle and, as a consequence, was presented with a gray Arab stallion, Smetanka, by the Turkish Admiral. Smetanka was bred with a variety of Danish mares and one of his progeny, Polkan I, went on to become the sire of the foundation stallion Bars I. Bars I foaled in 1784, son of Polkan I and a Dutch mare called Hartsdraver. Bars I was moved to the new Khrenov Stud, and there he was crossed with a variety of mares of Arab, Dutch, Danish, English half-bred, and Mecklenburg descent. The best of the progeny were then interbred until fixed characteristics had been established. The Orlov was developed as a quality carriage horse and a racing trotting horse.

Between 1885 and 1913, there was a large introduction of American Standardbred to the breed to increase the trotting speeds. It is considered that this crossbreeding began to destroy the fixed characteristics of the Orlov and it became necessary to re-establish the Russian breed. The modern Orlov does not compare in speed to the American Standardbred, but is widely used in Orlov only trotting races in Russia. There is quite a wide regional diversity within the Orlov breed, with the best specimens being produced at the Khrenov Stud. They are also bred at Dubrovski, Novotomnikov and Perm, and the horses from these different studs exhibit different traits, although mostly coarser in appearance and conformation.

The Orlov is a lightweight but powerful horse with great stamina and endurance, and a quiet, but energetic temperament. Their heads are fine and attractive, and they should have a nicely arched neck set high on the shoulders, which are very straight. Typically, they have a long, straight back and powerful quarters, they tend to be long in the leg and have well-formed hooves. Predominantly gray in color, they can also be bay or black, and stand at around 16 hh.

Top

This handsome horse is usually gray and has a prolific, flowing mane and tail.

Bottom

The breed does not have the speed of the American Standardbred but is widely used in trotting races in Russia.

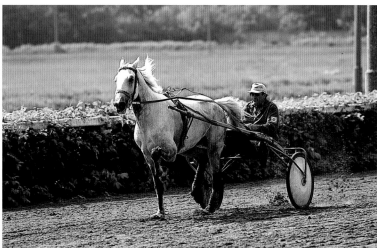

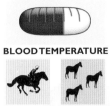

BLOOD TEMPERATURE

USES TEMPERAMENT

Palomino

○ ○

BREED INFORMATION

NAME	Palomino
APPROXIMATE SIZE	14–16 hh
COLOR VARIATIONS	Palomino
PLACE OF ORIGIN	United States

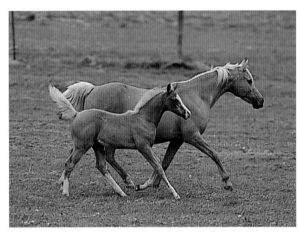

PALOMINO IS, strictly speaking, a color type and not a breed, although the American Palomino Horse Society and similar societies in England are trying to establish the Palomino by selective and careful breeding. Palomino is an ancient coat coloring, as is the spotted coat pattern, and was originally quite widespread among the Spanish Horse. America, in fact, is not really the country of origin, as palominos were first seen there after the Spanish conquistadores arrived with Spanish horses there.

America was, however, responsible for the first registry of the palomino and this coat coloring is now being widely bred there, especially in the North and South. There are rigid rules that must apply to a horse or pony in order for it to be registered on the Palomino register. The coat color must be that of a newly minted gold coin, or three shades lighter or darker. Minimal white markings are allowed on the face, and there must not be any white markings above the knee or hock. The mane and tail should be silvery white, and must not contain more than 15 percent dark hair. They must have dark or hazel eyes – blue eyes or odd-colored eyes disqualify a horse from the registry. To be registered, a horse must have one parent already in the register, and the other must be a Thoroughbred, Quarter Horse, or Arabian.

The color characteristics are hard to reproduce but the most common combinations to produce palomino offspring are palomino to palomino, chestnut to palomino, or chestnut or palomino to albino. The most popular cross is the Palomino to chestnut which, usually produces a very rich shade of palomino coat coloring. Palominos make good

riding horses and are used for all spheres of riding from pleasure, trail, showing, jumping, and so on.

In recent years they have enjoyed an increase in popularity and are now highly valued for their coloring. Often, Palominos will exhibit some Spanish characteristics which is a throwback to their roots, but there is still a general lack of conformational conformity. In general, they tend to have a small head with a straight

profile, a long and well-formed neck, a deep chest, reasonably sloping shoulders, a straight back, and muscular quarters. They usually have a prolific mane and tail, and stand between 14 hh and 16 hh.

Top Left
These are attractive horses whose manes and tails are always lighter than their coat.

Top Right and Bottom
The Palomino is presently a color rather than a breed, but horse societies are trying to establish it as a breed.

Paso Fino

BLOOD TEMPERATURE

USES TEMPERAMENT

THE PASO FINO developed in Puerto Rico, South America during the 16th century when the Spanish conquistadores brought their Spanish horses to America. The first horses to arrive in Puerto Rico were taken there in 1509 by Martin de Salazar. More Spanish horses arrived in South America in 1511, including eight stallions, and then again in 1512, 1517, and 1524. By the mid-1550s selective breeding had begun and there are now gaited horses throughout South America which exhibit marginal differences and generally have their own breed name. It is generally considered that the Paso Fino evolved through a cross between the now extinct Spanish Jennet and the Andalusian, possibly with some Barb blood. The Spanish Jennet was a natural pacer and gaited animal, and the Paso Fino is born with its natural gaits.

In those early days, it was necessary for long distances to be covered and the Paso Fino was specifically developed due to its comfortable stride and its endurance. They have three gaits: *the paso fino*; the *paso corto*; and the *paso largo*. The *paso fino* is a slow-moving pace where the feet move up and down very quickly, and this is the pace which is now used most often in the show ring. The *paso corto* is equivalent in speed to the trot and is a very comfortable gait for travelling long

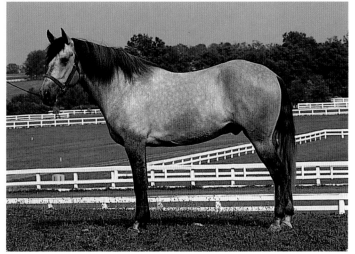

distances. The *paso largo* is the fastest of the three, and is somewhere between a canter and a gallop in speed. Typically, the Paso Fino has a vigorous action in front, supported by powerful use of the hindlegs, while keeping the quarters low. This is very comfortable to sit to and can be maintained over long periods of time, with the concussion absorbed through the horse's back and quarters making the ride very smooth.

Generally biddable, but lively, the Paso Fino is exceptionally tough and is known for its distinct personality. They have neat heads set onto a muscular and well-formed neck. The shoulders are very powerful, and the chest broad and deep. They have great depth through the body, allowing room for large lungs; the back is usually short, the croup rounded, and the legs very strong. They can be of any color, and stand between 14 hh to 15 hh.

HORSE FACT:
The Centaur was a mythical creature that appeared to be human from the waist up, and equine from the withers down and back.

Top
The Paso Fino is a descendant of the Spanish Horse which came to America with the Spanish invaders.

Bottom
This breed has five distinct gaits and is often used in displays of traditional Puerto Rican riding skills.

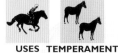

BLOOD TEMPERATURE

USES TEMPERAMENT

Persian Arab

○○○○○○○○○○○○○○○○○○○○○○○○○
BREED INFORMATION

NAME	Persian Arab
APPROXIMATE SIZE	14.2–15.2 hh
COLOR VARIATIONS	Gray, bay, or chestnut
PLACE OF ORIGIN	Iran

THE PERSIAN ARAB is an ancient breed of horse, and is believed to have existed in Persia from approximately 2,000 B.C., which makes it older than the Arabian by roughly 1,500 years. The name Persian Arab covers a vast number of different regional strains throughout Iran which were named after the families that bred them. The Persian Arab is now greatly reduced in numbers, partly due to African horse sickness, which affected Iran in the 1950s, and which wiped out a vast number of the breed. They were, of course, the primary means of transport until the advent of motor vehicles and only relatively recently has the horse become used for sporting purposes, such as Arab racing.

The southern regions of Khuzestan is an area where Arab breeding has been increasing and Khuzestan produces some notable strains of the Persian Arab. They also have very set rules on the breeding and selective breeding process and this has helped to keep the strains pure. In general terms, the Persian Arab is similar to the Arabian in conformation and characteristics although they are slightly heavier in build. They are attractive horses with great presence and natural carriage and bearing. They make very good riding horses and are quick and agile with enormous stamina and spirit.

In appearance, they have the typical Arab type head, broad through the forehead with a dished profile and small pricked ears. They are compact and muscular through the body, have an arched neck, a broad and deep chest, rounded quarters and a tail set and carried high. Generally they are gray, bay, or chestnut in color, and stand at between 14.2 hh and 15.2 hh.

Two breeds in Iran that have developed from the Persian Arab are the Jaf from Kurdistan and the Darashouri from the Fars region. Both these breeds have predominantly Arab characteristics, are spirited, quick, and have good stamina, and tend to stand at approximately 15 hh. The Jaf is considered to have better stamina than the Darashouri and be better able to cope in the extreme desert conditions. The Darashouri on the other hand is more attractive and more elegant than the Jaf.

Top

The Persian Arab has a typical Arab head and carries its tail in the same high manner.

Bottom

The breed has a broad, dished profile with small, alert ears.

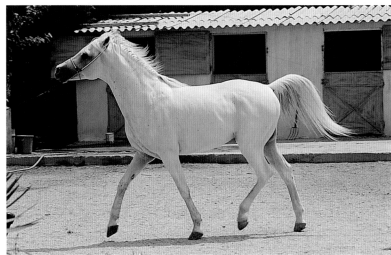

BLOOD TEMPERATURE

USES TEMPERAMENT

Peruvian Stepping Horse

BREED INFORMATION	
NAME	Peruvian Stepping Horse
APPROXIMATE SIZE	14–15.2 hh
COLOR VARIATIONS	Mostly chestnut or bay, but can be any color
PLACE OF ORIGIN	Peru

THE PERUVIAN STEPPING HORSE, or the Peruvian Paso, developed in Peru from the first horses taken there in 1531 by Governor Don Francisco Pizarro. The breed is descended almost entirely from a mixture of Andalusian and Barb blood, having a greater degree of Barb than Andalusian in its make-up. However, the Peruvian Paso is a naturally gaited animal and it is, therefore, possible that there may have been some early infusion of Spanish Jennet blood.

Through the centuries, and especially after Peru's independence from Spanish rule in 1823, there were various breeds imported into the country, among which were Thoroughbred, Hackney, Arab, and Friesian. While it is likely that these breeds had a small influence on the Paso, they probably also contributed towards the development of other South American breeds of horse. The Peruvian Paso has what is considered to be one of the smoothest gaits of all the gaited horses and is also able to maintain a fairly cracking speed of approximately 11 mph, even over difficult terrain. Its lateral gait is unique to the breed, although it does have some similarities to the gaited paces of the Missouri Fox Trotter and Tennessee Walking Horse.

The Paso moves with an extravagant front action, powered from their muscular quarters, which are kept low to the ground. The front leg action has a high knee lift and an exaggerated dishing movement, while the hind legs are used energetically, and overstep the front tracks. Concussion and movement is absorbed through the horse's back and quarters, leaving the rider with a very smooth and undisturbed ride. Both the hind legs and hind pasterns are long, which helps the smoothness of the movement.

The Peruvian Paso characteristically has great stamina and endurance and is able to adapt to different climates with ease. They are attractive horses with lots of presence and spirit, while also having a very good temperament. Usually they have a quality head, set onto an arched and muscular neck. They are compact through the body and deep through the girth, and have very muscular quarters. Their legs and feet are particularly notable for their strength and soundness. Invariably they are chestnut or bay in color, and stand between 14 hh and 15.2 h.

Top
The breed is showy with long manes and tails and has a good, quiet and willing disposition.

Bottom
This Peruvian horse has five gaits and can travel consistently at some speed for long distances.

HORSE FACT:
In Britain Henry VIII, (1491–1547), was responsible for trying to increase the size of the British horse. Up until then, the British 'horses' were pony-size, which limited their weight-carrying and draft capabilities.

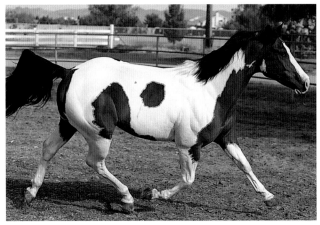

BLOOD TEMPERATURE

USES TEMPERAMENT

Pinto

BREED INFORMATION

NAME	Pinto
APPROXIMATE SIZE	14.2–15.2 hh
COLOR VARIATIONS	Part-colored
PLACE OF ORIGIN	United States

PART-COLORED, or odd-colored horses are known as either Pintos or Paints. In England they are called either piebalds, which are black and white, or skewbalds, which are any other color and white. This coat coloring is an ancient color, similar to the spotted coat, and is frequently seen depicted in cave art. The color probably originated in Europe or Russia, but there are now more colored horses in America, which is, therefore, termed country of origin.

They were highly prized for their color amongst the Indian culture. The colored horse has little conformity in physical aspects, being simply a color, although in recent years, there have been efforts to create a type. There is an important distinction which should be made between the Pinto, and the Paint. There are two organizations in America – the Pinto Horse Association of America and the American Paint Horse Association. Any part-colored horse can be registered with the Pinto Horse Association, and they are divided into stock type such as hunter type, pleasure, saddle, and so on. However, with the Paint Association, only colored horses with Thoroughbred, Quarter Horse, or Paint bloodlines may be registered, so that they are an association primarily concerned with bloodlines. Any Paint horse can be on the Pinto register, but not every Pinto can be on the Paint register.

Within the colored horse category, there are two distinct color patterns which occur called the tobiano and the overo. The tobiano has a white base with large colored patches, the legs are usually white and there are usually white markings across the back. The overo is a colored base with white patches that tend to start under the belly and spread upward, but rarely across the back. The overo often has a white face with blue eyes. Many of the early Spanish horses exhibited part-colored coats, and it is generally considered that many of the part-colored horses of today may have developed from the Spanish Horse. There are often Spanish characteristics evident in the part-colored horses.

As a rule, these horses are generally stocky, well-built, and powerful animals with a quality head and muscular quarters. On the whole, they have good conformation and make very good riding horses. They stand between 14 hh and 15.2 hh, although there are of course also part-colored ponies, which stand up to 14 hh.

Top and Center
Pintos are highly prized among Native American Indians for their unusual markings.

Bottom
The breed has a fine, neat head and a good character, making ideal riding horses.

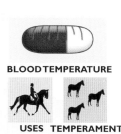

```
┌─────────────────────────────────────────┐
  ○○○○○○○○○○○○○○○○○○○○○○○○○○○
    B R E E D   I N F O R M A T I O N

  NAME              Pleven
  APPROXIMATE SIZE  15.2–16 hh
  COLOR VARIATIONS  Chestnut
  PLACE OF ORIGIN   Bulgaria
└─────────────────────────────────────────┘
```

Pleven

BLOOD TEMPERATURE

USES TEMPERAMENT

DEVELOPMENT OF the Pleven began in 1898 in Bulgaria, at the former state stud known as Klementina, which is now called the Georgi Dimitrov Agricultural Center. They are, Anglo-Arab in essence, having evolved as a result of crossing Arab, or half-bred local mares with Russian Anglo-Arab and half-bred stallions. Later, Gidran stallions were also introduced, and by 1951, the breed was officially recognized. At around this time, English Thoroughbred blood was introduced to add refinement and quality, and to try to increase the average size of the Plevens.

The Pleven is a rarely publicized and little-known breed, which belies its talents and qualities. They make first-class riding and competition horses and have an excellent natural jump. They also have a particularly attractive way of going and very good, free-flowing paces, which make them eminently suitable for dressage. They have good temperaments, are calm, willing, and obedient, and are also economical to keep and feed. Typically they have a very sound constitution and are tough and enduring.

In appearance, they are almost universally well put together, and have a nicely proportioned head with a straight profile. The neck is quite long, muscular, and generally has a good topline. They are broad and deep through the chest, and have well-formed, nicely sloping shoulders which account for their very correct action. They are reasonably deep through the barrel, which is rounded, have high withers, and a fairly long back. The quarters are very muscular, and the croup is slightly sloping, with a tail set and carried well. Their legs are mostly very well-conformed, muscular, with good density of bone, and well-made large, broad joints.

They tend to have muscular forearms, strong, and well-defined tendons, and very hard, well-formed feet and hooves.

The Pleven has a natural carriage and presence, and elevation through the strides, all qualities that have probably been inherited from their Arab ancestors. They are always chestnut in color, and stand between 15.2 hh and 16 hh. Plevens are still widely selectively bred in Bulgaria and there are continued efforts to increase the overall size of the horse, which would make it a more viable option on the international sports horse market, while maintaining its excellent qualities.

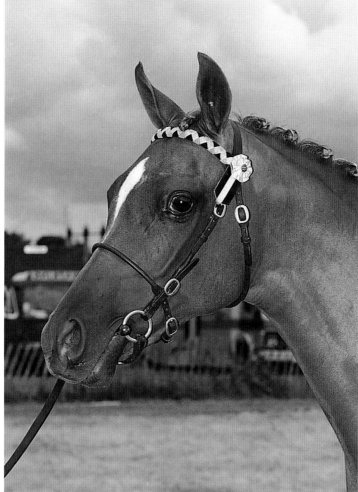

Left
The Pleven has a fine face with a noticeable Arabian influence; the profile is slightly concave and the ears pricked.

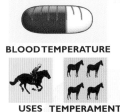

BLOOD TEMPERATURE

USES TEMPERAMENT

Quarter Horse

BREED INFORMATION	
NAME	Quarter Horse
APPROXIMATE SIZE	14.3–16 hh
COLOR VARIATIONS	Any solid color
PLACE OF ORIGIN	United States

THE QUARTER HORSE is one of America's oldest and certainly its most popular breed of horse. It developed during the 17th century from the horses that the Spanish conquistadores took to America with them – mainly Andalusian, Barb, and Arabian. This base stock was then crossed with the early Thoroughbred types that were imported to America in 1611 and hence the foundations for the Quarter Horse were laid.

The first English horses imported in 1611 were known as running horses, and would have been the forerunners of the English Thoroughbred. They were transported to Virginia and, after the legalisation of racing by Governor Nicholson in about 1620, there began concerted efforts to breed horses for speed. The early races were almost always short – usually about one quarter of a mile – and by 1690, the prize money being offered was considerable. This was the background against which the Quarter Horse developed and it is often considered that the breed was primarily geared toward prowess on the racecourse, before its many other qualities were discovered.

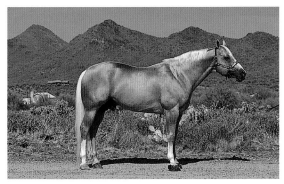

The early Quarter Horse was a solidly built small horse, standing at only approximately 15 hh, and was notable for its tremendously powerful hindquarters. It was quickly realized that the Quarter Horse was far superior to the Thoroughbred types over short distances and, to this day, the Quarter Horse is still faster over a short course than the Thoroughbred. They became known at first as Short Horses, due to the short distances they excelled in racing over, and then later their name was changed to Quarter Horse, after the quarter-of-a-mile races they ran. One of the important early Thoroughbred influences on the development of the Quarter Horse was that of the horse Janus, who was imported in 1752. Janus had a son by the same name and he became the foundation sire of the important Printer line of Quarter Horses. The other influential Thoroughbred was Sir Archy, son of Diomed, who was the winner of the first English Epsom Derby. Several lines of impressive Quarter Horse today can still be traced back to Sir Archy. Gradually, however, distance racing gained in popularity and the Quarter Horse was no longer able to

Top
The Quarter Horse is so-called for their bursts of speed, which can only be sustained over short distances.

Bottom
The horse has an excellent temperament, making it a superb riding horse.

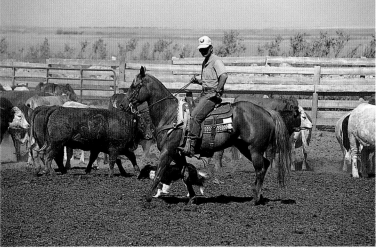

rodeo, with which it has become synonymous, all forms of ranch and cow work, and once again on the racetrack. In recent years Quarter Horse racing has become more popular, although it is considered by some that there has been a detrimental amount of Thoroughbred blood introduced to the racing Quarter Horse lines.

The Quarter Horse characteristically has a superb, calm and well-balanced temperament, and is highly intelligent, making it a first class riding horse. In appearance, they have excellent, powerful conformation. The head tends to be smallish and broad across the forehead, the neck is muscular and well-formed, the chest wide and deep, the shoulders strong, sloping, and powerful. They should be compact through the barrel and have immensely strong hindquarters. The legs are well formed, the cannon bone short, and the feet very hard. They can be any whole color, and range in height from 14.2 hh to 16 hh.

compete against the Thoroughbred. By the 1850s distance racing was firmly established and the Quarter Horse would have dwindled had their other impressive talents not become apparent. It quickly became evident that the Quarter Horse was a natural ranch animal, possessing 'cow sense' to a very great degree. It is more than likely that this natural instinct to work cows was inherited from their Spanish ancestors, who are also excellent cow horses, and are frequently used in the bullring. The Quarter Horse is virtually unsurpassable in the capacity of cow work, and their great agility, speed and tenacity, as well as intelligence, makes them one of the modern cowboy's favourite mounts. The Quarter Horse is truly the universal horse and is quite capable of performing well in virtually any sphere.

Back in the 1800s as people started to move towards the Western states of America, the Quarter Horse was frequently used in harness as well as for ridden transportation. They were capable of completing all the chores around the early settlers' homesteads, and as well as making sporting horses, are most often suitable for children and novices to ride too. The extraordinary versatility of the Quarter Horse is perhaps unequalled by any other breed and is entirely due to their quite exceptional temperaments. The Quarter Horse Association, which was not formed until 1940, now has the largest register of any breed in the world, numbering over three million entries. The Quarter Horse is used for all areas of leisure riding, in competitive sports, especially the

Top
The versatility of the Quarter Horse means that it also works well with cattle.

Bottom
The horse has a small, neat head, with a broad forehead and a well-formed, muscular neck.

BLOOD TEMPERATURE

USES TEMPERAMENT

Rocky Mountain

○ ○

BREED INFORMATION

NAME	Rocky Mountain
APPROXIMATE SIZE	14.2–16 hh
COLOR VARIATIONS	Any solid color
PLACE OF ORIGIN	United States

THE ROCKY MOUNTAIN HORSE is a new American breed that developed in the early 20th century, but did not form a breed association or studbook until 1986. The breed was developed by Sam Tuttle, of Kentucky, using his prolific stallion Old Tobe. Tuttle had the riding rights to Natural Bridge State Park and used his horses for all levels of riders, including total novices. Old Tobe was regularly used in this capacity, as were his progeny, and one of the excellent traits of the Rocky Mountain Horse is its very calm and kind temperament. Old Tobe passed on his conformation, temperament, and smooth lateral gait to all his progeny, hence founding a distinctive group of horses.

The Rocky Mountain Horse also clearly exhibits Spanish characteristics, especially in its overall outline and conformation, as well as in its gait and coloring. They are likely to be related to both the Tennessee Walking Horse, and the Saddlebred, both of which are descended from Spanish horses. Typically they have a very smooth gait, which was very popular, when people were having to travel long distances over rough terrain, and also now for leisure riding. Traditionally, the Rocky Mountain would be used for riding, and also in light harness, making attractive and functional horses for pulling buggies and carriages. As a breed they have great stamina and endurance and are able to travel at 7–16 mph over long distances. They have become increasingly popular throughout America due to their versatility, temperament, and unusual coloring, and are becoming increasingly popular in Canada. They are also tough and hardy, resistant to cold and particularly kind and gentle in disposition.

In appearance they are highly attractive, with fine intelligent heads and long, graceful necks set to muscular shoulders. They are deep and wide through the chest, have quite low withers, a nicely proportioned back, well-made quarters and strong, tough legs. Conformation of the shoulders is generally good and this accounts for their smooth, free-flowing action. The ideal coat coloring is an unusual and attractive chocolate brown with flaxen mane and tail, although they can be any solid color, and they stand at between 14.2 hh and 16 hh.

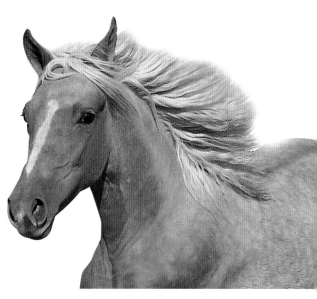

Top and Center
This is a new breed of horse which is extremely attractive; often it has an unusual chocolate brown coloring.

Bottom
The Rocky Mountain has a gentle, intelligent head and kind eyes.

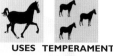

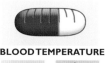

BREED INFORMATION	
NAME	Russian Trotter (Métis Trotter)
APPROXIMATE SIZE	15.3–16 hh
COLOR VARIATIONS	Mostly bay, can be black, chestnut, or gray
PLACE OF ORIGIN	Former U.S.S.R.

Russian Trotter
Métis Trotter

BLOOD TEMPERATURE

USES TEMPERAMENT

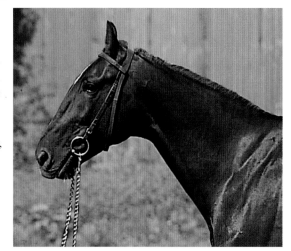

HORSE FACT:
The Parthenon frieze in Athens shows many beautiful bas relief sculptures of horses being ridden by young Greek men. The artist was called Phidias, and in approximately 477 B.C. he executed the frieze to show the Greek ideal of perfection.

THE RUSSIAN TROTTER was developed in Russia to create a horse with greater trotting speeds than those demonstrated by the older Russian trotting breed, the Orlov Trotter. In the years between 1890 and 1914, 156 American Standardbred stallions and 220 mares were imported to Russia. The American Standardbred was the best and fastest in its field, so it was decided to crossbreed it with the Russian Orlov Trotter. Early crosses produced a faster, but small animal of lesser quality; further selective breeding produced a larger trotting horse of a better quality. The best of the early progeny interbred using further infusions of Orlov and Standardbred.

By 1950, the breed characteristics had become fixed and the Russian Trotter gained official recognition. There are, however, still periodic infusions of both pure Orlov and Standardbred blood to maintain the breed's qualities. Although the Russian Trotter is a faster animal, it still lacks the quality and refinement of the Orlov and does have some conformational defects. The Russians have imposed certain breed standards on the Trotter to improve the overall standard of the horse: a height limit of not less than 15.3 hh for mares and 16 hh for stallions; a girth measurement of approximately 6 ft 1 in; and a bone measurement below the knee of 7¾ in. The Russian Trotter has a good temperament and is quiet, but energetic, and easy to train.

In appearance, it has a plain but well-set head, a long and muscular neck, a wide and deep chest, long, sloping, muscular shoulders, and a long straight back. They have strong legs with clearly defined tendons. They do frequently have a defect of the limbs whereby they are slightly knock-kneed and often sicklehocked, causing the feet to move outwards in a semicircular motion, known as dishing. Although technically a defect, this does allow them to find their pace more easily when lengthening the stride, and therefore can be an advantage when racing. They are also rather too light in bone, and have very upright and long pasterns. Their coat is usually bay in color, but can be black, gray, or chestnut, and they stand at between 15.3 hh and 16 hh.

Top
The Russian Trotter is a plain breed but has greater speed than the Orlov Trotter.

Bottom
Usually bay in color, this horse has a well-set head, well-sloping shoulders and long, strong legs.

BLOOD TEMPERATURE

USES TEMPERAMENT

Salerno

HORSE FACT:

*'Oh, I'm a Texas cowboy
and far away from
home,
And if ever I get back
again no more will I ever
roam,
Wyoming's too cold for
me, the winters are too
long,
And when round up
comes again, my
money's all gone.'*

THERE WAS NO FIXED breeding program for the Salerno until the 1780s, when they began to be selectively bred at the Persano Stud in Italy. There was a very solid foundation base stock

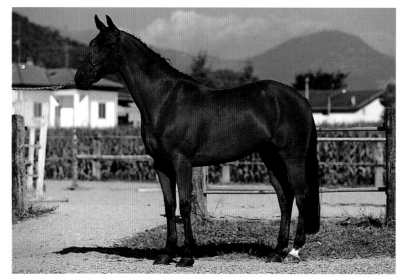

largely composed of a combination of Neapolitan, Spanish, and oriental blood. The breed was greatly promoted by King Charles III, King of Naples and then Spain, who was responsible for establishing the Persano Stud. At the stud, a combination of local stock and Lipizzaner was introduced and three influential stallions on the breed were Pluto, Conversano, and Napoletano, who are considered the foundation sires. At first the horses were known as Persano horses, and they developed into a quality and useful riding horse of some weight, bearing similarities to its Spanish ancestors.

Breeding continued at Persano until 1864 when the stud closed, and the breeds numbers started to dwindle. It was not until the 1900s that there was a revival of interest and about this time the name was changed to Salerno. Thoroughbred, and possibly some Hackney blood, was introduced and the Morese Stud, which is close to the site of the original Persano Stud, became one of the most influential studs.

The infusions of Thoroughbred blood had the obvious effect of greatly refining and improving the

Salerno, and also led to a general average increase in size. The Salerno became a first-class riding horse of quality and a popular cavalry mount. Now, sadly, it is quite rarely seen and the breed numbers have decreased. This is not a reflection of the breed's qualities, however, which are many – they have very good temperaments and make excellent sports horses, having a good natural athletic jump. In fact two of the most famous Salerno horses were probably Merano and Posillipo; the former was ridden to victory by Raimondo d'Inzeo at the 1956 World Showjumping Championships, and the latter won him the individual gold medal at the 1960 Olympics.

In appearance, they tend to have a light but well-set head, on a long and muscular neck. The back should be well-proportioned, the shoulder sloping, the quarters muscular, and the legs slender but strong. The most common coloring now is bay, black, or chestnut, and it stands from between 16 hh and 17 hh.

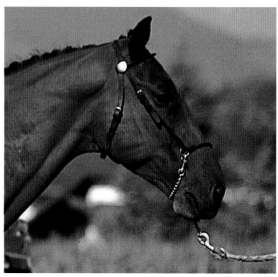

Top

The Salerno has a mixture of Neopolitan, Spanish and oriental blood in its gene pool.

Bottom

The horse has a light head on a muscular neck with long, sloping shoulders and good legs.

BLOOD TEMPERATURE

USES TEMPERAMENT

BREED INFORMATION

NAME	San Fratello
APPROXIMATE SIZE	15–16 hh
COLOR VARIATIONS	Bay, black, or dark brown
PLACE OF ORIGIN	Italy

San Fratello

LITTLE IS KNOWN about the ancestry of the San Fratello, although the breed is believed to have evolved from the ancient horses associated with the province of Messina in Sicily. They may

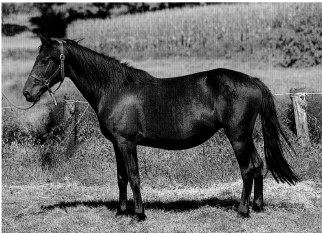

have strong connections to the old Sicilian Horse, which is known to have been highly regarded, especially by the Greeks. It is also likely that in the past there have been infusions of Anglo-Arab, Salerno, and Spanish Anglo-Arab blood into the breed and, more recently, some Nonius and some English Thoroughbred blood.

The San Fratello are raised almost exclusively in a semiwild state in wooded areas of Messina and on the northern slopes of the Ebrodi mountains. The horses are exposed to difficult weather conditions that range from hot and humid in the summer to very cold in the winter, and have to forage for their food, which can often be in short supply. This environment has produced an excellent horse of very sound constitution, resistant to most modern equine diseases, highly economical to keep, and extremely tough and enduring. The breeding stock is carefully controlled to maintain the breed's commendable characteristics, and also to continually improve the

stock. Around the 1930s there was an effort made to improve some conformational aspects of the breed, especially their rather heavy heads and importantly to wipe out a weakness in the pasterns. To do this, English and oriental horses were imported to the region, and they have indeed had some good effect.

The San Fratello has a good temperament and is an excellent prospect as a modern sports horse. They are naturally athletic and sound, as well as being brave and fast, all qualities making them suitable for jumping. In appearance, they are attractive but still retain a slightly heavy head with a straight or convex profile. The neck is muscular and often slightly on the short side, and the chest is broad and deep. The shoulders have improved in recent years, and are sufficiently sloping, the back is strong, and reasonably straight. They have muscular hindquarters which are well formed, and have a tail set and carried nicely. They should have strong legs with hard tendons and good feet. They are always bay, brown, or black in color, and stand at between 15 hh and 16 hh.

Top

This breed may have developed from ancient horses found in Messina on Sicilly.

Bottom

The San Fratello has a good nature and, although on the heavy side, makes a good riding horse.

BLOOD TEMPERATURE

USES TEMPERAMENT

Sardinian

BREED INFORMATION	
NAME	Sardinian
APPROXIMATE SIZE	15.2 hh
COLOR VARIATIONS	Bay or brown
PLACE OF ORIGIN	Sardinia

HORSE FACT:

The B.E.T.A., the British Equestrian Trade Association, is responsible for setting standards for the industry. Buying products from a BETA recognised retailer should ensure that you get good value for money, efficient service, knowledge-able advice, and quality goods.

Top

The Sardinian may have been bred from Barb horses brought to the island by North African traders.

Bottom

The Thoroughbred has recently been introduced to help the bloodline of this breed.

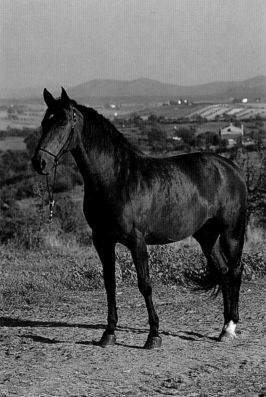

THE SARDINIAN, or Sardinian Anglo–Arab, as it is also called, is an old breed that was established in Sardinia during the 15th century. Geographically, Sardinia is well situated for trade with North Africa, and has for centuries imported the North African Barb horses and Arabians, which would then subsequently be crossed with local stock. This formed the foundation for the breed, with a fixed type in the 15th century, and led to the formation of a stud of Spanish Horses by Ferdinand of Spain, near Abbasanta.

The Spanish Horse, which was later to become the Andalusian, played a major role in the development of the Sardinian Horse and further studs established at Padromannu, Mores and Monte Minerva helped to promote its breeding. It flourished until 1720, when Sardinia was passed to the House of Savoy and horse breeding was greatly reduced. The Sardinian Horse dwindled in numbers until the early 1900s. As horse breeding started to pick up again, there were further infusions of Arabian blood to the breed, and this helped to improve the horses, giving them greater refinement and stamina.

More recently, there has been an introduction of English Thoroughbred blood to the breed and this again has helped the quality of the horses. They are hardy and tough with good stamina, and make very good riding horses being willing, calm and bold. They also have a natural athletic jump, and the recent crosses with Thoroughbred blood have made them suitable for use as a sports horse. They have an oriental look, which is a clear indication of their Arabian blood, but their conformation in some cases varies in correctness due to earlier slack breeding policies. They tend to have a long head that is often plain, the neck should be nicely arched and muscular and is usually elegant, the shoulders are sloping, the back inclined to be long and straight, and the quarters somewhat light. They are generally long in the cannon bones, and of a light build, but remain tough and wiry. Usually they are bay or brown and stand at 15.2 hh.

BREED INFORMATION

NAME	Selle Française
APPROXIMATE SIZE	15.2–16.2 hh
COLOR VARIATIONS	Bay, chestnut, brown
PLACE OF ORIGIN	France

Selle Française

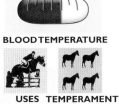

BLOOD TEMPERATURE

USES TEMPERAMENT

THE CHEVAL SELLE Française, or the Selle Française, meaning French Saddle Horse, developed during the 19th century in France from a very good base stock. The primary breeding areas were, and still are, those around Normandy, which has had a long tradition of producing first-class horses. The breed developed through crossing the local Norman horses with imported English Thoroughbreds, and half-bred stallions. The local Norman horses, which were of ancient origins, were highly commendable for their powers of stamina and endurance, and had frequently been used as warhorses, as well as exerting an influence on some native English breeds. The half-bred stallions imported from England contained a very high percentage of Norfolk Roadster blood and in fact it was the infusions of trotter blood to the breed that were to give it some of its particularly commendable traits. The interbreeding of the Norman mares and the Thoroughbred and half-bred stallions gave rise to what was known as the Anglo-Norman riding horse, which was a riding horse of considerable class and talent. This was to form the foundation for the Selle

Française, and the Selle Française studbook is, in fact, a continuation of the old Anglo-Norman one. As with many breeds of horse, the First and Second World Wars severely depleted numbers of the burgeoning Selle Française, and after the Second World War, there were renewed efforts to maintain the breed. Important and influential Thoroughbred stallions to the breed were Lord Frey, Ivanhoe and Orange Peel, whose lines still exist today, and more recently the stallions Ultimate and Furioso have been used.

Today, the Selle Française is an excellent competition horse, having a naturally athletic jump, and being bold and courageous. They are frequently used by the French show jumping team, and have a particular talent in this field. Typically, they have a small attractive head with a broad forehead, the neck is muscular and well set on, the chest broad and deep, the shoulders are quite sloping, the back straight, and the quarters muscular and slightly sloping. They have solid and strong legs, with a bone measurement of the cannon being not less than 8 in. Usually they are chestnut, bay or brown, but can be any solid color, and stand between 15.2 hh and 16.2 hh.

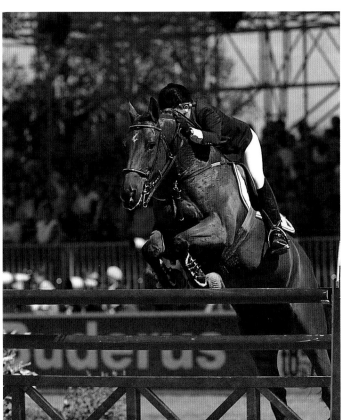

Top

The Selle Français was bred in and around Normandy and is now in great demand for its classy looks.

Bottom

This is a naturally athletic breed; being brave and strong, the horses make good competition animals.

HORSE FACT:

In America, the I.A.E.S. is the Institute for Ancient Equestrian Studies, which was created in 1994 to investigate the origins, development, and domestication of the horse down through the ages.

BLOOD TEMPERATURE

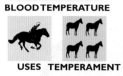

USES TEMPERAMENT

Shagya Arabian

BREED INFORMATION

NAME	Shagya Arabian
APPROXIMATE SIZE	15 hh
COLOR VARIATIONS	Mostly gray
PLACE OF ORIGIN	Hungary

Top

These attractive horses are mostly gray in color and show a strong Arab influence with their concave profiles.

Bottom

Shagya Arabians are slightly heavier than their cousin the Arab but have the same lively, energetic temperament.

D URING THE YEARS 1526 to 1686, Hungary was under Turkish occupation and many oriental horses were imported to the country. This was to prove an extremely influential factor on horse breeding in Hungary and many of the Hungarian breeds can trace some Arabian blood in their ancestry. The Shagya Arabian, however, was not established until the 19th century. In 1789, the famous Hungarian stud farm of Bablona was bought by the government from a private family, possibly to act as an overflow for the other famous Hungarian stud of Mezohegyes. By 1870, Bablona was exclusively breeding Arabian horses. The Hungarians were trying to selectively breed a new type of Arab horse, with a larger frame and build than the traditional Arab, but with all the excellent Arabian qualities.

In 1833, the foundation sire Shagya was imported from Syria to the stud and he passed his characteristics on to his progeny. Other important stallions in the development of the breed were Siglavy Bagdady, Gazal, Kemir, Koheilan, Jussuf, O'Bajan, Kuhaylan Zaid, and Mersuch – all of which founded their own lines within the breed. The Shagya Arabian was not in fact named until 1982; previously they had just been called Arabs. Shagya passed his distinctive stamp and coat coloring to all his progeny and was, therefore, subsequently honored by the use of his name. The breed numbers were devastated in 1945, and although the Shagya Arabian

continues today, their numbers are greatly reduced. They have recently enjoyed an increase in popularity in America and are just starting to gain some recognition on an international scale.

They are very similar in appearance and conformation to the Arabian, but are of a heavier build with greater substance. Like the Arabian, they are renowned for their speed and stamina, and have a lively and energetic temperament. They make very useful, versatile horses, both for riding and in harness, and are good performers in competitive fields. Typically they have highly attractive heads with a broad forehead and intelligent dark eyes. They are compact through the body, have strong, fairly sloping shoulders, a broad and deep chest, and muscular quarters. They have very correct conformation of the legs, especially in the hind legs. Nearly always gray in color, they tend to stand at approximately 15 hh.

HORSE FACT:

Horses are measured from the highest point of the wither to the ground, making sure the ground is level. For an accurate height reading, the horse should be measured without its shoes on.

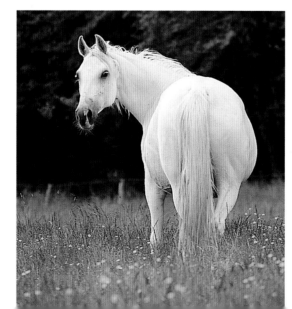

Standardbred

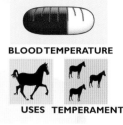

BREED INFORMATION	
NAME	Standardbred
APPROXIMATE SIZE	15.3 hh
COLOR VARIATIONS	Bay, brown or chestnut
PLACE OF ORIGIN	United States

THERE HAS BEEN a long tradition of trotting races in America and the Standardbred is without a doubt one of the world's fastest and classiest trotters. The breed derived its name in 1879

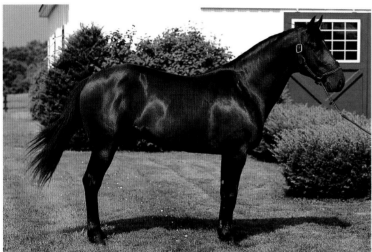

when a standard was set for entry on the trotting register. The standard called for horses able to trot one mile in two and a half minutes, or for horses to pace one mile in two minutes and 25 seconds. Today, trotting speeds have greatly increased, through selective breeding, and it is now not uncommon for horses to cover a mile in less than two minutes. Interestingly, in America there is a much larger percentage of pacers, approximately four to one, while in Europe, there is still a greater number of diagonal trotters. This may indicate an early infusion of Spanish Jennet in the development of the American trotter, which, although now extinct, was a naturally gaited animal which laterally paced.

The history of the Standardbred goes back to the 18th century, and the English Thoroughbred Messenger. Messenger was imported to America in 1788, after a successful career on the flat in England. Messenger was of

admirable ancestry, tracing back to all three of the foundation sires of the Thoroughbred, and also having a percentage of the indomitable Norfolk Roadster blood. Messenger spent 20 years at stud and fathered over 600 foals. He was mated with various mares, including the Narragansett Pacers and Canadian Pacers, both now extinct, and Morgan mares. One of Messenger's descendants was a horse called Hambletonian, foaled 1849, which went on to become the foundation sire for the modern Standardbred breed. Hambletonian fathered four stallions, to which almost every modern Standardbred can be traced – George Wilkes, Dictator, Happy Medium, and Electioneer.

The Standardbred has a good temperament, and is willing and naturally competitive. They are associated with the Eastern states, but are now bred throughout the country. They are similar to the Thoroughbred but are more robust and sturdy with incredibly hard and strong legs and feet. They are powerfully built, and tend to be higher in the croup than the withers, which lends a propulsive thrust to the quarters. They are long through the back, with good depth of girth and plenty of room for heart and lung expansion. Usually they are bay, brown, or chestnut, and stand around 15.3 hh.

Top
The Standardbred is one of the fastest trotting breeds in the world.

Bottom
The horses have a biddable nature and are naturally competitive, which makes them well-suited to trotting races.

BLOOD TEMPERATURE

USES TEMPERAMENT

Swedish Warmblood

BREED INFORMATION	
NAME	Swedish Warmblood
APPROXIMATE SIZE	16.2 hh
COLOR VARIATIONS	Bay, brown, chestnut, or gray
PLACE OF ORIGIN	Sweden

THE SWEDISH WARMBLOOD originated in the early 17th century in the Swedish studs of Stromsholm, which was established in 1621, and the Royal Stud of Flyinge, established in 1658. Early formation of the breed was based on a very diverse breeding process which did not result in any kind of fixed type. Early crosses involved a Spanish, oriental and Friesian stallions which were crossed with local stock, and horses were imported to the stud from countries as diverse as Turkey, Hungary, England, Russia, France, Germany, and Spain.

Although no type was established, the resulting stock produced was a useful riding horse, which was favored by the military for use within the cavalry.

The early stock was quite coarse in appearance, which was probably due to the use of the local native mares of no outstanding physical appearance. Later, the progeny was improved by infusions of Thoroughbred, Hanoverian, Arab, and most importantly, Trakehner blood. Through a careful process of selecting the best of the progeny and interbreeding, a fixed type emerged which became known as the Swedish Warmblood. Notable stallions which had a good effect on the breed were the Thoroughbred, Hampelmann, the Hanoverians, Hamlet, Schwabliso, and Tribun, and most importantly the recent influence of the Trakehner stallions, Polarstern Anno, Heinfried, and Heristal, who is a direct descendent of the famous English racehorse Hyperion.

The excellent qualities of the Swedish Warmblood are maintained through a rigorous selection process to which both mares and stallions are subjected before being granted a breeding license. The assessments for stallions involve testing of all the paces and gaits, jumping ability, cross-county ability, and temperament, while the mares have to demonstrate good paces. The modern Swedish Warmblood is a big, quality horse of great ability in dressage, showjumping, and eventing competitions. They naturally have good conformation and a calm and well-balanced temperament.

In appearance, they have an attractive head set to a long and well-formed neck. The shoulders should be muscular and sloping, allowing for free movement, the chest is broad and deep, they are compact through the body, with well-sprung ribs, and muscular quarters. They have solid strong legs and a well shaped foot. They are usually bay, brown, chestnut, or gray, but can be any solid color, and stand at approximately 16.2 hh.

Top
The Swedish Warmblood has been the subject of rigorous selective breeding to improve the stock.

Bottom
The horse has an attractive head with a long, well-formed neck.

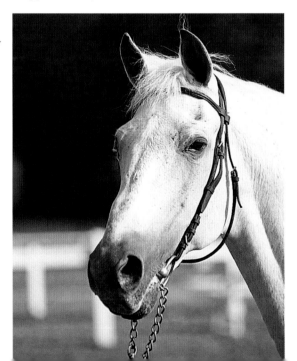

Swiss Warmblood

BLOOD TEMPERATURE

USES TEMPERAMENT

BREED INFORMATION

NAME	Swiss Warmblood
APPROXIMATE SIZE	15.2–16.2 hh
COLOR VARIATIONS	Any color
PLACE OF ORIGIN	Switzerland

THE SWISS WARMBLOOD, or Einsiedler, has a long history that goes back to the 10th century and the Benedictine monastery of Einsiedler. There the monks bred a useful and versatile animal able to perform all chores, including light agricultural, light draft and riding, and probably based their early breeding on the local Schwyer stock. By the Middle Ages, the monks had developed a high-class and quality horse which became known as the *Cavalli della Madonna*. The breed went on to be called the Einsiedler and by 1655 a studbook had been established.

Switzerland has had a long tradition of importing horses and, during the 17th century, many Turkish, Italian, Spanish, and Friesian stallions were introduced to the area and used in the continuing development of the Einsiedler. These crosses did not improve the breed and were even having some detrimental effect, so that in 1784, the original studbook was scrapped and a new one formed by Father Isidor Moser. In the 19th century, the successful use of a Yorkshire Coach Horse stallion and Anglo-Norman mares was followed by the introduction of Holsteiner blood to the breed. In the 20th century, there was the use of French, Irish, English Thoroughbred, German, and Swedish blood, again having good results. It is rather remarkable that from such a wide diversity of

influences, a set type emerged, but it certainly did, and the Swiss Warmblood continues to be a highly successful breed.

As with many of the Warmbloods, the Swiss Warmblood is subjected to rigorous selection and testing, and this process helps to maintain the high standard of the breed. Stallions are performance tested at three-and-a-half years and at five years of age, and are required to

demonstrate ability at jumping, dressage, cross-country jumping and, in some cases, driving, while their conformation is also taken into account.

The Swiss Warmblood is a very versatile, talented, and attractive horse, suitable for competitive riding and for driving. Generally, they have a well proportioned, quality head, a muscular neck, a broad and deep chest, sloping shoulders, a longish and straight back, and sloping quarters. Their legs tend to be long, hard and strong with clearly defined tendons, and well-shaped hooves. Their coat can be any color, and they stand between 15.2 hh and 16.2 hh.

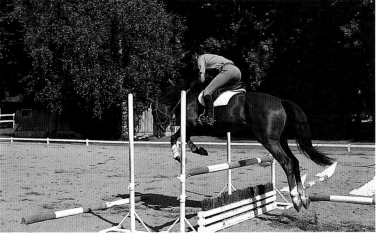

Top
This Warmblood breed has a mixture of blood as many horses were imported to Switzerland during the seventeenth century.

Bottom
The Swiss Warmblood has become a good all-rounder, and can be used for dressage, cross country and jumping.

HORSE FACT:
Wheat straw is the best kind of straw to use for bedding. Horses tend to eat oat straw, and barley straw can have prickly awns.

BLOOD TEMPERATURE

USES TEMPERAMENT

Tennessee Walking Horse

BREED INFORMATION	
NAME	Tennessee Walking Horse
APPROXIMATE SIZE	15–16 hh
COLOR VARIATIONS	Mostly chestnut and black
PLACE OF ORIGIN	United States

THE TENNESSEE WALKING HORSE originated during the 19th century in Tennessee, America. As people settled in the Tennessee area they needed a stylish horse suitable for use on

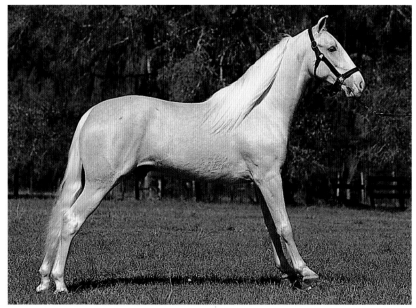

Top

The Tennessee Walking Horse has an unusual stance with both pairs of legs pushed away from the body.

Bottom

With a large head and kind eyes, this breed is known for its gentle , quiet nature.

the land, in harness, for riding, suitable for all members of the family. It was important to have a horse with good stamina and a comfortable stride to cover the long distances and rough terrain. Early settlers developed the breed by using gaited Spanish Horses, the Narragansett Pacer, and Canadian Pacer, with later infusions of Thoroughbred, Morgan, Standardbred, and Saddlebred blood. In 1886 a black colt was born called Black Allan or Allan F-1. Black Allan was by a stallion called Allandorf, of the famous Hambletonian trotting line, out of a Morgan mare called Maggie Marshall.

Black Allan was originally intended to be a trotting horse, but was unsuccessful due to his peculiar gait. He passed this gait on to all his progeny and it ended up becoming the valued gait of the Tennessee Walker. When the Tennessee Walking Horse Breeders Association of America was founded in 1935, Black Allan was considered to have had the most influential effect on the breed and was named as the foundation sire.

Characteristically, the Walkers have three very comfortable gaits. These are a flat walk, a running walk, and a smooth rolling canter. Both the walks are a four-beat pace, the head nods in time, and the hind feet overtrack the front feet imprints. The running walk is very fast, and is often used in the show ring. The horses can average approximately 8 mph over long distances in this pace, and an amazing 15 mph over a short distance. There is pronounced head nodding in time to the pace, the ears swing, and invariably the teeth click. The hindquarters are kept lowered, and the paces are all very smooth. The Walker has the most superb temperament and is naturally sociable, quiet and amenable, making an excellent mount for children or novices.

In appearance, they have a largish head with a straight profile, a muscular and arched neck, pronounced withers, a broad chest, sloping shoulders, a short back, and a muscular flat croup. The tail is set high, and is commonly nicked to attain an even higher carriage. They can be any solid color, and stand between 15 hh and 16 hh.

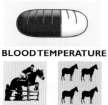

BLOOD TEMPERATURE

USES TEMPERAMENT

BREED INFORMATION

NAME	Tersk
APPROXIMATE SIZE	15 hh
COLOR VARIATIONS	Mostly gray, very occasionally chestnut
PLACE OF ORIGIN	Former U.S.S.R.

Tersk

THE TERSK IS A young breed that was developed between the 1920s and 1940s at the Tersk and Stavropol Studs in Northern Caucasus of the

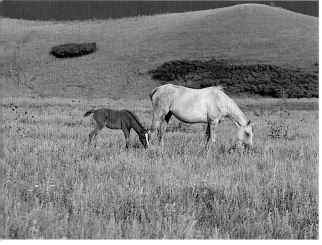

former U.S.S.R. The breed was carefully developed with a great input from Marshal S. M. Budyonny. The basic nucleus of the Tersk breed was formed by the dwindling Strelets Arabians, which were virtually extinct by 1920. Two Strelets stallions, Tsenitel and Tsilindr, were mated with various Arab, Don, Strelets, Kabarda and crossbred mares. All the remaining Strelets stock was absorbed within the production of the Tersk horse.

Early crosses produced a successful stamp of horse of Arabian type, and this was further improved three Arab stallions – Marosh, Nasim, and Koheilan.

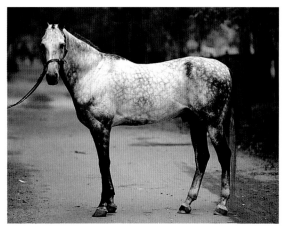

The breed has continually been improved with infusions of Kabardin, Thoroughbred, Arab, and Don blood, and by 1948, was officially recognized. The breeding of the Tersk horse has been a great success story, and the emergence of the breed's fixed characteristics within a fairly short time is due in part to the care with which they were selectively bred. They are extremely tough horses, a fact which is belied by their extraordinary beauty and apparently fragile appearance. They cope admirably with their harsh climatic conditions, despite a very thin coat.

They are great endurance horses, and were once notably entered in a long distance ride of 192 miles in which every Tersk entry finished in good time and good shape. The Tersk also makes a first-class competition horse. They have inherited the graceful Arabian stride, making them eminently suitable for the dressage arena, while also extremely athletic and bold, making them suitable for both show jumping and eventing. The Tersk is a very fast horse and is frequently raced successfully against Arabians. They have a very calm temperament and are intelligent and quick learners.

In appearance, they have attractive fine heads, often with very expressive eyes, a well-formed and muscular neck, good sloping shoulders, a broad chest, a straight back with a flattish croup, and well-constructed, muscular legs. They are a light-framed horse, and are quite light in bone; the breed standard calls for a measurement of 7 ½ in (19 cm). They are almost always gray in color, but can very occasionally be chestnut, and stand at approximately 15 hh.

Top
The Tersk is a new horse breed that was carefully developed in the Northern Caucasus in the 1920s and 1940s.

Center and Bottom
The horses are very handsome with fine heads; they are generally gray but can be chestnut.

HORSE FACT:
The horse's hock is roughly equivalent to the human heel.

BLOOD TEMPERATURE

USES TEMPERAMENT

Thoroughbred

BREED INFORMATION

NAME	Thoroughbred
APPROXIMATE SIZE	15.2–16.3 hh
COLOR VARIATIONS	Any solid color
PLACE OF ORIGIN	Britain

THERE HAS BEEN a long tradition in England of racing in one form or another and since the early 17th century racing has enjoyed royal patronage. There were running horses before the development of the Thoroughbred and these running horses were

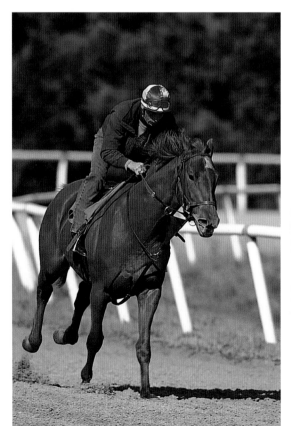

influential in the development of the Thoroughbred. The early running horses are believed to have been a combination of Spanish, Neopolitan, and Barb blood, with contributions from the Irish Hobby (predecessor to the Connemara), and various native pony breeds.

The formation of the Thoroughbred is largely attributed to three Eastern horses. The first of these was the Byerley Turk, who was captured from the Turks in battle and used by Captain Byerley as his charger during the King William wars in Ireland, and then was retired to stud in 1690 in County Durham. It is likely that the Byerley Turk, who is often quoted as being an Arabian, was in fact a Turkmene horse, probably an Akhal-Teke. He sired the horse Jig, who went on to sire the horse Herod, foaled in 1758, who himself sired an impressive line of racehorses who won over 1,000 races.

The second important foundation sire was the Darley Arabian who was imported from Aleppo in 1704, at the beginning of the reign of Queen Anne, and was responsible for the dawn of a new era of horse breeding. He stood at stud in East Yorkshire, and was perhaps the most influential of the founding stallions. Breeding between him and the mare, Betty Leedes, who was a descendent of the Leedes Arabian line herself, gave rise to the Devonshire Flying Childers, one of the fastest racehorses of the day. The same mare produced the Bleeding or Barlett's Childers, who sired Squirt, who in turn sired Marske, who was the sire of the famous

Top and Bottom Left
The Thoroughbred has been the premier racing breed in Britain for many years.

Bottom Right
The horse has excellent conformation, with a fine head and elegant, arched neck.

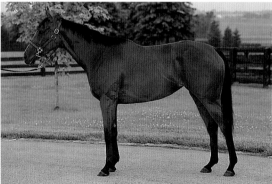

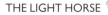

Eclipse. Eclipse was possibly one of the most famous racehorses of all time and was unbeaten on the track. The third foundation sire was the Godolphin Arabian, (see Barb) who was a Barb horse and not an Arabian. The Godolphin Arabian arrived in England, probably from Morocco, in 1728, and by 1730 was being used as a teaser at the Cambridgeshire stud of Lord Godolphin. A stallion called Hobgoblin was lined up to be mated with a mare called Roxana but as Roxana would have nothing to do with Hobgoblin, the Godolphin Arabian was allowed to mate with her instead. The pair then gave rise to Lath, foaled 1731, who was second only in skill and fame to Flying Childers, and to Cade. Cade in turn sired the stallion Matchem, foaled in 1748, and highly influential on the breed's development.

This was how the first three great Thoroughbred lines developed through Herod, Eclipse and Matchem; the fourth notable line was through Highflyer, who was a son of Herod. There were, however, obviously other notable stallions influential in the breed, and some of these were the Unknown Arabian, the Helmsley Turk, the Lister Turk, and Darcy's Chestnut. After 1770, there were no further infusions of Arabian blood. In 1773, James Weatherby was made keeper of the match book to the Jockey Club, which was formed in 1750 and continues to act as the governing body of racing in England. Then in 1791, *An Introduction to a General Stud Book* was published by Weatherby's, who were, and continue to be, the official agents of the Jockey Club. The first volume of the stud book was published in 1808, again by Weatherby's, and continues to be published periodically today. A Thoroughbred is any horse which has its pedigree published in the studbook.

Although the Thoroughbred is most commonly associated with racing, they are incredibly versatile and adaptable, and can be used in all disciplines of riding. They are extremely popular within the eventing world, as well as showjumping and showing. The Thoroughbred can have a difficult temperament, being quick to react, and often over-react, to outside stimuli. For this reason they are generally best ridden by experienced and knowledgeable riders. A Thoroughbred crossed with other breeds of horse invariably makes an excellent riding horse, possessing the presence and ability of the Thoroughbred with a more docile and easily managed temperament. One such extremely popular cross is that of the Irish horse and the Thoroughbred.

In appearance, the Thoroughbred should have excellent conformation, having a finely modelled head set onto an elegant and arched neck. The shoulder should be sloping, with a defined wither, and a short, strong back. The quarters should be muscular with clean legs and let-down hocks. Their coat is often silky smooth, and can be any whole color with white markings. They tend to stand at between 15.2 hh and 16.hh.

Top
The quarters of the Thoroughbred are muscular, the legs clean and the coat silky smooth.

Bottom
Sometimes the breed can be temperamental or easily frightened but generally it is an ideal hacking or eventing horse.

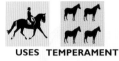

BLOOD TEMPERATURE

USES TEMPERAMENT

HORSE FACT:
'Before assuming a horse has a light mouth one must be certain the rider has a light hand'.
Alessandro Alvisi.

Trakehner

○○○○○○○○○○○○○○○○○○○○○○○○

BREED INFORMATION

NAME	Trakehner
APPROXIMATE SIZE	16–16.2 hh
COLOR VARIATIONS	Any solid color
PLACE OF ORIGIN	Germany

THE TRAKEHNER originated in the former East Prussia, which is now part of Lithuania, and is an extremely ancient breed. Very early settlers to this area were the Scythians who were great horsemen, and bred a tough and stocky type of horse to act as their transport and for use during battle. These very early horses were based on a combination of the local native Schweiken breed, which is now extinct, Mongolian ponies, and possibly Turkmenian blood. While that ancient original breed bears no comparison to the modern Trakehner, it is likely that the Trakehner owes its toughness, endurance and stamina to those early forefathers.

By the 13th century, a horse-breeding system had been firmly established and horses were being bred to perform all necessary chores, including working the land, working in harness, being ridden and warfare. It was not, however, for another 500 years that efforts were made to establish a set breed of a far more elegant and refined nature. In 1732, a Royal Stud was opened at Trakehnen by Frederick William I of Prussia which became a center for the development of a new breed. Local base stock was crossed with Arab, Turkoman and early Thoroughbred types, and selective breeding of the progeny led to the emergence of a breed with fixed characteristics. Principal aims had been to develop an elegant carriage horse which was also suitable for use by the military in the cavalry.

In 1787, after the death of Frederick, the stud was taken over by the state and there were further

infusions of Thoroughbred, Turkish, Danish, and Mecklenburg blood. The studbook was finally opened in 1878, and Arab and Thoroughbred blood was used continually to upgrade the stock. The Trakehner quickly became extremely popular and was widely used by the cavalry during the First World War. The period between the First and Second World Wars saw the Trakehner reach new heights of popularity, as they were ridden to victory in the 1924, 1928, and 1936 Olympic Games.

Between 1921 and 1936, the Trakehner proved its mettle and won the hair-raising Grand Pardubice Steeplechase an astounding nine times. Disaster struck, however, during the Second World War and the breed was all but wiped out. In 1944, a total of approximately 800 of the best Trakehner specimens fled in the face of

Top
The Trakehner is an ancient breed that originated in Prussia.

Bottom
Nowadays a wonderfully versatile horse, the Trakehner is used in all manner of competitive riding.

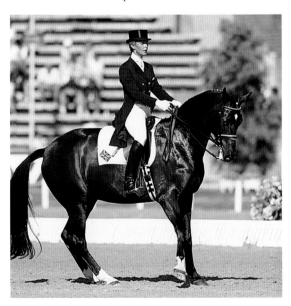

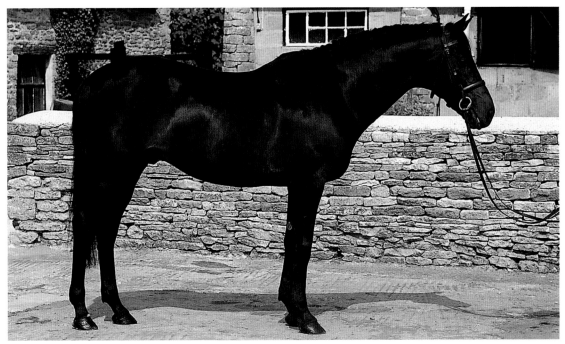

the Russian army towards West Germany. The gruelling journey only left approximately 100 Trakehners – the others having died *en route*. Those that had been left behind were taken by the Russians and there is a strain of Russian Trakehner still thriving there today. An association was formed in Germany in 1947 to try to re-establish the breed, which was a success, and now the Trakehner is bred widely throughout Germany.

The Trakehner has been very skilfully developed as a breed and, although a large amount of Thoroughbred blood has been used, there have always been efforts made to maintain the Trakehner sense and temperament. One early Thoroughbred who was to have a great influence on the breed, was Perfectionist, son of Persimmon, who ran to fame winning the Epsom Derby and the St. Leger in 1896. Perfectionist sired the stallion Tempelhuter, and most modern Trakehners can be traced back to these two horses. There has also been a steady use of Arab blood on the breed, which was considered to offset any possible flaws the Thoroughbred might pass on, and in some cases the Arabian heritage is still visible in the modern Trakehner.

The Trakehner of today has become one of the most versatile competition horses of our time and is recognized as such on an international scale. They have competed in virtually every ridden sphere at the very highest levels of competition, and have proved themselves to be both excellent dressage and jumping horses. Through selective and carefully monitored

breeding, the Trakehner has become an animal of excellent conformation and great quality. They naturally have great stamina, are very courageous and have a quiet, but energetic temperament.

In appearance, the head shows the influence of the Thoroughbred, and is finely modelled and very attractive. They have a well-made and elegant neck set to powerful sloping shoulders, which allow for their excellent free-flowing movement. They have a strong and muscular frame, which denotes speed and athleticism, with sturdy and hard legs. They are deep and wide chested, have a nicely rounded barrel and compact back, with very powerful hindquarters. The tail is set and carried high, and adds to their overall presence and elegance. Any solid color is permissible and they range in height between approximately 16 hh and 16.2 hh.

Top and Bottom
The influence of the Thoroughbred is obvious in the fine shape of the head, the powerful shoulders and the free-flowing movement.

369

BLOOD TEMPERATURE

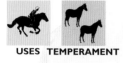

USES TEMPERAMENT

Turkoman

○ ○

BREED INFORMATION

NAME	Turkoman
APPROXIMATE SIZE	15–16 hh
COLOR VARIATIONS	Any solid color
PLACE OF ORIGIN	Turkmenistan, Iran

THE TURKOMAN, or Turkmene, was a very ancient breed of horse bred in the Turkmenistan area of Central Asia. The Akhal-Teke and Yamud are the modern representatives of the ancient breed, which is now technically extinct, but horses raised in the Turkmenistan area are still referred to as Turkoman and do have similar characteristics. The Turkoman horse has a unique body shape, which is extremely slender, and is probably best described as the equine version of the grayhound. They have often been severely criticized as being poor and weak, which in fact could not be further from the truth. This ancient breed, and its modern representatives, are among the toughest in the world and not only that, they have also been influential in the development of numerous breeds, not least the Thoroughbred.

The Turkoman horses are raised in a very unusual manner which, nevertheless, has contributed towards their particular characteristics. The mares are kept in large herds in a semiwild state and have to fend for themselves against the climate and predators, and find their own food. Colts are caught when they are approximately six months old which is when their training effectively starts.

The Turkoman horses are now bred mainly for racing, at which they are very talented. The colts are kept on the end of long tethers and this is how they will remain, often for life. At just eight months old, they are saddled and ridden by young, lightweight riders, and by the time they are one, they are performing on the racetrack. The horses are fed a highly specialized, high-protein diet, consisting of boiled chicken, barley, dates, raisons, alfalfa, and mutton fat, and are kept under cover of thick felt blankets which produce profuse sweating during the hot day and helps to keep the horses lean and with practically no body fat.

Their training and care is done very carefully and they are animals of exceptional endurance and stamina. They are naturally extremely fast and have a free-flowing movement with an elegant disposition. In appearance, they have a proud head with a straight profile, a long muscular neck, sloping shoulders, a long back, sloping quarters, a tucked-up abdomen, and long muscular legs. Their coat can be any solid color, often with a metallic sheen, and they stand at between 15 hh and 16 hh.

Top
The Turkomen is a very ancient horse breed with a slender body shape.

Bottom
Despite its fragile appearance, this is a very tough breed which is also extremely fast.

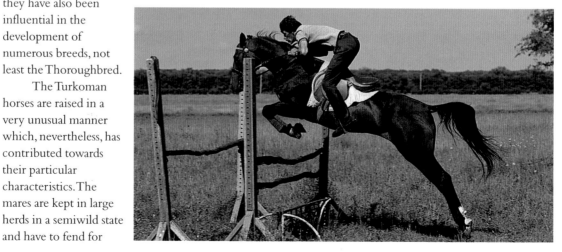

Ukrainian Riding Horse

BREED INFORMATION

NAME	Ukrainian Riding Horse
APPROXIMATE SIZE	15.1–16.1 hh
COLOR VARIATIONS	Bay, brown, and black
PLACE OF ORIGIN	Ukraine

BLOOD TEMPERATURE

USES TEMPERAMENT

THE UKRAINIAN RIDING HORSE is a recent breed that was developed in the Ukraine at the end of the Second World War to meet increasing demands for an all-around sports horse. The breed was developed at the Ukraine stud in Dnepropetrovsk, and is now bred at three other main studs in the Ukraine those of Derkulsk, Yagolnitsk and Aleksandriisk. The breed was very successfully established; its characteristics were fixed in a relatively short space of time due to the very careful selective breeding processes.

Initially, the breed evolved as a result of crossing Trakehner, Hanoverian, and English Thoroughbred stallions with local mares, or with Furioso and Gidran mares from Hungary. The resulting progeny were then assessed and the best were interbred to establish a type. Sensible use was made of both the Thoroughbred and Hanoverian and progeny that was too heavy in build and lacking quality was subsequently crossed with Thoroughbreds; those that were too fine were crossed with Hanoverian. Hanoverian and Thoroughbred is the only blood that has been used to improve, upgrade, and establish the stock, after the initial foundations were laid. When breeders were laying the foundations for the breed, there was a concentrated effort to use stock containing the blood of the Russian Saddle Horse, a breed which is now extinct, and there is one line, the Bespechny line, which contains Russian Saddle Horse blood.

The horses are kept in a very regulated environment and are fed on a very good diet. Their training starts just before they turn two and they are required to undergo performance testing as two- and three-year-olds, both on the racetrack, and in dressage and jumping. Only the best of the performers are then returned to stand at stud.

They are big, upstanding, quality horses that are ideally suited to competitive work, and have proved to be excellent at dressage, showjumping and cross-country.

In appearance, they have a well-proportioned, attractive head, a long and muscular neck, a deep and wide chest, sloping shoulders, a long back which can be hollow, and a long and sloping croup. The legs tend to be sturdy with good feet. Mostly chestnut, bay, or black in color, they stand from 15.1 hh and 16.1 hh.

Top
The Ukranian has been bred since the 1940s in direct answer to demand for an all-round sports horse in the Ukraine.

Bottom
The horse has well-balanced head and long, muscular neck.

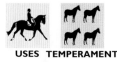

BLOOD TEMPERATURE

USES TEMPERAMENT

Wielkopolski

○○○○○○○○○○○○○○○○○○○○○○○○○○

BREED INFORMATION

NAME	Wielkopolski
APPROXIMATE SIZE	16–16.2 hh
COLOR VARIATIONS	Any solid color
PLACE OF ORIGIN	Poland

THE WIELKOPOLSKI developed in Central and Western Poland during the end of the 19th century so is still a relatively young breed. They developed primarily through crossing between two Polish warmblood breeds which are now sadly extinct. These were the Pozan and Masuren, the former being bred at studs at Posadowo, Racot, and Gogolewo, and the latter being bred at Liski in the Masury region. Both the Pozan and Masuren were notable breeds in their own right. The Pozan, which was a mix of Arabian, Thoroughbred, Trakehner, and Hanoverian blood, was a versatile middleweight farm worker, useful for riding and agricultural chores. The Masuren was a quality riding horse, chiefly Trakehner in origin. Once these two breeds had been crossed, and a base was formed, there were further infusions of Thoroughbred, Arab and Anglo-Arab blood, until the breed had established fixed characteristics.

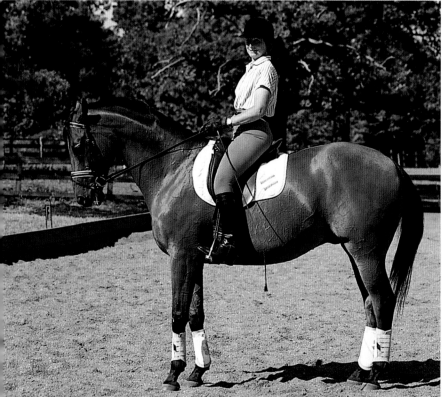

Top and Bottom
The Wielkopolski is a relatively young breed of horse, which has become a strong, talented warmblood horse.

The Wielkopolski is an extremely talented and versatile horse and is quite possibly one of the best warmblood breeds, although it is the least publicized. They have excellent temperaments, are strong and hardy, and are noted for their comfortable, long, free paces. They are naturally athletic and fast, due in part to the Thoroughbred blood in their background, and as such make first-class jumping and eventing horses. The Wielkopolski has also proved its abilities in the higher eschelons of the dressage world and has a naturally balanced and poised way of moving. They are highly versatile, and are generally bred along two lines: one lighter for competitive riding, and one slightly heavier, which makes an excellent harness horse as well as a good, middleweight riding horse.

In appearance, the Wielkopolski is an attractive, quality horse with presence and style. They have a fine head with a straight profile, and intelligent eyes. Both Arab and Thoroughbred influences are sometimes apparent in the head, which is well set to an elegant and long neck. The shoulders are sloping and muscular, and the chest is deep and wide. They are compact and deep through the body, with very muscular 'power house' quarters. Often they are inclined to be long in the leg, with good joints and well defined tendons. They can be any solid color, and stand between 16 hh and 16.2 hh.

Württemberg

BLOOD TEMPERATURE

USES TEMPERAMENT

THE WÜRTTEMBERG ORIGINATED at the state owned Marbach stud in Württemberg, Germany during the 17th century. The Marbach stud was, and is, widely respected as a center for horse breeding of a very high quality, and during the 17th century, was primarily concerned with breeding versatile horses suitable for riding and driving. The original Württemberg was rather different from that which we see today. The breed was produced as a result of crossing local warmblood mares with Arab stallions, and then later Trakehner, Anglo-Norman, Friesian, Spanish, Barb, and Suffolk Punch blood was introduced.

One of the most significant early influences on the Württemberg was an Anglo-Norman stallion called Faust, who was a cobby type, and appears largely responsible for establishing the early shape of the breed. They were originally more coblike in conformation and stature and were suitable for light draft and farm work, as well as for ridden work. The Württemberg was officially recognized as a breed in 1895 when their studbook was formed. However, there has been a steady change in the breeding of the Württemberg, towards the lighter sports horse we see today. Highly influential in this change was the infusion of Trakehner blood, most notably from a stallion called Julmond (which died in 1965), which has greatly improved the breed.

Typically, the Württemberg has an excellent temperament, and is also extremely tough and hardy, as well as being economical to feed. They are generally considered to be a sensible type, which probably stems from the early influence of Faust, and yet combine this with a lively and free action which is a throwback to their Arabian ancestry. They are very correctly proportioned for a riding horse and make excellent competition horses, excelling at both jumping and dressage.

In appearance, they are attractive, medium-sized horses of quality, with a sensible head with alert ears, a muscular neck, and prominent withers. They should be deep and broad chested, with a long, straight, and strong back. The quarters should be sloping with the tail well set on. They have very strong legs with hard hooves, and generally have a good, free action. Normally bay, chestnut, brown, or black in color, they stand at approximately 16 hh.

Top
The horse has been deliberately bred to a lighter standard than previously as this has made the breed faster.

Bottom
With a sensible head and very strong legs, these are good quality riding horses.

HORSE FACT:
The first proper, and formal, racetrack in America was established in 1665 on Long Island, and was originally called New Market after the English racing center.

Useful Addresses

SOCIETIES, ASSOCIATIONS, AND CLUBS

Canadian Driving Society
PO Box 52587
1801 Lakeshore Road West
Mississauga, Ontario
L2J 456 Canada
Phone: (905) 822-4638

Canadian Sport Horse Association
Box 98, 40 Elizabeth Street
Okotoks, Alberta
TOL 1TO Canada
Phone: (403) 938-0887
Fax: (403) 938-5441

Canadian Equine Research Center
50 McGilvary Street
Geulph, Ontario
N1G 2W1 Canada
Phone: (519) 837-0061
Fax: (519) 767- 1081

Canadian Federation of Humane Societies
102-30 Concourse Gate
Nepean, Ontario
K2E 7V7 Canada
Phone: (613) 224-8072
Fax: (613) 723-0252

Canadian Equestrian Federation
2460 Lancaster Road
Ottawa, Ontario
K1B 4S5 Canada
Phone: (613) 248-3433
Fax: (613) 248-3484

Draft Horse Association
2065 Noble Ave
Charles City, Iowa
50616-9108 USA
Phone: (515) 228-5308

Horse Trials of Canada
RR#1
Dwight,Ontario
POA 1HO Canada
Phone: (705) 635-1569
Fax: (705) 635-9790

Horses in Canada
Website: www.horsesincanada.com

National Cutting Horse Association
4704 HWY 377 South
Fort Worth, Texas
76116-8805 USA
Phone: (817) 244-6188
Fax: (817) 244-2015

North American Riding for the Handicapped Association
PO Box 33150
Denver, Colorado
80233 USA
Phone: (303) 452-1212
Fax: (303) 252-4610

MAGAZINES AND PUBLICATIONS

EQUUS
PO Box 420235
Palm Coast, Florida
32142 USA
Phone: (904) 445-4662
Fax: (904) 447-2321

Draft Horse Journal
PO Box 670, Dept EQ
Waverly, Iowa
50677 USA
Phone: (319) 352-4046
Fax: (319) 352-2232

Polo Player's Edition
3500 Fairlane Farms Road #9
Wellington, Florida
33414-8749 USA
Phone: (561) 793-9524
Fax: (561) 793-9576

Miniature Horse World Magazine
C/O AMHA
5601 South Interstate 35W
Alvarado, Texas
76009 USA
Phone: (817) 783-5600
Fax: (817) 783-6403

Jump! Magazine
2593 Chino Hills Parkway, Suite K
Chino Hills, California 91709 USA
Phone: (909) 393-3393
Fax: (909) 606-3468

The Blood-Horse
PO Box 4038
Lexington,Kentucky
40544-4038 USA
Phone: (606) 276-6757
Fax: (606) 276-4450

Bibliography & Further Reading

Anthony Amaral, *Movie Horses, Their Treatment and Training* (1967)

D W Antony, R H Meadow and H P Uerpmann (eds.), *Equids in the Ancient World (Domestication of the Horse)* (1991)

Alessandro Alvisi, *Horse and Man, Aphorisms and Paradoxes* (London Country Life Limited)

J Baker, *Saddlery and Horse Equipment* (Arco Publishing Inc. 1982)

Norman Barrett, *The Daily Telegraph Chronicle of Horse Racing* (Guinness Publishing, 1995)

Maurizio Bongianni, *Horses and Ponies* (Simon & Schuster, 1987)

Stephen Budiansky, *The Nature of Horses* (The Free Press, 1997)

T Bullfinch, *Bullfinch's Mythology*

Juliet Clutton-Brock, *Horse Power* (Natural History Museums Publications, 1992)

E H Edwards, *Complete Book of Horse and Saddle* (Exeter Books, 1981); *The Illustrated Encyclopedia of Equestrian Sport* (Chartwell Books, 1982); *Horses* (Dorling Kindersley, 1993); *Encyclopedia of the Horse* (Dorling Kindersley, 1994)

Jo French, *The BHSAI Course Companion* (J A Allen, 1990)

Sir Ernst Gombrich, *The Story of Art* (Prentice Hall Humanities/Social Sciences 1995)

B L Hendricks, *International Encyclopedia of Horse Breeds* (University of Oklahoma Press, 1995)

Georgie Henschel, *Horses and Ponies* (Kingfisher Books, Ward Lock Ltd, 1980)

J Hickman & M Humphrey, *Hickmans Farriery* (J A Allen, 1988)

E D Hirsch, J F Kett and J Trefil (eds.), *Dictionary of Cultural Literacy Second Edition*

D Machin Goodall, *Horses of the World* (Country Life Ltd, 1965)

Sandra Olsen (ed.), *Horses Through Time* (Roberts Rinehart Publishers for Carnegie Museum of Natural History)

J Pullein Thompson, *The Batsford Colour Book of Ponies* (Batsford, 1962)

R J Riegel and S E Hakola, *Clinical Equine Anatomy and Common Disorders of the Horse* (Equistar Publications Ltd, 1996)

D E Rubin, *Horse Trivia, A Hippofiles Delight* (Half Halt Press, 1995)

Julian Seaman, *Turfed Out* (Robson Books, 1988)

A Shinitzky, *Teeth, A Guide to Aging* (Equus Medical Library, 1993)

G G Simpson, *Horses, The Story of the Horse Family in the Modern World and Through Sixty Million Years of History* (Oxford University Press, 1951)

Colin F Taylor, *Native American Myths and Legends* (Salamander, 1994)

The Pony Club and BHS, *The Manual of Horsemanship* (1983)

Robert Vavra, *Classic Book of Horses* (William Morrow & Co Inc, 1992)

J N P Watson (ed.), *The Worlds Greatest Horse Stories* (Paddington Press Ltd, 1979)

Glossary

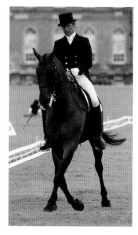

Above the bit: when the horse carries its head high, so that the level of the horse's mouth is above the level of the rider's hand.

A good length of rein: a neck that is nicely in proportion to the body, and not too short; also well set on to a good shoulder.

Aged: a horse that is 15 years old or older.

Aid: a signal given to the horse by the rider such as the aids for canter, asking the horse to canter.

Airs above the ground: exercises of the High School or classical equitation which result in either both forelegs, or forelegs and hind legs, leaving the ground.

Backed: the process of starting a young horse; mounting and riding away for the first time.

Barrel: the horse's body from behind the shoulder to the loins.

Bars of the mouth: the area of the mouth between the incisors and the molars, where the bit rests.

Behind the bit/over bent: when the horse holds its head behind the vertical with the chin brought in too close to the chest; is a form of resistance.

Bone: a horse's bone is measured just below the knee or the hock; the larger the circumference of the bone, the more weight-carrying ability the horse should have.

Bow hocks: a conformational defect, when looking at the horse from behind, the hocks appear to bow out from each other. The opposite of cow hocks.

Boxy feet: hooves that are excessively narrow and upright in formation; similar to those seen in a donkey.

Broad and deep: a well-structured chest that is solid and wide, but not too wide. Traditionally, if a bowler hat could be placed between the two front legs directly under the chest, it was an indication of a good size of chest.

Bronc: a bucking horse, usually used in the rodeos of the American West.

Brush/to brush/brushing: a faulty action where the horse strikes into the fetlock and lower leg region with the shoe of the opposite foot.

Capped elbows/ capped hocks: when a swelling occurs in either area as a result of a direct blow, or chaffing.

Capillary test: press the gum with your thumb which temporarily restricts the flow of blood to that area. When you remove your thumb, the blood should immediately flow back into the capillaries; if it takes longer than normal, it is a sign of ill health.

Clean-legged: a horse that does not have any feathering (long hair) on the lower part of the leg.

Cobby type: a horse that has conformation similar to a cob – stocky, sturdy and strong, with short legs and rounded barrel.

Collection: the horse moving forward with impulsion from behind into a shortened and raised stride.

Colt: an uncastrated male horse under four years of age.

Concussion: the jarring caused to the foot and lower leg by the impact of the horse's foot hitting the ground. Concussion is greater on harder ground.

Condition: the shape the horse is in, its state of health, how much work it is doing, and how much food it is eating. Good condition describes a fit and healthy horse with good muscle development. Poor condition describes a horse that is run down, underweight and with little muscle development. 'Good but soft condition' describes a healthy horse that is not fully fit and lacks muscle development.

Conformation: the way the horse is constructed, with particular emphasis on the proportion of the body parts. (This phrase is not to be confused with 'condition.')

Cover: the mating process between a mare and a stallion, when a mare goes to stud to be covered by a stallion.

Cowboy: someone who makes his living through working on a ranch with cows.

Cow-hocked: a conformational fault. When looking at a horse from behind, if the hocks turn in towards each other it is called 'cow-hocked.'

Cow-sense: a horse with cow-sense has a particular aptitude for working cows, and appears to anticipate the cow's next move.

Crib-bite: an undesirable vice consisting of the horse chewing on the stable door, fences, or any hard surface. Persistent crib-biting can develop into windsucking.

Dam: the female parent of a horse.

Dappled: a coat coloring where a pattern of darker hair overlays a lighter coat, often in seemingly circular or semi-circular fashion.

Dorsal stripe: most commonly seen on a dun coat coloring, a dark stripe running from the withers along the spine to the top of the tail. Occasionally seen in conjunction with wither stripes, which are another dark line extending out from the withers on either side, down towards the shoulders.

Deep through the girth/depth of girth: the measurement taken from the wither to the elbow; a good depth of girth is a desirable conformational feature indicating plenty of room for the expansion of the lungs.

Dishing: a type of faulty front action where the front legs from the knee down move in an outward circular motion.

Engaged hocks: when a horse moves well behind, with a good muscular hind action, with the hind legs well underneath the horse and not trailing out behind the quarters.

Ergot: the small horny growth present at the back of the fetlock joint.

Ewe-necked: a conformational defect; a neck that has over-developed muscle on the underside and a dipped outline on the top side.

Farrier: the trained and qualified person responsible for shoeing and trimming horses' feet.

Feathering: long hair on the lower part of the legs, most often seen in the heavier horse breeds and in some of the highland pony breeds.

Feral: an animal that was once domesticated, but has since been released/escaped into the wild and has established itself living successfully in a wild state.

Filly: a female horse until she is fully grown, which is generally taken as four years of age.

Flea-bitten: a horse with a grey coat coloring that has a quantity of dark hairs distributed throughout it, giving it a freckled appearance.

Flexion: when the horse yields to the bit through the jaw, with the head bent in the correct position through the poll. There should be no tension or resistance.

Forearm the top part of the horse's front legs, above the knee.

Forehand: the horse's body from the withers forward, including the forelegs, shoulders, neck, and head.

Four-square: a horse that is solidly built and appears to have a 'leg at each corner.'

Frog: the wedge-shaped, elastic horn which is found on the sole of the foot; helps concussion and grip.

Frugal: a horse which survives well on minimum food rations.

Gelding: a male horse that has been castrated and so is unable to reproduce.

Good doer: a horse that thrives on a minimum amount of food.

Grooming: the process by which horses bond and clean each other, by mutual chewing up and down the neck, withers, and back. Also the process used to brush and clean the domestic horse.

Half-bred: the progeny of two different breeds of horse; for example, a Thoroughbred crossed with an Irish horse would be a half-bred.

Hands (hh): the unit of measuring a horse. One hand is equal to 4 in (10 cm), horses are measured in hands and inches, so, for example, a horse that is 15.2 hh, is 15 hands and two inches high.

Harem: a band of a few mares that a stallion will preside over in the wild.

High School/haute école: advanced dressage movements; the art of classical equitation.

High-set tail: a horse with a tail starting from high on the quarters; they tend to often carry the tail high and this can often be quite eye-catching.

Hindquarters/quarters: the area of the body from the flank backward to the start of the tail.

In heat/in season: a mare who is in her oestrus cycle; it is at this the time that she is likely to be receptive to a stallion.

Jibbah: the shield-shaped bulge on the forehead of the Arabian.

Kicking boards: wooden boards placed around the inside wall of the stable up to a height of 4 ft (1.2 m). They can also be used around the inside walls of both indoor and outdoor schools, and in this case they are often much lower.

Kicking boots: felt boots placed on the back feet of a mare before she is covered by a stallion. They protect the stallion, should she kick him.

Knock-kneed: where the knees appear to bow in toward each other.

Koumiss: a drink made from fermented mare's milk.

Leg at each corner: a horse that has a good, deep chest, and ample room between the legs so that they do not appear excessively narrow.

Light-boned: when the measurement of bone below the knee is too small in comparison to the size of the horse, which is a conformational fault.

Loaded shoulder: when a horse has excessive muscle development over the shoulder, which can restrict movement.

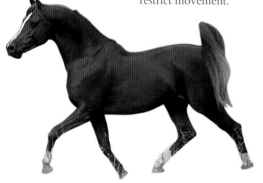

Loins: the lower part of the back, behind the saddle and in front of the quarters.

Low-set tail: a tail that sits low on the quarters, which can often be indicative of weak and sloping quarters.

Mare: a fully grown female horse.

Mitbah: the angle at which the Arabian horse's head meets the neck; it forms a particular arch that allows for a very free movement of the head.

Nap/nappy: a horse that refuses to proceed in the direction asked. It is obstinate and wilful, and will often rear or spin round to avoid going forward. This type of behavior is commonly demonstrated when a horse is asked to leave a group of horses behind, or when it is leaving its stable or yard.

Near side: the left-hand side of the horse; the near fore is the front left leg.

Nicked: the practice of cutting and rejoining the muscles under the tail to produce an exaggeratedly high tail carriage.

Numnah: a protective pad worn underneath the saddle.

Off side: the right-hand side of the horse; the off fore is the front right leg.

Oriental horse: a horse originating from Central or West Asia.

Overreach: an injury which occurs when the horse strikes into the heel area of the front foot with the toe of its hind foot.

Pacing: when the horse moves its legs in lateral pairs at the trot; i.e. off fore, off hind together, followed by nearside pair.

Pack: a horse or pony used to transport goods on its back, usually in a 'pack saddle,' which is designed for this purpose.

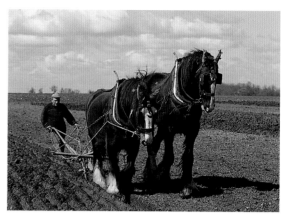

Part-colored/coloured: either a skewbald or a piebald horse.

Piebald: a horse which is black and white in color.

Pigeon-toed: a horse that has its hooves turning inwards; this is a conformational defect.

Pinto: the American term for a part-colored horse, such as a skewbald or a piebald, which is when the coat is white and has patches of another color.

Plenty of bone: a horse that has a generous measurement of the circumference of the bone below the knee; this is generally taken to be 8 in (20 cm) or more in the horse.

Poll: the area of the top of the head that lies between the ears.

Primitive features: a horse which exhibits characteristics associated with the primitive horse breeds such as the Tarpan and the Przewalski.

Pulling the mane: the process by which the mane is thinned and shortened by removing hairs from the underside of the mane. Tails can also be 'pulled,' the hairs are removed from the sides and underneath of the top section of the tail to improve the appearance.

Quality: a horse with evident good breeding and refinement, most commonly associated with the Thoroughbred or the Arabian.

Recoil test: on a healthy horse, if you pinch the skin of the neck and then release it , the skin should recoil immediately. If the skin takes longer than normal to recoil, it is an indication that the horse is unwell and can in cases indicate dehydration.

Roached mane: a mane that has been shaved off, usually also referred to as 'hogged,' and commonly seen in both polo ponies and cobs.

Roman nose: a convex profile to the head, often associated with the heavier breeds.

Running horse: the early English horses used for racing, which influenced the development of the Thoroughbred.

School/arena/menage: the enclosed area used for

training and riding. These may be indoor, with a roof and walls, or outdoor, where they are surrounded by a fence with no roof.

School (the verb): the procedure of riding and training the horse for a specific purpose.

Schoolmaster: a seasoned, experienced horse.

Sclera: the white outer membrane of the eyeball, seen mostly in the Appaloosa.

Sickle-hocked: a conformational fault, describing a horse with weak hocks and with the cannon bone angled too steeply forward.

Sire: the male parent of a horse, for example, the sire of Eclipse was a stallion called Marsk.

Skep: a plastic or rubber container similar to a basket which is used for collecting droppings from the stable.

Skewbald: a horse that is white and one other color, usually brown.

Slab-sided: a horse which has a 'flat' ribcage.

Stallion: an uncastrated (entire) male horse of over four years in age.

Stud book: the book kept by different breed societies in which the pedigree of stock eligible for entry are listed.

Stud: a breeding establishment or a stallion.

Sway-backed or dipped back: when the back dips excessively in the middle; this is most often seen in older horses and ponies.

Tack: the popular slang name for saddlery.

Teaser: a stallion that is used to test if a mare is in season and will be receptive to mating.

Thin soles: the surface area of the underneath of the foot which is in some breeds such as the Thoroughbred, 'thin' being susceptible to bruising very easily.

Tied-in below the knee: a conformational fault which describes a horse that has a smaller measurement of bone below the knee than above the fetlock.

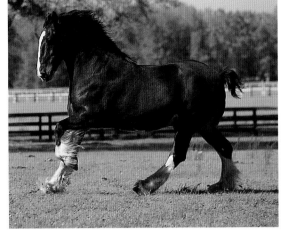

Top-line of the neck: the upper-most line of the neck from the withers to the poll. A good top-line should show a gentle upward curve from withers to poll, indicating that the horse works well in a natural outline.

Turned away: the period of rest of some duration, commonly given to the young horse after it has been 'backed.' It can also be used to describe the horse that has been turned out to grass for a holiday. For example hunters are often 'turned away' for the summer to recover from the hard work of the winter hunting months.

Weave/weaving: an undesirable vice where the horse stands and rocks itself from side to side, which in severe cases can result in strain to the front limbs.

Well let-down (with reference to the hocks): means that the hocks are close to the ground with the first and second thigh being well muscled.

Well-set (often used in reference to the neck or head being 'well set'): indicates that the conformation is good and the junction between the neck and head is correctly put together.

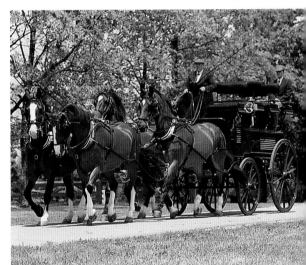

Well-sprung ribs: a horse with a nicely rounded ribcage allowing plenty of room for the heart and lungs.

Windsucking: a highly undesirable vice where the horse grips a solid object between its teeth, tenses its neck muscles, and swallows air down. In severe cases a horse will learn to do this without fastening on to anything, which can result in indigestion problems.

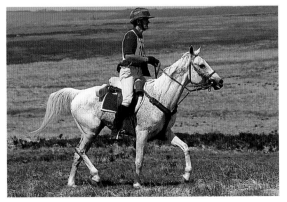

Picture Credits & Acknowledgements

With thanks to Claire Dashwood, Mark Stevens,Polly Willis and Karen Villabona for valuable editorial and design assistance.

The publishers would like to point out that veterinary practice differs from country to country and that local medical advice should always be sought.

Anatomical illustrations by Suzie Green: 10 (b), 11 (bl), 18 (tl), 19 (t), 47 (all), 60 (tl). **General illustrations** by Jennifer Kenna and Helen Courtney, courtesy of Foundry Arts 1999.

All pictures courtesy of Bob Langrish Photography except:

AKG, London: 135 (b), 144 (b), 145 (t), 145 (r), 145 (b), 146 (t), 146 (b), 147 (b), 148 (t), 148 (l), 148 (b), 149 (t), 149 (l), 149 (b), 150 (c), 151 (t), 151 (b), 156 (t), 156 (b), 157 (t), 157 (bl), 157 (br), 158 (t), 158 (b), 159 (t), 160 (tr), 160 (tl), 160 (bl), 161 (t), 161 (b).

Allsport USA: 132 (t), 132 (bl), 132 (br).

Animal Photography: R. Willbie 204 (b), 214 (b), 264 (t), 264 (b); Sally Anne Thompson 204 (t), 214 (t), 216 (tl), 216 (cr), 216 (bl), 237 (tr), 251 (b), 257 (t), 257 (b), 266 (t), 266 (b), 268 (b), 270 (tl), 270 (tr), 300 (b), 324 (t), 324 (b), 327, 331 (b); V. Nikiforov 220 (t), 220 (b), 237 (tl).

Ann Ronan at Image Select: 134 (l).

Ardea: 162 (t), 236;Ake Lindau 171 (t); Chris Knights 221 (b), 235 (tl), 235 (b), 268 (tl), 268 (tr); Dennis Avon 224 (b); Hans D. Dossenbach 196, 311 (b), 317, 331 (t); Jean-Paul Ferrero 204 (tl), 235 (tr); Joanna Van Gruisen 172 (cl); J. M. Labat & Y. Arthus-Bertrand 223, 322 (t), 322 (b); John Daniels 318 (t), 318 (b); Monica Dossenbach 348 (t), 348 (b); M. Watson 170 (t), 171 (b); P. Morris 229 (bl); S. Roberts 172 (t).

Bob Gibbons Natural Image: 38 (tr), 38 (l), 38 (br), 39 (tl), 39 (tr), 39 (b).

Bridgeman Art Library: 156 (l), 158 (l) 159 (b), 160 (br).

Bridgeman/Giraudon: 154 (t).

Christie's Images: 161 (cr).

Dorling Kindersley Picture Library: 231, 286, 293 (t), 293 (b), 370 (t), 373.

Giraudon: 150 (t), 150 (b).

Kit Houghton Photography: 18 (tr), 32 (tr), 32 (bl), 32 (br), 33 (r), 33 (bl), 40 (t), 41 (tr), 41 (l), 43 (tr), 43 (b), 44 (t), 45 (l), 50 (b), 58 (t), 59 (tr), 62 (t), 62 (b), 64 (t), 64 (b), 65 (br), 66 (bl), 67 (br), 68 (tl), 68 (tr), 68 (br), 69 (t), 71 (r), 71 (b), 72 (t), 78 (tr), 80 (bl), 80 (cr), 81 (tr), 81 (b), 98 (t), 98 (b), 99 (t), 107 (b), 136 (c), 195, 213 (t), 236 (t), 265 (cr), 275 (b), 291, 323 (t), 323 (b), 337 (b), 346 (tr), 350 (cr), 364 (b), 368 (b), 369 (t).

Topham: 134 (b), 135 (t), 136 (b), 138 (t), 138 (l), 138 (b), 139 (b), 140 (t), 140 (b), 141 (cr), 144 (t), 144 (l), 147 (t), 151 (r), 152 (b), 153 (t), 153 (r), 153 (b), 154 (l), 154 (b), 342.

Every effort has been made to contact the copyright holders and we apologise in advance for any ommisions. We will be pleased to insert appropriate acknowledgements in subsequent editions of this publication.

Index

INDEX

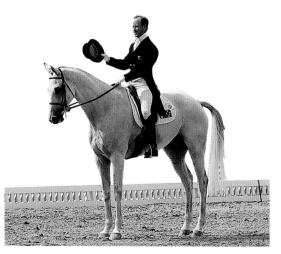

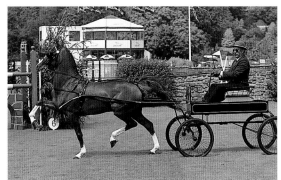

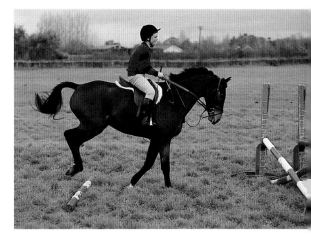